PRINTS AND PRINTMAKING

*A Dictionary and Handbook
of the Art in Nineteenth-Century Britain*

By the same author

British Romantic Art
(Bell & Hyman)

Infernal Methods: A Study of William Blake's Art Techniques
(Bell & Hyman)

Great Images of British Printmaking
(Robin Garton)

Letters of Samuel Palmer *(editor)*
(Oxford University Press)

Edward Calvert
(Bell)

George Richmond
(Robin Garton)

Samuel Palmer: A Biography
(Faber)

Samuel Palmer and His Etchings
(Faber)

William Blake: An Introduction
(Bell)

Old Maps and Globes
(Bell and Hyman)

Victorian Narrative Paintings
(Museum Press)

Prints
and
Printmaking

A DICTIONARY AND HANDBOOK
OF THE ART IN NINETEENTH-CENTURY BRITAIN

RAYMOND LISTER

METHUEN

First published in Great Britain in 1984
by Methuen London Ltd
11 New Fetter Lane, London EC4P 4EE
Copyright © Raymond Lister 1984

British Library Cataloguing in Publication Data

Lister, Raymond
 Prints and printmaking.
 1. Prints, British
 I. Title
 769.941 NE628

ISBN 0-413-40130-8

Typeset by ⟦F⟧ Tek-Art, Croydon, Surrey
Reproduced, printed and bound in Great Britain by
Hazell Watson & Viney Limited,
Member of the BPCC Group,
Aylesbury, Bucks

To John and Vera Hensher

with affection

Contents

List of Illustrations

Cheltnam, after J.P. Knight, 'The Army and the Navy: Meeting of
Lord Nelson and the Duke of Wellington (when Colonel Wellesley)'
from *Illustrated London News*.

William Blake, 'Satan smiting Job with Boils' from *Illustrations of
the Book of Job*.

James Duffield Harding, 'Shipley Bridge, Devon.'

Thomas Shotter Boys, 'Entry to the Strand', from *London as It Is*.

Edward Calvert, 'Ideal Pastoral Life'.

J. Brandard, 'Carlotta Grisi in the Ballet of The Peri'.

Alfred Concanen, based on designs by John Tenniel, Cover for music,
'The Looking Glass Quadrille'.

Daniel Maclise, J.H. Robinson, John Thompson and others, £5 note.

Henry Corbould, Perkins, Bacon and Petch, and others, One Penny
Black postage stamp.

Francis Holl, after W.P. Frith, 'The Railway Station'.

William Miller, after J.M.W. Turner, 'Melrose' from *The Poetical
Works of Sir Walter Scott*.

Acknowledgements

It is impossible in a book of this kind, the result of years of research and interest, to thank everybody who has helped with the work, or indeed even to recall every nuance of such help, but I must record my gratitude to Mr Eric Chamberlain of the Fitzwilliam Museum, who has read my typescript and offered many valuable suggestions and corrections. My cousin, Mrs Verna Cole, typed the work and helped in other ways. And, as always, I am grateful to my wife, Pamela, for help and suggestions at all times.

R.L.
Wolfson College
Cambridge

CHAPTER I

Introduction

Printmaking in the nineteenth century was so diverse both in its techniques and in its forms that we ought to begin by defining what is meant by a print. In general we may take it that it is a design or a picture printed from a block or plate engraved, cut, etched or otherwise treated by one or a mixture of a group of processes. Many of these processes are outlined in the following pages.

There is no difficulty in recognising a print as a separate artefact, whether it is an etching, a stipple or line-engraving, a wood-engraving, or even a photogravure. But the term spills over into so many manifestations, particularly during the period with which we are dealing, that we must look somewhat farther afield to see how much this definition ought to be extended.

Certainly it should include original prints used for book illustration, for which the demand was vast. The population of Britain had doubled between 1801 and the middle of the century and by 1901 had doubled again, reaching 40,000,000; it was, too, becoming more literate and therefore demanded more books than had previously been available, and these required illustrations which engravers were called upon to supply. Some engravers, like the Dalziel Brothers, were almost wholly occupied with book illustration.

Of course, not all book illustrations are prints in the sense of Cruikshank's illustrations for *Oliver Twist* or Leech's illustrations for the novels of Surtees — etchings or engravings printed by a non-photographic or non-mechanical technique. Yet if it had not been for the illustration of books it is unlikely that reproductive printmaking techniques would have developed so quickly or so plentifully as they did. So again some consideration, both of illustration and of the new techniques, is imperative if we are to appreciate fully the development of printmaking at this time.

For the same reasons it is necessary to include some consideration,

however limited, of such ephemera as postage stamps, banknotes and popular prints, for they accounted for a large part of the output of printmakers. Nor is it percipient to dismiss such things as mere products of commerce, for some of them are of considerable artistic merit: for instance, the line-engraved one penny black postage stamp of 1840 and the early lithographed stamps of the colony of Victoria, showing the Queen after whom it was named, seated on her throne. These are quite clearly works of art; the fact that they were printed in their millions does not alter that. In fact they could stand as object lessons in showing the possibilities of the application of good design to manufacture.

The same may be said of some banknotes, like the old black and white Bank of England £5 with its delightful little medallion of Britannia, engraved by John Thompson (1785—1866), who also engraved William Mulready's design for the envelopes issued with the first postage stamp in 1840.

Other forms of ephemera, too, must come within our definition, provided they are not merely typographical and contain designs or pictorial elements. The woodcut, for instance, played an important part in the printing of such things as posters and grocery and tobacco labels, these sometimes bearing exotic scenes from Cathay and the Indies. Wine and whisky labels, billheads, letterheads and trade cards are among other ephemera produced in lithography, line-engraving and other techniques. Some of them are objects of considerable beauty and artistic achievement, despite being more often than not the work of anonymous jobbing engravers. Not that this was invariably so, for William Blake (1757—1827) engraved a visiting card, one of the more pleasing of his smaller designs, for George Cumberland, an advertisement leaflet for Moore and Company of Moorfields, London, and pages for a catalogue for Josiah Wedgwood.

Notwithstanding what I have just written, we must keep this in perspective: the main subject of this book is the separate print — etching, line-engraving, lithograph, or what you will — intended for framing or mounting in an album, with book illustration close behind and ephemeral prints in a secondary, though not unimportant, place.

CHAPTER II

Printmaking at the Beginning
of the Nineteenth Century

British printmaking at the beginning of the nineteenth century was
in a promising state. Although some did not consider it to be one of
the higher arts — it was a long time before engravers were admitted
to the Royal Academy and, even when they were, they were at first
restricted to Associate Membership — many talented engraves were
or had been at work. Among these were William Woollett (1735—85),
Sir Robert Strange (1721—92), Gainsborough Dupont (1754—97)
and Thomas Watson (1743—81); some were still alive and working
at the beginning of our period — for instance John Raphael Smith
(1752—1812) and Valentine Green (1739—1813).

Working mainly in mezzotint, these engravers made plates after
old masters and contemporaries such as Sir Joshua Reynolds, Thomas
Gainsborough, George Stubbs and many others, exploiting the
painterly effects of mezzotint in order to reproduce the qualities of
the original paintings. These works were available among a wider
section of society than would have been able to see the originals.

But mezzotint did have its limitations; one of which was that,
until steel came into use, the plate was worn away in printing much
more quickly than in other, more deeply incised media, so that
comparatively few impressions could be taken from a plate. Also, as
in all forms of reproductive engraving, the reduction of a large
picture to the size of a smaller copperplate_involved considerable
simplification and the loss of a certain amount of detail. But the
fact remains that mezzotint is on the whole the nearest approach to
painting among engraving techniques and, in the hands of artists like
Valentine Green and John Raphael Smith, that approach was very
close indeed.

Mezzotint was the dominant technique of the late eighteenth
century, though a little later it was rivalled by aquatint. Sometimes
it was combined with other techniques; as in line-engraving and

3

aquatinting, the subject was sometimes etched on the plate before mezzotinting began, but etching was also used, sometimes combined with aquatint, after the subject had been mezzotinted, in order to enrich the tones.

There were nevertheless three great flowerings of the mezzotint during the early nineteenth century: in the *Liber Studiorum* of J.M.W. Turner (1775–1851), issued from 1807 to 1819, in the plates made by David Lucas (1802–81) after landscapes by John Constable, the first of which was published in 1830, and in the plates of John Martin (1789–1854).

In the *Liber Studiorum* a member of leading engravers, notably Charles Turner (1773–1857), were employed to mezzotint plates after drawings in pen and sepia by J.M.W. Turner, representing different methods of composition in landscape, pastoral, marine and historical subjects. Turner himself made many of the etched outlines and in a few cases also did the mezzotinting. Seventy-one plates were published.

Lucas's mezzotints after Constable were published as *English Landscape Scenery*. Artist and engraver collaborated so closely that these prints are among the most successful translations of painting into engraving ever made. They impart an added dimension to Constable's composition, by basing them on what he called 'the phenomena of the Chiaroscuro of Nature'.

Martin engraved his mezzotints on steel plates and they will be mentioned in this context in Chapter VI. But in passing we may note their excellence, especially in the case of his illustrations to *Paradise Lost* and the Bible.

Etching, after a period of neglect, was, at the beginning of the nineteenth century, becoming established as a medium in its own right as opposed to being a mere adjunct of other processes. Most of its practitioners, though, seem for a time to have been amateurs like John Clerk of Eldin, the Scottish etcher (1728–1812), but there were a few professionals of whom Alexander Runciman (1736–85), another Scot, is outstanding — his freely-worked plates of Romantic subjects adumbrate some nineteenth-century developments in the art. Other professionals included Thomas Worlidge (1700–66), who copied Rembrandt's plates, and Jonathan Richardson (1665–1745), Joseph Highmore (1692–1780) and Gervase Spencer (d. 1763), who etched their self-portraits.

The best work in the medium during the eighteenth century was

by artists like Thomas Rowlandson (1756—1827) and Paul Sandby (1725—1809), but then it was usually combined with aquatint. Thomas Gainsborough (1727—88) made soft-ground etchings, sometimes combined with aquatint, of landscape, and undoubtedly his work was an inspiration to others who came afterwards and worked in a similar imaginative vein.

Soft-ground etching was used also by Alexander Cozens (d. 1786) who amply and impressively demonstrated its effects. Later Cozens used conventional etching to splendid effect in his beautiful set entitled *The Shape, Skeleton, and Foliage of Thirty-two Species of Trees*, made in 1771; and he combined etching and aquatint in *A New Method of assisting the Invention in Drawing original Compositions of Landscape* (1785).

One of the most important forms of etching in the latter part of the eighteenth century was caricature. Many etched caricatures were made anonymously but in time the art attracted the attention of some first class artists, among whom Rowlandson and the highly satirical James Gillray (1757—1815) were supreme.

Rowlandson had more sides to his genius than caricature. He produced some inspired topographical and pastoral scenes, though the latter were cast in a more roughly bucolic mould than the later, more gently Virgilian pastoralism of artists such as Edward Calvert and Samuel Palmer (which we shall consider in their place). And we must not overlook Rowlandson's coloured book illustrations, for instance *The Tours of Dr Syntax* (1812—20) and the *Microcosm of London* (3 vols., 1808—10), for they were the predecessors of those fine engravings in illustrated books which were of major importance in the nineteenth century.

And not only in illustrated books, for in every form of printmaking colour became important. It had been partly developed during the eighteenth century, its earliest exponent in England being Elisha Kirkall or Kirkhall (1682—1742), the son of a locksmith, who made coloured engravings in a mixture of etching, line-engraving, mezzotint and roulette work. These were coloured and printed *à la poupée*.

Another engraver working on early colour prints was the German Jacob Christoph Le Blon (b. Frankfurt 1667), who got his effects by printing the three primary colours (red, yellow, blue) on three different plates, usually with a fourth plate in black. Finding no support for his invention on the Continent, Le Blon brought it to England where he was more successful.

Aquatint also was being developed in England and it is probable that it was first used here in 1771 by P.P. Burdett of Liverpool. The process was known in the previous century, but it was not until many years later, in 1768, that it was put to extensive use by the French painter and engraver Jean Baptiste Leprince (1734—81), who is said to have told Paul Sandby about it.

In time it was possible to aquatint a plate in up to three separate tints, the plate being inked to indicate three main planes: sky or distance, middle distance, and foreground. Some were printed in colour, but this caused difficulties in wiping, and they usually needed hand touching after printing. Because of this it was more customary to colour them by hand.

The applications of the aquatint were numerous, and it was outstandingly successful in the production of richly illustrated books, many of them of sporting or topographical interest. The greatest publisher of these — editions sometimes ran into two or three thousand copies — was Rudolf Ackermann (1764—1834) who employed a large number of colourists to work on them.

Ackermann, who was born in Saxony, started life as a coachbuilder. After travelling for a time on the Continent he eventually settled in London, at first working as a designer for coachbuilders, but later, in 1783, setting up as a printseller. His shop in the Strand, the Repository of Arts, became a mecca for publishers of prints.

Fine aquatints were of course issued by other publishers; one such work was the series of topographical aquatints in eight volumes, *A Voyage around Great Britain* by William Daniell, which was published by Longman and Company of Paternoster Row, London. It appeared between 1814 and 1825, at the beginning of our period, and marked the apogee of the art of aquatint applied to landscape. More than any of his predecessors, William Daniell realised the painterly qualities of his medium, working in tones to a greater extent than had hitherto been seen.

The results are magnificent, the coastline of Great Britain being lovingly and painstakingly represented and, in addition, overlaid with the spirit of Romanticism as surely as any painting. In this series the engraver's claim to be considered an artist of the highest class is vindicated. It is true that Daniell was working from his own designs, and was therefore to begin with on a different level from the reproductive engraver. But whatever the circumstances *A Voyage around Great Britain* is remarkable.

These aquatints are an almost mystical evocation of the British coast from its commercial aspect at Liverpool and on the Clyde, to the delights of Tenby and Southend and the grandeur of Fingal's Cave and the Shiant Islands. In a way they make a statement about Great Britain, steeped in the outlook of the early nineteenth century, which may be paralleled with Christopher Saxton's engraved cartographic illustrations of England during the Elizabethan Age in *An Atlas of the Counties of England and Wales* (1579) or with John Speed's *Theatre of the Empire of Great Britaine* (1611). These maps, like Daniell's views, manifest pride in Britain, although their statement is more formal, as might be expected considering the times in which they were made.

But Daniell's work is all Romanticism. The towering cliffs of the Shiant Isles, with their myriads of sea birds; the mouth of Fingal's Cave on a calm day with a party of sightseers arriving, with the hope perhaps of hearing its weird musical effects (it was, though, some years before Felix Mendelssohn was inspired by the same scene to compose his *Hebrides* overture); the dizzy Clett Rock on Holburn Head, its strata standing out in great serrations laid bare by erosion, with cormorants and gulls perched on it or flying around in flocks — these scenes are of the very stuff of Romanticism, located moreover in a Scottish setting, for Scotland was above all the Romantic country *par excellence*. These prints are among the most notable harbingers of nineteenth century Romanticism.

Wood-engraving, one of the most ubiquitous printmaking techniques of the next hundred years, especially in book illustration, was being freshly developed in the opening years of the century. This was due mainly to one man — Thomas Bewick of Newcastle-on-Tyne (1753—1828).

Bewick had found woodcutting (that is, cutting with a knife along the plank of the wood) in what can be best described as a state of crudity, restricted, with comparatively few exceptions such as the chiaroscuro woodcuts of John Baptist Jackson (*c.* 1700—*c.* 1770), to the roughest technique and used mainly for the decoration of broadsheets and ballad sheets or for the illustration of chapbooks. This kind of woodcutting was to become an influence again later in the nineteenth century, on the work of artists such as Joseph Crawhall (1793—1853) and in the early twentieth century on that of Claude Lovat Fraser (1890—1921); but at the beginning of the century it was Bewick who dominated the scene. He reacted completely from

7

black and white knife-work and instead engraved on the end grain of boxwood, composing in white lines which he used to suggest shapes and tones, but on the whole eschewing chiaroscuro.

Although he engraved a number of separate prints and a considerable amount of ephemera (including bookplates), Bewick's work was primarily in book illustration, and here his greatest masterpieces appear in his own works *A General History of Quadrupeds* (1790) and *A History of British Birds* (1797 and 1800). This is especially true of the little tailpieces in these books, which show late eighteenth century rural life in all of its aspects — pastoral, melancholy, cruel, crude, tragic and felicitous — and in which Bewick demonstrated by his own example the values and delights of wood-engraving as a vehicle for book illustration.

These vignettes amount to a social commentary, leavened with Bewick's droll sense of humour. They range from the idyllic — a wayfarer drinking a refreshing draught from the brim of his hat which he has filled at a spring — to the poignant — a haymaker has by accident killed a skylark which was sitting on her nest as he reaped; and from the comic — a dog lifting his leg against a washerwoman's tub — to the tragic — a suicide hangs by the neck from a tree above a stream.

The actual illustrations to these books — the delineation of birds and mammals — are quite poetic, while at the same time reporting the appearance of the subjects with scientific accuracy. Thus the hedge warbler is shown perched on a branch with all its plumage clearly defined, against a background of landscape after a snowfall, with a cottage nestling among trees, as delightful a picture of England in winter as may be imagined. Elsewhere a pied wagtail stands on a patch of pebbly margin beside a stream, with grasses and wild flowers growing nearby, depicting not only the bird with its plumage as well defined as before, but with its natural habitat suggested as well.

Both illustrations and tailpieces occupy the smallest area, some no more than one square inch, and the largest of them only about nine square inches.

Bewick was esteemed in his own day and his fame spread to the Continent and farther; among those who visited him at Newcastle was the great American bird painter, John James Audubon (1780—1851); and William Wordsworth paid tribute to him in four lines in *The Two Thieves* (1800):

O now that the genius of Bewick's were mine,
And the skill which he learned on the banks of the Tyne!
Then the Muses might deal with me just as they chose,
For I'd take my last leave both of verse and of prose.

He had a number of pupils who, in their different ways, became excellent wood-engravers, and we shall consider their work in due course. They, too, had pupils who carried on the tradition begun by Bewick. But Bewick's influence spread far beyond his own pupils and their followers; there is hardly a wood-engraver in the nineteenth century whose work was not at some stage conditioned by his example. He was one of those rare artists who redirected his medium unalterably and inevitably.

Bewick's engravings required careful printing and this was not always seen at its best in contemporary editions of his works. But it did happen that there was a contemporary movement, however restricted, that paid close attention to the improvement of printing from woodblocks. Some of the credit for this must go to Sir Egerton Brydges (1762—1837), the owner of Lee Priory Press in Kent, one of England's first private presses. This was established in 1813 and lasted until the end of 1822, during which period more than fifty titles were printed in editions not exceeding one hundred copies, and illustrated with wood-engravings. The press was operated by John Johnson (1777—1848) and a Mr Warwick; they undertook the costs of printing while Brydges supplied 'copy' gratuitously.

From our point of view the greatest interest in the press lies in the printing of the blocks, and this was done brilliantly on india paper laid down on heavier handmade paper. Although most of the blocks are extremely finely engraved, no detail is lost and the colour is a uniformly rich, almost luminous black.

Other private printers, too, were at the same time endeavouring with more or less success to print wood-engraved illustrations. One of these was James Henderson, a Scottish printer who operated the Hafod Press of Thomas Johnes (1748—1816) at Hafod in Cardiganshire, which operated from 1801 to 1809. Some of the books printed here have a view on their title pages of the house at Hafod with surrounding landscape, engraved on wood in a style reminiscent of Bewick's. The results, though, are not so good as Johnson's at Lee Priory. But the improvement had begun and as the

century waxed the technique of printing from wood-engravings was to leave little to be desired, even though there was a tendency by some wood-engravers to produce work that grew ever more refined and which was a far cry from the robustness of Bewick.

There was another wood-engraver, a contemporary of Bewick, whose work had an enormous influence in certain circles in the years ahead. This was William Blake (1757—1827) whose work in engraving was manifold — among other things he was one of the few original line-engravers working in England between the end of the sixteenth century and the present day. But let us for the moment remain with his wood-engravings, of which there are only seventeen, all of which illustrate one work, Ambrose Philips's 'Imitation' of Virgil's First Eclogue. All but one are no bigger than visiting cards, but their influence has been out of all proportion to their size.

They are different from Bewick's engravings both in conception and execution: they have every appearance of having been dug out of the wood, and are realised in strong chiaroscuro as well as in lines. They are also different in content, for whereas Bewick's works are based on the rural life of contemporary England, Blake's are visionary representations of the *locus amoenus*, the ideal pastoral landscape of the poet's mind. To Blake's young disciple, Samuel Palmer, they were 'visions of little dells, and nooks, and corners of Paradise; models of the exquisitest pitch of intense poetry Intense depth, solemnity, and vivid brilliancy only coldly and partially describe them. There is in all such a mystic and dreamy glimmer as penetrates and kindles the inmost soul, and gives complete and unreserved delight, unlike the gaudy daylight of this world.'

Less intensely, Edward Calvert, another of Blake's followers, said they were 'done as if by a child, several of them careless and incorrect, yet there is a spirit in them, humble enough and of force enough to move simple souls to tears.'

But not everybody was happy with them. Dr Robert John Thornton who had commissioned them, felt constrained to insert an apology in the book in which they appeared:

> The Illustrations of this English Pastoral are by the famous BLAKE, the illustrator of *Young's* Night Thoughts, and *Blair's* Grave; who designed and engraved them himself. This is mentioned, as they display less of art than genius and are much admired by some eminent painters.

Recently it was the fashion to denigrate Philips's 'Imitation' at the expense of Blake's wood-engravings, but I think that is unfair. While it is far from being a literal translation of, or even an approximation to Virgil's *First Eclogue*, it is full of charm, a pastoral poem in its own right; and one that after all inspired Blake to make his masterly wood-engravings, the only ones he ever attempted.

These little scenes, peopled by shepherds and herdsmen and their charges, set in idyllic landscapes, have never ceased to inspire artists and poets from Blake's own followers, like Palmer and Calvert, down to the late twentieth century when their influence may be seen in the work of such artists as Graham Sutherland, Robin Tanner and Paul Drury.

Blake's engraved work extended into many fields. He learnt his trade as an engraver under James Basire II (1769—1822) and in his line-engraved work (which usually contains at least elements of other techniques) carried forward that master's by then old-fashioned and somewhat hard technique. Its very hard and exact quality suited Blake, who claimed, 'The great and golden rule of art, as well as of life, is this: That the more distinct, sharp, and wiry the bounding line, the more perfect the work of art; and the less keen and sharp, the greater is the evidence of weak imitation, plagiarism, and bungling.'

No bounding line could be more pronounced than those in his line-engravings, whether they are wholly original works like his *Illustrations of the Book of Job* (1825) or his illustrations to Edward Young's *Night Thoughts* (1797); or in reproductive engravings like those he made after Thomas Stothard for Joseph Ritson's *A Select Collection of English Songs* (1783).

Blake worked also in stipple, chalk line and etching, he used a wood-engraving technique on metal; he even produced one lithograph. But his most original method, one he used for most of his illuminated books, was relief etching, where instead of the lines being etched in intaglio, the surrounding areas are bitten away, leaving the lines standing up as a printing surface. In this he created some of his greatest visionary works, such as the powerful frontispiece to his prophetic book *America* (1793), which shows a titanic angel, his head between his knees in an attitude of mourning, chained by his wrists in a gap in a wall, with louring clouds in the sky above. A nude woman is seated near him comforting two children, and the barrel of a cannon lies on the ground. It is a conception as powerful as Florestan's recitative from Act II of Beethoven's *Fidelio* (1805):

'Gott Welch Dunkel hier! O grauenvolle Stille!' ('O God! how dark it is! how terrible this silence!'). Yet the whole composition occupies a space measuring only $9\frac{3}{16}$ by $6\frac{11}{16}$ inches.

While he was creating such monumental conceptions as this, Blake was earning his living by making elegant stipple and line-engravings for the publishing trade. It is a little difficult to realise that the artist who engraved the Virgil illustrations and etched *America* was the same craftsman who could purvey such pretty confections as 'The Fall of Rosamund' after Thomas Stothard (1783) and the portrait of 'Mrs Q' (Mrs Harriet Quentin) after Huet Villiers (1820). But such was the case, and if any one engraver can be said to bestride the end of the eighteenth century and the beginning of the nineteenth century, bringing the traditions of the old century into the new, that man is William Blake.

Of stipple, the greatest exponent at this time was Francesco Bartolozzi (1727—1815) the son of a Florentine goldsmith. He really belongs to the eighteenth century (he left England in 1802), but he continued working until he died and so overlaps the period with which we are concerned. He came to England in 1764, persuaded by George III's librarian, Mr Dalton, and received the appointment of 'engraver to the King'.

Bartolozzi's output was vast, though there is no doubt that many works signed by him were engraved by his assistants or employees, of whom there were fifty. Indeed he could not have engraved such an enormous output single-handed. Many plates engraved in his studio received his signature after a few finishing touches had been added by himself, and this association of his name with inferior work has tended to devalue his *oeuvre*. His own work at its best is superb.

He and his team engraved the work of many old masters, and it was through his prints that their works became more widespread than ever before; and needless to say he engraved the works of his contemporaries. Though at their best they are excellent, there is a certain facility about many Bartolozzi prints, perhaps due to their medium, for it must be admitted that stipple tended to impart a certain insipidity if not used with the greatest skill.

Bartolozzi's influence was enormous; there was hardly a stipple engraver of his period who did not come under it. And he trained a whole generation of pupils who carried on working well into the nineteenth century. But the school of stipple soon waned, engravers probably finding the growing use of lithography, the impact of the

new schools of wood-engraving, and, later on, new techniques, including the ubiquitous steel-engraving, too strong to resist. At the opening of the century, though, it seemed firmly enough entrenched, both in book illustration and for separate plates.

The Impact of Lithography

Lithography, invented in 1798, belongs essentially to the nineteenth century. It is the only major printmaking process, until the advent of the photographic techniques, whose origins can be traced.

It was invented by a Czech, Aloys Senefelder (1771—1834) who discovered it almost by accident. He had taken up printing and had by him a piece of Kelheim stone on which he ground his colours. He used this one day in about 1796 on which to write down a laundry list for his mother and in so doing stumbled on a method of making relief etchings on stone which sparked off a train of thought which in due course led him to the process now called lithography. He describes the event in his book, *A Complete Course of Lithography* (1819):

> I had just ground a stone plate smooth in order to treat it with etching fluid and to pursue on it my practice in reverse writing, when my mother asked me to write a laundry list for her. The laundress was waiting, but we could find no paper. My own supply had been used up by pulling proofs. Even the writing ink was dried up. Without bothering to look for writing materials, I wrote the list hastily on the clean stone, with my prepared stone ink of wax, soap, and lampblack, intending to copy it as soon as paper was supplied.
>
> As I was preparing afterward to wash the writing from the stone, I became curious to see what would happen with writing made thus of prepared ink, if the stone were now etched with aqua-fortis. I thought that possibly the letters would be left in relief and admit of being inked and printed like book-types or wood-cuts. My experience in etching, which had showed me that the fluid acted in all directions, did not encourage me to hope that the writing

14

would be left in much relief. But the work was coarse, and therefore not so likely to be undercut as ordinary work, so I made the trial. I poured a mixture of one part aqua-fortis and ten parts water over the plate and let it stand two inches deep for about five minutes. Then I examined the result and found the writing about one-tenth of a line, or the thickness of a playing card, in relief.

Eagerly I began inking it. I used a fine leather ball, stuffed with horsehair, and inked it very gently with thick linseed oil varnish and lamp-black. I patted the inscription many times with this ball. The letters all took the colour well, but it also went into all spaces greater than half a line. That this was due to the over-great elasticity of the ball was clear to me. So I cleansed my plate with soap and water, made the leather tense, and used less colour. Now I found colour only in such spaces as were two or more lines apart.

Printing in relief from stone was not entirely original, for, some years before Senefelder 'discovered' it, it had been practised by Simon Schmidt, a professor at the Military Academy in Munich. But it initiated a series of experiments, carried out, sometimes in the face of great difficulties and many setbacks, until in 1798 Senefelder hit upon the idea of making his designs on prepared paper with chalk made of compacted stopping-out ink or varnish and transferring them to the stone. Impressions could then be taken without lowering any part of the stone, as described in Chapter VIII.

The design could also be made direct on to the stone without using transfer paper, but that meant working in reverse, although a sloping mirror placed behind the stone would allow the lithographer to observe the progress of his work as it would appear when printed. Thus used, it is a completely autographic medium, in its execution closer to the work of the painter and draughtsman than any other printing technique.

It did not take long for the benefits of the new invention to be recognised. It was at first called polyautography, but before long it was given the less clumsy name of lithography.

In 1799 Senefelder was granted the privilege of being the sole practitioner of lithography in Bavaria (where he lived) for a period of fifteen years. He placed too much reliance on this and, in his own

words, 'I did not think it necessary to keep our art any longer a secret, but took a pride in explaining it to any stranger who, attracted by the novelty of the invention, came to our office.'

This was indiscreet, but it did have one result in that a music publisher of the town of Offenbach, Johann Anton André saw the possibilities of the technique and persuaded Senefelder to sell him his secret for 2000 florins. With the assistance of his brother Frederick, André set up a lithographic press in Offenbach and had printers trained to use it.

It was planned to take out patents for the method in other countries, England included; and Senefelder came here in 1800. With the help of a brother of Johann and Frederick, Philipp André, who was a printseller and publisher in London, a patent was obtained in 1801. Soon afterwards Senefelder sold his rights in the patent of Johann André for 3000 florins.

After many further disappointments and disillusionments — he took out patents, in Austria for example, but lost control of them — Senefelder published his book in Munich and Vienna in 1818, and it was brought out by Rudolf Ackermann in England in 1819.

Ackermann, who had set up a lithographic press in London, the first outside Germany, gave a demonstration of it at the Society of Arts in 1819 and also presented the Society with a copy of Senefelder's book. The following day the Society decided to present Senefelder with a gold medal which, after all his tribulations, must have given the inventor some wry pleasure. Recognition had in all conscience been long enough coming to him, for lithography had been practised in England, albeit on a limited scale, since the beginning of the century.

One of the earliest appearances of lithographs in England was in a book containing twelve prints entitled *Specimens of Polyautography, Consisting of Impressions taken from Original Drawings made purposely for this Work*, published in 1803 by Philipp André and J. Heath. Several artists contributed, including Thomas Stothard and Benjamin West, and the series was reprinted in 1806 by G.J. Vollweiler, 'successor to P. André'. Others toyed with the process, but it was not until Ackermann began to interest himself in lithography that it really began to flourish in this country.

The artist and antiquary John Thomas Smith (1766—1833), who lithographed a plate for his book *The Antiquities of Westminster* (1807), was an early practitioner. As it turned out, this was a partial failure for the stone broke after three hundred impressions had been

taken and an etching on copper of the same subject was used instead; this etching is present in addition to the lithograph in the first three-hundred copies of the book. But limited though it was, Smith's example pointed the way for one of the major future developments of lithography: in book illustration.

This example attracted more artists, and while it is true that many of them were amateurs, some professionals also tried out the technique, among them William Blake whose pen lithograph, 'Enoch', which shows the patriarch surrounded by allegorical figures, was made at about the same time that Smith's book (to which Blake was a subscriber) was published. The antiquary Thomas Fisher (?1781–1836) collected many of these early lithographs and his collection is now in the British Museum. In 1807 Fisher himself made a number of pen lithographs of wall paintings in the Church of the Trinity at Stratford-on-Avon in an edition of one hundred and twenty; they were hand coloured.

Subsequently Fisher did much to popularise lithography by writing about it in *The Gentleman's Magazine*. He also introduced to the *Magazine* the work of D.J. Redman, Vollweiler's former assistant.

On Vollweiler's departure from England, Redman sold the secret of the technique, together with a quantity of equipment, to the Quarter-Master-General's Office in Whitehall, and became the official printer of plans and maps. On his own account he also advertised his services to the public as a lithographic printer, and he was responsible for printing many of the amateur lithographs made at the time. And not only amateur work, for he printed lithographs by Cornelius Varley and perhaps also for Cornelius's brother, John.

Redman evidently tired of his cartographic work and in 1813 set up a lithographic press at Bath to work from artists' designs, and as he was the only lithographer working there at the time, it became during his sojourn the centre of the art in England. Those for whom he worked included Thomas Barker ('Barker of Bath'; 1769–1847), for whom he printed two large sets of lithographs, one of rustic figures and one of landscape, the first of such sets issued in England.

He also lithographed work by local artists, mostly amateurs, but by 1815 business had fallen off and he returned to London. He worked there until 1823; in the meantime, in 1819, he had been awarded a silver Isis medal by the Society of Arts, but apart from this and despite producing a number of topographical lithographs, his success was limited.

17

Redman's prints were not particularly good, being somewhat rough and lacking in delicacy. But a first-class lithographer was already at work, even if his best work lay in the future. This was Charles Hullmandel the landscape painter (1789—1850), who met Senefelder in Munich in 1817, and was able to observe how well lithographs were printed in Germany. In 1818, being dissatisfied with the way some of his views had been lithographed by the firm of Moser and Harris, Hullmandel decided to set up his own press which he did either in that year or in 1819. This, the publication by Ackermann of Senefelder's treatise and Ackermann's retail outlet for Hullmandel's lithographs were the true and firm foundations of the spread of lithography in England.

It was not so long after the appearance of J.T. Smith's *The Antiquities of Westminster* that the use of lithography for book illustration began to spread. One of the most important early examples — started but never completed — was the imperial folio *Britannia delineata: comprising views of the antiquities, remarkable buildings, and picturesque scenery of Great Britain*, printed by Hullmandel and published in 1822—3. Dedicated to George IV, it was intended to cover every part of the kingdom, but in the event only the twenty-five plates for the county of Kent were published. The plates were shared between Hullmandel, William Westall, James Duffield Harding and Samuel Prout, each of whom was an important early exponent of the technique.

It is interesting to compare in this work the different ways in which these artists used the medium. As would be expected from a water-colourist, Prout's drawing and tonal areas are achieved with great freedom of handling — even John Ruskin, who hated lithography, had a good word for Prout (and incidentally for John Frederick Lewis the painter of exotic subjects, himself a lithographer) for in his *Elements of Drawing* (1857) he wrote: 'Let no lithographic work come into the house if you can help it nor even look at any except Prout's and those sketches of Lewis's'.

On the other hand Hullmandel's work is tight and laborious; Westall's is delicate, as befits an engraver who was trained in aquatint — indeed many of his plates may be described as lithography in the manner of aquatint. Harding's work is thoroughly skilled and exploits every nuance of the lithographer's medium, giving it a wider technical range than could be seen in the work of any other contemporary lithographer.

Many artists, it should be added, either at this time or later, did not carry out the actual lithography. They drew their designs on transfer paper in lithographic chalk or ink, and the transfer and printing were done by a skilled lithographic printer.

Some years after the appearance of *Britannia delineata* two lithographs appeared that demonstrated the delicacy and conciseness of which the medium was capable. These are 'The Flood' and 'Ideal Pastoral Life', lithographed in 1829 by Blake's follower, Edward Calvert (1799—1883), each of which measures $1\frac{11}{16}$ by $3\frac{1}{32}$ inches. Despite their diminutive size they are full of detail and poetic symbolism. 'Ideal Pastoral Life', for instance, shows a naked shepherdess with her flock within a fold, with a primitive cottage in the background. In the wooded distance at the right a naked shepherd approaches the fold with a stray sheep, under a crescent moon riding in the sky. In this way Calvert's design symbolises the return of a lost soul to its spiritual home. Few artists, even skilled miniaturists, could have packed so much sentiment into a few square inches; in such a medium as lithography it is doubly impressive.

These two works, especially 'Ideal Pastoral Life', show the unmistakable influence of Blake's Thornton's Virgil wood-engravings, surely the only examples of such influence in nineteenth-century lithography.

More typical of the general trend was the use of lithography for depicting topographical views, which was one of the main outlets of the art from the mid—1830s to the mid—1850s. This development brought an increasing use of colour in the printing of lithographs, which hitherto had usually been printed in monochrome, and were sometimes tinted by hand. There had earlier been tinted lithographs in which a second stone was used to impart a neutral tint in order to retain the colour of the stone on which the original drawing was made; or to insert white highlights, although this effect was sometimes made by scraping away the lights in the tinted background. Many of these developments were either initiated or refined by Hullmandel.

In 1836 Hullmandel printed a work that is recognised to be the perfection of tinted lithography: J.D. Harding's *Sketches at Home and Abroad*, fifty plates of Romantic views published in an edition of a thousand copies by Charles Tilt. In this Hullmandel and Harding brought together all the resources of tinted lithography. In the words of the publisher: 'Mr Harding has applied a new mode of his own for

19

introducing the *whites* in *printing* instead of laying them on with the pencil. By this process a lasting effect is produced; the tints thus obtained being permanent and free from the liability to dinginess, which has hitherto been such a fatal objection to their production in the usual manner.' In short *Sketches at Home and Abroad* was a culminating point in the development of tinted lithography as applied to topographical views, the future for which it helped to ensure.

Other topographical lithographers included the mainly reproductive printmaker Louis Haghe (1806—85), a Belgian by birth who worked for a time in England. He made some splendid prints, especially those illustrating J.R. Planché's *Lays and Legends of the Rhine* (1827—29), highly Romantic views, worked with great delicacy with a pleasing finely granulated surface. They were printed by William Day Sr, with whom, from about 1820, Haghe had a business partnership as Day and Haghe.

Thomas Shotter Boys (1803—74) was another significant topographical lithographer; his most important original works were *Picturesque Architecture in Paris, Ghent, Antwerp, Rouen* (1839), *A Series of Views in York* (1841) and *Original Views of London as it is* (1842). He also made reproductive lithographs, including some subjects after works by Clarkson Stanfield and David Roberts. Much of his work was printed by Hullmandel, some of it in chromolithography.

Apart from its intrinsic artistic value Boys's original work is of great importance because of the extremely accurate records it provides of the topography of his time; for unlike some printmakers, who did not hesitate to omit details in order to gain picturesqueness, Boys recorded every detail with clarity and accuracy. Yet his lithographs are not without exciting qualities and at least a leavening of Romanticism, like the chromolithograph of 'La Chapelle de l'Institut, au bord de la Seine, Paris' from *Picturesque Architecture in Paris*, with its dramatic perspective and chiaroscuro; or the spacious sweep of the architecture in 'Entry to the Strand from Charing Cross, London', from *London as it is*. Nor did Boys neglect human interest, for his lithographs are always generously supplied with staffage, some like 'Entry to the Strand', being almost crowded.

More exotic views were lithographed by John Frederick Lewis (1805—76), especially in his *Sketches and Drawings of the Alhambra* (1835) and *Sketches of Spain and Spanish Character* (1836); and by David Roberts (1796—1864) whose *The Holy Land, Syria, Idumea,*

Arabia, Egypt and Nubia (1842–9) was issued in forty parts and consists of two hundred and forty-eight plates, which could be had plain or coloured. It was printed by Day and Haghe. Roberts also, like Lewis, made a set of lithographs of Spanish subjects: *Picturesque Sketches in Spain* (1837).

An historical perspective is provided by the lithographs of Joseph Nash (1808–78) in such works as *Views Illustrative of the Examples of Gothic Architecture* (1830) and *Architecture of the Middle Ages* (1838). Architecture was also the subject of lithographs by Richard Parkes Bonington (1802–28), whose *oeuvre* in this medium includes *Restes et fragmens d'architecture du moyen age* (1824), *Vues pittoresques de l'Ecosse* (1826) and *Cahier de six sujets* (1826), all published in Paris.

Some of the best of all landscape lithographs were made by Edward Lear (1812–88), whose *Views in Rome and its Environs* (1841) and *Views in the Seven Ionian Islands* (1863) mark peaks of Romanticism in this branch of the art. As in 'The Hill Town and castle at San Buci, seen across the cloud-filled valley' from *Views in Rome*, which shows a small promontory in the foreground, with a goatherd in a cloak and hat leaning on his stick, while one of his goats rests beside him, and in the middle distance the hill town itself with cypresses growing behind it on the slope of a headland. In the valley between the goatherd and the town is a sea of cloud, which gives the whole composition a portentous prospect. Some other plates, like 'Castel Sant' Angelo' from *Views in the Seven Ionian Islands*, with its great hills and cliffs towering above a bay, accomplish in terms of lithography what William Daniell had done so well in aquatint.

Lear also made lithographs of birds, and his *Illustrations of the family of the Psittacidae* (1832) with its vividly coloured plates printed by Hullmandel, is one of the greatest bird books of the nineteenth century.

Illustrated books on birds and flowers are two of the grandest categories of lithographed book illustration, in books such as John Gould's *A Monograph of the Ramphastidae, or family of toucans* (1833–5), which also contains some plates by Lear, and which was printed by Hullmandel; and Richard Bowdler Sharpe's *A Monograph of the Paradiseidae, or birds of Paradise, and Ptilonoryhnchidae or bower birds* (1891–8), engraved by John Gerrard Keulemans and William Hart. These folios are typical of the range of bird books

produced throughout the nineteenth century, though there were many books of smaller format like Joseph Wolf's *Feathered favourites* (1854), with twelve chromolithographs by the author.

The range and colouring of these lithographs are both impressive and superb and, like Thomas Bewick's simpler wood-engravings of an earlier date, they combine scientific reporting with a Romantic observation of their subjects.

The same is true of the great flower books of the period, like James Bateman's *A Monograph of Odontoglossum* (1864—74) with plates drawn and lithographed by W.H. Fitch (1817—92); William Curtis's *Flora Londinensis* (1817—28) which among engraved plates contains a number of lithographs by Pellitier (fl. 1820s); and, in much smaller format, Robert Tyas's *Favourite field flowers* (1847—50) and *Flowers from foreign lands* (1853), each with lithographs by James Andrews (fl. 1840s—50s).

Other subjects were lithographed by many artists, including George Cattermole (1800—68), whose imaginative Romantic illustrations of mediaeval scenes are among the best of their kind. Cattermole used and helped to develop Hullmandel's lithotint process (see Chapter VIII).

The sons of John Linnell Sr, John (1821—1906), James Thomas (1823—1905) and William (1826—1906) made some excellent lithographs, mainly reproductions of paintings. One especially pleasing is 'The Sonnet' after William Mulready, by John Linnell, Jr, thought by some to be even better than the original it reproduces. The three brothers collaborated to make six designs from a series *The Prize Cartoons* (1845), of eleven lithographs of historical subjects by various artists including G.F. Watts, C.W. Cope and Joseph Severn. They were printed, five by Hullmandel and six by M. and N. Hanhart, the noted lithographic printers.

Particularly evocative of the Romantic period are lithographs portraying ballet dancers. They belong chiefly to the 1840s and tell us more about the contemporary ballet than pictorial records of any other period, apart from our own when the camera can record a dancer in action and her very movements can be captured on a film. But how can a photograph or a film be compared with the splendid artistry of these old prints, in which we may see such legendary performers as Marie Taglioni, Fanny Cerrito, Lucile Grahn, Carlotta Grisi and Fanny Elssler, arrested in a *pas* or *enchaînment* from one of their great roles?

Some of the best artists of the period designed for or worked on these lithographs, A.E. Chalon (1780—1860), J. Brandard (1812—63)

and J. Bouvier (fl. 1840s—50s) among them, and without doubt they brought off some of the most lyrical effects in a medium notable for its poetic qualities. Thus we may, in Brandard's print of Carlotta Grisi in *La Péri*, see the very ideal of the Romantic ballet, with the dancer almost floating across the stage, her *pointes* not even in contact with the floor; while in the background, beyond the pillars of an archway, her companions watch her from within an exotic landscape. Or in a print by J.H. Lynch (d. 1868) after A.E. Chalon, Marie Taglioni in *La Sylphide* stands in an open casement where she has just alighted, so softly that the flowers in a jar at her side are undisturbed; while in Jules Perrot's famous *Pas de quatre*, lithographed by T.H. Maguire (1821—95) after A.E. Chalon, the four greatest dancers of the period — Grisi, Taglioni, Grahn and Cerrito — may be seen together in a single dance. In yet another print by J. Brandard we may see Carlotta Grisi in her most famous role, that of *Giselle*, a print which has many attributes of Victorian Romanticism: flowers, boscage, a lake in the middle distance, and the cross on Giselle's grave at the left. Again the dancer herself, and the wraith of Giselle, manifests the lightness which was such an essential attribute of the Romantic ballet, and was accentuated by dancing *sur les pointes*, a style probably first used in 1815 by the ballerina Geneviève Gosselin.

The chromolithographed music covers issued from the middle of the nineteenth century until its later years are not unrelated to lithographs of the ballet. These gave impressions of contemporary scenes, public, domestic and theatrical, and especially of the music hall, as vividly as the ballet lithographs did for their branch of art.

The greatest exponent of the lithographed music cover was Alfred Concanen (1835—86) who in his designs covers numerous aspects of Victorian life. The *Streets of London Quadrilles*, for instance, depicts a snowy scene looking towards Trafalgar Square from the Strand. Street traders are offering hot soup and chestnuts, a hawker of song sheets is crying his wares, a small boy is turning a somersault, and at the right five 'peelers' are walking in single file by a shop. Simultaneously there are single figures, others in little groups, and in the distance horse-drawn vehicles may be descried. At the stall of the soup vendor a man stands with a paper cover over the crown of his hat, with an inscription advertising 'The Coal Hole', a public house in the Strand.

Another Concanen design is that for C.H.R. Marriott's *The Looking Glass Quadrille*. It is based on John Tenniel's illustrations for Lewis

Carroll's *Through the Looking Glass and what Alice found there*; 'The Jabberwock' occupies the centre and various other subjects surround it, including the Red Queen, the Walrus and the Carpenter and Tweedledum and Tweedledee, all set within a rustic treillaged framework.

Some music cover designs are distinctly comic; such is Concanen's design for Adrien Taxley's *The Hansom Galop*, in which a hansom cab is being driven recklessly, its occupant a dandy, while other cabs, their passengers and drivers, and loose dogs are thrown into disarray.

Brandard, whose ballet lithographs we have just noted, also lithographed music covers. In the *Zuleika Cellarius Valse and Mazurka* he takes the dance into the ballroom and shows a couple — the woman in an enchanting crinoline decorated with sprays of centifolia roses — who might pass for Queen Victoria and the Prince Consort.

As the century progressed, lithography was applied to all kinds of printed artefacts, such as labels, writing paper and envelopes, playing cards, maps, posters, Christmas cards and not least Valentines, the latter including some of the most delightful contemporary chromolithographed ephemera. Valentines were often assembled from several separate units; on a base of embossed paper lace, printed in gold, a landscape would be affixed, which showed perhaps a church in the distance viewed from a balustrade in the foreground. In front of this would be hinged a paper wreath formed of the branches of trees, and this could be made to stand up half an inch in front of the prospect, giving an effect of depth, like stage scenery in little.

One of the most delightful Valentines I have seen is 'The Rose Leaf Valentine'. Within a border of flowers stuck down on a frilly background is a coved rectangle and on this is a hinged green leaf held in place by a ribbon. Below this on the background is the inscription: 'Lift the leaf and you will see/The Face that always pleases me.' The leaf is lifted and beneath is a tiny convex mirror.

Posters — especially those for the theatre — were also printed by lithography, which gave great freedom for the placing of a layout; the lettering, for example, could be curved at will, whereas in typographic printing it was limited by the chase in which it was laid out. It also made it easier to print what were considered to be more pleasing pictorial elements than the old and crude if sometimes (to us) attractive woodcuts of the past. Frequently lithography was combined with letterpress on the same poster, especially in standard

lithographed designs kept in stock with blank spaces left for the insertion of the name and place of the theatre and details of performances which could be printed from movable type. Such posters are still used today, particularly by travelling circuses and fairs.

Towards the end of the century standard posters with a blank left for the name were available for a range of trades, including tailoring and bootmaking.

Posters were mainly the work of jobbing artists and printers, but sometimes, though more rarely, they were designed by well-known artists such as Frederick Walker (1840—75). Later it was to be different, when the art of the poster attracted artists like John Hassall (1868—1948), Aubrey Beardsley (1872—98) and the 'Beggarstaff Brothers': John Pryde (1869—1941) and Sir William Nicholson (1872—1949), who between them designed about ten posters.

Lithography was also used to some extent in security printing. For instance, the firm Mawdesley and Co. of 2 Castle Street, Liverpool, printed a number of telegraph stamps of delightful designs. Some, like the now extremely rare stamps they printed for the British Telegraph Company (?1854) have elements of design built up from elaborate engine turning, which is more typical of line-engraved stamps (there was however an example of it in Hullmandel's book *The Art of Drawing on Stone* (1824)). Other designs, like those for The English and Irish and The British and Irish Telegraph Companies (1857, ?1859) have pretty arrangements of roses, thistles and shamrocks, which are combined in the English and Irish design with stars and a banner. Others were lithographed in 1864 by Waterlow and Sons for the Universal Private Telegraph Company; they are an almost sentimental design of entwined twigs and sagittate leaves.

Later in the century (1872—84) certain Cambridge and Oxford colleges issued lithographed (and some line-engraved and embossed) messenger stamps to pay for Fellows' local and inter-college mail delivered by college porters. They were all designed around the appropriate college crest or arms and in appearance unmistakably to the Gothic Revival.

From the time when photographic processes came into wide use at about the middle of the century, lithography began to lose ground as a reproductive process (yet it was also adapted for photo-lithography and kindred methods), and as an original medium it was largely cast aside. In book illustration it was eschewed in favour of media like wood-engraving which could be printed with the text. Commercially

it continued to flourish and ephemera such as letter headings and tradesmen's cards were lithographed in large numbers all through the period.

But there was a revival later in the century — in the 1870s — by the lithographic printer Thomas Way, who besought artists to try the medium. He managed to collect a number of original lithographs, and these were published in 1874 under the title of *Hogarth Sketches*. But this was only a beginning and Way's most splendid *coup* came when he persuaded James McNeill Whistler (1834–1903) to adopt the medium.

Lithography came as an inspiration to Whistler, who discovered in it nuances of expression hitherto elusive. But at first the public was indifferent or even hostile, and it was to be some years before his lithographs commanded the attention they deserved. Indeed it was not until 1893 when a demonstration and lecture were given by Way's son, and the cataloguer of Whistler's lithographs, Thomas R. Way (1851–1913), at the London headquarters of the Art Workers' Guild, that interest, nay enthusiasm, suddenly blossomed.

Among those present who tried out the medium were Sir Frank Short (1857–1945) and Joseph Pennell (1858–1926), of whom the former held the influential posts of etching instructor and professor of engraving at South Kensington, and was so able to pass on the message; while Pennell was to write what was to be for many years the standard work *Lithography and Lithographers* (1915) and was able to underwrite in this (although by this time it had become historical) Way's and Whistler's great work in the revival.

There were, too, other forms of encouragement — from the art press especially, *The Studio* including original lithographs in several issues during the 1890s. Charles Haslewood Shannon (1863–1937) who ran a magazine called *The Dial*, also lauded the medium, as well as printing lithographs himself on his own press.

These are but a few of those who were responsible for the revival of artistic lithography, or auto-lithography as Charles Holme, editor of *The Studio*, preferred to call it. Among others were Alphonse Legros (1837–1911), Slade professor of fine art at University College, London, William Strang (1859–1921), C.E. Holloway (1838–97), Sir William Rothenstein (1872–1945) and Charles Conder (1868–1909). But Whistler was the greatest of all and, although an American he had a profound influence on the development of English printmaking.

In his work the true advantages of lithography as an expressive medium may be seen. In 'The Garden' (1891) he has packed into a few light lines all the fragrant delights of a summer's afternoon tea party in the open air; in 'The Smith's Yard' (1895) the same treatment is given to a bucolic scene, the farrier and his companion looking out from the smithy while their iron is being heated in the forge and the horse waits beside them to be shod, and another awaits his turn in the yard; while his portrait of Thomas Way (1896), conceived almost entirely in chiaroscuro, demonstrates the dramatic possibilities of lithography, using the simplest means.

CHAPTER IV

The Spread of Wood-engraving

The art of engraving on the end grain of boxwood was a dominant mode of book illustration during the nineteenth century. At the end of the eighteenth century, in Thomas Bewick's hands, it was already a fully developed technique, and it was only ousted as a general illustrative method by photo-mechanical processes in the last decades of the century, having enjoyed in the 1860s an unprecedented vogue, during which some of the best living artists designed for it. There were, it is hardly necessary to add, wood-engravings in their own right, separate from books, but they were comparatively few: wood-engraving is above all an illustrative medium.

In time it became an important industry with numerous practitioners at all levels; yet at the beginning of the century, in Bewick's day, there was only a handful of engravers working on boxwood, according to some no more than a dozen. These were, so to speak, the patriarchs of the art, whose followers over the next two or three generations made up the myriads of wood-engravers who were to flourish during the next ninety or so years.

Of Bewick's pupils Charlton Nesbit (1775—1838) is generally accepted to be the most accomplished; he engraved some of the tailpieces in the first volume of Bewick's *British Birds: The History and Description of Land Birds.* Also, towards the end of his apprenticeship, he cut one of the largest wood-engravings ever made in England up to that time. This is a somewhat pedestrian view of St Nicholas's Church at Newcastle-on-Tyne, the tower of which may, incidentally, be seen in the background of a few of Bewick's tailpieces. Nesbit's block measures twelve by fifteen inches and was engraved on twelve separate pieces of boxwood clamped together and mounted on a cast iron plate. The watercolour from which it was taken was the work of another pupil of Bewick, Robert Johnson (1770—96).

The view of St Nicholas's Church was a *tour-de-force*, but the

best of Nesbit's work is to be found among some of his smaller
works, and of these one of the most pleasing is the frontispiece,
after a design by John Thurston, for the editions of Robert
Bloomfield's *The Farmer's Boy* issued from 1800 onwards.

In a pastoral setting a shepherd sits playing on a pipe, while his
dog lies beside him. His crook, hat and bottle are leaning against the
bole of the tree. In the distance, beyond a river, lambs gambol, and
on the horizon, among trees, is a church spire, the whole design
evoking perfectly Bloomfield's lines:

> The sheep-fed pasture, and the meadow gay;
> And trees, and shrubs, no longer budding seen,
> Display the new-grown branch of lighter green;
> On airy downs the idling Shepherd lies,
> And sees *to-morrow* in the marbled skies.
> Here then, my soul, thy darling theme pursue,
> For every day was *Giles* a SHEPHERD too.

An engraving such as this owes much of its charm to the work of
the original designer, but the engraver also played his part, if only
in the transformation of a work from the terms of one medium into
the terms of another: brush strokes, pencil lines and colour washes
into strokes of the graver or jabs of the spitstick. But there is often —
certainly in most of Nesbit's work — more to it than that, for in
examples where one can compare the original drawing with the
engraving, the latter is often seen to be a creative transfer with its
own nuances, comparable with the way in which a composer will
take a theme by, say, Purcell, and in his own arrangement make it
into another original work.

It is interesting to compare this engraving with another one by
Nesbit from an unidentified work. In this a piper in Elizabethan
dress is seated on a bank beneath a tree playing his instrument, while
on a nearby stream two swans drift by, and beyond them a landscape
with cypresses may be descried. If the cut from *The Farmer's Boy*
evokes the pastoral spirit, this one evokes the feeling of a more
contrived, even courtly, rural *mise en scène*. But it is as packed with
sentiment as an epithalamion of the sixteenth century.

Of other pupils of Bewick, Luke Clennell (1781—1840) was one of
the most important. He had a sad life and from 1817 suffered from
bouts of insanity; his wife too became insane.

From about 1810 he abandoned wood-engraving for water-colour, but not before he had created a distinguished *oeuvre*. Like Nesbit he worked on Bewick's *Birds*, in his case on the tailpieces for the second volume: *The History and Description of Water Birds*. Like Nesbit, too, he produced at least one large *tour de force*, an engraving for the diploma of the Highland Society. It measures about 10½ by 13½ inches and shows two Scots, a fisherman and a soldier, in national dress, holding between them a large circular wreathed picture of Britannia surrounded by allegorical figures. The original design was by Benjamin West.

Clennell engraved this twice. The first version was engraved on a composite block consisting of pieces of boxwood veneered on to a piece of beech. He worked on this for about eight weeks, but then the block suddenly split beyond repair, causing Clennell in his wrath to throw the tea things on the fire. He then had a new block made, this time built up from pieces of solid box firmly clamped and screwed together, and this time he was able to complete it success-fully. On both occasions he got Thurston to copy the central part of West's design on to the wood, but he drew the supporting figures himself.

Some of Clennell's best work was done after pen and ink sketches by Thomas Stothard, illustrating Rogers's *Pleasures of Memory and other poems* (1810), in which the engraver made a robust inter-pretation in his own medium of Stothard's sensitive pen work.

A different approach to wood-engraving was taken by another pupil of Bewick, William Harvey (1796—1866), for he brought to it the minute handling of a miniaturist, as may be seen in his engravings for Dr Henderson's *History of Ancient and Modern Wines* (1824) which he both drew and engraved. Some think that Harvey went too far in the refinement of his handling and it is indeed true that there is a monotony of texture in some of his blocks, as if in being anxious not to leave any square millimetre unworked he lost sight of the total effect. Yet in his best work this is overcome and one is moved to admiration of his pertinacity.

Harvey strained his technique in other directions, too. In his engraving of B.R. Haydon's 'The Death of Dentatus' he imitates in wood the technique of line-engraving including even the complicated dot and lozenge style — that is, where a network of lines cross, forming diamond shaped interstices, and a dot is placed in the centre of each space. It is a tremendously important piece of work, contrived

in a manner that would have been quite beyond the capabilities of many wood-engravers. Despite this, there is little to be said for it beyond admiration for the dexterity of the engraver. It is a truism that if the effect of line-engraving is desired it is better to realise it in that medium than in another.

Among engravers at this early period who were not directly connected with Bewick, Allen Robert Branston (1778—1827) is one of the better known. He began life in King's Lynn as a copperplate engraver under his father's tuition, and only adopted wood-engraving after coming to London in 1802. He felt he could engrave better than Bewick and in an attempt to prove this he made some cuts of two or three birds, and others for a projected edition of Aesop's *Fables*, a work earlier illustrated by the Newcastle engraver. But excellent though one would consider his work if one were unaware of Bewick's, it must be admitted that in spite of his cuts being elaborately wrought, they have nothing of the vigour of that master's work.

As I wrote in Chapter II, William Blake was the other great wood-engraver in the early years of the century, and two or three of his followers made wood-engravings much influenced by his illustrations for Thornton's Virgil. One of them was Samuel Palmer (1805—81) who, however, created only one work in this medium, and it is possible that even this was engraved by his friend Welby Sherman, a professional engraver, after his design. But whoever cut it created a little masterpiece. Made in 1826, it is called 'Harvest under a waning moon' and measures only $1\frac{1}{32}$—$1\frac{1}{16}$ by $3\frac{1}{32}$ inches. In the foreground two workers with sickles are cutting corn, while a third is tying it into bundles; stooks are already standing at the right. In the distance are little hills and at the left the roof of a cottage is visible above the growing corn. The moon is low in the sky at the right.

Palmer painted some magical water-colours at Shoreham in Kent between the mid—1820s and 1832, some of them among the best pastoral and visionary works of the nineteenth century. But in this engraving he distilled into just over three square inches much of the inspiration that initiated them. It is a perfect visual counterpart of Palmer's own verse:

> Methinks the lingring, dying ray
> Of twilight time, doth seem more fair,
> And lights the soul up more than day,

When wide-spread, sultry sunshines are.
Yet all is right, and all most fair,
 For Thou, dear God, hast formed all;
 Thou deckest ev'ry little flower,
 Thou girdest ev'ry planet ball —
 And mark 'st when sparrows fall.
 Thou pourest out the golden day
 On corn-fields rip'ning in the sun
 Up the side of some great hill
 Ere the sickle has begun....

If Palmer's little engraving can thus move us, what of that master-piece of another of Blake's followers: Edward Calvert's 'The Chamber Idyll', that wonderful representation of the honeymoon night of a shepherd and shepherdess? Or what, for that matter, of Calvert's other wood engravings 'The Bacchante', 'The Ploughman', 'The Cyder Feast', 'The Brook', 'The Lady with the Rooks' and 'The Return Home', each reflecting the influence of Blake and of Calvert's classical learning, and which although minutely engraved, have a vigour far removed from the lacy engraving of William Harvey. They are some of the greatest triumphs of wood-engraving.

'The Chamber Idyll', engraved in 1831, was Calvert's last engraving in any medium (he also made line-engravings and lithographs). It is not known why after this he abandoned engraving, although it has been suggested that he felt he could not further improve in the medium and feared for his integrity if he continued. Whatever the explanation, he did not engrave again, and with his *oeuvre* the small school of wood-engravers who took their inspiration from Blake came to an end, until Blake's influence once again became effective later in the century.

One of the most important factors in the spread of wood-engraving was the appearance from the 1830s of cheap periodicals. Some of them were educational, others political, some comic, but most of them had this in common — they were illustrated; and this led to a boom in wood-engraving.

In our context one of the most influential of these periodicals was *Punch, or the London Charivari,* which was first published in 1841. It was conceived out of an idea originated by the wood-engraver Ebenezer Landells (1808—60) and the journalist Henry Mayhew (1812—87), best known for his book *London Labour and the London*

Poor (1851). Mayhew was its first editor, but he was soon succeeded by Mark Lemon (1809–70).

Many of the illustrations in *Punch* were by great Victorian artists, whose work was reproduced with painstaking fidelity by craftsmen whose dexterity is staggering. The painter W.P. Frith once expressed astonishment at the interpretation of a drawing by John Leech. 'Some of the lines,' he said, 'finer than the finest hair, had been cut away or *thickened*, but the character, the vigour, and the beauty were scarcely damaged.' Only a photo-line block could have reproduced the artists' original work with greater accuracy.

Not that this was invariably so, for some artists were in despair at what the wood-engravers had made of their work. Samuel Palmer for one; he wrote page after page of instructions and appeals to the craftsmen who engraved his illustrations for various books, among them Dickens's *Pictures from Italy* (1846), all to little avail, even if some of the results are better than others. On the other hand some designers, appreciating the limitations of wood-engraving, made their drawings so that they could be more easily translated into that medium.

In 1842, the year after *Punch* first appeared, another important periodical was published that was to encourage further the spread of wood-engraving. This was the *Illustrated London News*, founded by Herbert Ingram (1811–60) of Boston in Lincolnshire. This differed from *Punch* in that it was a weekly newspaper, and the fact that it was illustrated was a great novelty. It also put great pressure on the ingenuity of the artists who against time made drawings at the scene of news stories, and on the engravers who were expected to produce blocks engraved with the greatest speed, so as to be prompt with the news. Ingram was so successful in organising all this and the paper sold so well that he was soon employing his own staff of artists and engravers, and sales rocketed to 200,000 copies a week.

In 1855 the *Illustrated London News* published a colour supplement, printed from blocks engraved by Thomas Bolton. This was the first time anything of the kind had been seen and crude though the results were in comparison with what was to come later, they must have made a great impression. In 1860 the *Illustrated London News* made another innovation, with the first wood-engraving made from a block on which a photographic image had been printed.

There was in fact hardly any event of national or even international importance which was not covered by the artists of the

Illustrated London News, who rushed to the scene of a battle, a disaster or a triumph, making their sketches and hurrying back so that they might be transferred to the block, which was then speedily and efficiently engraved by craftsmen. If the illustration was large, then small blocks would be put together and after the drawing was made on them or transferred to them, they would be distributed among several engravers and when finished put together again and any inconsistencies worked over, despite which one can sometimes see the places where the blocks join. The engraving of a large illustration would in this way be completed in an hour or so.

Other periodicals followed *Punch* and the *Illustrated London News*, and they nearly all increased the demands on contemporary wood-engravers. They included *The Cornhill* edited by W.M. Thackeray, which began in 1860; *Good Words* which had a religious bias and was begun in 1859; in the same year *Once a Week* was first published by Bradbury and Evans, who were by then proprietors of *Punch*; and in 1869 appeared *The Graphic*, founded by the wood-engraver William Luson Thomas (1830—1900) who had worked on the *Illustrated London News*.

In book illustration in the middle years of the century wood-engraving could be seen at its most brilliant, especially during the 1860s. Yet one thing is certain — the history of the *art* of wood-engraving at this time is really that of the designers who drew on the wood rather than that of the engravers who progressively took a secondary role as interpreters of other men's work. Not interpreters in the sense of engravers like Charlton Nesbit and Luke Clennell, for they made a creative interpretation of the original work. The later craftsmen, as I have just remarked about engravers for *Punch*, made, so far as was in their power, a copy of the original drawing, line for line. This is not to belittle their accomplishment, rather the reverse, because their skill in doing this was astonishing. But it was primarily craftsmanship and not art.

Many of the leading artists of the day designed for wood-engraved illustrations, either drawing directly on to the block for the craftsman to engrave, or drawing on paper for the craftsman to transfer to the block. Sometimes they did both, making their first design on paper and then drawing it on the block themselves; there are indications that Palmer might have done this for his illustrations for *Pictures from Italy*. Among other artists who designed wood-engraved illustrations were Thomas Creswick, Dante Gabriel Rossetti, Daniel

34

Maclise, Clarkson Stanfield, Sir John Everett Millais, Birket Foster and William Mulready, to mention but a few.

Many of these works are brilliantly conceived like Millais's illustration for Tennyson's 'Mariana' from *Poems* (1860), with its weeping figure sitting on a window seat with a melancholy landscape outside, a tragedy in a few square inches conveyed with Pre-Raphaelite intensity and detail. Millais's illustration to the same poet's 'St Agnes' Eve' is another instance of miniature intensity: the young woman, lighted candle in hand, pausing on a spiral staircase, her breath vapourising in the cold air, to look through a window at snow-covered convent buildings under a star-bright sky. It illustrates perfectly the opening lines of Tennyson's poem:

> Deep on the convent-roof the snows
>> Are sparkling to the moon:
> My breath to heaven like vapour goes:
>> May my soul follow soon!

Millais was one of the finest illustrators of the 1860s. Few others equalled his gift of capturing the work he was illustrating, even adding nuances to it. It was a gift he shared to some extent with Rossetti, but Rossetti's work was much more mannered and somewhat overcrowded, like his illustration to Tennyson's 'Palace of Art' with the weeping queens of Avalon. At his best, however, he can use this crowding — probably the result of *horror vacui* — to good effect, as in his designs for the poem *Goblin Market* by his sister Christina (1862), which were engraved by William Morris (1834—96). The frontispiece to this, 'Buy from us with a golden curl' is menacing with latent evil. The heroine Laura is in the act of cutting off one of her curls to buy magic fruits from the goblins who crowd around her:

> One had a cat's face,
> One whisked a tail,
> One tramped at a rat's pace,
> One crawled like a snail,
> One like a wombat prowled obtuse and furry,
> One like a ratel tumbled hurry skurry.

Arthur Hughes (1832—1915) came close to Millais in his gift for portraying atmosphere, and of his illustrations the most effective is

one for *The Princess and the Goblin* by George Macdonald (1872) which shows a little girl in her nightgown stealing up a stairway, from around the corner of which, through an archway, come rays from a hidden light. It is charged with mystery and poetry.

Wood-engraving remained supreme in book illustration until in the early 1870s photographic methods superseded it. The first experiments in such methods had been made in the 1820s, and various processes had been developed in the meantime, but by the 1870s they were in general use and wood-engraving for a time almost disappeared.

The Dalziel Brothers were among the superb craftsmen at work at the height of the fashion; they were also the most ubiquitous. One can hardly pick up an illustrated book of the mid-nineteenth century without seeing their signature on at least one or two of the blocks — those by Millais, Rossetti and Hughes which I have just mentioned were all engraved by the Dalziels. And in periodicals their name occurs again and again.

There were eight brothers of whom the most important were George (1815–1902) and Edward (1817–1905). Of the other brothers, John (1822–69) was an engraver and Thomas (1823–1906) was a draughtsman but did not engrave. There were also four sisters, of whom Margaret (b. *c*. 1819) worked with the engravers. They were all born at Wooler in Northumberland.

The Dalziels worked as a firm and employed other engravers, and their work was all done under one general signature: DALZIEL, usually scrawled inconspicuously in a corner of the design.

For a period from 1835, George Dalziel worked for the London engraver Charles Gray, and his fellow assistants included one of Thomas Bewick's former pupils, Ebenezer Landells, who, as we have seen, was one of the founders of *Punch*. He also worked for a time with Isaac Nicholson (*c*. 1790–1848) yet another pupil of Bewick. He therefore came under Bewick's influence if only at second hand and might have been aware of the master's methods. Yet George and his brothers belonged firmly to the new school of wood-engravers who reproduced, as nearly as possible line for line, the drawing from which they were working.

The Dalziel's range of interpretative engraving is most impressive and ranges among the sensitive close drawing of Millais and Hughes, the more open style of Arthur Boyd Houghton's designs for *The Arabian Nights Entertainments* (1865), John Tenniel's firm drawing

for the *Alice* books (1866 and 1872), and the finely detailed drawings, by Frederick Sandys and others for Robert Aris Wilmott's *English Sacred Poetry* (1862). Indeed the Dalziels engraved designs by most of the leading artists of the day, including among many more Birket Foster, Ford Madox Brown, Frederick Pickersgill, Richard Doyle, W. Holman Hunt and G.J. Pinwell.

The Dalziels had set up on their own as engravers in 1839 but their activities went beyond engraving, for they were also printers and publishers of books. In 1857 they started the Camden Press in Camden Town, and, in collaboration with the publisher George Routledge, produced and issued many gift and poetry books.

Here again in these works of many famous artists are represented. One of the most impressive of these books was another volume edited by Willmot: *Poets of the nineteenth century* (1857) which contains a masterpiece by Millais engraved by the Dalziels — an illustration of Coleridge's poem 'Love'. In a moonlit copse, in which, in the middle distance, a hare may be discerned, a couple embrace. The man is a minstrel, and his left hand is touching his harp which stands at his side, his right hand cups his lover's head while she lies on his breast with her arms around his shoulders. It is a perfect visual rendering of the closing lines of Coleridge's poem.

> Her bosom heaved — she stepp'd aside,
> As conscious of my look she stept —
> Then suddenly, with timorous eye
> She fled to me and wept.
>
> She half enclosed me with her arms,
> She press'd me with a meek embrace;
> And bending back her head, look'd up,
> And gazed upon my face.
>
> 'Twas partly love, and partly fear,
> And partly 'twas a bashful art,
> That I might rather feel, than see,
> The swelling of her heart.
>
> I calm'd her fears, and she was calm,
> And told her love with virgin pride;
> And so I won my Genevieve,
> My light and beauteous Bride.

37

The design seems to show overtones derived from a painting by George Richmond, a follower of William Blake. This is 'The Eve of Separation' now in the Ashmolean Museum, which shows a couple embracing passionately in a nocturnal setting. As to the symbol of the hare, this was sometimes used in Christian art to denote fecundity and Millais could have intended it to symbolise the same idea.

Later the Dalziels collaborated with the publishers Ward and Lock in the production and publication of 'Dalziels' Illustrated Editions', which included the large *The Arabian Nights Entertainments* of 1865, with its two hundred-odd illustrations. At the same time they continued their collaboration with Routledge and their work for other publishers. The firm continued for another generation and just into the present century, closing in 1905.

The Londoner William James Linton (1812—97) was another important reproductive wood-engraver; he is especially remembered nowadays as a radical reformer and republican. Misfortune with the insistence of a Greek tragedy dogged him for much of his life: the early death of his first wife, the deaths and incurable illnesses of several of his children by his wife's sister who became his mistress, and an unhappy second marriage to the Victorian novelist Elisa Lynn. In the meantime he had set up a kind of socialist colony at Branston near Coniston Water, occupying a property he later sold to John Ruskin.

In 1866 he went to America where he had somewhat better luck and where he received a number of honours including an honorary MA of Yale University. He settled with a daughter near New Haven, Connecticut.

Linton's work was not so ubiquitous as that of the Dalziels, but it is no less interesting. His most successful engravings include those he made for Alexander Gilchrist's *Life of William Blake* (1863) in which he made some remarkably convincing reproductions of pages from Blake's illuminated books. His reproductions of Richard Doyle's drawings illustrating Thomas Hughes's novel *The Scouring of the White Horse* (1859) should not be overlooked. In these he skilfully interpreted the characteristic and sensitive lines of Doyle's often elaborate designs.

Rossetti, who like some other artists was often highly dissatisfied with what engravers did to his designs, seems to have rated Linton slightly higher than the Dalziels. He makes an interesting comparison of the two in a letter written in 1856 to William Allingham: 'But

these engravers! What ministers of wrath! Your drawing comes to them, like Agag, delicately, and is hewn to pieces before the Lord Harry. I took more pains with one block lately than I had with anything for a long while. It came back to me on paper the other day, with Dalziel performing his cannibal jig in the corner [a reference to his signature], and I have really felt like an invalid ever since. As yet, I fare best with W.J. Linton. He keeps stomach aches for you, but Dalziel deals in fevers and agues.[1]'

Elsewhere he writes in a parody of George Pope Morris:

Address to the D————1 Brothers.

O woodman, spare that block,
O gash not anyhow;
It took ten days by clock,
I'd fain protect it now.

Chorus, wild laughter from Dalziel's workshop.

The Dalziels and Linton are the best known reproductive wood-engravers. Others were numerous and we may briefly notice Henry Vizetelly (1820–94), Joseph Kenny Meadows (1790–1874), W.T. Green (fl. mid 19th century), W. Measom (fl. mid 19th century) and Horace Harrall (fl. 1856–76), each of whom made important contributions to contemporary book illustration.

The technique of photographing the artist's drawing on to the block which was in limited use by 1860, began within a few years to come into more general use. Innocuous though this may seem, it was the beginning of a tendency which was in a short time to lead to the invention and improvement of many photo-mechanical methods which hastened the decline of wood-engraving as a general black and white illustrative method, and indeed which soon superseded it completely, although it was revived as an art form towards the end of the century.

Alongside the developments in black and white wood-engraving, coloured wood-engraving had been gradually evolving. There had been attempts to print coloured woodcuts from 1482, and those known as chiaroscuro prints, as far back as 1507–8. In Germany at

[1] Doughty, O. and J.R. Wahl (eds.) *The Letters of Dante Gabriel Rossetti*, Oxford 1965, Vol. I, pp. 310, 318.

that time these prints had been built up from three separate blocks — one for the base colouring with highlights cut out, one for outlines in black and one for tinting. This method was later elaborated so that it could be combined with intaglio printing. Many years later, in the late eighteenth or early nineteenth centuries, an Englishman William Savage (1770–1843), built up colour prints from a series of wood blocks, using sometimes as many as twenty-nine.

George Baxter (1804–67) was one of the most famous colour printers of the nineteenth century. His method, which he patented in 1835, combined a metal intaglio plate for the basis of the design, on top of which up to twenty wood blocks or metal plates were printed in oil-based inks to give the requisite colouring, although on later prints the metal base plate was abandoned. For successful results, perfect register in printing was essential and this Baxter achieved. On the other hand he also gained further richness of effect by allowing some of the blocks to overlap in printing, but this was controlled with great care.

This somewhat laborious technique was used to make prints which were usually intended to be framed, but they were sometimes used for book illustrations.

From 1849 Baxter licensed others to use his process, and the licensees included Le Blond and Co., Kronheim and Co. and Bradshaw and Blacklock. He became bankrupt in 1865, but licensees continued to issue his prints.

In the early days of his process Baxter made a speciality of prints of martyrdoms for missionary societies, but soon his subjects could be counted in hundreds. Judging by this and by the numbers that have survived, Baxter prints must have been extremely popular, and Baxter's aim of bringing 'taste of a refined and intellectual nature to the working people' seems to have been amply realised. Some Baxter prints have an unattractive hardness, but others are most pleasing, and this is especially true of smaller subjects.

The greatest printer of coloured wood-engravings later in the century was Edmund Evans (1826–1905), who, from the mid–1870s to the mid–1880s, printed the very attractive colour books for children designed by Kate Greenaway, Walter Crane and Randolph Caldecott.

Evans's method was first to engrave key blocks from the artist's designs, proofs from which were coloured by hand by the artist, and from these he made a block for each colour, five in all. Later the base

block was made by a photo-line process, and the colour blocks were engraved by hand on box. It was thus that such children's master-pieces as Richard Doyle's *In Fairyland* (1870), Kate Greenaway's *Under the Window* (1878), Walter Crane's *Baby's Opera* (1877) and Randolph Caldecott's *John Gilpin* (1878) were printed. Though chracteristic of their age, these works are in fact also timeless and still enjoy considerable popularity.

Towards the end of the century there was a revival of wood-engraving as a serious artistic technique. Thomas Sturge Moore (1870—1944) was prominent among the newer wood-engravers; his engravings belong to the tradition established by William Blake rather than to that of Bewick, for they are conceived in chiaroscuro, although white line is also present. Moore made a number of book-plates and book illustrations, but the finest of them are in the book *The Centaur and The Bacchante* by Maurice de Guérin, published by the Vale Press in 1899. They are highly romantic: the illustration of the Centaur in a river with swans to his right, a rising, partly wooded landscape beyond and a little waning moon in the sky, has much in common with the scenes depicted by Edward Calvert and with those in some of Blake's Thornton's Virgil illustrations. It is another 'corner of Paradise', to use Palmer's words, something beyond 'the gaudy daylight of this world'.

The Vale Press was one of the great private presses that began to function at the end of the nineteenth century. It was founded by Charles Ricketts (1866—1931) who ran it with the collaboration of his friend Charles Shannon (1863—1937). One of their finest pro-ductions was a sumptuous illustrated edition of George Thornley's translation of Longus's *Daphnis and Chloe* (1893); it contained woodcuts designed by Shannon and cut by Ricketts. In these both the white line technique of Bewick and the chiaroscuro of Blake are abandoned and a return is made to the black line technique of wood-cutting as practised in the fifteenth century, like the illustrations in the *Hypnerotomachia Poliphili* (1499). In their way they are very attractive, but they do not belong to the nineteenth century; rather they are a nostalgic backward glance at a tradition that was already well and truly dead before the nineteenth century began.

Much the same might be said of the wood-engravings designed by Sir Edward Burne-Jones for the Kelmscott Press of William Morris most of which were cut by W.H. Hooper (1834—1912), although it is true that Burne-Jones used more tonal effects than Ricketts. These

may be seen throughout the Kelmscott books, particularly in the great Chaucer of 1896; others designed by Burne-Jones and cut by Morris were planned for *The Story of Cupid and Psyche*, but they did not appear until 1974, when they were printed for the first time by Will Carter.

The wood-engravings of Edward Gordon Craig (1872–1966) belong mostly to the twentieth century — he engraved over five-hundred blocks between 1895 and 1923 — and those he did make in the nineteenth century belong more to the traditions of the woodcut. Nevertheless Craig matured in the nineteenth century and his engravings are not unrelated to the kind of late nineteenth century developments typified by the work of Sturge Moore.

Those developments gave rise to the new and highly original school of wood-engravers that still flourishes in this country in the twentieth century. The work of engravers such as Agnes Miller Parker (1895–1980), Eric Ravilious, (1903–42), Reynolds Stone (1909–79), Joan Hassall (b. 1906) and John Lawrence (b. 1934), is firmly entrenched in the tradition founded by their nineteenth-century precursors.

CHAPTER V

Technique and Design
in Security Printing

The production of banknotes, postage stamps and related material is an important aspect of the art of printmaking in the nineteenth century. Security printers, by taking advantage of a number of new techniques, helped to establish them more quickly than could otherwise have been the case. And because the requirements of such material are primarily functional rather than decorative, these helped to show how design itself could be successfully adapted to the new methods and to the demands of security.

Banknotes were used first in China during the ninth century. But apart from emergency paper money issued during sieges in the fifteeneth century, banknotes first appeared in Europe in 1691; this was in Sweden where they were necessitated by a particularly heavy copper coinage difficult to carry about.

The first English notes appeared in 1694 and were issued by the Bank of England. They were of three types: accomptable notes, sealed bills and what the Bank called 'running cash notes'. The last named closely resembled modern banknotes and were printed from engraved plates for the sums of £5, £10, £20, £50 and £100; they had to be filled in with a number, the name of the bearer and the date. A figure of Britannia appeared at the top of the note.

Throughout the eighteenth century developments in the type, quality and watermarking of the paper on which the notes were printed, and variations in design and lettering and methods of printing and numbering were made. Most of the developments were introduced to combat forgery and faking, which flourished despite the fact that they were punishable by death; later uttering a forged banknote also was so punishable, and even to be in possession of a forged banknote made the bearer liable to transportation for life — penalties that remained in force until 1832.

Other banks also issued notes during this early period: the British

Linen Company from 1747, the Bank of Scotland from 1696, Smiths of Nottingham from 1736 or earlier, and at various times they were issued by Gurney's of Norwich, Stuckey's of Somerset and Lloyd's of Birmingham. The earliest of these banknotes were little more than plain printed forms, but others issued in later years were more elaborately engraved, some with vignette views of places in the vicinity in which they were issued.

The Bank of Ireland, too, issued its own notes from the time of its foundation in 1783, and it was here that important developments took place in the early nineteenth century, due to the ingenuity of the printer, engraver and miniaturist, John Oldham (1779–1840). For one thing he invented a mechanical and automatic device for applying numbers to banknotes, which was adopted by the Bank of Ireland in 1812; for another, in 1816, he was the first printer to apply steam power to the printing of banknotes. He had one of his numbering devices attached to the printing machine, not to apply the numbers (for technical reasons that was done separately), but to record the number of banknotes printed. Further, also in 1816, he was one of the first printers to print banknotes from engraved steel plates. Later, as we shall see, he came to London to work for the Bank of England.

The printing of banknotes from steel plates was taken a step further by the American printer and inventor Jacob Perkins who came to England in 1819 and set up in business as Perkins and Fairman at 29 Austin Friars in the City of London. His partners were Joseph Cheeseborough Dyer of Manchester, a card maker, and an engraver named Gideon Fairman, another American. Dyer had made a number of inventions which Perkins improved upon and these were patented in 1819 in Perkins's name.

The firm used a method of making a given number of plates from a master or check-plate, which was later to be applied with great success to the printing of postage stamps. This is the process known as siderography, in which an impression on a softened steel roller is taken up from a hardened steel plate by being rocked over it under great pressure. The roller is then hardened and the requisite number of impressions (two hundred and forty in the case of a sheet of stamps) rocked on to a large soft steel plate, which is in its turn also hardened.

A machine for engraving lines invented by yet another American, Cyrus Durand, was also brought into use; as was the rose engine, an

improved version of which was part of Perkins's 1819 patent. This was an engraving lathe that cut many types of patterns, including rosettes, and all kinds of reticulation. One of its greatest assets was the fact that it was virtually impossible to work out a combination of gears to cut a pattern from a given design; the variations were infinite, and the machine almost thought for itself. This was the subject of a discussion at a meeting of a select committee on postage stamps on 20 April 1852. The questions were asked by Mr J. Greene and the answers given by Mr Joshua B. Bacon.

The Queen's head [i.e. stamp] is done by machinery in your establishment? — Yes.

Have other parties in London similar machinery? — I believe, within a short time, one party has.

Any person who has machinery of that description can, of course, copy that? — They cannot; they can do many things we do, and we can do many they can do; but if we had a die taken, that die, for instance, which contains the machine-work around the Queen's head, and we were asked which we would prefer, to reproduce that same die again, unless we had kept all the calculations and division upon all the wheels, or to make a thousand fresh ones, but not like that, we would prefer making a thousand; we could do it quicker; it is self-acting machinery. We cannot dictate to the machine; we can cause it to make an oval, or a straight line, but as to the particular pattern it is going to produce, we know nothing of it until it is done.

It would not in fact be far wide of the truth to claim that the rose engine was, once it was set in motion, a kind of self-articulated robot. In the heady *avant-garde* days of Expressionism during the first quarter of the twentieth century, one heard much talk of a machine aesthetic, but here, one hundred years before, was a machine that not only met all the demands of such an aesthetic, but which actually made its own designs, a kind of artistic ancestor, as it were, of the computer. And it is perhaps not without significance that Charles Babbage, the 'father of the computer' about the same time, in 1826, provided machinery with a time and motion notation of its own, in *A Method of Expressing by Signs the Action of Machinery*, thus

putting it on a level with music and dancing. One further step, alas never taken, might have combined this with the work of the rose engine, to lay the foundations of a hitherto unsuspected art form.

The Bank of England set up its own printing works on the Bank premises in 1808, as it was felt that dependance on private individuals and firms was potentially unreliable, especially as the demand for notes had reached 30,000 a day. So in April of that year Garnet Terry of Paternoster Row, who had worked for the Bank of Ireland and, since 1795, for the Bank of England as a freelance banknote printer and engraver, was appointed copperplate engraver to the Bank with the high salary of £1000 a year in consideration of his having given up his own business.

For twenty-five years, from 1796 to 1821, the Bank sought a design, or a method of producing banknotes, that would be impossible to imitate, and many designs and suggestions were submitted. It was one of the tasks of Terry and his successors to attempt to copy these accurately in order to prove — or more usually to dispose of — the claims made for them, and a considerable amount of time was taken up at the Bank by engravers thus employed.

Many of the designs sent in were notable for their extreme complication, and one would probably think that a complicated design would be the best protection against forgery. That, however, is not the case; an imitation of a simple design, the details of which may be clearly memorised, is much less likely to deceive.

The watermark in the paper is of considerable importance in security printing, and this received much attention in attempts to outwit the forger. Accordingly, from 1801, the denomination of the note was worked into the watermark and the straight (laid) watermark lines running across the sheets were made wavy. The watermark design is picked up from a wire or mesh frame on to which the paper pulp is poured and, being fractionally thinner where it touches the wires, the design shows up when the paper is held against the light. In laid paper, parallel wires lie across the whole of the papermaking frame, and they are attached to other wires at right angles, which occur at much wider intervals.

One of the designs submitted during the quest for an inimitable banknote was a wood-engraved design submitted by Thomas Bewick, but it was found that this could easily be imitated in line-engraving. Rudolf Ackermann suggested the use of machine engraving transferred to stone by lithography, but the Bank did not like the idea of

lithography. Yet, in passing, it might be mentioned that lithography was put to at least one useful function in security printing. This was in connection with credit notes issued by Coutts and Co., and by Herries, Farquhar, Davidson and Chapman and Co., of 16 St. James's Street, Pall Mall, London, and carried by travellers during the nineteenth century, somewhat like the modern travellers' cheques. Copies of the traveller's signature were lithographed and sent to appropriate banks in the country he was visiting, in order that his signature could be confirmed when he cashed his notes.

A complicated but beautiful design was submitted by J.C. Dyer on behalf of Perkins. It consisted of a heading showing Britannia surrounded by allegorical figures and flanked by two identical portraits of the Prince Regent in stipple. The lettering occupies over half of the lower part of the design, printed over a ground consisting of lines and of the words 'one pound' repeated two thousand times in microscopic size. At the bottom, on either side of this background, are two line-engraved oval vignettes of Britannia. The left and right-hand edges of the note are filled with rose-engine work and on that at the right, enclosed in four rosettes, is the inscription, £ONE.

Some of the rose-engine turning on this note is in white line; this was easily accomplished by introducing one more step into the transfer process so that the black lines are reversed.

Perkins's design was rejected after some of the more difficult parts had been successfully copied by a bank engraver. This despite the fact that Perkins's method had been used with success in the United States of America.

Yet another interesting proposal came from Augustus Applegarth, a well-known printer, and his partner Edward Cowper. It was for a note printed from stereotyped plates, with an overall design in black and with infilling patterns in one or two colours; the design on the back of the banknote was the same as that on the front, but reversed. It was printed in a press that ensured perfect register between back and front.

To begin with the Bank authorities had been impressed by Applegarth and Cowper's notes, but when they were put to the usual test, it was found that they too could be imitated by the Bank's engravers. They tried again, making a note in black and three colours, and yet again in five colours, but yet again they were successfully imitated. In fact the only permanent feature to come out of this quest was the wavy-lined laid watermark.

47

In 1831, Jacob Perkins was again involved in the production of banknotes, this time not in connexion with the actual printing of them, but with an invention he had made for heating the engraved printing plates by hot water. It is essential to heat intaglio plates during printing to keep the ink at the right consistency and they had previously been heated by charcoal, which gave off fumes hazardous to the workmen's health. By this time Perkins's colleague Fairman had returned to the United States and the firm had been re-named Perkins and Heath, the other partners being Charles Heath the engraver, and after he had become bankrupt, his brother George Heath. On the recommendation of William Bawtree, the Bank's chief engraver and superintendent, the new device was fitted to all the twenty-six presses in the Bank's workshop.

In 1832 the Bank entered into consultation with the Bank of Ireland, and their engineer, John Oldham, came to London to give his advice, subsequent to which a select committee was set up, consisting of the famous scientists and engineers, Charles Babbage, Marc Isambard Brunel, Bryan Donkin and Joshua Field. The result of all this was that in 1835 many of John Oldham's inventions and improvements, including his numbering mechanism and a security device for controlling the supply of banknote paper during printing, were put to use in London. Soon afterwards, in 1836, Oldham entered the employment of the Bank of England as mechanical engineer and principal of the engraving, plate-printing, numbering and dating office.

In 1838 the question of changing the design of the notes was again mooted, and a sub-committee of the engravers William Wyon, H. Le Keux and J.H. Robinson, the artist Henry Corbould, the Bank's architect C.R. Cockerell, and John Oldham, was formed to consider a new design which had been sketched by Corbould after consultation with Wyon and Le Keux. Variations of this were considered and the final version was submitted to the Court of Directors in 1839.

The design is rather elaborate. Set within a decorative border, and with the lettering at the centre, a representation of Britannia stands at each side. Above are the Pleiades, and below in a medallion are portraits of King William III and Queen Mary II, supported by figures of Mercury and Fortune. Rose-engine turning was to be included and the proposed printing was to be by a mixed method of line, stipple and anaglyptography.

The proposal was not accepted and the search for something more

suitable began once more. It was not however until some years later, in 1853, that a satisfactory new design and method of production were finally approved. The printing technique proposal was electro-typing, using a method developed by the medical practitioner and scientist, Dr Alfred Smee FRS, whose father was the Bank's chief accountant. The new chief engraver and supervisor, John Coe (Oldham had died in 1851), and the Bank's engineer, Henry Hensman, collaborated with Smee to produce cheques by the new method by way of experiment. This was successful and it was decided to print bank-notes by the same method.

A vignette designed by Daniel Maclise was engraved by J.H. Robinson (1796—1871) and a relief from this was made in steel by John Thompson (1785—1866), who is also well known as the engraver of the plates for printing the Mulready envelopes issued in 1840 with the first postage stamps. The lettering and remaining decorations on the note were engraved by craftsmen employed by the Bank, and reliefs from them were made in copper by the punch-cutter, John Skirving. From these reliefs the moulds were taken, copper electrotypes were made in them, and these were afterwards reinforced with solder.

A new press was necessary for printing from the electrotypes, the requirement of copperplate printing being entirely different from surface printing, and after much discussion and many trials the choice fell upon the Napier platen press, which had recently been patented by the engineer J.M. Napier, a member of the firm of D. Napier and Son. This would print 1500 notes an hour. The Bank was thus prepared to supply the new notes which were issued in January 1855. With very little difference they remained the same until the last of them — the £5 note — was withdrawn in 1963 to make way for the new Treasury notes. The Napier presses remained in use until 1945.

The innovation of printing the notes from electrotypes was not made without criticism, and this came in particular from Henry Bradbury the printer and a partner in the firm Bradbury and Evans, later to become Bradbury, Wilkinson and Company. In a lecture to the British Institution, published in 1856 and illustrated with plates by John Leighton, he criticised the new method, claiming that it was much easier to copy than line-engraving. Bradbury's strictures did not prevail, but in one respect he was right, in that he mentioned the possibility of the use of photography in forgery. He suggested as a

means to overcome this, the use of underprinting the main design with a background of repeated miniscule lettering (as in the Dyer-Perkins design described a few pages back) in a colour that would photograph in black and therefore obscure the main inscription. Although this device was not used in Bank of England notes, it was used elsewhere on cheques and on other security printing.

The design of all the notes from £5 up to £1000 was the same, except for the statement of value. It was plain but beautiful, an example of what may be achieved with good taste and imagination in a simple piece of functional engraving. The paper itself was rich and strong, yet thin, and embellished by watermarking, and the printing was an intense black. At the top left is the oval vignette of Britannia designed by Maclise, surmounted by a crown and surrounded by baroque leaves. The lettering is a mixture of black letter, copperplate script and serif capitals, and the signature of the chief cashier varies of course from period to period. At the bottom left the value is expressed in white gothic lettering, on a black background, surrounded by beads and preceded by a £ sign with many flourishes. The numbers of the notes are superimposed at right and left of the main inscription. When one handled one of these finely printed notes on crisp paper, it gave the impression that here was something really worth the value it expressed.

Treasury notes for 10s. and £1, and later for larger amounts, belong to the twentieth century and are therefore outside the scope of this study. But Bank of England notes for £1 and £2 had been issued up to 1821. Abortive attempts to again introduce Bank of England notes for 10s and £1 were made in 1891 and it was not until just after the outbreak of war in 1914 that these denominations at last appeared, and then as Treasury notes and not as banknotes.

Apart from banknotes printed at the Bank of England, various firms like Perkins, Bacon and Co. and Thomas de la Rue and Co. produced currency notes for foreign and colonial administrations. Other items printed by them in, or related to this category, are cheques (which often incorporated interesting and beautiful lithographed or stereotyped designs), dividend warrants, bonds, and share certificates. And the Bank itself was also concerned in the printing of postal orders, production of which was authorised by an Act of Parliament in 1880.

The printing of postage stamps began much later than that of bank-notes, the world's first stamps being issued in Great Britain during May 1840 — the famous one penny black and two pence blue. They were part of Rowland Hill's reforms in the Post Office which led to a universal penny post for a 1oz letter. Before that the charge for a 1oz letter from, for example, London to Edinburgh was 1s 4½d; under the new arrangement it would cost a penny. Even so, Hill calculated, it ought still to allow the Post Office a reasonable profit, for he had proved that the actual cost of conveying the letter was one thirty-sixth of one penny. He argued that the cheaper rate would lead to a great increase in the use of the mail service, which would add to the net profit shown under the old system which, because of the high charges, prevented large numbers of people from making use of it, or tempted them to use illegal means to carry their mail. Hill's suggestions were adopted in 1839 and the penny post was established on January 10, 1840, although the stamps were not ready until May.

They were issued simultaneously with Mulready envelopes which had the same power of prepayment as the stamps. They were named after William Mulready, who designed them; the engraving was by John Thompson. The design depicts Britannia at the centre with a tame looking lion at her feet; her outstretched arms send letters to all parts of the world, symbolised by elephants, camels, Red Indians, negroes, Hindus, settlers and others. A space was left for the insertion of the name and address to which the letter was being sent. The envelopes were received by the public with scorn and derision and they were both caricatured and lampooned. They were soon discontinued.

The stamps on the other hand were a great success, even if they were ill received by some and by others likened to corn plasters. But whatever some contemporaries thought of it, the design of the first stamps is one of the most beautiful ever made for the purpose.

The Queen's profile (for long the stamps were known as 'Queen's Heads'), with a simple diadem, rests against an engine-turned background. The design is flanked with columns of colourless engine turning, and each of these is surmounted with a Maltese cross and supported on a square containing a check letter. Check letters were a guard against forgery; there were two on every stamp in each sheet of two hundred and forty, arranged in twenty horizontal rows of twelve. The top row was lettered AA, AB, AC and so on to AL, the second row BA to BL, the third row CA to CL, down to the twentieth

row which was lettered TA to TL. Between the Maltese crosses is the word POSTAGE and between the squares containing the check letters the value is indicated, ONE PENNY or TWO PENCE.

The design of the 1840 stamps cannot be attributed to any one person. A competition had been organised by the Treasury for suitable designs, but nothing suitable was submitted and Hill sought a solution to his problem elsewhere, consulting Henry Corbould who in February 1840 submitted a rough sketch of what was to become the penny black design. The head finally chosen was based on that of William Wyon's medal commemorating Queen Victoria's first visit to the Corporation of London at Guildhall, on November 9, 1837. The head was engraved by Charles Heath and his son Frederick. The engine-turned background was the work of Perkins, Bacon and Petch (as Perkins's firm was called at this time), and they also carried out the preparation of the plates and the printing of the stamps.

The plates for the stamps were built up by siderography, and they were printed on sheets of watermarked paper — a small stylised crown appearing at about the centre of each stamp.

In 1841 the colour of the penny stamps was changed to red and there was a minor alteration to the design of the two pence value, in that two thick white lines were added, one below POSTAGE and one above TWO PENCE. Later still, perforations were added between the stamps for ease of separation and the watermark was altered to a large crown. Again, in 1864, the design of each value was slightly altered by the removal of the Maltese crosses and the insertion of check letters in place of them. The letters are the same at the top as at the bottom, but reversed: thus AB at the bottom is BA at the top. In 1870 halfpenny and one penny halfpenny stamps of different designs were added to the series.

In 1880 the Crown terminated its contract with Perkins, Bacon and Co. (as it had then become) and the one penny and two pence stamps of the 1840 type went out of use after nearly forty years. They were replaced by surface printed stamps produced by acierage by Thomas de la Rue and Co., who since 1855 had used this method to print stamps of higher values ranging from 2½d to £5. Some of the high value stamps were of pleasing design, especially a three pence stamp issued in 1862, a four pence value issued in 1855, and a five shillings value issued in 1867. But the kindest thing that can be said of the new low-value stamps is that their designs are uninspired, and so in fact they continued, though changed several times, until the

end of Victoria's reign.

A particularly unpleasant series appeared in 1883—4 which made the preceding series of 1880 look almost brilliant in comparison. Printed in dull green and lilac they are often faded (the fugitive ink was yet another guard against forgery) and have a washed-out look, while the designs themselves look as if they were made up by a particularly unimaginative schoolboy using a set of geometry instruments.

The 'Jubilee' issue which followed these in 1887 is better, but after the restraint of the penny black, its designs are overcrowded and fussy.

Apart from the official stamps of Great Britain and those of private firms like the private telegraph and telephone companies, the security printers in this country supplied stamps all over the world. Perkins Bacon and Co. printed many of the early issues of British colonial administrations, including the famous triangular stamps of the Cape of Good Hope (these were later taken over by de la Rue); delightful heraldic designs for Newfoundland, New Brunswick and Nova Scotia; the standardised issue, showing a seated Britannia, of Mauritius, Barbados and Trinidad; and early issues of Van Diemen's Land (Tasmania), Queensland, Grenada and Bahamas with a portrait of Queen Victoria taken from her coronation portrait by A.E. Chalon: these issues rival the penny black for beauty. And they printed stamps, among others, for the government of Chile, the Picific Steam Navigation Company (Peru) and Liannos's local post (Constantinople, Turkey).

Other British stamp printers working in line-engraving, surface printing or lithography, or sometimes in all three, and for customers all over the world, included Bradbury, Wilkinson and Co., London; Maclure, Macdonald and Co., Glasgow; Waterlow and Sons Ltd., London; Nissen and Parker, London; Mawdesley and Co., Liverpool; Truscott and Sons, London; and Charles Whiting, London. Some, like Waterlow, printed hundreds of issues; others, like Whiting, were much more restricted. But taken together the total output of these security printers is impressive and the standard of their work commendably high.

CHAPTER VI

The Age of Steel Engraving

Although steel engraving had been practised as far back as the sixteenth century, when Albrecht Dürer used iron as a base for etching, as a widespread medium for the production of prints and for the illustration of books, it belongs essentially to the nineteenth century. It was especially in evidence between 1825 and 1845, although it remained in more limited use until the end of the century.

One of the most important factors in its rise at this period was the growing fashion among all classes to possess pictures, and original paintings being too expensive for most pockets, the print provided a comparatively inexpensive surrogate.

Traditional line-engraving on copper was however still being used for such prints, and it was given a new lease of life when it was discovered that the copperplate could be faced with steel by electrolysis, thus providing infintely more impressions before wearing. But many of these line-engravings were dull in the extreme, pedestrian copies of originals, and before long it quickly began to lose ground to steel engraving; until by the end of the century it was all but a dead art, only to be revived during the present century by a limited number of engravers such as Stephen Gooden (1892–1955), Robert Austin (1895–1973), Charles Sigrist (fl. 1920s) and Leo Wyatt (1909–81).

Also of importance in the growing popularity of steel engraving was the demand for reasonably priced illustrated books, especially art books, something less expensive than the colour-plate books of a previous generation, but which would be, or seem to be, of higher quality than books illustrated with wood-engravings. In short the demand was for a cheaper form of engraving capable of giving the impression of traditional line-engraving.

For steel engraving is not pure line-engraving but a combination of line-engraving with etching, aquatint, stipple, or mezzotint, sometimes all together on one plate; pure line-engraving on such a hard

metal being far too laborious. Usually therefore the general outlines were etched on the plate, which was then worked up by engraving, mezzotinting or other methods, although etched passages were often left untouched.

The appearance of steel engraving differs from line-engraving on copper. A steel engraving lacks the richness and softness of a print made in the traditional medium. It is hard and cool and on the whole more finely engraved, as the hardness of steel lends itself to crisp, thin lines. And because it is a harder metal than copper it is capable of yielding fewer effects.

Steel had another drawback in its tendency to rust, and great care was necessary, particularly during storage, to prevent this — coating the plate with beeswax or with fat while it was warm was a common method.

None of the foregoing shortcomings precludes steel engraving from having its own delights and fascinations, but they do explain why for many years there was a somewhat snobbish disdain for it. The fact is that it is different from copper engraving, its attractions dissimilar.

One technical detail which contributed to the popularity of steel engraving among printmakers was the application of siderography, a master plate being used from which secondary plates could be taken to replace those beginning to show signs of wear. How often this was necessary is not altogether clear, but it is known that some plates printed half a million impressions without deterioration.

The first man to produce a successful steel engraving in this country during the nineteenth century was Charles Warren (1762–1823), a copperplate engraver who earlier had been engaged on making plates for calico printers, but who also worked for gunsmiths, engraving the designs on the steel mountings of their firearms. Later he became a well-established and recognised engraver of book illustrations.

At the beginning of the century Warren began engraving banknotes, producing vignettes for the Plymouth Dock Bank, and in 1818 he was involved in experiments connected with an enquiry initiated by the Society of Arts, which sought to find a method of preventing forgery in banknotes. He was, he said, convinced that softened steel could be engraved as easily as copper, and he softened some old saw blades on which to try out his ideas, his first experimental engraving being a head of Minerva. The blades were softened by heating, for which they were placed in cast iron boxes, which were heated nearly to melting point, and then allowed to cool gradually. It was

sometimes necessary, to get the best results, to repeat the process once or twice. The plate in this process was not hardened before printing, as it was found that nearly a quarter of a million impressions could be taken without affecting it.

Warren's first published steel engraving was made in 1822. It was taken from a design by Thomas Uwins for an edition of Milton's *Paradise Lost*, published by F.C. and J. Rivington in 1822 and depicts Adam and Eve with the Archangel.

In 1823 Warren presented his findings to the Committee of Polite Arts of the Society of Arts, showing to those present plates that had been used in printing illustrations in books in editions of 4000 to 5000 copies, and in printing illustrations in a magazine with a circulation of 25,000 copies. He was to have received the Society's large gold medal for his work in this branch of art, but did not live to receive it; it was presented to Warren's brother on May 28 1823, just over a month after his death.

Various engravers tried out Warren's softened steel plates, including William Holl and W.T. Fry, and so the technique of steel engraving began to spread. It was given further impetus by the Society of Arts, which offered medals, including silver and gold, for the best steel engravings of historical compositions, landscapes and portraits by an engraver under thirty years of age.

Although steel engraving became well established, notably for book illustration, it was threatened by other techniques, especially by electrotyping and the steel facing of copperplates. Yet it held its own for a long time. For the reason already stated steel engraving was never really liked by the majority of the artists whose work was reproduced by it, though J.M.W. Turner was an exception. For this reason many of them turned to etching, a technique by which they could engrave their designs themselves, in their own way.

Not only were artists' original designs modified by engravers, but, as in wood-engraving, the position was reached where the artist modified his design to accommodate the technique of the steel engraver. Nor were such modifications limited to the work of artists of the second rank, for well-known draughtsmen like Thomas Creswick, Thomas Allom and even J.W.M. Turner made such adjustments. And professional artists were often employed to adapt and work up sketches of amateurs to make them suitable for engraving.

Such adaptations were not always possible. In the case of large paintings, for instance, it was preferable to have the originals in the

workshop while the engraving was made direct from them, so as to allow the engraver time to carry out the difficult work of interpreting their textures into the various kinds of shading, lining and tones at his command. For this there were various conventions — a peaceful sky for example being represented by horizontal strokes parallel with the horizon, or slightly waved, becoming stronger higher in the sky; whereas for storm clouds, curved and straight lines were mixed, forming a pattern of lozenges. For engraving parallel lines like the foregoing, machines were sometimes used, one such being invented by Wilson Lowry (1762—1824). The engraver had also to reduce the size of the original in such a way that as little detail as possible was lost.

Sometimes the owner did not agree to allow the original out of his possession, in which case it was necessary to make a drawing of the picture in its original position. This posed obvious difficulties, for the engraver was rarely the copyist, and so the engraving was made at second hand. Sometimes the copyist was a first class and well-known artist, in which event the copy would presumably have been better than one made by a skilful hack, who was the more usual type of artist employed on such work.

To copy a painting it was sometimes possible to begin with an outline taken from the original through tracing paper. As in many cases this might risk damage to the original it was instead more often carefully copied; the original was divided into squares of uniform size by tying pieces of cotton horizontally and vertically across the painting, a piece of paper was similarly divided and the design copied on to it square by square. The engraver would use this as his guide in working on his plate, comparing it from time to time with the original which if it had not been allowed out of its gallery or house, meant a number of journeys to and fro with proofs to make the comparison.

At this stage the artist who made the copy of the original work would 'touch' a proof with chalk, pencil or watercolour to show how and where any adjustment or amendment should be made. Mistakes could be rectified by knocking up the plate from the back and re-engraving the area.

It is surprising in most instances how little detail was lost between the original and the engraving. With small drawings and watercolours that is understandable, but with a vast and crowded work like W.P. Frith's 'The Railway Station' of 1862 the problems were much increased. The original painting measures 46 by 101 inches and the

steel engraving taken from it by Francis Holl measures 25¼ by 48 inches, something like a quarter of the area of the original.

The picture depicts a crowded scene — there are nearly one hundred figures — on Paddington Station in London, as a train is filling with passengers and being loaded with luggage. It is alive with incident: a malefactor is arrested by two detectives as he is about to enter a carriage; a family, late in arriving at the station, is rushing towards the train; a cabby is arguing with a foreigner about his fare; a bridal party is standing nearby ready to speed the bride and bridegroom on their honeymoon; to say nothing of sailors, soldiers, railway staff and many more. All this is rendered in great detail, the delineation of which Frith was such a master and all is reduced by Holl to the proportions of his print. The velveteen of a porter's uniform, the stuff of the women's dresses from silk to bombazeen, the leather and basketwork of the luggage, the metal, glass and wood of architecture and train — everything is brilliantly translated from terms of paint into terms of engraving, and hardly a detail is lost.

It was a popular work. When Frith's painting was exhibited by the dealer, Louis Victor Flatow in 1862, it was seen by more than 21,000 people, and of Holl's engraving 3000 proofs were issued at prices from eight to fifteen guineas, to say nothing of the thousands of ordinary impressions.

Proofs, which were usually taken on india paper laid down on a heavier paper, were of two main kinds. The first had the name of the artist at the left just below the engraved area, and that of the engraver in a similar position at the right, but without the lettering that was later added by a specialist engraver to the lower margin of the plate. These are called 'proofs before letters'. The second kind were proofs after the addition of the title, date, name of the publisher and printer and other details. Sometimes, if an artist had made a copy of the original for the engraver to work from, his name was also added, usually between those of the original artist and the engraver.

The word 'Proof' usually appeared in the margin of these early impressions; it was removed before the ordinary impressions were printed. In some cases the artist signed the proofs in holograph.

The *raison d'être* of proofs — the fresh clarity of the first impressions carefully pulled from the plate — is considerably diminished in steel engravings, as many impressions could be taken from the plate before the slightest wear became apparent. Nevertheless such proofs were issued and found a market.

One other point. It was also the custom during the printing of the actual edition to check a print as each batch of fifty was completed, to ensure that the quality was being maintained. These impressions were often considered to be the perquisite of the engraver.

Despite the popularity of prints in the nineteenth century, the engraver's lot was in many ways unenviable. It was not until 1855 that an engraver was admitted to full membership of the Royal Academy; this was Samuel Cousins. Societies of engravers had been formed in the meantime, the Society of Engravers in 1810 and the Chalcographic Society a little later. Engraving was in fact looked down upon as a second-rate art form, and this view persisted for many years.

And if this was the lot of the leading members of the profession, how very much worse was that of the badly paid, plodding and labouring journeyman engraver, who spend his days bent over his work, peering through a magnifying glass for up to fourteen hours a day, copying the work of other artists, and often compelled to re-work passages that had taken many days, because they fell short of requirements, or because the original artist had corrected or criticised them. The prospect of membership of the Royal Academy did not even occur to such an engraver; he was content to receive a fair payment for work done, whether he was working as an employee or pupil of an established engraver, or as a freelance. He would on the whole have been better off as an employee, for the freelance (even if well known) would have found it difficult to get through enough work to earn an adequate living, for steel engraving was essentially team-work, the plate being divided among specialist engravers — one might engrave drapery, another figures or portraits, yet another animals. One engraver claimed that it would take a craftsman thirty years to complete ten large steel engravings. Divided among several engravers this could be reduced to weeks.

So far as separate engravings (as apart from book illustrations) are concerned, the artist came off best. He held the copyright of the original — even if he sold the original he almost invariably retained the copyright — and he could make considerable sums by selling or letting the reproduction rights to a publisher. The London dealer Gambart paid £5,500 for the engraving rights of Holman Hunt's 'Christ in the Temple', although this was exceptional.

The publishers, despite the fact that their part in the transaction was speculative, did well too; their average annual income from prints

was in the region of £16,000, equivalent to about a quarter of a million pounds in present-day money. The engraver was given a set fee and therefore came a very bad third; David Lucas, the first-rate mezzotinter of Constable's landscapes, died in a workhouse in 1881. Although this was exceptional it does illustrate the precariousness of the engraver's craft.

There were three main centres of steel engraving in Britain: at Birmingham, Edinburgh and London, of which London, being the capital, was the most important, though many of the engravers who practised there had been trained in the excellent art schools at Birmingham or Edinburgh.

At Birmingham William Radclyffe (1783—1855) was one of the leading figures. He served an apprenticeship under a letter engraver with his cousin John Pye (1782—1874), after which the two young men decided to seek work in London, walking all the way from Birmingham. But Radclyffe soon returned after he had made the acquaintance of Charles Heath and other eminent engravers, who provided him with a great deal of work in the years ahead.

Radclyffe took in a number of pupils, some of whom were to achieve eminence in the future; they included James Tibbitts Willmore (1800—63) and Thomas Garner (1789—1868). It is in the training of such engravers that Radclyffe's greatest importance lies.

Radclyffe was one of the first eminent engravers to adopt steel engraving, and between 1823 and 1829 made for Alexander Blair's *Graphic Illustrations of Warwickshire* thirty-two steel plates after designs by a number of eminent artists including David Cox Sr, James Duffield Harding, Peter de Wint, William Westall and others. This was the beginning of a whole series of landscape and topographical illustrations made by Radclyffe, some of which were done for Oxford Almanacks issued between 1840 and 1855. For the *Art Journal* of 1847 and 1848 he engraved two genre pictures, one by William Muller and the other by William Collins.

J.T. Willmore, who was Radclyffe's most important pupil, moved to London in 1823, where he worked for Charles Heath before setting up on his own. Like Radclyffe, Willmore excelled at landscape and topography and some of his most pleasing work was done to illustrate such works as *Heath's Picturesque Annual, Jennings's Landscape Annual* and Brockendon's *Italy*. He worked after such famous artists as Samuel Prout, Thomas Creswick, Clarkson Stanfield and J.M.W. Turner, engraving two large plates for the latter. Willmore

was elected an Associate Member of the Royal Academy in 1843.

Other important Birmingham engravers included Robert Brandard (1803 or 5—62) and his brother Edward Paxman Brandard (1819—98) and James Baylis Allen (1803—76), each of whom engraved topographical book illustrations.

In Edinburgh the most eminent steel engraver was William Miller (1796—1882) who was for four years an apprentice of a Quaker engraver in Edinburgh, William Archibald, after which he set up independently. In 1819 he moved to London where he studied under George Cooke, returning to Edinburgh in 1821. In 1825 he took up steel engraving and in the years ahead engraved some two hundred plates for book illustrations, some topographical and many for literary works such as those of Scott and Burns.

Miller was particularly apt in adapting some of J.M.W. Turner's conceptions, like the great panorama of Edinburgh from Blackford Hill which appears as an illustration to *Marmion* in the various editions of *The Poetical Works of Sir Walter Scott Bart* from 1833—4. It measures only $3\frac{5}{8}$ by $5\frac{11}{16}$ inches, yet takes in the whole sweep of the landscape from Arthur's Seat to the Castle and farther, with the Firth of Forth in the distance and beyond this the hills on the far shore. More detail could hardly have been worked into the elaborate embroidery of this little engraving in which every landmark of importance may be descried. In the same work Miller makes a similar *tour-de-force* of Turner's view of Melrose Vale as an illustration for the *Lay of the Last Minstrel*.

Other Edinburgh steel engravers included William Home Lizars (1788—1859), best known for banknote engraving; Robert Charles Bell (1806—72), who assisted Miller with engraved portraits; John Horsburgh (1791—1861), who combined his career as an engraver with that of a Baptist lay pastor; and John Talfourd Smyth (1819—51), noted for his work after Sir David Wilkie.

As I have already said, London led the trio of steel engraving centres at this time. It was for one thing the centre of the publishing world, and any engraver who wished to make progress as a book illustrator would have gravitated there. One of the most important London studios was that of the Finden Brothers, William (1787—1852) and Edward Francis (1791—1857), whose work was among the most obiquitous of the time.

After working as line-engravers for years, the two brothers embarked, as they approached middle life, on steel engraving. They ran

their practice as a business and took in pupils and employed many well-known engravers as assistants. Among the former were Samuel Sangster (?1804—72), Samuel Hollyer (1826—1919) and Frederick Bacon (1803—87), and assistants included Lumb Stocks (1812—92), John W. Archer (1808—64) and James B. Allen (1803—76).

The brothers undertook much work for the publisher John Murray and this included illustrations for topographical and literary works, among the most famous being *Childe Harold's Pilgrimage* by Lord Byron (1841). But William Finden's most noted works were for the publishers Thomas Cadell and Edward Moxon: Samuel Rogers's *Poems* (1834) and *Italy* (1830).

The Findens also published some works by themselves which had some success. Some of them were issued in periodical fascicles, one such being *Finden's Landscape Illustrations to Mr Murray's First Complete and Uniform Edition of the Life and Works of Lord Byron* (1832—34) and *Finden's Female Portraits of the Court of Queen Victoria* (1839). The success did not last, despite the fact that distribution of their publications was for a period undertaken by professional publishers; and some of their later productions sold tardily with the result that the Findens found themselves in financial difficulties which overshadowed their later years.

The Findens were mainly engravers of book illustrations, largely of landscape but also including a number of portraits. But when they found themselves in difficulties they engraved some large plates in an attempt to help alleviate their position, and William engraved some genre and religious plates for the Royal Irish Art Union and the Art Union of London, and others after works by Sir Edwin Landseer, Sir David Wilkie, William Hilton and Frederick Goodall.

The work of the Findens is clear, neat and minutely detailed. They fully exploited the special qualities of steel engraving, using its some-what hard and sharp linear quality to interpret the work of illustrators in a way that could only be achieved through this medium, something far removed from line-engraving on copper. If a parallel is to be found in the techniques of draughtsmanship, the copper engraving would resemble a rich pen and ink drawing, the steel engraving a drawing made with a hard, well pointed lead pencil, and it is this quality which the Findens exploited so ably.

The Cousen brothers, John and Charles (1804—80 and *c.* 1819—89), who came from Yorkshire and settled in London, specialised in engravings of landscape and topography. John is the better known of

the two and his plates are notable for their wide variations of tone, some being so rich that they almost approach mezzotints. The books he illustrated included Julia Pardoe's *Beauties of the Bosphorus* (1840), William Beattie's *The Danube* (1844) and Robert Walsh's *Constantinople* (1838—40).

Another London engraver, Robert Wallis (1794—1878), first worked on steel in 1825, after having spent some years as a copper engraver. His work, notable for delicacy of tone, was much used in elegant annuals like *The Keepsake, The Literary Souvenir, Heath's Picturesque Annual* and *The Landscape Annual,* for which he engraved works by Samuel Prout, J.M.W. Turner, Clarkson Stanfield and W.H. Bartlett.

Edward Goodall (1795—1870), a native of Leeds, settled in London and took up steel engraving in about 1826, working especially after Turner and Stothard. James Charles Armytage (1802—97) is said to have practised steel engraving longer than any other engraver; he was still using it in 1890, in which year his plate after Keeley Halswelle, 'Non Angli sed Angeli' was published in the *Art Journal.* John Clough Bentley (1809—51), another Yorkshireman who settled in London, was a landscape painter who took up engraving when he was aged twenty-three, and studied under Robert Brandard. Being a painter he was able to make his own copies for engraving, and so well did he work that he completed about two hundred plates in the nineteen years that were left to him before his early death from tuberculosis.

Lumb Stocks, who as we have already seen was for a time an assistant of the Findens, was another Yorkshireman who became an eminent engraver. He learned his art in London from Charles Rolls (1800 — c. 1857), after which he set up independently. He worked much for the annuals and for other literary works, but from 1842 turned to larger prints. In that year he engraved 'Rafaelle and the Fornarina' after A.W. Callcott, for the Art Union of London, and in time he engraved plates after Thomas Uwins, Robert Scott Lauder, James Eckford Lauder, T. Faed, W.P. Frith, D. Maclise, Lord Leighton, and others. He was elected an Associate Member of the Royal Academy in 1852 and Academician in 1871.

So far we have dealt with the technique most generally understood from the term 'steel engraving', but there remains one important department of engraving in which steel was extensively used during

the nineteenth century: that of the mezzotint. As we have seen, 'line-engraving' on steel was used largely for book illustration. There were also large numbers of separate prints, but the mezzotint was the technique *par excellence* for large prints in the nineteenth century.

Mezzotints had in fact many advantages in the reproduction of paintings, not the least of which was the comparative speed with which they could be engraved, one expert claiming that a mezzotint could be scraped in a twentieth of the time required to engrave a plate in line. Moreover its tonal qualities were much closer than line-engraving to painting.

By 1819 Jacob Perkins had made steel plates soft enough to be worked on with mezzotinting tools, and it is said that within a year he sold nearly a thousand plates. The only drawback was that the plate needed four times as much rocking as copper when the ground was laid.

William Say (1768–1834) was one of the first engravers to use Perkins's softened plates, his first essay being a portrait of Queen Caroline after Arthur William Devis, and some 1,200 impressions were taken from the plate after it was hardened; this was about ten times as many as could have been taken from a copper plate. But the most important early exponent of the steel mezzotint was Thomas Goff Lupton (1791–1873), who was awarded a gold medal by the Society of Arts for a mezzotint portrait. He claimed to have printed 1,500 impressions without wearing the plate. This brought the new method to the attention of many other engravers and after a period in which it had all but disappeared, mezzotint again became established as a fashionable technique.

There is no doubt that for the reproduction of paintings steel mezzotinting was more satisfactory than steel line-engraving, for, while it lacks some of the precision of that method, it is full of tonal qualities and textures impossible to match by engraving in lines. This is demonstrated by the mezzotint made in 1856 by Samuel Cousins after Sir J.E. Millais's *'The Order of Release'*, in which many textures, from tartan to fur, are represented with great accuracy.

But pure mezzotint was rarely used. As with line-engraving on steel, it was usually combined with different methods, including line-engraving itself, stipple and etching. This combination was necessary in order to give clarity and depth to the print which in pure mezzotint on a steel plate rarely accomplished the desired effect. Typical examples of mixed mezzotints are the engraving by

James John Chant (?1820—76) of William Charles Dobson's picture *'Remembrance'* (1869) in which mezzotint is combined with stipple, and the engraving by Frederick Stacpoole (1813—1907) of Holman Hunt's 'The Shadow of Death' (1878) realized in mezzotint with etching, though the etched passages could easily be mistaken for line-engraving.

The most spectacular mezzotints on steel made in England during the nineteenth century were those of John Martin (1789—1854) and they varied from small book illustrations such as those for Gideon Mantell's *The Wonders of Geology* (1838) and Thomas Hawkins's *The Book of the Great Sea Dragons* (1840), to huge plates like 'The Fall of Nineveh' (1830; $21\frac{1}{8}$ by 32 inches). and 'Balshazzar's Feast' (1832; 18½ by 28½ inches).

Martin's apocalyptic vision comes over very well in this medium, from which it derives both depth and mystery. It must have appealed to Martin both for that and for the comparative speed with which the plate could be scraped — such huge areas as those of his bigger plates would have been daunting in regular steel engraving; and although Martin was a skilled etcher he obviously preferred mezzotint, for out of his twenty-three separate engravings, only two were etchings.

Reproductions of paintings for framing were legion whether made in traditional techniques or by the more usual mixed line-engraving or mixed mezzotint methods on steel, and the total number of impressions must have run into millions — nearly 5,000 subjects were declared between 1847 and 1894. Around this enormous production was built up a vast distributive trade; by the 1890s the Printsellers' Association had a London membership of one hundred and twenty-six, and most of them were prosperous.

Apart from dealers, the most important distributors of prints were the Art Unions, the idea of which originated in Germany where a number of such bodies were set up in 1825. In this country the members paid a subscription of a guinea a year. Lotteries were organized with works of art as the prizes: the winner was awarded a sum of money to be spent on a work of art to be selected from an approved exhibition. The Unions also published prints in book form, sometimes around a literary theme, such as *Songs from Shakespeare.*

Usually the committee of the Union commissioned a print of a choice made by a winner, impressions of which were distributed to members. This of course did much to promote the craft of print-

making, even if the choices did not always meet the approval of critical opinion. Later, traditional techniques were superseded by collotype and other photographic methods for producing Art Union prints.

The first British Art Union was the Art Union of London, founded in 1837 with Prince Albert as its President. The Royal Irish Art Union was founded in 1839. Others sprang up in Bath, Birmingham, Bristol, Leeds, Liverpool, Manchester and Norwich.

But the days of the steel engraving, line or mezzotint, were numbered. In book illustration its greatest rivals were wood-engraving and lithography. The wood-engraving, as we have seen, was capable of almost any effect in the hands of craftsmen like the Dalziels and their contemporaries and by 1845 coloured wood-engravings had begun to appear in books; while lithography could not only dispense altogether with the services of interpretative engravers, but was capable of the most subtle effects of tone and colour. By the late 1840s there was every sign that the steel engraving was being ousted as a method of book illustration.

But so far as the larger prints were concerned the biggest enemy was photography. A method of photographic engraving was first discovered in 1826 by Joseph Ničecphose Niépce (1765–1833), who made an etched printing plate by covering a zinc plate with light-sensitive bitumen, and then exposing it under a copper engraving which had been washed over with oil to make it translucent so that it could be used like a photographic negative. The image of this was fixed on the plate which was then etched and afterwards deepened by hand with a burin, providing an intaglio printing plate.

Various developments were made using Niépce's discovery as a point of departure, but using alternative materials such as gelatin for a base, and in time a number of different processes were perfected, several of which are described in Chapter VIII. These could be relied upon to give a completely accurate reproduction of the original work . with comparative ease, dispensing with all the interpretative tones and patterns used by the engraver. The result was that by the 1890s reproductive engraving was almost dead. Photographic processes took over and still dominate reproductive printmaking both in book illustration and in larger prints. Today every art book and very many others would be impossible in their present form without them.

The artist-engraver, disillusioned by the course taken by line-engraving and mezzotinting, turned to other techniques, and especially to etching, and it is this which we have to consider in the next chapter.

CHAPTER VII

The Resurgence of Etching

As we have seen in Chapter II, a certain amount of fine etching was being done at the beginning of the nineteenth century by artists such as Thomas Rowlandson and James Gillray. It was not, however, until later in the century that a general resurgence of etching took place.

But etching never disappeared, and was in fact used extensively in some forms of popular art, especially in juvenile drama sheets and fashion plates.

The juvenile drama consisted of sheets of characters and scenes from plays printed on paper which could be pasted on card and cut out and used for performances on a toy stage, similarly constructed but usually with a wooden frame. The sheets were called 'penny plain, twopence coloured' from the fact that they could be bought for one penny each plain or uncoloured and for two pence each hand coloured. A majority of boys (it seems to have been mainly a male activity) preferred to colour their own. A book of words for each play was also available. Etching was the dominant technique but later a number of lithographed sheets were available, also some printed from woodblocks, but neither of these techniques gave such good results as etching and were never popular.

Today the sheets of the juvenile drama give us the finest available record of the early nineteenth century theatre and of the style of acting then in fashion, with broad exaggerated gestures as practised by Mr Vincent Crummles and his company in *Nicholas Nickleby*. The *décor* and costumes are highly stylised nineteenth century imaginings of the costumes of Muscovy, Turkey, India, China and of historical periods. There was no question of historical verisimilitude, but every-thing was filtered through the contemporary vision: the armour of the knights, the costume of the heroines and of the Emperor of China and of Calmucca, Prince of Cappia, could not have been invented at any other time. Like the Royal Pavilion at Brighton, the

67

Pagoda at Kew, and the Chinese Dairy at Woburn, they are reflections of an imaginary world.

The same is true of the scenery. The onion domes of M. and M. Skelt's scenery for *Timour the Tartar*, Orlando Hodgson's palatial backdrops for *Aladdin*, and the Gothic mysteries of his scenery for *Chevy Chase* — these are typical examples of the world of Cathay, of Muscovy and of Gothick romance as seen in the heyday of nineteenth century Romanticism.

Tinsel portraits, which are closely related to the juvenile drama, afford other views of the same world. A popular actor (more rarely an actress) is shown in a dramatic pose from a well-known play — usually standing with legs apart, his weight thrown on to one of them, arms held up in grand gestures, sometimes brandishing a weapon or weapons, and in the background, a suggestion of the scenery of the play.

Tinsel portraits were usually etchings; they were sold plain and were embellished by the purchaser with tinsel decorations — a whole series of which was available — pieces of silk and watercolour, the final encrustation giving the appearance of a profane rizah-covered ikon.

But tinsel portraits were not invariably of stage personalities, and engravings of popular heroes were sometimes, but more rarely tinselled. I have seen at least two steel engravings of the Duke of Wellington tinselled with colourful military accoutrements. And I have seen at least one juvenile drama sheet of Harlequin and Columbine beautifully and minutely tinselled.

As to etched fashion plates, they belong more to France than to England, but not exclusively. Some delightful specimens were issued in *Le Beau Monde or Literary and Fashionable Magazine* which despite its name was published in London by J.B. Bell and Co. The plates include not only women's dresses for every occasion, but also men's dress for morning walking or riding, full and court dress and others. There are even designs for carriages, such as 'A Single Crane Barouche Chariot' and 'A Modern Curricle' which are delineated in all their elegant and colourful splendour.

Of the costume plates in this series, one of the most delightful is a design for 'Court Dress for her Majesty's Birth Day' for a man and a woman, both of a wonderful Regency richness and garlanded with flowers. The woman's dress, looped and tasseled, and her hair surmounted with white ostrich feathers, is colourful enough to take its

place on a juvenile drama sheet. All of these designs are hand-coloured.

Etching was widely used for book illustration, especially in the early and middle years of the century and in this the greatest exponents were George Cruikshank (1792—1878) and Hablot K. Browne (1815—82) who worked under the pseudonym of 'Phiz'.

Among Cruikshank's best known etched illustrations are those for Dickens's *Oliver Twist* (1837—39), which well convey the strain of malignancy that runs through that novel, and which culminate in the highly dramatic representation of 'Fagin in the Condemned Cell', in which the old Jew sits manacled on his bench, with staring eyes and biting his fingers in horror at his fast approaching nemesis.

But Cruikshank illustrated many novels besides those of Dickens, those for the works of W. Harrison Ainsworth being especially good. He is at his best in portraying supernatural subjects, like the ghostly scene of 'Herne the Hunter plunging into the Lake' in Ainsworth's *Windsor Castle* (1843). In this the antlered figure of Herne looks back over his shoulder and blows his horn, from which comes '...a bright blue flame, which illumined his own dusky and hideous features, and shed a wild and unearthly glimmer over the surrounding objects'. Cruikshank does full justice to every detail of this haunted scene.

Some of Cruikshank's most horrific representations are to be found in his illustrations to fairy stories. 'The Giant Ogre discovers Hop o' my Thumb and his brothers whom his wife had endeavoured to conceal from him' is really frightening; it was published in *George Cruikshank's Fairy Library* (1853). The Ogre is shown seated by the table with his wife at his side placing a restraining hand on his arm, while Hop o' my Thumb's brothers kneel beseechingly before him. He is holding Hop o' my Thumb in his left hand, leering at him, with his open mouth displaying shark-like teeth, and grasping a wicked looking knife in his right hand.

'Phiz' was altogether different from Cruikshank, less dramatic but with a greater sense of comedy, yet to some extent sharing the same sense of pathos. 'Phiz' will always be closely associated with Dickens and indeed, Cruikshank apart, he was the finest illustrator Dickens had, whether in comic scenes from *The Pickwick Papers* (1836—7), in interior scenes in *David Copperfield* (1849—50), or in the several layers of contemporary society depicted in *Dombey and Son* (1846—8). But 'Phiz' illustrated other authors, too, especially Charles Lever and R.S. Surtees.

69

On occasion he combined his etching with what he called the 'dark plate' technique, a method closely related to mezzotint in which the plate is worked over with a roulette or rocker where necessary, to add sometimes extremely rich tones to the composition. This technique was used to splendid effect in 'The Mausoleum at Chesney Wold' and 'The Ghosts' Walk' in *Bleak House* (1852–3), in 'The Room with the Portrait' and 'Damocles' in *Little Dorrit* (1855–7), and in 'On the Dark Road' in *Dombey and Son.*

John Leech (1817–64), illustrator of the sporting novels of Surtees, also illustrated Dickens's *A Christmas Carol* (1843), Gilbert A'Beckett's *The Comic History of England* (1847–8) and other works. Among other illustrators who used etching were Robert Buss (1804–75) and Robert Seymour (?1800–36), both of whom made illustrations for early chapters of *The Pickwick Papers.*

Nineteenth century etchers of pastoral landscape were one of the most important general groups of painter-etchers of the period. Their outlook stemmed from the work of Thomas Gainsborough and Paul Sandby, and was continued by John Crome (1768–1821) and John Sell Cotman (1782–1842) who, among others, handed it on to the Victorian etchers.

John Crome ('Old Crome'), who began life as an errand boy, became the founder of the Norwich School of artists and one of the greatest landscape painters of his day. His etchings (which included some soft-ground plates) were a sideline and were not published until thirteen years after his death, yet he was one of the most important landscape etchers of the nineteenth century. His work is drawn with great freedom, as much as if he were working with pencil. And it is packed with poetry, depicting the Norfolk countryside seen through a vision derived largely from Dutch painters like Hobbema and Ruysdael, but also from Gainsborough.

The subject-matter of Crome's etchings is limited to lanes, backwaters and trees in East Anglia, with here and there a village scene like 'Front of the New Mills' (1813), a somewhat complex study incorporating buildings and trees, with human interest supplied by boys fishing and, in the distance, workmen on a barge. But in most of Crome's etchings it is trees that dominate — dead trees, trees in leaf, all kinds of trees — and in fact the whole series could be seen as variations on a theme of trees. Some go beyond this: 'Road Scene, Trowse Hall, near Norwich', for instance, is in itself a whole

symphony of interlacing branches, springing from a group of boles that seem almost to dance.

These etchings were first issued in 1834 and were reissued several times, but none of the reissues has the quality of the original impressions. Some were even disastrously rebitten and retouched, even with machine-ruled lines in the sky.

John Sell Cotman's etchings have more variety in their subject-matter than those of Crome, and include figures, landscape and architecture. Cotman also was a member of the Norwich School and many of his plates are landscapes similar to those in Crome's *oeuvre*. But he did work farther afield and then sometimes arrived at a dramatic Romanticism in his interpretations, as in his study 'Harlech Castle', which effectively portrays the *Sturm und Drang* of landscape. But whether he was working in Surrey, Yorkshire, Normandy or in his own East Anglia, his etchings are charged with mood that ranges from the dramatic to the nostalgic.

Cotman etched a number of studies of architectural antiquities, some of which have considerable appeal. They were issued in book form and include *Sepulchral Brasses of Norfolk and Suffolk* (1819), *Architectural Antiquities of Norfolk* (1818), *Architectural Antiquities of Normandy* (1822) and *Antiquities of Saint Mary's Chapel, at Stourbridge, near Cambridge* (1819; the etchings themselves are dated 1817 and 1818). The last named also includes plates of details of Ely Cathedral and of the now demolished gate of Cambridge Castle. These plates are really records rather than interpretations, yet they do not lack charm: for example the 'Interior View of St. Mary's Chapel', with a shaft of soft light shining across the ruined chancel has something of the nostalgic yearning that was to appear many decades later in the etchings of F.L. Griggs.

Cotman's eldest son Miles Edmund (1810–58), another member of the Norwich School, was also an etcher and his work shows much of his father's influence. His studies of shipping are particularly successful. Other etching members of the Norwich School include Joseph Stannard (1797–1830), whose delicately worked plates seem full of movement, and his brother Alfred Stannard (1806–89) with whom he shared a studio; Thomas Lound (1821–61), noted especially for his river scenes; John Middleton (1827–56) whose etchings, reminiscent of those of Crome, have an especially poetic poignancy. And there were others, of whom the following may be briefly mentioned: S.D. Colkett (1800–63), R. Dixon (1780–1815),

71

E.T. Daniell (1804—42), D. Hodgson (1798—1864), H. Ninham (1783—1874), J. Stark (1794—1859) and G. Vincent (1756—1831). Altogether these etchers formed an impressive and influential body that helped to point the way for the future development of the art.

Etchings of a different kind were made by Sir David Wilkie (1785—1841) and Andrew Geddes (1783—1844), whose plates, sometimes mixed with drypoint, were largely of genre subjects. Wilkie was in full command of his technique and his compositions are drawn with a free and sensitive line, his textures rich and varied. His subjects are along the same lines as those of his paintings, such as 'The Lost Receipt', 'Flemish Mother', 'Benvenuto Cellini offering his Censer for the approval of Pope Paul III' and 'Reading the Will'. The last named was made in 1819, and the etched work is much enriched with drypoint. It is a typical specimen of early nineteenth century genre: the bespectacled lawyer sits at a table holding a will from which he is reading, while around him are grouped some eight interested parties, wearing different expressions which vary from anxiety to suspicion, and one of them listens to the lawyer through a hearing horn.

Geddes's subjects are similar, but also include portraits, landscapes and topographical subjects. He was not such a good etcher as Wilkie, but is not without importance in the development of the art. He used drypoint extensively to improve the etched lines, and some of his plates are very rich indeed, as may be seen in 'Sir William Allan' (1826), which has almost the depths of a mezzotint.

The Etching Club (known as 'Old' Etching Club to distinguish it from the Junior Etching Club and from the later Society of Painter-Etchers and Engravers) was founded in 1838 by a group of artists including Thomas Oldham Barlow (1824—89) and Charles West Cope (1811—90). The aim was to bring the best etchers together regularly (it has been said that at first it was really a dining club), and it was incumbent on each one to produce a given number of etchings periodically, failure to do so bringing expulsion.

One of the aims of the Club was the publication of volumes of etchings around various themes. The first of these was issued in 1841, *The Deserted Village of Oliver Goldsmith;* it contained seventy-nine small etchings on forty plates. Some were merely random collections, like *Etchings for the Art-Union of London by the Etching Club* (1872), which included such diverse subjects as 'The Old Bridge' by Thomas Creswick, 'The Illuminator' and 'Summer Dreams' by

C.W. Cope, and 'Silver Thames' by Richard Redgrave. Others included *Etched Thoughts* (1844), *Songs and Ballads of Shakespeare* (1853), *Elegy Written in a Country Churchyard* (1847) and *L'Allegro by John Milton* (1849). These publications continued until 1880.

The membership of the Etching Club included some of the best etchers of the period. Among them, in addition to Barlow and Cope, were Thomas Creswick (1811—69), John Bell (1811—95), J.C. Horsley (1817—1903), Richard Redgrave (1804—69), Richard Ansdell (1815—85), P.H. Calderon (1833—98), J.C. Hook (1819—1907), W. Holman Hunt (1827—1910), Sir John Everett Millais (1829—96) and Joseph Severn (1795—1879), besides many others; the cream, in fact, of the etchers working in England at the period.

Samuel Palmer joined the Club in 1850, submitting as his probationary plate his first etching 'The Willow'. He was elected by a unanimous vote, despite the fact that he was admonished by Thomas Creswick for ruling some of the lines in the sky. For the Club it was an important election, for Palmer's work was a shining example of the importance of attention to detail both in technique and design. Until Palmer's admission, the members had on the whole been content to entrust the biting of their plates to a professional craftsman, and this had led to a lamentable uniformity in the texture of their work. But Palmer was never content to leave such an important matter to a second person; the very essence of etching lies in its biting and if that is to be left to another person, however skilled, the resulting work is likely to be only a pale shadow of its creator's intention. Everywhere throughout his notes and letters attention to details of technique is apparent.

'Etching', wrote Palmer, 'seems to me to stand quite alone among the complete arts in its compatibility with authorship. You are spared the dreadful death-grapple with colour which makes every earnest artist's liver a pathological curiosity...But the great peculiarity of etching seems to be that its difficulties are not such as excite the mind to "restless ecstasy", but are an elegant mixture of the manual, chemical and calculative, so that its very mishaps and blunders (usually remediable) are a constant amusement. The tickling sometimes amounts to torture, but, on the whole, it raises and keeps alive a speculative curiosity — it has something of the excitement of gambling, without its guilt and its ruin. For these and other reasons I am inclined to think it the best *comptu* exponent of the artist-author's thoughts'.[1]

[1] Lister, R. (ed.) *The Letters of Samuel Palmer* Oxford 1974, p. 865.

As I have indicated in Chapter IV, Palmer is best known today for the brilliant drawings and paintings he executed during his youth, particularly at Shoreham in Kent where he spent much of his time. His later water-colours, while still beautiful, are of a different kind, and lack the intensity of vision he put into his earlier works. But in his etchings he found that his vision had returned. It was of less intensity than that of Shoreham, but it was vision nevertheless, and I have compared it elsewhere to Wordsworth's 'emotion recollected in tranquillity'.

He made only thirteen etchings, and had begun work on four more when he died. His son A.H. Palmer finished off the four and they were published with another already finished, 'Opening the Fold', in *An English Version of the Eclogues of Virgil*, a translation by Samuel Palmer, which was published in 1883.

Palmer's thought was much influenced by Virgil and by other poets, including especially Milton, Spenser and Fletcher; his vision was much influenced by William Blake's Thornton's Virgil wood-engravings, echoes of which may be found throughout his etched work. He comes closest to the Shoreham mode in the small plates 'Christmas or Folding the Last Sheep' (1850) and 'The Sleeping Shepherd; Early Morning' (1857); but his greatest etchings are the larger 'The Bellman' and 'The Lonely Tower' (both completed in 1879). Each has a background of poetry: 'Christmas' is based on a sonnet by John Codrington Bampfylde, the two large plates on passages from Milton's *Il Penseroso*, and 'The Sleeping Shepherd', while not directly based on a poem, contains overtones from Milton's *L'Allegro*.

In fact Palmer in his etchings reached greater poetic feeling than almost any other British etcher in the nineteenth century. They are not illustrations as such but true visual renderings of the poetry that imspired them. In this they have never been surpassed and, as in his concentration on the minutiae of technique, they make Palmer a pivotal figure in British etching at this period.

The Etching Club was responsible for the foundation in about 1858 of the Junior Etching Club. This Club issued two books of etchings and had some distinguished members. The books were *Passages from the Poems of Thomas Hood* (1858) and *Passages from Modern English Poets* (1862), which contained two etchings by James McNeill Whistler; among the members were Charles Keene (1821–91), Simeon Solomon (1840–1905), Sir John Tenniel (1820–

1914) and Walter Severn (1830—1904). The plates are on the whole poorly printed and in some instances look more like wood-engravings than etchings.

These two clubs did much to publicise etching. This was also assisted by the publication of Philip Gilbert Hamerton's book *Etching and Etchers* (1868) and his magazine *The Portfolio* which commenced publication in 1870. And there were two further magazines, *The Etcher* which was published in 1879 to 1883, and *English Etchings*, published monthly at first, and then quarterly, from 1881 to 1888. These not only discussed the art, but also published original impressions.

The new interest in etching did not meet with everybody's approval. Ruskin raised his influential voice against it more than once, despite using it himself from time to time. Engraving, he said, was a better art than etching because it was more disciplined; it was easier to scratch an etched line than to engrave one with a burin. It was a negative process, the etcher working in bright lines on a dark background, which would in the end be reversed to black (or brown) lines on a light background; and the acid bath introduced an element of chance into the process. Finally, it was impossible to shade properly in etching; even Rembrandt, he claimed, did not overcome this.

Fortunately Ruskin's view did not prevail; on the contrary, in this country at any rate, the art of etching was about to commence one of its finest periods, at the centre of which was the work of three splendid artists: Sir Francis Seymour Haden (1818—1910), James Abbott McNeill Whistler (1834—1913) and Alphonse Legros (1837—1911).

Haden was the son of a doctor and himself a surgeon by profession; because of this he originally used a pseudonym for his etched work: 'H. Dean'. At first Haden took up etching as a relaxation, but he was soon completely absorbed by it, so much so that it became a second profession, and in time he completed two hundred and fifty plates, mostly of landscape, but also one or two portraits and figure studies.

In 1880 Haden, with the assistance of other etchers, including Legros and Sir H. Herkomer, founded the Society of Painter-Etchers. The Etching Club had finished in the same year leaving an hiatus, and Haden felt that there ought to be some body to replace it. The first meetings were held at his house and it was soon a successful society; it was given the title 'Royal' in 1888 and two years later, in 1890,

adopted the title by which it is still known, The Royal Society of Painter-Etchers and Engravers.

Haden was a very difficult and abrasive character and ran the Society like a dictator. But it is doubtful if without his driving personality it would have succeeded.

Haden's etchings, though rich in chiaroscuro, are as lightly conceived as paintings on Japanese screens. Whole areas of the plate are left untouched, yet in the midst of this a landscape appears, delicately yet painstakingly wrought, as if a portion of a misted window had been rubbed clear to disclose part of what was beyond. This is illustrated in many plates, such as "Opposite the Inn, Purfleet' (1869), 'The Little Boat House' (drypoint, 1877) and 'The Two Sheep' (1870). In other plates — for example, 'On the Test' (1859) — one is reminded of the textural pattern in a Rembrandt etching, especially in the treatment of foliage and sky. In others, such as 'Mount's Bay' (1868) Haden used other media to enrich his etched lines, in this case drypoint and a graining of the copper to give the effect of mezzotint.

There were gaps in Haden's output, no doubt caused by his medical commitments. Thus he did little or no etching between 1844 and 1858, but during this period he got to know the great American painter and etcher, J.A. McN. Whistler, whose half-sister Haden married. When Haden started to etch again his work showed much of Whistler's influence. The converse is also true, for Whistler derived much from the work of his brother-in-law. But Whistler is by far the greater etcher of the two, and his influence on the development of the art is incalculable.

He was born in Lowell, Massachusetts, the son of an American artillery officer and civil engineer. When he was eight years old, his father was appointed to build a railway from St Petersburg to Moscow, and the Whistler family settled in St Petersburg. Whistler's father died in 1849 and his wife and family returned to the USA, where James became a student at the West Point Military Academy. He failed in everything but drawing and had to leave. After this he spent a year working for the United States coast geodetic survey and then decided to make his career in art.

Whistler went to Paris where, despite an appearance of indolence, he made good progress, becoming a first class painter, draughtsman and etcher. In 1858 he published a set of thirteen etchings, called 'The French Set'. In 1859 he came to London for a few months, staying with the Seymour Hadens, and in that year and in 1860 he

exhibited a number of etchings and drypoints at the Royal Academy. He now determined to settle in London, and from 1860 until his death it was to all intents and purposes his home.

Whistler was deeply influenced by contemporary trends in French art, particularly by the work of Courbet and Fantin-Latour, and he was largely responsible for the introduction of such trends into English art.

His plate of 'The Embroidered Curtain', etched after a visit to Amsterdam in 1889, shows a typically Impressionist preoccupation with light and textures; it also looks forward to work in painting by Bonnard, Vuillard and others. His handling of the elaboration of repetitive rectangles, relieved in places by human figures and curves, is adroit. It is as freely conceived as a painting and effectively belies Ruskin's assertions of the poverty of the etching technique.

Many of Whistler's plates, like Haden's, are only partially etched — this may be seen in particular in some of his Venetian scenes, in which great blank areas are carefully balanced against richly etched passages.

In his plates of Thameside scenes, like 'Limehouse' (1859) and 'Rotherhithe' (1860), Whistler exploits the complicated pattern of masts and rigging of moored ships to develop some pleasing compositions. In this, 'Rotherhithe' is a remarkable *tour de force;* it is divided by a cornerpost of a building into two main vertical rectangles, with masts and rigging filling that on the left, while slightly more distant ships provide similar filling at the bottom of the second rectangle, which balances the first with a dark vertical area of wall and a hopper at the right. At the bottom, two men are talking together; the darker one on the left is leaning against the vertical post and helps to connect the two main rectangles; his companion on the right is wearing a white coat which relieves the dark area against which he is standing. Above the heads of these men, and in the distance, the river bank extends across the whole composition like a tapering black bar, and this helps to prevent the vertical elements in the composition from becoming too dominant. Everything is perfectly arranged; alter one of these components and the composition would fall to pieces. This is Whistler at his best.

With the French artists Fantin-Latour and Alphonse Legros, Whistler formed a group which they called the 'Society of Three', and it was his encouragement that persuaded Legros to settle in England in 1863. Not only was Legros a brilliant and prolific etcher (he made two hundred and fifty-eight plates), but he was one of the most influential teachers of his age. He became Slade professor of

fine art at University College, London, and teacher of the engraving class at South Kensington, appointments he retained until 1892. He had many distinguished pupils among whom were Sir William Rothenstein (1872–1945), W.R. Sickert (1860–1942), William Strang (1859–1921) and Lucien Pissarro (1863–1944).

Legros's portraits are among his most important etchings; indeed in these he was unsurpassed. His portraits of G.F. Watts (1879), Cardinal Manning (*c.* 1885) and his early portrait of Victor Hugo are typically brilliant examples. One of the best of all is his portrait of the sculptor Dalou (1877), which is not only beautifully modelled, but is also a penetrating psychological study; but it is arguable that its background of horizontal lines is less effective than the unetched background in his portrait of Watts.

Apart from portraits Legros etched landscapes and figure studies. Some of the landscapes are highly dramatic, like 'Un Orage' (*c.* 1884) which shows a heavy rainstorm beating down on to a river bank. In contrast 'Le Long de la Rive' (*c.* 1885) is the very epitome of peace. It is another river bank scene, progressively more lightly etched towards the distant horizon, and shows a wayfarer seated with his back towards us at the foot of a tree, with his walking stick in his hand.

Legros's figure studies are usually poignant portrayals of suffering or death or sometimes of people at their devotions. 'The Wayfarer' (?1884), for instance, shows a poor, bent old man dressed in a cloak, struggling along a country path, as if he were being stalked by death. Yet the figure is not without dignity, its drama unsentimental. In such etchings it is as if the artist were asking us to recognise a sad and cruel side of human life. Other typical etchings in this branch of Legros's work are 'La Mort du Vagabond' (*c.* 1876–77), 'La Mort et le Bûcheron' (of which there are at least four versions, about 1875–80) and a set of four entitled 'La Triomphe de la Mort' (?1890s).

Sir Frank Short was another notable etcher working towards the end of the nineteenth century; he was particularly important as a teacher. And there were Charles Keene, already mentioned as a member of the Junior Etching Club, who etched some fine landscapes and portraits; Legros's pupil William Strang, who used subject-matter which included landscape, allegory and literature, among which was a set of thirty etchings illustrating the work of Rudyard Kipling; Sir George Clausen (1852–1944) who made studies of such subjects as farm workers and barn interiors; and Sir David Young Cameron (1865–1945), who created superb landscapes.

Of a generation whose work was to reach its maturity in the early twentieth century there are Sir Muirhead Bone (1876–1953), whose etchings and drypoints have, with some justice, been compared with those of Piranesi; Augustus John (1878–1961), whose etched portraits are among the best ever made; and F.L. Griggs (1876–1938), who was able, in a series of real and imagined views of architecture and landscape, to evoke the very essence of Englishness.

One aspect of the technique of etching that gave constant trouble to many of its exponents was printing, and here there were a number of specialist craftsmen who were prepared to take over this demanding process from the artist. Whistler insisted that an etcher should make his own prints, and there is much to be said for that; but not everybody possessed enough of the specialised skills to bring it off successfully. On the other hand, the specialist craftsman was rarely able to give what the etcher wanted: Samuel Palmer railed again and again against the way his etchings were printed, and in the end had his son trained by the great copperplate printer Frederick Goulding (1842–1909), so that he could get what he wanted.

But Goulding was quite exceptional, the best copperplate printer in England. Even Whistler was prepared to allow Goulding to print his etchings. 'He had', wrote A.H. Palmer, 'that "hand of a duchess" on which he harped as an essential. I have known of artists and etchers (my father amongst them) who would never have learned to handle the muslins [in *retroussage*] to full effect in fifty years. This thing and some others in printing, are like the mystery of "hands" in riding and driving. In "hands" in printing, Goulding excelled'.

Nineteenth century developments in etching laid the foundations for a brilliant school of British etchers during the twentieth century. There was for some years a temporary setback during the slump of the 1930s when etchings simply did not sell, but the etching has now come into favour again. Of those whose work developed out of the traditions begun by such etchers as Palmer, Haden, Legros and Whistler, one immediately thinks of Gerald Brockhurst (b. 1891), Joseph Webb (1908–62). and James McBey (1883–1959), but there are many more whose work, like theirs, demonstrates the relevance of etching to the art of our time.

Printmaking Techniques

Printmaking techniques may be divided into three main categories: intaglio, relief and planographic.

In intaglio a plate, usually of metal, has the lines and/or tones of the design engraved, scratched or bitten into it. Ink is introduced into these indentations, the rest of the plate is wiped clean, and paper is laid on the plate. The plate and paper are then put into a press, which forces the paper into the indentations so that the ink is picked up and transferred to it.

In relief or surface-printing the printing surface stands above the remainder of the block which has been engraved, cut or bitten away.

In planographic printing there is no difference in level between the printing and non-printing surfaces, the separation being achieved usually by chemical action.

Each of these categories is treated separately in the following list. I have also added a fourth section on photographic processes. This contains processes belonging to each of the three main categories, but there are so many of them, and they are of such importance in that they usurped traditional printmaking techniques in the second half of the century, that they merit separate description.

There are also one or two types of print that do not fall exactly into any of the main categories. They are listed under *Miscellaneous*.

INTAGLIO TECHNIQUES

Aquatint. Etching by tones instead of by lines. In aquatinting the plate is covered with a porous ground of powdered resin or asphaltum before biting. This imparts to a print a toned or granulated surface which closely resembles washes of watercolour.

To receive the powdered ground the plate is placed in a specially-made box and the ground is blown on to it with bellows or through

sieves. The larger particles settle first, the finer grains floating somewhat longer, so that if a fine tone is required the plate is inserted in the box later. The plate is heated for a few seconds so that the grains melt, thus fixing the ground.

Another method is to dissolve the resin in spirits of salts and spread it on the plate; when the spirits evaporate, the dust remains in place and it may be fixed by heating as in the other method.

The plate is bitten by immersion in an acid bath, but further work is necessary before this is done, since, with the even spread of the ground, biting would at this stage produce nothing but granular tone. The aquatinter therefore paints stopping-out varnish (see under Etching) over those parts of the grounded area not to be bitten. By such stopping-out and by rebiting different areas of tone whole compositions may be built up.

Further variations of texture are obtainable by stopping-out with acid-resisting grease pencils.

Chalk or Crayon Engraving. A variant of the etching technique, in which the effect of chalk or crayon drawing is attempted. Chalk engravings are often printed in sanguine (red) ink. It involves the use of the roulette, a handled tool fitted with a small wheel with a spiked perimeter. The composition is transferred to the prepared plate, as in etching, but instead of being scratched through the ground with a needle, the roulette is run up, down and along its lines. The lines are then worked over with a graver and with a coarse punch called a mattoir, which imparts a matt surface. The plate is then etched in an acid bath.

Drypoint. A technique in which the design is scratched with a needle direct on to a copperplate without subsequent biting with acid as in etching. It is one of the most direct and spontaneous methods of printmaking, but one which demands great skill.

The plate is covered with blacking from burning wax candles or tapers and the design is scratched through this direct on to its surface, the blacking contrasting with the bright scratches. The design completed, the blacking is cleaned off and prints may be taken as from an etched plate.

The effects of drypoint are more limited than those of etching, but the line is often softer, due to the burr left on the edges of the scratches. This effect does not usually last for many impressions as

81

the burr wears away very quickly; and because of this, and so as to give a uniformity to impressions, some artists remove the burrs with a scraper before printing. Sometimes drypoint and etching are combined on the same plate.

Etching. Biting a design into a prepared plate with a corrosive.

A polished plate, usually of copper but sometimes of zinc, steel or of some other material, is covered with an acid-resisting wax ground (there are several kinds, but a mixture of beeswax and asphaltum is traditional); the design is scratched through this with an etching needle and the ground is usually smoked to provide contrast with the bright metal exposed by the scratching. Sometimes the artist composes his design directly on to the plate; more usually he traces it from an original drawing on to tissue or tracing paper, through which it is traced in reverse on to the ground, although it may be transferred by placing the tracing face down on the plate and passing them through a rolling press.

The plate is then immersed in a bath of acid which bites the exposed lines of the design, the protected parts remaining unaffected. It is removed and any lines or areas which have been bitten to a sufficient depth are painted over as necessary with the wax resist; this process is called stopping out.

Any new lines to be bitten may be scratched through the resist, and the plate may now be immersed for further biting. This may be repeated as many times as necessary to achieve all the tones and lines of the composition, after which the ground is removed and proofs taken, from which the etcher may judge the progress of his work. Usually a new ground is laid at this stage so that lines which needed strengthening may be again exposed and rebitten or new passages introduced.

Lines may be removed by burnishing the plate, and others are sometimes added in drypoint or with an engraver's burin. Further proofs are taken, and further bitings and corrections are made until the desired result is realised.

It is these successive bitings and proofs that provide the 'states' of an etching. Quite apart from intrinsic differences in the design itself, marginal lettering may be introduced in one state or be removed in another. Sometimes an artificial state may be made by etching a 'remarque' in the margin; this might be simply a spray of flowers or leaves or some sketch related — or for that matter unrelated — to

the main design.

For printing, the plate is heated and printing ink spread over it with a roller or dabber so that the lines are filled. The ink is wiped from the surface, first by a pad of canvas or muslin and then by the palm of the hand which has been previously rubbed on a block of whitening.

The plate is again slightly warmed and a stage known as *retroussage* (dragging) often follows. In this a piece of folded muslin is dropped on to the inked lines, which brings or drags up the ink in them, increasing their strength where desired.

Finally the print is made by placing a piece of dampened paper on the plate and passing them through a press, the ink being thus transferred to the paper.

Etching, Soft-ground. A variant of etching giving a line similar to that of crayon. Its name comes from the fact that to the standard ground 50% of tallow is added, which softens it considerably.

Instead of the lines of the design being scratched through the ground, a sheet of paper is stretched over the prepared plate. The design is drawn on the paper with a pencil, which causes it to adhere to the ground so that when it is removed those parts which lie under the lines will come away with it, leaving the plate exposed and ready to be bitten. Biting is done as for an ordinary etching.

One of the advantages of soft-ground etching is that the strength of the lines may be varied with the pencil and stopping out is therefore less necessary.

Line-engraving. Engraving on polished metal plates, usually copper, with incised lines. The usual engraving tool is a burin which is made from a piece of highly-tempered steel, square or lozenge-shaped in section, ground to a sharp point and fitted into a wooden handle. The handle is held in the palm of the hand and the point of the tool, which is held between the thumb and forefinger, is pressed into the surface of the metal, while with about the same amount of pressure, and with the other hand, the plate is pressed against the point. This makes the engraved line, which may be varied in several ways, either by using a burin of a different section, or by modifying the angle at which it is held, or by diversifying the pressure with which it is pushed into the metal.

The newly engraved line has a burr along each side. Although

for a limited number of impressions this can give a rich line, it quickly wears away and so it is the usual practice to remove it with a scraper before any impressions are taken, especially if there are likely to be many.

Printing is done as in etching, that is by warming the plate, then inking it and wiping the ink off the surface. A sheet of damp paper is laid on it and put through a press, the paper being thus forced into the engraved grooves to pick up the ink.

Lightly engraved lines may be removed by burnishing, heavier lines by hammering up the plate from the back followed by burnishing the face.

Modelling is accomplished in line-engraving by many types and combinations of lines and dots, one of the commonest being cross hatching. In this one set of more or less parallel lines is crossed by another set. These form a net of diamond or lozenge shaped interstices. Sometimes a dot is added to the centre of each one of these, the resulting pattern being known as dot and lozenge.

Mezzotint. Mezzotint engraving is carried out on metal plates, usually copper but sometimes steel. The surface is first covered with a tone by means of a rough-faced implement called a rocking tool or cradle; this is rocked over the plate until it has imparted a uniformly granulated surface. If inked and printed from in this state a uniformly black impression would result.

After the plate is thus prepared the design is traced or etched on to it and it is then worked up by scraping and burnishing for which several special tools are available. First the highlights are scraped and burnished, then the secondary tones, and so on through the various stages, until the darkest passages are reached and for these the original surface is left untouched.

Printing is done as in line-engraving, but if the plate is to be printed in colour, it is coloured appropriately with a dabber of cloth or leather called a *poupée* and the whole print is made in one operation just as if it were in monochrome. This is called printing *à la poupée*.

Polygraph or Pollaplasiasmos. A print made by a now lost method, perhaps a form of aquatinting combined with some chemical or mechanical process. Only some eighty of such prints, which closely resemble paintings, were produced.

Poupée, à la. A method of colouring a printing plate. See under Mezzotint.

Roulette. See under Chalk Engraving.

Siderography. A term sometimes applied to steel engraving in general, but more properly to a commercial adaptation of that technique used especially for the production of adhesive stamps, share and bond certificates and banknotes.

In this technique a master die is first made and case-hardened. A transfer or indenting roller is then made from this: it is like a little flat wheel with a spindle projecting from each side. In a special machine and under considerable pressure, it is rolled backwards and forwards on the hardened die until it receives an impression from it. This in turn is case-hardened and rolled backwards and forwards in a series of positions on a larger plate until a sufficient number of impressions has been made (240 in the case of a sheet of postage stamps). This also is case-hardened and prints are taken off much as in the case of ordinary engravings. A skilled operator can make some three hundred prints in a day.

Also used in siderographic printing where security is a factor, is engine turning. It is a form of decoration consisting of concentric and entwined lines, loops, circles or curves. It could be made by means of an instrument known as a geometric pen, but more usually is made on one of a number of engraving lathes fitted with eccentric face-plates, including the Improved Rose Engine invented by Jacob Perkins.

Steel Engraving. A process in which etching is combined with various forms of engraving. On a polished steel plate a resin-based ground is laid as in etching, but somewhat thicker. It is then smoked by a taper or candle to provide contrast. The design is transferred to the plate in reverse, from the artist's original design, by scratching through the ground with an etching needle.

The plate is then bitten. For this, in order to retain the acid, a wall of wax about one inch high is built around the area to be etched. Biting is quick, the usual maximum time allowed being a quarter of an hour, as longer submersion could lead to underbiting. Subsequent bitings with stoppings-out may follow as in ordinary etching.

This is followed by line-engraved work with a burin which is

sometimes used to finish or sharpen etched areas, but usually there are also some areas of pure engraving. Even mezzotinting and stipple are sometimes used for special effects. And ruling machines are used for large areas of parallel lines as in skies and areas of water.

Lettering is added by a specialist engraver.

Mistakes may be rectified by punching up the plate from the back, burnishing the face and re-etching or re-engraving the passage.

See also **Siderography**.

Stipple. A form of etching in which the plate is covered with ground through which the design is composed in dots and flicks made with a point.

Outlines are sometimes made with a roulette (see under **Chalk or crayon engraving**). A limited amount of line-engraving is sometimes used to finish off the plate. Biting is carried out as in ordinary etching.

RELIEF TECHNIQUES

Acierage or en **épargne.** A French method of engraving much used in the production of postage stamps. A die is engraved in intaglio from which a mould is made in plaster or papier mâché, and from which, in turn, type-metal casts are made. This is known as stereotyping.

If the metal is deposited in the mould by electrolysis instead of being cast, a wax mould is used and the process is called electrotyping.

The printing blocks thus made are called stereos, and as in postage stamp production, may be clamped together in sufficient quantities to print sheets of uniform impressions.

Acierage can also mean the process of steel-facing on engraved or etched plate.

Acrography. A technique in which a drawing is made by scratching away a white compound spread on lithographic stone or glass. A metal cast is taken from this and used as a printing surface.

Baxterotype. The name given by V.R.A. Brooks (see *List of Engravers*) to monochrome prints made from Baxter's woodblocks and plates.

Chemitype. A chemically produced stereotype made in relief from an engraved plate; it was seen as a means of combining the subtle and versatile qualities of the etched line with the resources of relief printing.

An etching is made on a zinc plate and filings of fusible metal are spread on it. The plate is then heated from below, which melts the fusible metal, making it run into the etched lines. After cooling, the surface is machined down until the zinc face is again fully visible; it is then bitten with hydrochloric acid which reduces the zinc, but leaves the fusible metal standing to provide a printing surface.

Chromoxylography. The art of printing wood engravings in colour, either by using a separate block for each colour, or by overprinting a black and white foundation with colour.

Electro-Etching. A form of relief printing invented in 1839 in which the plate is prepared as for an etching. It is then connected to the negative pole of an electric battery and copper is deposited on the exposed parts to provide a printing surface in relief.

Electrotint. A similar process to electro-etching (q.v.) but applied to aquatinting.

Electrotint. A method of making relief plates by electrotyping (see under Acierage).

Electrotyping. See under *Acierage*.

Glyphography or Galvanography. A technique patented in 1842 and developed from the electrotint process. A metal plate was stained black and an opaque white mixture spread over it. This provided the artist's ground, on which he worked with knives and points, cutting it away until his composition showed through from the underlying black plate. When completed it was used as a mould in which an electrotype was taken to provide a relief printing block.

Graphotype. A process used in the 1860s for the illustration of a few books.

A design was drawn in a mixture of glue and lampblack on a block of compressed chalk; the surrounding chalk was then removed

by brushing, the inked parts resisting the brush. Finally the whole block was treated with silicate.

Graphotyping was not widely used because, although it was cheaper than wood-engraving and closely reproduced the artist's intentions, it was not very practical as the chalk block would not stand up to the pressures required in printing.

Gypsography. A process patented in 1837, but soon abandoned. A drawing was made through plaster mounted on a metal base. This was used as a mould in which to cast a stereotype.

Kerography or **Electrography.** As electrotyping process about which little is known. It is thought that a drawing was made through wax which was then electrotyped to provide the block. It was invented by W.J. Linton (see *List of Engravers*).

Nature Printing. A process in which a natural object such as a fern or a leaf, is placed between two plates, a hard one of copper or steel and a soft one of lead. The plates are then put through a press, during which the lead becomes imprinted with the natural object.

From this imprint an electrotype is taken and this forms the printing surface. In the case of flowers or plants any remains have, with great care, to be removed by a blowpipe before the electrotype is made.

In printing, colours are applied to the plate one by one, each in the appropriate areas, the plate being wiped after each application. Extra realism is often added by embossing, for which pieces of blanket are added to the printing press.

A more direct form of nature printing was to print by lithographic transfer from the actual object, or even direct from the object itself, but this was almost exclusively an amateur area.

Relief Etching. A method of etching in which the lines of the design are left in relief like a stereotype, the clear areas being etched away. It was perfected by William Blake (see *List of Engravers*) who, characteristically, claimed it had been communicated to him in a vision by his dead brother Robert.

Blake never divulged the particulars of the process and experts still do not agree on the details of his method. One of the most likely explanations is that the design was drawn in a stopping-out mixture

on thin paper, which was laid down on a heated copperplate and transferred to it under pressure from a roller. The paper was then removed and the plate was bitten in the normal way, leaving the reversed design in relief, ready for printing.

On the other hand, some noted scholars now believe that the design was painted in reverse in stopping-out mixture direct on to the plate, without being transferred from paper. The main argument against this is that throughout the many plates containing lettering, there is not a single mistake as would almost inevitably have been the case if Blake had worked in reverse, for even the most experienced engravers occasionally make such mistakes. Moreover on these plates Blake's lettering seems more consistent with writing than engraving.

On some plates Blake appears to have combined relief etching with a technique similar to that of wood-engraving. But here again some scholars believe that this part of the plate was also realised by etching.

Sir William Congreve's Method. A method of printing wood-engravings in several colours simultaneously, invented by Sir William Congreve (see *List of Engravers*).

A design in colour was made on a block which was then cut up into areas of different colours. These sections were placed in a special printing machine which applied the colours and printed them in one operation without running them together.

The method was widely applied to the printing of ephemera and bookbindings and to security printing.

Stereotyping. See Acierage.

Woodcutting. In woodcutting the design is first drawn in black on the plank of a polished block of a soft wood, like apple or pear. It is then cut with a knife, which is held like a pen, the unwanted areas being cleared by gouges or similar tools.

If a print is coloured it is usual to have a separate block for each colour.

Woodcutting was not a popular technique in the nineteenth century, but the popularity of Japanese prints, which were made in this way, brought about an increased interest during its closing decades.

Wood-engraving or Xylography. This technique differs from wood-cutting in being done on the end grain of hard wood (usually box) with engraving tools. There are several of these, the main ones being the burin or graver, which is similar to that used in line-engraving; the scorper, a round-edged tool which is used for making dots and stipples; the tint tool, which has a sharp triangular face, is used for making straight lines which grouped together give 'tints' or textures to a composition; and the spitstick with a curved triangular face, which is much used for making curved lines and fine stippling. There are also multiple tools, some of which were widely used in the nineteenth century; they have several cutting grooves on the same edge, by which large areas of parallel lines may be engraved with less effort.

The design is drawn or painted on, or transferred to the face of the prepared block. Sometimes it was transferred from the original design by tracing or copying; or, later in the century after methods of applying a sensitised surface to the block had been discovered, by photography. Transferring the design to the block had the advantage of preserving the original design which of course was destroyed by the engraver if it was made on the block itself.

The overall sizes of boxwood blocks are limited by the diameter of the tree trunk which is never large. Large compositions, therefore, such as appeared in many nineteenth-century periodicals, had to be constructed from a number of blocks joined together. The component blocks were distributed among a number of journeyman engravers, who each completed his section, the whole being then keyed together and the adjoining edges being worked over if necessary to hide any inconsistencies. Sometimes the divisions show, but usually the individual blocks are joined adroitly.

The actual engraving is carried out while the block is held on a sand-filled leather cushion. The block is held in the left hand, the engraving tool in the right with the handle resting in the palm, while the point is steadied with the thumb. The depth of incision is controlled by the angle at which the tool is held — the smaller the angle the shallower the cut.

It is necessary to work with the block in concentrated light. In the nineteenth century this was provided by a glass flask filled with water on a stand, through which a ray of light, thus magnified, was concentrated on the working area.

Mistakes may be rectified by drilling out the faulty part, plugging

it with a new piece of boxwood and re-engraving it.

William Blake sometimes used metal instead of wood for the wood-engraving technique. This is capable of affording very fine and delicate lines and has been used with notable success in recent years by Miss Joan Hassall for her book illustrations. Blake called it 'Wood-cutting on pewter' and described the process as follows: 'To Wood-cut on Pewter: lay a ground on the Plate & smoke it as for Etching; then trace your outlines, and beginning with the spots of light on each object with an oval pointed needle [probably a spitstick] scrape off the ground as a direction for your graver; then proceed to graving with the ground on the plate, being as careful as possible not to hurt the ground, because it, being black, will shew perfectly what is wanted.'[1]

PLANOGRAPHIC TECHNIQUES

Anastatic Process. A form of lithography intended for printing facsimiles. The transfer could be made direct from a print or a page of a book, provided this was printed in soapy or fatty ink. As this included linseed oil inks, the commonest variety in use until 1841, the date at which the process was patented, its possible applications were numerous.

There were some variations on the method, but in general the practice was to soak the original with dilute nitric acid, the period required for soaking varying with the age of the original, but with a maximum of ten days. An impression was then transferred from this to a zinc plate by passing plate and original through a rolling press; this provided a lithographic printing surface.

Auto-Lithography or **Artist Lithography**. Lithography in which an artist makes his design direct on to the printing surface.

Chromolithography. Lithographic printing in full colour from a succession of stones, one for each colour. Sometimes as many as eleven colours plus gold were used, and sometimes embossing was added to give a three-dimensional effect.

[1] William Blake *Complete Writings* ed. by Geoffrey Keynes 1966, p. 440.

Colour-printed Drawings. See under **Monotype.**

Lithography. Originally called polyautography, the technique of lithography was discovered in 1796 by a Czech, Aloys Senefelder.

The principle is based on the antipathy of water to grease. The printing surface is usually stone but sometimes zinc,[1] either of which is given a granulated surface. It is made chemically clean so that it is sensitive to grease, and the design is drawn on it with 'tusche', a greasy lithographic ink (linseed oil based), or with greasy chalk. The drawing is slightly absorbed below the granulated surface.

When the drawing is completed any chalk or ink remaining above the surface is removed with turpentine. Very diluted nitric acid and gum are applied to the surface to fix the drawing, and the stone is washed with gum arabic which protects the background and margins of the drawing. It is then moistened, an inked roller drawn over it, the ink adhering to the drawn parts but not to the clear areas which have absorbed the moisture. Prints are taken by applying paper to the inked surface, under pressure.

To overcome the difficulty of drawing the design on the stone in reverse, it may be made on transfer paper with lithographic ink or chalk. The paper is then dampened, laid on the stone, and put through a press, after which the paper is removed, leaving the design adhering to the stone.

Lithography may be used to reproduce engravings. For this a print is taken from the copperplate in appropriate ink and transferred to the stone as just described. Such transfers are made in postage-stamp production, the original line engraving being transferred one impression at a time or in small groups until the whole sheet is laid out.

Lithotint. A lithographic process in which liquid ink is applied to the stone with a brush and greater variety is given to textures by the use of the stump (a pencil-shaped cylinder of rolled paper used for softening areas of drawing). Lithotints were sometimes coloured by hand.

[1] Nowadays aluminium is sometimes used.

Monotype. A print from a metal plate or board on which a design has been painted. Sometimes the surface is simply painted with the design, sometimes the highlights are scraped away. Usually, as the name implies, only one impression is taken from each painting, but at times, it is possible to take two, or even more. Frequently monotypes are touched up with brushwork after printing.

Elaborate monotypes were produced by William Blake. Known as colour-printed drawings, they were extensively retouched and finished.

Oleograph. Chromolithographs on which a pattern of canvas is embossed. They are usually varnished giving them the superficial appearance of oil paintings, hence the name.

Polyautography. An early name for lithography.

PHOTOGRAPHIC TECHNIQUES

Albertype. A form of collotype invented by Josef Albert of Bavaria.

Autotyping, Autogravure or Carbon Process. In this a piece of paper is coated with a mixture of bichromated gelatin and powdered carbon, and then exposed below a negative of the subject. After this the gelatin tissue is transferred and stuck with rubber solution to a paper support, exposed-side downwards. The print is completed by washing away with warm water the unexposed areas of gelatin and the backing paper. This leaves a print of hardened gelatin of variable height, progressively deeper for dark areas, progressively shallower for light areas.

Cliché Verre. A photographic print made by means of a glass plate covered with a film of white collodion and placed over a black ground. The design is drawn through the film with a sharp point, the lines showing up black; tints are added with a metal brush tapped or dragged over the film. The black ground is then taken away, a sheet of sensitised paper substituted for it, and a print taken by exposing the plate to light. It is fixed in the usual way.

A sheet of polished and sensitised zinc may be used instead of paper. In this case the zinc plate is bitten, the background being removed by corrosion and the lines left in relief for printing, for

which the zinc is mounted on a wood block of type height. This method was used by George Cruikshank (see *List of Engravers*).

In yet a third method, called **hyalography**, after the drawing on glass has been made, it is photographed on a prepared surface of wax. From this a relief electrotype is made, and this provides the printing surface.

Collotype. In this a plate of ground glass or, less often, of copper, is coated with bichromated gelatin and exposed under a negative. A fine reticulated grain appears on the printing plate as the gelatin dries, the irregularity of which gives the print its tones.

There are many variations of the process, one of them at least being in use as early as 1855.

Collotype may also be used for colour printing, and was to some extent used thus for book illustration in the 1890s.

Dawson's Positive Etching Process. A technique probably named after the trade engraver Alfred William Dawson (fl. 1870s). A carbon print on glass was made from a negative and coated with gold, and from this an intaglio copper plate was made by electrotyping. A mezzotint ground was added afterwards, in order to make the plate hold ink, but it is not clear how this was applied.

Goupilgravure. Also known as photo-mezzotints, Goupilgravures were named after the firm of Goupil and Co., who perfected the process.

A mixture of bichromate, gum and glucose is spread on a metal plate to provide a sensitized surface, and this is exposed under a negative or transparency. After exposure the mixture remains tacky in various degrees according to its tones, from the highlights which are dry to the dark areas which remain very tacky.

The plate is then sprinkled with ground glass or emery powder, the coarse particles of which adhere to the dark areas, the fine particles to the light areas. This provides a granular surface, and a Woodburytype (q.v.) lead mould is taken from it, from which, in turn, a relief electrotype is taken. Yet another electrotype is taken from this, which provides an intaglio printing surface.

It is usually necessary in this process, because of the shallow relief obtained in the electrotypes, to work over part of the plates by hand.

94

Half-tone Engraving. Photo-engraving in which a screen of cross-lines is introduced to break up the image into dots of various sizes, thus enabling tones to be introduced or reproduced.

An attempt was made to give this effect by pressing a gelatin block against a grained paper, but the method at length adopted consists in placing a cross-line screen between the subject or the original photograph and the negative which is to be used for making the block.

This method was first used in the early 1880s. There are several variations.

Heliogravure. In heliogravure a carbon print is first made from a positive transparency. This is pressed on to a printing plate and its paper backing removed. An image of soluble lines remains and this is washed away with hot water, while the remaining gelatin forms a resist. The plate may now be etched.

Heliotype. A form of collotype (q.v.) invented by Ernest Edwards in 1869.

Herkomergravure or Herkotypic. A form of photo-engraving, named after Sir Hubert von Herkomer (see *List of Engravers*) in which electrotypes are taken from monotypes and used for printing.

Hyalography. See under Cliché verre.

Ink-photo. A form of collotype made on a surface of reticulated gelatin spread on glass. A print from a negative is taken on this, but instead of being used as a printing surface, a transfer is made so as to provide a lithographic surface and it is from this that impressions are taken.

The reticulation of the gelatin surface may be varied by its thickness — the thicker the gelatin the coarser the grain and vice-versa.

Line Process. A technique much used for book illustration, by which original designs made in intense black on a white ground may be reproduced; it is impossible to reproduce middle or neutral tints. Unlike wood-engraving, which it largely replaced, the line process can be relied upon to reproduce an artist's original line drawing correct in

every detail.

A negative of the original is made, usually on a wet collodion plate which gives more definite results than a dry plate. The negative is used to print an impression on a sensitized plate of polished zinc which is then etched, leaving the design in relief.

An alternative method, used from about 1870, was the swelled gelatin process. In this the negative was exposed for about a quarter of an hour over a layer of sensitized gelatin laid on a glass base. This was now put into water for a number of hours, which caused the unexposed parts of the gelatin to swell. A plaster of paris mould was taken from this, which in turn had a gutta-percha cast taken from it, and from this cast an electrotype was made.

Photoaquatint. A name sometimes given to certain prints made by photographic processes, especially where dust particles are used and where hand printing is involved. See for example Goupilgravure.

Photo-chrome-lithograph. A print made by a process in which a key impression of a photo-lithographic transfer is first printed, followed by printings from colour-separated negatives transferred to separate stones.

Photogalvanography. A photo-intaglio process based, like collotype (q.v.), on the reticulations of gelatin, but more especially on its tendency to swell where not exposed to light. This swelling gives areas of varying depth according to the amount of light falling on them.

A gelatin plate is prepared and an electrotype taken from it, and from this another electrotype is taken which in turn provides an intaglio plate, this being the printing surface which may be inked and wiped in the usual way.

Photogram Process. A form of nature printing in which the dried skeleton of, for example, a leaf was directly exposed over a photographic negative.

Photogravure. The name given to several photo-engraving processes, the first of which was discovered in 1826 by the Frenchman J.N. Niépce (1765-1833). The term is also sometimes used to include such processes as Goupilgravure, heliogravure and the Woodburytype.

There are two main categories of photogravure proper — screened and unscreened. In the unscreened form the printing plate is first covered with an aquatint ground, then dusted with fine asphaltum powder. The plate is heated in order to melt the powder, after with a carbon tissue print is pressed on to it. The backing is removed from the print, the soluble gelatin washed away and the plate is etched, the biting through the hardened gelatin varying with its thickness. The surface of the plate is now covered with tiny indentations or cells, which vary in depth according to the intensity of the area. These hold the ink during printing.

The biggest advance in photogravure came when the Bohemian engraver and inventor Karl Klič discovered a method of replacing the dust ground with a screen consisting of clear cross lines with opaque squares between, and of printing it on the carbon tissue before it was exposed to a transparency. This provided a surface of myriads of minute rectangular cells of uniform size, much more regular than those on the surface of an unscreened plate.

Klič's invention made possible the production of cylindrical printing plates and hence rotary printing, which resulted in enormously increased output. This type of photogravure is called rotogravure or rotary gravure. It was at first applied to textile printing, but its applications were later widened and included the production of Rembrandt prints (q.v.). Today it is widely used in security printing, especially for postage stamps.

Photo-Lithograph. A lithograph made from a photographic impression on a sensitised stone or plate.

There were some three methods in use during the nineteenth century, only one of which, apparently, was used in England. This was invented by John Pouncy (see *List of Engravers*), and consisted of coating a sheet of transparent paper with what he called 'black stuff', which was a sensitive mixture of bitumen dissolved in benzole and mixed with printer's ink. This was exposed beneath a negative, and the light caused the 'black stuff' to harden. The unhardened parts were then washed away with turpentine, and a positive print from the negative was revealed. This was used as a lithographic transfer.

The two continental methods differed from Pouncy's method mainly in the composition of the sensitive mixture used.

If zinc was used for a printing surface instead of stone, the process was sometimes called photo-zincography.

Photo-Mechanical Printing. A generic term indicating printing mechanically from a surface prepared by photography.

Photo-Mezzotint. Same as Goupilgravure (q.v.)

Photo-Zincograph. A photo-lithograph printed from a zinc plate instead of from a stone.

Rembrandt Print. A photogravure printed from a cylinder, and issued by the Rembrandt Intaglio Printing Co.

Rotogravure or **Rotary Gravure.** See under **Photogravure.**

Woodburytype. A print made by a process invented by and named after Walter Bentley Woodbury (see *List of Engravers*). In this a gelatin relief is produced photographically and hardened. It is then placed in a press on a steel plate with a sheet of lead above it and subjected to a pressure of four tons a square inch, an intaglio impression of the relief being left on the lead.

Prints were made from this in a mixture of water, gelatine and colour. They may be distinguished by a lack of surface smoothness.

MISCELLANEOUS

Anaglyptography. Engraving by means of an instrument, a kind of pantograph, for reproducing a three-dimensional appearance in representations of relief objects such as medals, coins, bas-reliefs and sculpture.

The object to be traced was clamped in position and a tracing arm moved across it; the relief moved the tracer up or down and this movement was reproduced by an etching needle which moved across a printing plate. This movement was repeated at suitable intervals until the whole relief of the object had been reproduced in lines on the plate.

Embossing. A method of raising an impression, usually colourless, on paper or card, much used in security printing and in the printing of ephemera. The paper is placed between two dies, one concave and one convex, which are brought together under great pressure.

Giles Method. A technique of printing in oil colours from metal plates, perfected by William Giles (see **Dictionary**).

Mechanical Ruling. This was carried out on an engraver's ruling machine, of which there were many forms, some very elaborate. But the basic mechanism varied little and consisted of a frame fitted with a straight edge with an etching needle or diamond point in a sliding socket, and a dividing attachment. The plate to be engraved was placed under this and parallel lines at any given interval could be marked. Mechanical ruling was used in many types of engraving including lithography, etching, steel engraving and others.

Protean Prints. Coloured prints made in a number of techniques, in which the subject is transformed when held up to the light. To achieve this they were printed on both sides of the paper and usually fixed in a mount, often with a thin backing paper to hide the under-print. When held up to the light a portrait of Wellington would be transformed into one of Bonaparte, or a view of the Piazza of San Marco in Venice would become crowded with merrymakers during the carnival.

Sometimes, instead of being printed on both sides, two separate prints are mounted one above the other.

Tinsel Portrait. A print, usually a portrait of a player in a theatrical performance, which is covered with tinsel decorations.

General Bibliography

Unless otherwise stated the place of publication is London.

ASLIN, E. *Victorian Engravings*. 1973.

BEAUMONT, Cyril W., and Sacheverell Sitwell *The Romantic Ballet in Lithographs of the Time*. 1938.

BECK, Hilary *Victorian Engraving*. Exhibition catalogue, Victoria and Albert Museum. 1973.

BÉNÉZIT E. *Dictionnaire critique et documentaire des Peintres, Sculpteurs, Dessinateurs et Graveurs* 8 vols. Paris, 1976 (revised edn.)

BIGGS, John R. *Woodcuts, Wood-engravings . . .* 1958.

BLISS, Douglas P. *A History of Wood Engraving*. 1928.

BUCKLAND-WRIGHT, John *Etching and Engraving*. 1953.

BURCH, R.M. *Colour Printing and Colour Printers*. 1910.

CALLOWAY, Stephen *English Prints for the Collector*. 1980.

CAVE, Roderick, and Geoffrey Wakeman *Typographia Naturalis*. Wymondham, 1967.

CHATTERTON, E.K. *Old Ship Prints*. 1927.

Chromolithography, The Numbers I-LII. 1867-69.

CLEAVER, James *A History of Graphic Art*. 1963.

COHEN, Jane R. *Charles Dickens and his Original Illustrators*. Columbus, Ohio 1980.

COLNAGHI and Co Ltd., P and D. *The Mezzotint Rediscovered*. Exhibition catalogue. 1975.

CURWEN Harold *Process of Graphic Reproduction in Printing*. 1934.

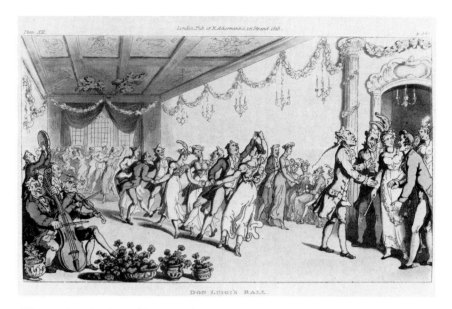

Thomas Rowlandson, 'Don Luigi's Ball' from *Naples and the Campagna Felice: in a Series of Letters* [by Engelbach]. R. Ackermann, London, 1815. Etching with aquatint. 115 x 196 mm.

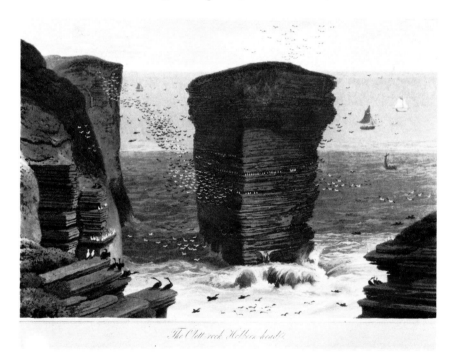

William Daniell, 'The Clett-rock, Holborn Head' from *Voyage around Great Britain*, London, 1820. Aquatint, 227 x 300 mm (plate mark).

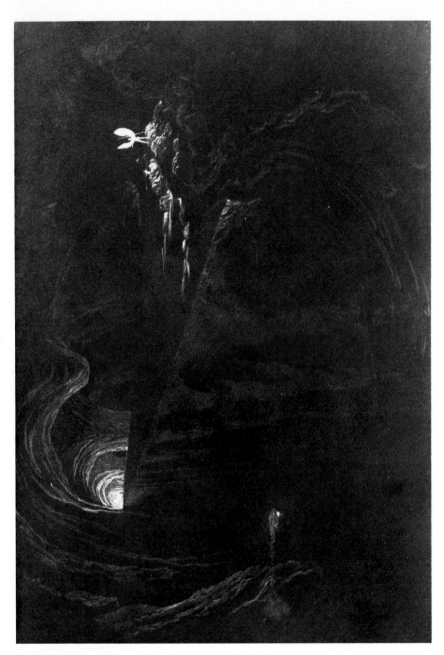

John Martin, 'At the Brink of Chaos' from *Paradise Lost* by John Milton, London, 1833. Mezzotint, 45 x 210 mm.

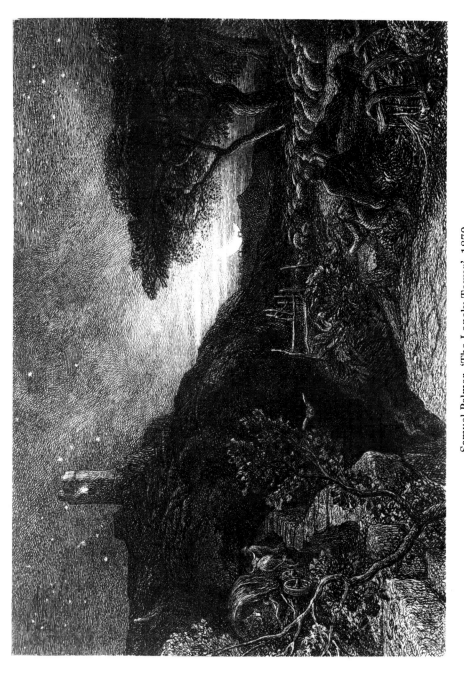

Samuel Palmer, 'The Lonely Tower', 1879.
Etching, 189 x 252 mm (plate mark).

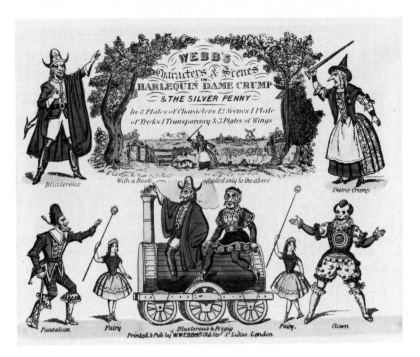

W. Webb, 'Characters &
Scenes in Harlequin Dame
Crump', 1854.
Etching, 170 x 216 mm.

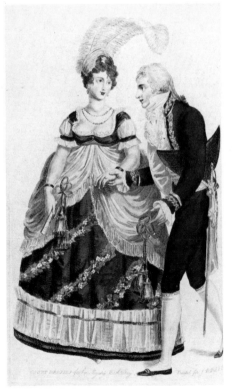

'Court Dresses for her
Majesty's Birth Day'
from *Le Beau Monde,
or Literary and
Fashionable Magazine*,
London, 1806-7.
Etching, 211 x 135 mm
(plate mark).

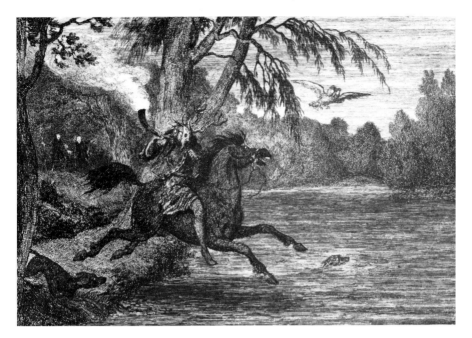

George Cruikshank, 'Herne the Hunter plunging into the Lake' from *Windsor Castle* by William Harrison Ainsworth, London, 1843. Etching, 99 x 145 mm.

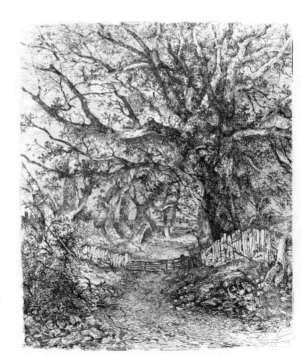

John Crome, 'Road Scene,
Trowse Hall, Nr. Norwich'
1813. Etching,
227 x 195 mm
(plate mark).

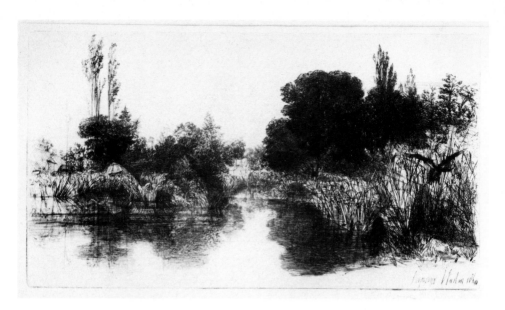

Sir Francis Seymour Haden, 'Shere Mill Pond', 1860. Etching, 178 x 334 mm
Courtesy of Robin Garton, Fine Art Dealers and Publishers.

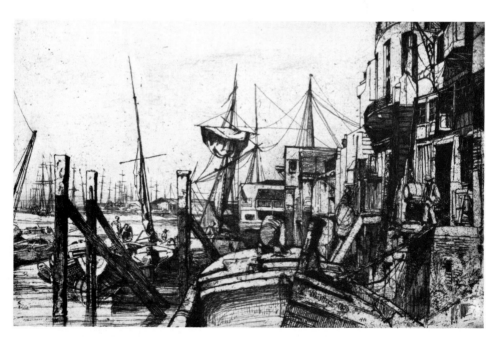

James Abbott McNeill Whistler, 'Limehouse', 1859. Etching, 127 x 200 mm.
Courtesy of Robin Garton, Fine Art Dealers and Publishers.

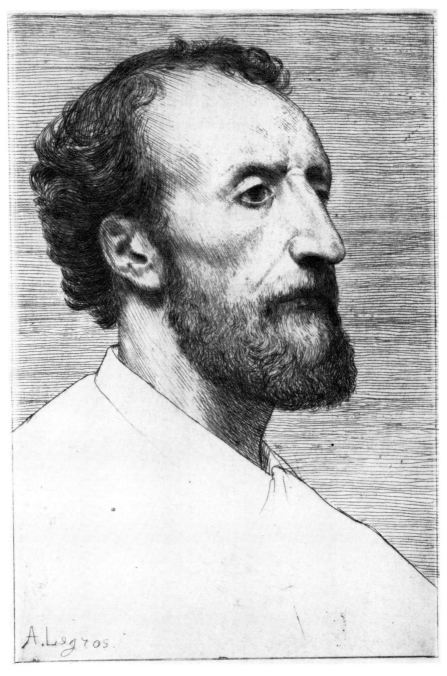

Alphonse Legros, 'Portrait of Jules Dalou', 1877. Etching, 251 x 163 mm.
(plate mark). Fitzwilliam Museum, Cambridge.

Thomas Bewick, Tailpiece from *A History of British Birds*, Newcastle, 1826 ed. Wood engraving 36 x 80 mm.

William Blake, Illustration from 'Imitation of Eclogue I' from *The Pastorals of Virgil ... adapted for Schools* by Robert John Thornton, London, 1821. Wood engraving, 34 x 75 to 76 mm.

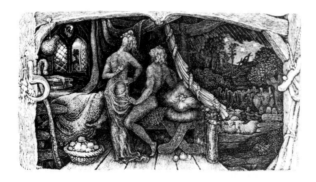

Edward Calvert, 'The Chamber Idyll', 1831. Wood Engraving, 41 x 76 mm.

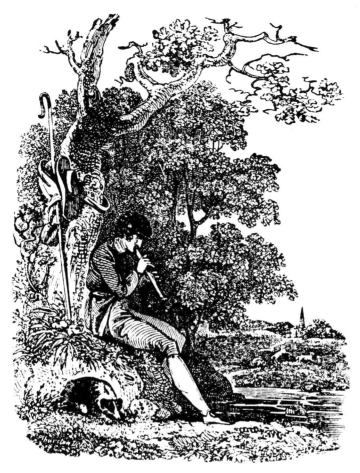

Charlton Nesbit, after John Thuston, Frontispiece, 'A Shepherd Boy', to
The Farmer's Boy by Robert Bloomfield, London, 1806 ed.
Wood engraving, 92 x 72 mm.

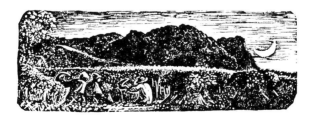

Samuel Palmer, 'Harvest under a Crescent Moon', *circa* 1826.
Wood engraving, 26 to 27 x 77 mm.

Dalziel Brothers, after J.E. Millais, 'Mariana' from *Poems* by
Alfred Tennyson, London, 1866 ed. Wood engraving, 92 x 77 mm.

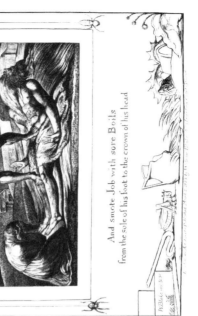

William Blake, 'Satan smiting Job with Boils' from *Illustrations of the Book of Job*, London, 1825. Line engraving, 216 x 169 mm (plate mark).

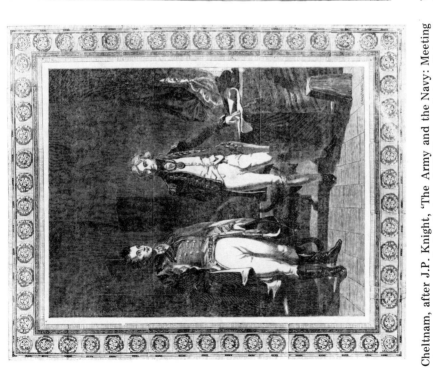

Cheltnam, after J.P. Knight, 'The Army and the Navy: Meeting of Lord Nelson and the Duke of Wellington (when Colonel Wellesley)' from *Illustrated London News*, November 20, 1852. Wood engraving, 269 x 220 mm.

James Duffield Harding,
'Shipley Bridge, Devon,
1859, issued in the series
Picturesque Selections,
1861. Lithograph,
400 x 286 mm.
Courtesy of
William Weston Gallery.

Thomas Shotter Boys,
'Entry to the Strand',
from
London as it Is,
1842. Lithograph,
273 x 451 mm.
Courtesy of
William Weston Gallery.

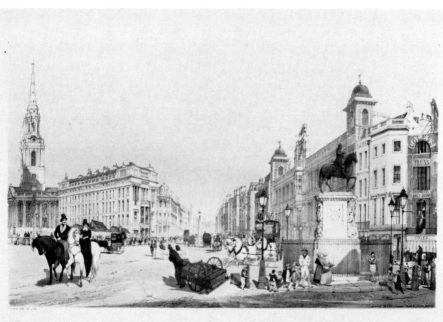

Edward Calvert, 'Ideal Pastoral Life', 1829. Lithograph, 43 x 77 mm.

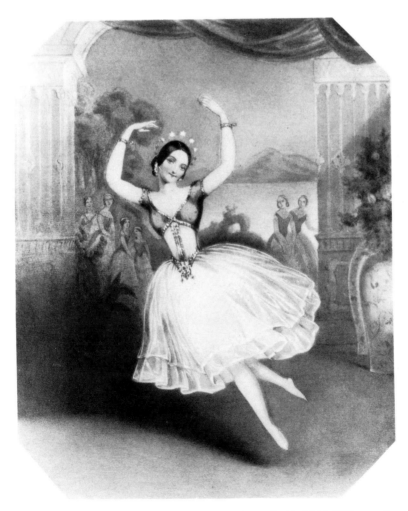

J. Brandard, 'Carlotta Grisi in the Ballet of The Peri', 1844. Lithograph, 340 x 276 mm.

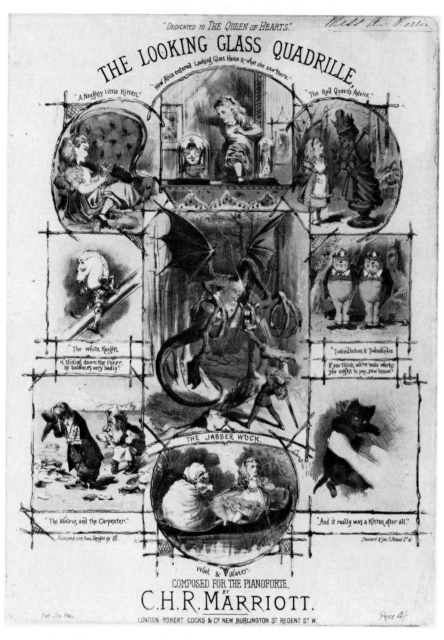

Alfred Concanen, based on designs by John Tenniel, Cover for music,
'The Looking Glass Quadrille', 1872 (?). Lithograph, 348 x 259 mm.

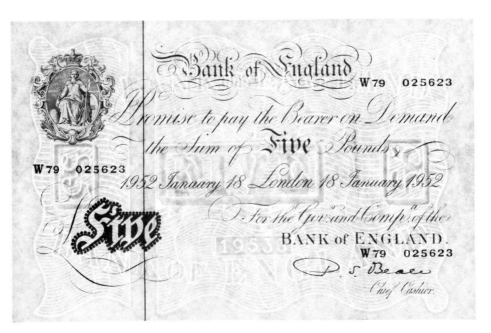

Daniel Maclise, J.H. Robinson, John Thompson and others, £5 note of the type issued from 1855 to 1963. Stereotyped, 134 x 211 mm.

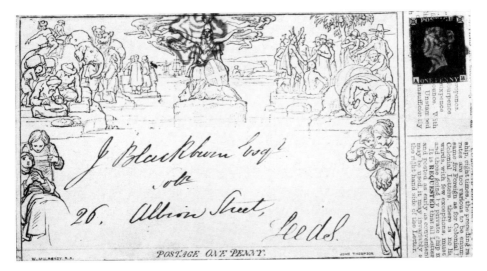

Henry Corbould, Perkins, Bacon and Petch, and others, One Penny Black postage stamp, 1840, produced by siderography; used on a Mulready envelope, 1840, engraved by John Thompson after a design by William Mulready.
Courtesy of Stanley Gibbons, Ltd.

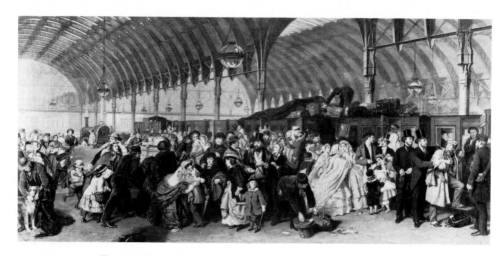

Francis Holl, after W.P. Frith, 'The Railway Station', 1866.
Steel engraving, 64.5 x 122 cm. Victoria and Albert Museum.

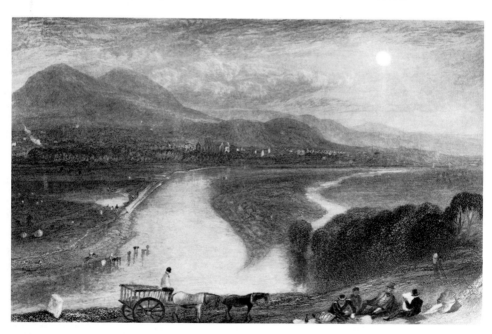

William Miller, after J.M.W. Turner, 'Melrose' from
The Poetical Works of Sir Walter Scott, Edinburgh, 1853.
Steel engraving, 87 x 135 mm.

DAVENPORT, C. *Mezzotints*. 1904.

DE MARÉ, Eric *The Victorian Woodblock Illustrators*. 1980.

Dictionary of National Biography 22 vols. plus supplements. 1882 *et seq.*

DUGGLEBY, V. *English Paper Money*. 1975.

ENGEN, Rodney K. *Dictionary of Victorian Engravers, Print Publishers and their Works*. Cambridge 1979. *Victorian Engravings*. 1975.

FAGAN, L. *Engraving in England*. 3 vols. 1893.

FARLEIGH, John *Graven Image*. 1940.

FIELDING, T.H. *The Art of Engraving*. 1841.

FOXON, F.W. *Literary Annuals and Gift Books*. 1912. (Repr. Pinner, Middlesex, 1973.)

FRIEND, G.W. *An Alphabetical List of Engravings declared at the Office of the Printsellers' Association 1847—1891*. 2 vols. 1892.

GODFREY, R.T. *Printmaking in Britain*. Oxford, 1978.

GRANT, Col. M.H. *Catalogue of British Etchers*. 1952.

GRAVES, Algernon *Royal Academy Exhibitors 1769—1904*. 8 vols. 1905—6 (repr. 1970).

GRAY, Basil *The English Print*. 1937.

GUISE, Hilary *Great Victorian Engravings*. 1980.

HAMERTON, Philip Gilbert *The Etcher's Handbook*. 1871 and later edns. *Etching and Etchers*. 1868 and later edns.

HARDIE, Martin *English Coloured Books*. 1906.

HARRIS, G.M. *Experimental Printing Processes in England 1800—59*. 1965.

HERBERTS, Kurt *The Complete Book of Artists' Techniques*. New York, 1958.

HIND, Arthur M. *A History of Engraving and Etching from the 15th century to the year 1914*. 1923 (repr. 1963).

HODGSON, Thomas *Essay on the Origin and Progress of Stereotype Printing*. Newcastle-on-Tyne, 1820.

HOLMAN, Louis A, *The Graphic Processes: Intaglio, Relief and Planographic*. Boston, 1929.

HOUFE, S. *Dictionary of British Book Illustrators and Caricaturists 1800—1914*. 1978.

HUBBARD, E. Hesketh *On Making and Collecting Etchings.* 1920.

HULLMANDEL, C. *The Art of Drawing on Stone.* 1824 (later edns. 1833, 1835).

HUNNISETT, Basil *A Dictionary of British Steel Engravers.* Leigh-on-Sea, 1980. *Steel-Engraved Book Illustration in England.* 1980.

IMESON, W.E. *Illustrated Music-Titles.* 1912.

IVINS, William M., Jr. *How Prints Look.* New York, 1943 (repr. Boston, 1958). *Prints and Visual Communication.* 1953.

JACKSON, John, and W.A. Chatto *A Treatise on Wood Engraving Historical and Practical.* 1839 (second edn. 1861).

LALANNE, Maxime *A Treatise on Etching.* Boston, 1880.

LANDSEER, John *Lectures on the Art of Engraving.* 1807.

LAVER, James *English Sporting Prints.* 1970. *A History of British and American Etching.* 1929.

LEIGHTON, Clare *Wood-Engraving and Woodcuts.* 1932.

LEWIS, C.T. Courtney *The Story of Picture Printing in England during the XIX century.* 1928.

LILIEN, O.M. *History of Industrial Gravure Printing to 1920.* 1972.

LINTON, W.J. *The Masters of Wood Engraving.* New Haven and London, 1889.

LISTER, Raymond *Great Images of British Printmaking.* 1978.

LUMSDEN, E.S. *The Art of Etching.* 1924. (repr. New York, 1962).

MACKENZIE, A.D. *The Bank of England Note.* Cambridge, 1953.

McLEAN, Ruari *Victorian Book Design.* Second ed. 1972.

MAYER, Ralph *The Artists's Handbook of Materials and Techniques.* Second revised edn. edited by Edwin Smith, 1964.

MASON, Lauris, and Joan Ludman *Print Reference Sources.* 1979.

MELVILLE, Fred. J. *Postage Stamps in the Making.* 1916.

NEWBOLT, Sir F. *The History of the Royal Society of Painter Etchers and Engravers.* 1930.

NORTH LEE, Brian *British Bookplates. A Pictorial History.* 1979.

O'DONOGHUE, F. and H.M. Hake *Catalogue of Engraved British Portraits preserved in the British Museum.* 6 vols. 1908–25.

PEARSALL, Ronald *Victorian Sheet Music Covers.* Newton Abbot, 1972.

PENNELL, Joseph *Etchers and Etching. 1926. Lithography and Lithographers.* 1915.

PRIDEAUX, S.T. *Aquatint Engraving.* 1909.

Print Collector's Quarterly. Vols. I—XXX. London and Kansas City, 1911—51.

RAY, Gordon N. *The Illustrator and the Book in England 1790 to 1914.* Oxford and New York, 1976.

REDGRAVE, Samuel *A Dictionary of Artists of the English School.* 1878 (repr. 1970).

REID, Forrest *Illustrators of the Sixties.* 1924.

ROBINS, W.P. *Etching Craft.* 1922.

SALAMAN, Malcolm C. *Whitman's Print-Collector's Handbook.* Sixth edn., 1912.

SÉFI, Alexander J. *An Introduction to Advanced Philately.* 1926, second edn. 1932.

SENEFELDER, Alois *A complete Course of Lithography.* 1819 (repr. New York, 1977).

SHORT, Frank *On the Making of Etchings.* 1898.

SITWELL, Sacheverell, and Wilfred Blunt *Great Flower Books 1700—1900.* 1956. — , Handasyde Buchanan and James Fisher *Fine Bird Books 1700—1900.* 1953.

SLATER, J. Herbert *Engravings and their Value.* Sixth edn. revised and enlarged by F.W. Maxwell-Barbour, Kew, 1978.

SMITH, J. Chaloner *British Mezzotint Portraits.* 4 vols. 1878—83.

SPARROW, Walter Shaw *A Book of British Etching.* 1926.

SPEAIGHT, George *The History of the English Toy Theatre.* 1969.

SPELLMAN, Doreen and Sidney *Victorian Music Covers.* 1969.

STRANG, David *Printing of Etchings and Engravings.* 1936.

THIEME, Ulrich and Felix Becker *Allgemeines Lexikon der Bildenden Künstler* 37 vols. Leipzig 1907 *et seq.*

TOOLEY, R.V. *English Books with Coloured Plates 1790—1860.* 1973.

TWYMAN, M. *Lithography 1800—1850.* 1970.

VITZELLEY, Henry *Glances back through Fifty Years.* 1893.

WAKEMAN, Geoffrey *Aspects of Victorian Lithography.* Wymondham, 1970. *Nineteenth Century Illustration.* Loughborough, 1970. *Victorian Book Illustration.* Newton Abbott, 1973.

WHITE, Gleeson *English Illustration. The Sixties 1855—70.* 1897.

WHITMAN, Alfred See under Salaman, M.C.

WILDER, F.L. *English Sporting Prints.* 1974. *How to Identify Old Prints.* 1969.

WILLIAMS, L.N. and M. *Fundamentals of Philately Sections* 1 to 5. New York, 1958—68.

WILSON, A.E. *Penny Plain Two Pence Coloured.* 1932.

ZIGROSSER, C. (ed.) *Prints: Thirteen Essays.* New York, 1967.

Dictionary

*A List of Engravers and Others Concerned in the
Production and Distribution of Prints in Great Britain
during the Nineteenth Century*

In the following list I have in general included engravers who, although working mainly in the eighteenth century, were still alive in 1810, and could thus have made an active contribution to printmaking in the nineteenth century. At the other limit I have excluded engravers born after 1880, as the work of their maturity belongs to the twentieth century. Even here I have omitted engravers born just before that, whose work has little or no relationship with nineteenth century printmaking — for example such engravers as Vanessa Bell (b. 1879) and Charles Ginner (b. 1878), who have both been excluded. I have included foreign engravers who worked in Great Britain or who made engravings after works by British artists.

In addition to engravers (a term I have interpreted in its widest sense) I have also included brief entries for some important printers, printsellers and publishers, especially those whose names appear in inscriptions on prints. In some instances (for example on most juvenile drama sheets) only the publisher's or printseller's name appears.

Unless otherwise stated, the publishers listed were mainly concerned with issuing separate engravings. Any exceptional activity, such as the publication of photo-engravings, is usually noted. Book publishers are not included unless they also published separate plates.

A word of explanation about the arrangement of the entries is necessary.

The name of the subject is followed by the years of his birth and death if they are known, with the places of birth and death shown in brackets. In cases where such details are not known, indications of the period and, if known, the main place of the subject's activity are given.

These details are followed on a separate line by a list of the media used (e.g. aquatint, lithography) and on a further line by the categories

of subject in which the engraver worked (e.g. landscape, portraits). Brief biographical and other details follow, with lists of artists whose works were engraved, of the engraver's assistants, pupils, publishers, and of other engravers with whom he shared work, and the names of engravers who reproduced his own designs. These lists are followed by notes of books and articles for further reading.

In addition to the recommendations for further reading it should be remembered that many of the books listed in the main bibliography may well contain further information. For example it may be assumed that details of many portrait engravings will be found in O'Donoghue and Hake's six-volume *Catalogue of Engraved British Portraits in the British Museum*.

The fact that an engraver is listed as having reproduced works by other artists does not preclude original work. Indeed most engravers have produced original work, at least occasionally. At the same time there are a few who, like William Blake, not only produced numerous reproductive engravings but who made even more engravings of their own conception and design.

The information available for each entry in the list varies enormously and in some cases is severely limited. But I have tried to make each entry as detailed as possible within the scheme I have been set.

By its very nature a list of this kind cannot be considered exhaustive, but it contains most of the names likely to be encountered by the average dealer and collector.

The following Latin words and their abbreviations from inscriptions on prints are worth noting.

DELINEAVIT. DEL. INVENIT. INV. PINX.	Indicate the artist or designer

FECIT. FEC. SCULPSIT. SCULP. SC.	Indicate the engraver

Abbreviations

Aft.: after — i.e. engravings after work or works by the artist named.
All.: allegory.
An.: animals.
Anat.: anatomy.
Antiq.: antiquities.
Aq.: aquatint, aquatinter.
A.R.A.: associate member of the Royal Academy.
Arch.: architecture.
Assits.: assistant, or assistants include.

Bank.: banknotes.
Bot.: botanical.

Caric.: caricature.
Chalk: engravings in chalk-line manner.
Chromolitho.: chromolithographer, chromolithography.
Cost.: costume.

Des. eng.: The subject's own original designs or paintings engraved by.
Des. litho.: ditto lithographed by.
Dry.: drypoint.

Ephem.: ephemera.
Et.: etcher, etching.
Ex libris: bookplates or book labels.

Fig.: figure subjects.
Flor.: floral, flowers.

Gen.: genre.

Hist.: historical, history.
Hum.: humorous.

Illus.: book and/or magazine illustrations.
Incl.: including.

Juv. dram.: juvenile drama, i.e. toy theatre engravings.

Land.: landscape.

Line: line-engraver, line-engraving.
Lit.: literary.
Litho.: lithographer, lithograph.

Mezzo.: mezzotinter, mezzotint.
Marine.: marine and/or seascape subjects.
Mil.: military.
Mixed.: mixed method.
Music.: music covers.
Myth.: mythological.

Nat.: natural history.

Orn.: ornament, ornamental.

Panor.: panoramas.
P.C.Q.: Print Collector's Quarterly.
Photo.: photographs.
Photo-eng.: photo-engraver, photo-engraving.
Port.: portraits.
Print.: printer.
Pub.: publishers include.
Pup.: pupils include.

R.A.: Royal Academy or Royal Academician.
Relig.: religious, sacred, biblical.

Scien.: scientific.
Sculp.: sculpture.
Shared: work on a plate or plates shared with the engraver named.
Ship.: shipping, naval.
Sport.: sporting, including coaching.
Steel.: steel engraver, steel engraving.
Stip.: stipple engraver, stipple engraving.

Tech.: technological.
Theat.: theatrical.
Tinsel: tinsel theatrical portraits.
Topog.: topographical.

Wood.: wood-engraver, wood-engraving.

ABBOT John White 1763 (Exeter) —
c. 1827.
Et.
An. / nat.
Amateur painter who made a few
etchings.

ABLETT William Albert 1877
(Paris) — 1937.
Line.
Gen. / port.
A pupil of A. Aubet and Gérome,
Ablett is best known as a painter.

ABRECK — fl. 1830s.
Steel.
Illus. / land.

ABRESCH Franz fl. 1830s.
Steel.
Illus. / land.

ABSALON J. fl. mid 19th c.
Wood.
Illus.

ACKERMANN Rudolf 1764
(Stolberg, Saxony) — 1834 (London).
ACKERMANN and Co.
ACKERMANN Arthur (son of
Rudolf).
ACKERMANN Rudolf Jr. (son of
Rudolf).
Printsellers.
Rudolf Ackermann, after completing
his education, worked for his father, a
coachbuilder, and then travelled to
various places, settling for a period in
Paris. He came to London where he
married an Englishwoman. After
making a living as a designer for
coachbuilders he set up in 1783 as a
printseller, and until 1806 ran a
drawing school which had been
founded by William Shipley. He was
an inventive man and his other
activities included the manufacture of
waterproof cloth and paper at a
factory at Chelsea, and the invention
of a moveable carriage axle. He was
largely responsible for the
establishment in England of
lithography as a fine art, by persuading
well-known artists to practise it. In
1819 he published a translation of a
Complete Course of Lithography by
A. Senefelder, the inventor of the
medium.
 He was one of the most influential
publishers of his time, issuing all kinds
of prints and illustrated books.
 Rudolf Ackermann's shop, The
Repository of Arts, was in the Strand,
London, at no 96 and no 101 at
different periods. In 1830 the firm's
name was changed to Ackermann and
Company. This lasted until about
1856, when his two sons split the
partnership, Arthur carrying on
business under his own name and
Rudolf jr. as The Eclipse Sporting and
Military Gallery at 191 Regent Street,
London.
Lit.: Prideaux S. *Aquatint Engraving*
1909.

109

ACLAND E. fl. mid 19th c.
Et.
Land.

ACON John fl. London 1832—46.
Line, steel.
Land.
Aft.: W. Tombleson.

ACON Robert fl. 1818—30s.
Steel.
Arch.

ADAM Joseph Denovan 1842
(Glasgow) — 1896 (Glasgow).
Et.
An. / fig. / gen.
Also a painter, J.D. Adam was a
pupil of his father Joseph A. Adam.
He also studied at South Kensington
School of Art, and founded at
Craigwell a school of painting.

ADAM T. fl. (?) early 19th c.
Stip.
Gen.
Aft.: Van Assen.

ADAMS H. Isabel fl. late 19th c.
Et.
Ex libris / illus.

ADCOCK George Henry
fl. 1830s—40s.
Line, steel.
Fig. / port.
Aft.: Sir T. Lawrence, Reynolds,
G.L. Saunders.

ADENEY fl. 1852.
Wood.
Illus.

ADDISON William Grylls d. 1904.
Et.
Topog. / illus.
Lived and worked in Chelsea.

ADLARD Alfred fl. London 1850.
Line, print.
Ex libris.
Adlard's headquarters were at 7
Wardrobe Place, Doctor's Commons.
Other London printers of the same
name, probably relations, were Henry
Adlard (q.v.), Charles Adlard and
James William Adlard.

ADLARD Henry fl. 1825—65.
Line, steel.
Arch. / gen. / illus. / port.
Probably related to A. Adlard (q.v.).
Aft.: W. Hogarth, W.H. Bartlett, Sir T.
Lawrence.

ADOLPHO F.R. fl. London (134
Oxford Street) early 19th c.
Et.
Ex libris.

AFFLECK Andrew b. 1877
Et.
Land. / topog.
Lit.: Craddock and Barnard *Modern
Etchings (19th & 20th centuries)*
No 135, 1977.

AFFLECK Edouard Louis b. 1874.
Et.

AGAR John Samuel 1776(?)—
1858(?)
Line, steel, stip.
All. / cost. / gen. / hist. / illus. / port.
Also a portrait painter. Pupil of
M. Bovi and T. Cheesman (qq.v.)
Aft.: E.F. Burney, R. Cosway, Isabey,
C. Jones, Sir T. Lawrence, Ann Mee,
Reynolds, L. Sharpe, H. Singleton,
T. Uwins.
Pup.: James Mitan (q.v.)
Pub.: Ackermann.

AGLIO Augustine 1777 (Cremona)
— 1859 (London).
Aq., litho.
Antiq. / hist. / port. / ship.
An Italian national and a noted
decorator, Aglio was educated in
Milan. He later made the acquaintance
of the architect William Wilkins, with
whom he travelled in Italy and Greece;
he made the aquatint illustrations to
Wilkins's *Magna Graeca.* He later came
to England, where he decorated Drury
Lane Theatre, the Opera House and
other buildings. He was a most
industrious artist, and to one work
alone, *Antiquities of Mexico*
(1830—48), he contributed a thousand
lithographs.
Aft.: A. Webb.

AGNEW Thomas and Sons fl. from
c. 1848 London (Old Bond St.) and
Manchester.
Publishing firm founded by Thomas
Agnew. Became Thomas Agnew and
Sons 1860—1894. One of the more
important print publishers in the 19th
century. The firm Thomas Agnew and
Sons Ltd. still exists at 43 Old Bond
Street and 3 Albemarle Street, London
W.1.

AIKEN John M. 1880—1961.
Et.
Land. / port. / topog.

AIKMAN Alexander T. fl. 1840s.
Steel.
Fig. / land.

AIKMAN George W. 1830
(Edinburgh) — 1905 (Edinburgh).
Et., line., mezzo.
Gen. / land. / port. / topog.
A son and pupil of George Aikman, an
engraver employed by W.H. Lizars
(q.v.) and later self-employed.
Educated privately and at Edinburgh
High School. Attended the Trustees
Academy, Edinburgh, and the Life
Class of the Royal Scottish Academy.
Following his apprenticeship, and after
a period as a journeyman in London
and Manchester, Aikman became a
partner of his father. He wrote on art
for *The Art Journal,* and also practised
as a painter.
Aft.: A. Nasmyth, H. Raeburn, Sir G.
Reid, T. Smart.

AITCHESON-WALKER Jessie fl.
London late 19th — early 20th c.
Line.
Gen.

AKEN Henry fl. 1816—69.
Et.
Sport.
Aken was also a painter and writer; he
was author of *The Art and Practice of
Etching* (1849).

ALAIS Alfred Clarence fl. London
(Shepherd's Bush) 1878—93.
Line, mezzo., mixed, stip.
*An. / gen. / illus. / land. / lit. / mil. /
port. / sport. / topog.*

Aft.: C. Barker, S. Berkeley, Rosa
Bonheur, J.H. Bromley, S.J. Carter,
A.C. Dodd, E. Douglas, T. Faed, J.A.
Fitzgerald, F. Grant, Miss E. Greenhill,
H. Hardy, A. Hughes, W. Hunt,
E. Landseer, F. Paton, G.F. Thomson,
W.H. Trood, Ada E. Tucker.
Pupil: W.J. Alais, his son (q.v.)
Lit.: *Art Journal* 1879, p. 208.

ALAIS J. fl. 1816—30.
Stip.
Gen. / port.
Aft.: De Wilde, E. Douglas, Stella,
F. Wheatley.

ALAIS William John fl. 1877—94.
Line, mezzo., mixed, stip.
An. / flor. / gen. / illus. / port. / topog.
Son and pupil of A.C. Alais (q.v.)
Aft.: T. Brooke, R. Cosway,
R. Cruikshank, W.A. Delamotte,
F. Ford, G.A. Holmes, E. Landseer,
N. Paton, F. Wheatley.
Pub.: B. Brooks and Sons.

ALBEMARLE Earl of — See Coutts W.

ALBERT Prince Consort 1819
(Rosenau, Coburg) — 1861 (Windsor).
Et., Litho.
An. / gen. / port. / topog.
Husband and consort of Queen
Victoria (q.v.). His art instructor was
Sir Edwin Landseer (q.v.). He made
forty etchings, signed "Albert".
Aft.: E. Landseer, W.C. Ross, and
various Dutch painters.
Shared: Queen Victoria. These signed
"Albert del. VR sclt" or "VR del et A
sct."
Lit.: *The Art Journal* 1848, p. 351.
Engen R.K. *Victorian Engravings*
1975. *The Printseller* I, 12, 1903.
Warner Marina *Queen Victoria's
Sketchbooks* 1979.

ALBON Charles Frederick fl. London
1874—92.
Et.
Land. / marine.
Also a painter.

ALBUTT W.E. fl. 1830s—60s.
Steel.
Arch.

ALDIN, Cecil 1870—1935.
Et.
An. / sport.
Also a watercolourist.

ALEXANDER Edwin 1870—1926.
Et.
An.
This painter probably produced only
one plate, a study of a hen.

ALEXANDER R.M. fl. mid (?)
19th c.
Line.
Sport.

ALEXANDER William 1767
(Maidstone) — 1816.
Et.
Antiq. / cost. / illus. / hist. / land.
Alexander became a student at the
R.A. schools in 1784. In 1792 he was
junior draughtsman with Lord
Macartney's embassy to China, and
some of his drawings were used to
illustrate books on the embassy. He
was appointed professor of drawing at
the Military College, Great Marlow,
1802, and in 1808 became the first
keeper of prints and drawings at the
British Museum.
Pub.: Nicol.

ALKEN Henry Jr. — See Samuel
Henry Alken.

ALKEN Henry Gordon fl. late
19th c.
Et.
Sport.
Son of S.H. Alken (q.v.)

ALKEN Henry Thomas 1785
(London) — 1851 (Highgate).
Aq., et. (incl. soft-ground), mixed.
*An. / flor. / gen. / hum. / illus. / lit. /
land. / sport.*
A son of S. Alken (q.v.), H.T. Alken
was a noted sporting artist whose work
included painting and drawing in
addition to engraving. He is said to
have been originally employed by the
Duke of Beaufort as a stud-groom,
trainer or huntsman, but it was
probably not long before he discovered
his gifts as an artist, and he became
one of the finest sporting artists of his
times. Until 1819 he used the
pseudonym "Ben Tally-Ho", and
signed his work thus. He wrote *The Art
and Practice of Etching* (1849).
 He is not to be confused with his
nephew, Henry G. Alken (q.v.) who
tried to pass off some of his much
inferior work as his uncle's.
Aft.: E. Grill, J. Harris, W.P. Hodges,
Levinge.
Shared: E. Duncan, F.C. Lewis,
T.J. Rawlins, R.G. Reeve, T. Reeve,
G.A. Sala, T. Sutherland.
Des. eng.: C. Bentley, J. Harris,
F.C. Lewis, J. Pollard, C.R. Stock.
Pub.: Ackermann, Fores and Co.,
T. McLean.
Lit.: Baillie-Grohman, W.A. *Sport in
Art* 1919. Laver, James *English
Sporting Prints* 1970. Sparrow
Walter Shaw *Henry Alken* 1927.
Wilder F.L. *English Sporting Prints* 1974.

ALKEN Samuel *c.* 1750—1825.
Aq., et. (incl. soft-ground), mezzo.,
mixed.
*Gen. / illus. / land. / orn. / port. /
sport. / topog.*
Father of H.T. Alken (q.v.). Not to be
confused with the artist Seffrien Alken,
who signed his work "S. Alken".
Aft.: B. Broughton, R. Cooper,
G. Morland, J. Parker, P. Pindar,
T. Roberts, T. Rowlandson, J. Smith,
J.W. Upham, H. Wigstead, R. Wilson,
F. Wheatley.
Shared: F. Bartolozzi (q.v.).
Des. eng.: T. Sutherland, E. Walker
(qq.v.).
Lit.: Laver James *English Sporting
Prints* 1970.
Wilder F.L. *English Sporting Prints*
1974.

ALKEN Samuel Henry (called Henry
Alken, Jr.) 1810—94.
Ag., Et.
Hist. / sport.
Father of H.G. Alken (q.v.).

ALLAN Robert Weir fl. 1873—90.
Et.
Gen.
Allan was born in Glasgow, where his
father practised as a lithographer. He
later worked in London and for a time
in Paris. He was also a marine painter.
Aft.: W.H. Bartlett, J.H. Lorimer.

112

ALLANSON John 1800
(Newcastle-on-Tyne) — 1859 (Toronto, Canada).
Wood.
Illus.
Allanson, who was a pupil of Thomas Bewick (q.v.), worked from 1840 in Leipzig and in France.

ALLCHIN J. Herbert fl. 1877—81.
Et.
Flor. / nat.

ALLEN Daniel fl. 1830s.
Steel.
Fig. / illus.

ALLEN George 1832.
(Newark-on-Trent) — 1907 (Orpington).
Line., mezzo., mixed.
Illus. / pub.
After being educated at a private grammar school at Newark-on-Trent, Allen was apprenticed as a joiner to his uncle, a builder. When the Working Men's College was founded in 1854 he joined the drawing class and studied under Ruskin, whose assistant he became. Encouraged by Ruskin, he studied engraving under John Le Keux, and studied mezzotinting under T.G. Lupton (qq.v.). After working for many years for Ruskin as general assistant, engraver and publisher, he opened his own publishing house in 1890.

ALLEN J. fl. London (23 Princes Road, Kennington; opposite the Asylum, Francis Rd., Westminster) early 19th c.
Pub.
Juv. dram.

ALLEN James Baylis 1803
(Birmingham) — 1876 (London).
Line., steel.
Gen. / hist. / illus. / land. / mil. / myth. / relig. / topog.
Allen began life as a button manufacturer, working for his father. He was later apprenticed to his elder brother, Josiah Allen, a trade engraver of Colmore Row, Birmingham. For a time he attended drawing classes under John Vincent Barber. He went to

London in 1824 and worked in the studio of W. Finden (q.v.), and for many years worked as an engraver at the Bank of England. He also worked for Charles Heath and Robert Wallis.
Allen was an important member of a school of landscape engravers who worked in Birmingham during the earlier part of the nineteenth century. Their work was a consequence of the activities of some of the numerous commercial engravers employed in iron and steel manufacturers. Other members of the school were William and Edward Radclyffe and Arthur and James Williams (qq.v.).
Allen was a contributor to *The Art Journal.*
Aft.: Allom, Armitage, Berchem, R.P. Bonington, A.W. Callcott, G. Chambers, Sir C.L. Eastlake, J.D. Harding, G. Hawkins, J. Holland, G. Jones, E. Lami, S. Prout, D. Roberts, S. Scott, W.C. Stanfield, J.M.W. Turner.

ALLEN James C. fl. 1821—31.
Et., line.
Arch. / illus. / ship. / topog.
Born in London, Allen was apprenticed to W.B. Cooke (q.v.)
Aft.: J. De Loutherbourg.
Shared: W.B. Cooke.

ALLEN R fl. 1840s.
Steel.
Arch. / illus. / land.

ALLEN S. fl. 1850s—60s.
Line., steel.
Illus.
Aft.: Sir E. Landseer.

ALLEN Thomas 1803—33.
Et., line.
Hist. / marine.
Son of a map engraver, Allen was also a topographical writer and illustrated his own books in whole or in part.
Aft.: N. Whittock.

ALLIÈS Mary H. fl. London 1874.
Line.

ALLINGHAM Arthur J. fl. 1864—99.
Et., photo-eng.
Hist. / port.
Aft.: L.C. Dickinson.
Pub.: Dickinson and Foster.

ALLINGHAM William J.
fl. 1890—1902.
Et., line.
Arch. / gen. / land. / ship. / sport.
Aft.: J.W. Barker, F.P. Barraud,
Rosa Bonheur, F. Carless, G. Hamilton,
M. Hemy, J.M.W. Turner,
A.H. Wardlow, J. Weiss.
Pub.: Dickinson and Foster; Gladwell
& Co.

ALLIPRANDI T. fl. early 19th c.
Stip.
Gen.
Engraved a set of F. Wheatley's "Cries
of London" when the original plates
were worn out.

ALLMER J.C. fl. early 19th c.
Stip.

ALLPORT T. fl. 1820s.
Litho.
Flor. / illus.

ALMA-TADEMA Sir Lawrence, O.M.,
R.A. 1836 (Dronryp, Friesland) —
1912 (Wiesbaden).
Et., litho.
Gen. / hist. / illus. / port.
Son of Dutch notary, Alma-Tadema is
best known for his historical paintings.
He attended Antwerp Academy, where
he was a pupil of Louis de Taye. Later
he was a pupil and assistant of Baron
Hendrik Leys. He settled in London in
1870.
Des. eng.: P.J. Arendzen, A. Blanchard,
A. Boulard, Mrs Minnie F. Cormack,
F.S. Hanfstaengl, N. Hinst,
L. Lowenstam, W. Bell Scott (qq.v.)
and many others.
Pup.: H.T. Thompson (q.v.).
Lit.: Ash R. *Alma-Tadema* 1973.
Maas, J. *Victorian Painters* 1969.

ANAGLYPHIC COMPANY
fl. London (Berners St.) mid 19th c.
Print., pub.
Theat. (ballet).

ANDERSON D.J. fl. London
1872—74.
Wood.
Illus.

ANDERSON G. fl. London
1815—25.
Pub.
Juv. dram.
Anderson may have been in partnership
with G. Slee (q.v.). His stock is
supposed to have passed first to
Robert Lloyd and then to Skelt (qq.v.),
both of London. Speaight (see general
bibliography) states that he knows of
none of Anderson's sheets existing today.

ANDERSON John fl. late 18th-
early 19th c.
Wood.
Illus.
Born in Scotland, where he received a
classical education, Anderson became
a pupil of T. Bewick (q.v.). He later
abandoned engraving.
Aft.: J. Samuel.
Pub.: T. Bensley.

ANDERSON John C. fl. Mitcham,
Surrey 1850s—60s.
Litho.
Port.
Noted for portraits of cricketers,
Anderson lived close to the village
green at Mitcham.
Pub.: F. Lillywhite.

ANDERSON Robert 1842
(Edinburgh) — 1885 (Edinburgh).
Et., line, steel.
Gen. / land. / ship.
Anderson lived in Edinburgh and was
an associate member of the Royal
Scottish Academy.
Pub.: T. Agnew & Sons.

ANDRÉ Philipp fl. London early
19th c.
Pub.
Litho.
André was a brother of an
associate of Aloys Senefelder (1771—
1834), inventor of the lithographic
process. He published *Specimens of
Polyautography* (1803), which was
reissued in 1806 by G.J. Vollweiler
(q.v.) with additional prints.

ANDREW — fl. Paris 1828—52.
Wood.
Illus.
Pupil of John Thompson (q.v.)

ANDREWS — fl. mid. 19th c.
Line, steel.
Illus. / port.
Aft.: T.A. Vauchelet.

ANDREWS George fl. London
(The Marine Print Warehouse,
Charing Cross) early 19th c.
Printseller, pub.
Ship.

ANDREWS Henry C.
fl. London 1799—1828.
Et.
Flor. / illus.

ANDREWS James A. fl. 1840s—
50s.
Litho.
An. / flor. / illus.

ANDREWS and Co. fl. London
(St. Luke's) 1890.
Pub.
Juv. dram.
The prints issued by this firm were
mainly reprinted from plates by Skelt
(q.v.) and sold as "Champion Parlour
Dramas" at one penny a packet.

ANGAS George French fl. mid 19th c.
Litho.
Illus.
The Angas family are closely bound up
with the history of South Australia
where they owned estates. George Fife
Angas (father of George French Angas)
was one of the founders of the colony.
George French emigrated to Australia
in 1843 in company of two sons of
Edward Calvert (q.v.). He wrote several
books on Australia, New Zealand and
Europe, which he illustrated with
lithographs.
Lit.: Hodder E. *George Fife Angas*
1891.

ANGERER L. fl. 1900
Photo-eng.
Arch.

ANGLEY H.J.P. fl. Lewisham
1850—90.
Et.
Land.
Aft.: J. Constable, Reynolds,
Rembrandt.
Pub.: Gladwell Bros.

ANGUS William 1752—1821.
Line.
Arch. / illus. / land. / port. / topog.
Aft.: V.J. Daynes, A. Elsheimer,
G. Samuel, P. Sandby, T. Stothard.
Pup.: W.B. Cooke (q.v.)

ANNAN and SWAN fl. from 1880s.
Printers of photo-eng.
Founded by Thomas Annan of
Glasgow, and Sir Joseph Wilson Swan
of London, this firm purchased rights
to use a photogravure process from the
Imperial Printing Works, Vienna.
See also Autotype Company.

ANNEDOUCHE A.J. fl. 1850s.
Steel.
Port.
Aft.: Greuze, Van Dyck.

ANNIS William fl. London c. 1790—
1819.
Mezzo.
Gen. / hist. / land. / marine.
Engraved some plates for Turner's
Liber Studiorum.
Aft.: S. Dewilde, J. Drummond,
G. Morland, J. Northcote, J.M.W.
Turner, J. Ward, F. Wheatley.
Shared: J.C. Easling (q.v.).

ANSDELL Harry Blair fl. London
(30 Duke Street, St. James's) 1870s—
80s.
Pub.
Probably related to R. Ansdell (q.v.).

ANSDELL Richard R.A. 1815
(Liverpool) — 1885 (Farnborough).
Dry., et.
*An. / gen. / hist. / land. / lit. / mil. /
sport.*
Ansdell, who was also a painter, was a
pupil of W.C. Smith, the portrait
painter. He visited Spain with the
painter, John Phillip. He lived at
Kensington, then at Farnborough, and

115

was probably related to the publisher
H.B. Ansdell (q.v.).
Pub.: H.B. Ansdell; Art Union;
Etching Club.
Lit.: *The Art Journal* 1860.

ANSTED William Alexander 1859 —
c. 1893.
Et.
Land. / sport. / topog.
Worked at Chiswick.
Aft.: E.H. Fahey, E. Goodwyn Lewis.
Pub.: L. Brall and Son; Fine Art
Society; Gladwell Bros.; A. Hasse;
Mawson, Swan and Morgan.

APPLEBY James fl. London 1820.
Line, steel.
Ex. libris. / heraldry.

APPLETON J. W. fl 1834—41.
Steel.
Illus. / land.

APPLETON Thomas Gooch 1854
(Shalford, Essex) — 1924.
Mezzo.
Gen. / hist. / port. / relig. / sport.
Appleton worked at Little Bushey,
Essex, and Great Missenden, Bucks.
With H.T. Greenhead (q.v.) he helped
to revive the art of mezzotint. He was
also a watercolourist.
Aft.: J.J. Barker, T. Blinks, G.H.
Boughton, S.J. Carter, J. Collier,
F. Dicksee, L. Fildes, H. Hardy,
F. Holl, Hoppner, Sir T. Lawrence,
Lord Leighton, C.E. Marshall,
A. Moore, G. Morland, Sir F.N. Paton,
Raeburn, G. Romney, J. Russell,
Santerre, S. Sidley, A. Stuart-Wortley,
G.H. Swinstead, F. Wheatley,
W. Wontner.
Pup.: Mrs M. Cormack (q.v.).
Pub.: H. Graves; A. Tooth.
Lit.: Engen R.K. *Victorian Engravings*
1975.

APPLETON T.W. fl. London 1840.
Line.

APPOLD J.L. fl. 1870.
Steel.
Fig.
Aft.: Da Murano.

ARCHER, J. fl. 1850—60.
Litho.
Port.
Aft.: H. Melville.
Pub.: J. Harris and Co, Sheffield
(anaglyptograph process).

ARCHER James fl. mid. 19th c.
Line., steel.
Illus. / land. / topog.
Worked for a time in U.S.A.
Aft.: A. Cooper, J.M.W. Turner.

ARCHER John Wykeham 1808
(Newcastle-on-Tyne) — 1864
(London).
Et., line., steel.
*An. / antiq. / gen. / illus. / sport. /
topog.*
Archer was apprenticed in London to
John Scott (q.v.) as an engraver of
animal subjects, after which he
returned to Newcastle and collaborated
with William Collard (q.v.). He
returned to London about 1831 and
worked for William and Edward
Finden (qq.v.) and other publishers,
working extensively on steel. When
steel began to fall from fashion,
Archer turned to watercolour and
drawing, although he drew on wood
for other engravers. He was also an
antiquary.
Aft.: A. Callcott, J. Carmichael,
E. Metcalf.

ARCHER W. fl. 1830s—40s.
Steel.
Illus. / mil.

ARCHIBALD William fl. Edinburgh
1811.
Line.
Pup.: W. Miller (q.v.)

ARDAIL Albert fl. 1885—1902.
Et.
Gen.
French reproductive etcher, much of
whose work was made after works by
British artists.
Aft.: T. Hughes; W. Dendy Sadler.
Pub.: A. Tooth and Sons.

ARENDZEN Petrus-Johannes fl.
1885—1905.
Et.
Arch. / gen. / port.
Dutch reproductive etcher who lived
and worked in Hampstead.
Aft.: Sir L. Alma-Tadema, P.J.H.
Cuypers, J. Israels, A. Mauve, J.F.
Portaels, Rembrandt, Ruysdael, Van
Dyck.

ARLETT Richard Austin
fl. 1830—43.
Line.
Port.
Aft.: A.E. Chalon, Sir T. Lawrence.

ARMSTRONG C. fl. second half of
19th c.
Line.
Armstrong was a pupil at the
Engraving School at South Kensington.

ARMSTRONG Charles b. London
1839.
Litho.
*Arch. / gen. / hist. / hum. / land. /
mil. / port. / ship. / topog.*
Armstrong was working for Vincent
R.A. Brooks (q.v.) in 1860, as a
lithographer and chromolithographer.
Later he worked in U.S.A. in New
York (1866) and Boston (1870).

ARMSTRONG Cosmo 1781
(Birmingham) — 1836 or after.
Line., steel.
Illus. / lit. / port.
Pupil of W. Milton (d. 1790),
landscape engraver.
Aft.: Sir T. Lawrence, T. Phillips,
R. Smirke, J. Thurston, Van Dyck.
Pup.: John Jackson (q.v.).
Pub.: Cooke; Kearsley.

ARMSTRONG Elizabeth Adela — See
Forbes, Elizabeth Adela.

ARMSTRONG John fl. 1810.
Line.
Gen.
Also an engineer.

ARMSTRONG Thomas fl. London
1830s—40s.
Wood.
Illus.

Was for a time an assistant of
E. Landells (q.v.).
Aft.: J. Franklin

ARMSTRONG W. fl. 1840s—60s.
Wood.
Illus.

ARMYTAGE James Charles
1802—97.
Line., steel.
Illus. / land. / relig.
Armytage is reported to have practised
steel engraving for longer than any
other engraver. He lived to the age of
95. Among his works are a number of
engravings made for John Ruskin.
Aft.: W.H. Bartlett, C. Baxter, H.
Bright; V.W. Bromley, J.L. Gerome,
K. Halswelle, J. Herring, Sir E.
Landseer, Sir W.Q. Orchardson, J.M.W.
Turner, Sir D. Wilkie.

ARNOLD Harriet (neé Gouldsmith)
1787—1863.
Line., litho.
Land. / port.

ARTLETT Richard Austin 1807—73.
Line., steel., stip.
*Fig. / illus. / land. / port. / sculp. /
topog.*
Artlett was a pupil of Robert Cooper,
and afterwards of James Thompson
(qq.v.).
Aft.: J. Absolon, C.B. Birch, J.
Bostock, Carrier-Belleuse, A.E. Chalon,
J.D. Crittenden, J. Dunham, J.H.
Foley, J.J. Jenkins, Jerichau, Sir T.
Lawrence, P. MacDowell, R. Mont,
G. Reid, G. Richmond, W. Say,
J. Thomas, F. Winterhalter.

ART PHOTOGRAVURE Co.
fl. London (Willesden) 1890s.
Print.
Formerly L. Collardon and Co., this
firm was one of a large number in
London (nearly ninety) producing
photogravure plates during the closing
years of the century.
Pub.: Robertson and Moffat (q.v.).

ART RECORD PRESS fl. late 19th
— early 20th c.
Pub.
Photo-eng.

117

ART UNION OF LONDON 112
Strand.
The Art Union of London was
founded in 1836. It organised lotteries
in which money prizes were offered to
enable winners to buy approved works
of art. It also published prints,
including collections in book form,
sometimes around a literary theme,
such as *Songs from Shakespeare.* Its
periodical *The Art Union* continued as
The Art Journal from 1849 to 1912.
 Other Art Unions with similar
programmes included the Art Union of
Scotland and the Art Union of Ireland,
and there were Art Unions at Bath,
Birmingham, Bristol, Leeds, Liverpool,
Manchester and Norwich.

ARYTON — fl. mid (?) 19th c.
Line.

ASHBY — fl. mid (?) 19th c.
Line.
Mil.
Aft.: P.W. Tomkins.

ASHBY W. fl. Paris 1821—33.
Et., line., stip.
Illus.

ASHLEY Alfred fl. 1830—50.
Et., line.
Fig. / gen. / illus. / land.
In 1849, Ashley published a book
entitled *The Art of Engraving.*

ASPERNE J. fl. early 19th c.
Line.
Port.
Asperne was also an editor.

ASPLAND Theophil Lindsey 1807
(Hackney) — 1890.
Et.
Land.
Aspland, who was also a painter, was a
pupil of G. Cooke (q.v.). He worked in
Manchester, Liverpool and the Lake
District.

ASSEN Benedictus Antonio van — See
VANASSEN, Benedictus Antonio.

ATKINSON F.L. fl. mid (?) 19th c.
Line.
An. / land.
Aft.: Rosa Bonheur, Sir E. Landseer.

ATKINSON Francis E. fl. Teddington
1890s.
Mezzo.
Gen. / land.
Aft.: R. Gallon, W.H. Gore, J. McLure
Hamilton, H. Stacy Marks, B. Wollen.
Pub.: C.E. Clifford; Leggatt Bros.;
T. McLean; A. Tooth.

ATKINSON Frederick fl. late 18th
— early 19th c.
Et. (amateur)
Port.

ATKINSON George 1880—1941.
Et.

ATKINSON George K. fl. 1806—84.
Et., mezzo.
Gen. / lit. / port.
Irish by birth, Atkinson began life as a
ship's carpenter and then worked in
Queenstown, Co. Cork, at a naval
appointment. Later he lived in Dublin.
Little appears to be known of his art
training or career.
Aft.: H. Barraud.

ATKINSON John Augustus 1775
(London) — 1831 or 1833.
Aq., et. (including soft-ground).
Cost. / gen. / illus. / mil. / ship. / sport.
Atkinson was taken by his uncle at the
age of nine to St. Petersburg, where he
studied in the Imperial galleries and
was patronised by the Empress
Catherine and her son the Tsar Paul.
He was also a painter and a
draughtsman and made many studies
of Russian character. He returned to
England in 1802.
Des. eng.: J. Burnett, J. Walker (qq.v.).
Pub.: Boydell; Orme.

ATKINSON Thomas Lewis 1817
(Salisbury) — c. 1890.
Line., mezzo., steel.
*An. / all. / gen. / hist. / land. / port. /
sport.*

Atkinson was a pupil of Samuel
Cousins (q.v.), and worked in London.
Aft.: Sophie Anderson, F. Ansdell,
Rosa Bonheur, T. Brooks, V. Bromley,
R. Carrick, Carter, J. Charlton, J.
Collier, L. Dickinson, W.C.T. Dobson,
E.U. Eddis, T. Faed, W.P. Erith, F.
Goodall, Sir F. Grant, H. Graves, Kate
Greenaway, Gustorf, J. Hallyer, H.
Hardy, G. Harvey, Sir G. Hayter, J.R.
Herbert, J.F. Herring jr., J.S. Hodges,
F. Holl, J.C. Hook, J.C. Horsley, Sir E.
Landseer, Lord Leighton, H. le Jeune,
E. Long, J. Lucas, C. Lucy, D. Macnee,
Sir J.E. Millais, F. Newenham, G.
Richmond, B. Riviere, W.D. Sadler,
S. Sidley, F. Stone, F. Tayler, W.
Tweedie, J. van Lerius, S.E. Waller,
Mrs E.M. Ward, H.T. Wells, F.
Winterhalter.
Shared: S. Cousins, F. Stacpoole
(qq.v.) Atkinson also finished the plate
by W.H. Simmons (q.v.) after Rosa
Bonheur, "The Lion at Home", left
uncompleted on Simmons's death.
Pub.: T. Agnew; B. Brooks; P. and D.
Colnaghi; Fine Art Society; Frost and
Reed; H. Graves; L.H. Lefèvre; I.P.
Mendoza; F.G. Moon; Moore,
McQueen and Co.; Hugh Paton;
A. Tooth.
Lit.: Engen R.K. *Victorian Engravings*
1975.

ATKINSON W.E. b. Canada 1862.
fl. Kew, late 19th c.
Line.

AUDINET Philippe 1766 (Soho,
London) — 1837 (London).
Line., mezzo., steel.
Hist. / illus. / port.
Of French descent, Audinet was
apprenticed to John Hall (1739—97).
He made only one mezzotint plate, a
portrait of his brother, S. Audinet, a
watch maker.
Aft.: J. Barry, H.P. Danloux, H. Fuseli,
W. Owen, S. Wale.
Pub.: Bell; Harrison.

AUGERER I. fl. end of 19th c.
Photo-eng.
Gen.
Aft.: C.E. Marshall.
Pub.: I.P. Mendoza.

AUSTEN R. fl. 1870s—1880s.
Litho.
Flor. / illus.

AUSTEN Winifred (Mrs O.O. Frick)
1876—1964.
Et.
An.
Noted especially for her studies of
birds.
Lit.: *Bookman's Journal* VI; XV, p. 30.
Print Connoisseur III, pp. 43, 51.

AUSTIN H. fl. 1840s.
Steel., stip.
Fig. / illus.
Aft.: A. Johnston, J.W. Wright.

AUSTIN Richard 1788—1830.
Wood.
Ephem. / illus.
Also a typefounder and proprietor of
Austin's Imperial Letter Foundry,
Worship Street, Shoreditch. This was
later taken over by his son George.
Possibly identical with Richard T.
Austin (q.v.).
Lit.: [Morison S.] *Richard Austin
Engraver to the Printing Trade . . .*
1937.

AUSTIN Richard T. fl. early 19th c.
Wood.
Illus. / land.
Austin was a pupil of John Bewick
(q.v.). He was also a miniaturist.

AUSTIN William 1721 (London) —
1820 (Brighton).
Et., line.
*Arch. / caric. / ephem. / land. /
marine. / topog.*
Austin, who was also a draughtsman,
was a pupil of George Bickham (d.
1769). For a period he kept a shop
and published some caricatures.
Aft.: A. Locatelli, I.B. Pannini,
Ruysdael, E.H. van der Neer, J. van
Goyen, A. Waterloo.
Shared: P. Sandby.

AUTOTYPE COMPANY fl. London
c 1870 — early 20th c.
Print., pub.
Photo-eng.
This firm purchased a photo-engraving
process from Joseph Wilson Swan (see
Annan and Swan). Their products were
sold at the Autotype Fine Art Gallery,
74 New Oxford St., London, and were
also distributed by J. Reville and Co.
(q.v.). Several catalogues of the

Company's publications were issued,
the sixth edition being published in
1896.
Lit.: *Prospectus of the Autotype
Company* 1868.

AYLESFORD Lord — see FINCH,
Heneage.

AYLIFFE E. fl. London 1874.
Line.

BACON Frederick 1803 (London)
— 1887 (California).
Et., line., mezzo., steel.
*An. / gen. / hist. / illus. / lit. / mil. /
port.*
Bacon was a pupil of E. Finden and
H. Fuseli (qq.v.). He became noted for
his plates in art annuals. He worked in
Camden Town, but later emigrated to
America.
Aft.: R. Ansdell, T.J. Barker,
F.W. Burton, A.W. Callcott, C. Dukes,
T. Duncan, T.G. Duval, W. Gush,
G.P.A. Healy, W. Hunt, Sir E.
Landseer, J. Lonsdale, Murillo,
F.R. Pickersgill, T. Ramsay,
A. Rankley, Sir W.C. Ross, G.M. Ward,
E.H. Wehnert, Sir D. Wilkie.
Pub.: Art Union of Ireland; Art Union
of London; Owen Bailey; P. and
D. Colnaghi; H. Graves; Hering and
Remington; Lloyd Bros., T. McLean;
R. Turner.

BADELEY Sir Henry John Fanshawe,
1st Lord Badeley K.C.B. 1874
(Elswick, Newcastle-on-Tyne) — 1951
(London).
Et., line.
Ex libris.
Badeley was an amateur engraver,
being a civil servant by profession. He
studied under Sir Frank Short (q.v.)
and at the Royal College of Art.
Despite his amateur status he became
an associate member of the Royal
Society of Painter-Etchers and
Engravers, and became its honorary
secretary.

BABEUX F. fl. early 19th c.
Line.
Lit.
Aft.: Sir A.W. Callcott.

BAILEY Arthur fl. c. 1880—90.
Pub.
Juv. dram.
Also published the magazine *The
Boy's Halfpenny Budget.*

BAILEY George fl. Derby 1880—90.
Et.
Topog.

BAILEY J., and Co. fl. London
1830.
Pub.
Juv. dram.
This firm also traded as "Bailey and
Hunt" and "Suzman and J. Bailey".
Their addresses at various times were
1 Clifford's Inn Passage; 65 Gray's Inn
Lane, Holborn; 2 Slade's Place, Little
Suffolk Street; 188 Fleet Street.

BAILEY John 1750 (Blades Field,
Yorks) — 1819 (Chillingham).
Et. (amateur).
Ex libris / illus. / ship. / topog.
Bailey was tutor to his uncle's children,
and in his spare time made etchings
which he later published. Later he
became mathematics master at Witton-
le-Wear and also set up as a land
surveyor. Afterwards he became land
agent to Lord Tankerville at
Chillingham.
Aft.: T. Whitcombe.

BAILEY Owen fl. London 1840s
and 1850s.
Pub.

BAILEY A. fl. 1820s.
Aq.
Flor. / illus.

BAILY James fl. about 1780—1815.
Aq., line.
Gen. / illus. / topog.
Aft.: E. Compton, E. Goodwin,
Newhouse.

BAIRD Nathaniel Hugues John
b. Yelholm, Roxburghshire 1865.
Et.
Gen. / land. / port. / topog.
Also a painter, Baird worked in
Dawlish, Devon.

BAIRD-CARTER A. fl. London
1890s.
Pub.
Photo-eng.

BAKER A. fl. Sydenham 1828.
Line.

BAKER B.R. *c.* 1800—*c.* 1850.
Litho.
Topog.

BAKER CHARLES 1844—1906
(Hague, New York).
Mezzo., stip.
Gen.
American national who worked for a
time in London.
Aft.: G. Smith.
Pub.: B. Brooks.
Lit.: Stauffer D. *American Engravers*
1907.

BAKER E.H. fl. London and
Sudbury 1855—65.
Mezzo., stip.
Gen.
Aft.: E.C. Barnes.
Pub.: B. Brooks.

BAKER James H. b. Beaconsfield
1829.
Line, steel.
Illus.
Baker was a pupil at the R.A. Schools
and of H.T. Ryall (q.v.).

BAKER John H. fl. London
1850—70.
Line, stip.
Gen. / lit. / port. / sculp.
Aft.: E.H. Baily, L. Dickinson,
G. Doré, Margaret Gilles, C.R. Leslie,
G. Richmond; and after photos.
Pub.: J.L. Fairless; McQueen & Co.;
Moxon & Co.: W. Schaus, D.T. White.

BAKER Oliver b. 1856
(Birmingham).
Et.
Arch. / gen. / land. / topog.
Brother of Samuel Henry Baker (q.v.).
Worked in Birmingham and Stratford,
and was active in the 1880s and 1890s.
Lit.: *Studio* XIX, pp. 127—9; XXIII,
p. 125; XXXII, p. 345; Winter number
1901—2; Summer number 1902.

BAKER R.R. fl. 1820s—40s.
Line, steel.
Heraldry / hist. / illus.
Aft.: H. Corbould, J. Stephanoff.

BAKER Samuel Henry 1824
Birmingham) — 1909.
Aq., et.
Arch. / gen. / land. / topog.
Samuel Baker was a brother of Oliver
Baker (q.v.). He began life as a lantern-
slide painter, and became a pupil of
Joseph Pettitt at the Birmingham
Society and the Birmingham School
of Design. Also a noted landscape
painter, he was father of the artists
Henry and Alfred Baker.

BALDING H.C. fl. 1869—84.
Line., steel.
Illus. / sculp.

BALDREY Joshua Kirby
1754—1828 (Hatfield Wood Side, Herts.).
Chalk, et., stip.
Arch. / myth. / port. / relig.
Baldrey worked both in London and
Cambridge between 1780 and 1810.
He is noted for a plate of the East
window in King's College Chapel. He
has been listed in error by some
dictionaries as John Baldrey.
Aft.: H. Bunbury, J. Downman,
D. Gardner, W. Hamilton, J. Hoppner,
J. Kendall, C. Maratti, G. Morland,
E. Penny, R. Redgrave, Reynolds,
S. Rosa, A. Zucchi.

BALL Arthur E. fl. Richmond 1880s.
Et.
Topog.
Also a painter.

BALL H.S. fl. *c.* 1843.
Litho., steel.
Theat. (ballet).
Aft.: E.D. Smith, H. Warren.
Pub.: J. Mitchell.

BALL Wilfred Williams 1853—1913.
Et.
Arch. / land. / ship. / topog.
Ball lived and worked in Putney. His
manner resembles that of
J. McN. Whistler (q.v.).
Pub.: Leggatt Bros.
Lit.: *Art Journal* 1905, p. 219. *Studio*
XVI, p. 3.

BALLIN Henry Edward 1783
(London) — 1853 (Hamburg).
Line., print.
Worked in Hamburg.

BALLIN John (Joel) 1822—85.
Line., mezzo., mixed.
Gen. / port. / relig.
A Danish national, Ballin lived and
worked in Bayswater. He worked also
in Copenhagen and Paris.
Aft.: C. Black, F. Goodall, R. Lehmann,
E. Long, T. McLean, H. Olrick,
J. Tissot.
Pup.: W.A. Cox (q.v.).
Pub.: A. Borgen; J. Fairless; A. Lucas;
Pilgeram and Lefèvre.

BANKEL F. fl. 1870s.
Mixed.
Gen. / lit.
Aft.: A. Liezen Mayer.
Shared: Johann Bankel (q.v., perhaps a
brother).
Pub.: Fine Art Society; Theodore
Stroeffer.

BANKEL Johann 1837 (Nuremburg)
— 1906.
Mixed.
Gen. / lit. / port.
A pupil of Albert Schultheiss in Paris,
Bankel also studied in Nuremburg.
Aft.: C. Jager, A. Liezen Mayer,
Rubens.
Shared: F. Bankel (q.v., perhaps a
brother).

BANKES H. fl. Bath 1813.
Litho.
Wrote the treatise, *Lithography; or the
Art of making Drawings on Stone* 1813.

BANKS W., and Co. fl. 1850s—90s.
Steel.
Illus.

BARBER J. fl. 1830.
Line.
Land.

BARBER Thomas fl. 1818—46.
Steel.
Illus. / land.
Aft.: T. Allom, W. Brockedon,
H. Gastineau, S. Prout, T.H. Shepherd,
Tombleson.

BARCLAY Edgar 1842—after 1893.
Et.
Gen.
Barclay, who was also a noted
landscape painter, studied under
Schnorr at Dresden, and in Rome. He
worked at Hampstead and
Christchurch, Hants. He was much
influenced by J.F. Millet.
Pub.: T. McLean.

BARCLAY BROS. fl. London 1890s.
Pub.
Photo-eng.

BARENGER M.S. fl. London
1818—31.
Steel.
Land.

BARKER Anthony Raine 1880—
1963.
Et., line., litho.
Gen. / land.

BARKER Henry Aston 1774
(Glasgow) — 1856 (Bilton, nr Bristol).
Line.
Panor.
A son of the Irish parorama painter,
Robert Barker (1739—1806), Barker
was a pupil at the R.A. Schools and a
friend of J.M.W. Turner and Sir Robert
Ker Porter (qq.v.). He also painted
paroramas.

BARKER J. fl. 1840s.
Steel.
Illus.

BARKER Thomas, of Bath 1769
(Pontypool) — 1847 (Bath).
Litho.
Fig. / hist. / land.
Barker is known mainly as a painter, in
which his work was much influenced
by Dutch and Italian painters. He was
also a successful portrait painter.
Pub.: Philip André; J. Heath.

BARLOW Thomas Oldham, R.A.
1824 (Oldham) — 1889 (Kensington).
Et., line., mezzo., mixed., steel.
Gen. / hist. / lit. / port. / sport. / topog.
A son of an Oldham ironmonger,
Barlow was educated at the Old
Grammar School in that town. He was
articled to a Manchester firm of
commercial engravers, Stephenson and
Royston, and after studying at the
Manchester School of Design, he
moved to London in 1847. He was
elected a member of the Etching Club
and for a time was its secretary; he
became director of the etching class at
South Kensington.

His best known works include a
portrait of Charles Dickens at his
writing table after W.P. Frith and
"The Death of Chatterton" after
H. Wallis.

Aft.: R. Ansdell, J. Barrett, C. Baxter,
H. Calvert, T. Crane, G. Doré,
C.A. Duval, W.P. Frith, Blanche
Jenkins, Sir G. Kneller, J.P. Knight,
Sir E. Landseer, R. Lehmann,
D. Maclise, Sir J.E. Millais, J. Phillip,
G. Richmond, J.E. Robertson, J. Sant,
F.W. Topham, J.M.W. Turner,
H. Wallis, P. Westcott.
Pub.: T. Agnew; H. Blair Ansdell;
Owen Bailey; Fine Art Society;
Gambart; H. Graves; Lloyd Bros.;
A. Lucas; T. McLean; J. McQueen;
Moore, McLean and Co.; Edward
S. Palmer; Pilgeram and Lefèvre;
E.F. White.
Lit.: Engen R.K. *Victorian Engravings*
1975.

BARNARD William S. *c.* 1774—
1849.
Mezzo.
All. / an. / gen. / land. / port. / relig.
Barnard was keeper of the British
Institution for many years.
Aft.: L.F. Abbott, W.R. Bigg,
R. Cosway, S. Drummond,
Gainsborough, H. Howard, J. Keenan,
B. Marshall, G. Morland, Page,
R.K. Porter, F. Wheatley,
D. Wolstenholme.
Shared: C. Turner (q.v.).

BARRALET (or BARALET or
BAROLET), John James 1747
(Dublin) — 1815 (Philadelphia).
Line.
Gen. / myth.
Barralet emigrated to U.S.A. and
settled in Philadelphia. He was also a
watercolourist.

BARRAUD Allan F. fl. Watford
1872—93.
Et.
Gen. / land.

BARRAUD Henry (formerly W. and
H. Barraud) fl. London 1840s—50s.
Pub.
The name of the firm was changed to
Henry Barraud in 1850.

BARRET (or BARRETT) Charles
Robert fl. 1890.
Et.
Land. / topog.

BARROW W.H. fl. Hastings late
19th *c.*
Et.
Marine.
Best known as a marine painter.

BARTH C. 1782 (Enfield) — 1853
(Cassel).
Line.
Topog.
Pupil of J.E. von Müller, noted for
plates of overseas towns including
Philadelphia and Quebec.

BARTOLOZZI Francesco 1725 or 1728 (Florence) — 1815 (Lisbon).
Et., Line., stip.
All. / ex libris / gen. / hist. / land. / lit. / myth. / port. / relig. / sport. / topog.
Bartolozzi was one of the most important and influential figures in the history of engraving. A son of a goldsmith of Florence, he became a student of the Florentine Academy under Ignazio Hugford, a minor historical painter. He was taught engraving by Joseph Wagner at Venice. Afterwards he went to Rome where he established his reputation.

He came to London in 1764 at the invitation of King George III's librarian, and engraved many works in the royal collection, including *Imitations of Original Drawings by Hans Holbein* (1792—1800) a series of drawings of members of the court of King Henry VIII.

Bartolozzi employed fifty pupils and assistants in his London studio, which became a kind of manufactory. Many plates were worked on by assistants under his instructions, while he added any necessary finishing touches. Most stipple engravers of the period were either pupils or came under his influence. He was father of G.S. Bartolozzi (q.v.).

When Bartolozzi retired he was succeeded by G. Vendramini (q.v.).
Aft.: Albano, J. Alexander, Appiani, Barker, T.T. Barralet, Lady Diana Beauclerk, J.H. Benwell, M. Browne, H. Bunbury, A. Carracci, Cipriani, J.S. Copley, Correggio, Maria Cosway, R. Cosway, Coypel, T. Downman, G. Dupont, H. Fuseli, Gainsborough, C. Gauffico, J. Guarana, Guercino, W. Hamilton, Holbein, H. Hone, Hoppner, Howes, Angelica Kauffmann, Sir T. Lawrence, Sir P. Lely, B. Luti, W. Martin, Minasi, G. Morland, Duchess of Montrose, J. Nixon, Opie, Pellegrini, Rev. M.W. Peters, Ramberg, R. Rebecca, Reynolds, Rigaud, G. Romney, A. Roslin, J. Russell, J.R. Smith, Countess Spencer, P.W. Tomkins, H. Tresham, Violet, R. Walker, B. West, R. Westall, F. Wheatley, Zocchi.
Des. eng.: G. and H. Minasi (q.v.).

Assist.: W.N. Gardiner (q.v.).
Pup.: M. Benedetti, M. Bovi, T. Cheesman, R.H. Cromek, J.M. Delâtre, T. Fielding, C. Knight, C.M. Metz, H. Meyer, J. Ogborne, B. Pastorini, J.H. Ramberg, E. Scott, R. Shipster, H. Sintzenith, A. Smith, B. Smith, J. Summerfield, C. Taylor, P.W. Tomkins, G. Vendramini and perhaps E. Scriven (qq.v.).
Shared: S. Alken, W. Byrne, J. Fittler, W.N. Gardiner, C. Knight, B. Pastorini (qq.v.).
Pub.: M. Bovi; Boydell; Dickinson; J. Jeffrys; S. Roma.
Lit.: Brinton S. *Bartolozzi and his Pupils in England: with an Abridged List of the more Important Prints in Line and Stipple* 1904. Hind A. *Bartolozzi, and other Stipple Engravers working in England at the End of the Eighteenth Century* 1912. *P.C.Q.* XIV, pp. 137—62.

BARTOLOZZI, Gaetano Stephen 1757 (Rome — 1821 (London).
Printseller, stip.
Fig. / illus. / port.
Son of Francesco Bartolozzi (q.v.), Gaetano was the father of Mme. Vestris the actress. His interests were in music rather than in his profession, and he got into difficulties and was forced to sell his entire stock at Christie's auction rooms in 1797. Afterwards he went to Paris, where he opened an academy of music and fencing, but despite some initial success it failed and Bartolozzi became impoverished.
Aft.: A. Carracci, R. Cosway.

BARWELL F. fl. Norwich (?) 1858—62.
Et.
Gen.

BASIRE James (II) 1769—1822 (Chigwell Wells).
Line.
Antiq. / arch.
Son of James Basire I (1730—1802), engraver to the Royal Society and to the Society of Antiquaries, and the engraver to whom William Blake (q.v.) was articled. James Basire II was in turn appointed engraver to the Society

of Antiquaries. It is almost impossible to distinguish the work of members of the Basire family from one another. Pup.: J. Parker (q.v.).

BASIRE James (III) 1796—1869.
Line.
Antiq. / arch.
Son of James Basire II. He worked much for the Society of Antiquaries.

BASKETT Charles Henry A.R.A.
1872 (Colchester) — 1953.
Aq., et.
Land. / ship. / topog.
Lit.: *Print Connoisseur* IV, p. 325.

BASTIN J. fl. 1840s—60s.
Wood.
Illus.
Aft.: E. Corbould, H.C. Selous, J. Tenniel.

BATE J. — See BUCK Adam.

BATE John fl. mid 19th c.
Inventor of the "Anaglytograph" mechanical engraving process. In this the engraving was carried out on a machine, the lines attempting to reproduce relief in subjects such as reliefs, medals and coins.

BATE M.A. fl. late 18th—early 19th c.
Et., stip.
Gen.
Shared: G. Garrard (q.v.)

BATEMAN E.L. fl. 1840s.
Litho.
Flor. / illus.

BATEMAN William 1806 (Chester) — 1833 (Shrewsbury).
Line.
Arch. / topog.

BATLEY Henry William b. 1846.
Et.
Arch. / gen. / land. / port.
Lived and worked in Putney.
Aft.: F. Bramley, H. Gandy, G.G. Kilburne, A. Lemon, G.F. Wetherbee.
Pub.: Belgravia Fine Arts Co.; C.E. Clifford; C. Klackner; E.E. Leggatt.

BATTEN John Dickinson 1860—1932.
Wood.
All.
Noted for coloured woodcuts much influenced by Japanese prints.

BATTERSHALL John R. fl. 1870s.
Wood.
Illus.

BATTY Robert 1789 (London) — 1848.
Et.
Land. / mil.
Batty started life in medicine, but abandoned it for a military career, taking part in the Peninsular campaign. Most of his military subjects are based on his own experiences.

BAUER Job fl. 1880s.
Steel.
Fig. / illus.
Aft.: H.A. Bone, Richter.

BAUERLE or BOWERLEY Amelia d. 1916.
Et.
Myth.
Also a watercolourist.

BAUGNIET Charles 1814—86.
Litho.
Gen. / port.
Belgian national who worked for a time in London. He also worked in Sèvres.
Aft.: F. Winterhalter.
Pub.: Ackermann and Co.; Duff and Hodgson; Gambart; Hering and Remington; J. Hogarth; W.H. Mason (Brighton).

BAUMER Lewis C. 1870—1963.
Et.
Fig.

BAWTREE J.S. fl. from 1831.
BAWTREE William fl. 1821—31.
Line., print.
Two brothers who were engravers and printers to the Bank of England. J.S. Bawtree succeeded William in 1831.

BAXTER George 1814 (Lewes) —
1867 (Forest Hill).
Pub., wood.
*All. / arch. / ephem. / hist. / illus. /
land. / lit. / mil.*
Sons of a Lewes printer and publisher,
John Baxter (1781—1858), George
Baxter was the inventor of a special
method of printing in oil colours,
which he patented about 1835. The
method, which was not altogether
original, having been used by other
printmakers during the 18th century,
consisted of building up a print colour
by colour from wood blocks
superimposed on an engraved
foundation plate. Baxter also issued,
by subscription, monochrome prints
called "Baxterotypes", which were
intended to rival daguerreotypes.

The process was licensed to various
other publishers, including Le Blond
and Co., Bradshaw and Blacklock;
Dickes, Grant, Kronheim and Co.;
George Baxter, Jr.; Mansell (qq.v.).
See also Mockler who acquired Baxter's
plates from Le Blond in 1888.

Baxter's large prints include his
masterpiece "Dogs of St. Bernard"
after Sir Edwin Landseer. It was
printed from fourteen blocks and
measures 17 by 24 ins.
Aft.: V. Bartholomew, F.J. Baynes,
T. Brooks, J. Burgess, J. Collinson,
E.H. Corbould, T. Creswick,
J. Fitzgerald, C. Hunt, W.E. Jones,
G. Lance, Sir E. Landseer, J. MacLeod,
K. Meadows, J. Partridge, J. Stewart.
Lit.: Courtney Lewis C.T. *George
Baxter; his Life and Work* 1908, *The
Picture Printer of the 19th c., George
Baxter* 1911, *The Le Blond Book*
1919, and *The Baxter Book* 1919.
Mitzman M.E. *George Baxter and the
Baxter Prints* 1978.

BAYES Alfred Walter 1831
(Todmorden) — 1909.
Et.
Arch. / gen. / land. / port. /topog.

BAYNES Thomas Mann 1794—1854.
Litho.
Land.
Baynes was also a painter.

BEAN Richard ?1792—1817
(Hastings).
Line.
Anat. / port.
Studied in Paris under Guérin.

BEAUMONT Jules fl. late 19th—
early 20th c.
Et.
Gen. / hist. / land. / topog.
Aft.: W.C. Piguenit, Richard
C. Woodville.
Pub.: H. Graves.

BECKER F.P. fl. 1830s—40s.
Print., steel.
Illus.
Inventor of "Mr. Becker's process" of
steel engraving.
Shared: C.G. Lewis (q.v.).

BEEFORTH and FAIRLESS
(formerly G.L. Beeforth) fl. 1760s—
1870s.
Pub.

BECKWITH Henry fl. London mid—
late 19th c.
Line., steel.
An. / illus. / land.
Beckwith spent a year in New York in
1842.
Aft.: Sir E. Landseer.

BECKWITH J.H. fl. 1840s.
Steel.
Orn.

BECKWITH W. fl. 1843.
Steel.
Heraldry

BEDFORD C. fl. 1820s.
Steel.
Illus. / land.
Aft.: G. Shepherd.

BEDFORD Francis fl. *c.* 1850s—60s.
Litho.
Illus. / still life.

BEDFORD Georgina Duchess of
Et. (amateur)
Pupil of Sir E. Landseer (q.v.)
Pub.: H. Graves.

127

BEHREND Arthur Coleman b. 1863.
Et.
Gen.
Aft.: Alexander Rossi
Pub.: L.H. Lefèvre.

BEILBY Ralph 1744 (Durham) —
1817 (Newcastle-on-Tyne).
Line.
Ephem. / illus.
Ralph Beilby was a son of William
Beilby, a goldsmith who moved to
Newcastle from Durham because of
lack of success in that city. Ralph
worked for his father as a seal and
silver-plate engraver; he also became a
copper-engraver, there being then no
such engravers in the north of England.
 Thomas Bewick (q.v.) was
apprenticed to Beilby in 1767, and
became his partner ten years later. The
partnership was dissolved in 1797,
when Bewick became sole proprietor.
 Beilby was also a musician and a
writer (he wrote parts of Bewick's
History of Quadrupeds and *History
of British Birds*) and was interested in
science.

BEKEN A. fl. mid (?) 19th c.
Line.
Beken was a pupil at the School of
Engraving at South Kensington.

BELCHER George 1875—1947.
Aq., etc.
Caric / port.
Lit.: *Studio* LXXXVI, p. 41.

BELGRAVIA FINE ARTS Co.
fl. London 1840s.
Pub.

BELL A. fl. second half of 19th c.
Wood.
Illus.

BELL Alfred fl. London 1890s—
20th c.
Pub.
Publications included photo-eng.

BELL Sir Charles 1774 (Edinburgh)
— 1842 (Hallow Park, Worcester).
Et. (amateur).
Land.
Also painted landscapes.

BELL Edward fl. 1795—1810.
Et., mezzo.
Gen. / port. / sport.
Aft.: Sir W. Beechey, J.W. Chandler,
J. Hoppner, G. Morland, J. Paul Jr.,
H. Singleton, W. Westall.
Also a painter.
Lit.: Wilder W.L. *English Sporting
Prints* 1974.

BELL John 1811 (Hopton,
Suffolk) — 1895 (Kensington).
Et.
Gen. / lit. / port.
Bell, who is best known as a sculptor,
studied at the R.A. Schools. He
contributed sculpture to the Albert
Memorial.

BELL John Monro fl. 1883.
Et.
Topog.

BELL Robert Anning b. 1863.
Et.
Gen. / relig.
Bell, who was also a painter and
designer, studied under Aimé Morot
in Paris and under Sir George
Frampton in London.
Aft.: Rembrandt.

BELL, Robert Charles 1806
(Edinburgh) — 1872 (Edinburgh).
Line., mezzo., steel.
Gen. / illus. / land. / lit. / mil. / port.
Bell served his apprenticeship with John
Beugho (q.v.) at the Trustees Academy,
Edinburgh. He was father of Robert P.
Bell, the genre painter. He assisted W.
Miller (q.v.) on several occasions.
Aft.: Sir W. Allan, W. Etty, J. Faed, T.
Faed, J.R. Fairman, A. Fraser, J.G.
Gilbert, J. Graham, Sir G. Harvey, J.E.
Lauder, C.R. Leslie, W. Martin, Mieris,
W. Mulready, E. Nichol. Sir J.N. Paton,
A. Richardson, Sir D. Wilkie, H. Wyatt.
Pup.: F. Croll (q.v.).
Pub.: Art Union of London; Royal
Scottish Association; P. Salmon
(Glasgow); W.H. Vannan (Edinburgh).

BELLIN Samuel 1799 (London) —
1893 (London).
Et., line., mezzo., mixed., steel.
*All. / gen. / hist. / lit. / myth. / port. /
relig. / topog.*

A pupil of James Basire II (q.v.), Bellin went to study in Rome in 1828. He returned to England about 1834. He retired in 1870.
Aft.: R. Ansdell, C. Baxter, J. Barrett, J. Bridge, T. Brooks, R. Buckner, R. Carrick, M. Claxton, H.C. Corbould, Sir C.L. Eastlake, A. Egg, W. Fisk, A. Geddes, R. Hannah, J.R. Herbert, S. Hodges, J.C. Horsley, W.H. Hunt, J. Lucas, C. Lucy, T.H. Maguire, O. Oakley, Opie, W. Percy, J. Phillip, G. Richmond, D. Roberts, T. Roberts, J. Sant, H.C. Selous, Sarah Setchell, G. Smith, F. Stone, E.M. Ward, R.W. Weir, P. Westcott, F. Winterhalter.
Shared: S. Cousins, W.H. Simmons (qq.v.).
Pub.: T. Agnew; Art Union of Glasgow; T. Boys; B. Brooks; P. and D. Colnaghi; Gambart; H. Graves; Lloyd Bros.; T. McLean; Moore, McQueen and Co.; F.G. Moon; Williams, Stevens and Williams.

BENDIXON S. fl. mid 19th c.
Litho.
Relig.
Pub.: Thomas Varty.

BENEDETTI Michele 1745 (Viterbe) — 1810 (Vienna).
Line., stip.
Gen. / illus. / myth. / port. / relig.
Italian national who spent much of his life in England. He studied under F. Bartolozzi (q.v.).
Aft.: Domenichino, H. Fuseli, G. Reni, Reynolds, H. Singleton.
Pub.: Macklin.

BENEWORTH — fl. first half of 19th c.
Wood.
Illus.

BENJAMIN E. fl. 1830s—40s.
Steel.
Illus. / land.
Aft.: Allom, W.H. Bartlett, C. Bentley, F. Hervé, H. Melville.

BENNETT William James 1787 (London) — 1830 (New York).
Aq., et.

Gen. / hist. / illus. / land. / ship. / sport. / topog.
Also known as a watercolourist, Bennett was a pupil of R. Westall. He worked in London, Rome and other important European cities, and later emigrated to U.S.A. He is noted especially for his American topographical views.
Aft.: N. Calyot, J.G. Chapman, G. Cook, W. Cooke, H. De la Motte, G. Holmes, J.C. Miller, J.C. Schatky, J. Townshend, C. Waldegrave, W. Walker, W. Westall.
Pub.: L.P. Clover.

BENTLEY Alfred 1879—1923.
Et.
Gen. / land.
Lit.: *Book Journal* VII, p. 186.

BENTLEY Charles 1806 (London) — 1854.
Aq., mixed., steel.
Illus. / land. / topog.
Bentley studied under the engraver T.H.A. Fielding (q.v.), and is best known as a marine painter. Work by J.C. Bentley (q.v.) has sometimes been wrongly attributed to him.
Aft.: J.P. Cockburn.
Des. eng.: J.C. Bentley (q.v.).

BENTLEY Joseph Clayton 1809 (Bradford, Yorks.) — 1851 (Sydenham).
Aq., line., steel.
Fig. / gen. / illus. / land. / port. / sport.
Bentley started out as a landscape painter, but in 1832 began to study engraving in London under R. Brandard (q.v.). After this most of his time was devoted to engraving, but he still continued to paint. He died of tuberculosis.
Aft.: H. Alken, T. Allom, W.H. Bartlett, C. Bentley, Sir A.W. Callcott, J. Constable, T. Creswick, A. Cuyp, Gainsborough, J. Linnell, J. Pollard, J. Salmon, J.M.W. Turner, R. Wilson, F. Zuccarelli.
Pub.: Fisher; Fores; S. and J. Fuller; Virtue.
Lit.: *Art Journal* 1851, p. 280; 1852, p. 15.

BERKELEY Stanley 1840—1909.
Et.
An. / hist. / sport. / topog.
Berkeley, who worked in London and
Esher, was the husband of Edith
Berkeley, landscape and genre painter.
Pub.: A. Lucas.

BERLIN PHOTOGRAPHIC
COMPANY fl. Berlin 1890s.
Printers of engravings and photo-
engravings. The firm made plates for
many London publishers, including
T. Agnew; P. and D. Colnaghi; Fine
Art Society; Frost and Reed; Stephen
T. Gooden; H. Graves; Harris and Sons;
Mawson, Morgan and Swan; A. Tooth.

BERRYMAN — fl. early 19th c.
Wood.
Ephem. / illus.

BERTHER — fl. 1870.
Steel.
Fig. / illus.
Aft.: C.I. Jalabert.

BERTHOUD Henry *c.* 1790
(London) — 1864 (Paris).
Et., mezzo.

BERTINOT J. fl. Paris 1880s.
Line.
Lit.
Pub.: A. Lucas.

BERTRAND C. fl. 1870s.
Steel.
Illus. / land.
Aft.: C. Werner.

BEST Edward S. 1826 (London) —
1865 (Philadelphia).
Line.
Hist.
Settled in U.S.A. in 1850.

BEST J.A.R. fl. 1828—40.
Line.
Land. / port. / topog.
Aft.: A. van der Velde.

BETTS Edwin Maurice b.
Hillmorton, d. Rugby 1885.
Et. (?)
Betts studied at Leicester College of
Art, and became art teacher at

Nottingham High School. He was also
a painter.

BEUGHO (or BEUGO) 1759
(Edinburgh) — 1841.
Line.
Port.
A friend of Robert Burns (whose
portrait he engraved), Beugho taught
at the Trustees Academy, Edinburgh.
Aft.: A. Nasmyth, Raeburn,
J. Reynolds.
Pup.: R.C. Bell (q.v.)

BEVAN Robert 1865—1925.
Et., litho.
An. / land. / topog.
Also a painter, Bevan worked in
Sussex.
Lit.: Dry G. *Robert Bevan 1865—1925:
Catalogue Raisonné* 1968.

BEWICK John 1760 (Cherryburn) —
1795 (Ovingham).
Wood.
Illus.
Younger brother of Thomas Bewick
(q.v.) to whom he was apprenticed.
After serving his time he came to
London, where he practised and
taught wood-engraving.
Pup.: R.T. Austin (q.v.)
Lit.: de Maré E. *The Victorian
Woodblock Illustrators* 1980.
Dobson A. *Thomas Bewick and his
Pupils* 1884.

BEWICK Robert Elliot 1788—1849
(Ovingham).
Pub., wood.
Illus.
The only son of Thomas Bewick (q.v.),
Robert worked in his father's business
and in 1812 became his partner. He
did little engraving beyond a few for
the unfinished work *British Fishes*, for
which he is said to have made the
coloured drawings and prepared some
descriptive text. He was, however,
mainly a publisher.

BEWICK Thomas 1753
(Cherryburn) — 1828 (Gateshead).
Et., wood.
*An. / ex libris / gen. / heraldry /
illus. / land. / port. (silhouettes).*
Thomas Bewick is one of the key

figures in the history of wood-engraving. A son of a small farmer, he was educated at a local school at Mickley. He showed early promise as a draughtsman, and in 1767 was apprenticed to Ralph Beilby (q.v.), a Newcastle engraver; he became Beilby's partner ten years later. The partnership was dissolved in 1797, when Bewick became the sole proprietor.

Bewick more than anybody was responsible for the revival of wood-engraving in Britain, a revival that was continued by his many pupils.

He is said to have etched some plates for Matthew Consett's *Tour through Sweden, Swedish Lapland, Finland and Denmark.*

Bewick was the elder brother of J. Bewick and father of R.E. Bewick (qq.v.).
Aft.: R. Johnson.
Pup.: J. Allanson, J. Anderson, J. Bewick, R.E. Bewick, L. Clennell, H. Hole, J. Jackson, J. Johnson, R. Johnson, M. Lambert, E. Landells, C. Nesbitt, I. Nicholson, J. Reiveley, W.W. Temple, C. Thompson, H. White, E. Willis.
Lit.: Bain I. *The Watercolours and Drawings of Thomas Bewick and his Workshop Apprentices* 1981. *Thomas Bewick an Illustrated Record of his Life and Work* 1979. Bewick Thomas *A Memoir written by Himself* 1862; new ed. edited by Iain Bain, 1975. de Maré E. *The Victorian Woodblock Illustrators* 1980. Dobson A. *Thomas Bewick and his Pupils* 1884. Stone R. *Wood Engravings of Thomas Bewick* 1953. Weekley M. *Thomas Bewick* 1953.

BIDDLE G. and Sons fl. early 20th c.
Pub.
Et.

BIGLAND Percy 1856—93 or later.
Mezzo.
Port.
Worked in London and Liverpool.
Pub.: Fine Art Society.

BILLING Martin fl. Birmingham 1840s.
Litho., wood.
Ephem.

A firm which initiated the use of decorative wrapping, labels, packages etc.

BILLINGS Robert William fl. 1830s—40s.
Steel.
Arch. / illus.

BINGLEY James fl. 1830s.
Steel.
Illus. / land.
Aft.: G.B. Campion, T.H. Williams.

BIRCH S.J. Lamorna R.A. 1869—1955.
Et.
Land.
Birch, a noted landscape painter, made only three etchings, two of which are said to have been made for Christmas cards.

BIRCH William Russel 1755 (Warwick, New York) — 1834 (Philadelphia).
Et., line.
Arch. / topog.
Birch came to London about 1775, and practised there until 1794, when he returned to U.S.A. and settled in Philadelphia. A few years before, in 1785, he had received a medal from the Society of Arts. He was also an enamel painter.

BIRCHE Henry fl. late 18th—early 19th c.
Mezzo.
Gen. / sport.
Birche did not sign his plates and they are sometimes attributed in error to Richard Earlom (q.v.). One or two plates signed with his name have, however, been accepted as Earlom's work.
Aft.: A. Green, G. Stubbs.
Pub.: Boydell.

BIRD Charles Brooke 1856—c. 1905.
Et., mezzo.
Arch. / ex libris / fig. / gen. / port. / topog.
Worked extensively on bookplates for Messrs. Bumpus.
Aft.: F. Boucher, Gainsborough,

131

Greuze, Holbein, Leonardo, Raphael, Rembrandt, J. Syer, Velasquez.
Pub.: Frost and Reed; C. Klackner; A. Lucas; Mawson, Swan and Morgan; Scott and Sons; W. Weaver; J.T. White.

BISHOP J. fl. 1840s—50s.
Steel.
Illus. / land.
Aft.: G. Cattermole, W. Tombleson.

BISHOP T. fl. 1830s.
Steel.
Illus. / land.
Aft.: W. Tombleson

BISHOP and CO. fl. London (Houndsditch) *c.* 1870.
Pub.
Juv. dram.
Succeeded by S. Marks and Sons (q.v.).

BISSET James 1760—1832 (Leamington).
Line.
Topog.
Bisset was a poet and miniaturist as well as an engraver, and was practising as a miniaturist at Newmarket in 1785. At the beginning of the 19th century he was living at Birmingham, where he also kept a museum. He wrote a prose and verse *Guide to Leamington* (1814).

BLADES, EAST and BLADES fl. London from 1883.
Security printers.
Stamps.

BLACK I. fl. 1840s.
Steel.
Illus. / land.
Aft.: W. Tombleson.

BLAIR D. fl. 1970s—80s.
Litho.
Flor. / illus.

BLAKE Robert fl. 1833.
Et.
Land. / topog.
Aft.: J. Callot.

BLAKE William 1757 (London) — 1827 (London).
Et., line., litho., mixed., monotype, stip., wood.

All. / caric. / ephem. / gen. / hist. / hum. / illus. / lit. / myth. / port. / relig. / sculp.
One of the most important figures in 18th and 19th century British art, William Blake was apprenticed to the line-engraver J. Basire I (1739—1802). He earned his living as a reproductive engraver working in many techniques, but his more original work, most of it visionary, was expressed both in traditional techniques and in experimental processes invented or developed by himself. These include among others, relief etching (in which the regular etching process is reversed, the lines of the design being left standing while the background is etched away) and woodcutting on pewter, in which the wood-engraving technique is used on a metal surface instead of on boxwood. Blake also worked in various painting techniques besides being one of the most important poets in the English tradition.
Aft.: R. Blake, C. Borkhardt, D.N. Chodowiecki, S. Collings, R. Cosway, G. Cumberland, X. Della Rosa, J. Donaldson, P.H. Dunker, J. Earle, J. Flaxman, M. Flaxman, H. Fuseli, T. Hayley, D. Heins, W. Hogarth, King, Sir T. Lawrence, J. Linnell, J. Meheux, C.M. Metz, Michelangelo, G. Morland, W. Pars, T. Phillips, I. Ponsford, Raphael, Reynolds, G. Romney, Rubens, Ruchotte, C.R. Ryley, J. Shackleton, J.G. Stedman, F. Stone, T. Stothard, H. Villiers, Watteau.
Des. Eng.: T. Butts, J. Byfield, R.H. Cromek, P. Jones, R.J. Lane, J. Linnell, W. Lowry, L. Schiavonetti (qq.v), Normand fils, Perry.
Pup.: T. Butts (q.v.).
Shared: T. Butts, J. Linnell, W. Lowry and possibly G. Maile (qq.v.).
Pub.: Audot (Paris); Barker; I. Barrow; J. Bell; T. Bellamy; Blake and Parker; C. Borckhardt; J. and J. Boydell; J. Buckland; Button, Whitaker & Co.; Cadell and Davies; J. Cooke; R.H. Cromek; R. Edwards; R.H. Evans; J. Fentum; J. Fielding; Fielding and Walker; R. Gough; G. Hadfield; G. Hamilton; Harrison and Co.; J. Hoole; Humphry; Hurst, Robinson;

J. Johnson; J. Linnell; Longman;
T. Macklin; W. Miller; Moore and Co.;
J. Murray; F. Newberry; T. Payne;
A.A. Paris; R. Phillips; I. Poole;
F. Rivington; Robinson, Egerton;
J. Robson; J. Seagrave; J.R. Smith;
Widow Spicer; J. Stockdale;
J. Thornton; A. Tilt; J. Varley;
J. Wedgwood; G. Wilkie; G. and
T. Wilkie; W. Wilson.
Lit.: Bentley G.E. Jr. *Blake Records*
1969. Essick Robert N. *William Blake*
Printmaker 1980. *William Blake's*
Relief Inventions 1978. *The Separate*
Plates of William Blake 1983. Gilchrist
A. *Life of William Blake* 1863 and
subsequent edns., including that
edited by R. Todd, 1945. Keynes
Sir G. *Blake Studies* 1949; new ed.
1971. *Engravings by William Blake.*
The Separate Plates 1956. *William*
Blake: Poet — Printer — Prophet 1964.
Lister R. *Infernal Methods: A Study*
of William Blake's Art Techniques
1975. Russell A.G.B. *The Engravings*
of William Blake 1912; repr. 1968.
Wilton Andrew and others *The Wood*
Engravings of William Blake 1977.

BLANCHARD Auguste Thomas Marie
1819 (Paris) — 1898 (Paris).
Line.
Gen. / hist. / myth. / port. / relig.
French national who engraved much
work after British artists and worked
for British publishers.
Aft.: Sir L. Alma-Tadema, W.P. Frith,
W. Holman Hunt, D. Maclise,
J. Phillip.
Pub.: Gambart; L.H. Lefèvre;
T. McLean; Pilgeram and Lefèvre.

BLANCHARD W.C. fl. 1860.
Wood.
Illus.
Aft.: H.C. Selous.

BLARE E. fl. early 19th c.
Litho.

BLAYLOCK Thomas Todd b.
Langhalm, Dumfries, 1876.
Et., wood.
Also a painter in oil and pastel,
Blaylock made some interesting
coloured wood-engravings.

BLECHINGER and **LEYKAUF** fl.
1890s—early 20th c.
Print., pub.
Photo-eng.

BLINKS Thomas 1860 (Maidstone)
— 1912.
Et.
Sport.
Worked in London, and better known
as a painter of sporting subjects.
Pub.: A. Tooth.

BLOOD T. or J. fl. London 1814—
23.
Stip.
Gen. / illus.
Aft.: S. Drummond, Russel, Sharp.

BLUCK J. fl. London late 18th—
early 19th c.
Aq.
Arch. / illus. / land. / marine. / ship. / topog.
Also noted as a landscape painter.
Aft.: Butler, Sir N.D. Holland,
J. Paine, R. Parker, R. Pocock,
A.C. Pugin, P. Reinagle, T. Rowlandson,
T.H. Shepherd, P.W. Tomkins,
J.W. Upham, E. Walsh.
Shared: W. Nicholls (q.v.).
Pub.: Ackermann.

BLUNT Miss S.A. b. 1880.
Et.

BOBBETT Alfred fl. 1840s—80s.
Wood.
Illus.
Bobbett worked mainly in U.S.A.

BOEHM Wolfgang fl. London
1850—63.
Line (?)
Gen. / port.
Also a painter.

BOILVIN Émile 1845 (Metz) —
1899 (Paris).
Et.
Gen. / hist. / lit.
French national, pupil of Pils, who
engraved plates after the work of some
British artists and whose engravings
were published by London distributors.
Aft.: Sir E. Burne-Jones.
Pub.: Boussod, Valadon and Co.;
T. McLean; A. Tooth.
Lit.: Engen R.K. *Victorian Engravings*
1975.

BOLTON Thomas fl. 1856.
Wood.
Illus. / sculp.
Bolton was one of the first engravers
to work successfully from a
photographic impression on the
woodblock.
Aft.: J. Absolon, T. Flaxman,
S. Palmer.

BOND H.W. fl. 1820s—40s.
Steel.
Arch. / illus. / land.

BOND T. fl. 1850.
Steel.
Illus. / land.
Aft.: T.H. Shepherd.

BONE Sir Muirhead 1876 (Glasgow)
— 1953 (Oxford).
Et., dry., litho.
Arch. / ex libris / port. / ship. / topog.
The son of a journalist, Bone studied
under Archibald Kay at Glasgow
School of Art. After unsuccessfully
endeavouring to set up as an art
teacher at Ayr, he moved to London
in 1901. His work is notable for its
accuracy of reporting. He travelled
abroad and for a time lived in Italy
and Spain.
Lit.: Arts Council *Drawings and Dry
Points by Sir Muirhead Bone* 1955.
Dodgson Campbell *Etchings and
Drypoints by Muirhead Bone I.
1898—1907* 1909. *Kunstwelt* 1912,
p. 383. *P.C.Q.* IX, pp. 173, 190.

BONINGTON Richard Parkes 1802
(Arnold, Nottingham) — 1828
(London).
Et., litho.
Arch. / illus. / topog.
Known mainly as a painter, Bonington
etched only one plate, a view of
Bologna, although he probably made
half-a-dozen trials in soft-ground
etching. His lithographs are more
numerous.
Pup.: T.S. Boys (q.v.).
Lit.: Bouvenne A. *Catalogue de l'oeuvre
gravé et lithographié de Richard Parkes
Bonington* 1873. Curtis A. *Catalogue
de l'oeuvre lithographié et gravé de
Richard Parkes Bonington* 1939.
Dubuisson A. and Hughes C.E.
*Richard Parkes Bonington, his Life
and Work* 1924. Hédiard G. *Les
Lithographies de Bonington* 1890.
Spencer Marion *R.P. Bonington
1802—1828* 1965. William Weston
Gallery *Bonington Lithographs*
Catalogue 9, 1976.

BONNAR William 1800 (Edinburgh)
— 1853 (Edinburgh).
Mezzo.
Gen. / hist. / land. / port.
Bonnar was also a painter. He helped
David Roberts with the decoration of
the assembly rooms for the visit of
King George IV to Edinburgh in 1822.

BONNER George Wilmot 1796
(Devizes) — 1836 (London).
Wood.
Illus.
Educated at Bath, Bonner was
apprenticed to a wood-engraver in
London. He was a nephew of
A.R. Branston (q.v.). His work is
notable for its success in using
combinations of a number of blocks to
produce gradations of tint.
Pup.: W.J. Linton (q.v.).
Shared: J. Byfield (q.v.).

BONNER or BONNOR Thomas d.
before 1815.
Aq., line.
Illus. / topog.
Bonnor, who was born in
Gloucestershire, was a pupil of Henry
Roberts (d. before 1790).

BOOSEY and CO. fl. London mid
19th c.
Litho., pub.
Music.

BORGEN A. fl. 1870s.
Pub.

BORROW William H. fl. Kentish
Town, London 1860s—1890s.
Et.
Land. / marine.

BOSHER S. fl. 1835.
Steel.
Illus. / land.

BOUCHER (or BOWCHER) William
Henry 1842—1906.
Et.
Gen.
Boucher is noted especially for his
numerous plates after W. Dendy Sadler.
He worked in London from 1883 until
his death. Late in life he changed his
name to Bowcher.
Aft.: G.J. Pinwell, G. Reid,
W.D. Sadler.
Pub.: Frost and Reid; Lefèvre;
A. Tooth.

BOUGH Samuel 1822 (Carlisle) —
1878 (Edinburgh).
Et.
Land.
Bough was the third child of a
shoemaker, and as a boy followed his
father's trade. Afterwards he was for a
brief period in the office of the town
clerk of Carlisle. But he abandoned
this, becoming a wanderer and an
associate of gypsies, making sketches
in watercolour in which he was self-
taught. In 1845 he became a scene
painter at Manchester, but later
concentrated mainly on landscape
painting.

BOULARD Auguste 1852 (Paris) —
1927.
Et., line.
Gen. / land.
French national who made some plates
after works by British artists, some of
which were published in England.
Aft.: Sir. L. Alma-Tadema,
K. Halswelle, B.W. Leader, Sir J.E.
Millais, D. Murray, J.M.W. Turner.
Pub.: A. Tooth.

BOURNE Herbert 1825—1907.
Line., steel.
*Fig. / gen. / hist. / illus. / lit. / port. /
stamps.*
Bourne's work was much in demand
by various security printers, including
Bradbury, Wilkinson and Co.; Perkins,
Bacon and Co.; Skipper and East;
Waterlow and Sons; Waterlow Bros.
and Layton.
Aft.: W.C.T. Dobson, G. Doré, P. Du
Connick, W.P. Frith, W. Hogarth,
Lord Leighton, P. Mignard, Sir J.E.
Millais, Emily M. Osborn, M. Stone,

Van Dyck, B. West, W.F. Witherington.
Pub.: Fairless and Beeforth.
Lit.: Engen R.K. *Victorian Engravings*
1975.

BOURNE J. fl. 1836.
Steel.
Land.

BOURNE John Cooke fl. mid 19th c.
Litho.
Railways.
Perhaps identical with J. Bourne (q.v.).

BOUSSOD, VALADON and CO. —
See GOUPIL and CO.

BOUTELIÉ Louis 1843 (Paris) —
1914 (Paris).
Line.
Relig.
French national who engraved work
after at least one English artist, and
some of whose work was published in
England.
Aft.: F. Goodall.
Pub.: Boussod, Valadon and Co.;
A. Tooth.

BOUVIER J. fl. 1830s—40s.
Litho.
Theat. (ballet).
Pub.: T. McLean.

BOVI Marino 1760 (Naples) — c.
1821.
Aq., et., stip.
Gen. / lit. / myth. / port. / theat.
An Italian national, Bovi was a pupil
of F. Bartolozzi (q.v.). He worked
mainly in London.
Aft.: F. Bartolozzi, Lady Diana
Beauclerk, H. Bone, H. Caleis,
G.B. Cipriani, R. Cosway, J.L. David,
L. Guttenbrun, D. Pellegrini, C. Read,
Mrs. Ross, Countess Spencer, Titian,
R. Westall, Lady Caroline Wortley.

BOWCHER William Henry — See
BOUCHER William Henry.

BOWDEN, SON and CO. fl. 1880s.
Pub.

BOWER J. fl. 1860.
Steel.
Land.

BOWERLEY Amelia — See
BAUERLE Amelia.

BOWKER James fl. early 19th c.
Line.
Ex libris.
Pub.: J. and J. Neale, Strand, London.

BOWLER Thomas William b. Vale of
Aylesbury early 19th c., d. 1869.
Litho.
Land. / mil. / topog.
Bowler worked as an assistant
astronomer in the observatory at Cape
Town, Cape of Good Hope. Afterwards
he set up as a landscape painter and a
teacher of drawing. He visited
Mauritius in 1866, and afterwards
came to England where he died.

BOWLES Carington fl. early 19th c.
Pub.
All. / gen. / hum.
There were also T. and J. Bowles who
might have been connected.

BOYD and CANNAVAN
Steel
Arch.

BOYDELL Josiah or Joseph 1752
(Hawarden, Flintshire) — 1817
(Halliford, Middlesex).
Mezzo.
Lit. / port. / relig.
Boydell was sent to London early in
life to be placed with his uncle John
Boydell (1719—1804), a publisher and
engraver. He studied painting under
Benjamin West and mezzotint under
Richard Earlom (qq.v.). He lived for
some years at Hampstead, where he
helped to form the Loyal Hampstead
Volunteers, becoming Lieutenant-
Colonel of the corps. In his last years
he lived at Halliford.
Aft.: C. Naratti, Parmigiano,
Rembrandt, Van Dyck.

BOYNE John *c.* 1750 (Co. Down) —
1810 (London).
Line.
Caric. / land.
Boyne was the son of a joiner, who
later became an employee of the
Victualling Office, Deptford. He was
apprenticed to William Byrne (q.v.)

the engraver, but after following this
trade for a time, sold his tools and
joined a band of strolling players. He
left them in 1781, returned to London
and established a drawing school.

BOYS Thomas fl. London (Golden
Square, Soho) 1840s—50s.
Pub.
Topog.
A cousin of Thomas Shotter Boys
(q.v.), whose first lithographs were
published by him. Boys retired from
publishing in 1859, due to financial
difficulties.

BOYS Thomas Shotter 1803
(Pentonville, London) — 1874.
Litho.
Arch. / illus. / land. / topog.
A cousin of the publisher, Thomas
Boys (q.v.), Thomas Shotter Boys
served an apprenticeship under George
Cooke the engraver (q.v.). After
completing his apprenticeship, he
visited Paris and studied under
R.P. Bonington (q.v.), who persuaded
him to devote himself to painting.
Boys visited Brussels in 1830, but
returned to England on the outbreak
of revolution. He again visited Paris,
staying there until 1837. As a token of
appreciation for his work, *Picturesque
Architecture in Paris, Ghent, Antwerp,
Rouen* (1839), King Louis-Phillipe
sent Boys a ring.
 Deceptive copies of some of Boys's
plates were made in the 1920s.
Aft.: D. Roberts, C. Stanfield.
Pub.: Art Union; Thomas Boys;
Hullmandel; Moon, Boys and Graves.
Lit.: Bedford J. *Victorian Prints* 1969.
Roundel J. *Thomas Shotter Boys*
1974. Twyman M. *Lithography,
1800—50* 1970. Victoria and Albert
Museum *Homage to Senefelder* 1971.

BRACQUEMOND Joseph Auguste (or
Félix) 1833 (Paris) — 1914 (Paris).
Et.
Ex libris / land. / port.
French national who made some plates
after works by British artists which
were published in England.
Aft.: R.P. Bonington, A. Solomon,
A. Stevens.
Pub.: Gambart; E. Parsons.

BRADBURY A.A. fl. 1875.
Et.
Antiq. / land.

BRADBURY Henry d. 1860.
Print.
Illus.
Bradbury introduced "nature printing",
into Gt. Britain; in this such things as
ferns or leaves were placed between a
copper plate and a soft lead plate and
passed under great pressure through a
press. They would thus be impressed
on the soft plate from which
electrotypes were taken for printing in
colours. Henry Bradbury produced
Ferns of Great Britain and Ireland by
this method in 1855. He took out a
patent for his own system of nature
printing. Henry Bradbury was the son
of William Bradbury of the printing
firm of Bradbury and Evans. He
committed suicide in 1860.
Lit.: Cave R. and G. Wakeman
Typographia Naturalis 1967.

BRADBURY, WILKINSON and CO.
Firm of London security printers
founded by Henry Bradbury.

BRADLEY John Henry b. Hagley,
Worcs. 1832 or 1834.
Et.
Land.
Bradley was a pupil of David Cox and
James Holland.

BRADLEY Thomas fl. 1805—49.
Line.
Arch. / port.

BRADSHAW G. fl. 1830s.
Steel.
Land.
Aft.: C. Stanfield.

BRADSHAW Samuel fl. 1830s—80s.
Line., steel.
Illus. / land. / topog.
Aft.: T. Allom, W.H. Bartlett,
E.W. Cooke.

BRADSHAW and BLACKLOCK fl.
mid 19th c.
Print., pub.
Licensees of the method of G. Baxter
(q.v.). Baxter prints produced by them
were issued on mounts. About 30 of
the prints were published in *The
Pictorial Casket of Coloured Gems*
(1854), but separate prints were also
produced.

BRADSORD William fl. 1813.
Line.

BRAGG Thomas d. 1840.
Line.
Pupil of W. Sharp.

BRAGGE S. fl. 1870s.
Steel.
Port.
Aft.: G. Kneller.

BRAIN E. fl. 1840s—50s.
Print.

BRAIN John fl. mid 19th c.
Line, steel.
Illus.
Aft.: W.P. Frith.

BRALL Louis and Son. fl. London
(38 Hart St., Bloomsbury) 1880s—90s.
Pub.

BRANDARD E.M. fl. 1880s.
Et.

BRANDARD Edward Paxman
1819—98.
Et., line., steel.
An. / arch. / land.
E.P. Brandard was a brother of J. and
R. Brandard (q.v.). He worked in Islington.
Aft.: J. Constable, A. Hunt,
J. MacWhirter, J. Ramage, J.M.W.
Turner, W.F. Witherington; perhaps
also after photos.
Shared: A. Willmore (q.v.).
Pub.: A. Lucas.

BRANDARD John 1812
(Birmingham) — 1863 (London).
Litho.
*Arch. / gen. / illus. / music. / port. /
theat. (ballet) / topog.*
J. Brandard was a brother of E.P. and
R. Brandard (q.v.). He was one of the
most important lithographers of the
Romantic ballet.
Aft.: J. Absolon, J.W. Child, W. Collins,
J. Thorpe.

137

Pub.: C.C. Claremont; Fores; Jullien; T. Mann; J. Mitchell; T. Ross.
Lit.: Beaumont C.W. and S. Sitwell *The Romantic Ballet in Lithographs of the Time* 1938. Spellman D. and S. *Victorian Music Covers* 1969.

BRANDARD Robert 1803 or 1805 (Birmingham) — 1862 (Kensington).
Et., line., litho., steel.
Gen. / illus. / land. / music. / nat.
R. Brandard studied for a year under E. Goodall (q.v.). He was a brother of E.P. and J. Brandard who were his pupils. He came to London in 1824, and worked in Islington. He was noted for his steel-engraved book illustrations.
Aft.: J. Absolon, Bartlett, W. Brockendon, Sir A.W. Callcott, G. Cattermole, J.F. Herring, J. Martin, S. Prout, D. Roberts, W.C. Stanfield, T. Stothard, J.M.W. Turner, W. Westall.
Pup.: J.C. Bentley (q.v.).
Pub.: Art Union; Lloyd Bros.; D.T. White.
Lit.: Bedford J. *Victorian Prints* 1969. Sitwell S. *Victorian Music Covers* 1969.

BRANDARD W. fl. 1850s.
Steel.
Illus. / land.
Aft.: W. Purser.

BRANGWYN Frank William R.A. 1869 (Bruges) — 1956 (Ditchling).
Et., dry., litho., wood.
Fig. / gen. / land. / topog.
A son of a Welsh architect Brangwyn started his working life in the William Morris workshop in Oxford Street, London, copying Flemish tapestries, but soon took to painting. He took up etching as a relaxation in 1900 and began to practise it seriously in 1903. His plates include views of Venice, Bruges, Paris, Constantinople, London and other cities.
Des. eng.: H.F.W. Ganz (q.v.).
Pup.: A.W. Dow (q.v.).
Lit.: Fine Art Society *Catalogue of the Etched Work of Frank Brangwyn* 1912. Furst H.E.A. *Modern Woodcutters: Frank Brangwyn RA, T. Sturge Moore, Gwendolen Raverat, Edward Wadsworth* 1920. Gaunt W. *Etchings of Frank Brangwyn RA, Catalogue Raisonné* 1926. Salaman M.C. *Frank Brangwyn* (Modern Masters of Etchings Series, No.1) 1924. Shaw-Sparrow W. *Frank Brangwyn and his Work* 1910 and 1915.

BRANNON George fl. mid 19th c.
Line., pub.
Topog.
Noted for views of the Isle of Wight.

BRANNON Phillip fl. *c.* 1950.
Steel.
Illus.
Wrote and illustrated *The Stranger's Guide and Pleasure Visitor's Companion to Southampton* (4th Edn. 1955).

BRANSTON Allen Robert 1778 (King's Lynn) — 1827 (Brampton).
Wood.
Ephem. / illus.
Usually called Robert Branston, this engraver was the son of a line-engraver and heraldic painter, to whom he was apprenticed. He was the brother of F.W. Branston and uncle of G.W. Bonnar (qq.v.). He settled in Bath *c.* 1797 and moved to London in 1799. A rival of Thomas Bewick (q.v.) Branston founded in London a school of wood-engraving comparable with that of Bewick in Newcastle. He was one of the first wood-engravers to make an electrotype.
Aft.: T. Thurston.
Pup.: A.J. Mason, J. and C. Thompson (qq.v.).
Lit.: de Maré E. *The Victorian Woodblock Illustrators* 1980.

BRANSTON Frederick W. fl. early 19th c.
Wood.
Illus.
Brother of A.R. Branston.
Aft.: J. Martin, J. Tenaich.

BRANWHITE Nathan fl. late 18th—early 19th c.
Stip.
Port.
The son of Peregrine Branwhite, a schoolmaster and minor poet, Nathan Branwhite was probably a native of Lavenham, Suffolk. He was a pupil of Isaac Taylor I (1730—1807) and was also a miniature painter.
Aft.: S. Medley.

BRETT Edwin J.　fl. *c.* 1866—80.
Pub.
Juv. drama.
Brett published *The Boys of England*
(founded by Charles Stevens) and other
magazines.

BRETT Henry　fl. 1845.
Steel.
Fig.
Aft.: W. Barclay.

BRETT John　1830—1902 (Putney).
Et.
Relig.
Known mainly as a Preraphaelite
painter, Brett made at least one
etching "Isaac and Jacob," after an
Italian master.

BREWER Henry Charles　b. 1866.
Et. (?)
Brewer attended Westminster Art
School. In 1913 he was awarded a gold
medal by the Society of Arts. He was
also a draughtsman and a painter.

BREWER James Alphège　fl. early
20th c.
Et.
Arch. / land. / topog.
Also a painter.

BREWER Leonard　b. Manchester
1875.
Et. (?)
Also a painter.

BREWER Otto　fl. 1863.
Litho.
Brewer lithographed only one work:
"The £400 match between Tom King
and Jean Mace," 1863. This was based
on about 250 photographs of those
represented. It was published by
George Newbold. Brewer was also a
painter.

BRICE A. and R.　fl. 1840s.
Steel.
Fig. / illus. / land.
Probably brothers.
Aft.: J. Fussell, G. Shepherd.

BRIDGWATER or BRIDGEWATER
Henry Scott　1864—*c.* 1946.
Mezzo.

All. / gen. / land. / lit. / myth. / port.
Aft.: C.B. Barber, A. Courbet,
F. Dicksee, Downman, A. Drummond,
L. Fildes, Greuze, Sir H. Herkomer,
Hoppner, B.W. Leader, Vigée Le Brun,
Lord Leighton, W.H. Margetson,
Sir J.E. Millais, Reynolds, B. Riviere,
G. Romney, J. Sant, H. Schmalz.
Pub.: T. Agnew, Dowdeswell and
Dowdeswells; Fine Art Society;
H. Graves, M. Knoedler; F. Leggatt;
Leggatt Bros.: Mawson, Swan and
Morgan; A. Tooth.

BRIDOUX François Eugène Augustin
1813 (Abbeville) — 1892 (Orsay).
Line.
Relig.
French national who made some plates
after works by British artists and others
which were published in England.
Aft.: Sir C. Eastlake, Murillo,
F. Winterhalter.
Pub.: P. and D. Colnaghi; T. McLean.

BRIGHTWELL Cecilia Lucy　1811
(Thorpe, Norwich) — 1876 (Norwich).
Et.
Fig. / gen. / illus. / land. / marine. /
myth. / relig. / topog.
Cecilia Brightwell was a daughter of a
Nonconformist solicitor who became
mayor of Norwich in 1837, and who
was also a noted naturalist. She was a
pupil of J.S. Cotman (q.v.), but was
largely self-taught. She was also a
writer, mainly for children, but also
wrote a good *Life of Amelia Opie*
(1854).
Aft.: A. Carracci, J.S. Cotman, Dürer,
H. Fuseli, Marcantonio, A. Raimondi,
Raphael, Rembrandt, Ruysdael,
R. Wilson.

BRIGHTY G.M.　fl. 1809—27.
Et.
Port.
Also a painter.
Aft.: G. Shepheard.

BRISCOE Arthur John Trevor　1873
(Birkenhead) — 1943.
Dry., et.
Gen. / marine. / ship.
Briscoe was also a marine painter.
Lit.: *Bookman's Journal* XIII p. 165.
Hurst A.A. *Arthur Briscoe — Marine*

Artist 1978. Laver J. *A Complete Catalogue of the Etchings and Drypoints of Arthur Briscoe* 1930. *P.C.Q.* XXV, pp. 284—311; XXVI, pp. 96—103. Salaman M.C. *Arthur Briscoe* (Modern Masters of Etching Series, No. 23) 1930.

BRITISH AND FOREIGN ARTISTS' ASSOCIATION fl. 1870s—80s.
Pub.

BRITTON John 1771 (Kingston St. Michael, near Chippenham) — 1857 (London).
Line.
Arch. / illus.

BROCAS Henry I 1766 (Dublin) — 1838 (Dublin).
Line.
Land.
Mainly known as a landscape painter, Brocas was a drawing teacher in Dublin. He was father of Henry II and W. Brocas (qq.v).

BROCAS Henry II fl. Dublin mid 19th c.
Line.
Land.
A son of H. Brocas I and brother of W. Brocas (q.v.).

BROCAS William c. 1794—1868.
Et., line.
Caric. / ex libris.
Brocas, who was also a painter, was the third son of Henry Brocas I, and brother of Henry Brocas II (qq.v.).
Aft.: W. Hogarth.
Pup.: F.W. Burton (q.v.).

BRODIE J. fl. 1860.
Steel.
Illus. / land.

BRODRICK W. fl. 1850s.
Litho.
An. / illus.

BROME C. fl. 1827.
Line.
Port.
Apparently this engraver is not the same as Charles Brome, portrait painter and engraver, who died in

1801, aged twenty-seven.
Aft.: G. Romney.
Lit.: Horne H.P. *Catalogue of Engraved Portraits etc. after Romney* 1891.

BROMLEY Clough W. 1850 — after 1904.
Et.
Flor. / gen. / land. / port. / topog.
Worked in Clapham, London.
Aft.: V. Cole, A.H. Cooper.
Pub.: Dowdeswell and Dowdeswells; E. Leggatt; A. Lucas; F.C. McQueen; I.P. Mendoza.

BROMLEY Frederick fl. London (St. John's Wood) 1830s—1870.
Mezzo.
Gen. / hist. / mil. / port. / sport.
Son of J.C. Bromley (q.v.).
Aft.: T. Brooks, A. Cooper, R.B. Davis, W.C.J. Dobson, G. Harvey, J.R. Herbert, J.P. Knight, C. Landseer, D. Maclise, T.K. Pelham, F. Tayler, F.W. Topham, P. Westcott.
Pub.: H. Graves; Robert Jennings; Lloyd Bros.
Lit.: Engen R.K. *Victorian Engravings* 1975.

BROMLEY James 1801—38 (London).
Line., mezzo., mixed.
Hist. / port.
Third son of William Bromley and brother of J.C. Bromley (qq.v.).
Aft.: R. Bowyer, Carrick, A. Cooper, H. Corbould, A.W. Devis, Sir G. Hayter, Sir T. Lawrence, H. Liverseege, Oakley, T. Phillips, H. Pickersgill, D. Wolstenholme.
Shared: J.G. Murray, J. Porter (qq.v.).
Pub.: R. Bowyer; Colnaghi; Hodgson, Boys and Graves; M. Parkes.

BROMLEY John Charles 1795 (Chelsea) — 1839 (London).
Mezzo.
Gen. / hist. / illus. / land. / port. / sport.
J.C. Bromley, who worked in London was the second son of W. Bromley and brother of James Bromley (qq.v.).
Aft.: W. Beechey, R. Bowyer, E. Corbould, H. Corbould, S. Drummond, Sir C. Eastlake, B.R. Haydon, Sir G. Hayter,

140

J.R. Herbert, H. Howard, Sir E.
Landseer, Sir T. Lawrence, C.R. Leslie,
G.F. Lewis, J. Lucas, Murillo,
E.T. Parris, T. Phillips, H. Pickersgill,
E. Prentis, Stephanoff, J.M.W. Turner.
Pub.: J. Bromley; Colnaghi; T. McLean;
Moon, Boys and Graves.

BROMLEY William I A.R.A. 1769
(Carisbrooke) — 1842.
Et., line., mezzo., steel.
*Antiq. / arch. / gen. / hist. / lit. / mil. /
port. / relig. / ship. / sport. / topog.*
W. Bromley was apprenticed to the
engraver, J. Wooding (fl. late 18th c.)
and worked in Hammersmith and
Pimlico, London. He was father of
James, J.C., Frederick, and William II,
and grandfather of William Bromley III
(qq.v.).
Aft.: Bowyer, Bromley, Burghersh,
L. Clennell, A. Cooper, E. Corbould,
H. Corbould, R.B. Davies, De
Loutherbourg, A.W. Devis,
Gainsborough, Gerard, Haddon,
G. Harvey, W. Hunt, A. Johnson,
C. Landseer, Sir T. Lawrence,
Lenney, C.R. Leslie, Fanny McIan,
D. Maclise, Murillo, E. Prentis,
Reynolds, Rubens, R. Smirke,
Stewart, T. Stothard, F. Wheatley,
D. Wolstenholme.
Pub.: Antiquarian Etching Club;
Macklin.
Shared: T. Landseer (q.v.).
Lit.: *Art Journal* 1898, p. 312. *Art
Union* 1842, p. 278.

BROMLEY William II fl. early—mid
19th c.
Et., line., mezzo.
*Antiq. / arch. / gen. / hist. / lit. / mil. /
port. / relig. / ship. / sport. / topog.*
William Bromley II was a son of
William Bromley I, brother of James,
J.C. and Frederick Bromley and
probably father of William Bromley III.

BROMLEY William III fl. London
1835—88.
Et., line., mezzo.
Gen.
William Bromley III was also a painter.

BROOK R. 1802—22.
Line. (?)
Gen. / land.

BROOKE Joshua fl. 1870s.
Pub.

BROOKER Thomas and Son
BROOKER and HARRISON fl.
London (78 Margaret Street,
Cavendish Square) 1850s—*c.* 1906.
Print., pub.

BROOKS B. and Sons fl. 1850s—
80s.
Pub.

BROOKS Vincent Robert Alfred
1814—85.
Litho. (incl. chromolitho.), print., pub.
*Arch. / gen. / hist. / hum. / land. /
mil. / port. / ship. / topog.*
Brooks worked first for the firm of
lithographic printers, Day and Son
(q.v.). In 1862 he set up the company,
Vincent Brooks, Day and Sons, Ltd.,
which published works for the Arundel
Society. The firm also acquired the
plates and blocks from George Baxter
(q.v.) for his "Baxterotype" prints. In
addition, Brooks worked independently
as a lithographer and his works were
sometimes issued by other publishers.
Aft.: H. Alken, T. Brooks,
G. Cattermole, J.S. Cotman, Lieut.
C.W. Crump, J.A. Fitzgerald,
F. Goodall, W. Mulready, J. Nash,
J.F. Taylor.
Assist.: Charles Armstrong (q.v.).
Pub.: J.L. Fairless; Gambart; Moore,
McQueen and Co.

BROOKSHAW R. fl. 1812.
Aq.
Flor. / illus.
Engraved plates for the botanist
George Brookshaw who was probably
a brother.

BROUGH Robert 1872 (Invergordon)
— 1905.
Litho.
All. / gen. / topog.
Brough studied engraving at the
Aberdeen School of Art and painting
at the Royal Scottish Academy.
Afterwards he studied in Paris under
Benjamin Constant. He was primarily a
portrait painter.

BROWN Ernest and PHILLIPS fl.
London 1890s.
Pub.
Photo-eng.

BROWN Ford Madox 1821 (Calais)
— 1893 (London).
Et.
Hist.
Brown is best known as a Preraphaelite
painter.
Lit.: Walker Art Gallery *Ford Madox
Brown 1821—1893* 1964.

BROWN Gertrude — See Dale
Gertrude.

BROWN H. fl. London (51 Baker
Street, City Road) *c.* 1830.
Pub.
Tinsel.

BROWN Henry 1816 (York) — 1870
(Antwerp).
Line., wood.
Illus.
Brown, who was a brother of William
Brown (q.v.), lived for many years in
the Low Countries. In 1840 he became
head of the Royal School of Engraving
at Le Haye.

BROWN Henry James Stuart 1871
(Bathgate) — 1941.
Dry., et.
Land.
Also a watercolourist and draughtsman.
Lit.: *P.C.Q.* XIV, pp. 362—92.

BROWN John George — See
BROWNE John George.

BROWN Joseph fl. London (Forest
Hill) 1840s—80s.
Line., mixed., steel., stip.
Gen. / illus. / port.
Aft.: J. Absolon, R.W. Buss,
M. Morgan, T. Phillips, G. Richmond,
G. Romney, H.T. Wells, J. Wood; and
after photos.
Pub.: Owen Bailey; B. Brooks; Fine
Art Society; J. Hayter; E.S. Palmer.

BROWN J.W. and Co. fl. 1870s.
Pub.

BROWN Morrison W. fl. late 19th c. (?).
Brown produced lithographs of the
Worcester Foxhounds and members of
the Hunt, but beyond this nothing
appears to be known of him.

BROWN Reginald b. 1868.
Et.

BROWN Richard *c.* 1770 (London)
— 1845 or soon after.
Line.
Arch. / gen.
Aft.: J.C. Ibbotson, G. Morland.

BROWN Thomas fl. 1870s—80s.
Steel.
Hist. / illus.
Aft.: H. Campotosto, E. Castan,
L. Fildes, B. Foster, J.C. Houston,
G. Koller, Millais, J.D. Watson.

BROWN T.J. fl. London (10 Great
May's Buildings, St. Martin's Lane;
21 Mercer Street, Long Acre) and
Manchester (61 Water Street,
Manchester) *c.* 1830.
Print., pub.
Juv. dram. / tinsel.

BROWN William 1814 (York) —
1877 (Belgium).
Wood.
Illus. / relig.
Brown, who was a brother of Henry
Brown (q.v.), worked for many years
in Brussels.
Aft.: Raphael, Rubens.

BROWNE Hablot Knight (peudonym
"Phiz"). 1815 (Kennington, London)
— 1882 (Brighton).
Et.
Illus. / sport.
Browne attended a life school in St.
Martin's Lane, where the painter
William Etty was a fellow pupil. He
won a silver medal of the Society of
Arts. Best known as an illustrator of
Dickens, he also illustrated the works
of Ainsworth, Leech, Lever, Smedley
and other novelists, in addition to
other classes of book and magazine.
Browne was paralysed for the last
years of his life.
Pub.: Fores; Grant and Griffith.
Lit.: Cohen Jane R. *Charles Dickens*

and his Original Illustrators 1980.
Steig M. *Dickens and Phiz* 1978.
Thomson D.C. *Life and Labours of
H.K. Browne* 1884.

BROWNE J. Garle fl. 1850s—60s.
Pub.

BROWNE or BROWN John George
1831 (Durham) — 1913 (New York).
Et. (?)
Gen.
Browne studied at Newcastle-on-Tyne
and at the Royal Scottish Academy,
Edinburgh. He lived in U.S.A. most of
his life.

BROWNE Tom 1872 (Nottingham)
— 1910 (London).
Litho.
Illus.
Browne was also a draughtsman and a
caricaturist.

BROWNLOW Charles Victor
1863—c. 1910.
Et.
Land.
Brownlow was a pupil of J.W.
Whymper (q.v.). He emigrated to
Germantown, Pennsylvania, U.S.A.,
in 1909. He was also a painter.
Aft.: A. Parsons.

BRUCE James fl. Brighton early
19th c.
Aq., et.
Land. / port. / topog.

BRUNET-DUBAINES Alfred Louis
1845 (Le Havre) — c. 1911.
Et.
*Gen. / hist. / illus. / hist. / land. /
myth. / ship. / topog.*
Brunet-Debaines was a French national
who etched plates after several British
artists, which were published in
England. He was a pupil of Charles
Normand, Paris, and worked for a time
in England and Scotland.
Aft.: R.P. Bonington, S. Bough,
V. Cole, J. Constable, D. Cox,
Gainsborough, P. Graham,
K. Halswelle, C. Johnson, B.W. Leader,
J. Linnell, W. Lockhart, J. MacWhirter,
Sir J.E. Millais, J.M.W. Turner.
Pub.: T. Agnew; Buck and Reid;

Colnaghi; Stephen T. Gooden; Goupil:
H. Graves; M. Knoedler; Leggatt Bros.;
A. Lucas; T. McLean; A. Tooth.

BRYAN Alfred 1852—99.
Litho.
Caric. / music.

BRYANT — fl. mid 19th c.
Wood.
Illus.

BRYDEN Robert 1865 (Coylton,
Ayrshire) — 1939.
Et.
Port.
Also a sculptor.

BUCK Adam 1759 (Cork) — 1833
(London).
Et., line.
Illus.
Buck settled in London c. 1795. He
was also a painter, chiefly of portraits,
and a wax modeller.

BUCK J. fl. Manchester 1790—1840.
Line.
Ex libris.

BUCK and REID fl. 1880s—90s.
Pub.
Photo-eng.

BUCKLE D. fl. London 1835—47.
Line., steel.
Illus. / land. / topog.
Aft.: W.H. Bartlett, J. Salmon.

BUCKLER John 1770 (Calbourne,
Isle of Wight) — 1851 (London).
Aq., et.
Arch. / topog.
Buckler was articled for seven years to
an architect in Southwark and
remained in the profession until 1826,
when he handed over his practice to
his eldest son.
 His son, John Chessell Buckler
(q.v.) made copies of his father's
plates, which he issued. He also
engraved illustrations for books from
drawings by his father not previously
published. J.C. Buckler's son, Charles
Alban Buckler, helped with some of
these.
 John Buckler was also a watercolourist.

143

BUCKLER John Chessell 1793–
1894.
Aq.
Arch. / illus. / topog.
Son of John Buckler, (q.v.) whose
plates he copied and issued, J.C.
Buckler was a pupil of William
Nicholson (q.v.). He was also a
draughtsman and watercolourist.
Aft.: John Buckler.

BUCKMAN Edwin 1841 – c. 1911.
Et., line.
Fig. / gen. / illus. / mil. / sport.
Buckman studied in Birmingham, Paris
and Italy. He worked in Bloomsbury.
Pub.: A. Lucas.

BUCKTON Eveleen 1872–1962.
Et.
Land.
A pupil of Sir Frank Short at the Royal
College of Art.

BUDD Barbara Nellie b. Dulwich
1855.
Line (?).

BUFF François, and Son fl. 1880s.
Pub.

BULL E. fl. 1840s.
Steel.
Illus.
Aft.: F.P. Stephanoff.

BULL S. fl. 1838–44.
Line., steel.
Hist. / illus. / port.
Aft.: G. Cattermole, T. Stothard,
J.M. Wright.

BUNBURY Henry William 1750
(Mildenhall) – 1811 (Keswick).
Et.
Caric. / sport.
H.W. Bunbury was the second son of
the Rev. Sir William Bunbury Bart. He
was educated at Westminster School
and St. Catharine's Hall, Cambridge.
He was an amateur draughtsman and
etcher; as an etcher he was unsuccessful
and his work was as a rule reproduced
by other engravers.
Des. eng.: J.K. Baldrey, F. Bartolozzi,
J. Chapman, T. Cheesman, W.
Dickinson, W. Heath, C. Knight, R.

Meadows, T. Ryder, J.R. Smith, F.D.
Soiron (qq.v.).
Pub.: Colnaghi; Robinson.
Lit.: Wilder F.L. *English Sporting
Prints* 1974.

BURBIDGE F.W. fl. 1870s.
Litho.
Flor. / illus.

BURGESS A. fl. 1860s.
Line (?)

BURGESS Henry W. fl. 1820s–30s.
Litho.
Flor. / illus.

BURGESS Walter William c. 1880
(Southampton) – c. 1906.
Et., line.
Arch. / land. / topog.
Worked in Chelsea.
Aft.: E. Margaret Pearson.
Pub.: C.E. Clifford; Gladwell Bros.

BURGESS William 1749–1813
(Fleet, Lincs.).
Line.
Arch.
Also a Baptist pastor.

BURGESS William fl. 1833–50.
Litho.
Cost. / mil. / topog.

BURGESS William Oakley 1818
(London) – 1844 (London).
Mezzo.
Illus. / port.
Burgess, who was the son of the parish
surgeon of St. Giles-in-the-Fields,
London, was a pupil of T.G. Lupton
(q.v.).
Aft.: Sir T. Lawrence.

BURKE Thomas 1749 (Dublin) –
1815 (London).
Chalk., mezzo., stip.
*All. / flor. / gen. / hist. / lit. / myth. /
port.*
Burke was a pupil of John Dixon the
mezzotinter (1740 – c. 1801), but
later abandoned mezzotint for stipple,
which was popularised by Bartolozzi.
Aft.: J. Bateman, W.R. Bigg, Cipriani,
R. Cosway, Dance, De Koster, Delâtre,
Downman, H. Fuseli, Huquier,

Angelica Kauffmann, J.H. Mortimer, Schroeder, Singleton.
Shared: W. Nutter (q.v.).
Pub.: Dickinson; Thomas Macklin.
Lit.: Wilder F.L. *English Sportin Prints* 1974.

BURKITT and HUDSON fl. early (?) 19th c.
Aq., pub.
Sport.

BURN Gerald Maurice b. London 1862.
Et.
Marine.
Also a painter.

BURNET John 1784 (Musselburgh, Edinburgh) — 1868 (Stoke Newington).
Et., line., mezzo., steel.
An. / gen. / hist. / illus. / mil. / port. / relig. / ship. / theat.
A son of the surveyor-general of excise for Scotland, Burnet was apprenticed for seven years to Robert Scott (q.v.), and was also a student at the Trustees Academy, Edinburgh, where among his fellow pupils was David Wilkie, whom he joined in London in 1806. Burnet visited Paris in 1815, where he studied at the Lourvre for five months. Working mainly in London, he was also a writer, among his works being *Rembrandt and his Works* (1849).
Aft.: Sir W. Allan, J.A. Atkinson, A.W. Devis, Sir F. Grant, J.F. Herring jr., Sir E. Landseer, R.M. Lloyd, C. Lucy, Metzu, Newton, H.W. Pickersgill, Raphael, Rembrandt, J.M.W. Turner, Sir D. Wilkie.
Assist.: C. Fox (q.v.).
Shared: H.F. Walker (q.v.).
Pub.: T. Agnew; Gambart; H. Graves; Ryman; Society of Artists in Scotland.

BURNEY Edward Francis 1760 (Worcester) — 1848 (London).
Line.
Illus.
A friend of Sir Joshua Reynolds, Burney was also a painter.

BURR Alexander Hohenlohe 1835 (Manchester) — 1899.
Et.

Gen. / land.
A pupil of John Ballantyne, Edinburgh, and of the Trustees Academy, Burr afterwards moved to St. John's Wood, London. He worked there with his brother, John Burr.
Aft.: J. Burr.
Des. eng.: R.S. Clousten (q.v.).
Lit.: *Art Journal* 1870, p. 309.

BURRIDGE Frederick Vango 1869 (Liverpool) — after 1905.
Et.
Gen. / land.
Burridge was a pupil of Sir Frank Short (q.v.) at the Royal College of Art. He worked in Brixton.
Pub.: E. Parsons.
Lit.: *Magazine of Art 1903—4* p. 384. *Studio* XLII, p. 279.

BURT Albin R. 1784 (London) — 1842 (Reading).
Stip.
All.
A pupil of Robert Thew (1758—1902) and later of Benjamin Smith (q.v.), Burt later specialised in painting heads.

BURTENSHAW H. fl. London (130 St. Martin's Lane) 1812.
Pub.
Juv. dram.
Agent for toy theatre sheets of J.K. Green (q.v.).

BURTON Sir Frederick William 1816 (Inchiquin Lake, Co. Cork) — 1900 (Kensington).
Et.
Gen.
Best known as a watercolourist and landscape painter, Burton was a pupil of W. Brocas (q.v.) and was much influenced by the Preraphaelites. He was director of the National Gallery 1874—94.
Des. eng.: H.T. Ryall (q.v.).
Pub.: Fine Art Society; Irish Art Union; F.C. McQueen.
Lit.: *Magazine of Art* May 1900.

BURY Viscount — See Coutts W.

BUSBY Thomas Lord fl. 1804—37.
Line.
Gen. / port.

BUSH Reginald Edgar James 1869
(Cardiff) — *c.* 1956.
Et.
Land. / topog.
Also a painter.
Pup.: Dorothy E.G. Woollard (q.v.).

BUSH R. fl. 1849.
Steel.
Illus. / land.
Aft.: G.S. Shepherd.

BUSHBY T.L. fl. 1814.
Aq. (?)
Flor. / illus.

BUSS Robert William 1804 (London)
— 1875 (London).
Et.
Gen. / illus. / port.
Buss served an apprenticeship with his
father, an engraver and enameller, and
later studied painting under George
Clint A.R.A. He worked in Camden
Town, London.
Aft.: W. Daniels, L. Mayer.
Des. eng.: J. Brown, T. Lupton,
J. Scott (q.v.).
Des. litho.: T. Fairland (q.v.).

BUTLER Angustus fl. mid 19th c.
Litho.
Music.

BUTLER A. fl. 1848.
Line., litho.
Sport.

BUTLER George Edmund
b. Southampton 1872.
Et.
Gen.
Butler was a pupil at The Lambeth
School, at the Julian Academy and at
the Antwerp Academy. He was also a
painter.

BUTTERWORTH Charles fl. 1880s
and 1890s.
Line., wood.
Gen. / illus. / lit. / port.
American national who engraved
plates after works by a number of
British artists.
Aft.: A. Hacker, Sir G. Hayter,
J.G. Todd; and after photos.

BUTTERWORTH William
— Pseudonym of Henry Schroeder
(q.v.).

BUTTS Thomas jr. 1788—1862.
Line.
All.
A pupil of William Blake (q.v.). He
shared work with Blake on a design by
the latter of "Christ trampling on
Urizen", which was probably made as
a model for practising various methods
of texture.
Lit.: Bentley G.E. jr. *Blake Records*
1969.

BUXTON Robert Hugh b. Harrow
1871.
Wood.
Illus. / land. / sport.
Also a painter.

BUZZARD Thomas fl. London
1866—81.
Line (?)

BYFIELD Ebenezer 1790—1817.
Wood.
Illus.
Brother of J. and Mary Byfield (qq.v.).
Father of the wood-engraver Louis
Byfield (1816—86). Uncle of Elizabeth
Clint (q.v.).

BYFIELD John 1788—1841.
Wood.
Illus.
Brother of E. and Mary Byfield
(qq.v.). Father of the wood-engravers
Ann (b. 1830), Edward (1838—60)
and Mary Byfield (b. 1840). Uncle of
Elizabeth Clint (q.v.).
Aft.: W. Blake, Holbein.
Shared: G.W. Bonner (q.v.), Mary
Byfield (his sister, q.v.).
Pub.: Francis Douce.
Lit.: *Private Library* winter 1980,
149—59.

BYFIELD Mary 1795—1871.
Wood.
Illus.
Sister of E. and J. Byfield (qq.v.).

BYRNE Elizabeth fl. 1830—50.
Et., line., steel.
Flor. / illus. / land. / topog.
Born in London, Elizabeth Byrne was
the youngest daughter and pupil of
William Byrne (1740—1805), on
whose plates she sometimes worked;
she was one of the few women to
engrave on steel. John and Letitia
Byrne (qq.v.) were her brother and
sister.
Aft.: F. Nash, J.P. Neall, van Huysum,
van Os.
Shared: J. Byrne (q.v.).

BYRNE John 1796 (London) —
1847.
Et., line.
Arch. / land. / topog.
Son and pupil of the engraver
W. Byrne (1740—1805), John Byrne
was the brother of Elizabeth and
Letitia Byrne (qq.v.). He travelled to
Italy 1832—37. Later he abandoned
etching and engraving and worked

exclusively in watercolour.
Aft.: J. Hakewill, F. Nash, J.P. Neale,
J.M.W. Turner.
Shared: Elizabeth Byrne (q.v.).

BYRNE Letitia 1779 (? London) —
1849 (London).
Et., line., steel.
An. / arch. / illus. / land. / topog.
The third daughter of the engraver
William Byrne (1740—1805) and
sister of Elizabeth and John Byrne
(qq.v.), Letitia Byrne worked in
London. She was one of the few
women to practise steel engraving.
Some of her etchings have the
appearance of engravings.
Aft.: T.T. Bury, J. Farington,
B. Ferrey, T. Girtin, J. Hakewill,
J.P. Neale.

BYSH S. fl. London (West
Smithfield) mid 19th c.
Pub.
Sport.

147

CADBURY, JONES AND CO LTD
fl. 1890s — early 20th c.
Print., pub.
Photo-eng.

CADENHEAD James 1858
(Aberdeen) — 1927.
Et.
Land.
Cadenhead, who was also a painter,
studied in Edinburgh at the School of
Art and the Royal Scottish Academy,
and with C. Duran in Paris.

CAFE James Watt b. 1857.
Et.
Arch. / topog.

CALDECOTT Randolph 1846
(Chester) — 1886 (Florida).
Et.
Fig.
Best known as an illustrator, many of
Caldecott's designs were reproduced in
colour by Edmund Evans (q.v.).

CALDERON Philip Hermogenes R.A.
1833 (Poitiers, France) — 1898
(London).
Et.
Gen.
Calderon is known primarily as a
painter of genre and historical subjects,
but his few etchings have considerable
quality.

CALDWALL James 1739 (London)
— after 1819 (London).
Et., line.
*Gen. / illus. / port. / ship. / sport. /
theat. / topog.*
Aft.: R. Adams, A. Callender,
G. Carter, J. Collet, Grignion,
W. Hamilton, W. Henderson, Murillo,
J. Opie, Sir J. Reynolds, J. Russell,
Teniers, R. Walker.
Shared: S. Smith (q.v.).

CALLCOTT, Sir Augustus Wall 1779
(Kensington) — 1844 (London).
Et.
Fig. / land. / lit. / marine.
Best known as a landscape painter,
Callcott etched occasionally. He was a
pupil of John Hoppner and worked in
Kensington.
Des. eng.: F. Bacon, G. Cooke, L.
Gaucherel, F. Lewis, L. Stocks, J.
Thompson, C. Turner (qq.v.).
Lit.: *Art Union* 1845, p. 15.
Portfolio 1875, pp. 161f.

CALVERT Edward 1799
(Appledore) — 1883 (London).
Line., litho., wood.
All. / relig.
Calvert began life as a midshipman in
the Navy and took part in the
bombardment of Algiers. He left the
Navy in 1820 and settled in Plymouth,
where he took lessons from Thomas
Ball and Ambrose Bowden Johns. He
married in 1924 and moved to London
where he met William Blake and

Samuel Palmer (qq.v.), becoming a prominent member of Palmer's circle, "The Ancients". Between 1825 and 1831 Calvert produced a few exquisite engravings and lithographs, some of the most beautiful works in the history of the art. Thereafter, for no apparent reason, he abandoned engraving and spent his time painting dreamy classical studies and working on theories of the philosophy of art.

Edward Calvert's son Samuel, who emigrated to Australia in 1843 with G.F. Angas (q.v.) was also a wood-engraver; he engraved several issues of postage stamps made in the colony of Victoria 1854—60.
Des. eng.: W. Sherman (q.v.).
Lit.: Binyon L. *The Followers of William Blake* 1925. [Calvert S.] *A Memoir of William Calvert Artist by His Third Son* 1893. Lister R. *Edward Calvert* 1962, *Edward Calvert. Eleven Engravings* 1966.

CALVERT Frederick fl. London 1811—44.
Line.
Land. / topog.
Best known as a watercolourist.

CAMERON Sir David Young R.A. 1865 (Glasgow) — 1945 (Perth).
Dry., et., mixed.
Ex libris. / land. / port. / ship. / topog.
The son of a clergyman, Cameron attended Glasgow Academy from the age of nine; here he was a pupil of the art master John Maclaren, who fired the lad's enthusiasm for art. He took up employment in the office of a Glasgow foundry, but in his spare time attended classes at the Glasgow School of Art. In due course he gave up his commercial post and became a full-time student at the Mound School of Art, Edinburgh. Cameron was encouraged by George Stevenson, a Glasgow amateur etcher, to take up that art. He travelled abroad a great deal, though he worked mainly in Glasgow and Kippen. He was also a noted painter and was engaged as an official war artist by the Canadian Government in World War I. Katherine Cameron (q.v.) was his sister.
Lit.: Grolier Club *Etchings and*

Drypoints of D.Y. Cameron 1908. Hind A.M. *The Etchings of D.Y. Cameron* 1924. P.C.Q. I, 74—6; XI, 44—68. Rinder F. *D.Y. Cameron: Catalogue of Etchings*, 1912. *David Young Cameron: Etchings and Drypoints from 1912 to 1932* 1932. Salaman M.C. *Sir D.Y. Cameron* Modern Masters of Etching Series, No. 7, 1925; No. 33, 1932. Wedmore F. *David Cameron Etchings* 1903. Wright H.J.L. *Original Etchings and Drypoints of David Cameron* 1947.

CAMERON Katherine (Miss Katherine Kay) 1874—1965.
Et.
Ex libris.
The sister of Sir D.Y. Cameron (q.v.).
Lit.: *International Studies* LXXV, 401.

CAMPBELL Charles William 1855 (Tottenham) — 1887 (Sevenoaks).
Mezzo.
Myth. / port.
Campbell began life working for his father, an architect. He studied at the Ruskin School of Art, Oxford, and was a pupil of Sir. H. Herkomer (q.v.).
Aft.: Sir E. Burne-Jones, G.F. Watts.

CAMPBELL Miss Molly fl. London 1890s and early 20th c.
Aq., et.
Land.
Also a painter.

CAMPION George Bryant 1796—1870 (Munich).
Litho.
Land. / mil. / sport.
Campion is known mainly as a watercolourist, but he was also a writer and contributed articles to *The Art Journal*. He was drawing master at the Military School at Woolwich.
Pub.: Ackermann; Bowdon and Sons.
Lit.: *Art Journal* 1870, p. 204.

CANTON Charles fl. 1819.
Aq., line.
Land.

CANTON Richard fl. London
(22—23 Aldersgate Street, E.C.) *c.*
1840.
Print. (chromolitho.)
Ephem.

CAPONE William Henry fl. 1830s
—40s.
Steel.
Arch. / illus. / land.
An engraver who signed his work
W. Capon is probably identical with
W.H. Capone.
Aft,.: T. Allom, W.H. Bartlett, W.L.
Leitch, Wolfensberger.

CARDON Antoine the elder 1739
(Brussels) — 1822 (Brussels).
CARDON Antoine the younger
1772 (Brussels) — 1813 (London).
The elder's work mainly in line; the
younger's work mainly in stip.
All. / gen. / hist. / illus. / mil. / myth. /
port. / relig. / sport. / theat.
The Cardons were Belgian nationals,
but the younger (who was the son and
pupil of A. Cardon the elder) came to
London at the time of the 1790
insurrection, and worked there from
1792 until he died. He was a pupil of
L. Schiavonetti (q.v.) for three years.
In 1807 he received a gold medal from
the Society of Arts.
 Philip Cardon, son of A. Cardon the
younger was also an engraver, but died
young in 1817.
Aft.: J.T. Barber, F. Bartolozzi, Bozé,
Castoldi, A. Chalon, Maria Cosway, R.
Cosway, P. De Loutherbourg, A.W.
Devis, C. Dolei, J. Eckstein, Edridge,
Guérard, Hamilton, W.W. Hodgson,
T. Kirk, Lodder, Masquerier, Ann Mee,
Pickersgill, C.M. Pope, Rembrandt,
Reynolds, Rubens, H. Singleton, T.
Stothard, T. Uwins, Van Loo, H.
Villiers, Watteau, R. Westall, F.
Wheatley.
Assist.: James Thomson (q.v.).
Shared: H.R. Cook, F. Eginton (qq.v.).
Pub.: Boydell.

CARDON F. fl. London 1825.
Stip.
Port.
Aft.: Busette, Laclotte.

CARDON Philip — See under
CARDON Antoine.

CARDONNELL Adam de d. 1820
(Cramlington).
Line.
Antiq. / illus.
Cardonell was born in Edinburgh, year
unknown.

CARLAW John 1850—1934.
Et.

CARLON — fl. early 19th c.
Line.
Illus.
Little is known of Carlon, who
contributed a plate to Thornton's
Temple of Flora (1805).

CARLOS W. fl. mid. 19th c.
Line., mezzo.
Gen. / hist. / lit. / port.
Aft.: J. Casey, T.M. Joy, W. Kidd,
J.G. Middleton, J. Vernet.
Pub.: Hering and Remington;
A. Meeson; C. Tilt.

CARLSE James 1798 (Shoreditch)
— 1855.
Line.
Arch. / fig. / gen. / illus. / land.
Carlse served his apprenticeship with
Mr Tyrrel, an architectural engraver.
Aft.: B. West.

CARPENTER William *c.* 1818
(London) — 1899.
Line.
Land. / topog.
Carpenter, who was also a painter,
spent much time in India.

CARPENTER William Hookham
1792 (London) — 1866.
Et.
Port.
Carpenter was a son of a publisher and
bookseller. He set up in business on his
own account, but later returned to his
father. He was encouraged in etching
by Andrew Geddes (q.v.). In 1845 he
became Keeper of Prints and Drawins
at the British Museum.
 His son, William Carpenter Jr, also
etched and practised lithography.

CARR — fl. Houndsditch, London
mid (?) 19th c.
Pub.
Juv. dram.

CARRERAS Theobald 1829—95.
Wood.
Illus.
The son of Spanish parents, Carreras
made many wood-engravings published
under the signature of James Davis
Cooper (q.v.).

CARRICK J. Mulcaster fl. 1850s
—70s.
Et.
Land. / lit. / marine.
Carrick worked first in London, and
then at Sudbury-on-Thames. He
travelled on the Continent.

CARRICK Robert C. fl. mid 19th c.
Litho. (incl. chromolitho.)
Arch. / illus. / land. / topog.
Carrick worked with Day and Son and
L. Haghe (qq.v.). He was noted for his
brilliant chromolithographs, one, after
Turner's "Rockets and Blue Lights",
measuring 27 x 21 ins.
Aft.: P. Brannan, E. Crawford, Copley
Fielding, H. Gastineau, H. McCulloch,
K. Macleay, J.M.W. Turner.
Pub.: Ackermann and Co.

CARRINGTON James Yates 1857—
92.
Et.
Gen.
Carrington worked in Chiswick and
St. John's Wood, London.
Pub.: Bowden, Son and Co.; Louis
Brall and Sons.
Lit.: *Art Journal* 1892, p. 224.

CARSE A. fl. 1832.
Steel.
Illus. / land.
Aft.: Allom.

CARTER James 1798 (London) —
1855 (London).
Line., steel.
Arch. / fig. / gen. / hist. / illus. / land.
Carter was first apprenticed to
Mr Tyrrel, an architectural engraver,
but later concentrated on landscape
and figure work. He worked extensively

on steel. The Society of Arts awarded
him a silver medal for drawing.
Aft.: W.H. Bartlett, C.R. Cockerell,
S. Drummond, F. Goodall, J. Holland,
A. Nasmyth, S. Prout, D. Roberts,
W.C. Stanfield, E.M. Ward, R. Wilson.
Pub.: S. Drummond; H. Graves;
J. Weale.

CARTER John 1748—1817
(Pimlico).
Line.
Arch. / topog.
Aft.: G. Chambers.

CARTWRIGHT William fl. early
19th c.
Aq.
Land. / myth. / topog.
There was another engraver named
William Cartwright who worked in the
second half of the 18th century and
should not be confused with this one.
The earlier engraver engraved a portrait
of Thomas Cranmer after Holbein.
And there was a T. Cartwright (fl.
1816), possibly a brother of William.
Aft.: Brewer, R. Bonington, T. Phillips,
T. Walmesley.

CASTLE H. fl. 1880s.
Et.
Arch. / topog.

CASTLES — fl. 1831.
Steel.
Arch. / illus.
Aft.: J. Fletcher.

CASTLEDEN George T.
b. Canterbury 1851.
Also a watercolourist.

CATES A.H. fl. first half of 19th c.
Line., wood.
Arch. / illus.

CATTERMOLE Charles 1832—1900.
Et.
Hist.
Charles Cattermole was a nephew of
George Cattermole (q.v.). He worked
in Kentish Town, London, and also
painted in oil and watercolour.

151

CATTERMOLE George 1800
(Dickleborough, Norfolk) — 1868
(London).
Litho.
Arch. / illus. / land.
Best known as a watercolour painter
and illustrator, Cattermole produced a
number of works in the lithotint
process of C.J. Hullmandel (q.v.)
which he helped to perfect. He is
remembered in particular for his
illustrations to Dickens's *Master
Humphrey's Clock* and *Barnaby Rudge.*

CATTON Charles the younger 1756
(London) — 1819 (U.S.A.)
Line.
An. / illus. / sport.
Catton attended the Schools of the
R.A. in London, of which his father,
Charles Catton the elder (1728—96),
was one of the original members.
Aft.: G. Morland.

CAVE Henry 1780 (York) — 1836
(York).
Et., steel.
Arch. / illus.
Also a painter.

CAVE Robert Haynes fl. 1870s.
Et.
Land. / topog.

CAWDOR Lady Caroline 1771—
1848.
Litho.
Topog.
The first amateur to make lithographs,
of which only two are recorded.

CECILY Samuel Hollings 1804
(Dronfield, Derbyshire) — 1849
(Maestricht).
Line., litho.

CHADWICK J.W. fl. first half of
19th c.
Wood.
Illus.

CHALLIS Ebenezer fl. 1846—63.
Line., steel.
Arch. / illus. / land.
Also a painter.
Aft.: W.H. Bartlett.

CHALON Henry Bernard 1770
(London) — 1849 (London).
Litho., mezzo.
An. / sport.
H.B. Chalon was a son of the Dutch
engraver Jan Chalon (1738—95).

CHALON John James 1778
(Geneva) — 1854 (London).
Litho.
Gen. / land. / myth.
Brother of the painter A.E. Chalon,
John James studied at the R.A.

CHAMBERS William 1843
(Dumbarton) — c. 1900.
Mezzo.
Gen.
Worked in Clapham, London.
Aft.: Gainsborough, T. Kennington.
Pub.: Fine Art Society.

CHANLER Albert b. Glasgow 1880.
Line.

CHANT James John 1820 (London)
— 1876 or after.
Line., mezzo.
Gen. / hist. / illus. / port. / ship. / sport.
Worked in London, largely for
booksellers.
Aft.: Sophie Anderson, R. Ansdell, G.
Boughton, T. Brooks, J. Burgess,
E.H. Corbould, T. Creswick, W.C.T.
Dobson, C. Dukes, E. Eagles,
E.U. Eddis, T. Faed, W. Field, W.P.
Frith, Sir F. Grant, Sir G. Hayter,
G. Holmes, J. Hook, J. Horsley,
H. Le Jeune, Sir E. Landseer, G. Leslie,
J. Lucas, T. Morgan, Emily Osborne,
J. Phillip, G. Pope, L. Pott, Sir E.
Poynter, Reynolds, B. Riviere, J. Sant,
C. Smith, S.C. Smith, M. Stone,
Elizabeth Thompson (Lady Butler),
W. Tweedie.
Shared: S.W. Reynolds (q.v.).
Pub.: A. Ackermann, B. Brooks;
Dixon and Ross; Fine Art Society;
Fores; Goupil; H. Graves; M. Knoedler;
A. Lucas; I.P. Mendoza.

CHAPMAN John fl. London 1770—
1823.
Et., line., mixed., stip.
All. / gen. / lit. / port. / sport.
Aft.: H.W. Bunbury, R. Corbould,
R. Dodd, C. Elliot, J. Smith, J. Wilkes.

CHAPMAN John Watkins 1832—c.
1903.
Mezzo.
Gen. / port.
Worked in Kensington, Sutton (Surrey)
and Ashford (Middlesex).
Aft.: H. Bunbury, Gainsborough,
Hoppner, Raeburn, Reynolds,
Romney, E. Taylor.
Pub.: Boussod, Valadon and Co.;
Dowdeswell and Dowdeswells; A.
Lucas; T. McLean; I.P. Mendoza;
Shepherd Bros.

CHAPMAN William fl. London and
York 1840s—70s.
Line., mezzo., steel.
Illus. / land. / marine. / topog.
Aft.: D. Cox, H. Dawson, A.W. Hunt,
J. Pyne, C. Stanfield, J.M.W. Turner,
W. Turner.
Shared: T.A. Prior (q.v.).
Pub.: H. Graves.

CHARLES William fl. 1801—20.
Et., line.
Land. / topog.
Charles was born in Scotland and
emigrated to U.S.A., where he died.

CHARLOTTE AUGUSTA MATILDA
Princess 1766 (London) —
Louisbourg (1828).
Line.
Port.
A daughter of George III who married
Frederick I, King of Wurtemberg. She
was a competent amateur.
Aft.: Gainsborough.

CHARLTON Edward William 1859
(Kent) — 1935.
Et.
Gen. / land. / ship. / topog.
Charlton, who worked in Tonbridge,
Kent, and Ringwood and Lymington,
Hants., made his first etchings in 1890.
In all he made some 120 plates. He
moved to Dresden in 1904 and
continued to work there.
Lit.: *Studio* VII, 219.

CHARPENTIER Georges fl. 1880s.
Line.
Gen.
French national who engraved some
plates after works by British artists

which were published in England.
Aft.: F. Goodall, J. Sant.
Pub.: Gambart.

CHATTOCK Richard Samuel 1825
(Solihull) — 1906 (Clifton).
Et.
Land. / topog.
Chattock, who studied in Rugby, and
worked in Solihull and London, wrote
Practical Notes on Etching (1880).
Aft.: W. Crome, J.M.W. Turner.
Lit.: Sparrow W. *A Book of British
Etchings* 1926.

CHAUVEL C. fl. 1882—1907.
Et.
Land.
French national who etched several
plates after works by British artists
which were published in England.
Aft.: B. Leader, J. Linnell, J.
MacWhirter.
Pup.: Mme. C.—E. Chauvel (q.v.).
Pub.: Colnaghi; A. Tooth.

CHAUVEL Mme. Clemence-Elisa
1865 (Paris) — c. 1902.
Et.
Land.
French national, a pupil of C. Chauvel
(q.v.). She engraved at least one work
after a British artist which was
published in England.
Aft.: B. Leader.
Pub.: A. Tooth.

CHAUVEL Théophile-Narcisse
1831 (Paris) — c. 1910 (Paris).
Et., litho.
Gen. land.
French national, a pupil of Picot,
who engraved several plates after
works by British artists which were
published in England. Altogether he
made a total of 149 etchings and 15
lithographs.
Aft.: V. Cole, B. Leader, Sir J. Millais.
Pub.: Boussod, Valadon and Co.;
Goupil and Co.; E. Savary; A. Tooth.

CHAUVET Jules Adolphe 1828
(Péronne, France) — c. 1905.
Line., photo-eng.
Gen.
French national who engraved several
plates after works by British artists

which were published in England.
Aft.: L. Cheviot, Maud Karl, P. Earl,
M. Orange.
Pub.: H. Graves; C. Klackner.

CHAVANE E. fl. 1830s—50s.
Line., steel.
Fig. / land. / still life.
Aft.: Hogarth.

CHEESMAN Thomas 1760—c. 1835.
Mezzo., pub., stip.
*All. / gen. / hist. / illus. / lit. / myth. /
port. / relig.*
Cheesman worked in London at 40
Oxford Street, 72 Newman Street and,
in 1834, 28 Francis Street, from which
addresses he published his own and
other prints. He was a pupil of
F. Bartolozzi, and for a time worked
for E. Harding (qq.v.).
Aft.: F. Bartolozzi, Beechey, Bowden,
Buck, H. Bunbury, R. Cosway, Cribb,
De Loutherbourg, De Wilde, Giotto,
Guercino, Hogarth, Holbein, Angelica
Kauffmann, Reynolds, Romney, Titian,
Trumbull, B. West, R. Westall.
Pup.: J.S. Agar, J. Mitan (qq.v.).
Pub.: E. Harding.

CHEFFINS C.F. fl. 1840s.
Litho.
Illus.

CHELTNAM — fl. 1852.
Wood.
Illus.
Aft.: J.P. Knight.

CHEVALIER Nicolas 1828 (St
Petersburg) — 1902 (London).
Line., litho. (incl. chromolitho.)
Antiq. / gen. / illus. / land. / port.
German national who studied under
Guiguard at Lucerne from 1845, and
then in Munich and London, where he
was working *c.* 1850. He was especially
noted for chromolithographs of
Australia, which he visited *c.* 1852.
Aft.: G. Kneller, J.P. Knight, W.
Shayer.
Pub.: Art Union of London; J.S.
Virtue.

CHEVALIER William 1804—66
(Auteuil).
Line., steel.

Gen. / illus. / relig.
French national who worked in
London.
Aft.: E. Corbould, J. Hook, S.E. Jones,
Sir E. Landseer, H. O'Neill, H. Richter,
W. Shayer, D. Wilkie.
Pub.: Gambart.

CHILDS G. fl. 1828.
Litho.
Illus. / land.

CHIQUET Eugène-Marie-Louis 1863
(Limeray) — after 1900.
Et., stip.
Gen. / illus.
French national who engraved a
number of plates after works by
British artists which were published
in England.
Aft.: J. Downman, J.S. Lucas, J.B.
Pater, W.D. Sadler, J.R. Smith,
W. Ward.
Pub.: H. Graves, C. Klackner.

CHRISTOE T. fl. London (34 Drury
Lane) 1819.
Pub.
Juv. dram.

CICERI Eugène 1813 (Paris) —
1890 (Marlotte Fontainebleau).
Et., litho.
Land. / port.
French national who engraved some
plates after works by British artists
which were published in England. He
was taught by his father Pierre-Luc-
Charles Ciceri.
Aft.: H. McCullogh.
Pub.: Gambart.

CLARK C. fl. Manchester (53 Temple
Street) 1888.
Pub.
Juv. dram.
Prints were inscribed "Clark's Juvenile
Drama" and "Clark's Celebrated
Halfpenny Plays".

CLARK J. fl. 1840s—60s.
Et., steel.
Arch. / lit.
Aft.: W. Tombleson.

154

CLARK John Heaviside (called "Waterloo Clark") *c.* 1770—1863 (Edinburgh).
Aq.
Illus. / mil.
He was nicknamed "Waterloo" because he made sketches on the battlefield.

CLARK (or CLARKE) Joseph or John fl. London 1789—1830.
Aq., et., mixed., stip.
Illus. / lit. / mil. / ship. / sport. / topog.
The actual name of this engraver is uncertain; he signed his work "J. Clark".
Aft.: H. Alken, Chalon, Cipriani, W.M. Craig, De Loutherbourg, Lt. Downman, W.D. Fellowes, J.F. Gilbert, C. Hillier, G. Humble, W. Pim, D. Serres, G. Temple, Rev. H. Waring, D. Wolstenholme.
Shared: M. Dubourg, J.R. Hamble (qq.v.).
Lit.: Wilder F.C. *English Sporting Prints* 1974.

CLARK Joseph Benwell 1857 (Orne Abbas) — after 1894.
Et., mezzo.
Gen. / illus. / interiors / myth.
A pupil of A. Legros (q.v.), Clark worked in London. He was a nephew of the painter Joseph C. Clark.
Aft.: J.C. Clark, G.F. Watts.

CLARK Thomas fl. 1832—40.
Steel.
Arch. / illus. / land.
Aft.: T. Allom, R.W. Billings, J.R. Thompson.

CLARK W. fl. 1820s—40s.
Litho.
Flor. / illus. / port.

CLARK Waterloo — See CLARK, John Heaviside.

CLARK W. and J.O. fl. London (High Holborn) 1820s.
Litho., print.
Music.
A firm.

CLARKE or CLARK, Harriet Ludlow b. London d. 1866 (Cannes).
Wood.
Illus.

The fourth daughter of a London solicitor, Harriet Clarke began to earn her living as a wood-engraver *c.* 1837. She attracted the attention of William Harvey (q.v.) who gave her instruction, and she was able to earn a considerable sum which she spent on building model labourers' cottages at Cheshunt. She was also a designer of stained glass and executed several church windows.
Aft.: W. Dyce, W. Harvey.

CLARKE H.G. fl. 1875—*c.* 1900 London (2 Garrick Street, Covent Garden; 252 Strand).
Pub.
Juv. dram.
Agent for A. Park, B. Pollock, W. Webb (qq.v.). Probably acquired the stock of S. Marks and Murray and Goode (qq.v.).

CLARKE H. Harvey b. 1869.
Et.

CLARKE John d. *c.* 1815.
Aq., stip.
All. / gen. / myth.
Aft.: F. Bartolozzi, Rubens.

CLARKE W. fl. London (265 High Holborn) 1821—24.
Pub.
Juv. dram.
Clarke was succeeded by his partner D.M. De Burson (q.v.).

CLAUSEN Sir George R.A. 1852 (London) — 1944 (Cold Ash, Newbury).
Et., litho., mezzo.
An. / arch. / fig. / land.
A son of a Danish sculptor and a pupil of Edwin Long, Clausen worked in London and Newport, Essex. He studied in Paris with Bouguereau and Robert-Fleury, was a founder of the New English Art Club and became professor of painting at the R.A. Schools. He was noted for his studies of bucolic life and scenery. Clausen's one mezzotint was made from a work by Georges Michel, the French artist. It was published by Boussod, Valadon and Co.
Lit.: Hussey D. *George Clausen* 1923.
P.C.Q. VIII, 220—27, 433.

CLAYTON Alfred B. 1795 (London)
— 1855.
Line.
Hist.
Also a painter and architect.

CLAYTON C. and P. fl. London
(150 Fleet Street) 1860.
Pub., steel.
Illus.
Aft.: T. Boys.

CLAYTON J.R. fl. 1860s.
Et.
Illus. / lit.

CLEGHORN John fl. 1827—80.
Aq., steel.
Arch. / illus. / topog.

CLEGHORN T. fl. 1829.
Steel.
Arch. / illus.
Perhaps identical with John Cleghorn
(q.v.).

CLEMENTS James fl. 1820s.
Et.
Sport.
Des. eng.: J. Gleadale (q.v.).

CLENNELL Luke 1781 (Ulgham,
Morpeth) — 1840 (Newcastle-on-Tyne).
Wood.
All. / ephem. / ex libris / illus.
The son of a farmer, Clennell was a
shop assistant with his uncle, Thomas
Clennell, a grocer and tanner at
Morpeth, until he was sixteen. He
transferred as an apprentice to Thomas
Bewick (q.v.) in 1797, and worked on
the tailpieces for the water birds
section in Bewick's *British Birds.* After
finishing his time in 1804 Clennell
came to London where he married the
daughter of the wood-engraver,
Charles Warren (q.v.). He gained a gold
palette from the Society of Arts *c.*
1810, but abandoned wood-engraving
for watercolour painting. From 1817
he became intermittently insane.
Aft.: T. Bewick, Sir C.L. Eastlake,
R. Johnson, Sir E. Landseer, T.
Stothard, J. Thurston, T. Uwins,
B. West.
Lit.: de Maré E. *The Victorian
Woodblock Illustrators* 1980. Dobson

A. *Thomas Bewick and his Pupils* 1884.
Jackson J. and W.A. Chatto *A Treatise
on Wood Engraving* 1861.

CLERK John 1728 (Penicuik) —
1812 (Eldin).
Et.
Land. / topog.
Known as "Clerk of Eldin", this etcher
was an amateur, and a pupil of Paul
Sandby; he etched 116 views. His wife
was Janet Adam, a sister of the
architects John and Robert Adam.
Clerk was best known in his own time
as an authority on naval tactics.
Pub.: Bannatyne Club.
Lit.: *P.C.Q.* XII, 14—39; XIII, 97; XX,
362, 364.

CLIFFORD C.E. fl. 1880s—90s.
Pub.

CLINT Elizabeth b. *c.* 1815.
Wood.
Illus.
Daughter of Elizabeth Clint (née
Byfield), sister of John Byfield (q.v.).

CLINT George 1770 (London) —
1854 (Kensington).
Chalk, mezzo.
An. / hist. / land. / port. / theat.
The son of a hairdresser in Lombard
Street, London, Clint was educated in
Yorkshire. He was first apprenticed to
a fishmonger, then worked in an
attorney's office and after that as a
house painter. After marrying, he
became an artist and met with some
success as a miniaturist. He
subsequently took up engraving. He
became an A.R.A. in 1821, but
resigned in 1835 and became a bitter
opponent of the Academy. He worked
in Bloomsbury, and among his
commissions were plates for Turner's
Liber Studiorum for which he received
six guineas a plate.
Aft.: W. Allingham, Ashby, W.
Beechey, B. Burnell, A.E. Chalon,
Dietrich, G. Douw, W. Drummond,
G.H. Harlow, Hoppner, Sir T.
Lawrence, J. Lonsdale, G. Morland,
C. Picart, H.W. Pickersgill, M. Shee,
Stubbs, Teniers, J.M.W. Turner.
Des. eng.: G. Cooke, T.G. Lupton,
E. Smith, T. Wright (qq.v.).

Pup.: T.G. Lupton, Elizabeth Reynolds (qq.v.).
Pub.: Colnaghi; W. Cribb; H. Graves.

CLOSE Samuel d. Dublin (?) 1817.
Line.
A deaf mute, Close worked for others, who signed his works. He is said to have been intemperate. He was of Irish birth.

CLOUSTON Robert S. d. Australia, 1911.
Mezzo.
All. / gen. / illus. / port. / relig.
Worked in Bushey and Watford but emigrated to Australia in 1909.
Aft.: A. Burr, Gainsborough, R. Herdman, Hoppner, Lord Leighton, A.D. May, G.B. Moroni, Raeburn, Reynolds, Sir W.B. Richmond, H. Schmalz, W. Trood, G.F. Watts.
Pub.: T. Agnew; Dowdeswell and Dowdeswells; Stephen T. Gooden; A. Lucas; I.P. Mendoza; Archibald Ramsden; A. Tooth; T. Wilson.
Lit.: *Art Journal* 1898, 202. *Portfolio* 1888, 184.

COCK John fl. mid (?) 19th c.
Line.
Land. / marine.
Aft.: J. Milton.

COCHRAN John fl. 1820s—60s.
Steel.
Illus. / port.
Also a miniaturist.
Aft.: W. Daniell, W. Drummond, Hayter, Sir T. Lawrence, H. Moses, W. Salter.

COCKBURN Major-General James Pattison 1778—1847 (Woolwich).
Aq.,
Line., mezzo.
Illus. / land.
Cockburn illustrated his own travel books.

COCKBURN R. fl. 1820.
Aq., line.
Land. / port.
Cockburn was custodian of the Dulwich Gallery and engraved fifty plates from famous pictures in the collection. A complete list is in Lowndes's *Bibliographer's Manual*

p. 857 under "Galleries".
Pub.: Ackermann.

COLE Sir Henry K.C.B. 1808 (Bath) — 1882 (London).
Et., litho.
Arch. / land.
An amateur engraver, Cole was the first director of the South Kensington Museum (1858—73). He studied watercolour drawing under David Cox. His only lithograph was a view "The Ruins of the Exhibition Buildings of 1862, as seen from the Museum Residence"; it was issued in 1864. He undertook much public work, including the chairmanship of the planning committee for the Great Exhibition of 1851.

COLE Joseph Foxcroft 1838 (Jay) — 1892 (Boston, Mass.)
Et.
Gen. / land.
Studied in France in the 1860s under Lambinet and later with Charles Jacques. Emigrated to U.S.A.

COLE Thomas William b. 1857 (Shrewsbury).
Et.
Land.
Also a painter.

COLE Timothy 1852 (London) — after 1910.
Wood.
Illus.

COLE William fl. 1828 (London).
Pub.
Juv. dram. / tinsel.
See Hodgson and Co., whose stock he probably continued to issue after the firm finished.

COLEMAN Charles d. Rome 1874.
Line.
Land.
Also a painter.

COLEMAN William Stephen *c.* 1829 (Horsham, Sussex) — 1904.
Et.
Ephem. / flor. / gen. / illus. / myth.
The son of a doctor, Coleman worked in London.
Pub.: Goupil; T. McLean; A. Tooth.

157

COLERIDGE F.G. fl. 1870s.
Et.
An.
Coleridge, who was probably an amateur, lived and worked at different times in Wargrave, Henley and Twyford.
Aft.: Sir E. Landseer.

COLKETT Samuel David 1806 (Norwich) — 1863 (Cambridge).
Line., litho.
Fig. / gen. / land.
A pupil of J. Stark (q.v.), Colkett lived in London 1828—36, after which he returned to Norwich and set up as a picture dealer and restorer and teacher of drawing. Seven years later he moved with his business to Great Yarmouth and then to Cambridge. He was the father of Victoria S. Hine (q.v.).
Aft.: W. Crome, P. Snayers, J. Wildens, W. Yetts.

COLLARD William fl. Newcastle-on-Tyne early 19th c.
General trade engraver.
Topog.
Shared: J.W. Archer (q.v.).

COLLARDON L. — See Art Photogravure Co.

COLLINS George E. 1880—1968.
Et.

COLLINS Robert C. b. Edenderry, Ireland 1851.
Wood.
Illus.
Collins emigrated to U.S.A.

COLLINS William R.A. 1788 (London) — 1847 (London).
Et.
Gen.
Known mainly as a genre painter, Collins published only six plates, each a genre study with a seaside setting.

COLLINS and SCARROTT fl. 1840s.
Print.

COLLINSON James ? 1825 (Mansfield, Nottinghamshire) — 1881.
Et.
Relig.
Collinson probably executed only one etching, which accompanied a devotional poem written by himself and published in *The Germ* (1850). He was one of the seven founders of the Preraphaelite brotherhood, but he quitted it.

COLLISON-MORLEY Lieut. Colonel Clive (?) d. 1915.
Aq., Et., mixed.
Gen. / land. / theat.
Pup.: L. Taylor (q.v.).

COLLS Walter L. fl. 1894—1901.
Photo-eng.
Gen. / illus.
Aft.: G. Norman-Crosse, J. Scott.
Pub.: Art Record Press; Dowdeswell and Dowdeswells.

COLLYER Joseph 1748 (London) — 1827 (London).
Chalk, line., stip.
Gen. / hist. / illus. / mil. / myth. / port.
Son of a well-known bookseller, Collyer was apprenticed to the engraver Anthony Walker (1726—65), who worked much for booksellers; he probably continued after Walker's death with Walker's brother William (1729—93). Awarded a premium by the Society of Arts in 1761, he became a student at the R.A. in 1771. He was appointed engraver to Queen Charlotte.
Aft.: Bardon, Sir W. Beechey, J. Downman, Groves, Jean, Sir T. Lawrence, Reynolds, J. Russell, T. Stothard, D. Teniers, F. Wheatley.
Pup.: F. Engleheart, J. Heath (qq.v.).
Pub.: Boydell.

COLNAGHI Paul 1751—1833 and Dominic Paul 1790—1879.
Printsellers, pub.
Father and son. Paul was born probably in Milan, and went to Paris early in life, becoming the French agent of the London printseller Signor Torre. He came to London and subsequently took over Torre's business, which he merged into his own. His son, Dominic Paul, became head of the firm in 1833. The firm has dealt in all kinds of engravings and prints including photo-engravings. It still exists as P. and D. Colnaghi and

Co. Ltd. The shop has been at 13 and 14 Pall Mall East and 144—146 New Bond Street; it is now at 14 Old Bond Street. It was once known as P. and D. Colnaghi and Obach. There was also a Martin H. Colnaghi.

COLSON Miss Julia b. 1867.
Et.

COMFORT Arthur fl. London, Leeds and Hawes (Yorks.) 1890s.
Line.
Gen. / hist. / myth. / port.
Aft.: Bruower, J. Collier, Margaret Dicksee, H. Draper, A. Elsley, R. Goodman, A. Hacker, G. Joy, G.S. Lucas, Murillo, Rubens, F. Skipworth, M. Stone, Van Dyck.

COMMONWEALTH PUBLISHING COMPANY fl. 1890s.
Pub.
Issued photo-eng. in addition to prints produced in traditional techniques.

CONCANEN Alfred 1835 (London) — 1886 (London).
Litho.
Illus. / music.
Of Irish descent, and the son of an artist, Concanen was one of the most prolific lithographers of music covers during the heyday of the form in the 19th century.
Shared: T. Lee, R. Mallyon (qq.v.).
Lit.: Sitwell S. *Morning, Noon and Night in London* 1948. Spellman D. and S. *Victorian Music Covers* 1969.

CONDER Charles 1868—1909.
Et., litho.
Gen. / ephem. / ex libris / land. / port. / theat.
Best known as a designer and painter.
Lit.: Gibson F. *Charles Conder* 1913.

CONDER Claude Regnier fl. London second half of 19th c.
Litho. (incl. chromolitho.)
Illus.

CONEY John 1786 (London) — 1833 (Camberwell).
Et., line.
Arch. / illus. / topog.
Coney was apprenticed to an architect.

He died in poverty, his heart broken by neglect.
Pub.: Moon, Boys and Graves.

CONGREVE Sir William 1772—1828 (Toulouse).
Inventor of a method of colour printing described as follows in *A Treatise on Wood Engraving* by J. Jackson, 1861, p. 630:
"Sir William Congreve's mode of colour printing, however, patented many years ago, and now practised by Mr Charles Whiting [q.v.] of Beaufort House, is one of the least expensive of all. It consists in printing several colours at one time, and may be thus described:- 'A coloured design being made on a block, the various colours are cut into their respective sections, like a geographical puzzle, and placed in an ingeniously constructed machine, which links them separately, and prints them together. By this mode speed is obtained in large operations, and the colours are prevented from running into each other. It is extensively applied to bookcovers, decorative show-cards, the back of country notes, and labels, where the object is to prevent forgery.' — See *Bohn's Lecture on Printing*, page 104."

CONNABEER Albert James b. Plymouth 1862.
Line.

CONNELL James and Sons fl. London 1890s.
Pub.

CONSTABLE John 1776 (East Bergholt) — 1837 (London).
Et.
Land.
The great East Anglian landscape painter; made two etchings: "Milford Bridge near Salisbury" and "West End of Netley Abbey".
Shared: D. Lucas (probably).

CONWAY Charles I 1820 (Whitehall) — 1884 (Whitehall).
CONWAY Charles II fl. Wales, *c.* 1870.
Et. (amateur).
Land.

COOK Charles fl. 1860—75.
Steel.
Illus. / port.
Aft.: Leighton, Raphael; and after
photos.

COOK Conrad fl. 19th c.
Line., steel.
Illus. / port. / relig.

COOK Henry R. fl. London 1813
—47.
Line., steel.
Illus. / port.
Aft.: Craig, Haines, Sir T. Lawrence,
Raeburn.

COOK J.W. fl. 1827.
Steel.
Illus. / port.
Aft.: S. Aikman, Lewis.

COOK Thomas c. 1744—1818
(London).
Line.
*An. / arch. / fig. / gen. / hist. / illus. /
land. / myth. / port.*
Cook was a pupil of Simon François
Ravenet (q.v.) who was at the time
living in London.
Aft.: J. Boydell, Dietrich, W. Hogarth,
J. Milton, Reynolds, P. Sandby, B.
West, R. Westall, W. Woollet.
Shared: S. Smith (q.v.).
Pub.: Boydell.

COOKE Edward William R.A. 1811
(Pentonville) — 1880 (Groombridge,
nr. Tunbridge Wells).
Et., line., mixed.
Gen. / marine / ship. / topog.
While still only nine years old and at
school, Cooke drew plants on wood at
a Hackney nursery, to illustrate
Loudon's *Encyclopedia of Plants.*
Other similar works followed. In 1825
he met Clarkson Stanfield and sketched
boats etc. for and after him. He then
began to work in oil and painted a sign
for the Old Ship Hotel, Brighton; for a
time he studied architecture under
Augustus Pugin, but gave this up for
the further study of boats. Cooke
travelled abroad to France, Belgium,
Holland, Spain, Morocco, Barbary,
Germany and Scandinavia; he also
visited Scotland and Ireland. He

worked in Barnes, Kensington and
Groombridge. He influenced M.E.
Colman (q.v.) who worked with him.
Des. eng.: S. Bradshaw, I. Jeavons,
Constance Pott (qq.v.).
Shared: G. Cooke (q.v.).

COOKE George 1781 (London) —
1834 (Barnes).
Line., mezzo., steel.
*Arch. / flor. / gen. / illus. / land. /
port. / relig. / ship. / topog.*
Cooke was a son of a wholesale
confectioner from Frankfort-on-Maine,
who settled in London. He was
apprenticed to J. Basire II (q.v.) and
was the younger brother of W.B. Cooke
(q.v.). His one mezzotint was
unsuccessful and was never published.
Aft.: A.W. Callcott, L. Clennell,
G. Clint, E.W. Cooke, J.S. Cotman,
De Wint, Harding, Havell, E. Nash,
Prout, Reinagle, Roberts, C. Stanfield,
Stark, J.M.W. Turner.
Pup.: T.L. Aspland, T.S. Boys, W.J.
Cooke, G. Hollis, W. Miller, J. Saddler
(qq.v.).
Shared: E.W. Cooke, W.B. Cooke,
J. Pye (qq.v.).
Pub.: Hakewell, D'Oyley and Mant.

COOKE T. fl. 1830s.
Steel.
Fig.
Aft.: Hogarth.

COOKE William Bernard 1778
(London) — 1855 (Camberwell).
Line., steel.
Illus. / land. / marine.
W.B. Cooke was the elder brother of
G. Cooke and a pupil of W. Angus
(qq.v.).
Aft.: E.W. Cooke, C. Fielding, B.
Marshall, J. Martin, J.M.W. Turner.
Shared: J.C. Allen (his apprentice),
G. Cooke (qq.v.).
Pub.: R.R. Reinagle; Charles Tilt.
Lit.: *Art Journal* 1855, p. 267;
1865, pp. 216, 260, 284. Gage J.
(ed.) *Collected Correspondence of
J.M.W. Turner* 1980.

COOKE William John 1797 (Dublin)
— 1865 (Darmstadt).
Line., steel.
Illus. / land. / topog.

W.J. Cooke was brought to England by his parents when he was one year old. He was placed under his uncle G. Cooke (q.v.). In 1826 the Society of Arts awarded him a gold medal for his improvements in engraving on steel. He left England and settled in Darmstadt *c.* 1840.
Aft.: A.B. Campion, D. Cox, E.T. Daniell, Sir E. Landseer, G. Petrie, C. Stanfield, J.M.W. Turner.

COOKSEY May Louise Grenville 1878 — after 1908.
Et.
Illus. / land.
Also a painter.

COOMBE Arthur E. fl.
Thirlstone, Dorking and Brighton 1880s.
Line.
Arch. / topog.
Aft.: W.B. Gardner, G. Reid.

COOMBS Joseph Epenetus fl. 1850s.
Mezzo.
Gen. / hist. / myth. / port.
Aft.: E. Corbould, G. Hayter, Poussin, Reynolds, C. Ruben.
Shared: A plate by Coombs after Reynolds was re-engraved by S. Cousins (q.v.).
Pub.: H. Graves.

COOPER Abraham R.A. 1787 (London) — 1868 (Greenwich).
Et.
An. / gen. / land. / mil.
A self-taught artist, best known for his historical, sporting and military paintings; he also made a few etchings. Father of A.D. Cooper (q.v.).
Des. eng.: J. Bromley, W. Finden, W. Giller, J. Goodyear, E. Hull, R. Parr, J. Rogers, J.C. Webb.

COOPER Alexander Davis fl. 1830s—80s.
Line.
Gen.
Son of Abraham Cooper (q.v.), A.D. Cooper worked in Manchester and Bloomsbury. He is best known as a painter of genre, landscapes and portraits.
Des. eng.: Charles Knight (q.v.).
Pub.: H. Graves.

COOPER James Davis 1823 (Lambeth) — 1904 (Highgate).
Wood.
Illus.
Cooper came from a family of musicians, his father being assistant organist at St. Paul's Cathedral and the Chapel Royal, and organist at St. Sepulchres, in each of which places J.D. Cooper succeeded him. He was educated at the City of London School and became a pupil of Josiah Whymper (q.v.). Some work under his signature was engraved by T. Carreras (q.v.).
Aft.: R. Caldecott, Etheline E. Dell, Birket Foster, C. Keene, S. Palmer, P. Skelton, H. Weir.

COOPER John fl. 1822.
Line.
Port.

COOPER Richard 1730 (London) — 1820 (London).
Line.
Port.
A pupil of Le Bas, at Paris.

COOPER Richard the younger *c.* 1740 (London) — 1814 (London).
Aq., et., line., litho., mezzo., stip.
Gen. / hist. / mil. / myth. / port. / relig. / topog.
Son of the engraver Richard Cooper the elder (1705—64), Richard Cooper the younger studied engraving under J.P. Le Bas, the French engraver. He probably visited Italy during the 1760s and/or 1770s. He settled in Charles Street, St. James's Square, London, *c.* 1787. His appointments included that of drawing master to Queen Charlotte and drawing master at Eton College.
 He signed his work "Riccardus Cooper".
Aft.: A. Buck, Burney, Corbould, Correggio, W.M. Craig, J.L. David, Edridge, Isabey, R. Jones, Place, N. Poussin, Rubens, S. Shelley, T.M. Slade, H. Stochling, Trevasini, Van Assen, Van Dyck, J.M. Wright, Des. eng.: S. Alken.
Pub.: Philip André, Edward Orme.

161

COOPER Robert d. 1836 or later.
Line., steel.
Illus. / port. / relig.
The Duke of Buckingham
commissioned a number of private
plates from this engraver, including
one of the "Chandos" portrait of
Shakespeare. For a time Cooper was
engaged in publishing, but without
success.
Aft.: H. Corbould, S. De Wilde,
Holbein, Mignard, Saunders, Van Dyck,
Velasquez.
Pup.: R.A. Artlett (q.v.).

COOPER Thomas George fl. 1840s—
90s.
Et.
An. / port.
A son of T.S. Cooper (q.v.), T.G.
Cooper is noted especially for paintings
of animals.

COOPER Thomas Sidney R.A. 1803
(Canterbury) — 1902 (Vernon Holme).
Line., litho.
An. / ephem. / interiors / land. / topog.
T.S. Cooper is best known as a painter
of cattle. He studied at the R.A.
Schools, and then went to Brussels as
a teacher, where he was influenced by
the animal painter Verboeckhoven and
by earlier Dutch masters. He settled in
London in 1831. Most of his
lithographs were made before 1840.
T.G. Cooper (q.v.) was his son.
Aft.: Sir E. Landseer, C.F. Tomkins.
Des. eng.: C. Cousen, J. Godfrey,
J. Harris, C. Hollyer, R. Parkes, H.
Sedcole (qq.v.).
Pub.: Ackermann; Dickinson; S. and J.
Fuller; T. McLean; F.G. Moon.

COOPER W.J. fl. London 1874—
1880s.
Et.
Land. / topog.

COPE Charles West, R.A. 1811
(Leeds) — 1890 (Bournemouth).
Et.
Fig. / gen. / lit. / port.
Cope is noted mainly as a painter. The
son of C.W. Cope the elder of Leeds,
he came to London and studied at
Henry Sass's Art School. He worked in
Leeds, London and Italy. His painted
works include some of the fresco
decorations in the Houses of
Parliament.
Des. eng.: J. Dobie, T.W. Knight, J.
Scott, C. Tomkins, T. Vernon.
Pub.: Art Union.
Lit.: Cope C.H. *Reminiscenes of C.W.
Cope* 1891. *Portfolio* 1890, p. xx.

COPLEY John 1875 (Manchester) —
1950.
Et., litho.
An. / fig. / land. / relig. / sport.
Also a painter, Copley was trained at
the Manchester School of Art and the
Royal Academy Schools. He was
secretary of the Senefelder Club
1910—16.
Lit.: *P.C.Q.* XIII, p. 273.

COPLEY John Singleton R.A. 1737
(Boston, Mass.) — 1815.
Line., litho.
Port.
American national who settled in
England and became a leading portrait
and historical painter.

COPPIER André-Charles 1867
(Annecy) — *c.* 1911.
Et., line., mezzo.
Port.
French national who made a number
of plates after works by British artists
which were published in England.
Aft.: P.T. Cole, Sir T. Lawrence,
Reynolds.
Pub.: H. Graves.

CORAM Thomas 1756 (Bristol) —
1812.
Line.

CORBAUX Louise b. London 1808.
Litho.
Fig. / port.
Also a painter.

CORBOULD George James 1786—
1846.
Line., steel.
Illus.
G.J. Corbould was the second son of
Richard Corbould and brother of
Henry Corbould (qq.v.). He was a
pupil of James Heath (q.v.).
Aft.: H. Corbould.

CORBOULD Henry 1787 (London) — 1844 (Robertsbridge).
Litho.
Brother of George James Corbould and son of Richard Corbould (qq.v.). Best known as a painter.

CORBOULD Richard 1757 (London) — 1831 (Highgate).
Litho.
Father of George James and Henry Corbould. Best known as a painter and miniaturist.

CORKS William E. fl. London (Northampton Square, Clerkenwell; Carnaby Street) late 19th c.
Line.
Ex libris.
Pup.: R. Osmond (q.v.).

CORMACK Mrs Minnie F. (née Everett) 1862 (Skibereen, Cork) — c. 1909.
Mezzo.
Fig. / gen. / lit. / port.
A student of T.G. Appleton (q.v.). Aft.: Sir L. Alma-Tadema, W. Etty, Greuze, Hoppner, Sir T. Lawrence, Sir P. Lely, W. Miller, F. Morgan, G. Morland, J. Opie, Sir E. Poynter, Raeburn, Reynolds, Romney, W. Wontner.
Pub.: Colnaghi; J. Connell; Fine Art Society; Frost and Reed; Frank Holl; McQueen; I.P. Mendoza; A. Tooth.

CORNER John fl. 1788—1825.
Gen. / illus. / port.
Corner's best-known work is in a publication entitled *Portraits of Celebrated Painters*, in which each plate is a portrait of an artist depicted with his most famous work. It was not a success and only twenty-five plates were published.
Aft.: M. Brown, S. De Wilde, W. Lawranson, J.C. Lochée, E. Penny, Van Dyck.

COSSÉ Laurence J. fl. London 1784 —1837.
Line.
Land.

COSWAY Maria Cecilia Louisa fl. 1820.
Et. (incl. soft ground).
Land. / port.
Best known as a miniaturist Mrs Cosway was born in Italy, where her father, whose name was Hadfield, kept an inn at Leghorn. She married Richard Cosway the fashionable miniaturist in 1781. She published a book of her etchings: *Gallery of the Louvre . . .* in 1802.
Lit.: Williamson G.C. *Richard Cosway R.A.* 1905.

COTMAN John Joseph 1814 (Gt. Yarmouth) — 1878 (Norwich).
Et.
Land.
Second son and pupil of J.S. Cotman (q.v.). He served an apprenticeship under his uncle, Edmund Cotman. With his brother, M.E. Cotman (q.v.), he taught drawing in Norwich. He is best known as a painter.
Lit.: Batchelor A. *Cotman in Normandy* 1926. "Sprite" (pseud. for J.J. Cotman) *A Norwich Artist's Reminiscenes* 1925. William Weston Gallery *Etchings by John Sell Cotman and his Sons* 1972.

COTMAN John Sell 1782 (Thorpe, nr Norwich) — 1842 (London).
Et. (incl. soft-ground), litho.
Antiq. / arch. / fig. / land. / topog.
Best known as a watercolourist, Cotman was a son of a Norwich silk mercer and lace dealer. Educated at Norwich Free Grammar School, he was intended for his father's business; he decided instead on a career in art and went to London c. 1798—99 to study. He returned to Norwich in 1807, and married Ann Miles, daughter of a Felbrigg farmer. He earned a living mainly from teaching art, but found time to visit Normandy in 1817, 1818 and 1820. On the recommendation of J.M.W. Turner, he became drawing master at King's College, London, and he settled in the metropolis, living at No. 42 Hunter Street, Brunswick Square. He suffered from depression in his last years.

Cotman, who based his etching style on that of Giovanni Battista

Piranesi, published several collections of etchings, among them *A Narrative of the Grand Festival at Great Yarmouth on Tuesday the 19th of April* (1814), Dawson Turner's *Architectural Antiquities of Normandy* (1822) and, best of all, *Liber Studiorum,* a book of soft-ground etchings published in 1838.
Pup.: C.L. Brightwell (q.v.).
Lit.: Kitson S.D. *The Life of John Sell Cotman* 1937. *P.C.Q.* IX, 236—73. Smith S.C.K. *Cotman* 1926. William Weston Gallery *Etchings by John Sell Cotman and his Sons* 1972.

COTMAN Miles Edmund 1810 (Norwich) — 1858 (Norwich).
Et., litho., stip.
Land. / marine.
A son of J.S. Cotman (q.v.), Miles Edmund was brought up as an artist. He assisted his father in his teaching practice and was in 1836 appointed his assistant at King's College, London; he succeeded him in 1843. This appointment did not last and he spent his last years painting and teaching in North Walsham. He is best known as a painter, but etched about 50 plates. He was much influenced by Edward Cooke (q.v.) with whom he worked.
Lithos aft.: J.S. Cotman.
Pub.: Charles Muskett (Norwich).
Lit.: William Weston Gallery *Etchings by John Sell Cotman and his Sons* 1972.

COTSWORTH M.B. fl. 1831.
Litho.
Railways.

COTTIN Pierre 1823 (Chapelle-Saint-Denis) — *c.* 1887.
Mezzo.
Hist.
French national who engraved at least one plate after a British artist which was published in England.
Aft.: R. Muller.
Pub.: Goupil.

COTTREL Wellsley fl. 1889—96.
Line.
Relig.
Also a painter.
Aft.: C. Dolci, G. Reni, B. West.

COULSON Henry Major b. South Shields 1880.
Aq., et.
Land.
Also as watercolourist.

COURTNEY J. d. after 1836.
Line.
Port.

COURTRY Charles Jean Louis 1846 (Paris) — 1897 (Paris).
Et., line.
Gen. / illus. / relig.
French national who made a number of plates after works by British artists which were published in England. A pupil of L. Flameng and L. Gaucherel (qq.v.), he worked for a time in London. He was father of C.L. Courtry, etcher and lithographer.
Aft.: A. Marsh, A. Stevens.
Pub.: British and Foreign Artists' Association.

COUSEN Charles *c.* 1819 (Yorkshire) — 1889.
Line., steel.
Fig. / gen. / illus. / land. / myth. / ship. / topog.
Cousen, who was noted for his steel engravings, was a pupil of W. and E. Finden (qq.v.) and a younger brother of J. Cousen (q.v.).
Aft.: J. Allom, R. Ansdell, W. Bartlett, Rosa Bonheur, V. Cole, W. Collins, Constable, J.S. Cooper, W. Cooper, W. Etty, B. Foster, J.C. Hook, W.H. Hunt, Sir E. Landseer, B.W. Leader, C. Leader, J. Linnell, W. Mulready, Murillo, J. Pettie, G. Pinwell, S. Prout, T. Stothard, J.M.W. Turner.
Pub.: Art Union of London; William Bartlett; Gambart; J. Hogarth; Virtue and Co.
Lit.: *Art Journal* 1889 pp. 363—64.

COUSEN John 1804 (Mingshaw, Yorks) — 1880 (South Norwood).
Steel.
All. / fig. / gen. / hist. / illus. / lit. / land. / myth. / relig. / ship. / topog.
John Cousen was a brother of Charles Cousen. He was apprenticed to John Scott (q.v.) and worked in South Norwood.
Aft.: T. Allom, R. Ansdell, W.H.

Bartlett, A. Callcott, G. Cattermole,
T.S. Cooper, T. Creswick, W.P. Frith,
J. Harding, J. Holland, Sir E. Landseer,
F. Lee, W.L. Leitch, D. Roberts, W.C.
Stanfield, J.M.W. Turner, H. Wallis,
Sir D. Wilkie.
Shared: Lumb Stocks (q.v.) engraved
figures on a plate by Cousen: "Peace",
after Sir E. Landseer.
Pub.: T. Agnew, J. Hogarth.
Lit.: *Art Journal* 1881, p. 63.

COUSINS Henry 1809—64
(Dorking).
Mezzo., mixed.
Gen. / hist. / port. / relig.
Younger brother of S. Cousins (q.v.).
Aft.: T. Barber, C. Baxter, W. Bradley,
H. Briggs, W.T.C. Dobson, T. Faed, Sir
F. Grant, Sir G. Hayter, J.C. Horsley,
Sir E. Landseer, J. Lonsdale, J. Lucas,
W. MacKenzie, Merle, J.G. Middleton,
A. Morton, F. Newenham, T. Partridge,
T. Phillips, H.W. Pickersgill, W.H.
Powell, G. Richmond, G. Romney,
J. Sant, Sir M. Shee, G. Watson, F.
Winterhalter.
Shared: R. Mitchell (q.v.) on a plate
entitled "Prayer, children of the Duke
of Argyle" after James Sant; this was
realised in a mixture of mezzotint and
etching. Some other plates shared with
S. Cousins (q.v.).
Pub.: Colnaghi; H. Graves; Moore,
McQueen and Co.; W. Schaus.
Lit.: Engen R.K. *Victorian Engravings*
1975.

COUSINS J. fl. 1830s.
Steel.
Illus. / land.
Aft.: T. Allison, W.H. Bartlett, C.
Stanfield, Turner.

COUSINS Samuel R.A. 1801
(Exeter) — 1887 (London).
Mezzo.
Arch. / fig. / gen. / hist. / relig. / sculp.
Cousins, who was the elder brother of
H. Cousins (q.v.), received his early
education at Exeter Episcopal School.
At the age of ten he was awarded a
silver palette by the Society of Arts.
Sir Thomas Dyke Acland, who
befriended him, ensured the
continuance of his education. He
became an apprentice of S.W. Reynolds

(q.v.) and at the same time received
lessons from T.G. Lupton (q.v.).
Cousins was an assistant to
Reynolds for four years, but thereafter
set up for himself at 104 Great Russell
Street, London, and later moved to
24 Camden Square. He was the first
engraver to be elected a full Royal
Academician.
Aft.: T. Barber, Rosa Bonheur, W.
Boxall, J. Bridges, H.W. Burgess,
Fanny Corbaux, Margaret Carpenter,
A. Chalon, Sir F. Chantrey, S. Cole,
Lady Coleridge, Correggio, C.M.
Cregan, J. Cristall, Dickenson, L.
Dickinson, F. Dicksee, C.M. Dubufe,
E. Dubufe, Sir C. Eastlake, E.U. Eddis,
W. Etty, T. Faed, F. Goodall, W.
Gordon, Sir F. Grant, Greuze, Hogarth,
A. Howard, J. Jackson, J. Knight,
Sir E. Landseer, B. Lauchert, Sir T.
Lawrence, T. Leakey, Lord Leighton,
C.R. Leslie, H. Liverseege, E. Long,
J. Lucas, H. Merle, Sir J.E. Millais,
T. Mogford, Murillo, Nasmyth, G.S.
Newton, M. Owen, J. Partridge, H.
Phillips, T. Phillips, H. Pickersgill,
Raeburn, J. Raoux, R. Reinagle,
G. Reni, Sir J. Reynolds, S.W.
Reynolds, G. Richmond, B. Rivière,
J. Robertson, Sanders, J. Sant, F.R.
Say, J. Severn, Sir M. Shee, T.
Stewardson, T. Sully, E.M. Ward,
H. Weigall, H. Wells, Sir D. Wilkie, F.
Winterhalter.
Pup.: T.L. Atkinson (q.v.).
Shared: T.L. Atkinson, S. Bellin, H.
Cousins, R. Mitchell, W. Walker (qq.v.)
Cousins also re-engraved a plate after
Sir J. Reynolds, originally engraved by
J. Coombs.
Pub.: Ackermann & Co.; T. Agnew; T.
Boys; E. Coleridge; P. and D. Colnaghi;
J. Dickinson; J. Eddowes; Fine Art
Society; H. Graves; Hodgson and
Graves; J. Hogarth; A. Lucas; T.
McLean; Molteno and Graves; F.G.
Moon; J. Ryman; J. Seacombe
(Chester); J. Watson; D.T. White;
Wyatt and Son.
Lit.: Engen R.K. *Victorian Engravings*
1975. Pycroft G. *A Memoir of Samuel
Cousins* 1887. Whitman A. *Nineteenth
Century Mezzotints: Samuel Cousins*
1904.

COUTTS William (Later Viscount
Bury, then Earl of Albemarle) 1832
—94.
Et.
Lit.
Worked in Liverpool.

COUZENS Charles fl. 1840s.
Litho.
An. / illus.

COVENTRY J. fl. London (80 King
William Street) mid 19th c.
Pub. of lithos.
Ship.

COWELL'S ANASTATIC PRESS fl.
Ipswich 1870s.
Print. (anastatic process).
Probably the only firm to practise this
process by way of business.
Publications include *Old Cambridge* by
W.B. Redfarn, 1876, which contains
twenty-six plates reproduced by the
anastatic process.

COWEN William 1797 (Rotherham)
— c. 1860.
Aq., et., litho.
Arch. / hist. / land. / port. / topog.
Under the patronage of Earl
Fitzwilliam, Cowen travelled abroad a
great deal in Italy and Switzerland.
Later he visited Corsica and on his
return resided at Gibraltar Cottage,
Thistle Grove, Old Brompton. His
work is much concerned with views
seen on his travels, although he also
engraved many British subjects.

COX David, the elder 1783
(Deritend, Birmingham) — 1859.
Aq., et. (soft-ground).
Land. / topog.
Cox, one of the greatest of English
landscape painters, was the son of a
blacksmith and whitesmith. He served
an apprenticeship with Fielding, a
locket and miniature painter of
Birmingham, who committed suicide
eighteen months later. After this he
found employment as an assistant to
a scene painter at Birmingham at a
theatre run by the father of Macready
the great tragedian. But Cox quarrelled
with Macready and went to London
where he obtained scene painting work
at various theatres. He was soon,
however, launched on his career as a
landscape painter, working mainly in
watercolours, but also in oils. He also
worked in aquatint and etching, both
of which he used to illustrate his own
publications: *A Treatise of Landscape
Painting* (1814); *Progressive Lessons
in Landscape* (1816); and *The Young
Artist's Companion* (1819—1921).
He was father of David Cox the
Younger (q.v.).
Des. eng.: W. Radclyffe, R. Reeve
(q.v.).
Lit.: Cox T. *Life of David Cox* 1948.

COX David (the younger) 1809
(Dulwich) — 1885 (Streatham Hill).
Et.
Land.
Son of David Cox the elder (q.v.)
whose style he followed.

COX J. fl. 1830s—40s.
Steel.
Illus. / land.
Aft.: W. Tombleson.

COX T. fl. 1840s.
Steel.
Arch. / illus. / land.
Aft.: J. Henshall, W. Tombleson.

COX Walter Alfred 1862 — c. 1908.
Et., mezzo., photo-eng.
*An. / arch. / gen. / hist. / mil. / port. /
sport. / topog.*
A pupil of J. Ballin (q.v.).
Aft.: F. Barraud, J.P. Beadle, Jane
Bowkett, A.W. Brown, R. Carter, L.
Davis, Maud Earl, M. Fraser, R. Gallon,
C. Garland, Gaucherel, T. Good, A.C.
Havell, T. Hemy, M. Kavel, S. Lucas,
A.H. Moore, J. Nicol, H. Page,
Raeburn, Romney, J. Russell, F.
Salisbury, R. Scott, A. Sedly, D.
Sherrin, Tenré, W. Trood, A.H.
Wardlaw, H. Wimbush, R. Woodville.
Shared: L. Gaucherel (q.v.).
Pub.: Louis Brall; Dickinson and
Fisher; Dowdeswell and Dowdeswells;
Fisher, Adler and Schwarz; Fores;
H. Graves; I.P. Mendoza.
Lit.: *Art Journal* 1908.

CRABB T. fl. 1816.
Aq.
Illus. / mil.

CRAFT Percy Robert 1856—1924.
Et., litho.
Gen. / land. / marine.
Craft was a pupil at the Slade School where he studied under A. Legros and Sir E. Poynter (qq.v.). He worked in London, Sydenham, Huntingdon and Penzance, and was also a painter.

CRAIG Edward Gordon 1872—1966.
Et., wood.
Ex libris / fig. / land. / myth. / theat.
This influential stage designer was the son of Ellen Terry, and a pupil of Sir William Nicholson. He is noted for his revolutionary ideas in the arts of the theatre.
Lit.: Craig E.G. *Woodcuts and Some Words* 1924. Leeper Janet *Edward Gordon Craig. Designs for the Theatre* 1948. Nash George *Edward Gordon Craig 1872—1966* 1967. *P.C.Q.* IX, 406—32. [Unsigned] *Catalogue of Etchings: Being Designs for Motions by Gordon Craig* 1908.

CRAIG William Marshall fl. 1788—1827.
Et., stip., wood.
Gen. / myth. / ship.
Craig was also a watercolourist and was the author of a satire on William Gilpin: *Essay on the Study of Nature in Drawing Landscape* 1803.

CRAMP V. fl. 1880s.
Et.
Land.
Aft.: J.B. Pierce.

CRANE Thomas 1808 (Chester) — 1859 (London).
CRANE William d. 1843.
Litho.
Illus. / port.
Brothers, sons of a Chester bookseller. William was father of Walter Crane, the noted book illustrator (q.v.).

CRANE Walter 1845—1915.
Litho.
Port.
A noted illustrator and designer, Crane made one original lithograph, a self portrait at the age of 60. For a time he was a pupil of W.J. Linton (q.v.). Des. eng.: Adolf Doring, Frederick Footlet (qq.v.).
Lit.: Masse Gertrude C.E. *A Bibliography of First Editions of Books Illustrated by Walter Crane* London 1923, repr. 1977. Crane Walter *An Artist's Reminiscenes* 1907.

CRANSTONE Lefevre T. fl. London 1845—67.
Et.
Land.
Also a painter.

CRAWFORD — fl. London (3 Dean Street, Holborn) c. 1850.
Pub.
Tinsel.
J. Redington (q.v.) was his agent.

CRAWFORD Susan d. Glasgow 1918.
Et.
Land.

CRAWFORD Thomas Hamilton 1860 (Glasgow) — c. 1923.
Mezzo.
Port.
A pupil of Sir H. Herkomer (q.v.), Crawford is best known as a painter of urban scenes and architecture. He took to engraving early in the 20th century, and worked in Highgate and Finchley.
Aft.: J. Collier, W. Dyce, Sir H. von Herkomer, Sir J.E. Millais, Sir E. Poynter, Reynolds, J.R. Smith, Mary Waller, J. Zoffany.
Pub.: T. Agnew; A. Baird-Carter; Leggatt; The Museum Galleries.

CRAWHALL Joseph I 1793—1853.
CRAWHALL Joseph II 1821—96.
Wood.
Illus.
Father and son who worked in Newcastle-on-Tyne. The work of Joseph Crawhall II was much influenced by cuts in old chapbooks and ballad broadsheets and in turn had a considerable influence on the work of Sir William Nicholson, E.G. Craig (qq.v.) and Claud Lovat Fraser.
Lit. Felver C.S. *Joseph Crawhall* 1872.

CREED G. fl. London (21 Exeter Street, Strand) 1818.
Pub.
Juv. dram. / tinsel.

CRESWICK Thomas R.A. 1811 (Sheffield) — 1869 (London).
Et., line., wood.
Land. / gen. / lit.
Creswick is best known as a landscape painter. He was a pupil, at Birmingham of John Vincent Barber. He studied in London, where he settled in 1828.
Des. eng.: G. Baxter, E. Radclyffe, R. Wallis, J. Williams (qq.v.).
Pub.: Art Union of London.

CREW John fl. 1863—80.
Steel.
Arch. / illus. / land. / port.
Aft.: J.C. Armytage, B. Foster, C. Werner, L.J. Wood; and after photos.
Aft.: W. Hughes, J.T. Lucas, J. Noble.
Pub.: B. Brooks, A. Lucas.

CRICKMORE Harry fl. 1879—92.
Et., mezzo., mixed., stip.
Arch. / gen. / mil.

CRISTALL Elisabeth *c.* 1770 (London) — after 1851.
Line.
Fig. / gen.
Sister of J. Cristall (q.v.).
Aft.: J. Cristall.

CRISTALL Joshua 1767 (Cambourne) — 1847 (London).
Et.
Fig. / gen.
Cristall served an apprenticeship as a porcelain painter at Rotherhithe. Despite parental opposition he became an art student in London, studying at the R.A. He was much encouraged by the art benefactor Dr. Munro. He is best known as a watercolourist. Elisabeth Cristall (q.v.) was his sister.

CRISTOE Thomas fl. London (34 Drury Lane) *c.* 1819.
Pub.
Tinsel.

CROKE Lewis Edmund b. London 1875.
Dry., litho.
Land. / topog.

CROKER Thomas Crofton 1798 (Cork) — 1857.
Et. (amateur)
Port.
Also a writer.

CROLL Francis 1827 (Musselburgh) — 1854 (Edinburgh).
Line., steel.
An. / gen. / hist. / illus. / mil. / port.
Croll served an apprenticeship in Edinburgh with Thomas Dobbie, a draughtsman and naturalist. Dobbie died before Croll's apprenticeship was completed and he served a further two years under the engraver Robert Charles Bell (q.v.); he also attended the Schools of the Royal Scottish Academy.
Aft.: J. Drummond, J. Faed, F. Goodall.
Pub.: Art Union; Royal Association for the Promotion of Fine Arts in Scotland.

CROMBIE Benjamin William 1803 (Edinburgh) — 1847 (Edinburgh).
Et.
Port.

CROME Frederick James 1796 (Norwich) — *c.* 1831.
Et.
Aft.: Old masters.

CROME John ("Old Crome") 1768 (Norwich) — 1821 (Norwich).
Et. (incl. soft-ground).
Land. / topog. / trees.
The son of a weaver, Crome began life as an errand boy. After this he became a house painter, and then set up as a drawing master. He was the founder of the Norwich school of artists, and was one of the great landscape painters of his day. He etched 44 plates, 14 of them in soft-ground, but did not publish them. He did, under the persuasion of his wife and family, prepare a prospectus in 1812, but nothing came of it and it was not until thirteen years after his death that they were published by his wife and son, J.B. Crome.
Pup.: J.B. Ladbrooke, J. Stark (qq.v.).
Shared: W.C. Edwards (q.v.) added details of the sky to the etching

"Mousehold Heath" after Crome's death.
Lit.: Clifford C. and T. *John Crome* 1968. Theobold H.S. *Crome's Etchings: a Catalogue* 1907. William Weston Gallery *The Complete published Etchings of John Crome* 1974.

CROME John Beney 1794 (Norwich) — 1842 (Gt. Yarmouth).
Et.
Land. / topog.
J.B. Crome, who was also a watercolourist, was a son of John Crome (q.v.) whose style he followed.

CROMEK Robert Hartley 1771 (Hull) — 1812 (London).
Line., printseller, pub.
Gen. / lit.
Cromek was intended for the law, but he abandoned this for a career in art and literature. After studying for a time in Manchester, he came to London, and became a pupil of Bartolozzi.
Aft.: W. Blake, H. Hone, T. Stothard.

CROOKE W.P. fl. Bayswater 1880s.
Et.
Arch. / topog.

CROSS John 1819 (Tiverton) — 1861 (London).
Line.
Ex libris. / gen. / hist.
Cross was best known as a historical painter.
Aft.: Henry Shenton.

CROSTICK T. fl. 1820s.
Steel.
Arch. / illus.
Aft.: J.M.W. Turner.

CROTCH William 1775 (Norwich) — 1847 (Taunton).
Line., litho.
Land.
Also a well-known musician.

CROWDY AND LOND fl. early 20th c.
Pub.
Photo-eng.

CRUCHLEY John Frederick
fl. London 1820—60.
Line., steel, wood.
Ex libris / illus.

CRUIKSHANK George 1792 (London) — 1878 (London).
Aq., cliché verre, et., wood.
Caric. / ephem. / gen. / illus. / lit. / music / political / ship. / temperance
One of the greatest of illustrators and caricaturists, George Cruikshank was almost untutored. He was the son of Isaac Cruikshank (q.v.), on whose style he based his own. His illustrations remain some of the best ever made; such are those for *Oliver Twist* and *Nicholas Nickleby*. He was brother of Robert Cruikshank (q.v.).
Des. eng.: C. Mottram (q.v.).
Shared: Some plates completed by C. Mottram.
Lit.: Bates W. *George Cruikshank: The Artist, the Humanist and the Man* 1879; repr. 1972. Cohn A. *George Cruikshank: A Catalogue Raisonné* 1924; repr. 1969. de Maré E. *The Victorian Woodblock Illustrators* 1980. Douglas R.J.H. *The Works of George Cruikshank Classified and arranged . . . and their approximate values* 1903; repr. 1976. Feaver W. *George Cruikshank* 1974. McLean R. *George Cruikshank his Life and Work as a Book Illustrator* 1948. Victoria and Albert Museum *George Cruikshank* 1974.

CRUIKSHANK Isaac c. 1756 (Leith) — 1811 or 1816 (London).
Et., stip.
Caric. / ephem. / illus. / lit. / political
Father of George and Robert Cruikshank (qq.v.), Isaac settled in London about the end of the 18th c.
Pub.: Laurie and Whittle.
Lit.: Krumbharr E.B. *Isaac Cruikshank: a Catalogue Raisonné* 1966.

CRUIKSHANK Robert Isaac 1789 (London ?) — 1856.
Aq., et.
Caric. / illus. / sport. / theat.
The eldest son of Isaac Cruikshank and brother of George Cruikshank, Robert began life as a midshipman in a ship of the East India Co., but left the service

to become an artist.
Lit.: Marchmont F. *The Three Cruikshanks: a Bibliography* 1897.

CRUSE A. fl. 1820s—40s.
Steel.
Arch. / illus. / land.
Aft.: J. Fussell, J.P. Neale, T.H. Shepherd, W. Tombleson.

CUFF R.P. fl. 1860.
Steel.
Illus. / land.
Aft.: J. Ruskin.

CUFF T. fl. 1845.
Steel.
Ex. libris / illus. / land.
Aft.: T. Allom.

CUITT George 1779 (Richmond, Yorks) — 1854 (Masham).
Et.
Arch. / port. / topog.
The son of the painter George Cuitt the elder, young George was attracted to etching by the works of Pirenesi, some of whose etchings his father had brought from Rome. He moved to Chester *c.* 1804 where he taught drawing. He published a collection of his works, *Wanderings and Pencillings among the Ruins of Olden Times* (1848).
Pup.: W.Y. Ottley (q.v.).
Lit.: Craddock and Barnard *Modern Etchings (19th and 20th centuries). Catalogue 135. 1977.*

CULLIFORD C.J. fl. 1850s.
Litho.
An. / illus.
Noted for illustrations of poultry.

CUMBERLAND George *c.* 1760—1848.
Et., litho.
Calligraphy.
A friend of William Blake (q.v.), Cumberland was a dilletante. He was a writer, and his works included an *Essay on . . . Ancient Engravers* (1827). He made a number of experiments in reproducing handwriting by means of etching and it is possible that these may have influenced Blake in the development of his method of relief etching.

CURRIE Robert fl. Bridge of Earn, Perthshire, 1880s.
Et.
Gen. / nat. / land.

CURTIS John 1791 (Norwich) — 1862 (London).
Aq., line.
Flor. / illus. / port.
Also a noted naturalist and a watercolourist.
Aft.: J. Boze, Dufroe.

CUTTEN — fl. 1832.
Steel.
Illus. / land.
Aft.: W. Tombleson.

DAGLEY Richard *c.* 1765—1841
(London).
Line.
Illus.
An orphan, Dagley was educated at
Christ's Hospital, after which he was
apprenticed to a jeweller and
watchmaker under whom he also
painted miniatures and ornaments. He
became drawing master of a ladies'
school in Doncaster, but returned to
London in 1815 and lived first at
Earl's Court Terrace, then at 12
Bateman's Buildings, Soho Square. He
was also a writer.

DAKE Carel L. 1859 (Amsterdam)
— 1900 or after.
Et.
Gen.
Dutch national who made at least one
plate after a work by a British artist
which was published in England.
Aft.: Jane Dealy.
Pub.: H. Dickens and W. Scott
Thurber.

DALE Gertrude (*née* Brown) fl.
Hampstead 1890s and early 1900s.
Mezzo.
Gen.
Aft.: Augustin, P. Calderon,
T. Dicksee, A. Emslie, W.P. Frith,
A. Hacker, C. Hallé, Blanche Jenkins,
G. Knowles, Romney, E. Scannell,
J. Haynes Williams.
Pub.: H. Graves; H. Littaur; A. Lucas;
T. McLean; I.P. Mendoza; A. Tooth.

DALE Henry Sheppard 1852
(Sheffield) — 1921.
Et.
Arch. / illus. / land. / topog.
Dale was a pupil at the Slade School,
after which he studied in Italy. He
worked in London, Scarborough and
Taunton.
Aft.: T. Barraud.
Pub.: Dickinson and Foster.

DALE Thomas fl. 1820s.
Steel.
Arch. / illus.
Aft.: T.H. Shepherd.

DALGLIESH Theodore Irving
b. Folkestone 1855.
Et.
Land.
Dalgliesh, who was also a painter, was
a pupil of A. Legros (q.v.). He lived in
Folkestone.

DALGLIESH or DALGLISH W.
fl. 1880s.
Et.
Land.

D'ALMAINE and CO. fl. London
mid 19th c.
Litho., pub.
Music.

DALZIEL Bros.
Wood.
Ex libris / illus.
The members of this firm of wood-
engravers included George 1815

(Wooler) — 1902 (Hampstead),
Edward 1817 (Wooler) — 1905
(Hampstead), Thomas (1823—1906)
and John (1822—69). Of these
Thomas was a draughtsman and not an
engraver and the others were engravers.
Their sister, Margaret (b. *c.* 1819)
worked with them.

The most important were George
and Edward. George came to London
in 1835 and became a pupil of Charles
Gray (q.v.). He subsequently set up on
his own account in Camden Town,
being joined in partnership by Edward,
who came to London in 1839.

Edward's son Gilbert (b. 1853) was
also a wood-engraver; another son,
Edward (1849—88), was a painter and
draughtsman. Two more, Harvey
Robert (b. 1855) and Charles Davison
(b. 1857) carried on the business as
Dalziel and Co. Ltd. (Camden Press)
from 1893—1905, when it closed.
Aft.: most of the leading illustrators
of their day.
Pup.: G.G. Kilburne (q.v.).
Pub.: numerous.
Lit.: Dalziel G. and E. *The Brothers
Dalziel: A Record of Work 1840—1890*
1901 (repr. 1978). De Maré E.
The Victorian Woodblock Illustrators
1980.

DANIELL Rev. Edward Thomas
1804 (London) — 1842 (Adalia).
Dry., et. (incl. soft-ground).
Land. / topog.
Daniell attended Norwich Grammar
School, the art master being John
Crome. Later he shared a studio with
Joseph Stannard (q.v.) who is said to
have taught him etching, and he
probably took painting lessons from
J.S. Cotman (q.v.). He matriculated at
Balliol College, Oxford, in 1823 and
took his B.A. in 1828, subsequently
travelling on the Continent and
painting. He took orders in 1832 and
in due course was appointed curate to
a London parish. In London he met
and entertained many famous artists,
including Turner. In 1840, becoming
infected with an enthusiasm for the
Near East, he left England to travel
in those parts, joining an expedition in
the surveying ship *Beacon* under the
command of Captain Thomas Graves,

R.N. In Lycia he contracted malaria
and died.
Lit.: Beecheno F.R. *E.T. Daniell — A
Memoir* 1889 (privately printed).
Dickes W.F. *The Norwich School of
Painting* 1905. *The Dome* New Series
IV (1899), p. 209. Taylor B. and
others *Norwich School Prints.
Paintings and Drawings by the
Rev. E.T. Daniell 1804—1842*
Aldeburgh, 1968.

DANIELL Frederick B. and Son fl.
London 1890s.
Printsellers, pub.

DANIELL James fl. late 18th —
early 19th c.
Mezzo.
Port. / relig.
Aft.: Coypel, Singleton.

DANIELL Samuel *c.* 1775—1811
(Ceylon).
DANIELL Thomas, R.A. 1749
(Kingston-on-Thames) — 1840
(London).
DANIELL William 1769—1837
(London).
Aq., et., line., stip.
*An. / arch. / illus. / land. / port. /
ship. / topog.*
Samuel and William Daniell were
brothers and Thomas Daniell was their
uncle. Thomas and William went to
India in 1784, where they made many
studies and sketches. They returned to
London and worked together to
publish their great *Oriental Scenery*
which appeared in 1808.

Samuel was interested in natural
history and visited the Cape of Good
Hope when it was first occupied by
the British, and he visited other parts
of Africa making many studies, some
of which were engraved by William.
Aft.: Bryant, G. Dance, S. Davis,
Capt. Smith.
Lit.: Bain I. *William Daniell's A
Voyage Round Great Britain 1814—
1825* 1966. *P.C.Q.* XV, pp. 50—64.
Sutton Thomas *The Daniells: Artists
and Travellers* 1954.

D'APREMONT Eugène fl. early 20th c.
Line.
Land.
French reproductive engraver who
worked largely after paintings by
British artists.
Aft.: Alexander Fraser.
Pub.: J. Connell.

DARHILL T.F. fl. 1845.
Steel.
Illus. / land.
Aft.: T. Allom.

DARTON W. and Co. fl. late 18th c.
— c. 1830.
Aq.
Flor. / illus.

D'ASH — fl. London (27 Fetter
Lane) 1826.
Pub.
Tinsel.

DAUTHEMARE J.F. fl. London
1848.
Line.

DAUTREY Lucien 1851 (Auxonne)
— 1926.
Et.
Land.
French national who made at least one
plate after a work by a British artist
which was published in England.
Aft.: G. Mason.
Pub.: E.E. Leggatt.

DAVENPORT Samuel 1783
(Bedford) — 1867.
Steel.
*Gen. / hist. / illus. / lit. / myth. / port. /
relig.*
Son of an architect and land surveyor
who moved to London when Samuel
was a child. He was apprenticed to
Charles Warren (q.v.) one of the first
engravers to use steel.
Aft.: R.T. Bone, R.W. Bust, J. Cawse,
A. Chisholm, H. Corbould, J.P. Davis,
T. Holmes, C.R. Leslie, Murillo,
Shenton, T. Stothard, Baron Wappers.

DAVEY George fl. 1860s.
Mezzo.
Aft.: J. Herring Sr.
Pub.: Lloyd Bros.

DAVEY William Turner 1818
(London) — c. 1890.
Line., litho., mezzo., stip.
*An. / gen. / hist. / lit. / port. / relig. /
sport.*
Aft.: R. Ansdell, C. Barber, T. Barber,
H. Barraud, W. Barraud, J. Bateman,
C. Baxter, F. Bird, Rosa Bonheur,
T. Brooks, H. Calvert, G. Cruikshank,
W.C.T. Dobson, W. Field, J.A.
Fitzgerald, Henrietta Gubbins,
Hamilton, B. Haydon, J. Herring Sr.,
S. Hodges, J. Hook, W. Hopkins,
A. Johnstone, G.E. Kiorbof, Sir E.
Landseer, G. Leslie, J. Mann,
C. Mercier, Munroe, H. O'Neil,
W.C.T. Phillips, L. Pott, E. Signol,
C. Smythe, Elizabeth Thompson
(Lady Butler), Van Schendel,
E.M. Ward, W. Watson, W. Wyllie.
Pub.: Ackermann and Co.; O. Bailey;
W. and H. Barraud; T. Boys; Louis
Brall; B. Brooks; Dickinson's; Fishel,
Adler and Schwartz; Fores; S. and J.
Fuller; H. Graves; Hering and
Remington; Lloyd Bros.; T. McLean;
Moore, McQueen and Co.; Sheldrick
and Co.
Lit.: Engen R.K. *Victorian Engravings*
1975. Wilder F.L. *English Sporting
Prints* 1974.

DAVID L. fl.. Chelsea 1890s.
Gen. / myth.
Aft.: Greuze, J. Waterhouse.

DAVIES Cyrus fl. 1836.
Steel.
Illus. / land.
Aft.: W.H. Bartlett.

DAVIES J. fl. 1840s.
Steel
Arch. / illus. / land.
Aft.: T. Allom, T.M. Baynes,
T.H. Shepherd, A.W. Wray.

DAVIES S.T. fl. 1830s—50s.
Steel.
Arch. / illus. / land.
Aft.: W.H. Bartlett.

DAVIS E. fl. 1860s.
Et.
Gen.

DAVIS Herbert fl. 1850s—60s.
Mezzo.
An. / fig. / gen. / hist. / port. / sport.
Aft.: C. Baxter, J. Doyle, Sir F. Grant,
J. Herring Sr., Sir E. Landseer,
S. Pearce, H.W. Pickersgill, E. Wehnert.
Shared: G. Ward (q.v.).
Pub.: Thomas Boys; Dixon and Ross;
H. Graves; Lloyd Bros.

DAVIS J. fl. 1830s.
Steel.
Illus. / land.
Perhaps identical with J. Davies (q.v.).
Aft.: W. Callow.

DAVIS Laurence b. London 1879.
Et.
Gen. / illus.
Also a well-known painter of genre
subjects.

DAVY Henry fl. Ipswich 1829.
Et.
Arch. / land. / topog.
Also an architect and landscape
painter.

DAWE George 1781 (London) —
1829 (London).
Mezzo.
Hist. / port.
A son of Philip Dawe (d. *c.* 1780) a
famous mezzotinter and pupil of
Henry Morland. George was brought
up as an engraver and entered the
R.A. Schools in 1794. He abandoned
engraving for historical painting when
he reached the age of 21. Brother of
H.E. Dawe (q.v.).
Aft.: Bacon, J. Graham, J. Northcote,
Raeburn, B. West.

DAWE Henry Edward 1790 (Kentish
Town, London) — 1848 (Windsor).
Mezzo.
*Gen. / hist. / illus. / land. / lit. / port. /
relig.*
A pupil of his father Philip Dawe (d.
c. 1780) a famous mezzotinter, Dawe
also studied in the R.A. Schools. He
engraved some *Liber Studiorum* plates
for J.M.W. Turner, who entrusted the
superintendence of the plates of this
work to him.
Aft.: G. Arnald, G. Bolognese,
H. Briggs, E. Bristow, G. Cattermole,

Constable, da Vinci. G. Dawe, Duchée,
J.F. Ellis, Fernet, H.J. Fradelle,
J. Graham, J. Knight, R.J. Lane,
Sir T. Lawrence, G. Morland, C. Penny,
Raeburn, H.J. Richter, C. Roqueplan,
H. Sharp, M. Sharp, W.W. Sharp,
G. Stubbs, J.M.W. Turner, G. Watson,
Sir D. Wilkie, A. Wivell.
Shared: T. Hodgetts (q.v.).
Pub.: R. Lamb.

DAWSON Alfred fl. Chertsey,
Chiswick and Thorpe Green 1860s—
90s.
Et., wood.
Arch. / illus. / land. / port. / topog.
Son of the landscape painter, Henry
Dawson and brother of Harry Thomas
Dawson the marine painter.
Aft.: H. Dawson, Reynolds.

DAWSON Nelson 1859—1941.
Et.
Gen. / land. / marine.
Also a painter and designer, Dawson
lived in Chiswick.

DAWSON R. fl. 1830s—60.
Line., steel.
Topog.
Aft.: photos.

DAWSON-WATSON John b. 1864
(London).
Et.
Land.
A pupil of Mark Fisher in London, and
of Carolus-Duran in Paris, Dawson-
Watson was also a landscape painter.

DAY Ellen fl. 1830s.
Et.
Arch.

DAY and SON fl. early 19th c.
J.B. DAY
DAY and HAGHE
VINCENT BROOKS, DAY and SON
DAY William, Sr. and Jr.
Litho. (incl. chromolitho.), print.,
pub.
The above are the successive names of
what was virtually the same firm. It
did much to develop
chromolithography in Britain. It
received the appointment of
lithographers to the King and Queen in

1830. Work was undertaken for other publishers, including George Bell.
Pup.: F. Goulding (q.v.).
Assist.: J.W. Inchbold, W. Simpson (qq.v.) and Edmund Walker (See under E. Walker).

DEAKIN A. fl. 1880s.
Et.

DEAN H. fl. London 1860s.
Dry., et.
Arch. / gen. / land. / topog.

DEAN T.A. fl. London 1830.
Line., steel.
Illus. / port.
Aft.: E.T. Parris.

DE BIEVRE — fl. mid (?) 19th c.
Line.
Port.

DEBLOIS Charles Theodore 1851 (Fleurines, Oise) — after 1888.
Et.
Gen.
French national who made a number of plates after works by British artists which were published in England.
Aft.: E. Long, E. Nichol.
Pub.: A. Lucas, A. Tooth.

DE BURSON B.M. fl. London (10 Wilson Street, Grays Inn Road) 1821—27.
Pub.
Juv. dram.
Successor of W. Clarke (q.v.).

DEEBLE William fl. London 1814—49.
Line., steel.
Illus. / topog.
Also a painter.

DEIGHTON W.R. fl. London (4 Grand Hotel Buildings) 1880s.
Printseller.

DELAMOTTE William 1775 (Weymouth) — 1863 (Oxford).
Aq., et., litho.
Land.
Also a painter of landscapes.
Pub.: Philip André.

DE LA RUE and SONS fl. from c. 1815.
Print.
Bank. / ephem. / illus. / playing cards / postage and telegraph stamps.
This famous firm of security printers was founded by Thomas De La Rue (1793—1886), who introduced several new printing inks and invented several new printing techniques.
There was also A. Delarue of 60 Rue J.J. Rousseau, Paris, who was probably related to the family.
Lit.: Gibbons Ltd, Stanley. Various stamp catalogues. Lister R. *Private Telegraph Companies of Great Britain and their Stamps* 1961.

DELÂTRE or DELATTRE Jean Marie 1746 (Abbeville) — 1840 (Fulham).
Chalk, line., stip.
All. / gen. / hist. / illus. / land. / lit. / myth. / port.
French national brought to England in 1770 by William Wynne Ryland; he became a pupil of F. Bartolozzi (q.v.).
Aft.: F. Bartolozzi, Charlton, Cipriani, J.S. Copley, Guercino, W. Hamilton, S. Harding, Angelica Kauffmann, Rigaud, J. Saunders, T. Stothard, P.W. Tomkins, F. Wheatley.
Shared: R.S. Marcuard (1751—c. 1792).

DE LOUTHERBOURG Philip J. 1740—1812.
Aq., polygraphy.
Illus. / land. / topog.
De Loutherbourg was also a painter and a creator of moving panoramas which he exhibited in London under the name "Eidophusikon".
Lit.: Klingender F.D. *Art and the Industrial Revolution* 1947 (new ed. 1968). Lister R. *British Romantic Art* 1973.

DENNIS F.T. fl. late 19th c.
Pub.

DESMAISON (Pierre) Émile 1802 (Paris) — 1880 (Moutlignon).
Litho.
Gen. / port.
French national who made a number of plates after works by British artists which were published in England.

175

Aft.: A. Diaz, Sir E. Landseer, Sir T. Lawrence, F. Stone, F. Topham, E.M. Ward, A. Wivell.
Pub.: A. and C. Bailey; Gambart; A. Roberts.

DESVACHEZ David Joseph 1822 (Valenciennes) — 1902 (Brussels).
Steel.
Fig. / illus.
Belgian national who engraved some plates after works by British artists.
Aft.: Sir L. Alma-Tadema, T. Graham, Sir J.N. Paton, A.J. Pott.

DE TABLEY John Fleming Leicester, Baron 1762—1827.
Litho. (amateur).
Also a collector and amateur painter.

DEVILLE Maurice fl. 1890s.
Et.
Gen.
French national who made some plates after works by British artists which were published in England.
Aft.: T. Blinks, W. Dendy Sadler.
Pub.: L.H. Lefèvre, A. Tooth.

DE WILDE Samuel 1748—1832.
Et.
Port.
Best known as a portrait painter.

DICK Thomas fl. Edenburgh 1841—74.
Steel.
Ex libris / myth. / port. / relig.
Aft.: Raphael, Rubens.

DICKES William fl. mid 19th c.
Litho., (incl. chromolitho.), print., pub., wood.
Bot. / ephem. / illus. / sport.
Licensee of the method of G. Baxter (q.v.). Dickes's prints are finely coloured.
Aft.: P.H. Gosse, W.N. Humphreys.
Lit.: Docker A. *The Colour Prints of William Dickes* 1924.

DICKINS Harry C. fl. London (14 Clifford Street) 1880s—90s.
Pub.

DICKINSON John fl. London 1831.
Pub. (litho.)
Theat. (ballet).
Possibly identical with or related to L.C. Dickinson the lithographer (q.v.) and possibly of the same family as the firm J. Dickinson and Co. of 65 Old Bailey, London, in the 1870s. Another possible relation was Joseph Dickinson, a publisher and printer, who was at 114 New Bond Street during the early 1880s.

DICKINSON L. fl. c. 1846.
Litho.
Gen. / illus.
Aft.: J. Deffett Francis.
Pub.: J.G. Welch.

DICKINSON Lowes Cato 1819 (Kilburn) — 1908.
Litho.
Marine. / port. / sport. / theat. / topog.
The son and pupil of a stationer and lithographic publisher, Dickinson visited Italy in the early 1850s and on his return became acquainted with the Preraphaelites. He taught drawing at the Working Men's College, other teachers at the time being D.G. Rossetti and J. Ruskin. He was probably related to the publisher J. Dickinson (q.v.).
Aft.: W. Allan, H. Bright, A. Chalon, J. Doyle, J. Ferneley, J.D. Francis, Sir E. Landseer, J. Richardson Jr., G. Richmond, R. Tait, Zauffely, Zoffany.
Des. eng.: J. Atkinson, J. Baker, G. Saunders (qq.v.).
Pub.: J. Dickinson; Gambart; J. McLean.

DICKINSON William 1746 (London) — 1823 (Paris).
Mezzo., printseller, pub., stip.
Caric. / gen. / hist. / lit. / myth. / port. / relig. / theat.
Dickinson abandoned caricature in 1767, after gaining a premium from the Society of Arts for a mezzotint portrait. He is said to have been in business partnership with the engraver Thomas Watson (1743—81) and the Royal drawing master, William Austin (? 1721—1820). He was carrying on business as a printseller and publisher

in 1791 at 158 New Bond Street, London, but after this went to live in Paris where he continued engraving.

Some of his plates were signed by F. Bartolozzi (q.v.) and he signed plates by some other engravers, including C. Knight (q.v.).
Aft.: Beach, H. Bunbury, A. Carracci, Correggio, R. Cosway, Emma Crewe, Dance, Lady Day, Dupont, Gainsborough, D. Gardner, F. Gérard, J. Graham, Hoppner, Angelica Kaufmann, Sir T. Lawrence, W.C. Lindsay, G. Morland, Mortimer, Nixon, Rev. W. Peters, R.E. Pine, Reynolds, G. Romney, Rubens, Russell, S. Shelley, G. Stubbs, A. Trivasani di Roma, Van Dyck, B. West, F. Wheatley, Zucchero.
Pup.: G. Keating (q.v.).
Pub.: Boydell, J. Harris.

DICKINSON and FOSTER
fl. 1880s—90s.
Pub. (inc. photo-eng.)

DICKSEE Herbert Thomas 1862—1942.
Et., litho., mezzo.
An. / gen. / hist. / land. / myth. / port.
Son of the painter Thomas Francis Dicksee, younger brother of the painter Frank Dicksee, and nephew of J.R. Dicksee (q.v.) H.T. Dicksee was a pupil at the Slade School. He became a drawing master at the City of London School, and lived in Hampstead. Many impressions of his plates are printed on vellum.
Aft.: Rosa Bonheur, F. Dicksee, G. Joy, Sir J.E. Millais, A. Strutt.
Pub.: C.E. Clifford; Fine Art Society; Frost and Reed; Gambart; C, Klackner; L.H. Lefèvre; T. McLean; Mawson, Swan and Morgan.
Lit.: Engen R.K. *Victorian Engravings* 1975.

DICKSEE John Robert 1817 (London) — 1905 (London).
Litho.
Port.
Brother of the painter Thomas Francis Dicksee and uncle of H.T. Dicksee (q.v.), J.R. Dicksee was a drawing master at the City of London School and also wrote on technical matters.

Aft.: T.F. Dicksee, R. Hamerton, H.W. Phillips.
Des. eng.: A.N. Saunders (q.v.).
Pub.: J. Hogarth.

DIGHTON Denis 1792 (London) — 1827 (Saint—Servan, Brittany).
Et., litho.
Illus. / mil. / port. / theat. / tinsel.
Son of Robert Dighton and brother of Richard Dighton (qq.v.). Denis Dighton is best known as a painter of battles. A student at the R.A., he attracted the attention of the Prince of Wales, through whom he obtained a commission in the army, which however he resigned in order to marry. He settled in London. His wife was a painter of flowers and fruit and became flower painter to the Queen.

DIGHTON Richard 1785 (London) — 1880 (London).
Et.
Caric. / theat. / tinsel.
Also a painter of caricatures and military subjects, Richard Dighton was a son of Robert Dighton and brother of Denis Dighton (qq.v.).

DIGHTON Robert 1752 (London) — 1814 (London).
Et., litho.
Caric. / gen. / lit. / mil. / port. / theat. / tinsel.
Father of Denis and Richard Dighton (qq.v.), Robert Dighton lived successively at three addresses in London: 12 Charing Cross (1794), 6 Charing Cross and 4 Spring Gardens, Charing Cross (1810). He stole a number of prints from the British Museum between 1794 and 1806, the theft being discovered by the art dealer, Samuel Woodburn. Although Dighton had sold them, most were recovered.

Robert's work may be distinguished from Richard's by the signature, for Richard signed his name in full, whereas Robert signed "R. Dighton" or "Dighton".
Pub.: Bowles and Carver; Carrington Bowles; W. Sams.

177

DIGHTON Thomas fl. 1837.
Line.
Also a draughtsman.

DIGHTON William 1752—1812.
Et.

DITCHFIELD Arthur 1842 (London)
— 1888 (London).
Et.
Land.
Studied at Leigh's School and the R.A.

DIXON Charles Thomas fl. 1840s—
50s.
Steel.
Illus. / land.
Aft.: T. Allom, H. Gastineau, Capt.
Stoddart, R. Varnham.

DIXON F. fl. 1816—20.
Wood. (incl. coloured).
Flor. / illus.

DIXON Mrs. J. fl. 1820s.
Litho.
Flor. / illus.

DIXON Robert 1780 (Norwich) —
1815 (Norwich).
Et. (incl. soft-ground).
Arch. / land. / topog.
Also a painter.

DIXON T. fl. 1832—42.
Steel.
Arch. / illus. / land.
Aft.: T. Allom, W.H. Bartlett.

DIXON and ROSS Established in
1833.
Print., pub.
The headquarters of this firm were at
4 St. James's Place, Hampstead Road,
London. By the 1860s the street was
re-numbered and the address became
60 Hampstead Road. Their successors,
Thomas Ross and Son, are at 5
Manfred Road, London.

DOBBIE Thomas fl. Edinburgh
1840s.
Steel.
Arch. / illus.
Aft.: T.M. Richardson Jr.

DOBIE G. fl. 1816—20.
Wood. (incl. coloured)
Flor. / illus.

DOBIE James 1849 (Edinburgh) —
1911.
Et., mixed.
*All. / gen. / illus. / land. / marine. /
myth. / port.*
Dobie, who worked in Stoke Newington
and Palmer's Green, etched over 105
plates after works by W. Dendy Sadler,
in addition to others.
Aft.: C. Bartlett, F. Bramley, C.W.
Cope, T. Faed, T. Good, F. Hall,
W. Hunt, W. Langley, T. Lloyd,
E. Long, S. Lucas, E. Nicol, Sir E.
Poynter, B. Riviere, W.D. Sadler,
S.J. Solomon, W. Thorse,
J. Waterhouse, E. Waterlow,
G.F. Watts, G. Wetherbee.
Pub.: T. Agnew and Sons; Dowdeswell
and Dowdeswells; H. Graves;
L.H. Lefèvre; T. McLean; A. Tooth.
Lit.: Engen R.K. *Victorian Engravings*
1975.

DODD Arthur C. fl. Tunbridge Wells
and Dedham 1870s—80s.
Et.
Gen.
Pub.: Shepherd Bros.
Also a painter.

DODD Daniel fl. early—mid 19th c.
Wood.
Illus.
Brother of John Dodd (q.v.).

DODD Francis R.A. 1874 (Holyhead)
— 1949 (Blackheath).
Et., mezzo.
Arch. / gen. / port. / topog.
The son of a Wesleyan minister who
was formerly a blacksmith, Dodd was
educated at Garnett Hill School,
Glasgow. After a period in commerce
he studied at Glasgow School of Art,
and with money from a scholarship,
studied in Paris. Acting on the advice of
J. McN. Whistler (q.v.) he also studied
in Italy. He settled in Manchester in
1895 and in London from 1904. He is
best known as a painter.
Lit.: *P.C.Q.* XIII, pp. 248—72,
369—75.

DODD John fl. early—mid 19th c.
Wood.
Illus.
Brother of Daniel Dodd (q.v.).

DODD Robert ? 1748—1816 or after.
Aq., line.
Arch. / hist. / marine. / sport. / topog.
Dodd lived at 33 Wapping Wall, near
St. James's Stairs, Shadwell (1779), at
which address also lived a painter,
Ralph Dodd, probably a brother. In
1782 he moved to 32 Edgware Road,
and near the end of his life he moved
to 41 Charing Cross.
Aft.: Dayes, J. Ibbetson, G. Morland,
Sartorius.
Des. eng.: F. Jukes, R. Pollard (qq.v.),
C. Morison.
Shared: R. Pollard (q.v.).

DOIG, WILSON and WHEATLEY fl.
1890s.
Pub. (incl. photo-eng.)

DONE or DORE W.M. fl. 1840s.
Steel.
Arch. / illus.
Aft.: T.H. Shepherd, A.W. Wray.

DONNELLY Sir John Fretchville
Dykes 1834—1902.
Et.
Land.
An amateur who also painted.

DOO George Thomas 1800
(Christchurch) — 1886 (Sutton,
Surrey).
Line., steel., stip.
*Antiq. / fig. / gen. / hist. / illus. / lit. /
port. / topog.*
Doo was a pupil of C. Heath (q.v.) and
later studied in Paris, He set up his
own school for study from the life and
the antique. Appointed Engraver-in-
ordinary to King William IV and
Queen Victoria, he worked in Dulwich
and Great Stanmore.
Aft.: Carracci, Correggio, S. Del
Piombo, W. Dyce, C. Eastlake, W. Etty,
Sir F. Grant, C. Heath, J. Knight,
Sir T. Lawrence, Luciana, W. Mulready,
G. Newton, J. Partridge, H.W.
Pickersgill, Poussin, Raphael, Reynolds,
A. Schaffer, Van Dyck, Sir D. Wilkie,
H. Wyatt.

Assist.: T.L. Grundy (q.v.).
Pub.: Art Union of London; Colnaghi;
London Printing and Publishing Co.;
F.G. Moon.

DORING Adolf G. fl. 1890s.
Line.
All.
German engraver who made a plate
after a design by W. Crane (q.v.).

DORRINGTON George fl. 1836—41.
Wood.
Caric / illus.
Aft.: R. Seymour.

DOTT, AITKEN and Son fl. 1890s.
Pub.
Goupilgravures / photo-eng.
Published for the Swan Electric
Engraving Co. (q.v.).

DOUBOURG M. — See Dubourg M.

DOUGHTON Dennis fl. early 19th c.
Litho.

DOUGLAS Edward Algernon Stuart
1850 — after 1892.
Et., litho.
Gen.
Lived and worked in Barnes, London.
Aft.: W. Taylor.
Pub.: A. Ackermann.

DOUGLAS James 1753 (London) —
1819 (Penton, Sussex).
Et.
Land. / port.
Also painted in oil and miniature.
Perhaps identical with the Rev. James
Douglas who aquatinted plates for a
work of his own, *Nenia Britannia*
(1793).

DOUGLAS William fl. 1838—43.
Steel.
Arch. / hist. / illus. / land.
Aft.: N. Castle, D.O. Hill, Raphael,
Rubens.

DOW Alexander Warren 1873
(London) — 1948.
Et.
Land. / lit.
A pupil of Brangwyn (q.v.) and of
Norman Garstin, Dow was also a painter.

DOWDESWELL and DOWDESWELLS LTD. fl. London (160 New Bond Street) 1880s—90s.
Pub.
Goupilgravures / photo-eng.
Founded in 1884 by C.W. Dowdeswell.

DOWER J. fl. 1830s.
Aq., steel.
Maps. / ship.
Aft.: Baugean, F.G. Webster.

DOWNWARD or DOWNARD Ebenezer Newman 1829 (Brighton) — 1894.
Et.
An. / gen.
Worked in Brighton, Bayswater and Hammersmith.
Aft.: H. de F. Cox, A. Rossi, A. Strutt.
Pub.: R.C. Isaac and Bowdon, Son and Co.; J.E. Jacobs.

DOYLE John 1797 (Dublin) — 1868 (London).
Litho.
Caric. / sport.
Doyle, who was also a portrait painter, made 917 satirical plates of political events between 1829—44. They are called the "H.B. Sketches" as they are marked with the pseudonymous monogram "HB". He was the father of the cartoonist and illustrator Richard ("Dicky") Doyle.
Pub.: Dickinson.

DRAKE Miss fl. 1840s.
Litho.
Flor. / illus.
Lived at Turnham Green.

DRÖHMER Hermann 1820 (Berlin) — 1890 (Berlin).
Mezzo.
Port.
German national who made at least one plate from a work by a British artist which was published in England.
Aft.: J. Hollis.

DRUMMOND Malcolm 1880—1945.
Et.
Gen.
A follower of W.R. Sickert (q.v.).

DRUMMOND and CO. fl. early 20th c.
Print., pub.
Photo-eng.

DRURY J. fl. 1830s.
Steel.
Illus. / land.

DUBOURG or DOUBOURG M.
fl. London 1786—1824.
Aq., stip.
An. / gen. / hist. / illus. / mil. / land. / ship. / sport.
French national who lived and worked in England at the beginning of the 19th century. He was possibly a descendant of the Dutch historical painter, Lodewyk Fabricius Dubourg (d. 1745).
Aft.: W. Anderson, J.A. Atkinson, H.B. Chalon, J.H. Clark, W. Heath, Heddington, Lieut. W. Lyttleton, J. Pollard, Lieut. G. Robinson, H. Smith, C. Thomson.
Shared: J. Clark, R. Pollard (qq.v.).
Pub.: Bowyer; E. Orme.
Lit.: Wilder F.L. *English Sporting Prints* 1974.

DUDLEY Howard 1820 (London) — 1864 (Pentonville).
Lith., wood.
Illus. / topog.
Dudley's father died when he was a boy and with his mother they moved to Easebourne, nr. Midhurst, in Sussex. Here he studied local history and in 1835 published the result in a book called *Juvenile Researches or a Description of some of the Towns in the Western Part of Sussex*; it was set up and printed by himself and illustrated with his own engravings. It was successful, was reprinted, and was followed by other similar books. Dudley lived in Edinburgh 1845—52, but returned to London after that, living in Holford Square, Pentonville.

DUDLEY Robert fl. 1865—98.
Litho.
Land. / topog.
Also a painter.

DUFF John Robert Keitley 1862—
1938.
Et.
Land. / topog.

DUGMORE Arthur Radclyffe
fl. 1870.
Et.

DUMAS F.G. fl. London (19
Cockspur Street, Charing Cross) and
Paris (53 Boulevard St. Michel), 1880s.
Printseller.

DUMÉE E.J. fl. late 18th—early
19th c.
Stip.
Gen. / myth.
Aft.: Cosway, G. Morland, J.R. Smith,
R. West.

DUNCAN Andrew b. 1795.
Line., steel.
Illus. / port.
Aft.: Guercino, Holbein, C.R. Leslie,
A. Maas, J. Steen.

DUNCAN David b. 1868.
Et.

DUNCAN Edward *c.* 1804 (London)
— 1882 (London).
Aq., et., litho., mixed.
*Illus. / land. / marine. / ship. / sport. /
topog.*
Also a noted landscape painter in
watercolours, Duncan served an
apprenticeship with R. Havell (q.v.).
He drew on the wood for illustrations
engraved by H. Harral (q.v.) and others.
Aft.: H. Alken, W. Clark, N.M. Condy,
Joan Ferneley, Garnerey, E. Gill,
G. Hancock, C.C. Henderson, W.J.
Huggins, W. Joy, W.A. Knell,
S. Walters.
Des. eng.: W.J. Linton (q.v.), who
engraved Duncan's illustrations for
Milton.
Shared: H. Alken, T.J. Rawlins,
C. Rosenberg, J.C. Webb (qq.v.).
Pub.: R. Ackermann; Fores; S. and
J. Fuller; T. Gosden.
Lit.: Wilder F.L. *English Sporting
Prints* 1974.

DUNCAN Thomas A.R.A. 1807
(Kinclaven) — 1845 (Edinburgh).
Et.
Gen.
Best known as a painter of genre and
history subjects.

DUNKARTON Robert 1744
(London) — 1811 or after.
Mezzo.
Flor. / gen. / illus. / port.
Dunkarton was a pupil of William
Pether. He first practised as a portrait
painter, but from about 1779 devoted
himself almost entirely to
mezzotinting.
Aft.: W. Artand, W.R. Bigg, Bullfinch,
J.S. Copley, Dance, A.W. Devis,
Downman, E. Edwards, R. Fagan,
Lawranson, W. Lawrence, G. Morland,
Rev. W. Peters, Rembrandt, Reynolds,
Romney, J. Russell, J.M.W. Turner,
Van Dyck, B. West.
Pub.: Boydell.

DUNOD Charles-René fl. 1890—
1905.
Et.
Sport.
French national who made at least one
plate after a work by a British artist
which was published in England.
Aft.: T. Blinks.
Pub.: A. Tooth.

DUPONT Félix (François Louis) *c.*
1835 (Bordeaux) — 1899 (Mulhausen).
Et., line., stip.
Gen.
French national who made a number
of plates after works by British artists
which were published in England.
Sometimes signed "L. Dupont".
Aft.: Helen Allingham, C. Baxter,
M.B. Foster.
Pub.: Alfred Bell, Paul Delarue.

DUTTON John fl. 1828—29.
Line.
Port.

DUTTON Thomas Goldsworth fl.
fl. London *c.* 1842—78.
Litho. (incl. chromolitho.)
Land. / marine. / ship. / sport.
Aft.: R. Beechey, O.W. Brierly,
H. Busk, M.N. Condy, Inglefield, Knell,

H. Luscombe, Lieut. M. O'Reilly,
Sargent, R.L. Stopford, C. Taylor,
Tupman.
Pub.: A. Ackermann; T. Cranfield
(Dublin); Day and Haghe; Fores;
W. Foster.
Lit.: Laver J. *English Sporting Prints*
1970.

DU VAL Charles Allen 1808
(Ireland) — 1872 (Alderby).
Line., litho.
Port.
Also a painter, Du Val went to
Manchester in 1830 and worked there
for the remainder of his life.
Aft.: Chantrey, F.C. Lewis, S.W.
Reynolds, J. Stephenson.

DYCE William 1806—64.
Dry., et.
Fig. / gen. / illus.
Best known as a painter, Dyce was at
first much influenced by Sir Thomas
Lawrence. He studied in Italy and
came under the influence of the
German Nazarene artists. He was
closely associated with the
Preraphaelites.
Des. eng.: G. Doo and John Thompson
(qq.v.).
Lit.: Pointon M. *William Dyce* Oxford
1979.

DYER J. and/or I.J. fl. London
1827—31.
Pub.
Juv. dram.
The firm, in which several members of
the family were involved, operated at
various London addresses, including
13 Dorset Crescent, Hoxton New
Town; 55 Bath Street, City Road;
Featherstone Buildings, City Road;
109 Aldersgate Street. Their toy
theatre sheets were variously
inscribed: Dyer; Dyer Senior; Dyer
Junior; I.J. Dyer and Co.; J. Dyer.
The Dyers later acquired some of the
sheets published by Hodgson and by
D. Straker and Co. (qq.v.), and
possibly they had connexions with
F. Edwards (q.v.).
 It is possible that some sheets were
published for the Dyers by Robert
Lloyd (q.v.).

DYER R.H. fl. 1832.
Steel., stip.
Illus. / port.
Aft.: C. Bestland, H. Corbould.

EAGLETON W. fl. 1835.
Steel.
Fig.
Aft.: D. Maclise.

EARLOM Richard 1743 (London) –
1822 (Clerkenwell).
Chalk., et., mezzo., mixed.; stip.
Flor. / gen. / land. / myth. / port. /
sport.
The son of a vestry clerk at St.
Sepulchre's, London, Earlom was in
1757 awarded a premium by the
Society of Arts. He was attracted to
art early in life and copied the
allegorical designs by Cipriani on the
Lord Mayor's coach. He became a
pupil of Cipriani, but is supposed to
have been self-taught in mezzotinting.
He is noted especially for his
mezzotints of the *Liber Veritatis* of
Claude Le Lorrain, which is now in
the British Museum, but was then in
the possession of the Duke of
Devonshire.
 A number of prints bearing the
signature of Henry Birche (q.v.) have
sometimes been attributed to Earlom:
these include "Labourers" after
George Stubbs and "Gamekeepers"
after George Stubbs and Amos Green.
 He resided in Cow Lane, Smithfield,
London.
 Earlom's son William showed talent
for art, but he died in 1789, aged 17.
Aft.: Beechey, F. Bol, Bourgeois,
Brandoin, Campidoglio, Ciprinai,
Claude, J.S. Copley, Dance, M. de
Fiori, M. de Vos, C. Dolci, Dupont
Gainsborough, G. Garrard, J. Graham,
Hamilton, Heemskerk, Hobbema,
Hogarth, Howard, T. Kettle, Sir P.
Lely, Q. Matsys, Mengs, Nelson,
Northcote, Pellegrini, Poussin,
Rembrandt, Reynolds, Rigaud,
Romney, Rubens, Scalken, Snyders,
Teniers, van den Erckhaut, van der
Werff, Van Dyck, Van Huysum, Van
Os, Velasquez, F. Wheatley, B. Wilson,
R. Wilson, J. Wright of Derby, Zoffany.
Pup.: J. Boydell (q.v.).
Shared: G.S. and J.G. Facius (q.v.).
Pub.: Boydells; B.B. Evans; Sayer and
Bennett.

EARTHROWL Eliab George b. 1878.
Et.
Land. / topog.

EASLING J.C. fl. 1815.
Mezzo.
Land. / port.
Pup.: Charles Turner A.R.A. (1.v.).
Aft.: R. Holme, Sir M.A. Shee, J.M.W.
Turner.
Shared: W. Annis (q.v.).

EAST Sir Alfred R.A. 1849
(Kettering) – 1913 (London).
Et.
Land.
Best known as a painter, East was the
son of a boot manufacturer and
received his education at Kettering
Grammar School. In 1875 he entered
the Government School of Art,
Glasgow, and also studied in Paris at
L'Ecole des Beaux-Arts and at the

Académie Julian. After a period in Glasgow he settled in London. He made many visits abroad including one to Japan.
Des. eng.: in mezzo by Sir F. Short (q.v.).
Lit.: *Studio* XXXIV (1905) p. 124.

EASTON A. fl. *c.* 1840.
Stip.
Port.
Possibly identical with A. Easto, who engraved a portrait after W. Lodder.

EASTON R. fl. 1837.
Steel.
Fig. / illus.
Aft.: H. Richter.

EDDY Isaac fl. mid (?) 19th c.
Steel (?)
Illus.

EDGE J.W. fl. London *c.* 1788—1829.
Aq., et.
Gen. / sport. / topog.
Aft.: W. Burgess, Fisher, Griffith, J. Pollard.

EDINGTON A fl. 1833.
Aq.
Topog.
Aft.: H. Wilder.

EDWARDS — fl. 1877.
Steel.
Fig. / illus.
Aft.: Schopin.

EDWARDS Edwin 1823 (Framlingham) — 1899 (London).
Et.
Arch. / illus. / land. / marine. / topog.
The son of Charles Edwards of Bridgham Hall, Norfolk, Edwin Edwards was educated at Dedham, Essex, under a Dr. Taylor. He began in the law, but abandoned this in 1860 for a career in the arts, although he wrote several legal books. He etched over 370 plates, and also painted.
Lit.: *L'Art* XIX (1879) p.109. Furst H. *Original Engravings and Etchings* 1931. Thibaudeau A.W. *Catalogue of the Works of Edwin Edwards* n.d.

EDWARDS F. fl. London (49 Leman Street, Goodman's Fields) 1824—28.
Pub.
Juv. dram.
Possibly connected with J. Dyer (q.v.).

EDWARDS J.C. fl. 1821.
Line.
Illus.
Also a painter.
Pup.: R. Staines (q.v.).
Aft.: W. Boxall, A. Cooper, W. Hilton, H. Howard, E. Sharp, Miss L. Sharpe, R. Smirke, J.W. Wright.

EDWARDS Samuel Arlent 1861—1938.
Mezzo.
An. / gen. / illus. / port. / relig. / sport. / topog.
Edwards was a student at South Kensington School of Art 1877—81. He worked in New York from 1890.
Aft.: C. Boult, Gainsborough, R. Gallon, Greuze, Isabey, Rosa Jameson, Sir E. Landseer, Sir T. Lawrence, Fra Filippo Lippi, G. Morland, Nattier, Rembrandt, Romney, G. Swinstead, W. Trood, A. Stuart Wortley.
Pub.: Colnaghi; H. Graves; George Rees; A. Tooth.
Lit.: Butler, Daniel and Co. *List of Mezzotint Engravings by S. Arlent Edwards* 1906. Knoedler E.L. *List of Mezzotint Engravings by S. Arlent Edwards* 1910. Minneapolis Institute of Arts *Mezzotints in Color after Famous Paintings: an Exhibition of S. Arlent Edwards* 1921.

EDWARDS William Camden 1777 (Monmouthshire) — 1855 (Bungay).
Aq., et., line., steel.
Flor. / gen. / illus. / land. / port.
Practised in Norfolk and Suffolk.
Aft.: J. Barry, A. Carpentier, R. Cosway, C. Fox, W.P. Frith, W. Hogarth, Hoppner, J. Jackson, Sir G. Kneller, Sir T. Lawrence, Sir P. Lely, R. Müller, J. Opie, T. Phillips, Raeburn, Reynolds, G. Romney, H. Room, J. Russell, S. Rosa, M.A. Shee, Van Dyck, T. Wright.
Pup.: C. Fox (q.v.).
Shared: Worked on the sky of

"Mousehold Heath" by J. Crome
(q.v.) after Crome's death.
Pub.: Brightly of Bungay.

EDWARDS W. Joseph fl. 1840s—60s.
Line., mezzo., steel., stip.
Gen. / hist. / illus. / port. / relig.
Aft.: W.C.T. Dobson, A. Egg, W.P.
Frith, H.R. Graves, F. Hardy, J.R.
Herbert, J. Jackson, Sir E. Landseer,
G. Landseer, Sir T. Lawrence, D.
Maclise, G.H. Mulvaney, H. Phillips,
G. Richmond, W. Ross, F. Sandys,
R. Thorburn.
Pub.: H. Graves; Lloyd Bros.; Virtue.

EDWARDS'S FOREIGN
REPOSITORY fl. London, 1840s.
Pub.
Litho. / theat. (ballet).

EDY John William fl. 1820.
Aq.
Illus. / land.

EGAN James 1799 (Roscommon) —
1842 (Pentonville, London).
Mezzo.
Arch. / gen. / hist. / port. / topog.
Egan learnt the rudiments of his art
while he was employed as a servant
by the mezzotinter Samuel William
Reynolds (q.v.), for whom he learnt
to lay grounds. He left Reynolds's
service and tried to earn his living
laying grounds for other engravers.
However, though he worked hard and
suffered many privations, he earned
little, despite making progress as a
mezzotinter in his own right. When it
seemed that he was about to become
successful he fell ill and died.
Aft.: C. Bentley, T.H. Carrick, G.
Cattermole, D. Cowper, J.R. Herbert,
W.H. Hunt, S.J.E. Jones, Sir T.
Lawrence, J.M. Moore, C.S. Newton,
W. Nicholas, Parris, S. Prout, Ellen
Stone, Zieter.
Pub.: Thomas Boys; H. Leggatt.

EGAN Pierce 1814 (London) —
1880 (London).
Et., line.
Illus. / port.
Also a writer.

EGERTON Daniel Thomas 1800
(London) — 1842 (Tukahaya, Mexico).
Litho.
Caric. / land.
Best known as a landscape painter,
Egerton spent the last years of his life
travelling in America and was
murdered in Mexico on April 29, 1842.

EGGINTON Francis 1781—1823
(Newport, Staffs.)
Line.
Topog.

EGINTON E.A. fl. Worcester 1842.
Et.
Land. / topog.
Probably the son of Harvey Eginton
the architect.

EGINTON Francis, the Younger
1775 (Birmingham) — 1823 (Newport,
Salop).
Aq., stip.
Gen. / myth. / port. / topog.
Son and pupil of the stained glass
artist, enameller and aquatinter,
Francis Eginton the elder (1737—1805)
and brother of John Eginton (q.v.).
Aft.: Domenichino, Hamilton, H.
Singleton, F. Wheatley.
Shared: P.W. Tomkins (q.v.).

EGINTON John fl. early 19th c.
Stip.
Gen. / myth.
Son of Francis Eginton the elder
(1737—1805), brother of Francis
Eginton the younger (q.v.).
Aft.: Hamilton, H. Singleton, F.
Wheatley.

EGLETON William Henry fl.
London 1830s—60s.
Line., mezzo., steel., stip.
*All. / gen. / hist. / illus. / myth. / port. /
relig.*
Aft.: H. Anelay, F. Barwell, E.H.
Corbould, W. Drummond, A. Egg,
G. Harvey, Sir G. Hayter, J. Hayter,
J.R. Herbert, A. Johnstone, H. Le
Jeune, E.T. Parris, A. Rankley, F.
Rochard, F. Stone, M. Stone.
Shared: D. Lucas (q.v.).
Pub.: Ackermann; H. Graves; Lloyd
Bros. and Spooner.

185

EKE James fl. 1827—31.
Steel.
Illus.
Eke was awarded a silver medal in
1827 by the Society of Arts for an
engraving on steel of a cotton machine.

EKEARNY — fl. mid (?) 19th c.
Line (?)

ELAND J. Shenton 1872—1930.
Et., litho.
Illus. / port.

ELD George 1791 (Coventry) —
1862 (Coventry).
Et. (amateur)
Antiq.

ELDER Arthur John b. 1874
(London).
Et.
A pupil of Sickert (q.v.), T. Roussel,
C. Huard, D. Muirhead and J. Pryde.
Also a teacher.

ELIAS Annesteff fl. 1880s to 1904.
Et.
Land.
Also a noted painter of landscape and
flowers.

ELLIS Tristram J. 1844 (Gt.
Malvern) — 1922.
Et.
Land. / topog.
Ellis worked in London after studying
in Paris under Bonnar at the École des
Beaux Arts. He travelled in the Middle
East.

ELLIS William 1747 (London) —
1810.
Line.
Land. / ship.
Pup.: William Woollet (1735—85) with
whom he shared work on some plates.
Aft.: T. Hearne, P. Sandby.

ELVEN J.P. fl. *c.* 1820.
Line.
Port.

EMANUEL Frank Lewis fl. 1881.
Et.
Gen.

EMMS John 1843 (Blowfield) —
1912 (Lyndhurst).
Et.
Gen. / sport.
Also a painter.

EMSLIE John 1813—75.
Line., steel.
Heraldry / illus. / maps.

EMSLIE John Philipp 1839—1913.
Line.
Gen.
Also a painter. Brother of W.R. Emslie
(q.v.).

EMSLIE W.R. fl. late 19th c.
Line.
Illus.
Brother of J.P. Emslie (q.v.).

ENGLEHEART Francis 1775
(London) — 1849 (London).
Line., steel.
*Antiq. / gen. / illus. / lit. / myth. /
port. / relig.*
Nephew of George Engleheart the
miniaturist and father of T.S. and J.H.
Engleheart (qq.v.), Francis was
apprenticed to Joseph Collyer (q.v.).
He was afterwards assistant to J. Heath
(q.v.).
Aft.: Fra Bartolommeo, Bower, A.E.
Chalon, R. Cook, W. Hilton, L. Sharpe,
R. Smirke, F.P. Stephanoff, T.
Stothard, Sir D. Wilkie.
Shared: J. Heath, whom he helped to
complete Stothard's "Canterbury
Pilgrims" began by L. Schiavonetti
(qq.v.).
Pub.: Thomas Boys; Cadell and Davies;
London Fine Art Association.

ENGLEHEART Jonathan or John H.
fl. early-mid 19th c.
Line., steel.
An. / illus. / relig.
Son and pupil of Francis Engleheart
and brother of T.S. Engleheart (q.v.).
Aft.: A. Cooper.

ENGLEHEART Timothy Stansfeld
1803 (London) — 1879 (London).
Line.
Antiq. / illus. / relig.
T.S. Engleheart was a son of Francis
Engleheart and brother of J.H.

Engleheart (qq.v.) and a relative of George Engleheart the miniaturist. He moved to Darmstadt for a period beginning *c.* 1840.
Aft.: Guido Reni.

ENSOM William 1796—1832 (Wandsworth).
Line., steel.
Gen. / hist. / illus. / land. / port. / relig. / topog.
Also a draughtsman and watercolourist. Among his works is a pen and ink portrait of William Blake (q.v.).
Aft.: Bonington, C. Cignani, C. Dolce, Sir T. Lawrence, Smirke, Stephanoff, T. Stothard.

ERXLEBEN J. fl. *c.* 1830—40.
Litho.
Port. / theat. (ballet)
Aft.: Mrs Philip Barnard.

ETHERINTON Edward fl. Paris *c.* 1860.
Wood.
Illus.
A friend and follower of G. Doré.

EVANS Benjamin Beale fl. *c.* 1824.
Line.
Gen. / port.

EVANS Edmund 1826 (Southwark) — 1905 (Ventnor).
Print. (colour), wood.
Illus.
Evans was educated in a private school and started life as a reading boy at a printing works. After serving an apprenticeship with E. Landells (q.v.) he set up in 1847 in business on his own account, receiving work from the *Illustrated London News* and from other publishers. He began to print in colour by using a succession of wood-blocks, one for each colour, and was especially successful in producing coloured books for children.
Aft.: C. Bennett, R. Caldecott, W. Crane, R. Doyle, M.B. Foster, Kate Greenaway, W.H. Roper, G.H. Thomas.
Lit.: de Maré E. *The Victorian Woodblock Illustrators* 1980. Evans E. *The Reminiscenes of Edmund Evans* (ed. R. McLean) 1967.

EVANS Edmund William 1858— after 1897.
Et.
Arch. / illus. / hist. / land. / topog.
Worked in London.
Aft.: F. Barraud, H. Brooks, J. Constable, J. Cooper, B. Evans, S. Flint, R. Halfnight, J.H. Hooper, W.H. Pike, C. Stanfield, J.M.W. Turner, A. Wardley, E. Warren.
Pub.: Bowden, Son and Co.; Dickinson and Foster; Dowdeswell and Dowdeswells; A. Lucas; F.C. McQueen; I.P. Mendoza.

EVANS Edward 1789—1835.
Printseller.
Evans's shop was in Gt. Queen Street, Lincoln's Inn Fields, London. His widow, Anne E. Evans and their son, Edward David (1818—60) opened another shop in 1853 at 403 Strand. It was continued after Edward David's death by his brother Albert.

EVANS William fl. end of 18th *c.*, beginning of 19th *c.*
Line., stip.
Gen. / illus. / port. / sculp.
Evans was assistant to Benjamin Smith (q.v.) *c.* 1800.
Aft.: A.W. Devis, H. Edridge, R. Smirke.
Shared: C. Picart (q.v.).
Pub.: Boydell.

EVE George W. 1855—1914.
Et., Ex libris, line.
An heraldic artist at the College of Arms.
Lit.: Viner G.H. *A Descriptive Catalogue of Bookplates by G.W. Eve* 1916.

EVERSHED Arthur 1836 (Billinghurst) — 1919.
Dry., et.
Arch. / land. / topog.
A pupil of Alfred Clint and at Leigh's (Heatherley's) Art School, Evershed was also a painter and a doctor. He worked in Amptill, Hampstead and Fishbourne, nr. Chichester, and etched over 300 plates in addition to a small number of drypoints.
Pub.: A. Lucas; E.Parsons.

187

EVERY George H. 1837 (Hendon)
— 1910.
Line., mezzo.
Gen. / lit. / port. / relig.
Aft.: Sophie Anderson, E. Caldwell,
J.E. Collins, A. Cope, J. Craig, T.
Dicksee, W. Drummond, E.U. Eddis,
Gainsborough, H. Hardy, A.S.
Henning, Sir T. Lawrence, F.R. Lee,
Lord Leighton, E. Long, J. Lucas,
D. Maclise, Sir J.E. Millais, C. Nicholls,
J. Opie, Rev. M.W. Peters, F.
Simoneau, M. Stone, J. Timberell,
H. Wallis.
Pub.: A. Ackermann; T.Agnew; T.
Boys; Ernest Brown; Fine Art Society;
H. Graves; S. Hollyer; Lloyd Bros.;
A. Lucas; A. Tooth.
Lit.: Engen R.K. *Victorian Engravings*
1975.

EVERY S.F. fl. mid (?) 19th c.
Et.
Arch. / topog.

EXLEY James Robert Granville
1878 (Great Horton, nr Bradford) —
1967.
Et.
An. / topog.
A pupil of Sir Frank Short (q.v.),
Exley became head of the Hull
Municipal School of Art 1912—19.

EYLES B. fl. *c*. 1850.
Line., stip., steel.
Illus. / lit. / port.
Aft.: A. Bouvier, A. Egg, J. Hayter,
R. Therburn.
Pub.: Hering and Remington; Lloyd
Bros.; Virtue.

EYRE AND SPOTTISWOODE
General publishers and printers who
also published a number of prints in
the 1890s and early 20th c. Still in
existence.

FACIUS George Sigmund *c.* 1750
(Ratisbon) — 1814.
FACIUS Johann Gottlieb *c.* 1750
(Ratisbon) — 1802.
Stip.
Gen. / lit. / myth. / port. / topog.
The brothers (who were sons of the
Russian consul in Brussels) always
worked together and their individual
work is indistinguishable. They studied
at Brussels and came to London in
1776, where they were employed by
Boydell.
Aft.: Abbott, Barry, Dietricy, L.
Gottenbrunn, Hamilton, Angelica
Kauffmann, C. Maratti, P. Potter,
Reynolds, Titian, H. Tresham, Van
Dyck, B. West.
Shared: R. Earlom (q.v.).

FAED James 1821 (Burley Mill,
Kirkcudbrightshire) — 1911 (Edinburgh).
Mezzo.
Gen. / lit. / port. / relig.
James Faed, who was also a painter,
was the brother of the painters John
and Thomas Faed. He worked in
London and Edinburgh.
Aft.: J. Collins, E.U. Eddis, John Faed,
T. Faed, J.W. Glass, Sir F. Grant, R.
Herdman, H. Le Jeune, N. Macbeth,
D. Macnee, A. Melville, W. Ouless, Sir
N. Paton, G. Reid, Reynolds, J. Sant,
F. Winterhalter.
Pub.: Colnaghi; H. Graves; J. Keith;
Lloyd Bros.; J. McLure and Son; F.C.
McQueen; George P. McQueen;
McQueen and Co.; H. Paton and Sons;
W. Schaus with Moore.

FAGAN Louis Alexander 1845
(Naples) — 1903 (Florence).
Et.
Cost. / illus. / port. / topog.
Fagan came of a family which
included diplomats and soldiers,
although his grandfather Robert Fagan
was a portrait painter as well as a
diplomat. His father was an attaché to
the British Legation at Naples. After
being sent to England in 1860 to
attend school at Leytonstone, Essex,
Louis himself became a member of the
diplomatic service, serving with his
father in Venezuela. Returning to
Europe in 1869, he worked in the
department of prints and drawings in
the British Museum until he retired in
1894, after which he lived mostly in
Italy. He wrote many studies of art
and collecting and was a practising
artist throughout his life.
Aft.: Meissonier, G.F. Watts.
Pub.: C. Klackner.

FAHEY James 1804 (Paddington) —
1885 (Shepherd's Bush).
Aq., et.
Land. / sport.
Fahey, who was also a painter, studied
art under his uncle John Swaine after
which he became a pupil of George
Schwarf and studied in Paris. He
became drawing master at Merchant
Taylors School in 1856, a position he
retained for twenty-seven years.
Aft.: C.H. Weigell.
Pub.: Ackermann.

189

FAIRBURN John fl. London
1801—37.
Printseller, pub.
Fairburn operated at various London
addresses at different times: 106—110
Minories; 40 Fetter Lane; 44 Barbican;
Featherstone Street, City Road. He
was probably succeeded by S. Fairburn
(*c.* 1837) of 44 Barbican.

FAIRHOLT Frederick William 1814
(London) — 1866 (Brompton).
Steel., wood.
Illus.
Fairholt, who was also a writer on
antiquities, was the sixteenth child of
a German named Fairholz, who came
to work in England. His mother was a
daughter of a Spitalfields silk weaver.
He was given regular drawing lessons
when he was twelve and, for a drawing,
gained a silver medal from the Society
of Arts. For some years he worked in a
tobacco factory, but at twenty-one he
became an assistant to S. Sly (q.v.) and
thereafter devoted himself to
engraving.

FAIRHURST Enoch 1874—1945.
Et.

FAIRLAND Thomas 1804 (London)
— 1852 (London).
Line., litho.
*An. / gen. / hist. / hum. / port. / relig. /
ship. / sport.*
Fairland showed an early aptitude for
art. He attended the R.A. Schools
under Fuseli (q.v.) and was awarded a
silver medal for drawing from the
antique. He turned to line engraving
and studied under C. Heath and A.
Warren (qq.v.). He subsequently took
up lithography, but found the
competition in that art too great and
set up as a portrait painter, although
he was not very successful in that art,
despite having many sitters. He was
perhaps a brother of W. Fairland (q.v.).
Aft.: J. Absolon, R. Ansdell, W.
Barraud, R.W. Buss, A. Cooper, J.L.
David, R. Farrier, G. Fenn, Sir F.
Grant, Gunston, C. Hancock, W. Hunt,
Sir E. Landseer, Q. Matsys, J. Miller,
Raphael, W.J. Shayer, H. Strafford,
C. Taylor, F.C. Turner, R. Westall,
F. Winterhalter, A. Wivell.

Shared: R.M. Meadows (q.v.).
Pub.: Colnaghi; H. Graves.

FAIRLAND William fl. early-mid
19th c.
Litho.
Anat. / gen.
Perhaps a brother of Thomas Fairland
(q.v.).
Aft.: R. Farrier, R. Smirke.

FAIRLESS James L. fl. 1860s—70s.
Print., pub.

FAIRLESS and BEEFORTH Same
as Beeforth and Fairless (q.v.).

FAIRMAN Gideon fl. Manchester
and London 1819—22.
Line.
Bank. / stamps.
A partner of J. Perkins (q.v.) in the
firm of Perkins and Fairman. He
returned to Philadelphia, his home, in
1822.

FAIRTHORN W. fl. 1829—31.
Steel.
Arch. / illus. / land.
Aft.: J.P. Neale.

FALCONER John M. 1820
(Edinburgh) — 1903 (New York).
Et.
Topog.
Falconer went to U.S.A. and became a
pupil at the National Academy of
Design in New York. He travelled
widely in Europe and made many
studies in watercolour. He also painted
on porcelain and in enamel.

FANSHAW Catherine Maria 1775
(London) — 1835.
Et. (soft-ground).
Gen.
Also a watercolourist. Younger sister
of Penelope Fanshaw (q.v.).

FANSHAW Penelope d. 1833.
Et. (amateur).
Topog.
Elder sister of Catherine Maria
Fanshaw (q.v.).

FARINGTON Joseph R.A. 1747
(Leigh, Lancs.) — 1821 (Didsbury,
Manchester).
Aq., line.
Land. / port.
Best known as a landscape painter,
Farington was a pupil of Richard
Wilson.
Aft.: R. Wilson.
Des. eng.: T. Byrne, T. Medland
(qq.v.), B. Pouncey (d. 1799).
Pub.: John Boydell, W. Bryne.

FARNBOROUGH Lady — See
LONG Amelia.

FARRAH Fred fl. 1873.
Pub.
Juv. dram.
Also published *The Wild Boys of
London* a magazine later banned.

FARREN Robert (1882 — after
1889) and M.
Et.
*Arch. / gen. / illus. / land. / sport. /
theat. / topog.*
Lived and worked in Cambridge.
Pub.: W. Farren.

FARREN William fl. Cambridge
(How House) 1880s.
Pub.
Et.

FARRER Henry 1843 (London)
— 1903.
Et.
Land. / marine / topog.
Farrer worked in U.S.A. and became
President of the New York Etching
Club.
Lit.: *American Art Review* 1879.

FARRER Thomas Charles 1839
(London) — 1891 (London).
Et.
Gen. / land. / topog.
A brother of Henry Farrer, (q.v.),
T.C. Farrer was self taught, but
studied in New York. He returned to
London in 1871.
Aft.: G. Boughton, R. Temple.
Pub.: Boussod, Valadon and Co.;
C.E. Clifford; M. Knoedler; A. Tooth.

FAWCETT Benjamin 1808 (Driffield)
— 1894 (Driffield).
Print., chromolitho., wood (some in
colour).
Illus. / nat.
Fawcett was also a bookseller. All of
his work was in book illustration.
Aft.: H. Briscoe, A.F. Lydon, C.
Voyez.
Lit.: Morris M.C.F., *Benjamin Fawcett,
Colour Printer and Engraver* 1925.

FELLOWES William Dorset
fl. 1817—28.
Aq., line.
Illus.
Des. eng.: J. Clark, J.T. Smith (qq.v.).

FELLOWS W. fl. early 19th c.
Aq.
Gen. / land.
Aft.: S.E. Jones.

FENN C. fl. 1850s—70s.
Steel.
Arch. / illus.
Aft.: Brodrick, Scott, T.H. Shepherd.

FENNEL John Greville 1807—85.
Steel.
Hum. / illus.
Also a painter.

FENNER Rest fl. 1820s—30s.
Steel.
Arch. / ex. libris / illus.

FENNER SEARS and Co. fl. early
19th c.
Steel.
Illus.
Firm of engravers which sometimes
issued plates under its own imprint
instead of under those of individual
artists.

FERGUSSON John Duncan 1874—
1961.
Et.
Fig. / port.
Also a painter, this Scottish artist was
much influenced by Manet, the Fauves
and the Glasgow School.

FERGUSSON and MITCHELL
fl. 1890s.
Pub.

FERNELL H. fl. 1830s.
Steel.
Fig. / illus.
Aft.: G. Harlow.

FERRIER C.A. fl. London 1860s.
Line.
Gen.

FERRIER George Straton fl. 1870s
—80s d. 1912 (Edinburgh).
Et.
Marine.
Born in Edinburgh, Ferrier was the son
of the landscape painter James Ferrier.
Aft.: R. Nisbet.

FIELD Robert d. Jamaica, 1819.
Mezzo., stip.
Port.
Field, who was born in Gloucester
worked in Halifax.
Aft.: Reynolds.

FIELD T. fl. 1846.
Steel.
Illus. / land.
Aft.: W. Tombleson.

FIELDING Newton Smith 1799
(Huntingdon) — 1856 (Paris).
Aq., et., litho.
*An. / illus. / marine / port. / sport. /
topog.*
Fielding was the youngest son of
Nathan Theodore Fielding the
portrait painter and brother of
T.H.W. Fielding (q.v.). He went to
Paris where he was engaged as teacher
to the family of King Louis-Philippe,
and lived there until he died. He was
the author of several works on art.
Aft.: H. Alken, Lieut. Caddy, Sir T.
Lawrence, E. Lami, F.C. Turner.
Pub.: A. Ackermann; Dean and Co.;
T. McLean; Sherwood Jones and Co.;
J. Watson.

FIELDING Theodore Henry Adolphus
1781 (Croydon) — 1851 (Croydon).
Aq., stip.
*Arch. / illus. / land. / marine / sport. /
topog.*
The eldest son of the painter Nathan
Theodore Fielding and brother of
N.S. Fielding (q.v.), T.H.A. Fielding
became teacher of drawing and

perspective at the East India
Company's College, Addiscombe. He
was also a painter and wrote several
books on art.
Aft.: H. Alken, B. Barker, R.P.
Bonington, A. Copley Fielding, J.
Pollard, J.M.W. Turner.
Pup.: C. Bentley (q.v.).
Pub.: Watson.

FIFE James fl. 1830.
Steel.
Arch. / illus. / land.
Aft.: W. Westall.

FINCH Heneage, 4th Earl of
AYLESFORD 1751—1812.
Et. (amateur)
Ex. libris / land. / topog.
Lit.: *P.C.Q.* XI, pp. 262—92.

FINDEN Adam Edward c. 1824—46.
Line.
Illus.

FINDEN Edward Francis 1791
(London) — 1857 (St. John's Wood).
Line., steel., stip.
Antiq. / gen. / illus. / land. / lit. / port.
The younger brother of William
Finden (q.v.) with whom he worked,
E.F. Finden was a pupil of James
Mitan (q.v.). Both Findens relied
heavily on the assistance of pupils and
employees and no work was completed
by them unassisted. They were noted
especially for large steel engravings.
Aft.: Beechey, W. Brockedon, G.
Cattermole, W. Collins, E.W. Cooke,
D. Cooper, F. Danby, W. Daniell, A.
Elmore, C. Fielding, R. Ford, W.P.
Frith, Gainsborough, J.D. Harding, Sir
E. Landseer, Sir T. Lawrence, D.
Maclise, J. Martin, G.S. Newton, T.
Phillips, S. Prout, R. Reinagle, D.
Roberts, A. Robertson, C. Stanfield,
J.M.W. Turner, Van Dyck, R. Westall,
Sir D. Wilkie.
Assist.: J. Stephenson (q.v.).
Pup.: C. Cousen, R. Hatfield, S.
Sangster, R. Staines (qq.v.).
Other assistants and pupils are listed
under William Finden.
Pub.: Ackermann and Co.; Gambart;
McQueen; F.G. Moon; Murray.

FINDEN George C. fl. London,
Streatham, Balham 1848—80.
Line., steel.
Gen. / hist. / illus. / port.
Aft.: G. Boughton, J. Hodgson, R.
Lane, Reynolds, T. Stothard, H. Wallis.
Pub.: H. Graves.

FINDEN William 1787 (London) —
1852 (Highgate).
Line., steel.
*Antiq. / gen. / illus. / land. / lit. / port. /
relig.*
William Finden was the elder brother
of E.F. Finden (q.v.) with whom he
worked, and was a pupil of J. Mitan
(q.v.). Both E.F. and W. Finden relied
heavily on the assistance of pupils and
employees and no important work by
them was completed without
assistance. William, who received a
gold medal from the Society of Arts in
1813, was noted especially for large
steel engravings.
Aft.: A.W. Callcott, A. Chalon, A.
Cooper, D. Cowper, F. Goodall, G.
Hayter, W. Hilton, Sir E. Landseer,
Sir T. Lawrence, C.R. Leslie, G. Leslie,
T. Phillips, G. Sanders, R. Smirke, C.
Stanfield, T. Stothard, Teniers, H.
Thomson, J.M.W. Turner, Van Dyck,
T. Webster, Sir D. Wilkie.
Assist.: J.B. Allen, J.W. Archer, F.
Bacon, C. Rolls, L. Stocks (qq.v.).
Pup.: S. Hollyer, T. Phillibrowne,
G. Price, S. Rawle, W.H. Simmons,
J. Stubbs (qq.v.).
Pub.: Moon, Boys and Graves; Murray;
Royal Irish Art Union; Sharpe; Sutton;
Trustees of the British Museum.

FINDLAY J. fl. 1827—31.
Aq., et.
Illus. / topog.
Also a watercolourist.

FINE ART SOCIETY LTD.
General art dealers and publishers of
prints, etchings and photo-engravings.
Founded in 1876 at 148 New Bond
Street the firm still exists there.

FINKE C. fl. 1830s.
Steel.
Arch. / illus.
Aft.: T. Shepherd.

FINN Herbert John b. 1860.
Et.
Arch. / topog.
Studied in Paris and Antwerp and
worked in London and Folkestone.

FINNEMORE Joseph 1860—1939.
Et.
Illus.

FINNIE John 1829 (Aberdeen) —
1907 (Liverpool).
Et., mezzo.
Land. / lit. / relig. / topog.
The son of a brass founder, Finnie
served apprenticeships with a
housepainter and a japanner. After
being a pupil of W.B. Scott (q.v.) at
Newcastle School of Design he went to
London in 1853 and studied in the
Central School of Design, Marlborough
House, where he also taught. In 1855
he was appointed master of Liverpool
School of Art, where he remained
until 1896. He was also a landscape
painter.
Pub.: Frost and Reed.
Lit.: Unsigned *Memorial Exhibition
Catalogue* 1907.

FISCHEL, ADLER and SCHWARTZ
American print publishers who issued
some prints by British artists. Their
address was 94 Fulton Street, New
York.

FISHER Alfred Hugh 1867 (London)
— 1945.
Et.
Arch. / fig. / port. / topog.
Also a painter.
Lit.: *P.C.Q.* XXVIII, pp. 380—81.

FISHER J. fl. 1829—34.
Steel.
Illus. / land.
Aft.: J.D. Harding, D. Roberts,
N. Whittock.

FISHER Samuel fl. Birmingham,
early — mid 19th c.
Steel.
Lit. / land. / topog.
Aft.: W.H. Bartlett, J.D. Harding,
D. Roberts, C. Stanfield, W.F.
Witherington.
Pub.: J. Vincent (Oxford).

FISHER Thomas 1782 (Rochester)
— 1836 (Stoke Newington).
Litho.
Antiq.
An amateur who worked in the India
Office, Fisher was also a painter and
an antiquary. He contributed articles
on lithography to the *Gentleman's
Magazine.*

FITCH John Nugent fl. 1880s—90s.
Litho.
Flor. / illus.
Nephew of W.H. Fitch (q.v.).

FITCH Walter Hood 1817—92.
Litho (incl. chromolitho.)
Flor. / illus.
Apprenticed to a firm of calico printers
in Glasgow, Fitch was noticed by Sir
William Hooker, who took him with
him to work as an artist when he was
appointed Director of Kew Gardens.
He was the uncle of J.N. Fitch.
Aft.: J. Hooker.

FITTLER James 1758 (London) —
1835 (Turnham Green).
Line.
*Gen. / hist. / illus. / land. / marine /
mil. / port. / relig. / ship. / theat. / topog.*
Fittler entered the R.A. Schools in
1778. He was appointed marine
engraver to George III, but undertook
no important work after 1822. In
1788 he was living at No. 62 Upper
Charlotte Street, Rathbone Place,
London.
Aft.: Bowyer, Brenton, Claude, W.
Delamotte, P.J. De Loutherbourg,
T. Luny, J. Miel, G. Morland, Moroni,
C. Nattes, Capt. M. Oates, J. Opie, R.
Paton, T. Phillips, G. Robertson,
Rubens, D. Serres, Snyders, Teniers,
H. Tresham, Velasquez.
Shared: D. Lerpinière (q.v.). Figures
on some plates by F. Bartolozzi (q.v.).
Pub.: Bell; V. and R. Green.

FITTON Hedley 1859—1929
(Haselmere).
Et., litho.
Arch. / port. / topog.
Fitton's work was much influenced by
that of D.Y. Cameron (q.v.).
Lit.: Dunthorne R. *Catalogue of
Etchings of Hedley Fitton R.E.* 1911.

FITZGERALD Lord Gerald 1821—
86.
Et.
Lit.
Worked in Dublin.

FLAMENG Léopold Joseph 1831
(Brussels) — 1911 (Courgent, nr.
Nantes).
Et.
All. / gen. / hist. / port.
Belgian national who etched some
plates after works by British artists
which were published in England.
Aft.: E. Abbey, J. Collier, H.W. Davis,
F. Dodd, L. Fildes, W.P. Frith,
Gainsborough, Sir T. Lawrence, Lord
Leighton, W. Nicholson, V. Prinsep,
F. Sandys, G.F. Watts.
Pup.: C.J.L. Courtry (q.v.).
Pub.: Ellis and White; Fine Art Society;
T. McLean; Parsons; A. Tooth.
Lit.: Engen R.K. *Victorian Engravings*
1975.

FLEMMING or FLEMING T.
fl. 1840s—70s.
Steel.
Arch. / illus. / land.
Aft.: T. Allom.

FLETCHER E. fl. 1820s.
Litho.
Flor. / illus.

FLETCHER Frank M. b. 1866.
Wood.
Land. / myth.
A pupil of Cormon at Paris.

FLINT Sir William Russell 1880
(Edinburgh) — 1969.
Dry., et.
Arch. / fig. / gen. / topog.
Best known as an illustrator and
watercolourist, especially for his studies
of the nude.
Lit.: Salaman Malcolm *W. Russell Flint*
Modern Masters of Etching Series No.
27 1931. Sotheby and Co. *The Arthur
Mitchell Collection of Drypoints by
Sir William Russell Flint* 1973. Wright
Harold J.L. *Etchings and Drypoints by
Sir William Russell Flint* 1957.

FLOYD William fl. Birmingham
1830s—50s.
Line., steel.
Illus. / land. / topog.
Aft.: T. Allom, W.H. Bartlett, Cotman,
C. Fielding, C. Marshall, H. Melville,
S. Prout, W. Purser, Rembrandt, J.
Salmon, C. Stanfield, J.M.W. Turner,
Lieut. White.

FOCILLON Victor Louis 1849
(Dijon) — 1918.
Et.
Gen. / land. / sport.
French national who etched some
plates after works by British artists
which were published in England.
Aft.: V. Cole, Downman, C. Hemy,
D. Murray, W.D. Sadler.
Pub.: Frost and Reed; H. Graves;
C. Klackner; A. Tooth.

FOGG A. fl. late 18th-early 19th c.
Line., stip.
Gen. / hist. / myth. / port.
Aft.: Brederman, J.S. Copley, W.
Hamilton.
Pub.: Fogg.

FOGGO George 1793—1869.
Litho.
Relig.
Worked with his elder brother, the
painter James Foggo. George Foggo
also wrote on lithography.
Aft.: Raphael.

FOLKARD W.A. fl. early—mid 19th c.
Wood.
Illus.
Aft.: John Gilbert.
Lit.: Jackson J. and W.A. Chatto *A
Treatise on Wood Engraving* Second
ed. 1861.

FONCE Camille Arthur 1867
(Briare-le-Canal, Loirer) — c. 1911.
Dry., et.
Arch. / land. / topog.
French national who etched some
plates after works by British artists
which were published in England. He
worked for a time in London (where
he was a pupil of the painter, John
Collier) and at Bristol. His works were
very popular in Gt. Britain.
Aft.: D. Adams, B. Leader, J.

MacWhirter, W.S. Lloyd, E. Waite.
Pub.: Adler; Boussod, Valadon and
Co.; Fishel; Goupil; H. Graves; M.
Knoedler; I.P. Mendoza; Schwartz;
A. Tooth.

FOOTTET Frederick Francis 1850
(Sheffield) — 1935.
Et., litho., mezzo.
Fig. / gen. / land. / myth.
Foottet was educated in Derby and
worked in London.
Aft.: W. Crane, G.F. Watts.

FORBES Elizabeth Adela (née
Armstrong) 1859—1912.
Dry., et.
Fig. / port.
Wife of the painter Stanhope Forbes.
Lit.: *P.C.Q.* IX, pp. 75—100.

FORD James d. after 1812.
Aq.
Land. / top.
A pupil at the School of the Dublin
Society, Ford made a number of views
in aquatint for the county surveys
published by that Society.

FORD Richard 1796 (London) —
1858 (Heavitree, nr Exeter).
FORD Harriet fl. 1820s.
Et.
Illus. / relig. / topog.
The relationship of these engravers is
obscure, but they were probably
husband and wife. Richard was an
amateur and also wrote a guide book
to Spain.
Aft.: Parmigiano.

FORES A.B.
FORES and CO.
FORES LTD. fl. mid 19th c.
Pub. of prints and photo-engravings.
Noted especially for sporting prints.
They also published prints of the
ballet.

FORMSTRECHER Hélène 1852
(Paris) — after 1890.
Et.
Gen.
French national who etched some
plates after works by British artists
which were published in England.
Aft.: W. Woolen.
Pub.: L. Brall and Son.

FORREST John B. *c.* 1814
(Aberdeenshire) — 1870 (Hudson,
New York).
Line.
Port. / sculp.
A pupil of W.T. Fry (q.v), J.B. Forrest
went to Philadelphia, where he worked
for the National Portrait Gallery then
to New York where he practised
portrait miniature painting.
Aft.: E.H. Baily.

FORREST William 1805 (Scotland)
— 1899.
Line., steel.
Hist. / illus. / land.
Lived and worked in London.
Aft.: W. Allan, H. Chevalier, F. Church,
Claude, W. Leitch, A. Waterloo.
Pub.: R. Ackermann; Day and Sons;
A. Hill.

FORSE R. fl. London (57 St. John's
Square) 1827.
Pub.
Tinsel.

FORSTER William C b. Dublin — d.
1911 (Canada).
Litho. (incl. chromolitho.)
An. / land. / topog.
Forster, who was best known as an
engraver of gems, emigrated to Canada
in 1872.

FORTEY W.C. fl. London
(Monmouth Court, Bloomsbury)
c. 1880.
Pub.
Tinsel.

FOSTER Myles Birket 1825 (North
Shields) — 1899 (Weybridge).
Et., line., litho., steel., wood.
Illus. / land. / lit.
One of the most prolific illustrators
of the 19th century, Birket Foster was
a pupil of E. Landells (q.v.) and his
drawing master was Charles Parry. In
1846 he started a wood-engraving
business and worked for such
periodicals as *Punch* and *Illustrated
London News.* His own prints were
made early in his career, most of his
designs being engraved by others.
Des. eng.: Dalziel Bros., M.H. Long,
W. Miller (qq.v.).

Pub.: Fine Art Society; T. McLean;
A. Tooth.
Lit.: *Art Journal* 1890.

FOTHERGILL J. fl. 1820s.
Steel.
Arch. / ex. libris / illus.
Aft.: G. Shepherd.

FOWLER William 1761 (Winterton)
— 1832 (Winterton).
Line.
Arch.
Fowler was brought up as a carpenter
at Winterton, Lincolnshire, where he
spent his life. He was also a
draughtsman.

FOX Augustus fl. 1820s.
Line., steel.
Illus.
Pup.: E.R. Whitfield (q.v.).

FOX Charles 1794 (Cossey, Norfolk)
— 1849 (Leyton).
Line., steel.
An. / gen. / illus. / port.
The son of a steward to Lord Stafford,
Fox was instructed in drawing by
Charles Hodgson of Norwich. He was
apprenticed to W.C. Edwards (q.v.). at
Bungay, after which he came to
London and became an assistant to
John Burnett (q.v.). He was also a
watercolourist.
Aft.: W. Allan, S. Denning, W.H. Hunt,
Sir E. Landseer, Sir T. Lawrence,
W. Mulready, G.S. Newton, H.W.
Pickersgill, F.P. Stephanoff, Sir D.
Wilkie.
Pub.: Cadell.
Lit.: Engen R.K. *Victorian Engravings*
1975.

FOX Charles fl. *c.* 1870.
Pub.
Juv. dram.
Also published *The Boy's Standard*
magazine.

FOX George b. 1851.
Et.
Gen.
Worked in London, and was also a
painter.
Pub.: Shepherd Bros.

FOX Henry Charles 1860—1913 or after.
Et.
Land. / topog.
Fox worked at Sunbury and Kingston-on-Thames, and was also a landscape painter.
Pub.: Gladwell Bros.

FOX M. fl. 1828.
Steel.
Arch. / illus.
Aft.: T.H. Shepherd.

FRANCIS Edward fl. (?) mid 19th c.
Steel.
Arch. / illus. / land.
Aft.: W. Westall.

FRANEY R. and CO.
fl. London (53 East Street, Marylebone) 1823.
Pub.
Tinsel.

FRANKLAND Sir Robert, Bart 1784—1849.
Aq., et.
Sport.
Signed work: R.F.
Pub.: Humphreys.

FREEBAIRN Alfred Robert 1794 (London) — 1846 (London).
Et., line., steel.
Illus.
The son of Robert Freebairn (1765—1808) the landscape painter, A.R. Freebairn was a student at the R.A. His later work was almost wholly by the Anaglyptograph process invented by John Bate.
Aft.: Arnold, T. Flaxman, J. Goujon, Nixon, S. Prout, Pyne, D. Roberts.
Pub.: Art Union.

FREEMAN Samuel 1775 (London) — 1857 (London).
Aq., steel., stip.
Gen. / hist. / illus. / lit. / myth. / port. / relig. / topog.
Aft.: Bartolozzi, A. Buck, Correggio, Miss Costello, Faringdon, Mrs Leigh Hunt, Sir T. Lawrence, Raphael, Reynolds, Thompson, Van Dyck, J. Wright.
Shared: J.C. Stadler (q.v.).

FREKE Alfred fl. 1890s.
Pub. (incl. photo-eng.)

FRENCH William 1815—98 (East Grinstead).
Line., steel.
Illus.
Reproduced many of his contemporaries' paintings.
Aft.: H.K. Browne, E. Crofts.

FROST — fl. 1832.
Steel.
Illus. / land.
Aft.: W. Tombleson.

FROST T. fl. London (40 Dudley Street, Soho) c. 1840.
Pub.
Juv. dram.
Agent for J.K. Green (q.v.).

FROST William Edward R.A. 1810 —77.
Et.
Fig. / gen.
Also a figure painter, Frost was a pupil of William Etty.

FROST and REED LTD.
General art dealers and publishers of prints, collotypes, photo-engravings and other facsimiles. Fl. from 1880s at 24 High Street, Cardiff; 12—13 Clare Street, Bristol (trading as The Sporting Gallery and Venture Prints); Albany Court, Piccadilly, London. The firm still exists at 41 New Bond Street, London.

FRY William Thomas 1789—1843.
Et., line., litho., steel., stip.
Gen. / illus. / port. / relig.
Fry was a pupil of H. Meyer (q.v.).
Aft.: J. Barney, Caracci, G. Dupont, R. Evans, T. Flaxman, J. Jackson, Sir T. Lawrence, Parmigiano, E.T. Parris, Singleton, R. Westall.
Pup.: J.B. Forrest (q.v.).
Shared: T. Sutherland, T. Wright (qq.v.).
Pub.: Ackermann and Co.

FULLER S. and J. fl. London (24 Rathbone Place) mid 19th c.
Pub.
Sport.

197

FULLWOOD John 1854–1931
(Twickenham).
Et.
Land. / topog.
Fullwood studied in Birmingham
Newlyn and Paris, and worked in
London, Cornwall, Twickenham,
Hastings, Slinford and Paris. He was
also a landscape painter.
Aft.: J. MacWhirter.
Pub.: J. Connell and Sons; Dowdeswell
and Dowdeswells; Fine Art Society;
T. McLean.

FUSELI John Henry R.A. 1741
(Zurich) — 1825 (London).
Litho.
Fig.
Swiss by birth Fuseli (real name
Johann Heinrich Fuessli) first came to
England in 1764, visiting it several
times thereafter and finally settling
there. He was primarily a painter of
allegorical and mythological subjects,
but is included here for a lithograph
entitled "Girl on a sofa looking out of
a window" which he contributed in
1803 to the publication *Specimens of
Polyautography*. His own designs were
extensively engraved by other artists.
Pup.: T. Fairland, G.R. Lewis, W.
Locke, J. Rubens Smith (qq.v.).
Pub.: Philip André, J. Heath.
Lit.: Tomory P. *The Life and Art of
Henry Fuseli* 1972.

FUSSELL Joseph 1818 (Birmingham)
— 1912 (California).
Line.
Illus.
Was a teacher at Nottingham School of
Art.

GAD and KENINGALE fl. London
1850s.
Printers of engravings and etchings.

GAGE J. fl. Liverpool (Pembroke
Place) c. 1880.
Pub.
Juv. dram.

GAHAN George W. b. 1871.
Et.

GALE William 1823 (London) —
1909.
Et.
Port.
Also a painter of genre, historical and
religious subjects.

GALLON Robert 1845—c. 1905.
Et.
Gen. / land.
A son of R.S.E. Gallon (q.v.), R. Gallon
lived and worked in London. He was
also a landscape painter.
Pub.: L. Brall.

GALLON Robert Samuel Ennis fl.
London 1830—68.
Litho.
Fig. / port.
Father of R. Gallon (q.v.).

GAMBART and CO. fl. mid 19th c.
Litho., pub.
Founded by Ernest Gambart an art
dealer, the firm flourished in the
1840s and 1850s as publishers of
Baxterotypes, etchings and lithographs.

Later it became Pilgeram and Lefèvre
(1880s—90s). See also L.H. Lefèvre.
Lit.: Maas J. *Gambart Prince of The
Victorian Art World* 1975.

GANZ Henry F.W. fl. late 19th—
early 20th c.
Et.
Land.
A pupil of A. Legros (q.v.) at the Slade
School. Also a painter.
Aft.: F. Brangwyn, G. Chester.

GARDINER William Nelson 1766
(Dublin) — 1814 (London).
Stip.
Gen. / illus. / lit. / port.
The son of humble parents, Gardiner
was nevertheless well educated and
studied for three years at Dublin
Academy, where he was awarded a
silver medal. After this he came to
London and at first earned a living
making silhouettes but subsequently,
falling in with a company of itinerant
players, worked as a scene painter. He
was befriended by Captain Grose who
placed him with an engraver. In due
course he returned to Dublin, where
he spent every penny he possessed,
and then returned to England. Here he
determined to enter the church,
studying at Cambridge University with
the idea of taking holy orders; he even
put himself up for a fellowship. But he
again turned to art, copying portraits
in watercolour. Finally he set up as a
bookseller in Pall Mall, but committed
suicide.

Aft.: Hamilton, S. Harding, Nixon,
R. Stanier, F. Wheatley.
Shared: F. Bartolozzi (q.v.).
Pub.: Bulmer; E. Harding; Macklin.

GARNER J. fl. 1829—31.
Steel.
Arch. / illus.
Aft.: Hogarth, J.P. Neale,
T.H. Shepherd.

GARNER Thomas 1789
(Birmingham) — 1868 (Birmingham).
Line.
Gen. / illus. / lit. / myth.
Garner was apprenticed to Samuel
Lines and W. Radclyffe (qq.v.) in
Birmingham, and practised in that city
most of his life.
Aft.: W. Daniell, W.E. Frost,
J.C. Horsley, Sir T. Lawrence,
P.F. Poole, T. Stothard, T. Webster.

GARRARD George 1760 (London)
— 1826 (London).
Et.
Gen. / nat.
Also a painter.
Shared: M.A. Bate (q.v.).

GARRATT Sam 1865—1947.
Et.

GASCOYNE or GASCOIGNE George
fl. London late 19th—early 20th c.
Et.
Gen.
Also a painter.

GASKELL George Percival 1868
(Shipley) — 1934.
Aq., line. mezzo.
Land. / topog.
Lit.: *Studio* LXI p. 283.

GASTINEAU Henry 1791—1876
(Camberwell).
Line.
Land.
After studying at the R.A., Gastineau
began work as an engraver but turned
to oil painting and later to watercolour.

GATTY Mrs. Margaret (née Scott)
1809 (Burnham) — 1873 (Ecclesfield).
Et.
Land.

Daughter of Dr. Scott, chaplain to
Viscount Nelson. Best known as a
writer for children.

GAUCHEREL Léon 1816 (Paris) —
1886 (Paris).
Et.
Land.
French national who etched some
plates after works by British artists
which were published in England.
Aft.: A.W. Callcott.
Pup.: C.J.L. Courtry (q.v.).
Shared: Walter Cox (q.v.).
Pub.: L. Brall; E.E. Leggatt.
Lit.: *Portfolio* 1873 pp. 177f.

GAUCI Maxim 1774—1854.
Litho.
Flor. / illus. / music. / theat. (ballet).
Father of W. Gauci (q.v.) and of the
landscape painter P. Gauci.
Aft.: J. Deffett Francis.
Pub.: Welch and Gwynne.

GAUCI W. fl. London 1830s—50s.
Litho.
Arch. / illus. / land. / port. / sport.
Son of M. Gauci (q.v.) and brother of
the painter P. Gauci.
Aft.: J.F. Lewis, J. Pyne.

GAUGAIN Thomas 1748 (Abbeville)
— 1805 (London).
Aq., line., litho., stip.
Flor. / illus. / port.
Also a painter.
Aft.: R. Cosway, G. Morland,
Northcote, Reynolds.

GAUJEAN Eugène 1850 (Pau,
Basses — Pyrénées) — 1900 (Andrésy).
Et., Line.
Gen. / myth. /relig.
French national who made many plates
after works by British artists which
were published in England.
Aft.: Sir E. Burne-Jones, R. Caldecott,
F. Dicksee, A. Gow, J.H. Henshall,
G. Kilburne, Sir. T. Lawrence,
H.S. Marks, Sir J.E. Millais, Sir N.
Paton, H. Rheau, D.G. Rossetti,
W.D. Sadler, F. Walker.
Pub.: T. Agnew; Boussod, Valadon
and Co.; Colnaghi; Frost and Reed;
Haydon Hare; E.E. Leggatt; A. Lucas;
A. Tooth.

200

GEAR J.W. fl. London 1821—52.
Line., litho.
Port.
Also a portrait painter.

GEDDES Andrew A.R.A. 1783
(Edinburgh) — 1844 (London).
Dry., et.
*Gen. / hist. / land. / port. / topog. /
relig.*
Geddes started life as a clerk, but his
father possessed a collection of prints,
which decided him to become an artist.
He entered the R.A. Schools as a pupil
in 1806. After practising for a time in
Edinburgh, he visited Paris in 1814.
Returning to London in 1823, he soon
established himself as an etcher. He
made some 40 plates.
Aft.: Rubens, Van Dyck.
Des. eng.: C. Turner, W. Ward (qq.v.).
Pup.: W.H. Carpenter (q.v.).
Lit.: Dodgson C. *The Etchings of Sir
David Wilkie and Andrew Geddes —
A Catalogue* 1936. Furst H. *Original
Engravings and Etchings* 1931.
Hamerton P.G. *Etchings and Etchers*
1880. *P.C.Q.* XVI, pp. 109—31.
Walpole Society Annual V, 1919.

GEIKIE Walter R.S.A. 1795
(Edinburgh) — 1837 (Edinburgh).
Et.
Gen. / land. / lit. / topog.
Geikie, who was also a painter and
draughtsman, became deaf and dumb
at an early age as a result of a fever. At
the age of fourteen he began lessons in
drawing from Patrick Gibson, and in
1812 he became a student at the
Trustees Academy, Edinburgh. He
began etching in 1825 or before.
Lit.: *P.C.Q.* XXII, pp. 304—24.

GELLER William Overend
fl. (London) 1830—54.
Line., mezzo.
*Gen. / hist. / lit. / mil. / myth. / port. /
relig. / sport.*
Not to be confused with William Giller
(q.v.), a contemporary. Also a painter.
Aft.: H. Barker, C. Hancock, J. Hayter,
S. Jones, G. Lance, J. Pardon,
H.P. Parker, Reynolds, W. Simson.

GEORGE Sir Ernest R.A. 1839
(London) — 1922.
Et.

Arch. / land. / topog.
Known chiefly as an architect, George
was also a watercolourist.
Lit.: *Portfolio* VI, p. 60.

GEORGE and MANBY fl. mid 19th c.
Litho., pub.
Music. / theat. (ballet).

GERARD Ebenezer c. 1783/4
(Norwich) — 1826.
Litho.
Illus.
A native of Norwich, Gerard for many
years earned his living as a miniature
and portrait painter. Because of a
weakness in his arms caused by a fever,
he abandoned painting and tried to
earn a living by writing; his *Letters in
Rhyme* was published in Liverpool in
1825, and was illustrated with his own
lithographs. He lived in Liverpool (No.
64 Lord Street) from 1821.
Lit.: *Apollo* November 1960.

GERAUT Robert fl. London
(Burlington Buildings, Heddon Street,
Regent Street) 1880s.
Pub.

GERE Charles March 1869—1957.
Wood.
Gen. / illus. / land.
Also a painter, Gere designed some
borders and illustrations for the
Kelmscott Press.

GEROUX Charles fl. *c.* 1900.
Et.
Arch.
Aft.: B. Lucas.
Pub.: H. Graves.

GETHIN Percy Francis 1874—1916.
Dry., et., litho.
Arch. / gen. / land. / mil.
This Irish engraver was also a
draughtsman and painter. He studied
at the Royal College of Art and under
Professor Moira in Paris. He became a
master at the Plymouth School of Art
and then at the City College of Art,
Liverpool. He was killed in the Battle
of the Somme in 1916.
Lit.: *P.C.Q.* XIV, pp. 69—93; XVII,
p. 106.

Gew

GEW J.　fl. early 19th c.
Line (?)
Sport.
Also a painter.

GIBBON Benjamin Phelps　1802
(Penally, Pembrokeshire) — 1851
(London).
Chalk, line., mixed, steel.
An. / gen. / hist. / port. / sport.
The son of the Rev. Benjamin Gibbon
of Penally, B.P. Gibbon was educated
at the Clergy Ophan School. He was
then apprenticed to Edward Scrivener
(q.v.) after which he placed himself
with J.H. Robinson (q.v.).
Aft.: A. Cooper, W. Fowler,
F. Gauermann, Sir E. Landseer,
A. Morton, W. Mulready, J. Simpson,
T. Webster.
Shared: P. Lightfoot, J.C. Webb.
Pub.: O. Bailey; T. Boys; T. McLean.
Lit.: *Art Journal* 1851, p. 238.

GIBBS —　fl. 1870s.
Steel.
Illus.
Aft.: G.S. Newton.

GIBBS M.　fl. 1839.
Steel.
Fig. / illus.
Aft.: J. Brown.

GIBBS W.　fl. 1846.
Steel.
Fig. / illus.
Aft.: A. Derby.

GIBSON James B.　b. 1880.
Et.
Gen. / port.

GIBSON Patrick　1762 (Edinburgh)
— 1829 (Dollar).
Et.
Topog.
Gibson studied under Nasmyth at the
Trustees Academy, Edinburgh.
Towards the end of his life he set up as
a teacher in Dollar. He was also a
landscape painter.

GILBERT Achille Isidore　1828
(Paris) — 1899 (Paris).
Et., line., litho.
All. / sculp.

French national who engraved plates
after works by British artists which
were published in England.
Aft.: Lord Leighton.
Pub.: British and Foreign Artists'
Association; L.H. Lefèvre.
Lit.: Engen R.K. *Victorian Engravings*
1975.

GILBERT Sir Alfred R.A.　1854
(London) — 1934.
Litho.
An.
Aft.: Rosa Bonheur.
Best known as a sculptor, among whose
works is the statue known as "Eros"
on the Shaftesbury Fountain in
Piccadilly Circus, London.

GILBERT Edward　fl. late 19th—
early 20th c.
Mezzo., photo-eng.
Gen. / relig. / sport.
Aft.: M. Hardy, C. Johnson, S. Lewin,
F. Roe, H. Schmalz, M. Stone.
Pub.: Dowdeswell and Dowdeswells;
A. Lucas; I.P. Mendoza.
Lit.: Engen R.K. *Victorian Engravings*
1975.

GILBERT James　fl. mid 19th c.
Pub.

GILBERT John　fl. mid 19th c.
Wood (incl. colour).
Illus.

GILES James　fl. 1840.
Steel.
Illus. / land.
Aft.: W.H. Bartlett, D.O. Hill.

GILES John West　fl. London and
Aberdeen 1830s—60s.
Litho.
Gen. / mil. / land. / sport.
Aft.: J. Benstead, H. de Darbrawa,
R.B. Davis, H. Desvignes, J.F. Herring,
S. Hubbard, Sir Ed. Landseer,
H. Martens, F. Taylor.
Pub.: H. Graves; J. Moore.
Lit.: Wilder F.L. *English Sporting
Prints* 1974.

GILES William　1872 (Reading) — c.
1920 (? Chelsea).
Et., line.

An. / land. / sport.
Giles attended the South Kensington
School of Art and also studied in Paris
and Germany. He perfected a method
("Giles Method") of printing in oil
colour from metal plates.
Aft.: R. Ansdell, S. Cooper.
Pub.: Gambart.

GILKS Thomas fl. 1840—76.
Wood.
Illus.
Also a writer on wood-engraving.

GILLBANK Haveill fl. early 19th c.
Aq., line.
Gen. / hist. / myth. / relig.
Aft.: Bigg, T. Brown, J. Opie,
Singleton, R. Westall, F. Wheatley.

GILLER William 1805 (London) —
c. 1868.
Line., mezzo., stip.
*An. / gen. / hist. / land. / mil. / port. /
sport.*
Aft.: Sir W. Allan, H. Andrews,
T. Barker, W. and H. Barraud,
A. Cooper, R.B. Davis, C. Hancock,
H. Harlow, J. Herring Sr., Hopkins,
Sir E. Landseer, Sir T. Lawrence,
J.E. Lewis, E. Paris, R. Redgrave,
Reynolds, F. Say, J. Stewart, Webb,
F. Williams, T. Woodward.
Shared: C.G. Lewis (q.v.)
Pub.: T. Boys; E. Brooks; Fores;
H. Graves; Lloyd Bros.
Lit.: Wilder F.L. *English Sporting
Prints* 1974.

GILLETT Edward Frank 1874—
1927.
Dry.
An. / gen.

GILLRAY James 1757 (Chelsea) —
1815 (London).
Et., mixed., stip.
Caric.
The son of a Chelsea pensioner who
was also sexton to the Moravian burial
ground, Gillray was apprenticed to a
letter-engraver, but he absconded and
joined a band of strolling players, in
time becoming a student at the R.A.
Schools. He practised orthodox
engraving in stipple for a period, but
later worked exclusively on caricatures,

which he is thought to have engraved
direct on to the copper. At first he
signed his plates with the letters J.S. in
a monogram. In all he made about
1500 plates. In 1811, at the age of 58,
he lost his reason and finally took his
own life.
Pub.: H.G. Bohn; Mrs. Humphrey,
St. James's Street.
Lit.: *Connoisseur* III, p. 24. *Gazette
des Beaux Arts* VI, p. 467. Grego J.
Works of James Gillray the Caricaturist
1873.

GIMBER Stephen fl. early 19th c.
Line., litho.
Probably identical with S.H. Gimber
(q.v.).

GIMBER Stephen H. fl. London
1825—28; New York and Philadelphia
1831—42.
Line., litho.
Port.
Probably identical with S. Gimber
(q.v.).
Aft.: Reynolds.

GIRADET Edward Henri 1819
(Locle) — 1880 (Versailles).
Et., line., litho., mixed.
Hist.
Swiss national who made some plates
after works by British artists which
were published in England. He was a
son of the lithographer and engraver
Charles Giradet and brother of Paul
Giradet (q.v.).
Aft.: E. Long.
Pub.: Fine Art Society.

GIRADET Léon 1857 (Versailles) —
1895.
Mixed.
Gen.
French national who made at least one
plate after a work by a British artist
which was published in England.
Aft.: J. Williams.
Pub.: C. Klackner.

GIRADET Paul 1821 (Neuchâtel) —
1893.
Line., mezzo.
Gen. / hist.
French national who made some plates
after works by British artists which

were published in England. He was a son of the lithographer and engraver Charles Giradet, whose pupil he was, and brother of Edward Giradet (q.v.).
Aft.: S. Lucas, Sir J.N. Paton.
Pub.: H. Hare; A. Lucas.

GIRLING Edmund 1796 (Gt. Yarmouth) — 1871 (London).
Et.
Gen. / land.
Brother of R. Girling (q.v.).
Aft.: Gainsborough, Rembrandt, Waterloo.

GIRLING Richard 1799 (Gt. Yarmouth) — 1863 (London).
Et.
Gen. / land. / port.
Brother of E. Girling (q.v.).
Aft.: J. Crome, W.H. Hunt, T. Phillips.

GIRTIN James (or Jack) 1773—c. 1820.
Line., print. pub.
Land. / port.
Brother of Thomas Girtin the landscape painter.
Lit.: Girtin T. and D. Loshak *The Art of Thomas Girtin* 1954.

GISBONNE Maria fl. early (?) 19th c.
Line.
Gen.
Aft.: S. Woodforde.

GLADWELL Bros.
GLADWELL and CO. fl. London (first at 20—21 Gracechurch Street, then, as Gladwell and Co., at 68 Queen Victoria Street) 1880s—90s.
Pub., print. (steel.).
Founded by Thomas Gladwell.

GLADWIN George fl. 1838.
Et., steel.
Arch. / topog.

GLEADAH Joshua fl. 1816—36.
Aq., line.
All. / illus. / land.
Aft.: J. Varley.

GLEADALE J. fl. 1820s.
Aq.
Sport.
Shared: J. Clements (q.v.).

GLENDAL Joshua fl. *c.* 1820.
Aq.
Sport.
Aft.: J. Clements.
Pub.: James Clements (Worcester).

GLENNIE John David fl. 1810—19.
Et., litho. (amateur).
Line. / Topog.
Also a painter.

GLINDONI Henry Gillard 1852 (Kensington) — 1913.
Et.
Gen. / theat.
Worked in Kensington and Chadwell Heath, Essex.
Also a painter.
Pub.: H.C. Dickens.

GLOVER John 1767 (Hough-on-the-Hill) — 1849 (Launceston, Tasmania).
Et.
Land.
Best known as a watercolour painter, Glover was President of the "Old Watercolour" Society in 1815. He emigrated to Australia in 1831.

GODBY James fl. London about 1800—20.
Stip.
Gen. / illus. / myth. / port. / relig. / stip. / sport.
Godby was living at 25 Norfolk Street, London, *c.* 1810.
Aft.: Cipriani, Craig, M. David, Godby, Guerin, S. Howitt, Angelica Kauffmann, Sir T. Lawrence, MacMurrough, H. Merke, W. Miller, Raphael, F. Rehberg, Remberg, H. Singleton, Smirke, M. Spilsbury, G. Stuart, Whitby.

GODDEN John 1801 (London) — 1862 (London).
Et., line.
A pupil of W.R. Smith (q.v.).

GODFREY John *c.* 1817—89 (London).
Line., steel.
Gen. / illus. / land. / topog.
Worked in London.
Aft.: S. Cooper, T.S. Cooper, Cuyp, Birket Foster, P. Potter.
Pub.: Colnaghi; S.C. Hill.

GODWIN Charles fl. Bath 1810.
Litho. (amateur).
Topog.

GOFF Colonel Robert Charles 1837
(London) — 1922.
Et. (amateur).
Land. / nat. / topog.
Worked in London, Brighton and
Florence.
Lit.: *Magazine of Art* 1903—4 p. 318.
Studio II p. 41.

GOLD Colonel Charles d. 1842
(Leamington).
Line. (amateur).
Cost.

GOLDBERG Georg 1830
(Nuremberg) — 1894 (Munich).
Steel.
Illus.
Also a painter, this German engraver
made a number of plates after works
by British artists.
Aft.: V.W. Bromley, F. Dicksee,
J. McL. Ralston.

GOLDIE Cyril R. 1872—1942.
Et.
Land.
Goldie's work has classical overtones
derived from such painters as Claude,
Pussin and Verrocchio.

GOLDIE L.L. b. 1872;
Et.

GOLDING Richard 1755 (London)
— 1865.
Line., steel.
Gen. / hist. / illus. / port.
Born of humble parents, Golding was
apprenticed in 1799 to one Pass, an
engraver, but left him after five years,
when his indentures were transferred
to James Parker (q.v.). When Parker
died in 1805, Golding completed his
plates. He was introduced to Benjamin
West who commissioned him to engrave
his "Death of Nelson". He died in poverty.
Aft.: W. Fowler, H.D. Hamilton, Sir T.
Lawrence, D. Maclise, T. Phillips,
Rubens, R. Smirke, Veronese, B. West,
R. Westall.
Shared: Assisted W. Sharp (q.v.) in
some works.
Pub.: Art Union of Dublin.

GONNE George *c.* 1764—1839.
GONNE Henry b. 1811.
Line.
Illus.
Father and son of Scottish family.
George worked in Dublin.

GOOCH John 1752—1823.
Et. (amateur).
Land. / port.

GOODALL Edward 1795 (Leeds) —
1870 (London).
Line., steel.
*Arch. / fig. / gen. / hist. / illus. / land. /
myth. / topog.*
Goodall was a self taught engraver. He
began as a landscape painter but was
persuaded by J.M.W. Turner to become
an engraver, and was especially noted
for his steel engravings. He was the
father of Frederick Goodall R.A. and
Edward A. Goodall the watercolourist.
Aft.: O. Achenbach, Rosa Bonheur,
Claude, Cuyp, Gainsborough,
F. Goodall, E.A. Goodall, G.E. Hering,
F.R. Lee, J. Martin, T.M. Richardson,
D. Roberts, C. Stanfield, T. Stothard,
J.M.W. Turner, W. Wyld.
Assist.: T.L. Grundy (q.v.).
Pup.: R. Brandard (q.v.).
Pub.: Art Union of London; Associated
Engravers; Thomas Boys; Gambart;
H. Graves.
Lit.: Hunnisett B. *Steel-Engraved
Book Illustration in England* 1980.

GOODE T. fl. 1831.
Steel.
Illus. / land.
Aft.: J.P. Neale.

GOODE BROS. fl. London
(Clerkenwell Green, Clerkenwell Road)
c. 1890.
Pub.
Juv. dram.
H.G. Clarke (q.v.) was their agent.

GOODEN Stephen T. fl. 1880s—90s.
Pub.
Issued among other things photo-
engravings made by the Berlin
Photographic Co. (q.v.).

GOODEVE C. fl. 1879.
Steel.
Arch. / fig. / illus.
Aft.: Sir J.E. Millais.

GOODMAN J. fl. 1838.
Steel.
Arch. / illus.
Aft.: G.S. Shepherd.

GOODMAN J. fl. London
(Pentonville) ? 1812.
Pub.
Juv. dram.

GOODMAN T. fl. 1840s.
Steel.
Hist. / illus. / land.
Aft.: G. Cattermole, H. Gastineau.

GOODWIN J. fl. (Pentonville)
London *c.* 1880.
Pub.
Juv. dram.

GOODYEAR Joseph 1797
(Birmingham) — 1839 (London).
Line., steel.
Gen. / illus.
After practising in Birmingham as an
engraver on plate and studying drawing
under G.V. Barker in the same town,
Goodyear went to London where he
worked for a time as a trade engraver.
He then became a pupil for three years
of C. Heath (q.v.) and was later
employed by the Findens (qq.v.).
Aft.: A.E. Chalon, A. Cooper,
H. Corbould, C. Eastlake,
J.G. Middleton, T. Uwins, J. West.

GORWAY Charles M. fl. early—mid
19th c.
Wood.
Illus.
Aft.: T. Landseer.

GORWAY W. fl. 1850s.
Wood.
Illus.
Aft.: J. Gilbert.

GOSSE Philip Henry F.R.S. 1810
(Worcester) — 1888 (St. Mary Church,
Devon).
Litho.
An. / illus. / scien.
Son of T. Gosse (q.v.) and a noted
scientist. He was a great populariser
of natural history.
Des. eng.: M. and N. Hanhart (q.v.).
Lit.: Stageman P. *A Bibliography of
the First Editions of Philip Henry
Gosse F.R.S.* 1955.

GOSSE Thomas 1765—1844
(London).
Mezzo.
Fig. / gen. / hist. / relig.
Father of Philip Henry Gosse F.R.S.
(q.v.) and grandfather of the littérateur,
Sir Edmund Gosse, Thomas Gosse
earned his living mainly as a miniature
painter.
Aft.: G. Morland.
Lit.: Lister R. *Thomas Gosse* 1953.

GOUGH J. fl. 1829—31.
Steel.
Arch. / illus.
Aft.: T.H. Shepherd.

GOULD John F.R.S. 1804 (Lyme
Regis) — 1881 (London).
Litho.
An. / illus.
One of the greatest of ornithological
illustrators, Gould produced nearly
3000 plates in forty-one folio volumes.
He received extensive assistance from
his wife, Mrs. E. Gould.
Lit.: Sitwell S., H. Buchanan and
J. Fisher *Fine Bird Books* 1953.

GOULDING Frederick 1842
(Islington) — 1909 (London).
Et., print. (copperplate).
Land. / port. / topog.
The son of a foreman printer and
descended from a line of copperplate
printers, Goulding attended a day
school at Holborn before being
apprenticed to the printers, Day and
Son (q.v.). After studying in his spare
time at the Clerkenwell School of Art
and the R.A. Schools he set up in 1881
on his own account. He assisted Legros
(q.v.) in his etching classes and
succeeded him as teacher of etching at
the National Art Training School.
Among those for whom he printed
were: J. McN. Whistler, Seymour
Haden, Legros, Samuel Palmer, Sir F.
Rajon and R.W. Macbeth.

His own etchings are not remarkable, and his reputation rests on his brilliant gifts as a printer from the plates of great engravers and etchers.

His brother Charles was also a copperplate and lithographic printer.
Pup.: Constance M. Pott (q.v.).
Lit.: Hardie M. *Frederick Goulding, Master Printer of Copperplates: with Catalogue of his Etched Works* 1910.

GOULDING or GOLDING J. fl. mid 19th c.
Partner of A. Park (q.v.).

GOULDSMITH Harriet — See Arnold, Harriet.

GOUPIL and CO.
later BOUSSOD, VALADON and CO.
fl. London, Berlin, Paris, New York from 1850s.
Pub.
This firm perfected the photo-engraving process known as "goupilgravure" or "photo-mezzotints". They were one of the largest publishers.

Photo-engravings and goupilgravures with the imprint of Boussod, Valadon and Co. were distributed by J.B. Sampson and Shepherd Bros. (q.v.).

GOYDER Alice Kirkby b. 1875 Bradford, Yorks.
Et.
Gen.
Worked at first in Bradford, but later in life lived in Orford and Woodbridge in Suffolk.

GRACE J.E. 1850—1908.
Et.

GRAF C. fl. 1800—50.
Litho., print.
Mil. / port. / relig. / theat. (ballet).
Worked for the lithographers and printers, Engelmann, Graf and Co. There was also a J. Graf, probably a brother.
Aft.: Numa Blanc, G. Campion.
Pub.: John Mitchell.

GRAHAM A.W. fl. 1832—69.
Steel., wood.
Illus. / land. / topog.
Pupil of H.H. Meyer (q.v.).

GRAHAM C. fl. 1839—46.
Litho.
Fig. / mil. / topog.

GRAHAM Thomas Alexander Ferguson 1840—1906.
Et.
An.

GRANGER B. fl. London early 19th c.
Line., stip.
Gen. / port.
Aft.: R. Corbould, G. Kneller, Saint-Elmer, T. Stothard.

GRANT — fl. mid 19th c.
Pub.
Possibly a licensee of the method of G. Baxter (q.v.).

GRANT C.J. fl. mid 19th c.
Wood.
Hum. / illus.
Worked extensively for *Punch.*

GRANT William James 1829 (Hackney) — 1866 (Hackney).
Wood.
Hist.
Also a painter.

GRANTHAM Thomas Philip Weddell, 3rd Baron Grantham 1781—1859.
Litho., wood. (amateur).
Cost. / land.

GRAPHOTYPING COMPANY fl. 1860s—90s.
A company founded by Henry Fitz-Cook to exploit an invention of the American engraver De Witt Clinton, in which chalk was used to make relief blocks. Although used for a time in book illustration the process did not survive, and the company was taken over by the Dalziel Brothers (q.v.) in 1897.

GRAVES Henry and CO. fl. 1840s—90s.
Pub.
This firm held Royal warrants from Queen Victoria, the Prince of Wales and the Prince Consort. It published over 1000 plates, and was one of the most important publishers of the period.

GRAVES Robert A.R.A. 1798
(London) — 1873 (London).
Line., steel.
Gen. / hist. / illus. / lit. / myth. / port. /
relig.
The son of Henry Graves (q.v.) a
member of an old established family
of London printsellers, Robert studied
from 1812 at the life school then held
in Ship Yard, Temple Bar. At the same
time he was a pupil of John Romney
(q.v.). He made facsimiles of rare
prints in pen and ink, but soon
devoted himself entirely to engraving.
Aft.: G.A. Abbot, L.F. Abbott,
R.W. Buss, J.S. Copley, W.C.T.
Dobson, Sir C. Eastlake, W.P. Frith,
Gainsborough, Sir G. Harvey,
J.F. Herring, Sir E. Landseer, T. Lane,
Sir T. Lawrence, C. Lucy, D. Maclise,
W. Mulready, Murillo, Sir J.N. Paton,
T. Phillips, Raphael, Reynolds,
Rochard, T. Webster, Sir D. Wilkie,
F. Winterhalter.
Pup.: J.R. Jackson (q.v.), who was his
only pupil and who engraved his
portrait.
Shared: A plate left unfinished on
Graves's death, a portrait after
Gainsborough, was completed by
James Stephenson (q.v.).
Lit.: *Art Journal* 1873, p. 125.
Printseller 1 Sept. 1903, pp. 381 f.

GRAVIER Alexandre Louis 1835
(St. Germain-on-Laye) — 1905.
Et.
Gen. / land. / lit.
French national who made a number
of plates after works by British artists
which were published in England. He
worked for a time in England at
London and Brighton.
Aft.: G. Boughton, V. Cole, J. Grace,
R. Halfnight, H. Hardy, Y. King,
T. Lloyd, E. Parton.
Pub.: H. Graves.

GRAY Andrew fl. early 19th c.
Line.
Illus.

GRAY Charles fl. 1835.
Wood.
Illus.
Aft.: H.G. Browne, C.W. Cope,
W. Dyce, J. Franklin, J.C. Horsley,

R. Redgrave, H.C. Selous, W.C. Thomas,
H.J. Townsend.
Pup.: G. Dalziel (q.v. under Dalziel
Bros.)
Lit.: Jackson J. and W.A. Chatto
A Treatise on Wood Engraving Second
ed. 1861.

GRAY Paul Mary 1842 (Dublin) —
1866 (Brighton).
Wood.
Illus.
Gray came to London in 1863 or 1864;
his work includes comic cartoons for
the weekly *Fun.*

GREATBACH George fl. mid 19th c.
Line., steel.
Illus. / port. / relig. / theat.
Aft.: J. Martin, Pickering; and after
photos.

GREATBACH Joseph fl. 1870s—80s.
Steel.
Fig. / illus.
Aft.: J.B. Burgess, F.A. Delobbe,
Baron Leys, J.D. Linton, A. Paoletti.

GREATBACH William 1802—c.
1865.
Line., steel.
Gen. / hist. / illus. / mil. / port. / ship.
Worked in London from 1820.
Aft.: T. Barker, A. Egg, A. Fraser,
Sir G. Hayter, R. Hind, Rubens,
Saillaire, W. Salter, R. Smirke,
Sir D. Wilkie.
Pup.: C.H. Jeens (q.v.).
Shared: R. Wallis (q.v.).
Pub.: Ackermann; Art Union of
London; Bentley, Boys and Graves;
Day and Son; London Printing and
Publishing Co.; F.G. Moon; R. Turner.

GREAVES Henry fl. late 19th c.
Et.
Land.
Brother of Walter Greaves (q.v.) and a
pupil of J. McN. Whistler (q.v.).

GREAVES Walter 1846—1930.
Et.
Fig. / port. / topog.
Brother of H. Greaves (q.v.) and the
first pupil of J. McN. Whistler (q.v.).

GREEN Charles 1840—98 (Hampstead).
Litho.
Better known as a printer and designer.

GREEN George J. fl. London (9 Thurlow Place, Walworth; 6 Chatham Place, Walworth) mid 19th c.
Pub.
Juv. dram. (including combat sheets).
Son of J.K. Green (q.v.).

GREEN I.K.
Almost certainly identical with John Kirby Green (q.v.).

GREEN John Hippisley fl. 1775—1820.
Line.
Land. / port.

GREEN John Kirby 1790—1860.
Pub.
Juv. dram.
Green claimed he was the "original inventor and publisher of Juvenile Theatrical Prints, established 1808". He operated from the following London addresses: Clements Inn Passage, Clare Market (the name here was I.K. Green, and was almost certainly identical); 3 George Street, Walworth; 34 Lambeth Square, New Cut; 16 Park Place, Walworth; 9 Thurlow Place, Walworth.
His agents included H. Burtenshaw, F. Frost, W. Hancock, G. Harriss, Moss Hyams, Jonathan King, B. Perkins, J. Redington, G. Slee, J.T. Wood.

GREEN T.W. fl. 1840s.
Pub.

GREEN Valentine A.R.A. 1739 (Salford, near Evesham) — 1813 (London).
Aq., mezzo.
Gen. / hist. / myth. / port.
First intended as a lawyer, Green was eventually apprenticed to Robert Hancock of Worcester, a line-engraver and potter. He taught himself mezzotinting and was one of the first to use it for historical subjects. He made about 400 plates in forty years, among them some 164 portraits and 38 aquatints.

Aft.: L.F. Abbott, T.L. Abbott, Barry, J. Boydell, F.G. Byron, Maria Cosway, R. Cosway, F. Cotes, Dance, Drake, Lieut. Elliott, P. Falconet, Fries, Gainsborough, Hoppner, Mortimer, R.M. Paye, C.W. Peale, C. Read, Reynolds, G. Romney, Rubens, J. Steen, Trumbull, Vanderwerff, Van Dyck, B. West, J. Wright of Derby, Zoffany.
Assist.: F. Jukes (q.v.) who assisted him with his aquatint plates.
Pup.: E. Thelot.
Pub.: Boydell.
Lit.: Whitman M.C. *British Mezzotinters, Valentine Green* 1902.

GREEN William 1761 (Manchester) — 1823 (Ambleside).
Aq., et. (incl. soft-ground).
Land.
Green began life in surveying, but did not like it and came to London where he studied aquatint. Later he settled in Ambleside and is particularly noted for his studies of the Lake District. Also a watercolourist.

GREEN W.T. fl. early mid 19th c.
Wood.
Illus.
Aft.: T. Creswick, Birket Foster, W. Harvey, J. Martin, S. Palmer, C. Stanfield.
Lit.: Jackson, J. and W.A. Chatto *A Treatise on Wood Engraving* Second ed. 1861.

GREENAWAY John fl. early mid 19th c.
Wood.
Illus.
Was for a period an assistant of E. Landells (q.v.). Father of the illustrator Kate Greenaway (q.v.).
Aft.: H. Weir.

GREENAWAY Kate 1846 (Hoxton) — 1901 (Hampstead).
Wood.
Illus.
The famous children's illustrator. Her work was usually engraved by others, but she is included here on account of six original small wood-engravings exhibited at the Dudley gallery in 1868.

GREENHEAD Henry T. 1849
(Hurstbourne Park, Hants.) — 1926.
Mezzo.
Gen. / lit. / myth. / port.
With Thomas Appleton (q.v.),
Greenhead helped to revive the art of
mezzotint.
Aft.: R. Cosway, Gainsborough,
Greuze, Hoppner, Sir T. Lawrence,
G. Morland, Reynolds, Romney,
T. Sant, H. Singleton, W. Wells,
F. Wilson; and after photos.
Pub.: Cadbury, Jones and Co.;
Dickinson and Foster; Eyre and
Spottiswood; Fine Art Society;
H. Graves; Graves and Co.;
I.P. Mendoza, A. Ramsden.

GREENWOOD W. fl. first half of
19th c.
Wood.
Topog.

GREIG John fl. early 19th c.
Et., litho., steel.
Antiq. / arch. / illus. / land. / topog.
Associated with J.S. Storer (q.v.) on a
series of antiquarian and topographical
plates.
Aft.: J. Hakewill, T. Higham, Prout,
F.W. Stockdale.
Pup.: T. Higham (q.v.).

GREVILLE Henry Richard See
Warwick, Henry Richard Greville,
Earl of.

GREY Charles Malcolm d. 1910.
Wood.
Illus.
Son of the painter Charles Grey.

GRIEVE A.R. fl. London 1840.
Litho.
Land. / topog.

GRIFFIN James Martin b. 1850
(Cork).
Line. (?)
Land.
Emigrated to California.

GRIFFITH W. fl. 1836.
Steel.
Arch. / illus.
Aft.: R. Garland.

GRIFFITHS Henry d. 1849.
Line., steel.
Illus. / port.
Aft.: T. Allom, W. Bartlett.

GRIFFITHS J.C. fl. 1850.
Steel.
Arch. / illus.
Aft.: Wood

GRIGGS Frederick Landseer Maur
R.A. 1876 (Hitchin) — 1938
(Chipping Campden).
Et., dry.
Arch. / land.
The son of a Hitchin pastrycook and
confectioner, Griggs was educated at
a Quaker school, later becoming a pupil
of the architect and draughtsman,
Charles Edward Mallows in Bedford.
In time Mallows and others advised
Griggs to take up illustration which he
did with considerable success especially
in the *Highways and Byways* series of
books. In 1904 he left Hitchin and
settled in Chipping Campden where he
spent the remainder of his life. He
took up etching in 1896, abandoned it
in 1903 and took it up again in 1912,
after which he made over 50 plates.
Lit.: Alexander R. *The Engraved
Works of F.L. Griggs* 1928. Comstock
F.A. *A Gothic Vision: F.L. Griggs and
his Work* 1966. *P.C.Q.* XI, pp. 94—124;
XX, pp. 320—45; XXVI, pp. 264—91.
Salaman M.C. *F.L.M. Griggs* Modern
Masters of Etching Series No. 12 1926.
Wright H.J.L. *The Etched Works of
F.L. Griggs* 1941.

GRIGGS William 1832 (Woburn) —
1911.
Print. (chromolitho.)
Illus.
Griggs was the son of a lodgekeeper on
the estate of the Duke of Bedford.
After serving an apprenticeship as a
carpenter he became in 1855 a
technical assistant to the Director of
the Indian Museum, in which post he
studied photography and lithography.
He introduced several new departures
in photo-lithography and became one
of the greatest exponents of
chromolithography in the last decades
of the 19th century.

GRIGNON or GRIGNION Charles
1716 (London) — 1810 (London).
Line.
Gen. / illus. / port. / relig. / theat. /
topog.
Of French descent, Grignon studied as
a boy under H.F. Gravelot (1699—
1773) and later studied for a time in
Paris under J.P. Le Bas. He returned to
London and worked for Gravelot and
for G. Scotin, but set up on his own *c.*
1738. In 1755 Grignon was a member
of the Committee of Artists appointed
to establish the Royal Academy. He
lived for a long period in James Street,
Covent Garden, but in his last years
lived in Kentish Town. The watch-
maker Thomas Grignon was his
brother.
Aft.: J. Barralet, W. Bellers, Gravelot,
F. Hayman, A. Heckel, Hogarth,
J.H. Mortimer, Pond, Raphael,
S. Rosa, S. Wale.
Pub.: Bell; Knapton.

GRINDLEY Edward fl. Liverpool
(73 and 75 Church St.) 1880s.
Pub.

GRISBROOK William fl. London
(6 Panton Street, Haymarket) 1880s.
Pub.

GROGAN Joseph H. fl. 1810.
Litho.
Illus. / land.
Son and pupil of the painter and
engraver Nathaniel Grogan Sr. (d.
1807).
Also a painter.

GRUNDY J.C. fl. London (Regent
Street) from 1849.
GRUNDY J.L.
GRUNDY R.H.
GRUNDY J.F.E.
GRUNDY and SMITH
Pub.
Grundy and Smith carried on business
at 4 Exchange Street, Manchester. It is
not certain, but probable, that the
firm was connected with the other
Grundys.

GRUNDY Thomas Leeming 1808
(Bolton, Lancs.) — 1841 (Camden
Town).
Et., line., mixed., steel.
Gen. / illus. / port.
The son of a Lieut. Grundy, Thomas
was apprenticed to a writing engraver
in Manchester, after which he came to
London and was employed by G.T. Doo
and then by E. Goodall (qq.v.). He was
a younger brother of the printseller
and art patron John Clowes Grundy.
Aft.: W. Bradley, Liverseege,
C. Stanfield.

GRUNER Guillaume Henri Louis
1801 (Dresden) — *c.* 1880.
Line.
Relig.
German national who engraved at least
one plate after a work by an English
artist which was published in England.
Aft.: Sir J.E. Millais.
Pup.: E.F. Mohn (q.v.).
Pub.: T. McLean; Moore, McQueen
and Co.

GUEST H. fl. London 1840s—50s.
Line.
Sport.
Aft.: C. Hancock.
Pub.: H. Graves.

GÜLICH John Percival 1865
(Wimbledon) — 1899.
Et.
Gen.
Of German descent, Gülich was a pupil
at Heatherley's School. He was much
influenced by Sir H. Herkomer (q.v.)
and soon made a reputation as an
illustrator and caricaturist.

GULLAND Elizabeth fl. Bushey,
Herts., and Edinburgh 1887—1934.
Mezzo.
Gen. / port.
A pupil of Sir H. Herkomer (q.v.).
Aft.: Gainsborough, Sir H. Herkomer,
Sir T. Lawrence, Raeburn, Reynolds,
Romney.
Shared: G.S. Shury (q.v.).
Pub.: Harry C. Dickens; Leggatt Bros.

211

GULSTON Elizabeth Bridgetta
d. before 1840.
Et. (amateur).
An. / lit.
Daughter of the amateur painter and
etcher, Miss Elizabeth Bridgetta
Gulston (d. 1780).

GUNN Harriet b. 1806 (Gt.
Yarmouth).
Et.
Port.
Daughter of the antiquary Dawson
Turner.

Aft.: I.P. Davis, T. Phillips, Shipper,
J. Ward.

GUTHRIE James Joshua 1874—
1952.
Et., wood.
Ex libris / illus.
Guthrie was also a printer and publisher
and owned the Pear Tree Press.

GWYNNE F.G. fl. 1840s—50s.
Pub.

HACKER Edward H. 1813—1905.
Mezzo., steel., stip.
Sport.
Father of the painter Arthur Hacker.
Aft.: R. Ansdell, W. and H. Barraud.
Pub.: Lloyd Bros.

HADEN Sir Francis Seymour 1818
(London) — 1910 (Woodcote).
Et., dry., mezzo., mixed.
Arch. / fig. / gen. / land. / port. /
sport. / topog. / trees.
A surgeon and the son of a doctor,
Haden was educated at Derby School,
Christ's Hospital, University College,
London, Sorbonne, Paris and Grenoble.
He first took to etching as a relaxation,
but it soon became a second
profession. In all he made 250 plates.
Haden married a half sister of J. Mc N.
Whistler who much influenced his
work. He wrote several works on
etching, including *The Etched Work of*
Rembrandt (1879); *About Etching*
(1879); *The Relative Claims of Etching*
and Engraving to rank as Fine Arts
(1883); *The Art of the Painter Etchers*
(1890); *The Royal Society of Painter*
Etchers (1890). For the first five years
during which he exhibited etchings at
the Royal Academy (1860—64) he
used the pseudonym "H. Dean".

All of Haden's work is original
except for one or two plates after
Turner and Wright of Derby and a
mixed-method engraving of a portrait
after Rubens.
Pup.: E.M. Synge, J.J. Tissot (qq.v.).
Pub.: E. Parsons.

Lit.: Associated American Artists (New
York) *Sir Francis Seymour Haden:*
Etchings, Drypoints, and Mezzotints
1973. Harrington H.N. *The Engraved*
Work of Seymour Haden, An Illustrated
and Descriptive Catalogue 1910.
Newbolt Sir F. *The History of the*
Royal Society of Painter-Etchers and
Engravers 1930. *P.C.Q.* I, pp. 9—31,
291—318, 405—42. Salaman M. *The*
Etchings of Sir Francis Seymour
Haden 1923. — *Sir Francis Seymour*
Haden Modern Masters of Etching
Series No. 11 1926. Schneiderman
R.S. *A Catalogue Raisonné of the*
Prints of Sir Francis Seymour Haden
1983.

HAGHE Louis 1806 (Tournay,
Belgium) — 1885 (Stockwell).
Litho.
Hist. / illus. / land. / ship. / theat. /
topog.
After attending the drawing academy
at Tournai, Haghe became a pupil of
the French artist, Chevalier de la
Barrière from whom he learnt
lithography and watercolour painting.
He moved to London in 1823 where
he became a partner of W. Day in the
firm Day and Co. Together they raised
the quality of lithography in this
country and established it as an
accepted art. Haghe was appointed
draughtsman to the King, an
appointment continued under Queen
Victoria. His younger brother Charles
(d. 1888) was also a good lithographer
and devoted his life to assisting his brother.

213

Aft.: Fossati, J.B. De Jonghe, D.
Roberts, J.C. Schetky, H.J. Vernon.
Assist.: R.C. Carrick (q.v.).
Pup.: A. Picken (q.v.).
Pub.: Day and Co.; Day and Haghe;
Gambart and Co.; Hering and
Remington; Smith, Elder and Co.

HAGUE K. fl. 1828.
Line (?)

HAIG Axel Herman 1835 (Wisby,
Sweden) — 1921 (Southsea).
Et.
Arch.
Swedish national who settled in
England and practised as an architect,
mostly on ecclesiastical work. He
etched 400 plates.
Pup.: Anders Zorn.
Lit.: Boland J. *Illustrated Catalogue of
Etchings by Axel Herman Haig* 1919.

HAIG Henry fl. 1841—47.
Line., steel.
Port. / relig.
Aft.: Rubens.

HAIGH-WOOD Charles H. 1856—
1927.
Et.

HAINES William 1778 (Bedhampton,
Hants.) — 1848 (East Brixton).
Line.
Illus. / port.
Haines was taken in infancy to
Chichester. Educated at Midhurst
Grammar School, he was later put
under Thew the Engraver, in whose
workshop he worked with Scriven on
plates for Boydell's Shakespeare. He
travelled to the Cape of Good Hope
and then went to Philadelphia,
returning to England in 1805, working
first in London, and afterwards
returning to Chichester. He was
befriended by William Hayley the poet,
but moved on to Southampton, and
soon after returned to London, where
he concentrated on painting miniatures
and portraits in oil.

HAINSWORTH Thomas b. 1873.
Et.

HALFPENNY Joseph 1748
(Bishopsthorpe, Yorks) — 1811 (York).
Line.
Arch. / illus.
The son of a gardener to the
Archbishop of York, Halfpenny began
life as a house painter, but later
became an artist and teacher. He was
clerk of works to the architect John
Carr during the restoration of York
Minster.

HALL — fl. 1846.
Steel.
Arch. / illus.

HALL Basil fl. 1827—30.
Et. (amateur).
Illus.
Marine officer and travel writer who
illustrated his own writings.

HALL C. fl. 1834.
Steel.
Arch. / illus.
Aft.: W. Tombleson.

HALL Edward fl. 1880s.
Et.

HALL George R. fl. 1851.
Steel.
Sculp.

HALL H. fl. 1846.
Steel.
An. / illus.
Aft.: A. Elmore.

HALL Henry Bryan 1808 (London)
— 1884 (Morrisania, New York).
Steel., stip.
Gen. / hist. / illus. / port.
A pupil of Benjamin Smith and Henry
Meyer (qq.v.), Hall emigrated to U.S.A.
in 1850 and founded a firm, H.B. Hall
and Sons. He also painted miniatures.
His son, H.B. Hall II was also an
engraver and was employed in the firm.
Aft.: R. Gallon, G. Hayter.
Shared: Henry Ryall (q.v.).
Pub.: H. Graves.

HALL Oliver R.A. 1869 (Tulse Hill)
— 1957.
Et., lith.
Arch. / land. / topog.

Hall attended the South Kensington School of Art, and worked in Sussex and Essex. He was also a painter.
Lit.: *P.C.Q.* XV, pp. 34—49. Singer H.W. *Modern Graphics* 1914.
Wedmore F. *Etching in England* 1895.

HALLIDAY Michael Frederick 1822 —69 (London).
Et. (amateur).
Gen. / lit. / myth.
Also a painter.

HALPIN Frederick W. 1805 (Worcester) — 1880 (Jersey-City).
Stip.
Port.
Went to U.S.A. where he met with considerable success as a portrait painter.

HALPIN Paget fl. Dublin late 18th c. early 19th c.
Line (?)

HAMBLE J.R. fl. mid 19th c.
Aq.
Arch. / illus. / land. / ship. / sport.
Probably related to J. Humble or Hamble (q.v.).
Aft.: Howlett, D. Serres.
Shared: J. Clark (q.v.).

HAMERTON Philip Gilbert 1834 (Shaw, near Oldham) — 1894 (Boulogne-sur-Seine).
Et.
Illus. / land.
The son of a solicitor, Hamerton was educated at Burnley and Doncaster grammar schools; and he was prepared for Oxford but did not proceed as academic pursuits were of little interest to him. He decided to follow his inclinations as an artist and writer, and moved to London in 1853 where he studied under an obscure painter named Pettitt. After 1858 he moved to France and settled at Autun, from which time he concentrated mainly on writing and art criticism. Hamerton edited *The Portfolio* an important art periodical, was art critic of the *Saturday Review* and author of many books including *Etching and Etchers* (1868 and subsequent edns.), *Drawing and Engraving* (1892) and *The Etcher's*

Handbook (1871). His *Autobiography* (which contains a memoir by his wife) was published in 1897.

HAMERTON Robert Jacob
fl. London 1831—58.
Litho.
Music. / theat. (ballet).

HAMILTON Mrs. fl. early 19th c.
Illus. / line.
Sister of C. Heath (q.v.).

HAMILTON G. fl. 1860.
Steel.
Illus. / land.
Aft.: T. Boys.

HAMILTON J. McLure fl. late 19th c.
Chromolitho., litho.
Port.

HAMILTON Vereker Monteith
fl. 1888.
Et.
Mil.
Also a painter.

HAMMOND J. fl. mid 19th c.
Wood.
Illus.

HANCOCK Robert 1730 (Burslem) — c. 1817 (Bristol).
Mezzo., stip.
Gen. / illus. / port.
Hancock at first worked on enamel and pottery engraving at Battersea and Worcester. He was one of the proprietors of the Worcester Porcelain Works 1772—74. His bank failed, but he saved a considerable sum, after which he turned to mezzotint studying under S. Ravenet (q.v.). He lived for a time at Worcester and later at Bristol.
Aft.: J. Miller, Reynolds, Wright of Derby.
Pup.: V. Green, J. Ross (qq.v.).

HANCOCK Thomas fl. Birmingham 19th c.
Printseller, stip.
All.

HANCOCK W. fl. London (2 Falcon
Place, Bethnal Green) *c.* 1840.
Printseller.
Juv. dram.
Agent for J.K. Green (q.v.).

HANFORD Alfred Sidney b. 1858.
fl. 1880s.
Et., mezzo., mixed.
Gen. / land. / marine.
Aft.: J.Y. Carrington, J. Crome, Sir E.
Landseer, J.M.W. Turner, A. Wardle.
Pub.: Louis Brall; C.E. Clifford.

HANDLEY-READ Edward Henry
b. 1870.
Litho.
Gen.
Also a painter, Handley-Read was a
pupil at Westminster Art School and
the R.A. Schools.

HANFSTAENGL Franz Seraph 1804
(Baternrain, Bavaria) — 1877 (Munich)
Litho., photo-eng.
*Fig. / gen. / hist. / land. / lit. / mil. /
myth. / port. / relig. / sport. / topog.*
Bavarian national who made many
plates after works by British artists
which were published in England.
Hanfstaengl was himself a noted genre
painter. He was assisted in his engraving
practice by his three brothers Peter
(1806—83), Max (1817—75) and Hanns
(1820—85).
Aft.: D. Adams, Sir L. Alma-Tadema,
G. Anderton, F.A.W.T. Armstrong,
J.W. Barker, S. Berkeley, R. Blind, T.
Blinks, R.H. Brock, H.J. Brooks, M.
Brown, Sir E. Burne-Jones, R.H.
Carter, J. Charleton, J.E. Christie, A.
Clay, E. Crofts, T.J. Cullick, J. Cullin,
C. Cutler, F. Davidson, F. Dicksee, J.
Dollman, E.A.S. Douglas, H. Draper,
A. Drummond, A. Elsley, A. Emslie,
J. Farquharson, N. Flower, J.C. Forbes,
W.R. Frye, R. Gallon, F. Gibbs, G.D.
Gileo, J. Godward, Maude Goodman,
P. Graham, Mary Groves, E. Hale,
Edith Hallyer, H. Hardy, J. Hardy,
C. Hemy, T. Hemy, A. Holden, G.
Holmes, T. Hughes, W. Hunt, L.B.
Hurt, H. Jamyn, C. Johnson, H.J.
Johnstone, Lucy Kemp-Welch, T.B.
Kenington, G.G. Kilburne, Y. King,
D.R. Knight, J.P. Knight, G.S.
Knowles, F. Lawson, B.W. Leader,
Lord Leighton, E.B. Leighton, S.
Lewin, A.N. Loraine, F. Lucas, S.
Lucas, H. Ludlow,, K. Mackenzie, J.
MacWhirter, W.H. Margetson, Sir J.E.
Millais, A. Moore, J. Mordecai, F.
Morgan, W. Muller, C. Padday, Sir J.N.
Paton, A. Pearse, L.J. Pott, Henrietta
Rae, C.K. Robertson, G.A. Short,
W.H.A. Sleigh, Shirley Slocombe, R.
Smith, C. Smithers, R. Staples, M.
Stone, A. Strutt, C. Stuart, J. Sylvester,
A. Tayler, A. Thorburn, W. Trood,
L. Tuxen, A.W. Wardlow, W. Weeks,
A. Wells, C. Whymper, J.H. Williams,
Rev. Withers-Lee, C.H. Wood, R.
Woodville, W. Wollen, A. Wortley, G.
Wright.
Pub.: A. Ackermann; A. Baird-Carter;
Colnaghi; J. Connell; Dickinson and
Foster; Dowdeswell and Dowdeswells;
Frost and Reed; Gladwell and Co;
Stephen T. Gooden; H. Graves;
Lawrence and Bullen; Leggatt Bros.;
A. Lucas; T. McLean; Mawson, Swan
and Morgan; I.P. Mendoza; John
Sampson; A. Tooth; Van Baerle Bros.

HANHART M. and N. A firm fl.
about 1820—65.
Litho. (incl. chromolitho.), print.
*Illus. / music. / relig. / sport. / theat.
(ballet) / topog.*
Printed work by J. Brandard, F.W.
Fairholt, P.H. Gosse (qq.v.) and others.

HANKEY William Lee See
Lee-Hankey William.

HANLON George A. fl. Dublin and
London 1840—60.
Wood.
Antiq. / illus.

HARDIE Martin 1875 (London) —
1952 (Tonbridge).
Dry., et.
Arch. / ex. libris / land. / topog.
Hardie, who came from a family with
a strong aesthetic background, was
educated at a private preparatory
school, St. Paul's School and Trinity
College, Cambridge. He obtained a
post at the Victoria and Albert
Museum and remained there until he
retired in 1935. Hardie studied etching
under Sir Frank Short (q.v.) head of
the engraving department at the Royal

College of Art. He also studied watercolour and wrote many studies of art and artists, especially of Samuel Palmer for whose rediscovery he was largely responsible.
Lit.: Ashmolean Museum *The Prints of Martin Hardie. Edited from the Artist's Manuscript Record* 1975. *Bookman's Journal* XVI. *P.C.Q.* XXIV, pp. 120—43; XXV, pp. 80—98, 217—34. Wedmore Sir F. *Etched Work of Martin Hardie* 1913.

HARDING Edward 1755 (Stafford) — 1840 (Pimlico).
Line.
Port.
After being apprenticed to a hairdresser, Harding abandoned the trade and set up with his brother Silvester (1745—1809) as engravers and booksellers. The partnership was later dissolved and carried on by Edward alone. He was appointed librarian to Queen Charlotte in 1803 and after her death in 1818 became librarian to the Duke of Cumberland.
Assist.: T. Cheesman, W.N. Gardiner.

HARDING James Duffield 1798 (Deptford) — 1863 (Barnes).
Et., line., litho.
Illus. / land. / sculp.
Harding was the eldest son of a drawing master from whom he received lessons; he also studied under Samuel Prout. The results of these studies were not good and he was apprenticed to an engraver J.C. Pye (q.v.) whom he left after a year to concentrate on watercolour printing. When he was eighteen he was awarded a silver medal by the Society of Arts. He took up oil painting in 1843. He also took pupils and so as to provide them with good examples, adopted lithography. In this he made use of two stones with tints; he also used lithotint, in which the design is drawn on the stone with a brush instead of a crayon.
Aft.: R.P. Bonington, C.J. Hardinge, A.W. Pugin, J.M.W. Turner.

HARDMAN Thomas fl. Liverpool (Atlantic Buildings, Brunswick Street) 1880s.
Printseller.

HARDY Heywood 1842 (Chichester, Sussex) — 1933.
Et.
An. / illus.
Best known as a painter, Hardy studied at Bristol, Antwerp and Paris.
Pub.: T. Agnew.

HARDY Thomas Bush 1842 (Sheffield) — 1897 (Maida Vale).
Et.
Marine.
Travelled in Italy and the Low Countries.
Pub.: A. Lucas.

HARE Haydon fl. Scarborough (15 St. Nicholas Street) 1800s—90s.
Pub.

HARGRAVE Edward fl. mid 19th c.
Mezzo.
Port.

HARLAND T.W. fl. 1832—54.
Stip.
Port.
Also a portrait painter.

HARLEY S. fl. early 19th c.
Litho.

HARPER J.H. fl. 1810.
Superintendent of the printing and engraving offices at The Bank of England.

HARRADEN F. fl. 1838.
Steel.
Arch. / illus.
Aft.: T.H. Abraham, T.W. Richardson.

HARRADEN J.B. fl. early 19th c.
Aq.
Illus. / land.
Aft.: T. Girtin.
Shared: T. Girtin.

HARRADEN Richard 1756 (London) — 1838 (Trumpington, Cambridge).
Aq., illus., litho.
Cost. / topog.
A member of a family from Flintshire originally called Hawarden, Richard was the son of a physician and was the father of R.B. Harraden (q.v.) He went

to Paris, but left after the fall of the Bastille and on his return worked in London until he moved to Cambridge in 1798. Some of his work was issued in conjunction with his son.

HARRADEN Richard Bankes 1778 —1862 (Cambridge).
Aq.
Mil. / topog.
Issued some work in conjunction with his father, R. Harraden (q.v.).
Aft.: H.A. Baker, Capt. Fryers, T. Girtin, Capt. Smith.

HARRAL Horace fl. 1856—76.
Wood.
Illus.
Pupil of John Orris Smith (q.v.).
Aft.: E. Duncan, S. Palmer, G.H. Thomas, E.H. Wehnert.

HARRILD Thomas fl. London (Shoe Lane, Fleet Street) 1860s.
Litho. (incl. chromolitho.), print.
Illus.

HARRIS Sir Augustus Henry Glossop 1852 (Paris) — 1896 (Folkestone).
Pub.
Juv. dram.
Apparently the sheets issued by Harris (who was an actor, dramatist and impresario) were not of the usual "penny plain twopence coloured" kind, but were issued plain as part of a competition in which those taking part coloured them.

HARRIS John Sr. d. 1834.
Aq.,
Illus. / marine.
Father of John Harris Jr. (q.v.). Also a painter.

HARRIS John Jr. 1791 (London) — 1873.
Aq.
Litho., mezzo., mixed.
Mil. / port. / sport. / theat. / topog.
Son of John Harris Sr. (q.v.) and father of John Harris the facsimilist (d. 1873). Also a painter.
Aft.: Lady Alexander, H. Alken, S. Blount, Bury, F. Cleland, R. Cleveley, Ab. Cooper, T.S. Cooper, H. de Daubrawa, R.B. Davis, G. Earp, E.

Gifford, H. Hall, C. Hancock, M.A. Haynes, C. Henderson, J.F. Herring Sr., Huggins, T. Knott, H. Martens, J. Pollard, R. Pollard, Scanlon, W.J. Shayer, F.C. Turner, Major C.F. White, W. Widgery.
Shared: W. Summers, T. Sutherland (qq.v.).
Pub.: R. Ackermann and Co.; O. Bailey; L. Brall; B. Brooks and Son; Dean and Co.; R. Dodson; Fores; Gambart; H. Graves; T. McLean; B. Moss and Co.; Sheldon; Tegg; J. Watson.
Lit.: *Bookman's Journal* XVII. Laver J. *Sporting Prints* 1970. Wilder F.L. *English Sporting Prints* 1974.

HARRIS T. fl. 1830s—40s.
Steel.
Arch. / illus.
Aft.: W. Tombleson.

HARRIS and Sons fl 1880.
Pub.

HARRISON John Augustus Charles 1872—1955.
Line.
Bank. / ex. libris / stamps.
Harrison's father was a line engraver at Manchester, and he followed the same profession, being at first mainly occupied with bookplates. In 1910 the Royal Mint commissioned him to engrave the high-value "seahorse" postage stamps, and later he worked exclusively for Waterlow's on banknote and stamp designs.

HARRISON Thomas Erat fl. London 1875.
Et.
All. / ex. libris / port.
Also a painter and sculptor.

HARRISON W. fl. London (27 Long Alley, Finsbury) *c.* 1830.
Pub.
Theat. (port.)

HARRISS G. fl. London (60 Bell Street, Edgware Road) *c.* 1840.
Printseller.
Juv. dram.
Agent for J.K. Green (q.v.).

HARRISSON Gerald E. fl. London
1898—1900.
Et. (?)

HART Robert fl. 1835—61.
Steel.
Fig. / illus. / port.
Aft.: Drouais, Lely, Morghen, H.W.
Pickersgill, Ramsay, F. Stone.

HART T.
Steel.
Arch. / illus.
Aft.: W. Tombleson.

HART William fl. 1840s—90s.
Litho. (incl. chromolitho.)
An. / illus.
Collaborated with J. Gould (q.v.) on
some of his bird books.

HARTLEY Alfred 1855 (Stocking
Pelham) — 1933.
Et.
Gen. / land.
Also a painter.
Lit.: *Studio* LXIV p. 99.

HARTLEY Harold fl. 1880s.
Et.

HARTLEY J. fl. 1835.
Steel.
Illus. / land.
Aft.: W.H. Bartlett, T. Creswick.

HARTNELL Nathaniel fl. London
1829—64.
Litho.
Land.
Also a painter.

HARTRICK Archibald Standish
1864 (Bangalore) — 1950.
Litho.
Gen. / illus. / land.
Also a painter. His wife Lily (née
Blatherwick) was a painter of flowers
and landscape. Hartrick was a vice-
president of the Senefelder Club.

HARVEY Thomas 1748—1820.
Et. (amateur)
An. / land.

HARVEY William 1796 (Newcastle-
on-Tyne) — 1866 (Richmond).
Line., wood.
Hist. / illus.
An apprentice of Thomas Bewick
(q.v.), Harvey, with Temple, another
pupil, engraved cuts in Bewick's *Fables*
(1818); with a third pupil, Robert
Johnson, they transferred many of the
designs to the wood blocks. He also
worked on Knight's *Pictorial
Shakespeare* and other works published
by Knight, and on Northcote's *Fables*.
In 1817 Harvey came to London and
placed himself under B.R. Haydon, at
the same time studying anatomy under
Sir Charles Bell. He did not abandon
wood-engraving until 1824, from
which time he devoted himself entirely
to designing.
 The last survivor of Bewick's pupils,
Harvey made finely detailed engravings,
which included several *tours de force*,
one being his engraving on wood (for
Haydon) of "The Assassination of
Dentatus" in imitation of a copper
engraving. According to Jackson and
Chatto he made between 3000 and
4000 designs.
Aft.: B.R. Haydon.
Assist.: E. Landells (q.v.).
Lit.: de Maré E. *The Victorian
Woodblock Illustrators* 1980. Dobson
A. *Thomas Bewick and his Pupils*
1884. Jackson J. and W.A. Chatto
A Treatise on Wood Engraving Second
ed., 1861.

HASSALL or HASSELL John 1767
—1825 (London).
Aq.
Illus. / ship. / sport. / topog.
John Hassall had a prosperous practice
as a drawing master. He wrote a life of
his friend George Morland (1806) and
*Graphic Delineation: a Practical
Treatise on the Art of Etching* (1836).
His son Edward (d. 1852) was a
well-known watercolour painter and
John himself painted in that medium.
He was one of the first engravers to
apply colour to aquatint.
Aft.: J. Cartwright, G. Morland, P.
Reinagle, T. Rowlandson.
Shared: F. Jukes, W. Nicholls (qq.v.).

HASSE Alexander fl. Leeds (31
Commercial Street) 1880s—90s.
Pub.

HASTINGS Thomas (called Captain
Hastings) fl. 1813—31.
Et.
Arch. / sport. / topog.
An amateur — he worked as a customs
collector at Liverpool — Hastings was
also a watercolourist.
Aft.: R. Wilson.

HATELIE — fl. 1835.
Steel.
Illus. / land.
Aft.: W. Tombleson.

HATFIELD Richard 1809 (London)
— 1867 (London).
Line., steel.
Gen. / hist.
Pupil of E. Finden (q.v.).
Aft.: G.S. Newton.

HATTON Brian 1887—1916.
Et.
Gen.
Also a painter, Hatton was killed in
action soon after taking up etching.

HAUGHTON Moses the younger
? 1772 (Wednesbury) — ? 1848.
Line.
All. / lit. / myth.
Haughton came to London and
became a pupil of George Stubbs and a
student at the R.A. He became a close
friend of Fuseli. A miniaturist, his own
portraits were sometimes engraved.
Aft.: Fuseli.

HAVELL Daniel fl. 1812—37.
HAVELL Frederick James (or John)
1801—40.
HAVELL George d. 1839.
HAVELL Robert the elder fl.
1800—40.
HAVELL Robert the younger fl.
1820—50.
Aq., line., mezzo., steel.
*Flor. / gen. / illus. / land. / marine. /
mil. / nat. / ship. / sport. / theat. /
topog.*
Of this group, Daniel was the father,
the others were his sons. Frederick
James lost his reason as he was making

progress in his profession. They were
really a firm and employed a staff of
artists; their address was 3 Chapel
Street, Tottenham Court Road,
London. Some plates were shared by
members of the family, and sometimes
a member of the family engraved
works by another.
Aft.: H. Alken, S. Atkins, J.J.
Audubon, Bowditch, Calvert, J.
Cartwright, H. Cave, I. Clark, J.J.
Dodd, W. Findlater, G. Foster, J.
Glendall, T. Harding, H. Hassler, W.
Havell, W.J. Huggins, W. Kinnard, D.
Laing, Col. Leigh, Nasmyth, Naylor,
Pocock, J. Pollard, R. Pollard, A.
Pugin, T.S. Roberts, T. Schatky,
Shepherd, Steele, Tytler, R. Walmsley,
H. Whitfield, C. Wilde, Zucarelli.
Pup.: E. Duncan (q.v.), apprenticed to
Robert Havell.
Shared: J. Pollard, J.C. Stadler.
Lit.: Wilder F.L. *English Sporting
Prints* 1974.
Pub.: Boydell; H. Graves; T. McLean;
Z. Warren.

HAWKE Peter 1801 (Newport,
I.O.W.) — 1887 (Tunis).
Et., line.
Illus. / topog.
Also a painter and draughtsman,
Hawke travelled widely visiting the
U.S.A. and spending nearly thirty
years in Algeria.

HAWKESWORTH Frances fl. early
19th c.
Et.
Antiq. / arch.
Aft.: S. Prout.

HAWKESWORTH John fl. 1819—48.
Steel.
Arch. /illus.
Aft.: R.W. Billings.

HAWKINS Benjamin Waterhouse
fl. London 1847—49.
Litho.
An. / port.
Also a painter.

HAWKINS George 1809 or
1810—52 (Camden Town).
Aq., litho.
Arch. / illus. / marine / ship.

Aft.: N.M. Condy, H. Fry, J. Walter.
Pup.: A. Newman (q.v.).
Pub.: Day.

HAWKINS J. fl. late 18th—early
19th c.
Line.
Port.

HAWKSWORTH Frances fl. late
19th—early 20th *c.*
Et.
Arch.
Pupil of S. Prout (q.v.).

HAWKSWORTH Miss J. fl. 1813.
Line.
Gen.
Aft.: G. Jones, S. Prout.

HAWKSWORTH John fl. London
1820.
Et., line., stip.
Illus.

HAWLEY W. and Co. fl. London
(10 Henry Street, Hampstead Road;
5 Seymour Row; 27 Molineux Street,
Bryanston Square) 1823—40.
Pub.
Juv. dram.
Also sold sheets pubd. by Hodgson
and Co. (q.v.). For some time A. Park
(q.v.) acted as their agent.

HAY Frederick Rudolph b. 1784.
Steel.
Arch. / illus. / land.
Aft.: H. Gastineau.

HAY James Hamilton 1874
(Birkenhead) — 1916 (Heswall).
Dry., et.
Line. / marine / port. / topog.
Also a painter.
Lit.: Morris E.S. *James Hamilton Hay*
1973. *P.C.Q.* XIV, pp. 163—88.

HAYES — fl. Bath 1813—15.
Litho.

HAYLES Jane C. fl. late 18th—early
19th c.
Et. (amateur).
Land.

HAYLLAR Algernon Victor
fl. Wallingford, Oxford 1880s.
Mezzo.
Land. / port.
Aft.: E. Ellis, G.D. Leslie.
Pub.: T. Agnew, T. McLean.

HAYNES F. Leslie fl. early 20th c.
Mezzo.
Port.
Aft.: E. Bisson, Hoppner, E. Hughes,
Sir T. Lawrence, G. Morland,
Reynolds, Romney, Ruysdael.
Pub.: A. Bell, H. Graves, E.B. Haines.

HAYNES Joseph 1760 (Shrewsbury)
— 1829 (Chester).
Et., mezzo.
Gen. / port. / relig.
Also a painter, Haynes was a pupil of
John Hamilton Mortimer R.A. He
became a drawing master at Chester.
Aft.: Hogarth, J.H. Mortimer,
Reynolds.

HAYTER Sir George 1792 (London)
— 1871 (London).
Et.
Gen. / relig.
Best known as a portrait and historical
painter, Hayter began life in the Royal
Navy, but soon returned to civilian life
and settled on art as a profession. In
1841, on the death of Sir David Wilkie,
he was appointed principal painter in
ordinary to Queen Victoria.
Des. eng.: T.L. Atkinson, J.C. Bromley,
W.H. Egleton, W. Greatbach, H.T.
Ryall, C.E. Wagstaff.

HEAD E. fl. *c.* 1860.
Pub.
Tinsel.
Publisher of *Turpin and Bess: A
Romance of the Road* a story issued in
periodical parts and containing
"portraits" of highwaymen etc., with
tinsel to decorate them.

HEAPHY Thomas 1775 (London)
— 1835 (London).
Line.
Port.
Also a painter, Heaphy was with
Wellington's army in the Peninsular
Campaign, during which he made
many studies.

HEARNE Thomas 1744 (Bringworth)
— 1817 (London).
Litho.
Gen. / land.
Studied engraving with W. Woollett
(1735—85).
Pub.: Philip André ; J. Heath.

HEATH Alfred T. fl. mid 19th c.
Steel.
Illus.
Aft.: E.H. Corbould, H. Corbould.

HEATH Charles 1785 (London)
— 1848 (London).
Line., steel.
Gen. / illus. / land. / myth. / port. /
theat. / topog.
Heath was the youngest and illegitimate
son of James Heath (q.v.) whose pupil
he was. He made an etching of a head
when he was only six; it is now in the
British Museum. He was a brother of
Mrs. Hamilton (q.v.). Charles Heath
was also a partner in the firm of
Perkins, Bacon and Co. (q.v.). His son,
Charles Heath Jr., who worked at the
beginning of the 20th century,
engraved portraits and was also a
painter.
Aft.: E. Corbould, H. Corbould,
C. Dolci, B.R. Faulkner, W. Hilton, Sir
T. Lawrence, C.R. Leslie, G. Newton,
S. Prout, Reynolds, M.W. Sharp,
T. Stothard, J.M.W. Turner, T. Uwins,
Van Dyck, B. West, R. Westall.
Assist.: J.B. Baylis, W. Radclyffe, R.
Rhodes (principal assistant for many
years), D. Smith, F. Stone, T. Wallis,
J.T. Willmore (qq.v.).
Pup.: G.T. Doo, T. Fairland, J.
Goodyear, J.H. Hurdis, James and
John Kirkwood, R.J. Lane, E.J.
Roberts, J.H. Watt (qq.v.).
Shared: John Pye (q.v.).

HEATH Frederick Augustus 1810
—78.
Line., steel.
Gen. / hist. / illus. / mil. / port. /
stamps
The son and pupil of Charles Heath
(q.v.), Frederick engraved the one
penny black postage stamp in March
1840 (issued in May 1840) for the
security printers, Perkins, Bacon and
Co. (q.v.).

Aft.: P. Calderon, E.H. Corbould, H.
Corbould, T. Faed, J. Pettie, E. Ward.

HEATH James A.R.A. 1757
(London) — 1834 (London).
Line., steel., stip.
Gen. / hist. / illus. / port. / relig. /
theat.
The eldest son of George Heath, a
yeoman farmer of Horton, Staffs.,
James was the father of C. Heath and
possibly of W. Heath (qq.v.). He was
articled to Joseph Collyer (q.v.) and in
1794 was appointed historical
engraver to the King.
Aft.: J.S. Copley, R. Holme, H. Hone,
Hoppner, Sir T. Lawrence, Murillo,
Nollekens, Northcote, J. Opie, Pollard,
Raeburn, Raphael, J. Slater, Smirke,
J.R. Smith, T. Stothard, Titian, B. West,
R. Westall, F. Wheatley, J. Wright of
Derby.
Assist.: F. Engleheart, J. Pye, A. Smith,
Pup.: G.J. Corbould, B. Howlett,
J.H. Robinson, J. Thurston (qq.v.).
Shared: J. Pye, L. Schiavonetti, J.
Thurston (qq.v.).

HEATH J.P. fl. 1830s.
Steel.
Arch. / illus. / land.
Perhaps related to Charles Heath (q.v.).
Aft.: W.H. Bartlett, W. Callow.

HEATH Percy fl. 1832—50.
Steel.
Arch. / illus. / land.
Perhaps related to Charles Heath (q.v.).
Aft.: T. Allom, W.H. Bartlett, Canaletto.

HEATH William 1795—1840.
Aq., et.
Caric. / hist. / hum. / illus. / marine /
mil. / ship.
Heath, who was also a humorous
draughtsman, sometimes used a small
figure of "Paul Pry" as a signature. He
was probably a son of C. Heath (q.v.).
Aft.: H. Bunbury.
Pub.: R.H. Laurie; McLean.

HEAVYSIDE John Smith ?1812
(Stockton-on-Tees) — 1864 (Kentish
Town).
Wood.
Illus. (espec. antiq.)
Heavyside took up art in his

twenty-sixth year, and after practising for a short period in London, went to live in Oxford. He was a brother of Thomas Heavyside (q.v.).
Pub.: Parker (Oxford).

HEAVYSIDE Thomas fl. mid 19th c.
Wood (?)
Port.
Brother of J.S. Heavyside (q.v.).

HEAWOOD Thomas fl. 1850—79.
Steel.
Illus.
Aft.: C. Arnold, E.T. Compton, E. Linning, A.H. Payne, S. Reed, C.A. Ruthart, J.B. Smith, C. Werner, J.D. Woodward.

HEBBERD Mrs M. fl. London (2 Upper Charlton Street, Fitzroy Square, Marylebone) 1811—14.
Pub.
Juv. dram.
Some of her plays were probably acquired by W. West (q.v.). Probably she was for some time agent for Skelt (q.v.).

HELLYER Thomas fl. London *c.* 1795—1810.
Aq., stip.
Gen. / hist. / relig. / ship.
Aft.: Bigg, E. Dayes, J. Weir, R. Westall, F. Wheatley.
Shared: T. Gaugain (q.v.).
Pub.: Boydell; Pollard.

HEMY Charles Napier R.A. 1841 (Newcastle-on-Tyne) — 1917 (Falmouth).
Et.
Marine.
Best known as a painter. Brother of T.M.M. Hemy.

HEMY Thomas Marie Madawaska 1852—1937.
Et.
Topog.
Brother of C.N. Hemy (q.v.), Thomas studied at Newcastle School of Art. He lived and worked in North Shields.
Pub.: Hills and Co.

HENARD C. fl. late 19th—early 20th c.
Et.
Port.
Also a miniaturist.

HENDERSON Andrew 1783 (Cleish) — 1835.
Line.
Port.
Also a painter.

HENDERSON Charles Cooper 1803 (Chertsey) — 1877 (Lower Halliford-on-Thames).
Et.
An. / land. / sport.
Henderson, who was also a painter, was an amateur. He took lessons as a boy from S. Prout. Educated at Winchester, he studied for the law but never practised.
Pub.: Ackermann; Fores.

HENDERSON John 1764—1834.
Et. (amateur).
Land.
Also a draughtsman and watercolourist.

HENDERSON William *c.* 1866 (Scotland) — *c.* 1926.
Mezzo.
Fig. / gen. / land. / port.
Aft.: P. Calderon, Fanny Corbaux, D. Cox, David, F. Day, W. Etty. Gainsborough, T. Glazebrooke, Mary Gow, Greuze, A. Hacker, P. Hall, G. Harlow, H. Henner, F. Holl, Hoppner, J. Jackson, N. Lancret, Sir T. Lawrence, Lord Leighton, Sir P. Lely, J. Nattier, G.S. Newton, A. Piot, Raeburn, Rembrandt, G. Romney, T. Uwins, D. Wehrschmidt, J. Wood, S. Woodford.
Pub.: T. Agnew; Dowdeswell and Dowdeswells; Fine Art Society; C. Klackner; A. Lucas; T. McLean; I.P. Mendoza; Museum Gallery; A. Tooth; Van Baerle Bros.

HENDERSON — fl. *c.* 1870.
Pub.
Juv. dram.
Also published boys' stories.

HENSHALL J. fl. 1820s—40s.
Steel.
Arch. / illus. / land.
Probably a brother of W. Henshall
(q.v.).
Aft.: J.C. Allen, T.C. Dibdin, J. Fussell,
C. Marshall, J. Meadows, S. Prout.

HENSHALL W. fl. 1830—50.
Steel.
Arch. / illus. / land.
Probably a brother of J. Henshall
(q.v.).
Aft.: C. Marshall, T.H. Shepherd.

HERBERT John Rogers R.A. 1810
(Maldon) — 1890 (London).
Et.
Mil.
Also a painter.

HERDMAN-SMITH Robert b. 1879.
Et.

HERING AND REMINGTON
fl. London (153 Regent Street)
1840s—50s.
Pub.
Noted especially for sporting prints.
Agents for the German art unions.

HERIOT Carline Isabel Robertine b.
London 1869.
Et.
Port. / still life.
A pupil of Roussel, Carline Heriot was
also a genre painter. Her parents were
French.

HERKOMER or von HERKOMER Sir
Hubert R.A. 1849 (Waal, Bavaria) —
1914 (Bushey).
Dry., et., mezzo., mixed., photo-eng.
Gen. / illus. / port.
Herkomer studied at the Munich
Academy and South Kensington
Schools, where he was a pupil of Luke
Fildes and F. Walker. Best known as a
painter, he also designed for stage and
cinema and composed music. He was
Slade Professor of Fine Art at Oxford
1885—94. His writings include *Etching
and Engraving, Lectures Delivered at
Oxford* 1892; *My School and my
Gospel* 1908; *A Certain Phase of
Lithography* 1910; *The Herkomers*
1910—11.

Herkomer's name was associated
with a type of photo-engraving:
'Herkomergravure' or 'Herkotypic'. In
this monotypes are first made, from
which electrotypes are taken and used
for printing.
Aft.: Sir J.E. Millais, Reynolds, F.
Walker.
Pup.: C.W. Campbell, T.H. Crawford,
E.B. Johnson, R.W. Macbeth, E.E.
Milner, E. Stamp, F. Sternberg, A.M.
Talmage, D.A. Wehrschmidt (qq.v.).
Pub.: Amster and Ruthardt; Fine Art
Society; Goupil, Obach and Co., T.
McLean.
Lit.: Baldry A.L. *Hubert von
Herkomer* 1901. Maas J. *Victorian
Painters* 1969. Mills J.S. *Life and
Letters of Sir Herbert Herkomer* 1923.
Studio XLIX, p. 277.

HESELTINE Arthur 1855 (near
London) — 1930 (Marlotte, Seine-et-
Marine).
Et.
Land. / topog.
Also a painter.

HESELTINE John Postle 1843
(Dilham, Norfolk) — 1929.
Et.
Illus. / land. / topog.
Director of the National Gallery,
London, and a friend of J. McN.
Whistler (q.v.).
Lit.: *Art Journal* 1881 p. 320.
Portfolio 1871, p. 28; 1872, p. 42.

HESELTINE W. fl. late 18th—early
19th c.
Stip.
Theat.
A pupil of M. Bovi (q.v.), Heseltine
was also a painter.
Aft.: Delaire.

HESTER Edward Gilbert 1843
(London) — 1903 (St. Albans).
Aq., et., line., mezzo.
*An. / gen. / lit. / myth. / port. / relig. /
sport. / topog.*
The father of R.W. Hester (q.v.). He
lived and worked in Chiswick.
Aft.: C. Aldin, H. Alken, R. Ansdell,
C.F. Allbon, T. Blinks, E. Caldwell,
H. Carmichael, J. Charlton, V.
Chevilliard, M. de Muncasy, A. Dodd,

J. Dollman, E.S. Douglas, Greuze, H. Hall, H. Hardy, J. Hardy, A.C. Havell, C. Henderson, S. Hodges, G. Holmes, Sir E. Landseer, Sir T. Lawrence, G.S. Leslie, E. Long, Helena Maguire, Sir J.E. Millais, E. Nicol, J.S. Noble, Sir J.N. Paton, J. Pettie, N.R. Roskell, W.J. Shayer, M. Stone, A. Strutt, J. Sturgess, F. Tayler, H. Trood, G. Veal, J.H. Walker Jr., T.N. Walsh, S. Watter, J.H. Williams, S. Williams. Shared: R.W. Hester.
Pub.: A. Ackermann; F. Ansdell; H.B. Ansdell; L. Brall; B. Brooks; Cadbury, Jones and Co.; Dowdeswell and Dowdeswells; Fores; L.H. Lefèvre, A. Lucas; T. McLean; F.C. McQueen; G.P. McQueen; I.P. Mendoza; H. Paton; Schmalz; Shepherd Bros.; A. Tooth.

HESTER E.M. fl. 1890s—1920.
Mezzo., photo-eng.
An. / arch. / gen. / sport.
Aft.: H. Carmichael, J. Connell, A.C. Havell, J. MacWhirter, W.R. Symonds.
Pub.: A. Bell; F.T. Dennis; Fores; A. Lucas; Schmalz; W.R. Symonds.

HESTER Robert Wallace 1866—c. 1923.
Aq., et., photo-eng.
An. / arch. / gen. / hist. / land. / mil. / port. / sport. / topog.
The son and pupil of E.G. Hester (q.v.), Robert lived and worked in London and Purley.
Aft.: D. Adams, W. Austen, F. Barraud, S. Berkeley, H. Bird, G. Browne, Sir P. Burne-Jones, E. Caldwell, E.A. Drage, A. Gow, Greuze, H. Hardy, Sir H. Herkomer, J.F. Herring, Hoppner, Sir T. Lawrence, S. Lewin, S. Lloyd, H.F. Lucas, C. Marshall, J. Opie, Rev. M.W. Peters, W.C. Piquenit, Raeburn, K. Robertson, G. Romney, W.D. Sadler, B. Shaw, R. Staples, A. Strutt, G.F. Thomson, S. Waller, W. Watson, W. Weekes, R. Woodville, J. Wright-Barker.
Pub.: C.E. Clifford; F.T. Dennis; Dickinson and Foster; Dowdeswell and Dowdeswells; Fine Art Society; Fores; Frost and Reed; H. Graves; L.H. Lefèvre; A. Lucas; F.C. McQueen; I.P. Mendoza; C.E. Millard; A. Tooth.

HEWLETT — fl. mid (?) 19th c.
Line (?)

HEYDEMANN or HEYDERMANN William fl. London 1880s—1917.
Et., mezzo.
Gen. / mil. / myth. / relig.
Aft.: J.P. Beadle, S. Berkeley, G. Boughton, F.C. Boult, H. Draper, S. Forbes, T. Good, A. Hacker, C. Hemy, Y. King, F. Krause, T. Linton, J. Lucas, A. Ludovici, J. Macpherson-Haye, Meissonier, J. Pettie, H. Piffard, Sir E. Poynter, A. Rossi, C. Smith, T. Smitzberger, S.J. Solomon, Velasquez.
Pub.: C.E. Clifford; F.T. Dennis; Fine Art Society; Fores; Frost and Reed; H. Graves; C. Klackner.

HIBBERT J. fl. Bath 1813—1815.
Litho.

HICKS Robert fl. first half of 19th c.
Steel., stip.
Port.
Aft.: J. Barry, W.M. Craig, G. Kneller, W. Nicholson, T. Phillips, Reynolds, G. Virtue.

HIGHAM Thomas 1795—1844.
Line., steel.
Illus. / land. / topog.
Pupil of T. Greig (q.v.)
Aft.: D. Cox, J.D. Harding, S. Prout, J.M.W. Turner.
Des.eng.: J. Greig.

HIGHMORE Thomas ?—1796.
(Suffolk) — 1844 (Islington).
Line.
Arch. / hist.

HILL — fl. 1849.
Steel.
Illus. / land.

HILL Alexander fl. Edinburgh 1940s—60s.
Pub.

HILL John 1770 (London) — 1850 (West Nyack, U.S.A.).
Aq., mezzo.
Hist. / illus. / land. / ship. / topog.
For a time Hill was employed by

225

Ackermann. In 1822 he emigrated to America and is especially noted for his American views. His son, John William (1812–75) and his grandson, John Henry (fl. 1865–79) were also engravers.
Aft.: De Loutherbourg, C. Dibdin, J. Homer, A. Pugin, W.G. Wall, Webster, Wright.

HILL W. fl. Birmingham mid. 19th c.
Steel.
Illus.

HILLS Robert 1769 (Islington) – 1844 (London).
Aq., et., litho., stip.
An. / land.
Best known as a watercolourist, Hills was a pupil of J.A. Gresse (1714–94). Secretary of the Society of Painters in Water-Colours for many years, he was among those who founded it.

HILLS AND COMPANY fl. 1860s.
HILL AND COMPANY
Pub.

HILTON William R.A. 1786 (Lincoln) – 1839 (London).
Line.
Gen.
Best known as a painter, Hilton was a pupil of V. Green (q.v.).
Aft.: G. Morland.

HINCHLEY P. fl. 1830s.
Aq.
Sport.
Aft.: J. Pollard.

HINCHLIFF John James 1805–75 (Walton-by-Clevedon).
Steel.
Illus. / land.
Son of the sculptor J.E. Hinchliff.
Aft.: W.H. Bartlett.

HINCHCLIFF W. fl. 1832.
Steel.
Arch. / illus.
Probably a brother of J.J. Hinchcliff (q.v.).
Aft.: G. Shepherd.

HINE Henry George 1811 (nr. Brighton) – 1895 (Hampstead).
Line.
Gen. / land.
Pupil of H.H. Meyer (q.v.). Also a painter.

HINE Mrs Victoria Susanna (née Colkett) 1840 (Norwich) – 1926.
Et.
Arch. / topog.
A daughter of S. Colkett (q.v.), Mrs Hine lived and worked in Botesdale, Diss.
Pub.: C.E. Clifford.

HINSCHELWOOD Robert b. 1812 (Edinburgh).
Et., steel.
Arch. / illus. / land.
Pupil of J.M. Johnstone. Was for a period employed by the Continental Bank Note Co., New York.
Lit.: *Art Journal* 1876, p. 332.

HIRST Norman 1862 (Liverpool) – c 1955.
Et., mezzo.
Fig. / gen. / land. / port. / ship. / topog.
Hirst studied in Leeds, Lucerne and Germany and also attended Sir Hubert Herkomer's School at Bushey, Herts. He lived at Seaford, Sussex, but later moved to Shaftesbury, and worked for a time in Christchurch, Hants., and Longport, Somerset.
Aft.: Sir L. Alma-Tadema, Sir W. Beechey, Constable F. Dicksee, H. Draper, Mary L. Gow, Sir H. Herkomer, Hoppner, Sir T. Lawrence, Le Brun, A. Moore, W. Muller, Henrietta Rae, Raeburn, Reynolds, G. Romney, J. Santerre, H. Schmaltz, M. Stone, J.M.W. Turner, A. Ward, J.H. Willaims, A. Wortley.
Pub.: T. Agnew; Buck and Reid; Dowdeswell and Dowdeswells; Fine Art Society; Fishel, Adler and Schwartz; Frost and Reed; H. Graves; C. Klackner; Leggatt Bros.; A. Ramsden.
Lit.: *Art Journal* 1892.

HIXON R. fl. 1813.
Aq.
Sport,
Nothing more is known of this
aquatinter.

HOBSON H. fl. London 1814—22.
Line (?)

HODGES Charles d. 1846
(Hamburg).
Line. (amateur).
Hodges, who was born in London,
worked much in Munich engraving
plates after works by Dutch masters.

HODGES Charles Howard 1764
(London) — 1837 (Amsterdam).
Mezzo.
Gen. / myth. / port. / relig. / sport.
Hodges settled in Amsterdam (where
he was taken by W. Humphrey (q.v.))
in or before 1794, after which he
devoted most of his time to portrait
painting, though he continued to
scrape a few plates. His son, J.N.
Hodges, was a minor mezzotint
engraver and printseller in Amsterdam.
Aft.: Alefounder, Beechey, Burckman,
M. Brown, J.W. Chandler, Gilpin,
Heins, Hodges, Hoppner, G. Metsu,
Opie, Parmigiano, R.M. Paye,
Rembrandt, Reynolds, Romney,
Rubens, Sharples, T. Stothard, B.
Strozzi, C.G. Stuart, G. Stubbs, Van
Dyck, B. West, F. Wheatley.

HODGETTS Robert M. fl. London
1820s—30s.
Probably the son of T. Hodgetts (q.v.)
with whom he was perhaps in practice
as "T. Hodgetts and Son". He was also
a genre painter and possibly lived for a
time in Edinburgh.
Aft.: D. Scott, J. Syme.

HODGETTS Thomas fl. London
1801—46.
Mezzo.
Land. / lit. / port.
Plates signed "T. Hodgetts and Son",
the son most probably being R.M.
Hodgetts (q.v.).
Aft.: T. Barker, W. Beechey, Lady
Burghersh, M. Carpenter, G. Dawe, A.
Geddes, J. Giles, Sir F. Grant, Sir G.
Hayter, G.F. Joseph, Sir T. Lawrence,
Oliver, Opie, T. Phillips, Raeburn,

Romney, R. Rothwell, A. Scheffer, J.
Syme, T.C. Thompson, J.M.W. Turner.
Shared: H.E. Dawe (q.v.).
Pub.: H. Graves.
Lit.: Whitman, A. *Master of Mezzotint*
1898.

HODGKINS Thomas F. d. 1903.
Litho.
Land.
Was active 1835—75.

HODGSON Bernard and CO.
fl. London (5 Cloth Fair) 1830.
Pub.
Tinsel.
Probably connected in some ways with
Hodgson and Co. (q.v.).

HODGSON David 1798 (Norwich) —
1864 (Norwich).
Et.
Arch. / topog.
Also a painter, David was the son of
the painter Charles Hodgson.

HODGSON E.S. fl. 1890s.
Et.
Arch. / topog.
Pub.: Dickinson and Foster.

HODGSON John Evan R.A. 1831
(London) — 1895 (London).
Et.
Ship.
Best known as a genre and historical
painter.

HODGSON Orlando fl. London
1831—43.
Pub.
Tinsel.
Probably a former partner in Hodgson
and Co. (q.v.), Orlando Hodgson
operated at various times from the
following London addresses: 10 Cloth
Fair, West Smithfield; 22 Macclesfield
Street; 111, 118 and 132 Fleet Street.
He also owned a printing works at
Isleworth.

HODGSON W. fl. London 1822.
Pub.
Juv. dram.
Little is known of this shadowy figure,
but he might have been the founder of
the firm of Hodgson and Co. (q.v.).

HODGSON and CO. fl. mid-late
19th c.
Sport.
Publishers in London, who became
successively Hodgson and Graves;
Moon, Boys, Graves and Co; Henry
Graves.

HODGSON and CO. fl. London
1822—30.
Pub.
Juv. dram. / tinsel.
The partners in the firm were named
Howes, W. Cole, S. Maunder and
perhaps H. Kenilworth (qq.v.).
Howes's name appears on some sheets
with that of Hodgson. W. Cole and S.
Maunder were probably printers,
operating in Newgate Street. Cole
probably continued to issue
Hodgson's sheets after the firm
finished. Other sheets were acquired
by J. Dyer (q.v.). Another name,
Langham (q.v.), appears on a few
sheets, but it is uncertain if he was a
partner or an agent. Yet another,
that of W. Layton (q.v.), appears
on same sheets.
See alwo W. Hodgson.
The firm operated from several
successive London addresses: 43
Holywell Street; 11-43 King Street,
Snow Hill; 10 Newgate Street; 111
Fleet Street; 10 Cloth Fair, West
Smithfield.

HODSON Samuel John 1836
(London) — 1908.
Litho.
Fig. / gen. / hist. / illus. / lit. / port.
Hodson was a pupil at the Royal
Academy Schools.
Aft.: L. Fildes, Lord Leighton, Sir
J.E. Millais, M. Stone, H.T. Wells,
J. Wood.
Lit.: *Art Journal* 1901.

HOFFY A. fl. 1846.
Litho.
Ship.

HOGARTH J. fl. London 1840s—
50s.
Pub.

HOGARTH T.C. fl. London 1859.
Et.
Port.
Also a painter.

HOGARTH HOUSE fl. *c.* 1870.
Pub.
Juv. dram.
Also published boys' stories.

HOLBROOKE John b. *c.* 1778.
HOLBROOKE William Henry b.
b. 1805 (Dublin).
Line., litho.
Hist. / port. / topog.
Father and son, who worked together
in Dublin.

HOLDGATE, Edward and Alfred.
Printsellers fl. London (39 London
Street, Fitzroy Square) 1880s.
There was also a printer of engravings,
R. Holdgate (fl. 1850s), who was
probably a relation.

HOLE Henry Fulke Plantagnet
Woolicombe *c.* 1781—*c.*1850.
Wood.
Illus.
A pupil of T. Bewick (q.v.) Hole lived
in Liverpool, and became a member of
the Liverpool Academy. He
abandoned engraving on succeeding to
an estate. Among his works were some
of the blocks for Bewick's *British
Birds.*
Aft.: T. Thurston.
Pup.: W. Hughes (q.v.).

HOLE William Brassey 1846
(Salisbury) — 1917 (Edinburgh).
Et.
Gen. / illus. / land. / topog.
Also a painter.
Aft.: R. Alexander, J. Constable,
J. Crome, J. Farquharson, L.
Kemp-Welch, C. Lawson, Sir J.E.
Millais, J.F. Millet, J. Thomson,
Velasquez, J. McN. Whistler,
Wimperis.
Pub.: Dowdeswell and Dowdeswells;
Fine Art Society; Frost and Reed;
Goupil; McOmish Dott and Co.;
Shepherd Bros.; J.S. Virtue.

HOLL Benjamin fl. 1835.
Steel.
Illus. / port.
Son of W. Holl the elder and brother
of F. Holl, C. Holl and W. Holl the
younger (qq.v.).
Aft.: E.T. Parris.
Pub.: Ackermann and Co.

HOLL Charles 1820 (London) —
1882 (London).
Steel., stip.
Fig. / illus. / port.
Son of W. Holl the elder and brother
of W. Holl the younger, C. Holl, B.
Holl and F. Holl (qq.v.).
Aft.: A. Bouvier, F. Goodall, G.
Richmond, Romney, F.W. Topham.
Shared: C. Hunt. Holl also completed
a plate, "Rebekah", after F. Goodall,
left unfinished by his brother William
when he died.
Pub.: Lloyd Bros.
Lit.: *Art Journal* 1854.

HOLL Francis, A.R.A. 1815
(London) — 1884 (Milford, Surrey).
Line., litho., mixed., steel., stip.
*Gen. / illus. / mil. / port. / relig. /
topog.*
Son and pupil of W. Holl the elder and
brother of W. Holl the younger, B.
Holl, C. Holl (qq.v.). Father of Frank
Holl the painter.
Aft.: J. Absolon, J. Archer, C. Baxter,
R. Buckner, W.C.T. Dobson, G. Doré,
E. Eddis, A. Elmore, T. Faed, J.
Fisher, W.P. Frith, W.E. Frost,
Margaret Gillies, Sir F. Grant, W.
Grant, J. Grund, R. Herdman, G.E.
Hicks, F. Holl, J.J. Jenkins, T.G.
Jones, Sir E. Landseer, C. Laurence,
J. Lucas, C.E. Perugini, E. Pingret,
G. Richmond, J. Sant, A. Solomon,
F.W. Topham, Valentini; and after
photos.
Shared: W. Holls, J.B. Hunt, G. Zobel
(qq.v.).
Pub.: T. Agnew; Art Union of
Glasgow; Art Union of Ireland;
Beeforth and Fairless; B. Brooks;
Colnaghi; J.L. Fairless; A.B. Fores; H.
Graves; J. Hogarth; J.J. Jenkins;
Kensington Fine Art Association;
Lloyd Bros.; T. McLean; Moore,
McQueen and Co.; W. Schaus.
Lit.: *Art Journal* 1876 pp.9—12.

Portfolio 1888 pp. 183f.
Reynolds, A.M. *The Life and Work
of Francis Holl* 1912.

HOLL William, the elder 1771—
1838 (London).
Steel., stip.
Antiq. / gen. / illus. / myth. / port.
Holl was probably of German origin.
He was a pupil of B. Smith and
father of B. Holl, C. Holl, and W. Holl
the younger (qq.v.). His work often
appeared under the name of other
engravers.
Aft.: E. Corbould, H. Tidey, R. Westall.

HOLL William, the younger 1807
(Plaistow) — 1871 (London).
Line., mezzo., steel., stip.
*All. / an. / gen. / hist. / illus. / land. /
lit. / myth. / port. / relig.*
Son and pupil of W. Holl the elder,
brother of B. Holl, F. Holl and C.
Holl (qq.v.).
Aft.: J. Absolon, R. Ansdell, T.J.
Barker, A. Bouvier, R. Carrick, T.
Crane, A. Elmore, J. Faed, P.
Falconer, J. Farquharson, W.P.
Frith, F. Goodall, J.F. Herring Sr.,
Kilburn, C. Landseer, C. Lawson,
C. Moore, H. O'Neil, G. Richmond,
A. Salome, R. Scanlan, Skirving,
A. Solomon, J. Swinton, H. Tidey,
T. Webster, B. West, Westall, E.
Wimperis; and after photos. by
Mayall.
Shared: F. Holl (q.v.) William's plate,
"Rebekah", after F. Goodall,
unfinished on his death, was
completed by his brother Charles.
Pub.: Art Union of London; Finden;
Fine Art Soceity; Fores; Frost and
Reed; Lloyd Bros.; T. McLean; Moore,
McQueen and Co.
Lit.: Engen, R.K. *Victorian Engravings*
1975.

HOLLAND W.T. fl. 1860s.
Mezzo
Gen. / port.
Aft.: T. Brooks, Reynolds.
Pub.: B. Brooks.

HOLLIDAY C. fl. *c.* 1890.
Et.
Topog.
Pub.: Gladwell Bros.

HOLLIS George 1793 (Oxford) — 1842 (Walworth).
HOLLIS Thomas 1818—43.
Et., line, steel.
Antiq. / illus. / land. / topog.
George Hollis was a pupil of G. Cooke (q.v.). His son, Thomas, was an etcher as well as an engraver. Thomas was a pupil of H.W. Pickersgill and was a student at the R.A. He assisted his father in engraving some plates and it is sometimes difficult to identify a work as by father or son.
Aft.: J.C. Buckler, H.F. De Cort, J.M.W. Turner.
Pub.: T. Agnew.

HOLLIS J. fl. 1833—46.
Steel.
Fig. / illus. / port.
Aft.: J. Browne, E. Corbould, G.H. Harlowe, McIain, K. Meadows.

HOLLOWAY Charles Edward 1838 (Christchurch, Hants). — 1897 (London).
Et., line, litho.
Land. / marine. / ship.
After attending Leigh's School in Newman Street, London, Holloway worked at the Working Men's College and assisted William Morris in making designs for stained glass. He visited Vienna in 1875. J. McN. Whistler was one of his friends.
Aft.: J. Constable.
Pub.: Colnaghi, W. Farren, A. Lucas.
Lit.: *Art Journal* 1896, p. 12; 1897, p. 127.

HOLLOWAY M.M. fl. 1840s—50s.
Pub.

HOLLOWAY Thomas 1748 (London) — 1827 (Coltishall, nr Norwich).
Line.
Hist. / illus. / port. / relig.
The eldest son of a merchant, Holloway was articled to Stent, a seal engraver, and attended the Royal Academy Schools. He was appointed historical engraver to King George III. He contributed many plates to the five-volume 4to edn. of Lavater's *Essays on Physiognomy* (1789—98).

Aft.: Dahl, Pine, Raphael, Van Dyck, West.
Assist.: R. Slann (q.v.).
Shared: J. Thomson (q.v.).
Pub.: Bowyer; Boydell; Macklin.

HOLLYER Christopher C. fl. early 1860s to early 1870s.
Mezzo.
An. / gen.
Aft.: T.S. Cooper, C.M. Dobell, W. Huggins, Sir E. Landseer.
Pub.: B. Brooks, H. Graves.

HOLLYER Frederick fl. 1860s.
Mezzo., mixed.
Gen.
Also a noted photographer, Hollyer photographed over 100 of Lord Leighton's paintings for him, as well as works by Sir E. Burne-Jones, G. Richmond, D.G. Rossetti and G.F. Watts.
Aft.: Sir E. Landseer.
Pub.: J. McQueen.
Lit.: Beck, H. *Victorian Engravings* 1973.

HOLLYER Samuel 1826 (London) — 1919.
Line., litho., mezzo., steel., stip.
Ex libris. / gen. / hist. / land. / port.
A pupil of E.F. Finden and his brothers (qq.v.), Hollyer worked in New York after 1866.
Aft.: T.S. Cooper, T. Faed.
Pub.: H. Graves.
Lit.: Stauffer, D. *American Engravers* 1907.

HOLM Rosalie Agathe Frederikke (née Petit) 1807—73.
Et.
Gen.
Wife of the Danish etcher and painter, Christian Frederick Carl Holm (1804—46).

HOLMES Sir Charles John K.C.V.O. 1868 (Preston) — 1936 (London).
Et.
Land.
Chiefly known as a painter and art critic, Holmes was educated at Eton and Oxford. He was taught etching by W. Strang (q.v.). In 1909 he became director of the National Gallery.

Altogether he etched over 80 plates.
Lit.: Fine Art Society *Sir Charles
Holmes K.C.V.O.* (with a foreword
by A.M. Hind) 1937.

HOLMES George fl. Dublin 1843.
Et.
Land.

HOLMES Marcus b. 1877.
Et.

HOLROYD Sir Charles 1861 (Leeds)
— 1917 (Weybridge).
Et., litho.
*Fig. / gen. / land. / myth. / port. /
relig. / trees.*
The son of a merchant, Holroyd was
educated at Leeds Grammar School
and Yorkshire College of Science. In
1880, abandoning the career of a
mining engineer for which he was
intended, he decided to become an
artist and attended the Slade School of
Fine Art in London and studied under
A. Legros (q.v.). He became an
assistant teacher at the Slade and spent
two years in Italy. Holroyd was keeper
of the Tate Gallery 1897—1906 and
director of the National Gallery
1906—16. He etched some 286 plates.
Lit.: *Connoisseur* Jan. 1919 pp. 85—90.
Dogson, C. *The Etchings of William
Strang and Sir Charles Holroyd ...*
1933.
P.C.Q. X pp. 309—44, 346—67.
Studio XXX pp. 285f.

HONE Horace A.R.A. 1756
(London) — 1825 (London).
Et.
Port.
Best known as a miniature and enamel
painter, Horace was the son of the
miniaturist Nathaniel Hone. He
worked in Dublin for many years. In
1795 he became miniaturist to the
Prince of Wales.
Des. eng.: F. Bartolozzi, R.H. Cromek,
J. Heath, H. Meyer, T. Nugent, L.
Schiavonetti, B. Smith (qq.v.).

HONE T. fl. 1840s.
Steel.
Illus. / land.
Possibly a brother of H. Hone (q.v.).
Aft.: W. Tomleson.

HONE William fl. early 19th c.
Pub.

HOOD Thomas 1799 (London) —
1845 (London).
Line., steel.
Illus.
Hood was first articled to his uncle, an
engraver, and subsequently to Le Keux
(q.v.). But he was not happy in this
profession and turned to literature. He
is best remembered today for his
humorous and satirical writings, such
as the "Song of a Shirt".

HOOD W. fl. 1832.
Steel.
Illus. / land.
Aft.: W. Tombleson.

HOOK C. fl. London (33 Windmill
Street, Tottenham Court Road) 1820.
Pub.
Juv. dram.
No further details of this publisher or
his works remain.

HOOK James Clarke R.A. 1819
(Clarkenwell) — 1907 (Churt).
Dry., et.
Gen. / marine.
Hook studied art at the British
Museum and the R.A. Schools, where
he was awarded three medals,
including one of gold for history
painting.
Pub.: Etching Club; Fine Art Society;
Edward Palmer.
Lit.: Palmer, A.H. *J.C. Hook* 1888.
Stephens, F.G. *J.C. Hook, his Life and
Work* 1890.

HOOKER Sir William Jackson 1785
(Norwich) — 1865 (Kew).
Et.
Arch. / land.
Best known as director of Kew
Gardens. Husband of Lady Hooker
(q.v.).

HOOKER Lady fl. mid (?) 19th c.
Et. (soft ground).
Arch.
Wife of Sir W.J. Hooker (q.v.).

HOOPER Luther 1849—1932.
Et., litho.
Land. / topog.
Also a painter of genre subjects.
Pub.: E.E. Leggatt.

HOOPER William Harcourt 1834—
1912 (Hammersmith).
Wood.
Ex libris. / illus.
Hooper cut many blocks for William
Morris's Kelmscott Press. He was
manager for J. Swain (q.v.).
Aft.: Sir E. Burne-Jones, F. Walker.
Pub.: C. Ricketts, C.H. Shannon.

HOPE C.M. fl. 1851.
Litho.
Port.
Also a painter.

HOPKINS Arthur fl. London 1872.
Et. (?)
Illus.
Also a watercolourist.

HOPKINS W. fl. Windsor 1803—11.
Et.
Port.

HOPPNER John R.A. 1759—1810.
Portrait painter. Engraved at least one
plate of a work by himself ("The
Shower").

HOPWOOD James Sr. 1752
(Beverley) — 1819 (London).
HOPWOOD James Jr. b. 1795.
HOPWOOD William 1784—1853.
Line., steel., stip.
Illus. / port.
Hopwood Sr. was self taught and did
not practise his art until middle age.
He came to London where J. Heath
(q.v.) allowed him to work in his
house. Although he faced many
difficulties and privations he overcame
them and earned a considerable
reputation.
His son, J. Hopwood Jr, went to Paris
where he gave lessons to the French
engraver Ferdinand Gaillard. He
worked in stipple, mainly on
portraits and book illustrations.
Another son, William, was also an
engraver, especially of illustrations.
Aft.: H. Corbould.

HORDS R. fl. 1831.
Steel.
Illus. / land.

HORNOR Thomas fl. 1828.
Line.
Land. / topog.

HORSBURGH John 1791
(Prestonpans) — 1869 (Edinburgh).
Line., steel.
*Gen. / hist. / illus. / land. / port. /
theat.*
After studying at the Trustees
Academy, Edinburgh, Horsburgh was
apprenticed to R. Scott (q.v.). For
nearly forty years he was an unpaid
pastor in the Scotch Baptist Church.
Aft.: Sir W. Allan, Sir J.W. Gordon,
McInnes, Sir. T. Lawrence, W.
Simson, J.M.W. Turner.

HORSBURGH T. fl. early to mid
19th c.
Steel.
Illus.

HORSLEY John Callcott R.A. 1817
(London) — 1903.
Et.
Gen. / illus. / lit.
The first member of the Etching Club.
Mainly known as a genre painter.
Pub.: Art Union of London.
Lit.: Horsley, J.C. *Recollections of a
Royal Academician* 1903.

HORSNELL 2nd Lieut. d. 1916.
Et.

HORWOOD and WATKINS
fl. 1840s—50s.
Print.

HOUSMAN Clemence d. 1955.
Wood.
Illus. / relig.
Sister of the writers A.E. and Laurence
Housman, Clemence was also a writer.
She was active *c.* 1898.
Aft.: L. Housman.
Lit.: *P.C.Q.* XI pp. 190—204.

HOUSTON George b. 1869.
Et.
Land. / marine.

HOW or HOWE J. fl. 1830s—40s.
Steel.
Arch. / illus. / land.

HOW L. fl. 1815.
Line.
Port.

HOWARD Frank 1805 (London) —
1866 (Liverpool).
Litho.
Myth.
Also a painter, Frank Howard was the
son and pupil of the genre painter
Henry Howard.
Aft.: E.H. Corbould.

HOWARD T. fl. 1830s—40s.
Steel.
Arch. / illus. / land.
Aft.: W. Tombleson.

HOWARTH Albany E. 1872—1936.
Dry., et.
Arch. / topog.
Lived and worked in Hutton, Essex.
Lit.: *Art Journal* 1909 p. 143.
Studio LVIII p. 122.

HOWES — fl. London 1822.
Pub.
Juv. dram.
A partner in the firm of Hodgson and
Co. (q.v.).

HOWISON or HOWIESON William
1798 (Edinburgh) — 1850 (Edinburgh).
Line., steel.
Gen. / illus.
Educated at Heriot's Hospital,
Howison was apprenticed to an
engraver named Wilson.
Aft.: Sir W. Allan, T. Faed, Sir G.
Harvey, D.C. Hill.
Pub.: Association for the Promotion
of the Fine Arts in Scotland; Gambart.
Lit.: *Art Journal* 1851 p. 44.

HOWITT William Samuel ? 1765
(Nottingham) — 1822 (London).
Aq., et., mixed.
*An. / ex libris. / hum. / illus. / land. /
sport.*
A member of an old Nottinghamshire
family, Howitt came to London,
studied at Dr Goodenough's Academy,
Ealing, and worked as a drawing

master. He married the sister of
Thomas Rowlandson. It is not true,
as has sometimes been stated, that he
lived some time in Bengal.
Aft.: S. Howitt, J. Wicksted.
Williamson.
Lit.: Wilder, F.L. *English Sporting
Prints* 1974.

HOWELTT Bartholomew ? 1767
(Louth) — 1827 (Newington).
Line.
Arch. / hist. / illus. / land. / topog.
Apprenticed to James Heath (q.v.).
Aft.: Girtin, Nash.

HUDSON S.T. fl. 1870s.
Litho (incl. chromolitho.)
Illus.

HUFFAM A.W. c. 1800 (Edmonton)
— after 1859.
Line., litho., mezzo., mixed.
An. / port. / sport.
Aft.: A. Aglio, J. Bacon, D.
Crosthwaite, J.F. Herring Sr., Sir E.
Landseer, J. Porter, J. Rogers.
Pub.: Dixon and Ross; Gambart;
Hering and Remington; A.J. Isaacs.
Lit.: Wilder, F.L. *English Sporting
Prints* 1974.

HUFFAM T.W. fl. London 1825—55.
Line., litho., mezzo.
Gen. / relig. / sport.
Aft.: J. Bateman, E.H. Corbould, da
Vinci, P. Delaroche, A.S. Hemming,
J.F. Herring Jr., A.M. Huffam,
Kohler, Reynolds, J.M. Wright.
Shared: J. Mackrell (q.v.).
Pub.: Bailey Bros.: T. Boys; Gambart.

HUGHES Henry b. c. 1796.
Wood.
Illus. / land.
Worked in London.

HUGHES Hugh 1790
(Pwllygwichiad, Llandudno) — 1863
(Gt. Malvern).
Litho., wood.
Illus. / land. / topog.
Hughes's parents died while he was
young and he was brought up by his
maternal grandfather. He was
apprenticed to an engraver in
Liverpool, and afterwards went to
London and learnt oil painting.

HUGHES Jane fl. early 19th c.
Wood.
Illus.

HUGHES John 1790—1857
(London).
Et.
Land.
Also a painter and sculptor.

HUGHES Mary Kathleen 1877
(Pole Hore, Ireland) — 1918
(Hindhead).
Et.
Land.

HUGHES Myra Kathleen ₃ d. 1918.
Et.
Arch. / land.

HUGHES S.G. fl. early 19th c.
Aq.
Railways / topog.
Shared: H. Pyall (q.v.).

HUGHES William 1793 (Liverpool)
— 1825 (Lambeth).
Wood.
Illus. / land. / port. / topog.
Apprenticed to Henry Hole (q.v.).
Aft.: Holbein, Linnell.
Assist.: J. Jackson (q.v.).
Lit.: Jackson, J. and W.A. Chatto *A Treatise on Wood Engraving* Second ed., 1861.

HUGHES, W fl. London (Aldine Chambers, Paternoster Row) 1840—51.
Steel.
Maps.

HULL Edward fl. 1820—34.
Litho.
Gen. / lit. / mil. / sport.
Also a designer.
Aft.: A. Cooper.

HULL William 1820 (Graffham, Hunts.) — 1880 (Rydal).
Et.
Illus. / topog.
Also a watercolourist.
Des. eng.: R. Langton (q.v.).

HULLAND William T. fl. 1850s—80s.
Line., mezzo., mixed.
Gen. / mil. / port.

Worked in London and Farnworth, Liverpool.
Aft.: J.E. Christie, Reynolds, Elizabeth Thomson (Lady Butler).
Pub.: Fine Art Society.

HULLEY Jr. — fl. Bath 1813—15.
Litho.

HULLMANDEL Charles Joseph
1789 (London) — 1850 (London).
Litho. (incl. chromolitho.), print.
Gen. / illus. / land. / mil. / topog.
The son of a German musician, Hullmandel took up lithography in 1818, after travelling on the Continent painting and sketching. He was most successful and soon artists were seeking instruction from him. Among improvements he introduced to the technique of lithography was a use of graduated tints and white in highlights. He also invented the process of lithotint, in which liquid ink was applied to the stone with a brush, and succeeded in giving greater variety to the texture by the use of the stump. He was a writer and his works included a translation of Raucourt's *Manual of Lithography*, and the original works *Art of Drawing on Stone* (1824), and *On Some Important Improvements in Lithographic Printing* (1827). There was also a partnership, Hullmandel and Walton, the latter possibly being C.W. or W.L.Walton (qq.v.). Aft.: H. Alken, T. Allom, T.M. Baynes, J. Bowell, G.B. Campion, Cattermole, P.H. Gosse, Haghe, C. Heapy, Nash, D. Roberts, C. Stanfield, T. Walton.
Pub.: T.S. Boys.

HULME Frederick William 1816
(Swinton} — 1884 (London).
Litho.
Topog.
Aft.: P. Browne.
Best known as a landscape painter.

HUMBLE or HAMBLE J. fl. 18th — early 19th c.
Aq.
Ship.
Probably related to J.R. Hamble (q.v.).
Shared: J. Clark (q.v.).

HUME Sir Abraham Bart. F.R.S. .
1749 (London) — 1838 (Wormley
Bury).
Et. (amateur).
Land.
Hume was a virtuoso and collected
pictures, precious stones and minerals.
He was elected F.R.S. for
contributions to natural history and
mineralogy. At the time of his death
he was the senior Fellow.

HUMPHREYS Henry Noel 1810
(Birmingham) — 1879 (London).
Litho., wood.
Book decoration. / illus.
Humphreys worked for a period in
Italy, but returned to England *c.*
1843.

HUMPHREYS Mrs fl. London (St.
James's Street) late 18th — early 19th
c.
Pub.
Caric.

HUMPHRYS William 1794
(Dublin) — 1865 (Genoa).
Line., steel.
*Bank. / gen. / illus. / lit. / port. /
sport. / stamps.*
Humphrys learnt engraving from the
banknote engraver, George Murray (a
pupil of Anker Smith, q.v.). Early in
life he went to the U.S.A. and worked
in Philadelphia on vignettes for
banknotes, which had been
introduced as a security against
forgery. He returned to London *c.*
1822 where he was similarly
employed. In 1843 he returned to
U.S.A., but came back to England in
1845. In 1854 he re-engraved the
Queen's head for the line-engraved
postage stamps produced by Perkins,
Bacon and Co. (q.v.). For this firm
he also engraved A.E. Chalon's
portrait of the Queen for stamps of
New Zealand, Grenada, Van Diemen's
Land and other issues, working from a
watercolour copy by Edward Henry
Corbould. He also engraved dies for
the Cape of Good Hope triangular
stamps, and for the first issues of
Ceylon, St. Helena, South Australia
and other colonies.
Aft.: H. Brockedon, Correggio, Sir

F. Grant, Sir T. Lawrence, C.R. Leslie,
Murillo, Reynolds, J. Stephanoff,
T. Stothard, C.G. Stuart.
Pub.: Colnaghi, H. Graves.
Lit.: *Art Journal* 1865, p. 140.

HUNT — fl. London 1830.
Pub.
Juv. dram.
Partner in the firm of J. Bailey and Co.
(q.v.).

HUNT — fl. early 19th c.
Stip. (?)
All.
Aft.: C. Turner.

HUNT Charles fl. London early 19th
c.
Aq., et., line., mixed.
Gen. / ship. / sport.
Aft.: H. Alken, H. Alken Jr., A.
Bouvier, J. Bouvier, G.B. Campion,
Lieut. Cockburn, Cooke, Lieut,
Cookham, R.B. Davis, A.F. de Prades,
C. Earp, Edgington, A. Fitzgerald, H.
Hall, H. Heath, W. Heath, C.C.
Henderson, B. Herring, J.F. Herring
Sr., B. Hubbard, S.J.E. Jones, E.F.
Lambert, J. Loader, J.W. Moore, C.B.
Newhouse, J. Pollard, W. Shayer, J.
Sturgess, G. Stubbs, W. Summers, C.
Towns, F.C. Turner, Wambill,
Wolstenholme.
Shared: C. Holl, G. Hunt, Mackrel,
R.W. Smart, C. Turner (qq.v.).
Pub.: R.Ackermann; Barnett Moss
and Co.: Louis Brall; Fores; A.J.
Issacs; J.W. Laird; Lewis and Co.:
Lewis and Johnson; Lloyd Bros.:
T. McLean; Mason of Brighton; J.
Moore; Moss and Co.; Rock Bros.
of Wallbrook.
Lit.: Wilder, F.L. *English Sporting
Prints* 1974.

HUNT George fl. *c.* 1831.
Aq., mixed.
Illus. / land. / sport.
Aft.: H. Alken, S. Alken, J. Pollard,
F.C. Turner.
Shared: C. Hunt (q.v.).
Pub.: J. Moore.
Lit.: Wilder, F.L. *English Sporting
Prints* 1974.

HUNT George Sidney 1856–
c. 1917.
Mezzo., mixed.
An. / gen. / illus. / port. / sport.
Lived and worked in Shackleton,
Leyton and Leigh-on-Sea, Essex.
Aft.: H. Herkomer, Sir. E. Landseer,
W. Winans.
Pub.: L.H. Lefèvre; F.C. McQueen.

HUNT J.B. fl. London 1850—80.
Line., mezzo., mixed.
An. / gen. / hist. / illus. / port.
Aft.: G. Boughton, J. Grund, Sir E.
Landseer, C.J. Staniland.
Shared: F. Holl (q.v.)
Pub.: H. Graves, M. Knoedler, W.
Schnaus.

HUNT Samuel Valentine 1803
(Norwich) — 1893 (Bay Ridge, U.S.A.).
Et., steel.
Illus. / land.
Also a painter.
Aft.: L. Haghe.

HUNT T.W. fl. London 1850.
Steel, wood.
Illus.
Aft.: J. Gibson, Nasmyth, Reynolds,
Shee, Wilkie.

HUNT William Henry 1790—1864
(London).
Stip.
Gen.
Best known as a still life and genre
painter, Hunt was a pupil of John
Varley and became a student at the
R.A. Schools in 1808.
Des.eng.: J. Egan, C. Fox, H. Ryall
(qq.v.).

HUNT William Holman 1827
(London) — 1910 (London).
Et.
Fig. / gen. / lit. / relig.
Mainly a painter, the Preraphaelite
Holman Hunt produced a few
etchings.
Lit.: Hamerton, P.G. *Etching and
Etchers* 1868.
Walker Art Gallery, Liverpool *William
Holman Hunt* 1969.
William Weston Gallery *An Exhibition
of English Etchings of the Victorian
Era.* London, 1971.

HUNT W. Howes fl. Norwich mid
19th c.
Et.
Land. / topog.

HUNT AND SONS fl. 1866.
Aq., et., mixed.
Sport.
Lit.: Wilder, F.L. *English Sporting
Prints* 1974.

HUNTER Colin A.R.A. 1841
(Glasgow) — 1904 (London).
Et.
Gen. / illus. / marine. / sport.
Also a marine painter.

HUNTER Frederick fl. 1858—90.
Et., mezzo.
Arch. / hist. / port.
Aft.: F. Barraud, T. Brooks, F.J.
Wyburd.
Pub.: Dickinson and Foster; H. Graves.

HUNTER Lieut. J. fl. early 19th c.
Aq.
Illus.

HUNTER James fl. 1848.
Steel.
Fig. / illus.
Aft.: E. Magnus.

HUNTER James Brownley
b. Edinburgh 1855.
Mezzo.
Port.
Aft.: J. Phillip, Velasquez.

HUNTLEY W. fl. 1860s.
Mezzo., stip.
Land.
Aft.: E. Johnson.
Pub.: B. Brooks.

HUNTLY T.D. fl. London 1815.
Line.
Ex libris.

HURDIS James Henry 1800
(Bishopstone) — 1857 (Southampton).
Et.
Hist. / hum. / port. / topog.
The elder son of James Hurdis, the
poet, who died when James Henry was
a baby. His mother remarried to a
Southampton physician. The boy was

educated in Southampton and then spent some years in France. After this he was articled to C. Heath (q.v.). He worked as an amateur. His residence was mainly at Newick, near Lewes.
Aft.: F. Colvin.

HUSON Thomas 1844 (Liverpool) — 1920.
Et.
Land.
Best known as a landscape painter.

HUSSEY Henrietta (née GROVE)
b. Salisbury 1819.
Et. (amateur)
Land.
Also a painter.

HUTCHINSON J.R. fl. 1890s.
Et.
Arch. / gen.
Aft.: R. Fraser.
Pub.: C.E. Clifford; H. Littaur; I.P. Mendoza.

HUTH Frederick fl. Edinburgh 1881—1905.
Et., line., litho.
Flor. / gen. / illus. / land. / port.
Aft.: E. Abbey, Gainsborough, H.W. Kerr, A. Moore, W.Q. Orchardson, A. Parsons, G. Reid, Watteau.
Pub.: Fine Art Society.
Lit.: *Art Journal* 1902 p. 366; 1903 p. 360.

HUTIN G.W. fl. Greenwich 1827—28.
Line.
Port.
Aft.: J. Clover, Reynolds.

HYAMS Moss fl. London (15 Mint Street, Borough) c. 1845.
Printseller
Juv. dram.
Agent for J.K. Green (q.v.).

HYDE William fl. London 1889.
Et., line., mezzo.
Illus.
Also a landscape painter.

IBBETSON Julius Caesar 1759 (Scarborough) — 1817 (Masham).
Aq., et.
Hum. / land.
Best known as a painter of animals and landscape, Ibbetson was educated by the Moravians, to which sect his father belonged, and afterwards at the Quakers' School in Leeds. He was then apprenticed to a Hull ship-painter and in 1777 went to London and married and soon began to paint pictures. He accompanied Col. Cathcart's embassy to China in 1788 but on his return ran into financial difficulties. In 1794 his wife died and in 1798 he fled to Liverpool to escape his creditors. He settled for a time in Ambleside and in 1801 married again. But he again got into financial trouble and it was not until William Danby, one of his most important patrons, invited him to settle in Masham, near his park, that he was able to settle into a tranquil existence. He wrote one or two treatises on painting.

ILLINGWORTH Adeline S. b. 1858.
Et.
Arch. / topog.

INCHBOLD John William 1830 (Leeds) — 1888 (Leeds).
Et.
Arch. / illus. / land.
Best known as a landscape painter, Inchbold worked for a time as a draughtsman for the lithographers, Day and Haghe (q.v. under Day and Son).
Lit.: Maas, Jeremy *Victorian Painters* 1969.

INCHBOLD T. fl. 1830.
Litho.
Port.

ISAAC John R. d. Liverpool 1871.
Line., litho., (incl. chromolitho.)
Ex libris / topog.

238

JACKMAN W.G. fl. 1840s.
Dry., steel., stip.
Fig. / illus. / port.
Worked in New York for a period
from *c.* 1841.

JACKSON Francis Ernest b. 1873.
Litho.
Port.
One of the founders of the Senefelder
Club. Also a painter.

JACKSON John R.A. 1778
(Lastingham) — 1831 (London).
Et.
Port.
Best known as a portrait painter and
watercolourist.

JACKSON John 1801 (Ovingham) —
1848 (London).
Wood.
An. / illus. / lit.
The son of humble parents, Jackson
was a pupil first of Armstrong and
Walker, engravers and printers of
Newcastle, then of Thomas Bewick
(q.v.). After a disagreement with
Bewick he came to London and
became a pupil of W. Harvey (q.v.).
Jackson employed many assistants
including E. Landells (q.v.) and himself
assisted W. Hughes (q.v.). He was the
father of Mason Jackson (q.v.). With
William Andrew Chatto (1799—1864)
the writer and his close friend, he
wrote *A Treatise on Wood Engraving*
(1839, Second edn., 1861).
Aft.: W. Harvey, J. Martin, J. Northcote.

Assist.: S. Sly, — Wilson (qq.v.).
Pub.: Charles Knight.
Lit.: de Maré E. *The Victorian
Woodblock Illustrators* 1980.
Dobson A. *Thomas Bewick and his
Pupils* 1884.

JACKSON John Richardson 1819
(Portsmouth) — 1877 (Southsea).
Line., mezzo.
Gen. / land. / port. / relig. / sport.
The second son of E. Jackson, a
banker, J.R. Jackson became a pupil
of R. Graves (q.v.) in 1836.
Aft.: Margaret Carpenter, R. Fowler,
Sir F. Grant, J.P. Knight, Sir E.
Landseer, Sir T. Lawrence, J. Lucas,
A. Morton, Murillo, H. Phillips,
Reynolds, G. Richmond, F. Say,
J.C. Smith, G.F. Watts, F. Winterhalter.
Pub.: Colnaghi; Dixon and Ross; Fores;
H. Graves; McLean; John Mitchell;
G.F. Moon.

JACKSON J. fl. 1830s.
Steel.
Arch. / illus. / land.
Aft.: W. Tombleson.

JACKSON Mason 1819 (Ovingham)
— 1903 London.
Wood.
Illus.
Son of John Jackson (q.v.).
Aft.: T. Creswick.

JACKSON Robert fl. early 19th c.
Mezzo., wood.
Port.

JACKSON T. fl. 1830s—40s.
Steel.
Illus. / land.
Aft.: W. Tombleson.

JACKSON W. fl. London (Gutter
Lane, Cheapside) early 19th c.
Line.
Ex libris.

JACOBY Max fl. New York (70 John
Street; 104—106 William Street) 1880s.
American publisher who issued some
plates by British artists.

JACOMB-HOOD George Percy 1857
(Redhill) — 1929.
Et., litho.
Gen. / illus. / lit. / port. / topog.
A pupil of A. Legross (q.v.) and Sir E.
Poynter at the Slade School. He
worked also under J. Laurens in Paris.
Lit.: Jacomb-Hood G. *With Brush and
Pencil* 1925.

JACQUET Achille 1846 (Courbevoie,
Seine) — 1908 (Paris).
Line.
Gen.
French national who made a number
of plates after works by British artists
which were published in England. He
was the brother of Jules Jacquet (q.v.).
Aft.: E. Long, F. Morgan.
Pub.: C. Klackner, A. Tooth.

JACQUET Jules 1841 (Paris) —
1913.
Et., line., mixed.
Gen. / hist. / mil.
French national who engraved a
number of plates after works by
British artists which were published in
England. The brother of A. Jacquet
(q.v.).
Aft.: G. Morland, W.D. Sadler,
H. Schmalz, J.H. Williams,
R.C. Woodville.
Pub.: J. Connell and Sons; Goupil;
H. Graves; C. Klackner; Knoedler and
Co.; L.H. Lefèvre; T. McLean; George
Petit; E. Savary; A. Tooth.

JAMAS Abel or Albert b. Cramant,
Meuse, 1862.
Et.
Gen. / mil.

French national who etched a number
of plates after works by British artists
which were published in England.
Aft.: R. Cosway, J. Russell,
R.C. Woodville.
Pub.: H. Graves.

JAMES Clifford R. fl. early 20th c.
Mezzo.
Port.
Aft.: J. McN. Whistler.
Pub.: J. Connell and Sons.

JAMES I. fl. London (13 Luke's
Court, Bow Street) *c.* 1850.
Pub.
Tinsel.

JAMES Sir Walter Charles Bart
fl. London 1849—53.
Et.
Land.
Also a painter.

JAMES Hon Walter John (Lord
Northbourne) 1869 (London) —
1932.
Et.
Land. / marine. / trees.
James lived in Eastry, Kent, and
Otterburn, Northumberland. He
studied at the School of Engraving at
the Royal College of Art under Sir
Frank Short (q.v.) and Nino Costa.
Lit.: *Studio* LIV, p. 103.

JAMESON J.H. fl. London (13
Dukes Court, Bow Street) 1811—27.
Pub.
Juv. dram.

JARMAN G. fl. 1853.
Steel.
Illus. / land.

JASINSKI or JAZINSKI Félix 1862
(Zabkow) — 1901 (Puteaux).
Et.
All. / gen. / lit. / myth. / relig.
Polish-born, naturalised French
national who made a number of plates
after works by British artists which
were published in England.
Aft.: Sir E. Burne-Jones, W.Q.
Orchardson, D.G. Rossetti, A. Stevens.
Pub.: T. Agnew; Fine Art Society;
A. Tooth.

JAZET Eugene Pontus 1815 (Paris) — 1856.
Aq., mezzo.
Gen.
French national who made some plates after works by British artists which were published in England.
Aft.: R. Westall, Sir D. Wilkie.

JEAKES J. fl. 1818.
Aq.
Illus.

JEANS W. fl. early 20th c.
Mezzo.
Port.
Aft.: G.F. Watts.
Pub.: Museum Galleries.

JEAVONS Thomas d. Welshpool 1867.
Line., steel.
Illus. / land. / marine. / topog.
Jeavons was born at the beginning of the 19th century and not in 1816 as is usually stated.
Aft.: W. Bartlett, N. Beecham, W. Brockedon, E.W. Cooke, J.D. Harding, Hobbema, S. Prout, D. Roberts, C. Stanfield, W.F. Witherington.

JEBB Miss Kathleen M. b. 1878.
Et.

JEENS Charles Henry 1827 (Uley, Gloucester) — 1879.
Line., mixed., steel., stip.
Ex libris. / gen. / hist. / illus. / port. / relig. / stamps.
Having studied under William Greatbach (q.v.) and John Bairn, Jeens worked for the security printers Perkins, Bacon and Co. (q.v.) for whom he made the dies for Queen Victoria's portrait on the stamps of St. Lucia, St. Vincent, Antigua, Turks Islands and possibly South Australia.
Aft.: E. Armitage, E.H. Corbould, da Vinci, F. Dicksee, Gainsborough, C. Haag, J. Linnell, Sir J.E. Millais, Romney.
Shared: H.C. Shenton (q.v.). He left unfinished the plate "Stolen by Gypsies: the Rescue" after J.B. Burgess; this was finished by L. Stocks (q.v.).

Pub.: Art Union of London; Colnaghi; Macmillan and Co.
Lit. *Art Journal* 1880.

JEFFERYS G.F. and CO. fl. London mid 19th c.
Pub.
Music / photo-eng.
This firm issued photo-engravings made by the Swan Electric Engraving Co. (q.v.).

JEFFERYS T. fl. mid (?) 19th c.
Line (?)
Topog.

JENKINS J. fl. 1844.
Line.
Lit. / relig.
Perhaps identical with J.J. Jenkins (q.v.).
Aft.: P.F. Mola, N. Poussin, Wilde.

JENKINS Joseph John 1811 (London) — 1885 (London).
Line. steel.
Gen. / illus. / lit. / port. / relig.
Jenkins, who was the son of an engraver, abandoned engraving for watercolour painting in about 1840. Possibly identical with J. Jenkins (q.v.).
Aft.: F. Mola, M.W. Sharp.

JENNENS John fl. 1860s.
Litho.
An. / illus.

JENNINGS R. fl. London 1870.
Et (?)
Also a painter.

JEWITT Llewellyn Frederick William 1816 (Kimberworth) — 1886 (Duffield).
Wood.
Illus.
Also a writer.

JEWITT Thomas Orlando Sheldon 1799 (Chesterfield) — 1869 (London).
Wood.
Antiq. / arch. / ex libris. / illus. / nat.
Jewitt attempted wood-engraving while he was still a boy, and illustrated literary works by his brother which were published by their father, Arthur

Jewitt. He moved to Oxford in 1838 and collaborated with J.H. Parker of Oxford, but later lived and worked in London. Later in his career he engraved from photographs.
Lit.: Carter H. *Orlando Jewitt* 1962. de Maré E. *The Victorian Woodblock Illustrators* 1980.

JOBBINS J.E. fl. 1841.
Print. (copperplate).
Illus.

JOHN Augustus Edwin R.A. 1878 (Tenby) — 1961.
Et., litho.
An. / fig. / myth. / port.
Best known as a painter and draughtsman, John was a pupil at the Slade School.
Pup.: C.M. Pearce (q.v.).
Lit.: Colnaghi P. and D. and Co. Ltd. *Augustus John: Early Drawings and Etchings* 1974. Dodgson C. *A Catalogue of Etchings by Augustus John: 1910-1914* 1920. *Graphischen Kunst* XXXII, p. 43. *P.C.Q.* VII, pp. 90—102; XVIII, pp. 270—87.

JOHNSON Charles Edward 1832 (Stockport) — 1913 (Richmond, Surrey).
Et.
Land.
Best known as a landscape painter, Johnson studied at the R.A. Schools. He began his working life in Edinburgh, but in 1864 moved to London.
Des. eng.: A.L. Brunet-Debaines (q.v.).

JOHNSON Ernest Borough 1867—1949.
Et., litho.
Gen.
Also a painter, Johnson was a pupil of Sir H. Herkomer (q.v.).

JOHNSON James d. Edinburgh 1811.
Line., pub.
Music.
A native of Ettrick, Johnson published songs by Robert Burns.

JOHNSON John fl. early 19th c.
Wood.
Illus.
Pupil of T. Bewick (q.v.).

JOHNSON Robert 1770—96.
Wood.
Illus.
Pupil of Thomas Bewick (q.v.).

JOHNSON Thomas fl. 1893—1900.
Wood.
Illus. / port.
Worked in Brooklyn, U.S.A. Also a watercolourist.
Aft.: J.W. Alexander, Munkacsy, Rembrandt.

JOHNSON W.S. fl. London (60 St. Martin's Lane) *c.* 1835.
Pub.
Tinsel.

JOHNSTON Graham b. (Edinburgh) 1869.
Line.
Ex libris. / illus.
Johnston worked for a time with Scott and Ferguson, Edinburgh, where he did work for the Lyon Court, to which he was later made heraldic engraver.

JOHNSTONE James M. fl. London 1890.
Et., steel.
Arch. / fig. / illus. / port.
Aft.: W. Bonner, G.M. Kemp, Sir J.E. Millais, D. Roberts.
Pup.: R. Hinschelwood (q.v.).

JOHNSTONE William fl. Edinburgh 1880s—90s.
Line.
Gen.
Aft.: C.M. Hardie, R.G. Hutchison.

JONES Dan Adolph Robert 1806—74.
Et.
Land.

JONES E. fl. 1835.
Steel.
Arch. / illus.
Aft.: R.W. Billings.

JONES Emma 1813 (London) —
1842 (London).
Et., mezzo.
Port.
The wife of Alexis Soyer,
chef-de-cuisine at the Reform Club,
Emma Jones was also a painter.
Lit.: Volart F. and J.R. Warren
Memoirs of Alexis Soyer 1859.

JONES J. fl. 1835.
Steel.
Arch. / Illus.
Aft.: H. Winkles.

JONES Owen 1809 (London) —
1874 (London).
Litho. (incl. chromolitho.)
Illus.
Jones's father died when he was a boy,
and he was sent by his guardian first to
Charterhouse, and then to a private
school. He was intended for the
church, but at the age of sixteen he
became a pupil of the architect Louis
Vulliamy, with whom he stayed for six
years, at the same time attending
the R.A. Schools. Thereafter he
travelled widely. On his return to
England in 1836 he commenced
lithographic work in the first of his
famous series of books on architecture
and ornament; this was *Plans,
Elevations, Sections and Details of the
Alhambra*, printed by Day and Haghe
(q.v.) and first published in 1842. He
was for a long period principal
designer for De La Rue and Co. (q.v.).
Aft.: W. Noel Humphreys.

JONES P. fl. 1818.
Line.
All.
Aft.: W. Blake.

JONES T. fl. 1820—46.
Aq., steel.
Illus. / port.
Aft.: W. McCall.

JONES Winifred fl. early 20th c.
Mezzo.
Gen.
Aft.: R. Herdman.
Pub.: Frost and Reed.

JORDAN E. fl. 1833.
Steel.
Fig.
Aft.: Hogarth.

JORDEN or JERDEN Henry
fl. 1829—33.
Steel.
Arch. / illus. / land.
Worked for a time in U.S.A.
Aft.: T. Allom, W.H. Bartlett, H.
Melville, J.P. Neale, T.H. Shepherd.

JOSEPH A. and S.
See under Myers and Co.

JOSEY John William b. 1866.
Line., mezzo.
An. / gen. / illus. / port.
The son of Richard Josey (q.v.), J.W.
Josey worked in Shepherd's Bush,
London.
Aft.: S. Berkeley, Sir E. Landseer.
Pub.: H. Graves.

JOSEY Richard c. 1840—1906.
Mezzo.
*An. / gen. / hist. / lit. / mil. / myth. /
port. / relig. / ship. / topog.*
The father of J.W. Josey (q.v.),
Richard worked in London and in
Penn, Bucks.
Aft.: J. Archer, C. Barber, Barzaghi,
A. Bayes, J. Burgess, P. Calderon, S.
Cockerell, Rosa Corder, J. Curington,
J.S. Cuthbert, L. Davis, L. Dickinson,
E. Douglas, S. Echena, E. Eddis, M.E.
Edwards (Mrs J.C. Staples), T. Faed,
Sir F. Grant, H. Graves, Greuze, F.
Holl, Georgina Koberwein (Mrs
Terrell), Sir E. Landseer, Lord
Leighton, P. Macquoid, Sir J.E. Millais,
F. Mills, J. Morgan, W. Ouless, S.
Pearce, Reynolds, G. Romney, A.
Sealy, M. Sucharowski, Elizabeth
Thompson (Lady Butler), S. Waller,
N. Weekes, A.H. Wardlow, G.F. Watts,
H. Weigall, J. McN. Whistler, J. Wilson.
Pub.: A. Ackermann; L. Brall and
Sons; Dickinson's; Dickinson and
Foster; Dowdeswell and Dowdeswells;
Fine Art Society; H. Graves; H.
Littaur; A. Lucas; Hugh Paton; A.
Tooth.

JOSI Christian d. Ramsgate 1828.
Aq., mixed., stip.
Gen. / port.
Josi, who was born in Utrecht, came
to England early in life and studied
and worked under J.R. Smith (q.v.).
He soon abandoned the practice of
engraving to become a restorer,
publisher and printseller. His son
Henry (1802—45), also an engraver,
became keeper of prints and drawings
at the British Museum. His *Life of
Ploos Van Amstel* contains much
autobiographical material.
Aft.: G. Morland, R. Westall; many
facsimiles of Dutch drawings.

JOUAININ Auguste Adrien 1806
(Cosne, Nièvre) — 1887.
Et., mezzo.
Gen.
French national who made at least one
plate after a work by a British artist,
which was published in England.
Aft.: C. Baxter.
Pub.: Lloyd Bros.

JOUBERT DE LA FERTÉ Jean
Ferdinand 1810 (Paris) — 1884
(Menton).
Line., mezzo., steel.
*Ex libris. / gen. / hist. / land. / myth. /
port. / relig. / stamps.*
Joubert de la Ferté was a French
national who worked in London for a
period; he studied under Henriquel
Dupont. He worked as chief engraver
for the security printers De La Rue
and Co. (q.v.), for whom he engraved
dies for stamps of Great Britain,
British Columbia and Vancouver
Island, Belgium (1865), Ceylon, Hong
Kong, India, Italy, Jamaica, Malta,
Mauritius, New South Wales and
elsewhere.
 Joubert introduced to English
postage-stamp printing the French
method of engraving *en épargne*, in
which the printing lines are left in
relief instead of in intalgio as in line-
engraving. From a die thus engraved
clichés are taken by electrolysis and
from these a plate of a given number
of stamps is assembled. The process,
invented by Joubert, is named *acierage*.
Aft.: T. Barker, E. Eddis, W.P. Frith,
H. Jeune, H. Le Jeune, Sir E.J.
Poynter, Reynolds, G. Richmond, Sir
W. Ross, R. Thorburn, T. Webster,
J. Williams, F. Winterhalter.
Pub.: Art Union of Glasgow; Fine Art
Society; Goupil; J.L. Grundy; Hering
and Remington; M.M. Holloway with
Ackermann and Co.; C. Klackner; T.
McLean; Robert Turner with Colnaghi.
Lit.: Engen R.K. *Victorian Engravings*
1975. Hunnisett B. *Steel-engraved
Book Illustration in England* 1980.

JOURDAN, BARDOT ET CIE fl.
Paris (14 Boulevard Poissonière) 1880.
French publishers who issued some
plates after works by British artists.

JOWETT Ellen fl. late 19th c.
Mezzo.
Port.
Aft.: Sir T. Lawrence, Romney.

JUKES Francis 1745 (Martley,
Worcestershire) — 1812 (London).
Aq., et.
*An. / gen. / hist. / illus. / marine. /
port. / sport. / topog.*
Also a landscape painter.
Aft.: Ansell, Belange, W.R. Bigg, T.
Boultbee, Callender, Catton, Chapman,
T. Cleveley, E. Dayes, R. Dodd, A.
Freebain, Hoppner, Capt. Knight, J. La
Porte, Sir T. Lawrence, T. Luny, R.
Paddy, N. Pocock, R. Pollard, A.
Robertson, T. Rowlandson, Sargent,
F. Sartorius, Schetky, Smirke, C.L.
Smith, J. Thee, R. Tollemache, E.
Tomkins, T. Walmsley, Capt. J. Weir,
Williams.
Shared: V. Green, J. Hassall, R. Pollard
(qq.v.).

JULLIEN — fl. London mid 19th c.
Litho., pub.
Music.

244

KAUFFMANN Angelica Catharina
Maria Anna 1741 (Coire,
Switzerland) — 1807 (Rome).
Et., stip.
Gen. / myth. / port.
Above all a painter, Miss Kauffmann's
best known engravings are executed
in stipple from subjects designed by
herself for the decoration of furniture
and ceilings.
Aft.: Correggio.

KAY John 1742 (Dalkieth) — 1826
(Edinburgh).
Et., printseller.
Port.
Also a miniaturist and caricaturist,
Kay is sometimes known as the
"Scotch Figaro" as during an unhappy
childhood, in the care of relatives, he
was apprenticed to a barber, and later
established himself in that trade. He
found he had a gift for drawing
portraits and was encouraged in this
by one of his customers, William
Nisbet of Dirleton, who later left him
a small annuity. Kay abandoned the
barber's trade for that of art in 1785.
His etchings all have an element of
caricature.
Lit.: Evans, Hilary and Mary *John
Kay of Edinburgh*, Aberdeen, 1973.

KEARNAN KEARNON or
KEARMAN Thomas fl. early 19th c.
Aq., steel.
Arch. / illus.

KEARSE Mrs See LAWRENCE
Mary.

KEATES C.F. fl. late 19th c.
Wood.
Illus.
Worked for the Kelmscott Press.
Aft.: Sir E. Burne-Jones.

KEATING George 1762 (Ireland) —
1842 (London).
Mezzo., pub., stip.
Gen. / lit. / port. / relig.
The son of Patrick Dickinson, a
bookseller, George also followed that
trade. For a time he had a shop in Air
Street, Piccadilly, London, but
afterwards went into his father's
business in Warwick Street, Golden
Square. The Keatings in 1800 acquired
the business of the Catholic bookseller,
J.P. Coghlan, which they carried on as
Keating, Coghlan and Keating in Duke
Street, Grosvenor Square. When
Patrick died in 1836 it became Keating
and Brown, Brown's widow continuing
with the partnership until 1840.
George Keating then opened a shop in
South Sreet, Manchester Square, but
it failed. Presumably his own prints
would have been sold at each of these
establishments.
Aft.: Gainsborough, Sir T. Lawrence,
H. Morland, J. Murphy, Reynolds,
G. Romney, Singleton.

KEENE Charles Samuel 1823
(Hornsey) — 1891 (London).
Et.
Fig. / gen. / land. / port. / topog.
Keene was apprenticed to the
Whympers (q.v.). He is best known as
an illustrator and humourous
draughtsman.
Lit.: *Magazine of Art* (1902-03) p. 490.
P.C.Q. XVII, pp. 23-47. Pennell, J.
Work of Charles Keene 1897.
Spielman, M.H. *Twenty-one Etchings
by Charles S. Keene* 1903.

KEITH J. fl 1840s— 50s.
Pub.

KEITH and GIBB fl. 1860s.
Print. (litho)
Illus.

KELL BROTHERS fl. 1850s.
Litho. (incl. chromolitho.), print.
Possibly connected with Washington,
Kell and Company (q.v.)

KELLY T.J. or J.T. fl 1834.
Steel.
Arch. / illus. / port.
Aft.: D.O. Hill.

KELSALL W.H. fl. 1830s—50s.
Steel.
Arch. / illus. / land.
Aft.: T. Allom, Austin, W.H. Bartlett,
G. Cattermole, Capt. R. Elliott.

KENEALY Noel Byron fl. Watford
1890s.
Line.
Gen. / port.
Aft.: A Clay, Greuze, Sir T. Lawrence,
J. Mordecai, Reynolds, G. Romney.
Pub.: C.E. Clifford; Harry C. Dickins;
H. Graves.

KENILWORTH H. fl. London (43
King Street, Snow Hill) 1822.
Pub.
Juv. dram.
Perhaps a partner in the firm of
Hodgson and Co. (q.v.)

KENNERLEY Ino fl. early 19th c.
Line.
Gen. / port.

KENNINGTON Thomas Benjamin
1856 (Grimsby) — 1916.
Et.
Gen.
Best known as a painter, Kennington
studied at Liverpool School of Art, the
Royal College of Art and in Paris.

KENSETT Thomas 1786—1829
(Hampton).
Line.
Gen.

KER Charles Henry Bellenden
c. 1785–*c.* 1871.
Et.
Land.

KERNOTT or KERNOT James
Harfield fl. 1820s—40s.
Line., steel.
Gen. / illus. / land.
Aft.: T. Allom, S. Austin, W.H.
Bartlett, Sir A.W. Callcott, A. Colin,
T. Creswick, J. Crome, Capt. Elliott,
J.D. Harding, E. Le Potterin, Marlow,
Murillo, G. Pickering, S. Prout, W.
Purser, D. Roberts, J. Ruysdael, C.
Stanfield, G.F. White.

KERR Henry Wright 1857—1936.
Et.
Fig.
Best known as a painter, this Scottish
artist studied at the Schools of the
Royal Scottish Academy, Edinburgh.
He was much influenced by Dutch
painting.

KERR-LAWSON James
b. Ansthruther 1865.
Litho.
Arch. / fig. / port.
Also a painter, Kerr-Lawson was a
pupil of Lefebvre and Boulanger
before studying in Italy.

KERRICK or KERRICH Rev. Thomas
1747—1828 (Cambridge).
Line (amateur).
Arch. / port.
Also a portrait painter.

KEULEMANS John Gerrad
fl. 1870s—1900.
Litho.
An. / illus.
Dutch national who collaborated in
the production of several English
books.

KILBURN William 1745 (Dublin) —
1818 (Wallington).
Aq.
Flor. / illus.
Worked chiefly in London.

KILBURNE George Goodwin 1839
(Norfolk) — 1924 (London).
Wood.
Sport.
Also a watercolourist. Pupil of the
Dalziels (q.v.).

KING Berkeley fl. London 1814—35.
Line., litho.
Land.

KING Jonathan fl. London (Chapel
Street, Somers Town; 56 Seymour
Street, Euston Square; Essex Street,
Islington) 1844—1913.
Printseller.
Juv. dram.
Agent for J.K. Green (q.v.).
There were three generations of the
King family who traded under this
name; one of them was a famous
collector.

KING Thomas 1781—1845.
Et., line., steel.
Antiq. / arch. / illus.
Lived and worked in Chichester.

KINGSBURY H. fl. early 19th c.
Mezzo.
Sport.
Aft.: J. Robinson.

KINNEBROOK W.A. fl. 1840s—60s.
Et.
Cost. / marine.
Aft.: M. Cotman.

KIRCHNER fl. mid 19th c.
Wood.
Illus.
Aft.: J. Gilbert.

KIRK Thomas fl. late 19th c.
Aq., stip.
Gen. / mil.
Aft: Angelica Kauffmann, E. Dayes.

KIRKUP Seymour Stockes 1788
(London) — 1880 (Leghorn).
Et.
Land. / topog.
A pupil at the R.A. Schools in 1809
Kirkup went to Italy on account of
delicate health. He received a
knighthood from King Victor
Emmanuel on the restoration of the
Kingdom of Italy. From 1872 he
settled in Leghorn. He was also a
painter.

KIRKWOOD George fl. c. 1850.
Et.
Irish by birth, Kirkwood was the son
and partner of John Kirkwood (q.v.).
His son Henry was also an engraver
and etcher.

KIRKWOOD James fl. Edinburgh
and Dublin early—mid 19th c.
KIRKWOOD John
Et., line.
Ex libris. / illus. / port. / topog.
James was the father of John and
John was the father of George
Kirkwood (q.v.). Both were pupils of
C. Heath (q.v.). Apparently the three
generations combined to form the firm
of Kirkwood and Son. Some
engravings were signed thus, some as
"J. Kirkwood" and some as
"Kirkwood".
Aft.: F.W. Burton, C. Grey, D.
Maclise.

KITTON Frederick George 1856
(Norwich) — 1904 (St. Albans).
Et., wood.
Illus.
Best known as a writer on the life and
works of Charles Dickens.

KLACKNER C. fl. New York and
London 1890s.
Print. (photo-eng.), pub.
Another C. Klackner, apparently a
different individual, but possibly
related to this one, carried on
business as a publisher and printseller
at 20 Old Bond Street, London. He

published a book entitled *Proofs and Prints, Engravings and Etchings, and How They are Made* (1886).

KNELL William Calcott fl. London 1820s—60s.
Aq.
Illus. / ship.
Best known as a marine painter.
Aft.: F.K. Hawkins.
Des.eng.: S. Miller (q.v.).

KNIGHT C. fl. 1855.
Steel.
Sculp.
Aft.: Finelli.

KNIGHT Charles 1743 (London) — c. 1826.
Et., stip.
Gen. / hist. / illus. / lit. / myth. / port.
A pupil of F. Bartolozzi (q.v.), Knight lived at Berwick Street, Soho, and later at Brompton. His daughter Maria was also an engraver. His plates were reprinted many times, were re-engraved by other engravers and have been reproduced by photogravure and lithography. Some poor copies exist signed "Bartolini".
 Not to be confused with Charles Knight (fl. 1850s—1870s, q.v.).
Aft.: Ansell, Beechey, J.H. Benwell, R. Boyne, H.W. Bunbury, Ciprinai, A. Cooper, Hamilton, T. Hardy, Hoppner, Angelica Kauffmann, Sir G. Kneller, Knight, Sir T. Lawrence, W. Locke, G. Morland, J. Northcote, Nutter, J. Opie, Rev. W. Peters, Reynolds, G. Romney, J. Russell, S. Shelley, H. Singleton, J.R. Smith,T. Stothard, R. Westall, F. Wheatley.
Shared: H. Merke (q.v.).

KNIGHT Charles fl. 1838—50.
Print.
Illus.
Knight took out a patent in 1838 for a method of colour printing similar to that of George Baxter (q.v.).

KNIGHT Charles fl. 1850s—70s.
Line.
An. / arch. / gen. / hist. / myth. / port.
Not to be confused with Charles Knight (1743—c. 1826, q.v.).
Aft.: F. Baird, E.C. Barnes, S.

Blackburn, B. Bradley, D. Cooper, E. Hopley, C.R. Leslie, S. Lucas, Elsa Melville, V. Prinsep, Reynolds.
Shared: F. Bartolozzi (q.v.).
Pub.: B. Brooks; H. Graves; Lloyd Bros; G.P. McQueen; Pilgeram and Lefèrve.

KNIGHT D. fl. 1847.
Line.
Orn.

KNIGHT E.C. fl. 1898—1915.
Litho.
Flor. / illus.

KNIGHT J. fl. 1860s.
Et., mezzo.
An. / arch. / sport. / topog.
Aft.: J.F. Herring Sr.
Pub.: Lloyd Bros.

KNIGHT John Pescott, R.A.
1803 (Stafford) — 1881 (London).
Et.
Fig. / gen.
Also a painter of genre and portraits.

KNIGHT John William Buxton
1842 (Sevenoaks) — 1908 (Dover).
Et., mezzo.
Arch. / land.
The son of William Knight the landscape painter, J.W.B. Knight worked in Chorley Wood, Herts., and in Kent. He was possibly related to Joseph Knight (q.v.).
Pub.: Dowdeswell and Dowdeswells.

KNIGHT Joseph 1837 (London) — 1909 (Bryn Glas).
Et., mezzo.
Arch. / land. / topog.
Although he lost his right arm at the age of seven in an accident, Joseph Knight took to art as a career. After visiting Holland, France and Italy to study, he worked in London 1871—75, after which he settled in North Wales. He was possibly related to J.W.B. Knight (q.v.) Also a landscape painter.

KNIGHT Dame Laura Johnson A.R.A.
1877—1971.
Aq., et., mixed.
Fig. / gen. / port. / theat.

Also a painter.
Lit.: Salaman, M.C. *Laura Johnson Knight*. Modern Masters of Etching Series, No. 29. 1932.
Studio LXXXVII p. 260.

KNIGHT T. fl. 1860s.
Line., stip.
Arch. / gen. / illus. / port.
Worked in U.S.A. for a period in 1856.
Possibly identical with T.W. Knight (q.v.).
Aft.: J.C. Armytage, T. Brooks, J. Hayter, Reynolds.
Pub.: H. Graves.

KNIGHT T.W. fl. 1840s—70s.
Line., mixed., steel.
Gen. / hist. / illus. / port. / sculp.
Possibly identical with T. Knight (q.v.).
Aft.: C.W. Cope, J. Foley, J. Hayter, J. Lucas, W.J. O'Doherty, Sir D. Wilkie.
Pub.: H. Graves.
Lit.: *Art Journal* 1850, p. 240; 1856, p. 148; 1861, p. 252; 1866, p. 364.

KNOEDLER M. AND CO. fl. New York (170 Fifth Avenue) 1870s—90s.
American based company of publishers and printsellers which published many plates after works by British artists.

KRATÉ Charles Louis 1848 (Paris) —1921.
Et.
An. / gen. / land. / marine. / sport.

French national who made a number of plates after works by British artists which were published in England.
Aft.: J. Constable, J.M.W. Turner.
Pub.: Boussod, Valadon and Co.; Harry C. Dickens; M. Knoedler.

KRAUSSE Alfred 1829 (Rössnitz) — 1894 (Leipzig).
Steel.
Illus. / land. / port.
German national who made a few plates after works by British artists.
Aft.: H. Fenn.

KRONHEIM AND CO. fl. mid to late 19th c.
Print., pub., wood.
Ephem. (e.g. Christmas cards) / gen. / illus.
This firm was a licensee of the method of G. Baxter (q.v.) in which eight to sixteen copper and zinc plates were used, each coloured individually to give gradations to flesh tints, etc. The principal of the firm was Joseph M. Kronheim.

KROSTEWITZ Fritz 1860 (Berlin) —1913.
Et.
Land.
German national who made a number of plates after works by British artists which were published in England.
Aft.: T.A. Brown, J. MacWhirter.
Pub.: J. Casper, H. Graves, A. Lucas.

LABY Alexander 1814—99.
Litho.
Music.

LA CAVE P. fl. early 19th c.
Et. (soft-ground)
Land.

LACEY Samuel fl. early 19th c.
Steel.
Illus. / land.
Aft.: T. Allom.

LACOUR Octave L. fl. Teddington
and London late 1880s — early 1890s.
Et., litho., wood.
Gen. / myth. / port.
Aft.: F. Dicksee, M. Menpes, J.M.W.
Turner, G.F. Watts.

LACEY Samuel fl. 1818—57.
Steel.
Arch. / illus. / land.
Aft.: T. Allom, W.H. Bartlett, T.M.
Baynes, Col. Cockburn, H. Gastineau,
H. Melville, W. Purser, G. Shepherd, C.
Stanfield, W. Tombleson, G.F. White.

LACY W. fl. 1830s.
Steel.
Illus.
Aft. W. Tombleson.

LADBROOKE John Berney 1803
(Norwich) — 1879 (Norwich).
Litho.
Land.
Also a painter. Pupil of J. Crome (q.v.).

LADBROOKE Robert 1768
(Norwich) — 1842 (Norwich).
Aq., litho.
Land.
Chiefly a painter, Ladbrooke was a
friend of John Crome (q.v.) with
whom he helped to found the Norwich
Society of Artists in 1803.
Pub.: J. Middleton, J. Stannard (q.v.).

LAFOSSE Adolphe (Jean Baptiste)
1810 (Paris) — 1879.
Litho.
Gen.
French national who made some prints
after works by British artists which
were published in England.
Aft.: J.F. Herring Sr.
Pub.: Gambart.

LA GUILLERMIE Frédéric Auguste.
1841 (Paris) — c. 1823.
Et.
Gen. / port.
French national who made a number
of plates after works by British artists
which were published in England.
Aft.: G. Boughton, L. Fildes,
Gainsborough, Sir J.E. Millais.
Pub.: T. Agnew; Colnaghi; H. Graves;
Lawrie and Co.; T. McLean; Charles
Sedelmeyer.

LAHEE James fl. 1810—52.
Print.
Line. / mezzo.

LAING Frank 1862 (Tayport,
Dundee) — 1907 (Tayport).
Et.
Arch. / land.
Having studied in Edinburgh for two
years, Laing became a pupil of J.P.
Laurens in Paris. He later worked for
some years in Edinburgh also in Spain.

LAING John Joseph ? 1832
(Glasgow) — 1862 (Glasgow).
Wood.
Arch. / illus.
Laing first practised in Glasgow, but
later worked in London.

LALAUZE Adolphe 1838
(Rive-de-Gier, Loire) — 1906.
Et.
Gen.
French national who made some
plates after works by British artists
which were published in England.
Aft.: F. Dicksee, H. Macallum.
Pub.: T. Agnew.

LAMBE R.C. AND SON fl. mid
19th c.
Pub.
Aq. (ship.)

LAMBERT J.F. fl. 1829—32.
Et., steel.
Arch. / illus. / topog.
Aft.: W.H. Bartlett, S. Prout, N.
Whittock.

LAMBERT Mark ? 1781
(Newcastle-on-Tyne) — 1855
(Newcastle-on-Tyne).
Wood.
Ex libris / illus. / orn.
A pupil of T. Bewick (q.v.).

LANCASTER Percy 1878
(Manchester) — 1951.
Dry., et.
Fig. / gen. / land. / topog.
Lancaster, who was also a painter,
made some forty dryprints and etchings.

LANDELLS Ebenezer 1808
(Newcastle-on-Tyne) — 1860
(Brompton).
Wood.
Ex libris. / illus.
Landells was the third son of Ebenezer

Landells, a Newcastle merchant. He
became an associate of George Dalziel
and was the teacher of Myles Birket
Foster (qq.v.). Educated at Mr Bruce's
Academy, Newcastle, he became a
pupil of T. Bewick (q.v.). At the age
of twenty-one he went to London
for a period in Clarendon Street,
Clarendon Square. He worked also for
W. Harvey (q.v.) and became a partner
of Charles Gray, another Newcastle
man. At one time he ran the fine-art
engraving department in the firm of
Branston and Vizelly.
 Landells was an original proprietor
of *Punch*, for with he made engravings;
the other founders in 1841 were
Henry Mayhew, Mark Lemon, Stirling
Coyne and Joseph Last. He worked
also for *Illustrated London News* and
founded the *Illuminated Magazine*.
Aft.: H.K. Browne, G. Cattermole,
J. Martin.
Assist.: T. Armstrong, E. Evans, J.
Greenaway (q.v.)
Lit.: de Maré, E. *The Victorian
Woodblock Illustrators* 1980.
Jackson, J. and W.A. Chatto *A Treatise
on Wood Engraving* Second ed. 1861.

LANDSEER Sir Edwin Harry R.A.
1802 (London) — 1873 (London).
Et., litho., mixed.
An. / gen. / sport.
The youngest son of J. Landseer
A.R.A. (q.v.), Edwin Landseer is best
known as a painter. He was an
accomplished artist by the age of
twelve, gained a silver palette from the
Society of Arts in 1813 and received
the Isis medal in 1814, 1815 and 1816.
He studied under B.R. Haydon and
entered the R.A. Schools in 1816. His
large fortune owed much to copyright
sales of engravings after his paintings.
Aft.: Count D'Orsay (lithos.).
Des. eng.: T. Atkinson, S. Cousins,
W. Davey, B. Gibbon, R. Graves,
J. and T. Landseer, R. Lane (lithos.),
C. Lewis, C. Mottram, W. Simmons
(qq.v.) and by many others.
Pup.: Georgina Duchess of Bedford,
Queen Victoria and Prince Albert,
J.C. Webb (qq.v.).
Shared: T. Landseer (q.v.).
Pub.: E. Gambart and Co.;
H. Graves.

Lit.: Graves A. *Catalogue of the Works of Sir Edwin Landseer* 1876.

LANDSEER F. fl. mid 19th c.
Line.
Gen.

LANDSEER Jessica 1810 (London) — 1880 (Folkestone).
Line.
An. / gen.
Aft.: Sir E. Landseer.

LANDSEER John A.R.A. 1769 (Lincoln) — 1852 (London).
Line., mixed., steel.
Flor. / gen. / illus. / land. / nat. / port. / relig. / topog.
The son of a jeweller, John Landseer was apprenticed to the engraver William Byrne (1740—1805). He set himself in opposition to the R.A. because of its exclusion of engravers, but was later elected an associate member. Yet he still complained because of their then ineligibility to full membership.
 He founded two short-lived journals *Periodical Review of the Fine Arts* and *The Probe* and wrote several books.
 In 1792 he lived at 83 Queen Anne Street East (later Foley Street), London; he later moved to No. 71. He turned to archaeology, publishing several works on the subject, though he did not abandon engraving. He was appointed engraver to William IV. Sir Edwin, Thomas Jessica (qq.v.) and Charles Landseer the subject painter were his children. He was also a painter.
Aft.: De Loutherbourg, Sir E. Landseer, J. Moore, Raphael, J.M.W. Turner.
Shared: T. Landseer (q.v.).
Pub.: Bowyer; Macklin.

LANDSEER Thomas A.R.A. 1795 (London) — 1880 (London).
Aq., et., steel., stip.
An. / caric. / gen. / lit. / myth. / port. / sport.
A son of John Landseer (q.v.), Thomas was a pupil of B.R. Haydon and studied with his brother Charles the portrait painter. Most of Thomas's plates were after works by his brother Sir Edwin (q.v.). He was the author of *The Life and Letters of William Bewick* (1871).

Aft.: Rosa Bonheur, B.R. Haydon, J.F. Herring, Sir E. Landseer, D. Maclise, Rubens.
Pup.: J.C. Webb (q.v.).
Shared: Sir E. Landseer, J. Landseer, J. Saddler, F. Stacpoole (q.v.).
Pub.: T. Agnew; Bohn; Fores; Gambart; H. Graves; Jerrard and Son; T. McLean; Pilgeram and Lefèvre; D.T. White.
Lit.: *Printseller* I, pp. 101f.

LANE Richard James A.R.A. 1800 (Hereford) — 1872 (Kensington).
Et., line., litho.
Hist. / lit. / port. / theat. (ballet).
Articled at the age of sixteen to C. Heath (q.v.), Lane afterwards, because of difficulties of earning a living as a line-engraver, switched to lithography. He was appointed lithographer to Queen Victoria and the Prince Consort, and became the director of the etching class at the South Kensington Museum. He made 1046 prints. Also a writer, he was the author of *Life at the Water-cure.*
Aft.: W. Blake, R. Buckner, F.W. Burton, A.E. Chalon, E.H. Corbould, S. Denning, Count D'Orsay, E. Eddis, B.R. Faulkner, J. Flaxman, Gainsborough, G. Hayter, J.P. Knight, Sir E. Landseer, Sir T. Lawrence, Lady Leighton, Michelangelo, Sir J.E. Millais, G. Richmond, Emma Sayer, J. Swinton, F. Talfourd, R. Thorburn, F.W. Wilkie, F. Winterhalter. And after photos by Pierre Petit, J. Watkins.
Pub.: J. Dickinson, H. Graves, J. Hogarth, J. Mitchell.
Lit.: *Magazine of Art* 1881, pp. 431—32.

LANE T. fl. London (4 Great Quebec Street New Row) *c.* 1830.
Pub.
Tinsel.

LANE Theodore 1800 (Isleworth) — 1828 (London).
Aq., line.
Gen. / hum.
Also a painter.

LANE William 1746—1819
(Hammersmith).
Stip.
Port.
Also a painter.
Aft.: R. Cosway.

LANGHAM — fl. London (Red Lion
Street, Holborn) 1828.
Pub.
Juv. dram. / tinsel.
Probably an agent or partner of
Hodgson and Co. (q.v.) as his name
appears on a few of their sheets.

LANGTON Robert fl. Manchester
1870s.
Steel., wood.
Illus.
Langton experimented with transferring
drawings to the wood block by
photography.
Aft.: W. Hull.

LAPORTE John 1761—1839.
Et. (incl. soft-ground).
Land. / trees.
Aft.: Gainsborough.
Shared: W.F. Wells.

LASCELLES Thomas W. fl. Lynwood,
Cookham Dean and London mid 1880s
— early 1890s.
Et., mezzo.
Gen. / port.
Aft.: H. Caffieri, E.J. Gregory.
Pub.: H.C. Dickins.

LAURENSON Edward Louis
b. Dublin 1868.
Et.
Topog.
Also a painter.

LAURIE Robert — See LAWRIE
Robert.

LAURIE AND WHITTLE see
WHITTLE AND LAURIE.

LAVENU L. fl. London mid 19th c.
Litho., pub.
Music. / theat. (ballet).

LAW David 1831 (Edinburgh) — 1901
(Worthing).
Et., steel.

*Arch. / gen. / hist. / illus. / land. / lit. /
topog.*
Apprenticed to the steel engraver
George Aikman (q.v.), Law also
studied at the Trustees Academy,
Edinburgh, under the painters
Alexander Christie and Elmslie Dallas.
Subsequently he worked for twenty
years at the Ordnance Survey Office,
Southampton, as an engraver of hills
on maps. He then took up watercolour
and etching and became one of the
pioneers of the revival of etching. He
etched over 45 plates.
Aft.: O. Brierly, J. Constable, Corot,
F. Dadd, Sir A. East, J. Farquharson,
K. Halswelle, C. Heffner, J.C. Hook,
C. Lawson, J. Linnell, J. MacWhirter,
Sutton Palmer, J.M.W. Turner,
E.W. Waite.
Pub.: Dowdeswell and Dowdeswells;
Fine Art Society; Frost and Reed;
A. Lucas; Mawson, Swan and Morgan.

LAWE fl. 1888.
Et.
Land.

LAWLESS Matthew James 1836
(Dublin) — 1864 (London).
Et.
Lit.
Pub.: William Tegg.

LAWRENCE Mary (Mrs. KEARSE)
fl. 1794—1830.
Et.
Flor. / illus.
Her plates "The Various Kinds of
Roses cultivated in England" were
published 1796—99, but she continued
to paint flowers until 1830.

LAWRENCE Sir Thomas P.R.A.
1769—1830.
Possibly etched one portrait of a lady,
a proof of which is in the Victoria and
Albert Museum, annotated in pencil:
"Supposed Etching by Sir Thomas
Lawrence". His own paintings were
reproduced by many engravers.

LAWRENCE and BULLEN LTD
fl. 1890s.
Pub.
Issued prints produced by the Swan
Electric Engraving Co. and J.J.
Waddington Ltd. (qq.v.).

253

LAWRIE or LAURIE or LOWRY
Robert 1755—1836 (Broxbourne).
Mezzo.
Gen. / port. / relig.

LAWRIE T. and SONS fl. Glasgow
(85 Vincent Street) 1870s—1890s.
Pub.

LAWSON Alexander 1773
(Ravenstruthers) — 1846 (Philadelphia).
Stip.
All. / an.

LAWSON Mary Caroline fl. late
19th—early 20th c. d. India 1912.
Line. (amateur).
Ex libris.

LAY E. fl. 19th c. (Brighton).
Topog.

LAYTON C. and E. fl. London
(Fleet Street) 1854.
Steel.
Illus. / land.
A firm.

LAYTON W.J. fl. London (10 Petty's
Court, Hanway Street) 1820.
Pub.
Tinsel.
Probably connected in some way with
Hodgson and Co. (q.v.) as the name
W. Layton and the initials W.L. appear
on some of their sheets.

LAZARUS E. fl. London (77
Chamber Street, Goodmansfields)
c. 1840.
Pub.
Tinsel.

LEAR Edward 1812 (Holloway) —
1888 (San Remo).
Litho.
An. / illus. / land. / topog.
Best known as a landscape painter and
as a humourous writer and illustrator.
Pub.: John Gould.
Lit.: Craddock and Barnard. *Modern
Etchings (19th and 20th Centuries)*
No. 135, London, 1977. *Print
Connoisseur* IV, p. 283.

LE BLOND Abraham fl. *c.* 1850 —
after 1868.
LE BLOND and CO.
LE BLOND and ELLIOT and CO.
Line., print., steel.
The firm was a licensee of the method
of G. Baxter (q.v.) until the patent
ended in 1854. Baxter's plates and
blocks came into its possession and
reprints were made. Such reprints are
called Le Blond Baxters. Many were
issued on mounts with gold borders
and embossed lettering, similar to
those used by Baxter. In 1888 the
plates and blocks were acquired by a
Mr. Mockler.
All the firm's work was on a small
scale. It included decorated almanacks
(of especial interest is a pastoral
almanack of 1853 made for the
perfumier, Eugene Rimmel), textile
labels, prints for the decoration of
boxes and cases, and small rural scenes
known as "Le Blond Ovals".

LE CONTE John fl. mid 19th c.
Line., steel.
Gen. / illus. / port. / relig. / sport.
Aft.: C. Lees, J. McDonald,
W. Macduff, D. Scott.

LEE James fl. mid 19th c.
Wood.
Illus.
Noted especially for his engravings of
fossils after drawings by Joseph Dinkel
for geological works by Gideon
Mantell.

LEE fl. early 19th c.
Wood.
Ephem. / illus.

LEE Sydney 1866—1949.
Aq., et., wood.
Arch. / topog.
Lit.: *International Studio* LIV, pp.
19—25.

LEE Thomas 1833—1910.
Litho.
Music.
Shared: A. Concanen, R. Mallyon
(qq.v.).
Lit.: Spellman D. and S. *Victorian
Music Covers* 1969.

LEECH John 1817 (London) —
1864 (Kensington).
Et., litho.
Hum. / illus. / port. / sport.
Leech started out in life studying
medicine at St. Bartholomew's Hospital,
but his father getting into financial
difficulties, he abandoned this to
become an illustrator. He was also a
painter and used an enlarging machine
to transfer designs, sometimes enlarged
eight times, to lithographic stones.
From these, rough prints were made
on canvas which were then coloured
with oil paints. Leech exhibited them
in 1862 as "Sketches in oil". They
were then reproduced in
chromolithography and published by
Agnew and Son. He also drew on the
wood.
 Leech's plates were sometimes
printed by J.E. Jobbins (q.v.).
Pub.: Agnew and Son; Richard Bentley.
Lit.: Chambers C.E.S. *A List of Works
Containing Illustrations by John Leech*
1892. Frith W.P. *Leech, his Life and
Work* 1891. Grolier Club *Catalogue of
an Exhibition of Works by John Leech*
1914.

LEE-HANKEY William 1869
(Chester) — 1952.
Aq., dry., et. (incl. soft ground),
mixed.
Fig. / gen. / land.
Lit.: *Bookman's Journal* 1924, p. 14.
Hardie M. *The Etched Work of W.
Lee-Hankey from 1904—20* 1921.
Studio LXXIV, p. 81.

LEFÈVRE Leon Henri formerly
PILGERAM and LEFÈVRE fl.
London (1A King Street, St. James's)
1880s.
Pub.

LEGGATT BROS.
LEGGATT Ernest E.
Pub.
Ernest E. Leggatt's premises from
1879 to 1889 were at 46 Fenchurch
Street, London. In 1890 the firm
became Leggatt Bros. with premises at
30 St. James's Street, London, where
the firm still exists.
 In the 1840s and 1850s there was a
firm Leggatt, Hayward and Leggatt,
possibly predecessors of the foregoing.

LEGROS Alphonse 1837 (Dijon)
—1911 (London).
Dry., et., litho., mixed.
*All. / ex libris. / fig. / gen. / illus. /
land. / lit. / port. / relig.*
A French etcher who was trained in
France, but who, encouraged by J.
McN. Whistler (q.v.), settled in England
in 1863. Legros became Slade Professor
of Fine Arts at University College,
London, and teacher in the engraving
class at South Kensington, to which
post he was recommended by Sir E.
Poynter (q.v.). He retained these
positions until 1892. He etched 258
plates. Legros was, with the French
artist, Fantin-Latour, a member of
Whistler's "Society of Three".
Aft.: Fragonard.
Assist.: Legros was assisted in his
etching class at the National Art
Training School by F. Goulding (q.v.).
Pup.: J.B. Clark, P.R. Craft, T.I.
Dalgliesh, H. Ganz, Sir C. Holroyd,
G.P. Jacomb-Wood, L. Pissarro,
Constance M. Pott, G.W. Rhead, Sir W.
Rothenstein, W.R. Sickert, W. Strang
(qq.v.).
Lit.: Malassis A.P. and A.W.
Thibaudeau *Catalogue Raisonné de
l'Oeuvre gravé . . . Alphonse Legros*
1877. *P.C.Q.* II, pp. 433—57. *Print
Connoisseur* V, p. 167. Salaman M.C.
Alphonse Legros Modern Masters of
Etching Series No. 9, 1926. Taranman
Gallery, London *An Exhibition of
Etchings by Alphonse Legros* 1974.

LEHMANN F.C. fl. 1890s.
Litho.
Flor. / illus.

LEIGHTON Charles Blair 1823—55.
Line.
Port.
Also a painter.

LEIGHTON Clare b. London 1819.
Wood.
Illus.

LEIGHTON Henry fl. mid 19th c.
Wood.
Illus.
Aft.: J. Leighton.

LEIGHTON BROS. fl. 1869.
Colour printers (chromolithography,
chromoxylography).
Illus. / lit. / mil.
George Cargill Leighton (1826—95),
a former apprentice of G. Baxter (q.v.),
was the principal member of this firm.
He produced colour illustrations —
tinted overprinting on black and white
woodcuts — for the *Illustrated London
News.* Some of these illustrations were
also printed and sold as separate prints,
and they included work after Sir J.E.
Millais and J.A. Sant. He also printed
plates for *The Art Journal.* Leighton
married a niece of Michael Faraday.
His brothers were Charles Blair (1823
—55), Stephen (fl. 1857), Archibald,
John (q.v.) and Henry. Henry was also
an engraver.
Lit.: *Private Library* I, No. 2.

LE KEUX Henry 1787 (London) —
1868 (Bocking, Essex).
Line., steel.
Arch. / illus. / relig. / topog.
The younger brother of John Le Keux
(q.v.) and a pupil of James Basire II
(q.v.), Henry worked among other
things on Basire's plates for the
Society of Antiquaries. He retired
from engraving in 1838 and joined a
crape manufactory at Bocking.
Aft.: Canaletto, Claude, J. Martin, S.
Prout, J.M.W. Turner.
Pup.: T. Hood (q.v.).

LE KEUX John 1783 (London) —
1846 (London).
LE KEUX John Henry 1812
(London) — 1897 (Durham).
Line., steel.
Arch. / illus. / topog.
John was the elder brother of Henry
Le Keux (q.v.). He was the son of a
pewterer of Huguenot descent to
whom he was apprenticed. When he
was seventeen he tried engraving on
copper and was transferred to James
Basire I (q.v.). His eldest son, J.H. Le
Keux was also a line engraver and had
as a pupil G. Allen (q.v.). He engraved
some plates in Ruskin's *Modern
Painters.*
Aft.: John Martin, A.W. Pugin, J.M.W.
Turner.
Pup.: G. Allen (q.v.).

LEMAN Robert 1799—1863
(Norwich).
Et.
Land.

LEMON G.H. — Probably identical
with H. Lemon (q.v.).

LEMON Henry 1823 — after 1882.
Line., steel.
Gen. / hist. / illus. / lit. / port.
Lemon, who lived and worked in
London, was probably identical with
G.H. Lemon.
Aft.: T. Absolon, Sophie Anderson, J.
Burgess, P. Delaroche, Count D'Orsay,
J. Faed, T. Faed, Sir F. Grant, R.
Hannah, S. Hart, M. Hornsley, H. Le
Jeune, C. Mercier, T. Webster.
Pub.: Art Union of Glasgow; Art
Union of London; B. Brooks; Colnaghi;
Gambart; Lloyd Bros; G.P. McQueen;
National Fine Art Gallery; A. Tooth.
Lit.: *Art Journal* 1855, p. 304; 1863,
p. 196.

LENEY William Satchwell 1769
(London) — 1831 (Longue-Point, Canada).
Aq., line., stip.
*Bank. / gen. / hist. / port. / relig. /
theat. / topog.*
Leney, who had been a pupil of P.W.
Tomkins (q.v.), emigrated to America
c. 1806, where he engraved portraits
of eminent Americans. He also
engraved banknotes, for the latter
entering into a partnership with the
banknote engraver William Rollinson.
He bought a farm up the St. Lawrence
to which he retired before 1808.
Aft.: J. Boydell, De Wilde, Downman,
Fuseli, J. Graham, Hackert, Isabey, W.
Miller, G. Morland, Rubens, R. Smirke,
R. Westall.
Pub.: Boydell.

LE PETIT A. fl. 1830s—40s.
Steel.
Illus. / land.
Aft.: T. Allom, G. Pickering.

LE PETIT William A. fl. early 19th c.
Line., steel.
Illus. / land.
Aft.: T. Allom, W.H. Bartlett, J.S.
Cotman, H. Gastineau, Henderson, G.
Pickering, S. Prout, W. Purser, W.
Tombleson.

LE RAT Paul Edmunde 1849—92.
Et.
Gen.
French national who made a number
of plates after works by British artists
which were published in England.
Aft.: A. Gow.
Pub.: Leggatt Bros.

LERPINIÈRE Daniel 1740
(London) — 1785 (Lambeth).
Line., mixed., stip.
*Gen. / land. / mil. / ship. / sport. /
topog.*
Aft.: A. Cuyp, De. Loutherbourg, R.
Paton, Robertson, J. Taylor, Vernet.
Shared: J. Fittler (q.v.).

LETHABY W.R. fl. 1890s.
Litho.

LEVILLY J.P. fl. late 18th — early
19th c.
Print. (colour), pub.
Gen.
Aft.: Boilly, H. Singleton.

LEWIN John William fl. late 19th —
early 20th c.
Et., line.
Illus. / nat.
John Lewin's brother William (d.
London *c.* 1795) engraved similar
works.

LEWIS Arthur James 1825—1901.
Et.
Land.
Also a painter, Lewis worked in
London.

LEWIS Charles George 1808
(Enfield) — 1880 (Felpham).
Et., line., mezzo., mixed., steel., stip.
*Gen. / hist. / land. / lit. / mil. / nat. /
relig. / ship. / sport. / topog.*
Son of F.C. Lewis whose pupil he was,
and brother of J.F. Lewis (qq.v.).
Retired in 1877.
Aft.: Sir W. Allan, S. Ansdell, J.T.
Barker, R. Beauvis, Rosa Bonheur,
R.P. Bonington, Byron, H. Calvert, S.
Carter, Claude, R. Cleminson, da Vinci,
H.W.B. Davis, W. Evans, A. Fraser,
W.P. Frith, Sir F. Grant, J.P. Herbert,
J.P. Knight, W.W. Laing, Sir E.
Landseer, J.F. Lewis, P. Reinagle, B.
Rivière, H. Selous, F. Tayler, J.

Troyon, O. Weber, Sir D. Wilkie.
Shared: F.P. Becker, W. Giller, F.G.
Lewis (qq.v.).
Pub.: T. Agnew; Art Union of
London; Louis Brall; Bristol Art
Union; B. Brooks; J. Garle Brown;
Gambart; H. Graves; Leggatt, Hayward
and Leggatt; G.P. McQueen; J.
McQueen; F.G. Moon; Moore,
McQueen and Co.; Pilgeram and
Lefèvre; G. Ramage and Son; Society
of Fine Arts in Scotland; R. Turner.
Lit.: *Printseller* I, no. 4, 1903.

LEWIS Frederick Christian 1779
(London) — 1856 (Enfield).
Aq., et., line., mezzo., mixed., steel.,
stip.
*An. / flor. / gen. / illus. / land. / mil. /
port. / theat. / topog.*
A pupil of J.C. Stadler (q.v.), Lewis
also studied at the R.A. Schools. He
was the father of C.G. and J.F. Lewis
(qq.v.). He was appointed engraver of
drawings to Princess Charlotte, George
IV, William IV, Queen Victoria and
Leopold, King of the Belgians. His
stipple engravings are sometimes
somewhat mechanical in effect from a
too-heavy use of the roulette.
Aft.: J. Agasse, H. Alken, Barker,
R.P. Bonington, A. Buck, A.W.
Callcott, Canaletto, A. Chalon, Claude,
F. Danby, Dawe, Count d'Orsay,
Flaxman, T. Girtin, S.J.E. Jones, F.
Kyte, Sir T. Lawrence, J.F. Lewis, J.
Martin, Michelangelo, F. Nash, W.Y.
Ottley, Parmigiano, Poussin, Raphael,
P. Reinagle, G. Richmond, S. Salviati,
J. Slater, W. Taylor, J.M.W. Turner,
J. Vanderlyn, Varley, F. Winterhalter.
Shared: H. Alken, C.G. Lewis, W.
Nicholls, J.C. Stadler, E. Weddell
(qq.v.).
Pub.: R. Ackermann.
Lit.: Gage J. *Collected
Correspondence of J.M.W. Turner*
1980. Wilder F.L. *English Sporting
Prints* 1974.

LEWIS George Robert 1782
(London) — 1871 (Hampstead).
Aq., et.
Fig.
Also a painter, Lewis was a pupil of
Fuseli (q.v.) at the R.A. Schools.

LEWIS J.C. fl. early 19th c.
Aq.

LEWIS James fl. 1813—37.
Steel.
Arch. / illus. / land.
Aft.: T. Allom, W.H. Bartlett, Prout,
C. Stanfield.

LEWIS John Frederick R.A. 1805
—76.
Et., litho.
An. / arch. / land. / sport.
Best known as a painter, Lewis was a
great traveller. But for that he might
have developed his etching and
become one of the leading exponents
of the art. He was a son of F.C. Lewis
and a brother of C.G. Lewis (qq.v.).

LEYDE O.H. Theodore 1835
(Wehlau) — 1897 (Edinburgh).
Et., line., litho.
Gen. / port.
German national who settled in
Edinburgh in 1854. He became
librarian of the Royal Scottish
Academy.
Aft.: J.C. Hook, Sir J.E. Millais.

LHUILLIER Victor Gustave 1844
(Alkirch) — 1889.
Et., line.
Gen. / land. / port.
French national who worked in
London.
Aft.: W.S. Bryne, E. Crowe, S. Lucas,
H.S. Marks, P. Morris, E. Nicol, B.
Riviere, W. Dendy Sadler.
Pub.: H.C. Dickens; Fine Art Society;
L.H. Lefèvre; Pilgeram and Lefèvre.
Lit.: *Art Journal* 1881, pp. 225f.
Portfolio 1877, pp. 117, 188f.

LIGHTFOOT Peter 1805—85
(Burton, Staffs.).
Line., steel.
Gen. / illus. / myth. / port. / relig.
Worked in London.
Aft.: A. Cooper, W.E. Frost,
Gainsborough, R. Home, A. Johnstone,
S.J.E. Jones, Sir T. Lawrence, H.
O'Neil, H.W. Pickersgill, Reynolds,
Rouillard, T. Webster, J.R. Wildman.
Pup.: T. Vernon (q.v.).
Shared: Completed a plate left
unfinished on the death of B.P.

Gibbon (q.v.): "The Boy with many
Friends" after T. Webster.
Pub.: Art Union of London; Gambart;
T. McLean.
Lit.: *Art Journal* 1852, pp. 53, 55, 57,
60. *Art Union* 1847, p. 129; 1848,
p. 50.

LINES Samuel 1778 (Allesley) —
1863 (Birmingham).
Et.
Land.
Also a painter.
Pup.: T. Garner (q.v.).

LINES Samuel Restall Jr. 1804
(Birmingham) — 1833 (Birmingham).
Et., litho.
Trees.
Also a genre painter.

LINLEY A. fl. 1853.
Steel.
Fig.
Aft.: W. Etty.

LINNELL John 1792 (Bloomsbury)
— 1882 (Redhill).
Et., line., mezzo., mixed.
*Antiq. / gen. / illus. / land. / port. /
relig.*
Known chiefly as a landscape painter,
Linnell was a pupil of B. West and J.
Varley at the Royal Academy Schools.
A friend and patron of William Blake
(q.v.) in Blake's old age, he was also
the father-in-law of Samuel Palmer
(q.v.). A controversial character,
Linnell was nevertheless an
accomplished artist. His sons, John
(1821—1906), James Thomas (1823—
1905) and William (1826—1906) were
also artists and made some lithographs.
Aft.: W. Collins, Michelangelo,
Ruysdael, J. Varley.
Des. eng.: J.C. Bentley, W. Blake, C.H.
Jeens, J. Scott (qq.v.).
Shared: W. Blake.
Lit.: Lister R. *Samuel Palmer, a
Biography* 1974 (1975). *Portfolio* III,
p. 45. Story A.T. *The Life of John
Linnell* 1892.

LINTON Henry Duff 1815—99
(Norbiton).
Wood.
Illus.

LINTON William James 1812
(London) — 1897 (New Haven,
Connecticut).
Wood.
Illus.
Of Scottish descent, Linton was
educated at Stratford and was then
apprenticed for six years to G.W.
Bonner (q.v.) He became in 1842 a
partner of J.O. Smith (q.v.), trading
as Smith and Linton, and produced
work for such publications as
Illustrated London News. The
partnership ended in 1843 with the
death of Smith. He also worked for
a time with W.H. Powis and J.
Thompson (qq.v.).
 Linton went to the U.S.A. in 1866
and devoted his remaining years to
the improvement of American
wood-engraving. Despite a large
following and much initial success his
work was impeded by the introduction
of new methods of process engraving.
He wrote several books on engraving
technique, invented the electrolytic
process known as kerography, and also
wrote poetry; and he was a political
reformer. He returned to England in
1887, but went back to the U.S.A. in
1892.
 Linton's younger brother Henry
Duff Linton (1812—99) was also an
engraver and collaborated in much of
his brother's work.
Aft.: J.W. Archer, W. Blake, H.K.
Browne, C.W. Cope, E. Corbould,
T. Creswick, G. Dodgson, E. Duncan,
J. Franklin, J.C. Horsley, R.R. McIan,
J. Martin, Sir J.E. Millais, F.R.
Pickersgill, R. Redgrave, D.G.
Rossetti, W.B. Scott, H.C. Selous, C.
Stanfield, Stonehouse, F.W. Topham,
H.J. Townsend, C.H. Weigall.
Pub.: W. Crane (q.v.).
Lit.: de Maré, E. *The Victorian
Woodblock Illustrators* 1980. Smith,
F.B. *Radical Artisan William James
Linton 1812—97* 1973.

LITTAUR H. fl. late 19th c.
Pub.

LITTLE Robert b. Greenock *c.*
1855.
Litho.
Fig. / land.

Little studied in Edinburgh, Rome and
Paris. He worked in East Grinstead.

LIVENS Horace Mann 1862—1936.
Et.
An. / land. / port. / topog.
Also a painter, Livens studied in
France and Belgium. He was much
influenced by J. McN. Whistler (q.v.).

LIVESAY W. fl. 1880s.
Et.

LIZARS Daniel fl. Edinburgh late
18th—early 19th c.
Line., print.
Pupil of Andrew Bell (1726—1809).
Pub.: W.H. Lizars (q.v.)

LIZARS William Howe 1788
(Edinburgh) — 1859 (Edinburgh).
Et., line, steel.
*An. / anatomy. / bank. / flor. / gen. /
hist. / illus. / land. / topog.*
Son of Daniel Lizars and brother of
the surgeon John Lizars, William was a
pupil of John Graham at the Trustees
Academy, Edinburgh 1802—5.
Aft.: R. Dadd, J. Howe, W.C. Sherriff,
G. Wappers, H.W. Williams.

LLEWELLYN S.H. fl. 1880s.
Et.

LLOYD Robert fl. London (40
Gibson Street, opposite the Coburg)
1828—33.
Pub.
Juv. dram.
Lloyd possibly published for D. Straker
(some of whose plates he is thought to
have acquired) and J. Dyer (qq.v.). Most
of his plates were later taken over by
Skelt's (q.v.), for whom Lloyd has
previously published play books.

LLOYD AND HENNING
fl. 1830s—50s.
LLOYD and CO.
LLOYD. B.F., and CO.
LLOYD R.
Line., steel.
Illus.
Firm of engravers which sometimes
issued plates under its own imprint
instead of under those of individual
artists.

LLOYD BROS.　fl. 1840s—60s.
Pub.

LOCKE or LOCK William　1767
—1847.
Et. (amateur)
All. /hist.
The son of William Locke (1732
—1810) the art amateur, William, who
also painted, was a pupil of Fuseli
(q.v.). He lived at Newbury until 1819,
after which he lived mainly in Paris
and Rome.
Des.eng.: C. Knight.

LOCKHART William Ewart　1847
(Dumfrieshire) — 1900 (London).
Et.
Land.
Best known as an historical, landscape
and portrait painter, Lockhart was a
pupil of R.S. Lauder at the Trustees
Academy, Edinburgh.

LONDON PHOTOGRAVURE
SYNDICATE　fl. 1890s.
Print.
Photo.eng.

LONG Amelia, Lady Farnborough
1762 (Wormley) — 1837 (Bromley
Hill).
Et.
Land.
Also a watercolourist.

LONG J. ST JOHN.　? 1797 (Ireland)
— 1834.
Line.
Relig.
Long is supposed to have been the son
of one O'Driscoll a poor basket-maker.
He was introduced to John Martin
(q.v.) by an Irish nobleman, but
Martin thought little of his work.
Although trained as an engraver, Long
did not follow the profession very
seriously, but tried painting. He
became a chiropodist, and later
claimed to be able to cure
consumption. A patient died under his
care, and he was tried for
manslaughter at the Old Bailey in 1831,
but acquitted. He himself died from
consumption.

LONG M.H.　fl. mid 19th c.
Litho.
Gen. / land.
Aft.: Birket Foster.
Pub.: G. Rowney and Co.

LONGMATE Barak, the Younger
1768 (London) — 1836 (London).
Line.
Ex libris. / port.
Son of the engraver Barak Longmate
the elder (1737—93).

LONSDALE —　fl. 1850.
Steel.
Illus.

LOUDON J.　fl. mid 19th c.
Wood.
Illus.

LOUND Thomas　1802—61
(Norwich).
Dry., et. (amateur).
Land. / marine. / topog.
Lound was a brewer. He collected
drawings and paintings of Norwich
artists.
Lit.: Christopher Drake Ltd. London
Thomas Lound 1974.

LOVE W.　fl. London (81 Bunhill
Row, nr. Finsbury Square) 1812—24.
Et., print., line.
Juv. dram.
Republished the plays of W. West
(q.v.).

LOWENSTAM Leopold　1842
(Amsterdam) — 1894.
Et.
Gen. / illus.
Dutch national who engraved some
plates after works by British artists
which were published in England. He
taught in Sweden until 1873.
Aft.; Sir L. Alma-Tadema, Rosa
Bonheur, Mrs Henry Merritt, Sir E.
Poynter.
Lit.: Engen Rodney K. *Victorian
Engravings* 1975.

LOWRY Joseph Wilson　1803
(London) — 1879 (London).
Line.
Illus. / scien.
The son of Wilson Lowry (q.v.) who

gave him his training, Joseph became engraver to the Geological Survey of Gt. Britain.

LOWRY Robert — See LAWRIE Robert.

LOWRY Wilson 1762 (Whitehaven) — 1824 (London).
Et., line., steel.
Arch. / illus. / / land. / scien. / tech.
The son of Strickland Lowry, the portrait painter, and father of Joseph Wilson Lowry (q.v.). At the age of seventeen he went to London and attended the R.A. Schools. His early plates are unsigned. He worked on plates for J. Browne, W. Byrne, J. Heath and W. Sharp. He was an inventor of several technical appliances, including an engraver's ruling machine. Lowry's portrait by John Linnell was engraved by W. Blake (qq.v.).
Aft.: W. Blake, G. Poussin, G. Robertson, S. Rosa.
Shared: W. Blake.
Pub.: Boydell.

LOXTON S. fl. late 19th c.
Et.
Arch. / topog.

LUARD John Dalbiac 1830—60 (Winterslow).
Et.
An. / gen. / port.
Best known as a painter, for which profession he abandoned a career in the army.

LUCAS Alfred fl. London mid and late 19th c.
Line.
Gen. / hist. / port. / sport.
Aft.: J. Batemam. M. Claxton, Clemison, Gros, Hornung, Nicholson, Thompson.

LUCAS Arthur fl. London (31 New Bond Street) 1880s—90s.
Pub.

LUCAS David 1802—81.
Mezzo., mixed.
Land.

Lucas, who was a pupil of S.W. Reynolds (q.v.), is known as "Constable's engraver" for his mezzotints after John Constable's works, published as *English Landscape Scenery* (1830).
Aft.: J. Constable, Gainsborough, J.D. Harding, Hoppner, E. Isabey, Jeaurat, Parker, Smirke, H. Vernet, G.F. Watts, P. Williams.
Shared: J. Constable (prpbably), W.H. Egleton (qq.v.).
Lit.: Gadney, R. *John Constable R.A. 1776—1837: A Catalogue of Drawings and Watercolours with a Selection of Mezzotints by David Lucas after Constable* . . . 1976. Shirley, A. *The Published Mezzotints of David Lucas — after John Constable R.A.* 1930. Wedmore, Sir F. *Constable: Lucas, with a Catalogue of the Prints they did between them* 1904. William Weston Gallery, London *John Constable and David Lucas English Landscape* 1979.

LUCAS Horatio Joseph 1839 (London) — 1873.
Et. (amateur)
Son of a West Indian merchant of Jewish descent, Lucas was educated at Brighton and University College, London. He studied painting with F.S. Cary.

LUCAS James Seymour fl. London, 1830s—50s.
Line., mezzo.
Gen. / hist. / lit. / relig. / ship.
Father of the painter, John Seymour Lucas, R.A.
Aft.: J. Martin, Reynolds, H. Vernet.

LUCAS John 1807 (London) — 1874 (London).
Mezzo.
Port.
Lucas was a pupil of S.W. Reynolds (q.v.) and of William Etty at the Clipstone Academy. He was the father of J.T. Lucas, W. Lucas (qq.v.) and Arthur Lucas the publisher. He was also a painter.
Aft.: Sir T. Lawrence, Reynolds, G. Sanders.
Pub.: H. Graves.

LUCAS John Templeton 1836—80 (Whitby).
Line.
Gen.
The eldest son of John Lucas and brother of W. Lucas (qq.v.) and of the publisher A. Lucas. He was also a writer of fairy tales and poetry and wrote a farce which was performed in London.
Aft.: J. Pettie.
Pub.: H. Graves.

LUCAS Richard Cockle 1800 (Salisbury) — 1883 (Chilworth).
Et.
Gen. / illus. / lit.

LUCAS William b. 1838.
Mezzo.
Port.
Second son of John Lucas, brother of J.T. Lucas (qq.v.) and of A. Lucas the publisher.
Aft.: J. Lewis.
Pub.: A. Lucas.

LUILLY — fl. 1812.
Aq.
Flor. / illus.

LUMSDEN J. AND CO. fl. Glasgow c. 1820.
Pub.
Tinsel.
Also published children's books.

LUND Niels Möller 1863 (Faaborg, Denmark) — 1916 (London).
Et., mezzo.
Land. / topog.
Also a painter, Lund who was of Danish birth, settled in England. He studied at the R.A. Schools and at the Académie Julian in Paris.

LUPTON Thomas Goff 1791 (Clerkenwell) — 1873 (London).
Mezzo. (incl. mezzo on steel).
Gen. / land. / marine. / mil. / port. / relig. / sport. / theat. / topog.
The son of a Clerkenwell goldsmith, Lupton became a pupil of G. Clint (q.v.) in 1805. In 1822 or 1823 he received the gold Isis medal of the Society of Arts for his application

of soft steel to mezzotint, the use of which is mainly due to him. He worked on the traditional copper. Lupton became an assistant of S.W. Reynolds (q.v.). The youngest engraver employed on Turner's *Liber Studiorum*, he engraved fifteen plates for the work. For thirty-six years he resided at 4, Keppel Street, Russell Square, London.
Aft.: Barraud, C. Baxter, H.W. Briggs, R.W. Buss, Claude, L. Clennell, G. Clint, A. Cooper, Cuyp, Fradelle, Gainsborough, T. Girton, J.W. Gordon, B.R. Haydon, W. Kidd, J.P. Knight, Sir T. Lawrence, G. Lindsay, T. Lonsdale, J. Martin, H. Meyer, T. Phillips, Raeburn, Ramsay, Reynolds, C. Smith, J.W. Snow, Teniers, J.M.W. Turner, A. Wivell.
Pup.: G. Allen, W.O. Burgess, S. Cousins, Elizabeth Reynolds, W. Walker (qq.v.).
Pub.: Gambart; H. Graves.
Lit.: *Art Journal* 1873, p. 208. Davenport, C. *Mezzotints* 1904. Haydon, A. *Chats on Old Prints* 1906. Rawlinson, W. *Turner's Liber Studiorum* 1873.

LYDON A.F. fl. 1860s.
Line, wood.
Flor. / illus.

LYNCH C.G. fl. 1844.
Litho.
Theat. (ballet)
Aft.: J.H. Lynth (q.v.) to whom he was probably related.
Pub.: William Spooner.

LYNCH James Henry d. London 1868.
Litho.
Mil. / port. / theat. (ballet). / topog.
Lynch was a pupil at Dublin Social School. He gained a prize for the finest lithograph awarded by the Irish Art Union in 1845. He worked in London.
Aft.: Barackeleer, A.E. Chalon, De Madrezo, J. Ferneley, J.W. Gordon, J. Harrison, M. Haynes, E. Hull, J.P. Knight, Sir T. Lawrence, G. Moira, H.W. Pickersgill, G. Richmond, C. Smith, F. Winterhalter. And after photos.

Des.eng.: C.G. Lynch (q.v.), to whom
he was probably related.
Pub.: J. Mitchell, William Spooner.
Lit.: *Apollo* V, p. 101. *Art Journal*
1868, p. 48.

LYSONS Daniel 1762—1834
(Hampstead).
Et. (amateur)
Illus.
Also a writer, typographer and
designer.

MACANDREW Ernest H. b. 1877.
Et.

MACBETH Robert Walker R.A.
1848 (Glasgow) — 1910 (London).
Et.
*Fig. / gen. / land. / myth. / port. /
sport. / topog.*
The second son of the painter Norman
Macbeth and brother of H.R. Macbeth-
Raeburn (q.v.), Robert was educated
in Edinburgh and Friedrichsdorf,
Germany, and afterwards studied in
the schools of the Royal Scottish
Academy. He also studied under Sir
H. Herkomer (q.v.) at the Schools of
the R.A. in London. Later he joined
the staff of the *Graphic* newspaper. He
started as a watercolourist but took to
etching and benefited from the fashion
for reproductive engravings which
began in 1880. Macbeth worked in
Lincolnshire and Somerset as well as in
London.
Aft.: Sir E. Burne-Jones, F. Dicksee,
J. MacWhirter, G. Mason, Sir J.E.
Millais, Sir W.Q. Orchardson, W.
Ouless, G. Pinwell, Romney, Titian,
Velasquez, F. Walker.
Pub.: T. Agnew; Colnaghi; Fine Art
Society; Stephen T. Gooden; Howell
and Co.; L.H. Lefèvre; E.E. Legatt;
T. McLean; A. Tooth.

MACBETH-RAEBURN Henry
Raeburn 1869 (Newbury) — 1947.
Aq., et., mezzo.
Gen. / land. / port. / topog.

A son of the portrait painter Norman
Macbeth and brother of R.W. Macbeth
(q.v.) this engraver added the name
Raeburn to his surname to distinguish
him from his father and brother. He
studied painting and etching in Spain
which he visited in 1889, and worked
in Edinburgh, Helensburgh and
London.
Aft.: J. Collier, D. Downing,
Gainsborough, A. Goodwin, J.
Hoppner, G. Joy, G.S. Knowles, J.
Linton, T. Lloyd, J. Macwhirter, G.
Mason, Sir J.E. Millais, Northcote,
Raeburn, Reynolds, W.D. Sadler, M.
Stone.
Pub.: C.E. Clifford; Colnaghi; Fine Art
Society; Goupil; H. Graves; Lawrence
and Bullen; L.H. Lefèvre; Leggatt
Bros.; A.J. Skrimshire.
Lit.: *Art Journal* 1888, p. 129; 1892,
p. 161. *Connoisseur* LXIII, pp. 16f.
Portfolio 1886, p. 28; 1891. p. 61; 1892.
p. 16.

McCLATCHIE A. fl. 1820s—30s.
Steel.
Arch. / illus. / land.
Aft.: G. Stephen.

McCORMICK, Arthur David 1860
(Coleraine, Ireland) -- 1943 (London).
Et.
Gen.
Studied at the Royal College of Art.
Best known as a painter and illustrator.
Aft.: J.C. Dollman.
Pub.: C.A. Millard.

MacCULLOCH George fl. Second
half of 19th c.
Chromolitho., litho., mezzo.
Illus. / port.
Aft.: Titian.
Pup.: J. Smart (q.v.).
Pub.: C.E. Clifford; Day and Son.

MACDONALD Thomas fl London
late 19th — early 20th c.
Line.
Bank. / stamps.
Engraved dies for the stamps of
Salvador from 1906 onwards, and the
1911 stamps for Greece.

McGAHEY J. fl. early (?) 19th c.
Steel.
Sport.
Nothing further seems to be known of
this artist.
Aft.: J. Armstrong.

MACGREGOR W. fl.1845.
Steel.
Fig. / heraldry / illus.
Aft.: MacCoinich, Capt. W. McKenzie.

McINNES Robert 1801—86.
Stip.
Flor.
McInnes worked in London,
Shropshire and Tunbridge Wells. He
began life in Edinburgh as a cabinet-
maker, but abandoned this for art. He
is best known as a painter.
Aft.: A. Bouvier.
Pub.: Hering and Remington.

MACKENZIE E. fl.1861.
Steel.
Illus. / port.
Aft.: D.F. Selma.

MACKENZIE Frederick 1787
(Scotland) — 1854 (London).
Aq., et.
Arch. / land. / topog.
Wrote a treatise *Etchings of
Landscape*, published in 1825.

MACKENZIE James Hamilton
1875—1926.
Et.
Arch. / topog.
Lit.: *Studio* LXXVIII p. 148.

MACKENZIE Samuel 1785
(Cromarty) — 1847.
Wood.
Illus.
Mackenzie abandoned engraving for
portrait painting after his imagination
was fired upon seeing works by
Raeburn at Edinburgh.

MACKENZIE William fl. c. 1850.
Print., pub.
Oleographs / photo-eng. / steel.
This firm had branches in London,
Dublin, Edinburgh and Glasgow.

MACKRELL James R. fl. London
mid 19th c.
Aq., line.
Sport.
Aft.: J.F. Herring Sr., T.W. Huffam,
W. Shayer, F.C. Turner.
Shared: T.W. Huffam, C. Hunt (qq.v.).
Mackrell shared work on most of his
plates.
Pub.: Ackermann and Co.; C.
Newbold.

McLACHLAN Thomas Hope
1845 (Darlington) — 1897
(Weybridge).
Et.
Land.
McLachlan was trained as a barrister,
but abandoned law for a career in
art. He was a pupil of Carolus-Duran.
Lit.: *Art Journal* 1887, p. 191.
Graphischen Kunst XXVII, p. 18.
Magazine of Art I, p. 117. *Studio* 1907,
pp. 134 f.

McLEAN Thomas M. fl. London
(26 Haymarket) 1830s—90s.
Pub.
*Aq. / litho. / theat. (ballet) / ship. /
sport.*
Eugene Cremetti took over the firm
c. 1894.

MACLISE Daniel 1806 (Cork) —
1870.
Et.
Caric. / illus. / land. / port.
Best known as a painter and
illustrator Maclise studied at Cork
Academy and came to London in
1827. He sometimes used the
pseudonym "Alfred Croquis". His own

paintings and drawings were
extensively engraved by other artists.
Lit.: Arts Council of Gt. Britain
Daniel Maclise 1806—70, 1972.
O'Driscoll W.J. *A Memoir of Daniel
Maclise* 1872.

MACLURE, MACDONALD AND CO.
fl. Glasgow 1860s—80s.
Photo-eng. litho.
Printed the first stamps issued by
Sarawak (1869) and the stamps of the
National Telephone Company
(?1889).
Lit.: Lister R. *Private Telegraph
Companies of Gt. Britain and
their Stamps* 1961.

M'NAB J. fl. 1860s—80s.
Wood.
Flor. / illus.

McQUEEN BROS.
McQUEEN J.H. George Peter and
F.C. fl. London 1890s.
Printers of steel engravings and
publishers. Issued photogravures
printed by the Swan Electric
Engraving Co. (q.v.). J.H. McQueen's
premises were at 184 Tottenham
Court Road, those of G.P. McQueen
were at 70 Berners Street. Apparently
they combined to form the firm of
McQueen Bros. about 1890. See also
Moore, McQueen and Co., who may
have been connected.

McTAGGART William, R.S.A. 1835
(Aros, Kintyre) — 1910
(Broomicknowe).
Et.
Fig. / marine.
Studied at the Trustees Acacemy,
Edinburgh, under Robert Lauder.
Lit.: Finchan, D. *William McTaggart*
1935.

MacWHIRTER John R.A. 1839
(Stateford, Edinburgh) — 1911.
Et.
Land.
After serving an apprenticeship with
an Edinburgh bookseller, MacWhirter
became a pupil of Robert Lauder at
the Trustees Academy, Edinburgh.
Best known as a painter.
Des. eng.: R. Macbeth (q.v.).

Lit.: *Art Journal* Christmas number,
1903. Spielman M.H. *The Art of
John MacWhirter* 1904.

MADDOX, or MADDOCKS T. fl.
early 19th c.
Aq.
Flor. / illus.

MADELEY George E. fl. *c.* 1840s—
50s.
Litho.
Theat. (ballet) / music.
Pub.: George and Manby.

MAGUIRE Patrick d. *c.* 1820.
Litho., wood.
Illus.

MAGUIRE Thomas Herbert 1821
(London) — 1895.
Litho.
*Gen. / hist. / lit. / port. / theat.
(ballet).*
Aft.: A.E. Chalon, W.P. Frith, C.
Leslie.
Pub.: Gambart; T. McLean; J.
Mitchell.

MAHONEY or MAHONY James
1816 (Cork) — 1879 (London).
Wood.
Illus.
Best known as a watercolourist.

MAILE George 1800—42.
Aq., line., mezzo., stip.
*An. / gen. / illus. / myth. /port. /
relig. / sport. / topog.*
Maile engraved some of the earliest
steel mezzotints to be used for book
illustrations.
Aft.: Borrel, G. Dawe, Dubufe,
Gaubaud, T. Harper, Johnson, Le
Brun, Leonardo, B. Marshall, Reinagle,
J. Taylor.
Shared: Possibly shared his plate of
"Windsor Castle" with W. Blake (q.v.).
Pub.: Ackermann.

MALCHAIR or MELCHAIR John
Baptist 1731 (Cologne) — 1817
(Oxford).
Et. (amateur).
Land.
Also a watercolourist.

MALCOLM James Peller 1767
(Philadelphia) — 1815 (London).
Et., lin.
Caric. / hist. / illus. / topog.
The son of a Philadelphia merchant,
Malcolm was educated in that city at
a Quaker school and afterwards at
Potts-Town. He came to England to
improve his art in 1788 or 1789,
studied at the R. A. Schools for two
years and was assisted by Benjamin
West and Wright of Derby. Failing as
a painter, he took to engraving in
which he was self taught. It is possible
that he returned to America, but if he
did he returned to England soon after.

MALLET Pierre d. 1898.
Et.
Land.
French national who lived in Brighton
and London and etched plates of
English landscape.
Aft.: W. Anderson, E. Parton, J. Snell

MALLYON Robert fl. 1850s.
Litho.
Music.
Shared: A. Concanen, T. Lee (qq.v.).
Lit.: Spellman D. and S.
Victorian Music Covers 1969.

MANCHON Gaston Albert 1855
(Rouen) — after 1900.
Et.
Gen.
French national who made some plates
after works by English artists.
Aft.: Lord Leighton.
Shared: C.O. Murray (q.v.).
Pub.: Boussod, Valadon and Co.;
J.S. Virtue.

MANNING William Westley 1868
(London) — 1954.
Aq., et., mixed.
Arch. / land.
Also a painter.
Lit.: Colnaghi P. and D., and Co.
The Aquatints of W. Westley Manning
1929.

MANSELL F. fl. 1830s.
Steel.
Arch. / fig. / illus.
Aft.: Sir G. Beaumont, J. Hewitt.

MANSELL J. fl. 1830s.
Steel.
Fig.
Aft.: Hogarth.

MANSELL Joseph fl. mid 19th c.
Embosser, print., pub.
Ephem. (e.g. Valentines).
Possibly a licensee of the method of
Baxter (q.v.). His prints are noted for
their exaggerated colouring.

MANSION L. fl. early 19th c.
Litho.
Costume.
Probably identical with the miniature
painter Léon Larue (1785—1834) who
under the pseudonum "L. Mansion"
wrote early in the 19th century a
book entitled *Letters upon the Art of
Miniature Painting.* It was published
in London by R. Ackermann and in
Paris by L. Janet. It has a lithographed
frontispiece.

MANSON George 1850 (Edinburgh)
— 1876 (Lympstone).
Et., wood.
Illus. / land.
In his wood-engravings Manson
worked in a style reminiscent of T.
Bewick (q.v.). He went to London in
1871 and in 1873 visited the Continent.
After returning to Edinburgh it became
apparent that he was suffering from a
severe chest ailment and he went to
the island of Sark in search of a more
clement climate, and also visited Paris
and Devonshire, but his illness
overcame him and he died young. He
was also a painter.

MARCH R. AND CO. fl. London
(18 St James's Walk, Clerkenwell).
Pub.
Juv. dram.

MARCHANT J. fl. 1846.
Steel.
Orn.

MARKS Henry Stacey R.A. 1829—
98.
Et.
Hum.
Marks studied in London under J.M.
Leigh, and in Paris under Picot. Best
known as a painter, his own paintings
were reproduced by several engravers.

MARKS J.L. fl. London 1822—39.
Pub.
Juv. dram.
Marks's premises were at various
London addresses: 17 Artillery Street,
Bishopsgate; 23 Russell Court, Drury
Lane; 91 Long Lane, Smithfield; 6
Worship Street, Finsbury Square.

MARKS R.M. fl. 1840s.
Print.

MARKS S. AND SONS fl. London
(Houndsditch) *c.* 1880.
Pub.
Juv. dram.
Successors of Bishop and Co. (q.v.).
Their stock was probably later
acquired by H.G. Clarke (q.g.).

MARLOW William 1740
(Southwark) — 1813 (Twickenham).
Et.
Land.
Primarily a painter, Marlow was an
apprentice, and later an assistant of
Samuel Scott.
Lit.: *Burlington Magazine* CXXII,
pp. 547—53.

MARPLES George 1869—1939.
Et.
An. / gen. / land. / sport.
Marples, who received his training at
the Royal College of Art, became a
teacher and was principal of the
schools of art at Huddersfield, Hull
and Liverpool.

NARR Charles W. fl. 1820s—30s.
Et., line., steel.
Gen.
German national who etched at least
two plates after works by British
painters.
Aft.: I. Taylor, Sir D. Wilkie.

MARRIOTT Frederick 1860 (Stoke-
on-Trent) — 1941.
Aq., et., mezzo.
Land. / topog.
Also a painter. Marriott studied
engraving at South Kensington.
Pub.: M. Ward.

MARSDEN Algernon Moses fl.
London (27 Sinclair Road, West
Kensington) 1880s.
Printseller.

MARSH — fl. Bath 1813—15.
Litho.

MARSHALL Herbert Menzies 1841
(Leeds) — 1913.
Et.
Topog.
Best known as a landscape painter,
Marshall became professor of painting
at Queen's College. London.
Lit.: *Studio* 1913, pp. 222f.; Special
number 1909.

MARSHALL J.R. fl. mid 19th c.
Wood.
Illus.
Signed blocks: J.R.M.
Aft.: G. Cruikshank.

MARTIN Alfred 1814—72.
Mezzo.
Hist. / relig.
The son of John Martin (q.v.), Alfred
became an engineer and later Chief
Superintendent of Income Tax in
Ireland.
Aft.: John Martin.
Lit.: Balston, T. *John Martin 1789—
1854. His Life and Works* 1947.

MARTIN Elias A.R.A. ?1740
(Sweden) — 1811 (Stockholm).
Chalk., stip.
Gen. / hist. / topog.
Swedish by birth, Martin came to
England *c.* 1766 and returned to
Sweden in 1780. His brother John
Frederick Martin (1745—1808) came
with him to England and produced
red-chalk engravings after Deprez,
Skioldebrand and others. Elias was
also a painter.
Lit.: Arts Council *Elias Martin* 1963.

MARTIN F. fl. early 19th c.
Et.
Land. / trees.
Martin became landscape painter and
etcher to the Princess Charlotte and
the Prince of Saxe-Coburg.

MARTIN Fredrik Erik 1776
(London) — 1854 (Stockholm).
Line.
Arch. / hum. / port.
Aft.: Hilleström.

MARTIN Henri b. 1809 (Beaumont)
— after 1890.
Et.
Gen. / land.
French national who made a number
of plates after works by British artists
which were published in England.
Aft.: G. Barker, D. Murray, W.T.
Richards, T. Webster.
Pub.: Boussod, Valadon and Co.; C.
Klackner; M. Knoedler; A. Tooth.

MARTIN John 1789 (Heydon
Bridge) — 1854 (Douglas, Isle of Man).
Et., mezzo., steel.
Bot. / illus. / myth. / relig. / topog.
The son of Fenwick Martin a fencing
master, John was apprenticed at
fourteen to a Newcastle coach painter,
but ran away and was placed with
Boniface Musso, an Italian china
painter, with whom he came to
London in 1806. He became noted for
his spectacular biblical paintings, many
of which were engraved by himself and
by others. He was appointed historical
painter to Princess Charlotte and
Prince Leopold, 1817. Alfred Martin
(q.v.) was his son.
Des. eng.: F.W. Branston, W.B. Cooke,
E. Goodall, F.C. Lewis T. Lupton,
A. Martin, C. Mottram, C. Wands
(qq.v.).
Pub.: S. Prowett.
Lit.: Balston T. *John Martin 1789—
1854 His Life and Works* 1947.
Feaver W. *The Art of John Martin*
1975. Johnstone C. *John Martin:
Master of the Mezzotint 1789—1854*
1974. *The Library* XIV, pp. 383—482.

MARTIN John b. c. 1795.
Aq.
Land.
Also a painter.

MARTIN H. fl. London (Leigh
Street, Red Lion Square) 1822.
Pub.
Tinsel.

MARTIN Miss fl. late 19th c.
Stip.
Myth.

MARTIN R. fl. London (124 High
Holborn) 1833.
Litho., steel.
Maps / topog.

MARTINDALE P.H. 1869—1943.
Mezzo.
Gen. / marine / port. / topog.
Martindale, a pupil of J.B. Pratt
(q.v.) lived and worked in
Woodchester, Gloucestershire.
Aft.: Bellit, J. Collier, Gainsborough,
Greuze, Hoppner, Sir T. Lawrence,
J. Opie, Romney, D.G. Rossetti,
Russell, G. Sheffield, J. Wright.
Pub.: Fine Art Society; H. Graves;
Grindley and Palmer; J.F.E. Grundy;
E. Haynes; C. Klackner; C.
Klindworth; F.M. Pettitt.

MARTYN Ethel King fl. mid
1880s—1920s.
Et.
Myth.

MARTYN John d. Dublin 1828.
Line.
Illus.

MASETTI F. fl. early (?) 19th c.
Line.
All. / myth.
Probably an Italian working in
England.
Aft.: Cipriani, W. Hamilton.

MASON Abraham John b. London
1794.
Wood.
Illus.
A pupil of A.R. Branston (q.v.). Went
to New York 1829.
Aft.: G. Cruikshank.

MASON Frank H. 1876—1965.
Et.
Marine / ship.
Also a painter and illustrator.

MASSARD Léopold b. Paris 1868.
Line., mixed.
Port.

French national who engraved a
number of plates after works by
British artists which were published
in England.
Aft.: G. Hicks.
Pub.: A. Lucas.

MASSÉ Pierre Augustin fl. 1880—
mid 1890s.
Et., line.
Gen. / topog.
French engraver who worked in
London 1880—90.
Aft.: S. Lucas, F. Morgan, Sir W.Q.
Orchardson, W.D. Sadler, C.W. Wyllie.
Pub.: C.E. Clifford; Fine Art Society;
L.H. Lefèvre; I.P. Mendoza; A. Tooth.

MASSEY Henry Gibbs 1860—1934.
Et.

MASTERS H. fl. London (Leigh
Street, Red Lion Square) 1822.
Pub.
Juv. dram.

MASTERS M.T. fl. 1860s—80s.
Wood.
Flor. / illus.

MATHEWS A. HOW 1856—1940.
Pub.
Juv. dram.
This publisher sold mainly reprints or
reissues of the sheets of earlier
publishers. He worked at Churchfield
Road, Acton.

MATHEY-DORET Emile Armand
1854 (Besançon) — c. 1905.
Et.
Gen. / port.
French national of Swiss parentage
who etched several plates after works
by British artists which were published
in England.
Aft.: Gainsborough, T. Hughes,
Eleanor E. Manley, Van Dyck.
Pub.: Colnaghi; Dowdeswell and
Dowdeswells; H. Graves; C. Klackner.

MATTHEWS C. fl. 1830s—40s.
Steel.
Flor. / illus. / land.

MAUD Miss Alice C. b. 1879.
Et.

MAUNDER S. fl. London 1822.
Print., pub.
Juv. dram.
A partner in the firm of Hodgson and
Co. (q.v.).

MAWDESLEY AND COMPANY
fl. Liverpool (2 Castle Street) 1850s.
Litho., print. (security).
Stamps (telegraph).
Lit.: Lister R. *Private Telegraph
Companies of Gt. Britain and their
Stamps* 1961.

MAWSON, SWAN AND MORGAN —
See under MORGAN AND SWAN

MAY William Holmes 1839—1920.
Et., mezzo. (amateur).
Land.
May is noted for his studies of
landscape in Derbyshire, Huntingdon-
shire and of the Thames. He also
made a plate of Calcutta.
Pub.: E. Parsons.
Lit.: Wedmore F. *Etching in England* 1895.

MEADOWS Robert Mitchell d. 1812.
Stip.
Gen. / illus. / lit. / myth. / theat.
Meadows was a pupil of J. Strutt
(q.v.). He published three lectures on
engraving in 1811.
Aft.: H. Bunbury, W. Hamilton, Sir T.
Lawrence, G. Morland, R.M. Paye,
Singleton, J.R. Smith, T. Stothard,
Thomson, R. Westall.
Pup.: R. Woodman (q.v.).

MEASOM W. fl. mid 19th c.
Wood.
Illus.
Aft.: H. Anelay, S. Palmer.

MEDLAND Thomas 1755—1833
(Hertford).
Aq., line.
*Antiq. / hist. / illus. / land. / lit. /
ship. / sport. / topog.*
Medland, who was also a water-
colourist, was in 1808 appointed an
art teacher at East India College,
Hertford (Haileybury). He lived in
London for much of his life.
Aft.: W. Alexander, R. Cleveley,
Farington, Hodges, T. Stothard, B. West.
Shared: W. Byrne (q.v.).

MEESON H. fl. 1840s.
Pub.

MELLING Henry fl. London
1829—53.
Et.
Gen.
Also a painter.

MELVILLE Henry fl. 1820s—
70s.
Line., steel.
Illus.
Pub.: Art Union of London.

MENDOZA I.P. fl. London (13 Old
Bond Street) 1880s—90s.
MENDOZA GALLERIES.
Print., pub.

MENPES Mortimer L. 1860
(Australia) — 1938 (Pangbourne).
Dry., et.
Gen. / port. / topog.
Born in Australia, Menpes settled in
England, where he made a reputation
as a painter and etcher. He was a pupil
of J. McN. Whistler (q.v.) whose style
he imitated.
Aft.: F. Hals, Rembrandt.
Pub.: Boussod, Valadon and Co.
Lit.: *Art Journal* 1881, p. 352.
Connoisseur XXXIX, p. 389.
Wedmore F. *Etching in England* 1901.

MERIGOT J. fl. London 1814.
Aq., line.
Cost. / illus. / topog.
Aft.: Berlanger, Chatelet.

MERKE Henri b. Zurich *c.* 1760.
Aq.
Flor. / marine / sport. / topog.
Merke worked in London between
1800 and 1820.
Aft.: S. Atkins, S. Howitt, E. Orme,
Reinagle.
Shared: C. Knight, T. Sutherland
(qq.v.).

MERRITT Anna Lea (Mrs Henry
Merritt) 1844 (Philadelphia) — 1930.
Et.
Port. / theat.
Of American birth, Mrs Merritt was
the wife of the English picture restorer
Henry Merritt, who collaborated with

G. Richmond (q.v.) on the restoration
of some important works of art. She
was also a painter, her most famous
work being "Love locked out",
purchased by the Chantrey Bequest.
Aft.: G. Richmond.
Shared: L. Lowenstam (q.v.) and
others.
Lit.: *American Art Annual* XX, p.
616. *American Art Review* I, pp.
229 f.

METCALFE R. fl. 1819.
Et.
Arch. / land.

METZ Conrad Martin 1755 (Bonn)
— 1827 (Rome).
Aq., stip.
Gen. / port. / relig.
A pupil of F. Bartolozzi (q.v.), Metz
lived in London from *c.* 1808.
Aft.: Holbein, Michelangelo.

METZMACHER Pierre Guillaume
b. 1815 (Paris).
Et., line., steel.
Gen.
French national who made a number
of plates after works by British artists
which were published in England.
Also a miniature painter.
Aft.: T.S. Gullick.
Pub.: H. Graves.

METZEROD G. fl. mid (?) 19th c.
Line (?).

MEYER Adolphe Campbell 1866
(Liverpool) — 1919.
Mezzo.
Land.
Also a landscape painter, Meyer lived
and worked in Conway, North Wales.
Pub.: Frost and Reed.
Lit.: *Studio* Summer no. 1902.

MEYER Henry Hoppner 1783
(London) — 1847 (London).
Aq., mezzo., mixed, steel, stip.
*Gen. / illus. / myth. / port. / relig. /
sport. / theat.*
Meyer was a pupil of F. Bartolozzi
and B. Smith (qq.v.), and was a
nephew of Hoppner. He was also a
noted painter.
Aft.: E. Bird, H.P. Briggs, A.E. Chalon,

G. Clint, W. Derby, A.W. Devis, S. Drummond, Eldridge, G.H. Harlow, Heaphy, W. Hilton, J. Holmes H. Hone, Hoppner, J. Jackson, W. Kidd, Sir T. Lawrence, C.R. Leslie, J. Northcote, J. Opie, W. Owen, Reynolds, A. Robertson, G. Romney P. Simpson, Stroehling, G. Stuart, H. Thomson, H. Tilson, H. Villiers, Volkoff, W. Ward, R. Westall, Sir D. Wilkie, W. F. Witherington, J.P. Zahn. Pup.: W.T. Fry, A.W. Graham, H.B. Hall, H.G. Hine, T. Wright (qq.v.). Pub.: H. Graves. Lit.: Meyer F.L. *English Sporting Prints* 1974.

MICHEL Jean Baptiste *c.* 1748 (Paris) — 1804 (London). Line., stip. *All. / gen. / myth.* Aft.: Caracci Hamilton, Peters, Rubens, Teniers.

MIDDIMAN Samuel 1750—1831 (London). Et., line, steel. *Gen. / illus. / land. / lit. / topog.* Pupil of W. Byrne the engraver (1740—1805) and father-in-law of T.J. Pye (q.v.). Aft.: Barret, N. Berchem, Cipriani, Farington, Gainsborough, Hearne, Smirke. Pub.: Boydell.

MIDDLETON Charles d. *c.* 1818. Line. *Arch. / garden design / orn,* Also an architect and writer, Middleton was appointed architect to George III.

MIDDLETON John 1828 (Norwich) — 1856 (Norwich). Et. *Land.* Best known as a watercolourist, Middleton was a pupil of R. Ladbrooke and J. Stannard (qq.v.).

MIGNON Abel Justin 1861 (Bordeaux) — *c.* 1910. Et. *All.* French national who made one plate after a work by an English artist, Sir E. Burne-Jones, which was published by A. Tooth.

MILLAIS Sir John Everett R.A. 1829 (Southampton) — 1896 (London). Et. *Gen. / illus. / lit. / relig.* Celebrated Victorian painter who made occasional etchings, and whose own paintings were widely distributed through engravings. An original member of the Preraphaelite Brotherhood. Des. eng.: T.L. Atkinson, T.O. Barlow, W. Simmons (qq.v.) and many others. Pub.: Art Union of London; William Tegg. Lit.: Baldry A.L. *Sir J.E. Millais* 1899. Millais J.G. *Life and Letters of J. Millais* 1899. Reid J.E. *Sir J.E. Millais* 1909. Victoria and Albert Museum *Catalogue of Prints and Wood Engravings after Sir John E. Millais* 1908.

MILLER Fred fl. London 1886—1915. Et., mezzo., mixed., photo-eng. *Gen. / land. / lit. / port. / topog.* Aft.: Fragonard, W.H. Margetson, H. Ryland, J.H. Snell, Watteau, W. Wontner. Pub.: T. Cowper; J.V. Davis; Harry C. Dickins; Frost and Reed; H. Graves; D. Knowles; F.C. McQueen; T. McQueen; Eleanor Manley; E. Roberts. Lit.: *Art Journal* 1899, p. 321; 1903, p. 225; 1908, p. 129.

MILLER J. fl. 1833. Steel. *Illus. /land.* Aft.: W. Daniell.

MILLER John Douglas 1860 (Hadley) — 1903. Mezzo. *All. / fig. / gen. / lit. / port.* Aft.: Bouguereau, F. Dicksee, L. Fildes, Greuze, W. Holman Hunt, Lord Leighton, G. Mason, Reynolds, G. Richmond, W.B. Richmond, G.L. Seymour. Pub.: Colnaghi; Fine Art Society; A. Tooth. Lit.: Davenport C. *Mezzotints* 1904.

MILLER R.　fl. 1820s.
Litho.
Flor. / illus.

MILLER S.　fl. 1850s.
Line.
Hist.
Aft.: W. Knell (q.v.).

MILLER William　1796 (Edinburgh)
— 1882 (Sheffield).
Et., line., steel.
*Gen. / hist. / illus. / land. / port. /
ship. / topog.*
Born into a Quaker family, Miller was
educated first at a Leeds boarding
school and then privately. He was
apprenticed in 1811 to William
Archibald an engraver, and in 1819
went to London where he became a
pupil of George Cooke (q.v.). He
returned to Edinburgh in 1821.
Aft.: S. Austin, S. Bough, F. Danby,
J. Faed, H. Birket Foster,
Gainsborough, G. Harvey, W. Havall,
D.O. Hill, W. Howison, R.S. Lauder,
H. McCullogh, S. Prout, Redgrave,
W.C. Stanfield, Rev. J. Thomson,
J.M.W. Turner, H.W. Williams.
Assist.: R.C. Bell (q.v.).
Pub.: R. Ackermann; Art Union of
London; H. Graves; Royal Association
for the Promotion of the Fine Arts;
D.T. White.
Lit.: *Art Journal* 1852, 1853, 1857-
59, 1861-64, 1866. *Art Union* 1847,
p. 239. Gage J. (ed.) *Collected
Correspondence of J.M.W. Turner*
1980. Hayden A. *Chats on Old Prints*
1906. Miller W.F. *Catalogue of the
Engravings of William Miller 1818-71*,
1886.

MILLER William G.　fl. London
1885—1905.
Et.
Gen.
Also a noted painter.

MILLS Afred　?1776—1833
(Walworth).
Wood.
Illus. (especially of children's books).

MILLS G.　fl. 1830s.
Steel.
Illus. / land.
Aft.: W.H. Bartlett.

MILLS John　fl. 1801—37.
Line, steel.
Gen. / hist. / port.
Also a painter.

MILNER Elizabeth Eleanor　1860
(Stockton-on-Tees) — 1903.
Mezzo.
Gen. / nat. / port.
Milner studied at Lambeth School of
Art, St John's Wood School and the
R.A. Schools, and was for a time a
pupil of Sir H. Herkomer (q.v.).
She worked in London and in Bushey,
Herts.
Aft.: Fragonard, Sir F. Grant,
Hoppner, Sir E. Landseer, Lely,
Raeburn, Reynolds, Romney, J.R.
Smith, W. Ward.
Pub.: Alfred Bell; C.E. Clifford; Fine
Art Society; L.H. Lefèvre, A. Lucas.

MILNES William H.　1865—1957.
Et.

MILTON Thomas　1743—1827
(Bristol).
Aq., line.
Illus. / land. / relig. / topog.
Probably a pupil of W. Woollet
(1735—85), Milton worked in London
and for some years from 1783 in
Dublin. He was the son of the marine
painter, John Milton (fl. 1770), and his
grandfather was a brother of John
Milton the poet.
Aft.: Ashford, Barralet, De
Loutherbourg, F. Wheatley.
Pub.: Boydell; Kearsley; Ottley;
Steevens.

MINASI G. and Henry　fl. London
c. 1795—1820.
Stip.
All. / gen. / myth. / port.
Aft.: A. Aglio, F. Bartolozzi, Cipriani,
R. Cosway, Delairess, Huet Villiers.
Pub.: Marino Bovi.

MINASI James Anthony 1776–
1865.
Litho., stip.
Gen. / hist. / port.
Aft.: L.A. Byam, R. Cosway, Holbein.
Lit.: Tuer A.W. *Bartolozzi and his
Works* 1881.

MINTERN BROS. fl. 1870s–80s.
Print. (litho).

MITAN James 1776 (London) –
1822 (London).
MITAN Samuel 1788–1843.
Aq., line, steel.
*Illus. / lit. / masonic / mil. / nat. /
ship. / theat. / topog.*
James Mitan was apprenticed in 1790
to Vincent, a writing engraver, and
received instruction in drawing from
J.S. Agar and T. Cheesman (qq.v.).
His brother and pupil Samuel Mitan,
was also an engraver and worked in
James's style; his work includes
topographical plates.
Not many of James's plates bear his
name since much of his work was done
for other engravers.
Pup.: W. and E.F. Finden (qq.v.).
Shared: J.C. Stadler, C. Turner (qq.v.).
A plate after C.R. Leslie left
incomplete on Mitan's death was
finished by one of the Englehearts.
Pub.: Ackermann.

MITCHELL Edward and T.B.
fl. Edinburgh *c.* 1805–16.
Line., stip.
Gen. / myth. / port. /theat. /topog.
Aft.: Raeburn, Singleton, J. Summers,
Teniers (T.B. Mitchell), Van Dyck.
Pup.: J. Smillie, W. Walker (q.v.).

MITCHELL James 1791–1852
(Bromley).
Line., steel.
Gen. / hist. / illus. / port. / sport.
Father of R. Mitchell (q.v.).
Aft.: H.P. Briggs, A. Cooper, Sir C.L.
Eastlake, A. Fraser, W. Kidd, Sir E.
Landseer, J. Northcote, R. Smirke,
C. Stanfield, Sir D. Wilkie, J.W.
Wright.
Pub.: H. Graves.

MITCHELL John fl. London (33
Old Bond Street) 1836–54.
Pub.
Litho. (ballet).

MITCHELL John 1791–1852.
Line.
Gen. / hist.
Lived and worked in Edinburgh.
Aft.: Sir D. Wilkie.

MITCHELL Peter M. b. 1879.
Et.

MITCHELL Robert 1820–73
(Bromley).
Et., line., mezzo.
An. / gen. /relig.
Son of James Mitchell (q.v.).
Aft.: R. Ansdell, A.D. Cooper, Sir E.
Landseer, R.S. Lauder, A. Rankley,
J. Scott.
Shared: Etched a number of plates
completed by other artist in
mezzotint, including one by S. Cousins
(q.v.) entitled "Prayer, children of the
Duke of Argyle" after J. Sant.
Pub.: Owen Bailey; Gambart; H.
Graves; A. Lucas.

MITFORD Bertram Osbaldeston
1777–1842.
Litho.
An. / illus.

MITTAG C. fl. *c.* 1841.
Litho.
Theat. (ballet).
Aft.: Bürde.
Pub.: Gambart and Co.

MOCKLER – fl. late 19th c.
Print.
Acquired Baxter's plates and blocks
from Le Blond (q.v.) in 1888. In 1893
made the first list of Baxter's work.

MOFFAT J. fl. 1800–35.
Steel.
Ex libris / port.
Probably lived in Edinburgh.
Lit.: *P.C.Q.* XVI, p. 268.

MOGLIA G. fl. *c.* 1900.
Phot-eng.
Gen.
Aft.: Thomas Blinks.
Pub.: C. Klackner.

MOHN Ernest Fürchtegott 1835
(Picchen, nr Dresden) — 1912
(Leipzig).
Gen.
German national who lived for a time
at Greenwich and made a number of
plates after works by British artists
which were published in England. He
was a pupil of L. Gruner (q.v.).
Aft.: E. Downard.
Pub.: A. Lucas.

MOLLE C. fl. *c.* 1831.
Litho.
Ship.
Shared: V. Adam (q.v.) and the
French lithographer, F.A. Saint-
Aulaire.

MOLLISON James fl. 1830s—40s.
Steel.
Fig. / illus. / port.
Aft.: Hogarth, Largilhiere, Redgrave.

MONGIN Augustin 1843 (Paris) —
1911.
Et.
Gen. / hist. / illus. / relig.
French national who made a number
of plates after works by British artists
which were published in England.
Aft.: Sir L. Alma-Tadema, H.
Glindoni, A. Gow, E.B. Leighton, Sir
J.E. Millais, W.D. Sadler, P. Tarrant.
Pub.: British and Foreign Artists'
Association; E.E. Leggatt; I.P.
Mendoza; A. Tooth.
Lit.: *Portfolio* 1876, pp. 82f; 1877,
pp. 96f.

MONK William 1863 (Chester) —
1937.
Et.
Topog.
Lit.: *P.C.Q.* XXIV pp. 308—17. *Studio*
LXIV p. 247.

MOON Sir Francis Graham 1796—
1871.
Print., pub.
An extraordinarily successful dealer

who retired in 1853 and died in 1872
and left the then enormous fortune of
£160,000. He operated in the 1840s
and 1850s at 20 Threadneedle Street,
London.
Lit.: Gage J. (ed.) *Collected
Correspondence of J.M.W. Turner*
1980.

MOON, BOYS and GRAVES
fl. 1832.
Pub.

MOORE Anthony John 1852—
1915.
Et.

MOORE C. fl. early 19th c.
Aq.
Arch. / illus.

MOORE Frank b. 1876.
Et.

MOORE Henry R.A. 1831 (York) —
1895 (Margate).
Et.
Illus. / land. / lit.
Best known as a marine painter and
watercolourist. Brother of the figure
painter Albert Moore.
Lit.: McLean F. *Henry Moore* 1905.
Portfolio 1887, p. 126; 1890 pp.
88, 110.

MOORE R.H. fl. 1880s.
Et.
Sport.

MOORE Thomas Sturge 1870—1944.
Wood.
All. / ex libris / illus.
Lit.: Easton M. *T. Sturge Moore
(1870—1944)* 1970. Furst H.E.A.
*Modern Woodcutters: Frank
Brangwyn R.A., Thomas Sturge
Moore, Gwendolen Raverat, Edward
Wadsworth* 1920. *P.C.Q.* XVIII pp.
203—19.

MOORE McQUEEN and COMPANY
fl. 1860s.
Pub.
See McQueen Bros. with whom there
might have been a connexion.

MORAN John d. Dalhey 1901.
Et.
Land. / topog.

MORGAN — fl. Bath 1813—15.
Litho.
Probably an amateur.

MORGAN Alfred K. 1868—1928.
Et.

MORGAN Henry fl. 1850s—70s.
Mixed, steel.
Gen. / illus. / land.
Best known as a landscape painter,
Morgan worked in Cork. Lithographic
reproductions of his paintings were
sometimes published.
Aft.: W.B. Scott, J.K. Thomson.
Pub.: A. Lucas.

MORGAN R. fl. 1898—1915.
Litho.
Flor. / illus.

MORGAN W. fl. London (25
Bartlett's Buildings, Holborn) 1838.
Pub.
Morgan issued a series of "Morgan's
Improved Protean Scenery", similar to
the "Protean views" of E. Orme (q.v.).
He also issued "Morgan's Changeable
Portraits" in which a portrait of one
person changes into another when held
up to the light, for instance No 1 in
the series, a portrait of the Duke of
Wellington, changes into one of
Napoleon Bonaparte.

MORGAN AND SWAN
MORGAN, SWAN AND MORGAN
fl. Newcastle-on-Tyne (24, 30, 32
Grey Street) late 19th c.
Issued photo-engravings made by
Berlin Photographic Co. and the Swan
Electric Engraving C . The firm later
abandoned publishing and, as Morgan
and Brown, became a department
store, which still exists.

MORIN Edmond 1824 (Le Havre) —
1882 (Sceaux).
Line., litho.
Topog.
French national who made at least one
print after a work by a British artist.
Aft.: W. Simpson.

MORING Thomas fl. second half of
19th c.
Line, wood.
Ex libris.
Some of Moring's designs are by Harry
Soame, himself not an engraver. He
was also the author of *Fifty Book-
plates on Copper* and *One hundred
Book-plates engraved on Wood.* (both
1900).

MORISON Douglas 1814
(Tottenham) — 1847 (Datchet).
Litho.
Arch. / hist. / topog.
Son of Dr. Richard Morison of
Datchet. Mainly a watercolourist, he
studied under Frederick Tayler.

MORLEY Henry 1869—1937.
Et.
Land.

MORRIS M. — Probably identical
with Mrs T. Wilson Morris (q.v.).

MORRIS, Mrs T. Wilson fl. London
1880.
Et.
Gen. / land. /marine.
Probably identical with M. Morris who
etched some plates after H. Stacy
Marks, V. Cole and O. Weber.
Aft.: V. Cole, A.J. Meadows.

MORRIS William 1834
(Walthamstow) — 1896
(Hammersmith).
Wood.
Illus.
The great Victorian craftsman,
designer and decorator. He made a few
wood-engravings.
Aft.: Sir E. Burne-Jones.
Lit.: Morris W. *The Story of Cupid
and Psyche* 1974. (The introduction,
by A.R. Dufty, deals among other
things with the wood-engravings by
Morris after Burne-Jones).

MORRISH C. fl. London (12 Rose
and Crown Court, Bloomfield Street,
Bishopsgate) *c.* 1840.
Pub.
Tinsel.

MORRISON James fl. 1830s—40s.
Steel.
Illus. / port.
Aft.: Allingham.

MORRISON W. fl. *c.* 1829—40.
Line.
Gen. / hist.
Aft.: A. Chisholm, Goode.

MORTON Edward fl. London
c. 1837—45.
Litho.
Theat. (ballet).
Aft.: A.E. Chalon, T.M. Joy.
Pub.: J. Mitchell.

MORTON Henry fl. London
1807- -25.
Aq. line.
Flor. / gen. / illus. / land.

MOSER AND HARRIS fl. 1816—21.
Print.
One of the earliest lithographic
printers in Great Britain.

MOSES Henry 1782 (Portsmouth) —
1870 (Cowley, Middx.).
Aq., et., line., steel., topog.
*Antiq. / arch. / hist. / illus. / land. /
lit. / mil. / myth. / sculp. / ship. / topog.*
Moses worked at the British Museum
as an engraver, where he made plates
of the Elgin marbles. He was noted in
particular for his outline plates. Moses
was also a painter.
Aft.: Barry, Northcote, J. Opie,
Retzsch, H.C. Selous, L. Vulliamy,
B. West, J.M. Wright.
Pub.: A. Ackerman; Art Union of
London.
Lit.: Prideaux S. *Aquatint Engraving*
1909.

MOSSES Thomas fl. early 19th c.
Wood.
Illus. / port.
Aft.: Gainsborough, Mengs, J. Opie,
Reynolds, R. Wilson.

MOSSMAN W. fl. 1840s.
Steel.
Illus. / land.
Aft.: W.H. Bartlett.

MOTE William Henry fl. London
1830s—50s.
Line., steel, stip.
Fig, /gen. /illus. / port.
Aft.: A. Bouvier, Mrs P. Christian,
W. Drummond, W.P. Frith, Margaret
Gillies, G. and J. Hayter, D. Maclise,
E.T. Parris.
Pub.: Ackermann and Co; David
Bogue; H. Graves; Lloyd Bros.

MOTTRAM Charles 1807 (London)
— 1876 (London).
Line., mezzo., mixed, steel, stip.
*An. / hist. / lit. / mil. / myth. / port. /
relig. / ship. / sport.*
Noted especially for his plates after
J. Martin.
Aft.: R. Ansdell, T. Barker, Rosa
Bonheur, G. Boughton, G. Cole,
G. Cruikshank, Sir F. Grant, Mrs
Edward Hopkins (Frances Beechey),
W.H. Hunt, T.M. Joy, M. Kendrick,
F.W. Key, Sir E. Landseer, J. Martin,
P.R. Morris, C.W. Nicholls, J.S. Noble,
S. Pearce, A Schreyer, H.C. Selous,
E.R. Smythe, T. Thomson, E.
Verbockhoven, M. von Thoren.
Shared: Completed work on some
plates of G. Cruikshank. (q.v.).
Pub.: G.L. Beeforth; B. Brooks;
Dixon and Ross; Goupil; H. Graves; M.
Knoedler; T. McLean; G.P. McQueen;
Pilgeram and Lefèvre.
Lit.: *Art Journal* 1870, p. 144; 1876,
p. 272; 1877, p. 20.

MOXON AND COMPANY fl. mid
and late 19th c.
Print., pub.
Issued many important illustrated books.

MUCKLOW J. fl. 1832.
Steel.
Illus. /land.
Aft.: T. Allom.

MUIR William fl. Edmonton
1884—94.
Technique unidentified.
Aft.: W. Blake.
Muir produced several facsimiles of
Blake's illuminated books at the
Blake Press, Edmonton. He was
assisted by J.B. Muir, Miss Muir,
Miss E.J. Druitt and J.D. Watts. His
agent was John Pearson.

MUIRHEAD John 1863—1927.
Et.
Illus. / land.

MULLER Louis Jean 1864 (Paris) —
after 1908.
Et.
Gen. / illus.
French national who made some plates
after works by British artists which
were published in England.
Aft: J. Farquharson, W.D. Sadler.
Pub.: Fine Art Society; L.H. Lefèvre;
A. Tooth.

MUNNOCH John 1879—1915
(Gallipoli).
Et.
Also a painter.

MURDOCH John G. fl. Holborn
(41 Castle Street) mid 19th c.
Print., pub., steel.

MURDOCK J.S. fl. 1830s.
Steel.
Arch. / illus.
Aft.: W.H. Bartlett, C. Stanfield.

MURPHY John *c.* 1748 (Ireland) —
1820 or after (London).
Mezzo., stip.
*Gen. / hist. / myth. / nat. / port. /
relig. / topog.*
Also a noted draughtsman.
Aft.: B. Beechey, P. Da Cortona,
Dagoty, L. Giordano, Grignon,
Guercino, Miller, G. Morland,
Northcote, J. Reinagle, Rembrandt,
Reynolds, G. Romney, S. Rosa, W.
Singleton, Snyders, T. Stothard,
G. Stubbs, Stuart, Titian, J. Ward,
B. West, F. Wheatley.
Des. eng.: G. Keating.
Pub.: Boydell.

MURRAY A. fl. 1860s—80s.
Wood.
Flor. / illus.

MURRAY Charles C. fl. second half
of 19th c.
Et.
Gen.
Work on at least one plate shared with
G.A. Machon (q.v.).

MURRAY Charles Oliver 1842
(Denholm, Roxburghshire) — 1923.
Et., mezzo.
*An. / arch. / fig. / gen. / hist. / illus. /
land. / lit. / port. / topog.*
Murray studied at the Edinburgh
School of Design and at the Royal
Scottish Academy School. He worked
in London.
Aft.: Helen Allingham, Sir L.
Alma-Tadema, P. Calderon, E.
Caldwell, H. Colls, F. Dadd, H.W.
Davis, L. Fildes, S. Forbes,
Gainsborough, A. Gow, H. Hardy, C.
Hemy, T. Hemy, H. Holiday, J.Y.
Hunter, Y. King, Lord Leighton, G.
Leslie, S. Lucas, H. Macallum, J.
MacWhirter, Sir J.E. Millais, F.
Morgan, G. Morland, H. Mosler, D.
Murray, D. Neal, J.S. Noble, E. Parton,
Sir E. Poynter, Raeburn, B. Riviere,
H.J. Riviere, W.A. Sadler, C. Seton,
J. Smart, W. Stevenson, A. Stewart,
W. Trood, J.M.W. Turner, T. Ward,
A.M. Wardlow, C. Whymper, H. Wood.
Shared: G.A. Manchon (q.v.).
Pub.: Boussod, Valadon and Co.;
British and Foreign Artists'
Association; C.E. Clifford; Dickinson
and Foster; Dowdeswell and
Dowdeswells; Fine Art Society; C.
Klackner; L.H. Lefèvre; A. Lucas;
J.S. Virtue.
Lit.: *Art Journal* 1881, p. 96; 1882,
pp. 7, 376; 1907, p. 31; 1909, pp.
353f. *Studio* 1927, pp. 88—9, 361.

MURRAY J. fl. London (54 Gt.
Queen Street) *c.* 1880.
Pub.
Juv. dram.
Murray's stock was probably later
acquired by H.G. Clarke (q.v.).

MURRAY James G. fl. Glasgow d.
c. 1905.
Et., litho.
Arch. / land.
Shared: J. Bromley, J. Porter (qq.v.).

MURRAY John George fl. London
1830—56.
Line.
Hist.
Aft.: W. Allan, R. Bowyer, A.W. Devis,
A. Johnstone, C. Landseer, G.
Landseer, Stephanoff.

MUSEUM GALLERIES fl. late
19th c.
Printsellers, pub.
The principal was G.J. Howell and the
firm's speciality was mezzotint
engravings after old masters.

MUSS or MUSSO Charles 1779
(Newcastle-on-Tyne) — 1842.
Et.
Illus. / lit.
Also a glass and enamel painter.

MUTCH George K. b. 1877.
Et.

MUTLOW — fl. London 1810—40.
Line.
Ex libris.

MYERS Simeon fl. 1880s.
Et., mezzo.
Illus. / land.
Aft.: J. Linnell.
Lit.: *Portfolio* 1885 p. 138; 1887
p. 107; 1888 p. 105.

MYERS AND CO. fl. London *c.*
1850—75 as A. and S. Joseph, Myers
and Co. 114 Leadenhall Street; *c.*
1875—1900 as A. N. Myers, 15
Berners Street, Oxford Street.
Juv. dram.
Educational and toy dealers. Agents
for toy-theatre sheets of W. Webb,
J. Redington, A. Park and Skelt
(qq.v.), and of foreign publishers.
Licensees of method of Baxter.

279

NARGEOT Adrien Jean 1837 (Paris)
— ?1900.
Et., Line., steel.
Fig. / illus.
French national who made some plates
after works by British artists.

NASH Frederick 1782 (Lambeth) —
1856 (Brighton).
Aq., litho.
Illus.
Also a painter and designer.

NASH Joseph 1809 (Gt. Marlow,
Bucks.) — 1878 (Bayswater).
Litho.
Arch. / hist. / illus. / lit. / topog.
Nash was educated by his father. He
studied architecture under A. Pugin
(1762—1832) with whom he visited
France. He was also a noted
watercolourist.
Aft.: Sir D. Wilkie.
Lit.: *Art Journal* 1879 p. 73. *Studio*
Spring no., 1915, pp. 10f. Twyman
M. *Lithography 1800—50* 1970.

NASH Walter Hilton *c.* 1850—
1927.
Et.
Arch.
Also an architect, Nash worked in
London.

NASMYTH James 1808 (Edinburgh)
— 1890 (London).
Et., monotypes (amateur).
Land. / marine.

Also a painter, James was the son and
pupil of the portrait and landscape
painter, Alexander Nasmyth (1758—
1840). He is best known as an
engineer.
Lit.: *P.C.Q.* XVI, pp. 3, 268.

NATTES John Claude 1765—1822
(London).
Aq.
Topog.
Also a noted watercolourist and
illustrator.

NEAGLE John *c.* 1760 (London) —
1816 or after.
Line.
*Archaeology / gen. / hist. / illus. /
lit. / myth. / sport.*
Aft.: Sartorius, Smirke, T. Stothard,
Teniers, F. Wheatley.
Shared: E. Dayes, J. Peltro (qq.v.).

NEALE Edward fl. 1880s.
Litho.
An. / illus.

NEALE John Preston *c.* 1771
(London) — 1847 (Ipswich).
Aq., line.
Topog.
Best known as a watercolourist and
illustrator.

NEAVE David S. b. Glasgow 1876.
Et.
Land. / topog.
Also a painter.

NEEDHAM Jonathan fl. 1850s—70s.
Litho.
Land. / topog.
Also a landscape painter.
Aft.: J.D. Harding.
Pub.: Gambart.

NEELE James Joshua fl. London
1820.
Aq., line.
Illus.

NEELE Samuel John ?1758—
1824.
Line.
*Antiq. / calligraphy / illus. / maps /
tech.*
Father of the poet Henry Neele.

NESBIT Charlton 1775 (Swalwell,
Durham) — 1838 (Brompton).
Wood.
*All. / hist. / hum. / illus. / lit. / land. /
nat. / relig. / topog.*
The son of a keelman, Nesbit was at
the age of fourteen apprenticed to
T. Bewick (q.v.). During his
apprenticeship he engraved some of
the tailpieces for Bewick's *British
Birds*. He gained a silver palette from
the Society of Arts for a large (15 by
12 ins.) wood-engraving. After moving
to London *c.* 1799, he was in 1802
awarded a silver medal by the same
Society. He returned to Newcastle *c.*
1818, but went back to London in
1830. Nesbit is generally recognised as
the best of Bewick's pupils.
Aft.: R. Johnson, J. Thurston.
Pub.: Lee Priory Press; Vernon and
Hood.
Lit.: De Maré E. *The Victorian
Woodblock Illustrators* 1980. Dobson,
A. *Thomas Bewick and his Pupils*
1884. Jackson J. and W.A. Chatto
A Treatise on Wood Engraving Second
ed. 1861.

NESS JOHN ALEXANDER d. 1931.
Et.
Arch. / land.
Ness was born in Glasgow and studied
at the Glasgow School of Art. He lived
at West Bridgford, Nottinghamshire.

NEWHOUSE C.B. fl. London *c.*
1835—45.
Aq.
Sport. (especially coaching).
Aft.: H. Alken.

NEWMAN Alfred 1827 (Cincinnati)
— 1866 (London).
Litho.
Arch.
Pupil of G. Hawkins (q.v.).

NEWMAN John and CO. fl. London
(45 Watling Street) 1860s—70s.
NEWMAN J.
Steel.
Makers of fancy goods decorated with
engravings.

NEWTON Robert fl. London 1809—
35.
Line.
Perhaps the brother of Sir W.J.
Newton (q.v.).

NEWTON Sir William John 1785
(London) — 1869 (London).
Line.
Son of the engraver James Newton
(1784—1804) and possibly the brother
of R. Newton (q.v.). Also a
miniaturist.

NICHALS or NICHOLS Catherine
Maud 1847 (Norwich) — 1923
(Norwich).
Et.
Land.
Also a portrait and landscape painter
and a writer.

NICHOLLS G.P. fl. London 1860.
Wood.
Illus.
Aft.: F.R. Pickersgill.

NICHOLLS or NICHOLS William
fl. London 18th—19th c.
Aq., illus., line.
Gen. / port. / sport. / topog.
Probably a relative of the 18th century
engraver and medallist Sutton
Nicholls.
Shared: Bluck, J. Hassall, F.C. Lewis
(qq.v.).

NICHOLLS William Alfred
b. London 1816.
Wood.
Illus.
Was working in Leipzig 1840.

NICHOLS AND COMPANY — See
under SEARLE Frederick.

NICHOLSON Francis 1753
(Pickering) — 1844 (London).
Litho.
Land.
Also a painter, Nicholson was
occupied solely with lithography
towards the end of his life. It is
claimed that he was the first
established artist in England thus to
occupy himself. He published
*Lithographic Impressions from
Sketches of British Scenery* (1821)
and *The Practice of Drawing and
Painting Landscape from Nature, in
Water Colours* (1820).

NICHOLSON George 19th c.
Litho.
Land.
Aft.: Rev. T. Bulmer.

NICHOLSON Isaac *c.* 1790
(Melmerby, Cumberland) — 1848.
Wood.
Heraldry / hist. / illus. / lit.
Pupil of T. Bewick (q.v.).

NICHOLSON Peter 1765 (Preston)
— 1844 (Carlisle).
Line (?)
Arch.
Also an architect and writer.

NICHOLSON T.E. fl. 1830s.
Steel.
Fig. / illus.
Aft.: Copley, Hogarth.

NICHOLSON Thomas Henry
d. Portland, Hants 1870.
Wood.
Illus.
Nicholson was employed for a number
of years at the Gore House studio of
Count d'Orsay who had admired some
of his drawings of horses. He modelled
equestrian statuettes for the Count.
Nicholson returned to wood-engraving

in 1848 when the Gore House
establishment was dispersed.

NICHOLSON William 1781
(Ovingham-on-Tyne) — 1844
(Edinburgh).
Et.
Port.
The son of a schoolmaster, Nicholson
was largely self-taught. Having moved
to Edinburgh *c.* 1814, he became a
founder and secretary of the Scottish
Academy of Painting, Scupture and
Architecture. He resigned in 1830
though still continuing as a member.
He also painted portraits.
Aft.: Nasmyth.
Des. eng.: T. Ransom (q.v.).
Pup.: J.C. Buckler (q.v.).

NICHOLSON Sir William 1872
(Newark-on-Trent) — 1949.
Wood.
An. / ex libris / illus. / port. / sport.
The noted portrait painter and
designer of posters, the art of which,
in collaboration with J. Pryde (q.v.),
calling themselves the "Beggarstaff
Brothers, he helped to revolutionise.
Likewise his wood-engravings brought
a new strength to book illustration.
Some of his woodcuts and drawings
have been reproduced by
chromolithography.
Pup.: E.G. Craig (q.v.).
Lit.: Arts Council *William Nicholson
Paintings, Drawings and Prints* 1980.
Browse Lillian *William Nicholson*
1956.

NICOL William W. fl. London
1848—64.
Litho.
Gen.
Also a painter.

NINHAM Henry 1793—1874
(Norwich).
Et.
Land. / topog. / trees.
Also a painter.
Pup.: A. Priest (q.v.).

NISSEN AND PARKER fl. London
1861—78.
Security printers (line., litho).
Stamps.

NIXON James 1741—1812
(Tiverton).
Line.
Port.
Also a painter in oils and miniature.

NIXON or NIXION — 1760—1818.
Et. (amateur).
Caric.
Also a draughtsman.

NIXON R. fl. London (385 Strand)
late 19th c.
Pub., stip.
All.
Aft.: Cipriani.

NOBLE Samuel 1779 (London) —
1853 (London).
Line.
Arch.
Noble, who was a Swedenborgian
minister, was the son of a bookseller
and brother of the engraver George
Noble (fl. 1795—1806) and of the
watercolourist William Bonneau
Noble. He devoted himself to his
ministry from early in the 19th c.

NOOTH W. Wright fl. London
(St. John's Wood) 1880s—90s.
Et.
Gen.
Aft.: D. Downing, Hals, J.A. Lomax,
Rembrandt, C. Sainton, Marianne
Stokes, G. Wetherbee.
Pub.: C.E. Clifford.

NORTHBOURNE Lord — See
JAMES Walter John.

NORTHCOTE James or Thomas
James R.A. 1746 (Plymouth) —
1831 (London).
Line.
Gen. / illus.
The noted history and portrait painter
and writer on art.
Des. eng.: by many engravers.

NOSEDA Jane fl. London (109
Strand) 1870s—80s.
Pub.

NUGENT Thomas *c.* 1765 (Ireland)
— 1829 or after (London).
Stip.
All. / gen. / port.
Worked in London from 1791.
Aft.: Beechey, S. Harding, H. Hone,
Hoppner, Morland, G. Romney.

283

OAKES John Wright A.R.A. 1820
(Middlewich) — 1887 (Kennington).
Et.
Illus. / land.
Also noted as a landscape painter in
watercolour.
Lit.: *Art Journal* 1879 pp. 193f;
1887 p. 287. *Portfolio* 1887, p. 186.

OBACH AND COMPANY
fl. 1880s—90s.
Pub.

OBEN or O'BRIEN James George
fl. late 18th — early 19th c.
Aq., mezzo.
Land.
Worked in Dublin and London.

O'DONOVAN Morgan F. fl. Cork,
early 19th c.
Line.
Ex libris.

O'DRISCOLL Alexander fl. 1840s.
Litho.
Cost. / mil.
Also noted as a painter.
Aft.: De Danbrawa, W. Heath.

O'DRISCOLL Stephen *c.* 1825—
95.
Litho.
Port.
Also a caricaturist, silhouettist and
designer. Worked in Cork.

OGBORNE John 1755 (Chelmsford)
— 1837 (London).
Aq., line., mixed., stip.
Illus. / port.
A son of the artist D. Ogborne and
pupil of F. Bartolozzi (q.v.). His wife
Elizabeth was a daughter of Sir John
Eliot. She was a noted historian of
Essex.
Aft.: W.R. Bigg, J. Boydell, W.
Hamilton, Angelica Kauffmann,
J.H. Ramberg, R. Smirke, T. Stothard,
R. Westall.
Shared: Mary Ogborn (his sister, b.
1764).

OGG H.A. fl. 1844—46.
Line., steel.
Illus. / port.
Also a painter.
Aft.: T.M. Baynes.

O'KEEFE Denis b. Cork 1810.
Wood.
Illus.
Worked in Dublin.

OLDHAM William the elder.
c. 1809—89 (Dublin).
OLDHAM William the younger.
d. before 1913.
Wood.
Illus.
Father and son.

O'NEILL George Bernard 1828
(Dublin) — 1917.
Et.
Gen. / hum. / port.
Also noted as a genre painter. Lived at
Woolwich.
Des. eng.: J. Scott, W.H. Simmons,
A. Turrell (qq.v.).
Lit.: *Art Journal* 1864 p. 260.

O'NEILL Henry 1798 (Clonmel) —
1880 (Dublin).
Litho.
Illus.
Also a designer, painter and
archaeologist.

O'NEILL Hugh 1784 (Bloomsbury)
— 1824 (Bristol).
Litho.
Land. / topog.
Also a painter.

ONWHYN Thomas *c.* 1820
(London) — 1886 (London).
Et., steel.
Illus.
Thomas was the younger son of
Joseph Onwhyn, a writer and
bookseller in the Strand, London. He
made "unofficial" illustrations for
works by Dickens including *Pickwick
Papers.* He sometimes signed his work
with the pseudonum "Peter Palette"
and was also known as "Sam Weller".

ONWYN R. or B. fl. 1830s.
Steel.
Illus. / land.
Aft.: G. Carter.

OPPENHEIMER Sir Francis
b. London 1870.
Et. (amateur).
Illus.
Also a painter, Sir Francis was British
consul-general at Frankfort-am-Main.

ORME Daniel 1765 (Manchester) —
c. 1832.
Mezzo., stip.
*Gen. / hist. / port. / ship. / sport. /
theat. / topog.*
Also a miniature painter. Brother of
Edward Orme (q.v.).
Aft.: Bigg, M. Brown, Collings, R.
Cooper, G. Morland, E. Orme, J.T.
Serres, Singleton.

ORME Edward d. 1838 or before.
Protean views, pub.
Orme, who was a brother of D. Orme
(q.v.) discovered a process by which
any print could be rendered semi-
transparent. Details were painted on
the back so that when held up to the
light the scene is transformed. For
example, a view of St. Mark's Piazza
in Venice is transformed into a
carnival scene, a view of the Royal
Exchange becomes a view of that
building on fire, and so on. These were
probably identical with the "Improved
Protean Scenery" published from
1838 by W. Morgan (q.v.). Orme was
also a general print publisher at Bond
Street, London.
Des. eng.: D. Orme.

ORR Monro Scott b. 1874.
Et.

ORRINSMITH Harvey Edward —
See under Smith, John Orrin.

OSBORNE Malcolm R.A. 1880
(Frome) — 1963.
Aq., et., line.
Fig. / illus. / land. / port. / topog.
Osborne studied at the Queen's School
of Art, Bristol, and under Sir Frank
Short (q.v.) at the Royal College of
Art, London.
Lit.: *Apollo* I, pp. 46—7; II, pp. 355f.
Art Journal 1908, pp. 175f.
Bookman's Journal XI, p. 63. *P.C.Q.*
XII, pp. 285—313. Salaman M.C.
Malcolm Osborne Modern Masters of
Etching Series No. 21, 1929. *Studio*
LXXV, p. 110.

OSMOND Robert 1874 (Islington) —
1959.
Line.
Ex libris.
An apprentice of W.E. Corks (q.v.),
Osmond engraved about half of the
bookplates sold by the booksellers,
J. and E. Bumpus. All Bumpus plates
are signed by the designer: "W.P.B."
(William Phillips Barrett, 1861—1938),
but it is uncertain to what extent he
was responsible for the designs.
Lit.: Jones Horace E. *Bookplates
signed 'W.P.B.' 1896—1928.* 1978.

OTTLEY William Young 1771
(Thatcham, Newbury) — 1836
(London).
Aq., et., line.
Fig. / orn. / relig.
The son of a guards officer, Ottley
became a pupil of George Cuitt (q.v.),
studied in the R.A. Schools and in
1791 continued his art studies in
Rome. He was appointed keeper of
prints at the British Museum. His own
publications include *An Enquiry into
the Origin and Early History of
Engraving upon Copper and on Wood*
(1816), *The British Gallery of Pictures*
(1823), *The Italian School of Design*
(1823), *Etchings . . . after the
Paintings and Sculpture of the
Florentine School* (1825), and
*Fac-Similes of Rare Etchings by
Celebrated Painters of the Italian,
German and Flemish Schools* (1826).
Aft.: Old masters.

OUDART Paul Louis fl. 1850s.
Litho.
An. / illus.

OUTHWAITE J. fl. 1836—79.
Steel.
Illus. / land.
Aft.: H. Gartineau, V. Heyden, T.L.
Rowbotham, P. Skeleton.

OUTRAM or OUTRIM John 1810 —
after 1870.
Line., steel.
Gen. / hist. /land. / nat. / port. / relig.
Worked in London from 1840s to
1870s.
Aft.: W. Collins, Sir E. Landseer,
T. Uwins, G.F. Watts.
Shared: Outram's plate after T. Uwins
"Vintage in the South of France" was
completed by L. Stocks (q.v.).
Lit.: *Art Journal* 1848, p. 268; 1850,
p. 136; 1852, p. 8; 1854, pp. 107,
356; 1879, p. 68.

OVENDEN T. fl. late 18th — early
19th c.
Line.
Ex Libris.

OVEREND William Heysham 1851
(Coatham) — 1898.
Et.
Illus. / marine.
Overend, who was also a painter, lived
in London.
Lit.: *Portfolio* 1890, p. 7.

OVERTON Thomas fl. London
1818—38.
Line.
Port.
Also a miniaturist.

OWEN — fl. 1830s—40s.
Steel.
Arch. / illus. / land.
Aft.: W.H. Bartlett, G.S. Shepherd.

OWEN Rev. Edward Pryce 1788—
1863 (Cheltenham).
Et. (amateur).
Antiq. / topog.
Also a painter.

OWEN S. fl. 1828.
Steel.
Arch. / illus.
Aft.: T.H. Shepherd.

OWEN T. fl. 1829—31.
Steel.
Arch. / illus.
Aft.: N. Whittock.

OWEN W. fl. 1849.
Steel.
Arch. / illus.
Aft.: J. Fussell.

PAAR — fl. mid (?) 19th c.
Line. (?)

PACKER Thomas fl. 1860s.
Litho.
Music.
Packer ran a large workshop with
many employees. He was an innovator
and used a new method for coloured
effects, which earned him the
nickname of "The Graduated-Tint
Packer". His work, though always
characteristic, is not always signed.
Lit.: Spellman D. and S. *Victorian
Music Covers* 1969.

PAGE — fl. 1825.
Stip.
Illus. / port.
Aft.: Lister.

PAGE R. fl. 1833.
Steel.
Arch. / illus.
Aft.: Hogarth.

PAGE W.T. fl. 1840s.
Steel.
Illus. / port.
Aft.: R. Page.

PAGET H.M. fl. 1870s—90s.
Litho.
Illus.
Also a painter.

PALGRAVE Sir Francis 1788
(London) — 1861 (Hampstead).
PALGRAVE Lady [Elizabeth]
Et. (amateur).
Arch.
Husband and wife. Sir Francis etched
two unimportant plates, but Lady
Palgrave etched a quantity of
architectural subjects. Among their
offspring was Francis Turner Palgrave,
professor of poetry at Oxford and
compiler of *The Golden Treasury.*

PALMER Edward fl. London 1841.
Maker of electrotype copies of
engraved plates, and inventor of
glyphography. His workshop was at
104 Newgate Street, London. There
was also a Vaughan Palmer, possibly
a relative, who in 1844 was making
electrotypes at 42 Gloucester Street,
Bloomsbury.

PALMER Edward S. fl. 1870s.
Pub.

PALMER J.F. fl. 1846.
Steel.
Illus. / land.
Aft.: W. Tombleson.

PALMER Samuel 1805 (London) —
1881 (Redhill).
Et., wood.
Illus. / land. / lit.
Palmer is best know for his visionary
drawings and paintings, especially
those made at Shoreham in Kent in his

youth, partly under the influence of William Blake (q.v.). He was the centre of a group of young artists and enthusiasts calling themselves "The Ancients", among other members being Edward Calvert and George Richmond (qq.v.). For a time Palmer seemed to have lost his vision, but much of it was regained later in life in his etchings. His one wood engraving belongs to the Shoreham period.
Des. eng.: T. Bolton, J. Cooper, W.T. Green, H. Harral, W. Measom, W. Sherman (qq.v.).
Lit.: Alexander R.G. *A Catalogue of the Etchings of Samuel Palmer* 1937. *Book Collector* Spring 1979, pp. 67-103; Spring 1980, pp. 112-13. Hardie M. *Samuel Palmer* 1928. Lister R. *Samuel Palmer a Biography* 1974 [1975], *Samuel Palmer and his Etchings* 1969, *Samuel Palmer in Palmer Country* 1980, *A Vision Recaptured* 1978. Palmer A.H. *The Life and Letters of Samuel Palmer* 1892 (repr. 1972). Palmer S. *The Letters of Samuel Palmer* (ed. by R. Lister) 1974 [1975] *P.C.Q.* III, pp. 207-40; XXIV, pp. 253-34.

PALMER W.J. fl. mid 19th c.
Wood.
Illus.
Aft.: Birket Foster.

PAPPRILL Henry A. fl. London 1840s–70s.
Aq., et.
Gen. / mil. / ship. / sport. / topog.
Aft.: F.C. Boult, J.S. Cotman, E. Crawford, W. Knell, G. Laforte, Sir E. Landseer, G.H. La Porte, B. Nightingale, J. Pollard, W.J. Shayer.
Pub.: Fores; A.J. Isaacs.
Lit.: Wilder F.C. *English Sporting Prints* 1974.

PAPWORTH Edgar George 1809 (London) — 1866 (London).
Et.
Papworth studied at the R.A. Schools. In 1833 he was awarded a gold medal and an award which enabled him to travel to Rome to complete his studies. Also a scuptor, he married the daughter of the scuptor Edward Hodges Baily.

PARK A. fl. London 1818—80.
Family business of retailers and publishers of toy-theatre sheets. It is thought the members were Arthur Park (d. 1863), artist and engraver; he had as partner J. Goulding (q.v.), 6 Old Street Road and 6 Oakley Street, Lambeth (Arthur Park emigrated to U.S.A. about 1835); Archibald Alexander Park (? brother of Arthur), 47 Leonard Street, Shoreditch; Mrs Sarah Park (? wife of Archibald), 47 Leonard Street; Alexander Park (? son of Archibald and Sarah), 47 Leonard Street; 40 Marshall Street; 150 High Street, Notting Hill; 30 St John's Road, Hoxton.
Park's acquired some of the plates of D. Straker (q.v.). They were agents for W. Hawley and Co. (q.v.). Myers and Co and H.G. Clarke (q.v.) were agents for Park's.
Some of Park's plays were reissued by B. Pollock (q.v.).
Pup.: W.G. Webb (see under W. Webb) was apprenticed to Archibald Alexander Park.

PARK George Harrison fl. 1880s.
Et.
Land.

PARK John fl. South Shields 1880s.
Et.
Topog.
Aft.: W. Müller.

PARK Thomas (?)1760 — *c.* 1834.
Mezzo. (amateur).
Lit. / port.
Especially noted for his plates after Reynolds.
Aft.: Beechey, Browne, Gainsborough, Hoppner, Page, Reynolds, Spilsbury.

PARKER Frederick d. 1847.
Wood.
Illus.
The son of John Parker, a publisher, Frederick showed great promise but died young.

PARKER James 1750 (London) — 1805 (London).
Line.
Gen. / hist. / illus. / lit. / port. / theat.
Parker was apprenticed to J. Basire II

(q.v.). For about three years from 1784 he ran a printselling shop in partnership with W. Blake (q.v.).
Aft.: T. Flaxman, O. Humphry, J. Northcote, Smirke, T. Stothard, R. Westall.

PARKER Robert Bowyer 1830—77 or later (London).
Mezzo.
Port. / theat. / topog.
Aft.: Crowe, Eyre, Gainsborough, Reynolds, G. Romney, Williams.
Pub.: Henry Graves and Co.

PARKER James 1744 (Shrewsbury) — 1828 (Shrewsbury).
Et.
Antiq.
Son of David Parkes the amateur watercolourist.

PARKES Mary fl. London (22 Golden Square) 1840s—50s.
Print.

PARKES Robert Bowyer 1830—91 or later.
Mezzo., mixed.
An. / gen. / hist. / land. / port. / relig.
Aft.: R. Ansdell, C.B. Barber, J.Y. Carrington, Constable, T.S. Cooper, E. Crowe, T. Davidson, E. Douglas, Gainsborough, J. Gow, Mary Gow, W.M. Hay, J. Hayllar, G.E. Hicks, E.K. Johnson, W. Linnell, Sir J.E. Millais, A. Nasmyth, J.T. Peele, T.K. Pelham, V. Prinsep, Reynolds, G. Romney, W.D. Sadler, G. Smith, G.H. Scrimstead, S. Waller, A. Wardle, W. Yeames.
Pub.: Louis Brall; B. Brooks; L.E. Clifford; Colnaghi; J. Dickinson; H. Graves; Max Jacoby; L.H. Lefevre; A. Lucas; T. McLean; I.P. Mendoza; Jane Noseda; A. Tooth.

PARKIN J. fl. 1877.
Steel.
Port.
Aft.: P. Bordone.

PARKYNS George Isham 1749 or 1750 (Nottingham) — c. 1820 (Cambridge).
Aq. (amateur).
Illus. / land.

PARR Richard fl. 1820s—30s.
Line., steel.
An. / gen. / sport.
Aft.: A. Cooper, Sir E. Landseer.
Pub.: H. Graves; London Printing and Publishing Co. Ltd; T. McLean.

PARRISH Stephen b. 1846.
Et.
Land. / ship.

PARRY James 1805 (? Liverpool) — 1871 (Manchester).
Et. (?).
Antiq. / illus.

PARSONS E., and SONS
fl. London (45 Brompton Road) late 19th c.
Print., pub.

PASQUIN Anthony Pseudonym of John Williams (q.v.).

PASS J. fl. 1831.
Steel.
Arch. / illus.

PASTORINI Benedetto b. c. 1747.
Aq., line., stip.
All. / caric. / furniture designs / gen. / lit. / port.
Pastorini, who was an Italian living in London, received instruction from F. Bartolozzi (q.v.) whose style he copied. He was also a draghtsman.
Aft.: Artaud, Hamilton, Angelica Kauffmann, Reynolds, Rigaud, Zucchi.
Shared: F. Bartolozzi, P.W. Tomkins (qq.v.).

PATERSON George fl. Glasgow and London 1830s—40s.
Et., line., mezzo., mixed., steel.
An. / gen. / sport.
Probably identical with "J. Patterson" who is said to have signed some plates.
Aft.: T. Allom, R. Ansdell, J. Bateman, C. Hancock, J.F. Herring Sr.
Pub.: Lloyd Bros.

PATERSON Robert fl. London and Edinburgh 1870s—80s.
Et.
Gen. / hist. / land. / relig.
Aft.: G. Clausen, J.H. Dell, G. Seymour, J.M.W. Turner.

PATON Frank 1856 (London) —
1909 (Gravesend).
Et.
*An. / ephem. (Xmas cards) / gen. /
land. / sport.*
Paton worked in London, Kent and
Essex, and was a noted animal and
genre painter.
Aft.: C.E. Black, T. Blinks, A.A.
Davis, J. Hardy, L. Hart, A.W. Holden,
G.G. Kilburne, C.G. Kilburne Jr., A.
Thorburn, S.E. Waller, C. Whymper.
Des. eng.: J.B. Pratt (q.v.).
Pub.: Frost and Reed; M. Knoedler;
E.E. Leggatt; Leggatt Bros.

PATON Hugh 1853 (Glasgow) —
1927.
Et.
Land.
Paton, who attended Glasgow
Academy, was also a well-known
painter. He wrote two technical
treatises on etching.

PATON Hugh, and SONS
fl. Edinburgh (115 Prince's Street)
1880s.
Pub.
PATON J. fl. Aberdeen *c.* 1820.
Line.

PATTEN E. fl. 1836.
Steel.
Illus. / land.
Aft.: T. Allom.

PATTERSON J. — See under
Paterson G.

PAUL John Dean fl. late 18th and
early 19th c.
Aq.
Sport.
A member of a well-known banking
family.
Aft.: H. Alken.
Pub.: S. and J. Fuller.

PAULUSSEN R. fl. 1890–1904.
Photo-eng;
*Gen. / hist. / land. / port. / relig. /
sport.*
Aft.: A. Beckingham, F. Bramley,
H.J. Brooks, A. Elsley, J. FitzMarshall,
H. Garland, A.C. Havell, T. Hemy, R.
Hillingford, E.R. Hughes, D. Knowles,
H. Mann, J.S. Noble, C. Perugini, D.
Wehrschmidt, H.I. Wells, J.W. West.
Pub.: Barclay Bros.; C.E. Clifford;
Fine Art Society; Fores; H. Hare;
Mawson, Swan and Morgan; R.
Wyman.

PAYE Richard Morton *c.* 1778
(Botley, Kent) — 1820.
Stip.
Caric. / gen. / port.
Also a painter, a chaser on metal and
possibly a poet, Paye had a son who
also engraved in stipple.
Des. eng.: V. Green, J. Young (qq.v.).

PAYNE Albert Henry 1812
(London) — 1902 (Leipzig).
Et., steel.
Fig. / hist. / illus. / lit.
Payne worked in Leipzig, Newcastle,
Leicester and London. His son Albert
Payne (1842—1921) was also an
engraver.

PAYNE G.T. fl. late 1830s—50s.
Line., mezzo., stip.
Hist. / port. / sport.
Aft.: F. Barraud, H.P. Briggs, J.D.
Francis, J.R. Herbert, J. Hollins, E.
Latilla, S. Laurence, J. Lucas, T.W.
Mackay, J. Munro, F. Newenham,
H.S. Parkman, G. Patten, H.W.
Pickersgill, R. Sayers, B. West.
Pub.: T. Boys; H. Graves; Hodgson and
Graves; T. McLean; C. Mitchell; Roe
of Cambridge; R. Turner; S. Welch.

PAYRAU Jules Simon fl. late 19th—
early 20th c.
Et., stip.
Gen.
French national who made some
plates after works by British artists
which were published in England.
Aft.: Sir E. Burne-Jones, J. Downman,
G. Morland, E. Semenowsky, R.C.
Woodville, J. Wright of Derby.
Pub.: Harry C. Dickins; H. Graves;
C. Klackner, A. Tooth.
Lit.: *Connoisseur* XXXVII.

PEARCE A.E. fl. 1880s.
Et.

PEARCE Charles Maresco 1874
(London) — 1964.
Et.
Arch. / fig. / flor. / land.
Pupil of A. John, W.R. Sickert (qq.v.),
W. Orpen and J.E. Blanche. Also a
painter.

PEARS Charles b. 1873.
Et. (?)
Illus.
Also a painter.

PEARSON George fl. Dartmouth
Park 1860s.
Line., wood.
An. / illus.
Aft.: John Wolf, Joseph Wolf.

PEGRAM Frederick 1870—1937.
Et.
Fig. / gen. / port.
Also a painter and etcher.

PELLITIER — fl. 1820s.
Litho.
Flor. / illus.

PENN William Charles b. London
1877.
Et.
Hist.
Also a painter.

PENNELL Joseph 1858—1926.
Et., litho.
Arch. / land. / topog.
American artist who produced a few
plates in England. He was also a noted
illustrator. Author of *Lithography
and Lithographers* 1915.
Lit.: *P.C.Q.* XIV, p. 47. *Studio* LXIX,
p. 200. Wuerth L.A. *Catalogue of the
Etchings of Joseph Pennell* 1928.

PENNY C. fl. London 1814—25.
Line.
Port.

PENNY W. fl. 1838.
Steel.
Heraldry / illus.
Aft.: T.M. Richardson.

PENSTONE John Jewel fl. 1835—
95.
Steel.
Gen. / illus. / port.

PERCIVAL Harold 1868 — c. 1916.
Et.
Gen.

PERIAM G.A. fl. 1840—50.
Steel.
Illus.

PERKINS B. fl. London (40
Marshall Street, Carnaby Market)
1812.
Pub., printseller.
Juv. dram.
Agent for J.K. Green (q.v.).

PERKINS, BACON AND CO.
PERKINS, FAIRMAN AND HEATH.
PERKINS AND FAIRMAN.
PERKINS AND HEATH.
PERKINS AND BACON.
PERKINS, BACON AND PETCH
fl. under various names 1819--1935.
Security printers.
Bank. / stamps (postage and telegraph).
This firm, which printed such famous
stamps as the one penny black and the
Cape of Good Hope triangulars had its
headquarters at the following London
addresses: 29 Austin Friars (1819—
20), 69 Fleet Street (1820—1904),
Southwark Bridge Road (1904—35).
Its printing works were at 36-40
Whitefriars Street (once known as
Water Street) and later at 1-2 Hanging
Sword Alley (at the back of
Whitefriars Street).
The partners included Jacob Perkins
(b. Boston, U.S.A.) who patented the
"Improved Rose Engine", a lathe for
engraving patterns on stamps and
bank-notes to prevent forgery. Other
partners at various times were Gideon
Fairman (q.v.), Joseph Cheesborough
Dyer, Charles Heath (q.v.), George
Heath (half-brother of Charles Heath
and a Serjeant-at-law), Joshua Butters
Bacon (b. U.S.A.), Henry Petch,
J.P. Bacon, James Dunbar Heath,
Alfred Bacon.
Assist.: W. Humphrys, C.H. Jeens
(qq.v.).
Lit.: Bathe G. and D. *Jacob Perkins*
Philadelphia 1943. de Worms P.
Perkins Bacon Records 1953. Lister
R. *Great Works of Craftsmanship*
1967, *Private Telegraph Companies
of Great Britain and their Stamps*
1961.

PERRET F. fl. early (?) 19th c.
Litho.
Ship.

PERRIAM E. fl. 1835.
Steel.
Illus.

PETERS J. fl. 1840s.
Steel.
Illus. / land.
Aft.: W. Tombleson.

PETERS Rev. Matthew William
d. London 1814.
Line. (amateur).
Illus.
Peters, who was born on the Isle of
Wight, was also a painter. His
paintings were reproduced by many
engravers.

PETERS William fl. mid (?) 19th c.
Et.
Gen.

PETHER William 1731 or 1738
(Carlisle) — 1821 (Bristol).
Mezzo.
Gen. / myth. / port.
Pether, who was a cousin of the
painter Abraham ("Moonlight") Pether,
was a pupil of Thomas Frye
(1710—62) whose partner he later
became. In 1756 he received a
premium from the Society of Arts. He
commenced life as a painter of
landscape and of portraits in oil and
miniature. Of a restless disposition,
he was constantly changing his
address. Late in life he became a
drawing master and picture cleaner in
Bristol.
Aft.: Bigg, Dance, Dow, Drouais, T.
Frye, G. Garrard, Giorgione, Mme.
Le Brun, Murillo, J.H. Ramberg,
Rembrandt, Richardson, Rubens,
J. Russell, Schalcken, Teniers, J.
Wright of Derby.
Pup.: E. Dayes (q.v.) and the
miniaturist Henry Edridge.

PETIT Georges fl. Paris (7 Rue St
Georges) 1880s—90s.
French publisher who issued some
plates after work by British artists.

PETRIE John fl. Edinburgh 1796—
1816.
Line.
Arch. / illus. / topog.
Lit.: *P.C.Q.* XVI p. 269; XVIII, p. 295.

PETTIE John R.A. 1839 (East
Linton) — 1893.
Et.
An. / illus. / land.
Mainly a painter, Pettie was a pupil of
R. Lauder at the Scottish Academy,
Edinburgh.
Des. eng.: E.G. Hester, J.T. Lucas, A.
Turrell (q.v.).
Lit.: *Art Journal* 1869 pp. 256f; 1893
pp. 206f.

PETTIT J. fl. early (?) 19th c.
Line.
Gen.
Apparently this engraver is known for
only one work: "Harley and old
Edwards at the grave of young Edwards",
after G. Morland.

PETTITJEAN François fl. late 19th
— early 20th c.
Et., mezzo., mixed.
Gen. / lit. / port.
French national who made some plates
after works by British artists which
were published in England.
Aft.: J.W. Godward, Sir J.E. Millais.
Pub.: T. McLean, I.P. Mendoza.

PETTITT F.M. fl. 1890s.
Pub.

PHELPS James fl. London 1807—
32.
Line., steel.
Illus. / land. / port.
Also a painter

PHILIP John R.A. 1817—67.
Et.
Fig.
Noted as a figure painter.

PHILIPS Nathaniel George 1795
(Mayfield, Manchester) — 1831
(Liverpool).
Et., line.
Arch. / topog.
The son of the famous collector John
Leigh Philips, Nathaniel was educated

at a Manchester Grammar School and at the University of Edinburgh, with the intention of qualifying for the medical profession, but he later turned to art. He visited Italy in 1824 for three years and settled in Liverpool on his return. Also a painter.

PHILLIBROWN — fl. 1860—72.
Steel.
Port.
Aft.: Honthorst, Mytens, Zucchero.

PHILLIBROWN A. fl. 1840s.
Steel.
Gen.
Aft.: A.L. Girodet-Trioson.

PHILLIBROWNE or PHILLIBROWN Thomas fl. LONDON 1830s—40s.
Steel.
Illus.
Pupil of the Finden Bros. (q.v.); emigrated to U.S.A.

PHILLIMORE Reginald b. 1855.
Et.

PHILLIP John R.A. 1817—67.
Et.
Topog.
Also a painter, Phillip was noted for his renderings of Spanish subjects.

PHILLIPS Alfred H. fl. London mid 1870s—1903.
Et., mezzo.
Gen. / sport.
Best known as a genre painter.
Aft.: H. Hardy, W.J. Shayer.
Pub.: A. Ackermann; I.P Mendoza.

PHILLIPS George Henry fl. London c. 1835—49.
Aq., mezzo.
Gen. / land. / myth. / port. / relig. / sport.
Also practised as a miniaturist and painter.
Aft.: F. Danby, W. Drummond, T. Girtin, J.J. Jenkins, Sir T. Lawrence, J. Martin, W. Owen, E.T. Parris, W.M. Sharp, J. Simpson, R. Thorburn, J.M.W. Turner, T. Webster, W.F. Witherington.
Pub.: T. Boys; Gambart; Hering and Remington; Lipschitz and Co.

PHILLIPS Lawrence Barnett 1842 (London) — 1922.
Et., line.
Arch. / land. / topog.
Phillips began life as a watchmaker, but at the age of forty became a professional engraver and painter.
Pub.: Harry C. Dickins; L.H. Lefèvre.
Lit.: *Connoisseur* LXIII p. 119; LXV, p. 54. *Portfolio* 1875 p. 124. *Studio* Summer number 1902; 1922, p. 22.

PHILLIPS Sam fl. end of 18th — early 19th c.
Stip.
All. / gen. / port. / relig. / sport.
Aft.: Maria Cosway, R. Cosway, Hogarth, Mola, L. Schiavonetti, Singleton, R. Westall.

PHIZ — Pseudonum of Hablot K. Browne (q.v.).

PICART Charles 1780 (London) — 1837 (London).
Line., stip.
Arch. / illus. / port.
Aft.: Beechey, Clint, Sir. T. Lawrence, Raeburn, C. Robertson, Wivell.
Shared: W. Evans (q.v.).

PICKEN Andrew 1815—45 (London).
Litho.
Arch. / illus. / land. / port.
A brother of Thomas Picken (q.v.), Andrew learnt lithography under Louis Haghe (q.v.). He was awarded the silver Isis medal by the Society of Arts in 1835 for his lithograph of the Houses of Parliament after the fire. He moved to Madeira for a time c. 1840, but later returned to London.
Aft.: E.T. Parris.
Pub.: H. Graves.
Lit.: *Art Union* 1845, p. 263. Brown R. *Memoir of E. and A. Picken* 1879.

PICKEN Thomas fl. London mid 19th c. d. Australia c. 1870.
Litho.
Hist. / land. / ship. / topog.
Youngest brother of A. Picken (q.v.).
Aft.: Capt. Beaufoy, O.W. Brierley, Pickering, W. Ranwell, Lieut. Stack, R. Stopford, E. Walker.

Shared: With W. Simpson (q.v.) work on lithograph of the Duke of Wellington's funeral.
Pub.: Ackermann.

PICKETT W. fl. early 19th c.
Aq.
Illus. / land.
Worked for T. Girtin (q.v.).
Aft.: T. Girtin.

PIDDING Henry James 1797 (Cornwall) — 1864 (Greenwich).
Line.
Gen. / still life.
A pupil of Agostino Aglio, Pidding was also a painter.

PIDGEON Henry Clark 1807—80 (London).
Litho.
Land.

PIERCY Ralph 1862—94.
Et., mezzo., mixed (incl. mezzo. over photo-eng.).
Land. / port. / topog.
Aft.: T.C. Dibden, E. Hughes, Sir E. Landseer, P. Norman.
Pub.: Gladwell Bros.; H. Graves.

PIERSON John or PEIRSON fl. late 18th — early 19th c.
Stip.
All. / gen. / relig. / sport.
Aft.: T. Pierson, Singleton.

PILCHER C.W. 1870—1943.
Et.

PILGERAM and LEFÈVRE — See under GAMBART.

PILOTELL Georges 1944— 1918 (London).
Dry., et., litho.
Port.
French national who lived and worked in England after the 1871 Paris Commune, engraving portraits of notable public figures. He also enjoyed a reputation as a caricaturist.
Pub.: Jane Noseda.

PINKERTON Eustace 1852 (London) — 1923 or later.
Et., mezzo.
Port.
Also a painter.

PIPER Elizabeth fl. Chelsea late 19th — early 20th c. d. Staines 1940.
Et.
Arch. / land.
Studied at Clifton School of Art, Royal College of Art and in Belgium and France.
Pub.: G. Biddle and Sons.

PIPER S. fl. 1820.
Litho.
Port.

PIPESHANK George — pseudonum of J. Wallace (q.v.).

PISSARRO Lucien 1863 (Paris) — 1944 (Southchard, Somerset).
Et., litho., mixed., wood.
Ex libris / gen. / illus.
Lucien was the eldest son of the Impressionist painter Camille Pissarro. After earning his living in various ways, practising drawing in his spare time, and visiting England to learn the language, he became a pupil of A. Legros (q.v.) at the Slade School of Fine Art, and fell under the influence of the work of J.M.W. Turner and J. McN. Whistler (qq.v.). He returned to Paris in 1884, but was in London again in 1890, and in 1894 set up his own press, named after his parents' house. From this time he lived permanently in England, though he visited France from time to time. As well as issuing finely produced books he also painted.
Lit.: Bain I. and David Chambers *Wood Engravings by Lucien Pissarro.* A new printing from the original blocks now in the Ashmolean Museum, Oxford, 1980. Johnson Una E. *Ambroise Vollard, Éditeur* 1944. Pickvance Ronald *Lucien Pissaro 1863—1944* 1963. Pissarro L., *Notes on the Eragny Press* (ed. A. Fern) 1957. Robb Brian *The Wood-engravings of Lucien Pissarro* 1948. Stain Donna and Donald Karshan *L'Estampe Originale: A Catalogue Raisonné* 1970.

PITCAIRN-KNOWLES James 1864
— after 1914.
Line. (?)

PITTS J. fl. London (Great St.
Andrews' Street, Seven Dials) *c.* 1840.
Pub.
Tinsel.

PLACE M. fl. London *c.* 1785–
1815.
Stip.
Gen. / mil.
Aft.: Cosse, Porter.

PLATT William 1798 (London) –
1852 (London).
Aq., et., line.
Illus. / port.
Aft.: A. Buck.

PLATTS F. fl. mid 19th c.
Print. (litho.).
Music.

PLAYTER Charles Gauthier
d. Lewisham 1809.
Stip.
Hist. / illus. / lit. / theat.
Aft.: Hamilton, Rigaud, S. Shelley.

PLOZCZYNSKI N. fl. England
1847–50.
Litho.
Port. / sport.
Plozczynski, was Polish by birth,
and also painted.
Aft.: N. Felix.
Pub.: Baily Bros.

POCOCK Geoffrey Buckingham
b. London 1879.
Et. (?)
Arch. / illus.
Pupil of W.W. Russell and P. Wilson
Steer.

POLLARD James 1797 (Islington) –
1867.
Aq., line., mixed., stip.
Ship. / sport. / topog.
James was a son and pupil of R.
Pollard I and brother of R. Pollard
II (qq.v.) who together formed the
firm of Pollard and Son. It is thought
that in preparing his aquatint grounds
he probably used a special resinous

gum, which gave the grain the
appearance of short parallel lines
instead of the usual tiny whorls or
circles.
Aft.: Saffrien Alken (who signed 'S.
Alken' and should not be confused
with Samuel Alken), E. Gill, N.
Pocock, J.N. Sartorius.
Des. eng.: J. Harris, C. Hunt, R.
Pollard, R. Reeve (qq.v.).
Shared: R. Havell and Son.
Pub.: W. Giles; T. Helme; J. Moore;
B. Moss.
Lit.: *Apollo* VII, pp. 158-61.
Connoisseur XIX, pp. 371, 409, 410;
LI pp. 15-22. Laver J. *English
Sporting Prints* 1970. *P.C.Q.* XII,
pp. 173-75, 180; XVII pp. 169-75.
Selway N.C. *The Golden Age of
Coaching Sport as depicted by James
Pollard* 1972, *The Regency Road: the
Coaching Prints of James Pollard*
1957. *Studio* Special number 1920.
Wilder F.C. *English Sporting Prints* 1974.

POLLARD Robert I 1755
(Newcastle-on-Tyne) – 1838 (London).
Mixed.
*Arch. / gen. / hist. / lit. / marine. /
ship. / sport. / topog.*
The father of James Pollard and
Robert Pollard II (qq.v.), Robert was
articled to a Newcastle silversmith and
afterwards became a pupil of Richard
Wilson R.A. He began as a painter of
landscape and marine subjects, but in
1782 set up in Spa Fields, London, as
an engraver and printseller, later taking
Robert II into partnership and trading
as Pollard and Son.
Aft.: Capt. Cockburn, R. Cosway, E.
Dayes, R. Dodd, Edwards, W. Ellis,
Gilpin, Angelica Kauffmann, Paye,
N. Pocock, J. Pollard, T. Rowlandson,
Serres, Singleton, R. Smirke, J.R.
Smith, T. Stothard, C. Thomson, F.
Wheatley, J. Widnell.
Pup.: J. Pollard, J. Scott (qq.v.).
Shared: F. Jukes, J.G. Wells (qq.v.).

POLLARD Robert II fl. early-mid
19th c.
Mixed.
Sport.
Son of Robert Pollard I and brother of
James Pollard, Robert II was in
partnership with his father in the firm
of Pollard and Son.

POLLOCK Benjamin 1856—1937.
Pub.
Juv. dram.
Pollock, whose address was 73 Hoxton
Street, London, succeeded J.
Redington (q.v.) on the latter's death
in 1876. He was himself succeeded by
his daughter Louisa Pollock who
carried on until 1944. In 1946 a firm
was started by Alan Keen, Benjamin
Pollock Ltd., and it continued to issue
old stock, reprints, reproductions and
new plays. Reissued some plays by A.
Park (q.v.). Agents included H.G.
Clarke.

PONCY Alfred Verier fl. London
1870s—90.
Mezzo.
An.
Known chiefly as a painter.
Pub.: Harry C. Dickins.

POPE Henry Martin 1843
(Birmingham) — 1908.
Et., litho.
Land. / topog.
Also a painter, as which he was trained
by Samuel Lines.

PORTBURY Edward J. 1795—1885.
Line., steel.
Gen. / illus.
Worked in London.
Aft.: R. Farrier, F.P. Stephanoff, T.
Uwins, P.Williams.

PORTER John fl. London 1820—50.
Mezzo.
Gen. / port.
Aft.: R. Bowyer, D. Cowper, C.
Hancock, G. Hayter, A.M. Huffman,
J. Simpson.
Pub.: R. Bowyer; H. Graves; J.
McCormick; T. McLean; M. Parkes;
Welch and Gwynne.
Shared: J. Bromley and J.G. Murray
(qq.v.), work on a plate of the trial of
Queen Caroline, 1820.

PORTER Sir Robert Ker 1777
(Durham) — 1842 (St. Petersburg).
Litho.
All. / hist. / myth.
Porter was at different times a painter,
soldier, author, diplomat and
printmaker. He was the son of a

military surgeon. When he was about
thirteen years of age his mother took
him to see Benjamin West who was
impressed with the boy's work and
helped him to secure a place in the
Schools of the R.A. Despite his many
other activities he always continued to
practise his art. He was made a knight
of the order of Hanover in 1832.
Des.eng.: J. Vendramini, W. Say and
others.
Pub.: Philip André; J. Heath.

POSSELWHITE James 1798—1884
(London).
Line., steel., stip.
Port.
Worked at Charterhouse. Plates signed
T. Posselwhite are possibly the work
of this engraver.
Aft.: H. Corbould, G. Howard, J.
Laure, Liotard, J. Lucas, G. Richmond,
Vidal.
Pub.: J. Budd and Co.; W.M. Holloway;
J. Watson.

POTT Constance Mary 1862 —
c. 1930.
Et.
Arch. / land. / port. / topog.
Pott worked in London. She was a
pupil at the Royal College of Art of
Sir Frank Short, F. Goulding and A.
Legros (qq.v.).
Aft.: E.W. Cooke.
Lit.: *Queen* 8 September 1906.
Studio 1901, pp. 18, 20; Special
Number 1902; 1911, pp. 282, 286f.;
Special Number 1913.

POULTER J.A. fl. 1850—mid 1880s.
Et.
Illus. / land.
Noted also for painting of twilight
landscapes.

POUNCY John fl. 1857.
Print., pub.
Topog.
Inventor of a photolithographic
process.

POUND D.J. fl. 1842—77.
Steel.
Port.

POWELL Francis (Frank) 1833
(Pendleton) — 1914 (Dunmow).
Et.
Illus. / land. / lit. / marine.
Better known as a watercolourist,
Powell studied at Manchester School
of Art.

POWELL or POWEL John 1780 —
after 1833.
Et.
Land.
Also a painter.

POWIS William Henry ? 1808—36.
Wood.
Illus.
Worked for a time with W.J. Linton
(q.v.).
Aft.: J. Martin, R. Westall.

POYNTER Sir Edward John P.R.A.
1836—1919.
Et.
Fig.
Best known as a painter of classical
subjects, Poynter was director of the
South Kensington Museum from 1860.
Pup.: W. Strang (q.v.).

PRATT Joseph Bishop 1854
(London) — 1910 (London).
Line., mezzo., mixed., photo-eng.
*All. / an. / fig. / gen. / hist. / illus. /
land. / lit. / mil. / myth. / port. / relig. /
sport. / theat.*
J.B. Pratt was the son of a mezzotint
printer, Anthony Pratt, himself a pupil
of David Lucas (q.v.); he was the
father of S.C. Pratt. His mezzotinting
tools were those previously belonging
to S. Cousins and T.O. Barlow (qq.v.),
which he bought. He worked in
Harpenden, Herts., Brenchley, Kent,
and in London.
Aft.: D. Adams, Sir L. Alma-Tadema,
C.B. Barber, J.W. Barker, J.H. Barnes,
J.H. Beard, S. Berkeley, R. Blind, T.
Blinks, Rosa Bonheur, G. Boughton,
M. Brown, C.T. Burt, S. Carter,
Constable, D. Cox, E. Crofts, H.W.B.
David, P. De Wint, J.R. Dicksee, J.C.
Dollman, Helen Donald-Smith, A.
Drummond, C. Dubufe, Maud Earl,
M.E. Edwards (Mrs Staples), A. Elsley,
T. Faed, D. Farquharson, G. Ferrier,
C. Fielding, L. Fildes, Fragonard,
Gainsborough, D. Gardner, H.
Garland, V. Geza, G.D. Giles, J.W.
Godward, F. Graham, P. Graham, L.J.
Gunnis, H. Hardy, J. Hardy, Sir H.
Herkomer, J.F. Herring Sr., F. Holl, G.
Holmes, Hoppner, W. Hunt, L. Hurt,
G.C. Kilburne, G.S. Knowles, Sir E.
Landseer, Sir T. Lawrence, V. Le
Brun, Lord Leighton, E.B. Leighton,
S. Lewis, G.E. Lodge, J.S. Lucas,
S. Lucas, H. Ludlow, Helena J.
Maguire, F. Morgan, R. Morley, T.
Mostyn, F. Paton, V. Prinsep,
Raeburn, Sir J. Reynolds, B. Riviere,
H.L. Rolfe, G. Romney, C. Scott, W.
Severn, B. Shaw, A. Stewart, A. Strutt,
S. Stuart, A. Thorburn, H.S. Tuke,
S. Waller, J. Ward, A.J. Warne-Browne,
J.H. Williams, Rev. Withers-Lee, W.
Wontner, R.C. Woodville.
Pup.: P.H. Martindale, H. Sedcole, S.E.
Wilson (qq.v.).
Shared: W. Simmons (q.v.).
Pub.: Adler and Schwartz; T. Agnew
and Sons; Louis Brall; B. Brooks;
Colnaghi, J. Connell and Sons;
Dowdeswell and Dowdeswells; Fine
Art Society; Fishel; Alfred Freke;
Frost and Reed; H. Graves; M.
Knoedler; L.H. Lefèvre; E.E. Leggatt;
Leggatt Bros; T. McLean; Mawson,
Swan and Morgan; I.P. Mendoza;
Pilgeram and Lefèvre; Archibald
Ramsden; Riddle and Couchman; A.
Tooth.

PRATT Stanley Claude 1882—1914.
Line., mezzo., mixed.
An. / gen. / land.
Son and pupil of J.B. Pratt (q.v.).
Aft.: Margaret Collyer, J. Farquharson,
J.F. Herring Sr., F. Paton, A. Strutt,
A. Wardle.
Pub.: Fine Art Society; Frost and
Reed; Leggatt Bros.; I.P. Mendoza; A.
Tooth.

PRESBURY George fl. London
1820s—30s.
Steel.
Gen. / illus. / land.
Aft.: T. Allom, W.H. Bartlett, P. Guerin.
Hogarth, F.W. Topham, J.M. Wright.

297

PRICE George fl. London 1840s.
Line., steel.
Illus.
Pupil of the Finden Bros. (q.v.);
emigrated to U.S.A.

PRIEST Alfred 1810—50.
PRIEST Mary fl. 1830s.
Et., litho.
Gen. / land. / marine.
Brother and sister who lived in
Norwich. Alfred, who was also a
painter, worked both as an etcher and
a lithographer; Mary was an etcher.
Alfred was a pupil of Henry Ninham
(q.v.).
Aft.: E.W. Cooke.

PRIEST Alfred 1874—1929.
Et.
Fig. / nat.
Also a portrait painter.

PRIESTMAN Bertram b. Bradford
1868.
Et.
Land.
Also a painter.

PRIOR Thomas Abiel 1809
(London) — 1886 (Calais).
Line., mezzo., steel.
*An. / gen. / hist. / illus. / land. / lit. /
myth. / ship. / topog.*
Prior was also a noted watercolourist
and designer. He settled in Calais later
in life and taught drawing there. So far
as is known he made only one
mezzotint "Sun Rising in a Mist"
(1874) after J.M.W. Turner, work on
which he shared with W. Chapman
(q.v.).
Aft.: J. Bateman, G. Chambers, E.
Duncan, J. Jacobs, Sir E. Landseer,
J. Linnell, Ruysdael, C. Stanfield, D.
Teniers, J.M.W. Turner, J. Ward, R.
Wilson.
Pub.: Art Union of London; H. Graves;
Lloyd Bros.
Lit.: *Portfolio* 1887, p. 25.

PROCTOR E.K. fl. 1831.
Steel.
Arch. / illus.
Aft.: W.H. Bartlett.

PROPERT John Lumsden 1834—
1902.
Et., mezzo., mixed.
Illus. / land.
An amateur, Propert was by profession
a physician. He was also an art critic
whose works include *A History of
Miniature Art* (1887) which helped the
revival of that art in Great Britain.
Aft.: J.M.W. Turner.
Pub.: T. Agnew.

PROUT Samuel 1783 (Plymouth) —
1852 (Camberwell).
Aq., et. (soft-ground), litho.
Arch. / illus. / land. / topog.
The distinguished landscape painter.
Educated at Plymouth grammar school
he later struck up friendships with B.R.
Haydon and David Cox, by whom he
was much influenced.
Pup.: F. Hawksworth (q.v.).
Pub.: R. Ackermann.

PRYDE James 1869 (Edinburgh) —
1941 (London).
Wood.
Posters.
With Sir William Nicholson (q.v.), and
calling themselves the "Beggarstaff
Brothers", Pryde helped to revolutionise
the art of the poster, to which he
applied wood-engraving. He is also
noted for genre painting.

PUGH Edward d. 1813.
Aq.
Illus.
Also a miniaturist and architectural
draughtsman.

PUGIN Augustus Welby Northmore
1812 (London) — 1852 (Ramsgate).
Line.
Arch. / illus. / orn.
Primarily an architect and writer,
Pugin was one of the leading figures in
the Gothic Revival. He had a successful
career but became insane at the end of
his life. He illustrated some of his own
works with engravings, among them
Designs for Gold- and Silver-Smiths
1836 and *Designs for Brass and Iron
Work* published in the same year.

PYALL H. fl. London (6 Lambeth
Walk) *c.* 1820—35.
Aq., line.
An. / gen. / illus. / mil. / port. /
railways / sport. / theat. / topog.
Not to be confused with H.T. Ryall.
Aft.: T.T. Bury, S. Galloway, J.F.
Herring Sr., S.J.E. Jones, Capt.
Marryat, J. Moore, G. Morton, J.
Pollard, T. Stothard, Capt. Thornton,
F.C. Turner, H. Walter.
Shared: S.G. Hughes, R. Smart (qq.v.).
Pub.: T. McLean.
Lit.: *Apollo* VIII, p. 62. *P.C.Q.* XII,
pp. 166, 177; XX, pp. 126, 133, 137.
Prideaux S. *Aquatint Engraving* 1909.
Wilder F.L. *English Sporting Prints*
1974.

PYE Charles 1777—1864
(Leamington).
Line., steel.
Illus. / port. / relig. / topog.
Elder brother of John Pye (q.v.).
Aft.: M. Heming, P. De Wint,
Michelangelo, J.M.W. Turner.
Pup.: C.J. Smith.
Shared: J. Pye (q.v.).

PYE John 1782 (Birmingham) —
1874 (London).
Line., steel.
Gen. / illus. / land. / marine. / relig. /
topog.
A cousin of W. Radclyffe (q.v.), John
was the younger brother of Charles
Pye (q.v.). Their father, Charles, a
writer, dissipated all his resources
indulging extravagant tastes in
expectation of a future which did not
materialise. John had therefore to
leave school prematurely and his
father began to instruct him in
engraving. Later he became a pupil of
Joseph Barker and was apprenticed to
Tolley a plate-engraver. He left
Birmingham when he was about
eighteen and was employed in London
by J. Heath (q.v.). Pye wrote several
works including *Evidence Relating to*
the Art of Engraving (1836) and *Notes*
on Turner's Liber Studiorum (1879).
He married the daughter of S.
Middiman (q.v.). He is not to be
confused with John Pye (b. 1745) the
etcher and stipple engraver.
Aft.: G. Barrett, A.W. Callcott,
Claude, G. Cuitt, J. Glover, W. Havell,
Sir E. Landseer, Michelangelo, G.
Poussin, S. Prout, D. Roberts, J.M.W.
Turner.
Pup.: J.D. Harding (q.v.).
Shared: G. Cooke, C. Heath, C. Pye
(qq.v.).
Lit.: Gage J. (ed.) *Collected*
Correspondence of J.M.W. Turner
1980.

PYNE William Henry 1769—1843.
Aq., et. (incl. soft-ground), steel.
Arch. / fig. / illus. / land.
Also known as "Ephraim Hardcastle",
Pyne was also a painter and writer. His
books include *Etchings of Rustic*
Figures for the Embellishment of
Landscapes (1814), *Costumes of Great*
Britain (1808), *The Royal Residences*
(1829), *Wine and Walnuts* (1823).

QUENTERY L. fl. 1850s.
Aq., et., mezzo.
Gen. / lit. / port. / sport.
Aft.: W. Brough, Margaret Carpenter,
W. Davidson, W. Frederick, C.
Hancock, J.F. Herring Sr., H.P. Parker,
C. Stanfield, J.M.W. Turner, W.
Worthington.
Shared: J. Harris (q.v.).
Pub.: R. Ackermann; W. Brough; J.
Carpenter; Frederick and Lombardin
(Huddersfield); H. Graves; S. Low;
Moon, Boys and Graves.
Lit.: Prideaux S. *Aquatint Engraving*
1909.

QUICK J. fl. London (4 Duke's
Court, Blackfriars) *c.* 1870.
Pub.
Juv. dram.

QUICK William Michael Roberts
1838—1927.
Wood.
Illus.

QUILLEY J.P. fl. London *c.* 1826
—42.
Aq., line., mezzo.
Flor. / gen. / illus. / lit. / port. / ship.
Aft.: R.P. Bonington, Rembrandt,
Richter, C. Stanfield, J.M.W. Turner,
Worthington.

RADCLYFFE Charles William 1817
(Birmingham) — 1903.
Litho., steel.
Arch. / land. / topog.
A son of W. Radclyffe and brother of
E. Radclyffe (qq.v). Another brother,
W. Radclyffe Jr., was a painter.
Charles also painted landscapes and
drew on the block for wood-engravers.
He worked in Birmingham.

RADCLYFFE Edward 1809
(Birmingham) — 1863 (London).
Et., line, mezzo., steel.
Gen. / illus. / land. / lit.
A son of W. Radclyffe and brother of
C.W. Radclyffe, Edward studied under
his father. He also studied under J.V.
Barber and was awarded medals by the
Society of Arts when he was fifteen
and seventeen. Having moved to
London when he was twenty-one, he
was employed by the Admiralty,
engraving charts. A close friend of
David Cox, he is especially noted for
his plates after Cox's work.
Aft.: J. Absoln, D. Cox, T. Creswick.
Pub.: Art Union of London; Colnaghi;
Lloyd Bros.
Lit.: Engen R.K. *Victorian Engravings*
1978.

RADCLYFFE T. fl. Birmingham
1810—26.
Line.
Illus. / port. / topog.

RADCLYFFE William 1783
(Birmingham) — 1855 (Edgbaston).
Line, steel.
*An. / ex libris. / gen. / illus. / land. /
port.*
William Radclyffe was a cousin of J.
Pye (q.v.). He was the father of C.W. and E.
Radclyffe (qq.v.) and of W. Radclyffe
Jr., the painter. Having been an
apprentice to Mr Tolley, a
letter-cutter, William set out with John
Pye to London where they intended to
establish themselves as engravers, but
they got no farther than Stratford-on-
Avon and returned to Birmingham
where William formed a school of
engravers. He worked extensively for
C. Heath (q.v.). At various times he
resided in Edmund Street and Paradise
Street, Birmingham, and in George
Street, Edgbaston. Plates signed
J. Radclyffe are probably the work of
this engraver.
Aft.: J.V. Barber, W. Collins, D. Cox,
F. Creswick, P. De Wint, J.D. Harding,
H. Hutchinson, R. Lawrence, S. Lines,
F. Mackenzie, W. Muller, J. Roe,
T.H. Shepherd, J.M.W. Turner, W.
Westall, B. Wyon.
Pup.: J. Garner, J.T. Willmore (qq.v.).
Lit.: *Art Journal* 1856 p. 72; 1864,
p. 40. *Art Union* 1846, p. 138.
Fincham H.W. *Artists and Engravers
of English and American Book Plates*
1897. Haydon, A. *Chats on Old Prints*
1906. *P.C.Q.* XVI, p. 176.

RADDON William fl. 1820s—60s.
Et., line., steel.
An. / gen. / illus. / land. / port.
Aft.: A. Cooper, R. Cosway, E.U.
Eddis, H. Fuseli, Sir E. Landseer,
S. Lane, Sir D. Wilkie.
Pub.: H. Graves, E. Turrell.

RAILTON Herbert 1857—1910.
Et.
Illus.
Also a draughtsman.

RAIMBACH Abraham 1776
(London) — 1843 (Greenwich).
Line (on steel plates).
Gen. / hist. / illus. / myth.
Abraham was the son of Peter
Raimbach, a Swiss who settled in
England. He became a pupil of J. Hall
(1739—97) and after completing his
apprenticeship became a student at the
R.A. Schools where he gained a silver
medal. He painted a few miniatures
but then took to engraving alone. His
method of line engraving on steel
plates was perfected by C. Warren
(q.v.). For a time he tried without
success to work on banknotes. His son
David Wilkie Raimbach (a godson of
Sir D. Wilkie) was a portrait painter
and a daughter was a miniaturist.
Aft.: J.S. Copley, Corbould, Reynolds,
R. Smirke, Thurston, R. Westall, Sir
D. Wilkie.
Pub.: Art Union of London; H.
Graves.
Lit.: Raimbach, M.T.S. *Memoirs and
Recollections [of Abraham
Raimbach]* 1843.

RAJON Paul Adolphe *c.* 1843
(Dijon) — 1888 (Auvers-sur-Oise).
Et., litho.
Illus. / port.
French national who settled in
London after the Franco-Prussian War
of 1870—71. Rajon later returned to
France where he lived with the
Barbizon painter Daubigny. He was
also a painter.
Aft.: Sir L. Alma-Tadema, J. Breton,
A. Fabri, J. Jacquet, S. Lucas, J.W.
Oakes, W.H. Ouless, Reynolds, F.
Walker, G.F. Watts; and after photos.
Pub.: T. Agnew; Boussod, Valadon
and Co.; British and Foreign Artists'

Association; Fine Art Society; M.
Knoedler; L.H. Lefèvre; E. Parsons;
Pilgeram and Lefèvre; A. Tooth.
Lit.: *Art Journal* 1876, pp. 331 f.
P.C.Q. VI, pp. 411f.
Portfolio 1874, pp. 81, 97, 113, 177;
1875, pp. 11, 33; 1876, pp. 16, 33,
112; 1877, pp. 125f.; 1878, p.9;
1885, p. 146; 1887, p. 207; 1888,
pp. 142—44.

RAMAGE George, and SON.
fl. 1870s—90s.
Pub.

RAMBERG Johann Heinrich 1763
(Hanover) — 1840 (Hanover).
Aq., chalk, line.
All. / illus. / port. / theat.
Ramberg came to England early in
life, where it is said he was a pupil of
Sir Joshua Reynolds and of F.
Bartolozzi (q.v.). He made many
caricatures for George III who
mentioned him to Benhamin West; as
a result he became a student at the
R.A. Schools where he was awarded a
silver medal. Ramberg travelled widely
in Italy, France, Holland and
Germany. He was also a painter.
Aft.: Ramberg made designs after
allegorical sketches by Princess
Elizabeth (later Landgravine of
Hesse-Homburg) which were
lithographed in Hanover by Julius
Gere.
Des.eng.: W. Nutter, J. Ogborne, W.
Pether, E. Scott, W. Ward (qq.v.); and
the foreign engravers J.F. Bolt, Baron
Denon and P.A. Martini.

RAMSAY James 1786 (Newcastle-
on-Tyne) — 1854.
Et.
Gen. / hist. / port.
Also a painter, Ramsay worked in
London.

RANDALL James fl. 1798—1814.
Aq.
Arch.

RANDOLPH Mrs Charles fl. 1851.
Litho.
Illus.

RANSOM Thomas Frazer 1784
(Sunderland) — 1828.
Line.
Port.
Ransome was apprenticed to an
engraver in Newcastle-on-Tyne. In
1814 he received the Society of Arts
medal for an engraved portrait, in
1821 the Society's gold medal for line
engraving, and in 1822 he received a
second gold medal for his engraving
after Wilkie's "Duncan Gray". In 1818
he became involved in a controversy
concerning the prevention of forgery
of Bank of England notes. He was put
on trial for possessing a forged
banknote, but the jury thought the
note was genuine and Ransom was
acquitted.
Aft.: T. Phillips, Sir D. Wilkie.
Pup.: W. Nicholson (q.v.).

RAVENHILL Leonard b. 1867.
Wood.
Illus.
Worked for *Punch.*

RAVENET Simon 1755 (London)
— 1813 or after.
Line.
Myth. / port.
Son and pupil of the French engraver
Simon François Ravenet, Simon
Ravenet studied under Boucher. He
then proceeded to Parma in Italy
where he endeavoured to engrave all
the works of Correggio in the city; he
was thus engaged 1779—85, and was
made a chevalier in recognition of this
work.
Aft.: Correggio, D. Morier, Rubens.
Pup.: Thomas Cook, R. Hancock
(qq.v.).

RAWLE G. fl. 1841.
Steel.
Arch. / illus.
Possibly a son of S. Rawle (q.v.).
Aft.: T. Allom.

RAWLE Samuel 1771 (London)
— 1860.
Et., Steel.
Illus. / ship. / topog.
Pupil of the Finden Bros (q.v.). Also
a watercolourist. Possibly the father of
G. Rawle (q.v.).
Aft.: N. Pocock.

RAWLINS T.J. fl. 1837.
Aq.
Illus.
Shared: H. Allen, E. Duncan (qq.v.).

READ David Charles 1790
(Lymington) — 1851 (Kensington).
Dry., et., line.
Illus. / land. / port.
Read went to London early in life,
and perhaps was a pupil of John Scott
(q.v.). He settled in Salisbury in 1820,
and became an art teacher, he also
practised drawing and watercolour
and, later, oil painting. In 1826 he
began to etch and in time etched five
plates a week — finally achieving a
total of 237 plates. He destroyed
sixty-three of these himself and his
family destroyed the remainder after
his death.
Aft.: Hogarth, J. Linnell.
Lit.: Craddock and Barnard *Modern
Etchings (19th and 20th Centuries),*
No. 135, 1977.

READ William fl. 1820s and 1830s.
Aq., steel.
Illus. / land. / port. / ship.
Aft.: W.J. Huggins, J. Varley.

READING Burnet or Benjamin
fl. 1770—1820.
Stip.
Illus. / lit. / port.
Reading, who was born in Colchester,
practised his art in London, where he
worked exclusively for booksellers. He
was riding and drawing master to Lord
Pomfret at Windsor.
Aft.: W. Bigg, P. Falconet, Mortimer.
Pub.: T. and H. Rodd.

REDAWAY James C. fl. 1818—57.
Line, steel.
Illus. / land. / topog.
Pub.: W. Evans ("Evans of Eton");
J. Hogarth.

REDAWAY W. fl. 1880s.
Et.
An. / gen.
Aft.: F. Paton.
Pub.: M. Knoedler; Leggatt.

REDGRAVE Richard, R.A.
1804—88.
Et.
Gen. / illus. / land. / lit. / relig.
Redgrave is best known as a painter
and writer, especially for the book *A
Century of Painters of the English
School.* He was in 1826 admitted as
a student to the R.A. Schools, and
later in life was largely responsible for
organising the Government School of
Design. From 1857 to 1880 he was
surveyor of Crown pictures of which
he made a detailed catalogue. For a
time he was Secretary of the Etching
Club. His elder brother, Samuel
Redgrave (q.v.) was co-author of
A Century of Painters.

REDGRAVE Samuel 1802—76.
Et.
Illus.
Elder brother of Richard Redgrave
(q.v.) whom he succeeded as secretary
of the Etching Club. Samuel is best
known as a writer; he was co-author
with Richard of *A Century of Painters
of the English School* (1866).

REDINGTON John 1819—76.
Pub.
Juv. dram.
Agent for sneets of Crawford and
J.K. Green. His own agents were Myers
and Co. (q.v.). Redington's premises
were at 208 Hoxton Old Town
(renamed and renumbered 73 Hoxton
Street) London.

REDMAN D.J. fl. early 19th c.
Printer (litho).
The first English lithographic printer,
who had worked with G.J. Vollweiler.

REES George fl. London (41—43
Russell Street, Covent Garden) 1880s.
Pub.

REEVE A.W. fl. early 19th c.
Aq.
Illus.
Shared: R.G. Reeve (q.v.).

REEVE Herbert b. 1870.
Et.

REEVE R.G. fl. London 1800—40.
Aq., mixed.
*All. / gen. / hist. / illus. / mil. /
railways / ship. / sport. / topog.*
Reeve, who worked in London and
Dorking, also painted occasionally.
Aft.: G.H. Alken Jr., H. Alken, H.
Berthoud, S. Bourse, J. Collard,
D. Cox, R. Davis, J. Doyle, Evans,
J.F. Herring, W.P. Hodges, G.H.
Laporte, F. Marshall, C.B. Newhouse,
J. Pollard, R. Pollard, Pretty, W.
Purser, J. Styles, F.C. Turner, J. Ward,
Warre, C.J. Williams.
Shared.: H. Alken, A.W. Reeve, T.
Reeve, C. Rosenberg, R.W. Smart
(qq.v.).
Pub.: Brall and Sons; Fores; S. and J.
Fuller; J. Laird; Landou; J.
McCormack; T. McLean; J. Watson.
Lit.: *Apollo VII*, pp. 160, 163.
Connosseur LXXXII, pp. 159, 187.
Laver, J. *English Sporting Prints* 1970.
P.C.Q. XII, pp. 175, 180; XVII, pp.
170, 177f.
Prideaux S. *Aquatint Engraving* 1909.
Wilder F.L. *English Sporting Prints*
1974.

REEVE Thomas fl. London *c.* 1820.
Line.
Gen. / sport. / topog.
Aft.: H. Alken, L. Clennell, Hodges,
R. Pollard, Wolstenholme.
Shared: H. Alken, R.G. Reeve (qq.v.).

REIVELEY James fl. early 19th c.
Wood.
Illus.
Pupil of T. Bewick (q.v.).

REMINGTON A. Wallace fl. 1880s.
Et.
Land.
Pub.: Fine Art Society.

REVEL Alfred d. 1865.
Steel.
Gen. / illus.
French national, some of whose plates
were published in England.

REVILLE J., and CO. fl. late 19th c.
Pub.
Issued photo-engravings made by the
Autotype Company and Swan Electric
Engraving Company (qq.v.).

REYNOLDS Elizabeth (née Walker)
1800 (London) — 1876 (London).
Line.
Port.
Pupil of T.G. Lupton and G. Clint.

REYNOLDS Frank d. Scarborough
1895.
Mezzo.
Port.
The son of S.W. Reynolds Jr., Frank
Reynolds was also a portrait painter.
Aft.: Caroline Boyle.

REYNOLDS Samuel William 1773
(West Indies) — 1835 (Bayswater).
Aq., mezzo., mixed, stip.
*All. / gen. / hist. / land. / lit. / mil. /
myth. / nat. / port. / relig. / sport. /
topog.*
Reynolds was descended from a
family owning property in the West
Indies and was himself born there. He
was sent to England to be educated
and settled here, studying at the R.A.
Schools and becoming a pupil of the
landscape painter William Hodges R.A.
He afterwards tried engraving and in
this was a pupil of V. Green and J.R.
Smith (qq.v.); he met with great
success. Reynolds became drawing
master to the daughters of George III
and was appointed engraver to the
King. He was offered a knighthood but
refused. During several visits to Paris
he made engravings after works by
French artists and exhibited at the
Salon. His patrons included Samuel
Whitbread, and Sheridan and Edmund
Kean were among his friends. He was
the father of Samuel William Reynolds
Jr. (q.v.).
Aft.: R. Ansdell, Barney, P. Boileau,
R.P. Bonington, M. Brown, Charlet,
L. Cogniet, W. Collins, Constable,
R. Cosway, Dance, Duntoux, De La
Roche, S. del Piombo, Debufe,
Eckstein, Fradelle, W.P. Frith,
Géricault, Gourbaud, Mme.
Haudebourg-Lescot, J.R. Herbert,
Hoppner, J. Jackson, J.P. Knight,
Sir T. Lawrence, V. Le Brun, S. Lover,
Michelangelo, G. Morland, Northcote,
J. Opie, W. Owen, Parkes, Sir R.K.
Porter, Ransdell, Rembrandt,
Reynolds, E. Rippingill, G. Romney,
H. Singleton, J.R. Smith, Stephanoff,
F. Taylor, J.M.W. Turner, C.F. van
Breda, H. Vernet, J. Ward, J. Watson,
F. Wheatley, D. Wolstenholme, Zoffany.
Assist.: T.G. Lupton (q.v.).
Pup.: S. Cousins, D. Lucas, J. Lucas,
H.T. Ryall (qq.v.), H. Hodges
(1744—97).
Lit.: Whitman A. *Masters of
Mezzotint: Samuel William Reynolds*
1903.

REYNOLDS Samuel William Jr.
1794—1872 (Felpham).
Et., line, mezzo.
*Gen. / hist. / illus. / port. / sport. /
stamps.*
S.W. Reynolds Jr. was the son of
S.W. Reynolds Sr. and father of F.
Reynolds (qq.v.). He began life as
private secretary to his father's patron
Samuel Whitbread. He took lessons
from William Owen the portrait
painter, and painted a number of
portraits which were exhibited at the
R.A. 1820—45. His father's health
deteriorated and Samuel abandoned
printing in order to help him complete
his commissions, and he thereafter
devoted himself exclusively to
engraving. He engraved the famous
"Prince Consort Essays" for proposed
postage stamps in 1850.
Aft.: R. Ansdell, Aylmer, S. Bostock,
W. Boxall, Hon. Carolina Boyle,
W. Bradley, T. Brooks, C. Clint, W.
Collins, M. Cregan, C. DuVal, A. Egg,
R. Evans, B.J. Faulkner, W.P. Frith,
O. Garside, Sir F. Grant, J. Hayter,
J. Hollins, J.P. Knight, S. Lane, C.R.
Leslie, J. Lonsdale, J. Lucas, D.
Maclise, O. Oakley, H.P. Parker,
H.W. Phillips, H.W. Pickersgill, E.V.
Rippingille, S. Rosa, J. Sant, W. Scott,
Sir M. Shee, J. Stewart, F. Taylor,
J.M.W. Turner.
Shared: T.J. Chant, S.W. Raynolds Sr.,
W. Walker (qq.v.).
Pub.: A. Ackermann; T. Agnew;
Anaglyphic Co.; T. Boys; Colnaghi;
S. Fuller; Gambart; Goupil and Vibert
(Paris); J. Grundy; Alexander Hill
(Edinburgh); J. and R. Jennings;
H. Lacey; T. McLean; J. Murray;
J. Sheppard; R. Swales; W. Walker.
Lit.: Whitman A. *Masters of
Mezzotint: Samuel William Reynolds*
(1903) (contains also biography of
S.W. Reynolds Jr., and a catalogue of
his engravings).

REYNOLDS Warwick 1800—26.
Et.
An.
Also an illustrator, Reynolds was the
son of Warwick Reynolds Sr., the
artist. He lived in Glasgow.

RHEAD George Wooliscroft 1855—
1920 (London).
Et., mezzo.
Gen. / hist. / illus. / lit. / myth. /
port. / topog.
A pupil of A. Legros (q.v.) and F.
Madox Brown, Rhead worked in
London. He expressed himself in
many media, for example fan painting,
and was also a critic and writer, his
books including *A Handbook of*
Etching.
Aft.: F. Barraud, G. Boughton, F.M.
Brown, L. Fildes, T. Hemy, J. Pettie,
J. Philip, M. Stone, A.H. Wardlow,
G.F. Watts.
Pub.: Dickinson and Foster.
Lit.: *Art Journal* 1903, pp. 246—49;
Connoisseur LIII, p. 230; LVIII, pp.
75—82.
Studio 1916, p. 138; 1920, p. 150.

RHODES Richard 1765—1838
(Camden Town, London).
Line.
Arch. / illus. / port.
Rhodes was for many years principal
assistant to C. Heath (q.v.).
Aft.: Fuseli, Geddes, Howard, T.
Stothard, Thurston, R. Westall.

RICHARDS Fred 1878 (Newport)
— 1932 (London).
Et.
Illus. / topog.
Richards studied at the School of Fine
Arts, Newport and at the Royal
College of Art under Sir F. Short
(q.v.). From 1926 to 1931 he travelled
in the Middle East. He was also a
draughtsman.

RICHARDS J. fl. 1832.
Steel.
Illus. / land.
Aft.: W. Tombleson.

RICHARDSON Charles fl. 1830s—
40s.
Steel.
Arch. / illus. / land.
Aft.: W.H. Bartlett.

RICHARDSON George c. 1836 — c.
1817.
Aq.
Illus.
Best known as an architect.
Richardson gained a premium from
the Society of Arts in 1765. He
travelled in the Mediterranean,
studying remains of ancient
architecture, 1760—63.

RICHARDSON George K. d. about
1891.
Steel.
Illus. / land.
Aft.: T. Allom, W. H. Bartlett, L.
Clennell, H. McCulloch.

RICHARDSON H.L. 1878—1947.
Et.

RICHARDSON Thomas Miles Sr.
1874—1948.
Aq., et.
Arch.
Also a painter.

RICHARDSON William fl. late
1840s—60.
Line, steel.
Gen. / topog.
Aft.: J.C. Brown, D.O. Hill, J.A.
Houston, J.P. Knight.
Pub.: H. Graves, Alexander Hill;
James Keith; Royal Association of
Fine Arts, Scotland.
Lit.: *Art Journal* 1862, p. 12.
Hayden A. *Chats on Old Prints* 1906.

RICHMOND George 1809
(Brompton) — 1896 (London).
Et., line.
Lit. / port. / relig.
George Richmond, a son of Thomas
Richmond the miniature painter
became one of the most successful and
fashionable portrait painters of the
19th century. His engravings were
made early in life. There were three
altogether, two line engravings made in
1827 and an etched portrait after

Filippino Lippi made in 1844. The two engravings show the influence of the work of his friends William Blake, Edward Calvert and Samuel Palmer (qq.v.).
Pup.: F. Sandys (q.v.).
Lit.: Lister R. *George Richmond* 1981. *P.C.Q.* XVII pp. 352—62.

RICHMOND W.D. fl. 1870s.
Litho., print.
Author of *The Grammar of Lithography*, first published in 1878, and the most detailed book on chromolithography published in England during the 19th century. He managed the lithographic department in the printing firm of Wyman and Sons.

RICHTER H.C. fl. 1840s—60s.
Litho.
An.
Collaborated with S. Gould (q.v.) on several of his books of birds.

RICKETTS Charles R.A. 1866 (Geneva) — 1931 (London).
Litho., wood.
Ex libris. / illus.
At an early age Ricketts travelled abroad in France and Italy with his mother. When she died in 1879 he returned to England and it is said he could hardly speak English. He was a pupil of W.H. Hooper (q.v.) and was apprenticed to Roberts a wood-engraver who was teaching at the City and Guilds Art School. He there met C.H. Shannon (q.v.) who was to be his lifelong friend and collaborator. Together they founded the Vale Press, which printed and published over eighty books.
Ricketts was also a painter and stage designer.
Lit.: Calloway S. *Charles Ricketts* 1979.
Moore T. Sturge *Charles Ricketts R.A.* 1933. *P.C.Q.* XIV, pp. 194—217.

RIDGWAY William fl. London 1860s—80s.
Line, steel.
Gen. / hist. / illus. / lit. / relig. / stamps / topog.
Ridgway worked for the security

printers, Perkins, Bacon and Co. (q.v.), where his work included dies for the 1895 issue of stamps for Sarawak. He also worked in New York with the American engraver, William Wellstood.
Aft.: E. Armitage, J. Burr, T. Girard, W.H. Hunt, F.R. Pickersgill, Sir E. Poynter, J. Phillip, M. Stone.
Pub.: Gambart.

RIDLEY Matthew White 1837 (Newcastle-on-Tyne) — 1888.
Dry., et.
Gen. / illus. / topog.
Ridley attended the R.A. Schools. He was a member of the Société des Aqua-Fortistes, Paris.
Lit.: *Connoisseur* Vol. LXXIV p. 251.
Portfolio 1873, pp. 81f.

RIDLEY Mathew White 1837—88.
Et.
Ship.
Lit.: Hamerton P.G. *Etching and Etchers* 1868.

RIGBY Harold A. fl. London early 20th c.
Line.
Genre.
Aft.: G. Sykes.

Riley Thomas fl. 1880—92.
Et.
Arch.

RIMNIER Alfred 1829 (Liverpool) — 1893 (Chester).
Wood.
Illus.
Also an antiquary.

RIPPER Charles b. 1864.
Et.

RIPPIN J. fl. London (Theobald's Road) 1818.
Pub.
Tinsel.

RITCHIE Alexander Hay 1822 (Glasgow) — 1895 (Brooklyn).
Line.
Port.
Richie, who was a pupil of Sir W. Allan (1782—1850) was also a painter. He moved to New York in 1841.

RIVIERE Briton R.A. 1840—1920.
Et.
An.
Best known as a painter, especially of
animal subjects.

ROBERTS David R.A. 1796
(Edinburgh) — 1864 (London).
Et., litho.
Arch.
Best known as a painter, Roberts was
the son of a shoemaker and began life
as an apprentice to a house-painter and
decorator. Later in 1822, he became a
theatrical scene-painter in Drury Lane
Theatre, London. He went to
Normandy soon afterwards and made
many topographical and architectural
studies. In 1824 he became a member
of the Society of British Artists and
gradually established himself as a
painter, becoming A.R.A. in 1839 and
R.A. in 1841.

ROBERTS Edward John 1797—1865.
Et., line., steel., stip.
Illus. / land. / myth.
Roberts was a pupil and assistant of
C. Heath (q.v.) from whose work
Roberts's is often indistinguishable. He
was noted for his work in laying etched
foundations on plates that were to be
engraved.
Aft.: A. Bouvier, Birket Foster,
J. Martin, S. Prout.
Shared: T. Rowlandson (q.v.).
Pub.: Lloyd Bros.
Lit.: *Art Journal* 1865, p. 140.

ROBERTS F. Angelo fl. 1830s—70s.
Steel.
Gen. / port.
Aft.: G. Harvey, T.H. Illidge,
J. Lonsdale.

ROBERTS J. fl. 1830s—40s.
Steel.
Illus. / land. / port.
Aft.: W.H. Bartlett, C.L. Eastlake.

ROBERTS P. fl. 1795—1828.
Line.
Port.
Perhaps identical with the aquatinter
Percy Roberts.
Shared: Joseph C. Stadler (q.v.).

ROBERTS R. fl. 1836.
Steel.
Illus. / land.
Aft.: C. Pickering.

ROBERTS Walter fl. London 1860.
Photographer.
A pioneer of the technique of
transferring a drawing to a wood-block
by means of photography.

ROBERTSON Alexander 1768
(Monymusk, Aberdeen) — 1841 (New
York).
Line.
Land.
Also a painter, Alexander Robertson
was a brother of the painters Andrew
and Archibald Robertson (q.v.), and
was a pupil of the latter. He also
painted miniatures and studied that art
under Samuel Shelley. In 1792 he
joined Archibald who had gone to
New York and with him founded an
academy of design.

ROBERTSON Archibald 1765
(Monymusk) — 1835 (New York).
Line.
Land.
Also a painter, Robertson studied
under Charles Sheriff of Bath and at
the R.A. Schools. He went to America
in 1791 where he painted portraits of
Washington and his family, and became
director of the National Academy of
Design in New York. He wrote a
treatise on the art of miniature
painting which was published in 1895
in *Letters and Papers of Andrew
Robertson* (another brother).

ROBERTSON Arthur b. 1850.
Et.
Worked in London.

ROBERTSON Charles 1844—91
(Walton-on-Thames).
Et.
Gen. / topog.
Robertson lived and worked in Aix-en-
Provence, Liverpool and Surrey. He
was also a painter. Father of
P. Robertson (q.v.).
Pub.: Dowdeswell and Dowdeswells.

ROBERTSON Henry Robert 1839
(Windsor) — 1921 (London).
Et., line.
Gen. / illus. / land. / topog.
Robertson who lived and worked in
London, studied at the Royal College
of Art. He also painted in oil,
watercolour and miniature (he was a
member of the Royal Society of
Miniature Painters) and wrote several
books, including *The Art of Etching
Explained and Illustrated* 1883.
Aft.: J. Constable, T. Lloyd,
J. MacWhirter, Sir W.Q. Orchardson,
Reynolds, C. Whymper.
Pub.: A. Ackermann; William Farren;
Fine Art Society; H. Graves.

ROBERTSON Percy 1868 (Bellagio,
Italy) — 1934.
Et.
Land. / topog.
The son of C. Robertson (q.v.), Percy
worked in Godalming and London.
Pub.: Fine Art Society.
Lit.: *Art Journal* 1889, p. 333; 1890,
p. 129; 1891, p. 193; 1892, p. 257;
1898, p. 321; 1899, p. 304; 1905,
p. 104. *Studio* Special No. 1915—16;
1919, pp. 18f.

ROBERTSON and MOFFAT
fl. early 20th c.
Pub.
Distributed plates made by the Art
Photogravure Co. (q.v.).

ROBINS Mabel Louisa 1884—1917.
Et.

ROBINSON Charles F. fl. 1870s—80s.
Et.
Land.
Also a painter.

ROBINSON George b. 1854.
Et.

ROBINSON Gerald Philip 1858
(London) — 1942 (Kelson, Bath).
Mezzo.
Gen. / lit. / port.
The son of Sir J.C. Robinson (q.v.),
Gerald Philip attended the Slade
School. He became engraver to Queen
Victoria from 1890 and to King
Edward VII from 1901, and was the
first president of the Society of
Mezzotint Engravers. He worked in
London, Leatherhead and Swanage.
Aft.: F. Dicksee, Gainsborough, Hals,
F. Holl, Lord Leighton, G. Romney,
Van Dyck.
Pub.: T. Agnew; Fine Art Society;
H. Graves; A. Lucas; T. McLean.
Lit.: Davenport C. *Mezzotints* 1904.

ROBINSON H. fl. 1866.
Wood.
Illus. / sculpt.
Aft.: T. Woolner.

ROBINSON Henry — See John
Henry Robinson.

ROBINSON Sir John Charles 1824
(Nottingham) — 1913 (Swanage).
Et.
Land. / marine. / topog.
The father of P. Robinson (q.v.) Sir
John was also a noted landscape painter
and had studied in Paris. He was a
member of the Society of Antiquaries,
superintendent at South Kensington
1852—69 and surveyor of the Queen's
pictures for twenty years. He rarely
signed his etchings.
Pub.: Colnaghi.
Lit.: *P.C.Q.* VIII, pp. 299—322. *Studio*
Spring number 1902; Special number
1913; XXVI, pp. 301—7.

ROBINSON John Henry R.A. 1796
(Bolton) — 1871 (Petworth).
Line., mezzo., mixed., steel., stip.
Gen. / hist. / illus. / land. / port. / topog.
Robinson, a former pupil of J. Heath
(q.v.), worked at Petworth. He was
possibly identical with "Henry
Robinson" to whom several plates
were attributed at this period. He
married a lady of property late in life.
In 1836 Robinson was one of a group
of artists which petitioned the House
of Commons to investigate the state of
engraving in this country, and of the
group which in 1837 petitioned the
King to request the admission of
engravings to the R.A. This did not
happen for some years afterwards.
J.H. Robinson was himself elected
A.R.A. in 1856 and R.A. in 1867. He
became an honorary member of the
Academy of Fine Arts at Saint Petersburg.

Aft.: J. Absolon, C. Baxter, W. Bradley,
T. Carrick, A.E. Chalon, G. Dawe,
B.R. Faulkner, P.A. Gaugain, Sir G.
Hayter, Miss Hayter, Isabey,
J.T. Jenkins, Sir. E. Landseer, Sir T.
Lawrence, C.R. Leslie, W. Mulready,
Murillo, G.S. Newton, E.T. Parris,
J. Partridge, T. Phillips, H.W.
Pickersgill, G. Richmond, H.C. Selous,
F.P. Stephanoff, F. Stone, T. Stothard,
Van Dyck, F. Walker, Sir D. Wilkie,
E. Williams.
Assist.: B.P. Gibbon (q.v.).
Pub.: H. Graves; J.C. Grundy;
J. Hogarth; Leggatt, Hayward and
Leggatt; T. McLean; F.G. Moon;
A. Whitcombe with Colnaghi.
Lit.: *Art Journal* 1871, p. 293.
Engen R.K. *Victorian Engravings* 1975.
P.C.Q. XVIII, pp. 233, 239.

ROBINSON Mabel Catherine 1875—
1953.
Et.
Arch. / topog.
Worked in London. Pupil of Sir F. Short.

ROBINSON Thomas 1770—1810
(Dublin).
Line.
Port.
Pupil of Romney.

ROBSON T. fl. 1820—30.
Line.
Ex libris.
Possibly connected with a copperplate
engraver, Thomas Frederick Robson
(1822?—1864) who later became an
actor under his real name which was
Thomas Robson Brownhill.
Lit.: *P.C.Q.* XVI, p. 271; XVIII, p. 296.

ROCK and CO. fl. London 1850s—
60s.
Steel.
Topog.

ROE Robert Henry 1793
(Cambridge) — 1880.
Et.
Land. / topog.
Son of the painter Fred Roe, R.H. Roe
worked in London and Scotland. He
was also a painter in oil and miniature.
He is sometimes referred to in error as
"R.E. Roe".

Aft.: H.B. Carter.
Pub.: C.E. Clifford.

ROFFE A. fl. 1830—55.
Steel.
Port.
A relative of J., R., W.C. and W. Roffe
(qq.v.).

ROFFE Edwin fl. 1852-77.
Steel.
Illus.
Probably a relative of A., J., R.,
W.C. and W. Roffe (qq.v.).

ROFFE John 1769—1850 (Upper
Holloway).
Line., steel.
Antiq. / arch. / illus. / port.
A relative of A., R., W.C. and W. Roffe
and probably of E. Roffe (qq.v.).

ROFFE R. fl. 1820s—30s.
Steel.
Illus. / land.
A relative of A., J., W.C. and W. Roffe.

ROFFE W. 1820(?)—90(?).
Steel.
Illus.
Relative of A., J., W.C. and W. Roffe.
and probably of E. Roffe (qq.v.),
W. Roffe is noted for his work on
illustrations for Ruskin's *Fors Clavigera*
(1883—84).
Aft.: Kate Greenaway.

ROFFE William Callio 1817
(London) — *c.* 1884.
Line., mezzo., steel., stip.
An. / gen. / hist. / illus. / land. / port. /
sculp.
W.C. Roffe was a relative of A., J., R.,
and W. Roffe and probably of E. Roffe
(qq.v.). The family included many
other painters and engravers. W.C.
Roffe was particularly noted for his
plates after Sir E. Landseer.
Aft.: J. Adam-Acton, E.H. Baily,
T. Brooks, J.H. Foley, G. Hayter,
Sir E. Landseer, Mrs Thorneycroft.
Pub.: H. Graves.
Lit.: *Art Journal* 1849 and *passim. Art*
Union 1848, pp. 20, 72, 104, 138,
182, 320.

ROGERS John fl. 1820s—50s.
Line., litho., steel., stip.
Illus. / port. / relig. / ship.
Rogers went to U.S.A. in 1851.
Aft.: A. Cooper, G. Harlowe, A.M.
Huffam, Raeburn, Raphael, H. Room.
Pub.: J. Limbird; J. Rogers; G. Virtue.

ROGERS Philip Hutchings *c.* 1786
(Plymouth) — 1853 (Lichtenthal,
Baden-Baden).
Et.
Illus.
Rogers, who was also a painter, was
educated at Plymouth Grammar School
under John Bidlake, who encouraged
his interest in art and paid for him to
study in London. He later returned
and settled in Plymouth.

ROGERS William Gibbs 1792
(Dover) — 1875 (London).
Wood.
Illus.

ROLLER George fl. 1860s.
Et.

ROLLINSON William 1762 (Dudley)
— 1842 (New York).
Illus., line., stip.
Ex libris / port.

ROLLS Charles 1800 — *c.* 1857.
Line., steel.
Gen. / illus. / port. / theat.
Rolls worked at times as an assistant
to the Finden brothers (qq.v.).
Aft.: R. Buss, R. Farrier, G.H. Harlow,
J.R. Herbert, Sir E. Landseer, Sir T.
Lawrence, T. Uwins, P. Williams.
Pup.: W.T. Davey, L. Stocks (qq.v.).
Pub.: A. Ackermann; H. Graves;
W. Hayward.

ROLLS Henry fl. 1839.
Line., steel.
Illus.
Pub.: Ackermann.

ROLLS J. fl. 1838.
Steel.
Gen. / hist. / illus.
Aft.: F.P. Stephanoff.

ROLPH John or J.A. fl. 1820s—30s.
Steel.
Arch. / illus. / land.
Aft.: T. Allom, W. Purser, G. Shepherd,
T.H. Shepherd, W. Tombleson.

ROMNEY John 1786—1863
(Chester).
Et., line., mixed., steel.
Arch. / gen. / illus. / lit. / sculp.
Aft.: R. Farrier, Gill, Smirke,
W.F. Witherington.
Pup.: R. Graves (q.v.).

ROOKE H. fl. early 19th c.
Aq.
Illus.

ROSCOE Mrs Edward fl. 1820s.
Litho.
Flor. / illus.

ROSE H.F. fl. London 1810—20.
Line.
Ex libris / port.

ROSENBERG Christian fl. London
c. 1790—*c.* 1815.
Aq.
Gen. / land. / ship. / sport. / topog.
Rosenberg, who was probably a brother
of F. Rosenberg and was probably
related to R. Rosenberg (qq.v.), was
portrait painter to George III and
Queen Charlotte.
Aft.: J.L. Agasse, W. Bartels,
B. Beaufoy, R.B. Davis, W.J. Huggins,
Newhouse, J. Pollard, T. Rowlandson.
Shared: E. Duncan, R.G. Reeve,
R. Rosenberg, T. Rowlandson.
Pub.: W. Huggins.
Lit.: Wilder F.C. *English Sporting
Prints* 1974.

ROSENBERG Felix fl. early 19th c.
Aq., mixed.
Sport.
Probably a brother of C. Rosenberg
and probably related to R. Rosenberg
(qq.v.).
Aft.: J. Pollard.
Pub.: J. Watson.
Lit.: Wilder F.L. *English Sporting
Prints* 1974.

ROSENBERG R. fl. early 19th c.
Aq., mezzo., mixed.
Sport.
Probably related to C. and F.
Rosenberg (qq.v.).
Aft.: J. Pollard.
Shared: C. Rosenberg (q.v.).

ROSENTHAL G. fl. mid 19th c.
Litho.
Arch.
Aft.: J. Ruskin.

ROSENTHAL S. fl. 1860s.
Line.
Port.
Also a painter.

ROSS James ?1745—1821
(Worcester).
Line.
Land. / topog.
Ross was in 1765 a pupil of R. Hancock
(q.v.). He had a considerable reputation
for his transfer prints for pottery.
Aft.: V. Green, Powle.

ROSSITER Charles b. 1827.
Et.
Gen.
Also a painter.

ROTHENSTEIN Sir William 1872
(Bradford, Yorks) — 1945 (Far
Oakridge).
Et., litho.
Land. / port. / topog.
Rothenstein was a pupil of A. Legros
(q.v.) at the Slade School and
afterwards completed his art education
in Paris. From 1920 to 1935 he was
principal of the Royal College of Art.
His lithographs were made between
1893 and 1900. He was also a painter.
Lit.: Stein D. and Karsham D.
*L'Estampe Originale. A Catalogue
Raisonné* 1970.

ROTHWELL Selim Botton 1815
(Manchester) — 1881 (Bolton).
Et.
Arch. / topog.
Also a watercolourist.

ROTHWELL Thomas ?1742—1807
(Birmingham).
Line.
Port.
Also a painter in enamel.

ROUSE J. fl. 1817.
Aq.
Illus.

ROUSSEL Theodore Casimir 1847
(Lorient, Morbihan) — 1926 (Hastings).
Aq., et. litho.
Gen. / land. / port. / topog.
A pupil of J.McN. Whistler (q.v.), this
French-born artist was also a painter.
He settled in Britain in 1847, and
began etching in 1888.
Lit.: *P.C.Q.* XIV, p. 325. Rutter F.
Theodore Roussel 1926.

ROUVEYRE Louveau fl. 1880s.
Et.
Relig.
French national who made at least one
plate after a work by a British artist
which was published in England.
Aft.: Alice Havers (Mrs Morgan).
Pub.: Fine Art Society.

ROWE George 1797 (Dartmouth) —
1864 (Exeter).
Litho.
Land. / port.
Also a painter.

ROWE H. fl. 1846.
Steel.
Illus. / land.
Aft.: W. Tombleson.

ROWE N. fl. early 19th c.
Et.
Land. / topog.
Aft.: Prout.

ROWLANDSON Thomas 1756
(London) — 1827 (London).
Aq., et
*Caric. / gen. / hum. / illus. / land. /
lit. / mil. / port. / sport. / topog.*
The son of a tradesman, Rowlandson,
who had shown early promise as a
draughtsman, studied at the R.A.
Schools, after which he visited Paris.
In 1777 he was back in London where
he set up as a portrait painter. After

1781 he devoted himself to caricature, though the extent of exaggeration in his studies varied considerably. He gave a wonderful portrayal of contemporary social life.

It has been said that his method of making a caricature print was first to make a watercolour drawing and then to etch the principal outlines on the copper plate, which was then aquatinted or coloured by a craftsman as close as possible to the drawing.

He was the brother-in-law of S. Howitt (q.v.).
Aft.: Bunbury, Baudouin, Gainsborough, G. Morland, Woodward.
Shared: S. Alken, E.J. Roberts, C. Rosenberg, H. Wigstead (qq.v.).
Pub.: Ackermann, T. Tegg, Robert Walker.
Lit.: Falk B. *Thomas Rowlandson: his Life and Art* 1949. *Gazette des Beaux-Arts* 1909, p. 287. Grego J. *Rowlandson the Caricaturist* 1880. *Magazine of Arts* 1902, p. 219. *P.C.Q.* II, pp. 388—406; XIX, pp. 11—30. *Printseller* XI, p. 63. Thornber H. *Thomas Rowlandson and his Work* 1886.

RUDGE Bradford fl. 1860s — early 1870s.
Litho.
Port. / sport.
Also a landscape painter.
Aft.: G. Madeley.

RUET Louis Valerie 1861 (Paris) — after 1905.
Et.
Gen.
French national who made a number of plates after works by British artists which were published in England.
Aft.: T. Blinks, F.C. Cowper, D. Downing, G.G. Kilburne.
Pub.: C.E. Clifford; J. Connell and Sons; Fine Art Society; C. Klackner; Mawson, Swan and Morgan.

RUOTTE Louis Charles 1755 (Paris) — 1814 (London).
Et., line., stip.
All. / myth. / port.
French national who worked in London for some years.
Aft.: R. Cosway, Gregorius, Angelica

Kauffmann, Le Fevre, Scholl, R. Westall.

RUSHBURY Sir Henry George R.A. 1880—1968.
Dry., et.
Arch. / land. / topog.
Rushbury studied at the Birmingham School of Art, and came to London in 1912. He was much influenced by Muirhead Bone (q.v.).
Lit.: *P.C.Q.* X, pp. 403—33. Salaman *M.C. Henry Rushbury* Modern Masters of Etching No. 18, 1928.

RUSKIN John 1819—1900.
Et., litho.
Land.
The great art historian. His etchings are mostly outlines.

RUSSELL Elizabeth Laura Henrietta (later Mrs Wriothesley) d. 1886.
Et.
Gen. / port.
Aft.: Callot, Rembrandt.

RUSSELL S. fl. 1840.
Steel.
Illus. / land.
Aft.: J.M. Wright.

RUSSELL Walter Westley b. London 1867.
Et.
Land.
Also a painter.

RUTHERFORD A. fl. late 18th— early 19th c.
Et.
Land. / port. / topog.

RUTTER T.W. b. 1874.
Et.

RYALL Henry Thomas 1811 (Frome) — 1867 (Cookham).
Aq., line., mezzo., mixed., steel., stip.
All. / gen. / hist. / illus. / lit. / mil. / port. / relig. / sport.
Ryall, who also painted in oils, was a pupil of S.W. Reynolds (q.v.). He held the appointment of historical engraver to the Queen. Not to be confused with H. Pyall.
Aft.: R. Ansdell, Rosa Bonheur,

W. Bonnar, H.P. Briggs, Sir F.W. Burton, A.E. Chalon, W. Donner, C.M. Dubufe, T. Duncan, E. Frère, W.P. Frith, J.L. Gérôme, Sir G. Hayter, W.H. Hunt, Sir E. Landseer, C.R. Leslie, F. Newenham, E.T. Parris, Sir J.N. Paton, A. Rankley, Sir W.C. Ross, F. Stone, F. Tayler, Elizabeth Thompson (Lady Butler), R. Thorburn, J.B.J. Trayer, F.C. Turner, B. West, Sir. D. Wilkie, F. Winterhalter; and after daguerreotypes by Claudet.
Pup.: J. Baker (q.v.).
Shared: H.B. Hall (q.v.).
Pub.: Ackermann and Co.; Louis Brall; Gambart; H. Graves; J.L. Grundy; R.H. Grundy; Hering and Remington; A. Hill and McClure and Son; J. Hogarth; J. Keith; Lloyd Bros.; G.P. McQueen; F.G. Moon; Royal Irish Art Union; J. Watson.
Lit.: *Art Journal* 1867, p. 249. Engen R.K. *Victorian Engravings* 1975. Hayden A. *Chats on Old Prints* 1906.

RYDER Thomas 1745 (London) — 1810 (London).
Line., stip.
All. / gen. / illus. / lit. / myth. / port. / relig.
Ryder was one of the first students at the R.A. Schools. He started as a painter but took up engraving and became a pupil of J. Basire I. His son Thomas was also an engraver.
Aft.: Abbot, Beechey, Bigg, H.W. Bunbury, Cipriani, R. Cosway, Craven, Downman, J. Dunro, S. Elmer, Hogarth, Huck, Angelica Kauffmann, Sir T. Lawrence, J. Opie, Ramberg, C.R. Ryley, S. Shelley, B. West, R. Westall, J. Wright of Derby.

RYE William Brenchley fl. 1849—66.
Et.
Antiq.

SADDLER John 1813—1892 (Wokingham).
Line, mezzo., steel.
An. / arch. / gen. / hist. / illus. / land. / port. / topog.
A pupil of G. Cooke (q.v.), Saddler worked in London and Wokingham.
Aft.: A. Bellows, Rosa Bonheur, A. Clint, H. Dawson, G. Doré, L. Fildes, Birket Foster, Miss M. Gillies, Sir H. Herkomer, F. Holl, Sir E. Landseer, G. Lawson, J. MacWhirter, H.W. Mesdag, Sir J.E. Millais, J. Nash, Sir E. Poynter, J.S. Prout, G. Reid, Sir J. Tenniel, J.M.W. Turner, J.L. Woods.
Shared: T. Landseer, J.T. Williams (qq.v.).), R. Dickens.
Pub.: H. Graves, A. Lucas.
Lit.: *Art Journal* 1872, p. 216; 1875, p. 332; 1876, p. 266; 1892, p. 160

ST AUBYN Catherine d. 1836.
Et. (amateur).
Port.
Aft.: Reynolds.

ST. DALMAS, F. Emeric de fl. Guernsey 1872—85.
Et.
Land.

SALA George Augustus 1828 (London) — 1895 (London).
Aq., et., litho.
Hist. / illus. / land. / political / ship.
Best known as a writer, Sala studied art under Carl Schiller, a miniature painter, but was self-taught as an etcher.

Aft.: J.M.W. Turner.
Shared: Worked on an aquatint of the Duke of Wellington's funeral with H. Alken (q.v.).
Pub.: Ackermann.

SALLES Léon 1868 (Paris) — c. 1908.
Et., mixed, stip.
Port.
French national who made a number of plates after works by British artists which were published in England.
Aft.: A. Chalon, J. Downman, Hoppner, Sir T. Lawrence, J. Russell, J. Wright of Derby.
Pub.: C. Brenner, H. Graves, A. Tooth.

SALMON or SALMSON, Louis Adolph 1806 (Paris) — 1895 (Paris).
Line., phot-eng.
Gen.
French national who made a few plates after works by British artists, which were published in England.
Aft.: G. Sheridan Knowles, A. Scheffer.
Pub.: T. Agnew; J. Connell.

SALMON S. fl. 1834.
Steel.
Arch. / illus.
Aft.: R.P. Bonington.

SALTER William fl. 1847—75.
Line.
Postage stamp dies.
Chief engraver for Perkins, Bacon and Co (q.v.)

315

SAMPSON John B. fl. York
(13 Coney Street) 1880s—90s.
Pub.
Photo-eng.
Distributed photo-engravings made by
Boussod, Valadon and Co. (see under
Goupil and Co.)

SANDERS Arthur N. 1838 — c. 1876.
Mezzo.
Gen. / port.
Sanders, who was possibly a relation of
George Sanders (q.v.), worked in
Lewisham, London.
Aft.: J.R. Dicksee, E. Douglas, Sir F.
Grant, J. Hayllar.
Pub.: H. Graves.

SANDERS or SAUNDERS, George
1810 (Exeter) — c. 1876.
Line., mezzo.
Gen. / hist. / port. / relig.
Sanders, who was possibly a relation
of A.N. Sanders (q.v.) worked in
Dublin and in Lewisham, London.
Aft.: L. Dickinson, T. Faed, W.H. Fisk,
Gainsborough, Sir F. Grant, H. Graves,
T.P. Hall, T. Harper, S.A. Hart,
E. Havell, W. Holyoake, T. Jensen,
W. Mulready, Rev. W. Peters, W.
Roeting, Schalken, R. Smith.
Pub.: Fores; H. Graves; Lloyd Bros.;
Moore, McQueen and Co.

SANDERS or SAUNDERS or
SANNDERS, John c. 1750—1825
(Clifton).
Line.
Port. / theat.
Possibly the son of the pastellist, John
Saunders or Sannders, and father of the
painter John Arnold Sanders, Sanders
became a pupil at the R.A. Schools in
1769. He was also a painter.
Aft.: R. Cosway.

SANDERS Joseph — see SAUNDERS,
Joseph.

SANDERS T. Early 19th c.
Line., mezzo.
Land.
Aft.: Constable.

SANDERSON G.T. fl. Barnes, Surrey
c. 1890.
Pub.
Juv. dram.

SANDOZ A. fl. 1880s.
Line.
Cost. / illus.

SANDS E. fl. 1840.
Steel.
Illus. / land.
Aft.: D.O. Hill.

SANDS H. fl. 1834.
Steel.
Arch. / illus.
Aft.: W. Tombleson.

SANDS James fl. London 1811—41.
Steel.
Illus. / land.
Also an architect. Perhaps the brother
of R. Sands (q.v.), and possibly
identical with John Sands (q.v.).
Aft.: T. Allom, W.H. Bartlett, W.L.
Leitch, P.F. Mola, G. Pickering,
S. Prout, D. Roberts, C. Stanfield.

SANDS John fl. 1855.
Steel.
Illus. / land.
Possibly identical with James Sands
(q.v.).
Aft.: W. Westall.

SANDS Robert 1792—1855.
Line.
Arch. / port.
Perhaps the brother of James
Sands (q.v.).
Aft.: T. Allom, D.O. Hill, S. Prout,
W. Tombleson.

SANDYS Frederick 1829 (Norwich)
— 1904 (Kenington).
Et., line., litho.
Hum. / illus. / port.
Son and pupil of the painter Anthony
Sandys, Frederick studied at the
R.A. Schools under S. Lawrence and
G. Richmond (q.v.). He designed
wood-engravings which were cut by
Joseph Swain (q.v.). He was a
Pre-Raphaelite.
Aft.: D. Rossetti, Sir J.E. Millais.
Lit.: Engen, R.K. *Victorian
Engravings* 1975. *P.C.Q.* VII,
pp. 200-16. White G. *English
Illustration* 1894.

SANGER A.T. fl. 1870s.
Mixed.
An.
Aft.: Rosa Bonheur.
Pub.: Louis Brall and Sons.

SANGER (or SANGAR) Thomas L.
fl. 1850s—70s.
Line., mezzo., stip.
Gen. / sport.
Aft.: H. Harraud, Sir E. Landseer,
F. Tayler.
Pub.: B. Brooks; H. Graves.

SANGSTER Samuel ?1804—72
(London).
Line., steel.
*Fig. / gen. / hist. / illus. / lit. / myth. /
port.*
A pupil of W. Finden (q.v.), Sangster
also painted in oil.
Aft.: R.P. Bonington, H.P. Briggs, C.
Dolci, A.L. Egg, W. Etty, B.R. Haydon,
H. Howard, J.J. Jenkins, H. Liverseege,
D. Maclise, K. Meadows, G.S. Newton,
H.W. Pickersgill, R. Rothwell, T. Uwins.
Pub.: H. Graves; Royal Irish Art Union.
Lit.: *Art Journal* 1872, p. 204.

SANNDERS John — See SANDERS
John.

SANSOM Francis fl. late 18th c. —
c. 1830.
Aq., et.
Flor. / illus.

SANSOM — Jr. fl. 1810.
Aq.
Illus.

SARGENT Frederick 1837—99.
Et.
Arch. / port.
Sargent was also a painter of genre,
portraits and miniatures. He worked
in London.
Shared: Arthur Turrell (q.v.), mixed
method plate of the drawing room at
Buckingham Palace.
Pub.: Gladwell Bros.; G.P. McQueen;
R. Tuck.

SARGENT John Singer 1856
(Florence) — 1925 (London).
Litho.
Fig.

American national who lived and
worked chiefly in England after 1884.
Is known mainly as a portrait painter,
although in his later years he
abandoned portraiture for landscape,
especially in watercolour.
Lit.: Hoopes D.F. *John Singer
Sargent* 1964. *P.C.Q.* XIII, pp. 30-45.

SARJENT F.J. b. 1802 (London).
Aq.
Land. / topog.
Also a watercolourist.

SARTAIN John 1808 (London) —
1897 (Philadelphia).
Mezzo.
Illus. / port.
Also a miniaturist, Sartain emigrated
to the U.S.A. in 1830.

SASS or SASSE Richard 1774
(London) — 1849 (Paris).
Et. (soft ground).
Land.
Also a painter.

SAUERWEID Alexandre Ivanovitch
1783 (Courland) — 1844
(St. Petersburg).
Aq.
Mil.
Russian national who worked for a
time in London.

SAUNDERS A.N. fl. mid — late
19th c.
Line. (?)
Port.
Aft.: J.R. Dicksee.

SAUNDERS J. fl. 1832—45.
Steel.
Arch. / illus. / land.
Aft.: W. Tombleson.

SAUNDERS John — See SANDERS
John.

SAUNDERS or SANDERS Joseph
1773 (London) — 1875 (Kazemienec).
Line. (?)
Gen. / port.
Pupil of Longhi, Saunders settled in
Poland.

SAVAGE William 1770 (Howden) —
1843 (London).
Print., wood.
Savage carried on business in Howden,
Yorkshire as a painter, engraver and
bookseller, with his brother James
(1767—1845) the antiquary as partner.
In 1767 he went to London and
became printer to the Royal Institute,
and in 1803 set up in London as an
independent printer. He became noted
for his improvements in the making of
printing ink, for which he won an
award and medal from the Society of
Arts. With the 18th century engraver,
J.B. Jackson, Savage was a pioneer
in the colour printing of wood-
engravings by using a separate block
for each colour.
 He was the author of several works
including *Preparations in Printing Ink
in Various Colours* (1832), *Dictionary
of the Art of Printing* (1840—41),
*Practical Thoughts on Decorative
Printing* (1822) etc.

SAVARY Emile fl. early 1880s.
Pub.

SAWYER R. fl. 1820—30.
Et., stip.
Port.

SAY Frederick Richard *c.* 1827 —
c. 1860.
Litho.
Port.
Also a portrait painter; son of W. Say
(q.v.).
Des. eng.: S. Cousins (q.v.).

SAY William 1768 (Lakenham) —
1834 (London).
Mezzo., steel.
*All. / arch. / gen. / hist. / land. / lit. /
myth. / port. / relig. / sport.*
Say, who was a pupil of J. Ward (q.v.)
was the first engraver to use steel
plates instead of copper for
mezzotint: this was for a portrait of
Queen Caroline. He made more than
330 plates. He was the father of
F.R. Say (q.v.).
Aft.: Beechey, Carracci, A.E. Chalon,
T. Clarke, Correggio, A.W. Devis,
B.R. Faulkner, H. Fradelle, Goubaud,
G.H. Harlow, Hilton, Hoppner, Sir T.

Lawrence, Lonsdale, Mackenzie,
J. Masquerier, Murillo, Northcote,
W. Owen, Phillips, Pickersgill, Sir R.K.
Porter, Raeburn, J. Ramsay, Raphael,
Rembrandt, Reynolds, M.W. Sharp,
Smyth, H. Thomson, J.M.W. Turner,
J. Ward.
Shared.: S.W. Reynolds (q.v.).

SAYER James — see SAYERS
James.

SAYERS or SAYER James 1748—
1825.
Et., mezzo.
Caric.
Sayers' work is never signed and is
difficult to distinguish from that of
Gillray.

SCHACHER C. fl. Edinburgh (?)
mid 19th c.
Litho.
Port.
Probably a German working in Britain.

SCHARF George 1788 (Mainburg,
Bavaria) — 1860 (Westminster).
Et., litho.
*Antiq. / arch. / hist. / illus. / land. /
nat. / port. / scien. / topog.*
Scharf, a German national, went to
Munich in 1804, and studied in the
Pinakothek. His work was noticed by
King Maximilian who bought one of
his prints. He worked for a time as
a drawing master and miniaturist and
learned the technique of lithography,
recently invented by Senefelder. Scharf
went abroad in 1810, working as an
itinerant miniature painter and after
working for a number of years in
France and the Low Countries, came
to England in 1816 and settled here,
working as a draughtsman-lithographer
for the *Transactions of the Geological
Society*. He was the father of Sir
George Scharf (q.v.).
Aft.: J.P. Hunter.

SCHARF Sir George 1820 (London)
— 1895 (London).
Et., litho.
Illus. / lit. / theat.
Son of George Scharf (q.v.), Sir George
began life as a pupil at the Schools of
the R.A. He was also a painter,

designer, archaeologist and traveller. He was secretary and director of the National Portrait Gallery 1882—95.

SCHAUS William fl. New York (749 Broadway) 1860—90s.
American publisher who issued some prints after works by British artists.

SCHENK Frederick fl. 1860s—80s.
Litho.
Flor. / illus.

SCHETKY John Christian 1778 (Edinburgh) — 1874 (Sweden).
Litho.
Ship.
The fourth son of Georg Christoph Schetky, of Transylvanian descent, and a nephew of Philip Reinagle R.A., John Christian was prevented by his parents from joining the navy, so he turned to the art of drawing ships as a consolation and became a pupil of Alexander Nasmyth. He became professor of drawing in the Royal Military College, Great Marlow, and then at the Royal Naval College, Portsmouth, remaining there until it closed in 1836. Thereafter he was professor of drawing in the Military College, Addiscombe. Schetky also painted marine subjects and was marine painter-in-ordinary to George IV, William IV and Queen Victoria.
Lit.: Chatterton E.K. *Old Ship Prints* 1927. Schetky S.F.L. *Ninety Years of Work and Play* 1877.

SCHIAVONETTI Louis or Luigi 1765 (Bassano) — 1810 (London).
Et., line., mixed., stip.
All. / gen. / hist. / illus. / lit. / port. / relig.
Italian national and a friend of F. Bartolozzi (q.v.) whom he assisted for a time. He came to England in 1790. He was the brother of N. Schiavonetti (q.v.).
Aft.: J. Aspinall, Benazeck, W. Blake, Maria Cosway, R. Cosway, De Loutherbourg, Edridge, S. Edwards, H. Hone, Angelica Kauffmann, Ann Mee, Michelangelo, Pellegrini, T. Phillips, Rembrandt, Reynolds, T.F. Rigaud, J. Russell, Sintzenich, T. Stothard, H. Tresham, Van Dyck,

R. Westall, F. Wheatley, Zuccarelli.
Pup.: A. Cardon the younger (q.v.).
Shared.: J. Heath, N. Schiavonetti (qq.v.). Heath completed Schiavonetti's plate of Stothard's "Canterbury Pilgrims"; he was assisted in this by F. Engleheart (q.v.).
Pub.: R.H. Cromek; William Miller; Simpson of St. Paul's Churchyard.

SCHIAVONETTI Nicolo 1771—1831.
Line., stip.
Gen. / port.
Brother of L. Schiavonetti (q.v.), Nicolo came to London in 1790.
Aft.: H. Tresham, F. Wheatley.
Shared: L. Schiavonetti.

SCHORT Franz fl. London 1889—1900.
Et. (?)
Probably a German working in Britain.

SCHRÖDER Hubert 1867—1930 or after.
Aq., et., line.
Land. / topog.
Worked in London and Bournemouth.
Aft.: W.G. Schröder.
Lit.: *P.C.Q.* XI pp. 369, 370, 372.

SCHROEDER Henry 1774 (Bawtry) — 1853 (Leeds).
Line., steel.
Illus.
After serving three years in the merchant navy, Schroeder settled in Leeds and engraved under the pseudonym "William Butterworth" under which he illustrated books on seamanship and travel. He was for a time an innkeeper at Kirkgate.

SCHULTZ Johann Karl 1801 (Danzig) — 1873.
Line., litho.
Gen.
German national who made at least one lithograph after a work by a British artist which was published in England.
Aft.: F. Lee.
Pub.: Gambart.

SCHUSTER Rudolph Heinrich 1848 (Markneukirchen) — 1902.
Et., photo-eng.
Gen. / sport.
German national who made a number of prints after works by British artists which were published in England.
Aft.: L.A. Clay, Dickinson, P. Massani, A. Zubland.
Pub.: Dickinson and Foster; Dowdeswell and Dowdeswells; Obach and Co; Schuster and Co.

SCHWARF George fl. early-mid 19th c.
Et. (?)
Pupils incl. J. Fahey (q.v.).

SCOTT Alexander fl. mid 1860s — late 1870s.
Mezzo., mixed.
Gen. / port.
Aft.: C.B. Barber, F. Dicey, Sir F. Grant, F.P. Graves, H. Graves, S. Pearce.
Shared: F. Stacpole (q.v.).
Pub.: Fores; H. Graves.

SCOTT David R.S.A. 1806—49.
Et.
Illus. / lit.
Best known as a historical painter, David was the son of R. Scott and brother of W.B. Scott (qq.v.).

SCOTT Edmund 1746 (London) — 1810 (London).
Stip.
Gen. / hist. / lit. / port. / theat.
Scott was a pupil of F. Bartolozzi (q.v.) and became engraver to Frederick, Duke of York.
Aft.: Ansell, Lady Diana Beauclerk, Braine, Dunthorne, G. Morland, J.H. Ramberg, Russell, Scott, Singleton, T. Stothard.

SCOTT James 1809 (? London) — 1875 or after.
Aq., mezzo.
An. / all. / arch. / gen. / hist. / lit. / port. / relig. / sport.
Scott worked in Holloway and Hornsey, London. His work should not be confused, as it sometimes is, with that of E. Scott (q.v.) or that of the 18th century mezzotinter, B.F. Scott.

Aft.: J. Archer, H. Barraud, A. Bayes, G.H. Boughton, R. Bowyer, R.W. Buss, S. Carter, A.E. Chalon, Chisholm, L. Cogniet, C.W. Cope, N. Crowley, L. Dickinson, E.A. Douglas, Mary E. Edwards (Mrs Staples), T. Faed, W. Fisher, W. Fisk, Julia Folkard, Gainsborough, H. Gales, J. Gilbert, Sir F. Grant, J. Hallyar, F.D. Hardy, T. Harper, Sir G. Hayter, F. Holl, W. Holyoake, S.J.E. Jones, Louise Jopling, T.M. Joy, E.S. Kennedy, Sir E. Landseer, J.E. Lauder, E.G. Lewis, J. Lilley, J. Linnell, T. Lucas, C. Lutyens, W. Macduff, G. Morland, G.B. O'Neill, H. O'Neill, W. Ouless, Sir J.N. Paton, S. Pearce, E. Prentice, A. Pugin, A. Rankley, Reinagle, Reynolds, Romney, Singleton, Stephanoff, M. Stone, G. Stubbs, F. Tayler, Thompson, J.A. Vinter, J. Walton, Wouverman, W. Yeames.
Shared: J. Webb (q.v.).
Pub.: Thomas Boys; B. Brooks; J.W. Brown; Dickinson; Goupil with M. Knoedler; H. Graves; Alexander Hasse; Lloyd Bros.; G. Ramage and Son.
Lit.: Engen R.K. *Victorian Engravings* 1975. Wilder F.L. *English Sporting Prints* 1974.

SCOTT John 1774 (Newcastle-on-Tyne) — 1827 (Chelsea).
Line., steel.
An. / arch. / hist. / illus. / sport.
The son of a brewery-worker, John Scott was apprenticed to a tallow-chandler, but towards the end of his time became interested in art. He went to London where he received assistance from his fellow townsman R. Pollard (q.v.), who instructed him in the technique of engraving. After this he was employed by Wheble, proprietor of *The Sporting Magazine*. He was awarded a gold medal by the Society of Arts. His workshop was in Coppice Row, Clerkenwell. Later in life he became insane. His son John R. Scott was also an engraver and made some plates for *The Sporting Magazine*.
Aft.: Cooper, Gilpin, B. Marshall, Reinagle, G. Stubbs, C. Tomson, M.T. Ward.
Pup.: J.W. Archer, J. Cousen and perhaps D.C. Read (qq.v.).
Pub.: Ottley.

SCOTT Robert 1777 (Lanark) — 1841.
Line., steel.
Ex libris / illus. / land. / topog.
Scott was the son of a skinner and
glover. After attending Musselburgh
Grammar School he was apprenticed
in 1787 to Alexander Robinson, an
Edinburgh engraver. He studied also in
the Trustees Academy, Edinburgh.
David and William Bell Scott (qq.v.)
were his sons.
Aft.: A. Carse, W.B. Scott, A. Wilson.
Pup.: J. Burnet, J. Horsburgh, J.
Stewart (qq.v.).
Pub.: Henry Mozley of Gainsborough.

SCOTT William 1848—1918.
Et.
Arch. / illus. / topog.
Primarily an architect, Scott worked
in London and Italy.
Lit.: *Studio* 1906, pp. 113-17.

SCOTT William Bell 1811
(Edinburgh) — 1890 (Penkill Castle).
Et., line., mezzo., steel.
All. / ex libris / illus. / myth. / relig.
The eleventh son of Robert Scott and
brother of David Scott (qq.v.), William
was educated at Edinburgh High School,
subsequently attended the Trustees
Academy, and for a period in 1831
drew from the antique in the British
Museum. Afterwards he was assistant
to his father. He was also a painter,
joining the Pre-Raphaelites, an illustrator
and a writer and became professor of
design at Newcastle 1843—58.
Aft.: Sir L. Alma-Tadema, W. Blake.
Des. eng.: W.J. Linton (q.v.).
Pup.: J. Finnie (q.v.).
Lit.: Minto W. *Autobiographical Notes
of the Life of William Bell Scott* 1892.

SCOTT and FERGUSON
fl. Edinburgh late 19th c.
Engravers and lithographers.
For a time employed G. Johnston (q.v.)

SCOTT and SONS fl. 1890s.
Pub.

SCRIVEN Edward 1775 (Alcester) —
1841 (London).
Line., steel., stip.
*All. / gen. / hist. / illus. / myth. / port. /
relig.*

Scriven may have studied under F.
Bartolozzi. He was a pupil of R.W.
Thew (q.v.) with whom he lived for
about seven or eight years at Northall,
Herts. Afterwards he came to London,
and in time held the appointment of
engraver to the Prince of Wales.
Aft.: Comerford, R. Cosway, A.W.
Devis, Hayter, Holbein, J. Jackson,
Lely, Pope, Raeburn, Reinagle,
Stephanoff, R. Westall.
Pup.: B.P. Gibbon, R.W. Sievier (qq.v.).
Shared: T. Gaugain (q.v.).
Pub.: Boydell; T.F. Dibdin; B.P. Gibbon.

SCRUTON R. fl. London (Coburg
Theatre), c. 1820.
Litho.
Theat.
Pub.: William West.

SEABY Allen William 1867—1953.
Et., wood.
An.
Seaby worked in Reading. He is noted
for his woodcuts of birds printed in
colours.
Lit.: Craddock and Barnard, London
*Modern Etchings (19th and 20th
Centuries)*. No. 135. 1977.

SEARS M.U. b. London 1800.
Wood.
Illus.
Worked in London, Leipzig and Paris.

SEARS R. fl. 1830s.
Steel.
Arch. / illus. / land.
Aft.: W.H. Bartlett, G. Hayward,
G. Pickering.

SEDCOLE Herbert 1864 (London)
— c. 1920.
Et., mezzo., mixed.
An. / gen. / land. / sport.
A pupil of J.B. Pratt (q.v.) at South
Kensington, Sedcole worked in
Holloway, London and Much
Hadham, Herts.
Aft.: H.W. Adams, S. Berkeley, T.
Blinks, Rosa Bonheur, E. Caldwell,
T.S. Cooper, H.H. Couldery, M.
Dieterle, Maud Earl, J. Farquharson,
Fragonard, Gainsborough, H. Hardy,
J.F. Herring, Sr., L. Hurt, Lucy
Kemp-Welch, N. Lancret, Sir E.

Landseer, T. Lloyd, Raeburn, R. Roetzelberger, Romney, Van Dyck, A. Wardle, W. Weekes, C. Whymper, S.L. Wood.
Pub.: A. Ackermann; A. Bell; Louis Brall; Cadbury and Jones; C.E. Clifford; J. Connell; Harry C. Dickins; Fine Art Society; Frost and Reed; H. Graves; E.E. Leggatt; H. Littaur; T. McClean; F.C. McQueen; I.P. Mendoza; W. Scott Thurber; A. Tooth.

SEDDON John Pollard 1827 (London) — 1906.
Litho.
Arch. / land.
Also an architect and writer; brother of Thomas Seddon the landscape painter.

SEDELMEYER Charles fl. 1880s—90s.
Pub.

SEED T.S. fl. Southampton 1795—1820.
Line.
Ex libris / heraldry / port.

SEGARD — fl. 1814.
Aq.
Illus.

SEGUIN Henry b. Dublin 1780.
Stip.
Illus.

SELOUS Henry Courtney — see SLOUS Henry Courtney.

SERRES John Thomas 1759—1825.
Et.
Topog.

SEVEREYNS G. fl. 1870s.
Litho.
Flor./ illus.

SEVERN Joseph 1795 (Hoxton) — 1879 (Rome).
Et.
Gen. / topog.
Severn began life as an engraver but abandoned it for painting, studying at the R.A. Schools, where he met G. Richmond (q.v.) who remained his friend. He went to live in Italy and befriended the poet John Keats at the end of his life. He met and became a friend of Samuel Palmer (q.v.) when Palmer visited Italy. His sons were the painters Arthur Severn and Walter Severn (q.v.).
Lit.: Birkenhead S. *Illustrious Friends* 1965. Sharp W. *Life and Letters of Joseph Severn* 1892.

SEVERN Walter 1830 (Rome) — 1904 (London).
Et.
Lit.
Son of Joseph Severn (q.v.). Also a painter.
Lit.: Birkenhead S. *Illustrious Friends* 1965.

SEYMOUR Robert 1800 (London) — 1836 (London).
Et., litho., wood.
Hum. / illus. / sport.
The son of an impoverished Somerset gentleman, Seymour was apprenticed to a pattern-drawer in Spitalfields. On completing his time he started painting in oil and miniature. He turned to book and periodical illustration, being largely employed by the firm of Knight and Lacey, drawing designs on the wood to be cut by journeymen. Their interpretations of his work were unsatisfactory and when Knight and Lacey went bankrupt he learnt to etch himself. For a short time he used the pseudonym "Shortshanks" but dropped it after complaints by George Cruikshank. He was the first illustrator of *Pickwick Papers* but committed suicide when it was apparent that most of the credit for that work was being given to Dickens.
Pub.: Chapman and Hall; William Kidd; McLean; Maddeley.

SEYMOUR Samuel fl. early 19th c.
Line.
Port.
Worked 1797—1822 in Philadelphia. Also a landscape painter.

SHANNON Charles Haslewood R.A. 1863 (Quarrington) — 1937 (Kew).
Et., litho., wood.
Fig. / gen. / illus. / marine. / port.
The son of a clergyman, Shannon was

educated at St John's School,
Leatherhead, after which he was
apprenticed to Roberts a wood-engraver,
on whose premises he met Charles
Ricketts (q.v.) who was to be his
lifelong friend and collaborator and
with whom he founded the Vale Press.
Shannon was also for a time a pupil
of W.H. Hooper (q.v.). He was in
addition a noted painter and designer.
Lit.: *L'Art et les Artistes* X. Colnaghi
P. and D. and Co. *Exhibition of the
Lithographs of the late Charles
Shannon* 1938. Derry G. *The
Lithographs of Charles Shannon: with
a Catalogue of Lithographs issued
between the Years 1904—1918* 1920.
P.C.Q. IV, pp. 392-420. Ricketts, C.
*A Catalogue of Mr Shannon's
Lithographs* 1902.

SHARBORN fl. mid-late 19th c.
Engraver of ex libris, probably identical
with C.W. Sherborn (q.v.).

SHARP W. fl. c. 1840.
Litho.
Theat. (ballet).
Aft.: Novello.

SHARP William — see SHARPE
William.

SHARPE Agnes fl. 1850s.
Et.
Daughter of C.W. Sharpe (q.v.).

SHARPE Charles Kirkpatrick 1781
(Hoddam Castle) — 1851 (Edinburgh).
Et. (amateur).
Illus.
Also a watercolourist.

SHARPE Charles William 1818
(Birmingham) — 1899.
Line., steel.
Gen. / hist. / theat.
C.W. Sharpe was a member of an
artistic family; he was the son of
W. Sharpe and father of Agnes Sharpe
(qq.v.). He worked in London,
Burnham and Maidenhead.
Aft.: N.J. Crowley, Sir C. Eastlake,
A. Elmore, W. Etty, T. Faed, W.P.
Frith, F. Goodall, T. Goode, C. Lucy,
D. Maclise, Sir J.N. Paton, H.J.
Townsend, T. Webster, Sir D. Wilkie.

Pub.: Art Union of London; J.
Hogarth; Lloyd Bros.; London
Printing and Publishing Co.; Royal
Irish Art Union.
Lit.: Engen R.K. *Victorian
Engravings* 1975.

SHARPE William 1749 (London) —
1824 (Chiswick).
Line., litho., stip.
*All. / gen. / hist. / illus. / lit. / mil. /
myth. / port. / relig. / ship.*
The son of a gunmaker, Sharpe
received a premium from the Society
of Arts and was apprenticed to Barak
Longmate (1737—93), engraver on
plate. After marrying, he set up as a
writing engraver, making such things
as door plates and card plates. He gave
up his shop in 1782 and went to live
at Vauxhall, where he began to
practise art engraving. After making
one or two further moves he settled
in Chiswick.
 Sharpe was a republican when
young and was examined by the Privy
Council for treasonable activities;
they discharged him. He also had
eccentric religious beliefs and went
to Exeter where he sought out Joanna
Southcott, then making her living as a
charwoman, and brought her to
London. He supported her for a long
period. His work was widely recognised
and he was elected an honorary
member of the Imperial Academy,
Vienna, and of the Royal Academy,
Munich.
Aft.: J.H. Benwell, J.S. Copley,
Maria Cosway, R. Cosway, W.A.
Hobday, Horne, Raeburn, G. Reni,
Reynolds, S. Rosa, Shee, T. Stothard,
Trumbull, Van Dyck, B. West,
Woodford, Woollett.
Pup.: T. Bragg, J. Stow (qq.v.).
Shared: W. Byrne, R. Golding, S. Smith,
W. Woollett (qq.v.).
Lit.: Engen R.K. *Victorian
Engravings* 1975.

SHAW George B. fl. London mid
1830s — mid 1870s.
Line., mezzo., mixed., steel., stip.
Gen. / port. / sculp.
Aft.: H. Anelay, R.S. Lauder, Sir J.N.
Paton, Raeburn, Reynolds, T. Sant.
Pub.: Art Union of London; Alexander

Hill; E.S. Palmer.
Lit.: *Art Journal* 1850, p.102. *Art Union* 1848, p. 238.

SHAW Henry 1800 (London) — 1873 (Broxbourne).
Line., steel.
Arch. / illus.

SHAW I. fl. 1830.
Line.
Industrial.

SHAW T.W. fl. 1833.
Steel.
Fig.
Aft.: Hogarth.

SHEA John fl. Dublin 1790—1814.
Line.

SHEARD Henry fl. Smethwick and Far East late 19th c.
Line.
Stamps.
Sheard worked as a die-sinker to the Hong Kong Mint and later worked at the Japanese Imperial Mint, Osaka.

SHEARDOWN AND SON fl. early 19th c.
Pub.
Aq.
Sport.

SHELDON — fl. early 19th c.
Pub.

SHENCK Frederick fl. early 19th c.
Litho. (incl. chromolitho).
Illus. / masonic (Schenck was a Mason).
German national who came to Edinburgh from Stuttgart *c.* 1830.
Lit.: Wakeman G. and G.D.R. Bridson *A Guide to Nineteenth Century Colour Printers* 1975.

SHENFIELD — fl. 1832.
Steel.
Arch. / illus.
Aft.: W. Tombleson.

SHENTON Henry Chawner 1803 (Winchester) — 1866 (Camden Town, London).
Line., steel.
An. / gen. / hist. / illus. / port. / sport.

Shenton was a pupil of C. Warren (q.v.) whose daughter he married. He was the father of the sculptors William Kernot Shenton and Henry Chawner Shenton Jr.
Aft.: L. Clennell, W. Collins, A. Cooper, E. Courbould, J. Cross, R. Crosse, F. Dicksee, J.R. Dicksee, A. Fraser, W. Kidd, C. Landseer, W. Mulready, R. Redgrave, G. Reni, T. Stothard, R. Uwins, R. Westall.
Shared: C.H. Jeens (q.v.).
Pub.: Art Union of London.

SHEPHEARD George ?1770—1842.
Mixed.
An. / gen. / port.
Shepheard was descended from an old Hertfordshire family. Himself a water-colourist he was the father of the watercolour painter, George Walwyn Shepheard.
Aft.: Bunbury, Morland, F. Rehberg.
Des. eng.: G.M. Brighty (q.v.).

SHEPHERD George 1760 (London) — 1814 or after.
Aq., mixed.
An. / gen. / port. / relig.
Aft.: Bunbury, Domenechino, G. Morland.

SHEPHERD Thomas Hosner or Hosmer fl. 1817—40.
Steel.
Illus.
Best known as a draughtsman and watercolourist. Probably a son of G. Shepherd (q.v.).
Aft.: T. Allom, H. Gastineau, W. Tombleson.

SHEPHERD BROTHERS fl. 1880s—90s.
Pub.
Issued goupilgravures made by Boussod, Valadon and Co. (See Goupil and Co.).

SHEPPERSON Claude Allin A.R.A. 1867 (Beckenham) — 1921 (L(ndon).
Et., litho.
Gen. / illus. / relig.
Lit.: *P.C.Q.* X, pp. 444—71.

SHERBORN Charles William 1831
(London) — 1912 (Kensington).
Et., line.
*Arch. / ex libris / heraldry / hist. /
land. / myth. / topog.*
Sherborn was educated at private
schools. When he left school he
attended the government school of
design at Somerset House, while
serving an apprenticeship with a
silver plate engraver in Soho, London.
After this he visited Paris and Italy. He
settled in Geneva in 1853 and earned
his living as a designer and engraver of
plate. Returned to London in 1856,
he worked as an engraver for jewellers
and silversmiths. He ceased business in
1872 and devoted himself to etching
and engraving, especially for
reproduction work and bookplates,
of which he made over 350. He
designed the president's badge of the
Royal Society of Painter Etchers.
Aft.: G. du Maurier, M.M.V. Lindsay
(Duchess of Rutland), G. Richmond,
J.J. Shannon, H.T. Wells, and after
photos.
Pub.: E. Parsons.
Lit.: Sherborn C.D. *The Life and
Work of C.W. Sherborn* 1912.

SHERLOCK William P. *c.* 1780.
Line.
Illus.
Also a painter.

SHERMAN Welby fl. 1827—34.
Line., mezzo., wood.
All. / relig.
Sherman was a member of "The
Ancients" the circle of young friends
of W. Blake, which also included
S. Palmer, E. Calvert and G. Richmond
(qq.v.). He is a shadowy figure who
made only a few engravings and fled
abroad after swindling Palmer's
brother over a game of billiards.
Aft.: E. Calvert, S. Palmer.
Lit.: *Connoisseur* CXCV pp. 212-13.
Lister R. (ed.) *The Letters of Samuel
Palmer* 1974 [1975]. *Samuel Palmer
a Biography* 1974 [1975]. *P.C.Q.*
XVII pp. 352-62.

SHERRAT or SHERRATT fl. 1860s—
1880.
Line., steel.

*Gen. / illus. / land. / mil. / port. /
relig. / topog.*
Worked in Bayswater.
Aft.: G.H. Boughton, Major A. Elliot,
H. Park, J. Phillip, T.M. Rooke, G.A.
Storey, H. Tidey.
Pub.: H. Graves.
Lit.: *Art Journal* 1857, p. 278; 1859,
p. 348; 1861, p. 328.

SHIPSTER Robert fl. late 18th-early
19th. c.
Stip.
Relig.
Pupil of F. Bartolozzi (q.v.).
Aft.: West.
Pub.: Macklin.

SHIRLAW Walter 1838 (Paisley) —
1909 (Madrid).
Et.
Illus.
Also a painter of portraits, landscapes
and murals.

SHORMAN — fl. Great Poultney
Street, London, *c.* 1880.
Pub.
Juv. dram.

SHORT Sir Frank (Francis) R.A.
1857 (Wollaston) — 1945 (Ditchling).
Aq., dry., et., litho., mezzo.
*All. / gen. / land. / marine / myth. /
port. / topog.*
Short began life as an engineer, but
forsook this for art. He attended
evening classes at Stourbridge School
of Art and later became a pupil at the
National Art Training School at South
Kensington, and at Westminster School
of Art under Frederick Brown. At
South Kensington he was noticed by
John Ruskin, due to whose
encouragement he made some forty
plates for a version of Turner's *Liber
Studiorum*. He was largely responsible
for the revival of the arts of lithography,
mezzotint and aquatint. Short became
etching instructor at South Kensington
in 1891, and was then professor of
engraving until he retired in 1924. He
was also a landscape painter.
Aft.: Constable, D. Cox, J. Crome,
G. da Costa, P. De Wint, Sir A. East,
J. Farquharson, C. Fielding, F. Goulding,
F. Holl, Hoppner, A. Parsons, Reynolds,

J.M.W. Turner, A. Vestier, G.F. Watts.
Pup.: Eveleen Buckton, F.V. Burridge,
J.R.G. Exley, W.J. James, M. Osborne,
Constance M. Pott, Mabel C. Robinson,
D.L. Smart, G. Soper, N. Sparks, E.M.
Synge, Dorothy E.G. Woollard (qq.v.).
Pub.: Stephen T. Gooden.
Lit.: *Bookman's Journal* VII, p. 174;
X, p. 168. Hardie M. *The Liber
Studiorum Mezzotints of Sir Frank
Short* 1938. *The Mezzotints and
Aquatints of Sir Frank Short* 1939.
*The Etchings, Dryprints, Lithographs
of Sir Frank Short* 1940. *International
Studio* XLII, pp. 3-13. Salaman M.C.
Sir Frank Short R.A., P.R.E. Modern
Masters of Etching Series No. 5, 1925.
Strange E.F. *Etched and Engraved
Works of Frank Short A.R.A.* 1908.
Studio XXXVIII, p. 50.

SHORTSHANKS — Pseudonym of
R. Seymour (q.v.).

SHURY or SHUREY George Salisbury
1815 (Holloway) — 1883 or later.
Line., mezzo., mixed., steel., stip.
Gen. / hist. / mil. / port. / relig. / sport.
Son of Inigo Shury (q.v.).
Aft.: J. Andrews, G. Armfield, H.
Barraud, M. Beard, F. Biard, T. Brooks,
A. Cooper, E.U. Eddis, Gainsborough,
E. Havell, J.C. Hook, Sir T. Lawrence,
H. Le Jeune, Fanny McIan, T.H.
Maguire, J. Morgan, Rembrandt,
Reynolds, Romney, W. Simpson, A.
Vernon, H. Weigall.
Shared: Elizabeth Gulland (q.v.).
Pub.: Louis Brall; B. Brooks;
Colnaghi; Fine Art Society; Fores;
Shaw and Sons; Gambart; H. Graves;
Leggatt Bros.; G.P. McQueen; Moore,
McQueen and Co,; J. Noseda.

SHURY or SHUREY Inigo fl. early
19th c.
Line.
Father of G.S. Shury (q.v.).

SHURY or SHUREY John fl. 1818—
40s.
Steel.
Arch. / illus. / land.
Shury had a son, Jno. Shury jr., and
plates are sometimes signed "John
Shury and Son."

Aft.: J. Fussell, H. Gastineau, D.H.
McKewan, C. Radclyffe, J. Salmon,
F.N. Shepherd, G.H. Shepherd,
T. Shepherd, N. Whittock,
J. Wrightson.

SHURY T. fl. early 19th c.
Aq.
Illus.

SIBSON Thomas 1817 (Cross
Canonby, Cumberland) — 1844 (Malta).
Et.
Gen. / illus. / lit.
Although intended for a commercial
career, Gibson soon decided he wanted
to become an artist and in 1838 went
to London where he found work as an
illustrator. In 1842 he went to Munich
and studied under Kaulbach. However,
he was consumptive and his poor
health forced him to come home in
1844. Later that year he went to the
Mediterranean, but died in Malta.
Lit.: *Art Union* 1845, p. 37. Scott W.
B. *Autobiography* 1892.

SICKERT Walter Richard 1860
(Munich) — 1942 (Bath).
Dry., et (incl. soft ground), mixed.
Arch. / gen. / port. / theat. / topog.
Sickert's father was a Dane who
became German when Schleswig was
conquered in 1864; his mother was of
Anglo-Irish descent. Walter received
encouragement in an early interest in
art, for his father was also a painter.
He studied at the Slade under
A. Legros and after this with J. McN.
Whistler (qq.v.) and he was much
influenced by the French
Impressionists, especially Degas. He
lived for a time on the Continent. He
is best known as a painter, especially
for his studies of music hall interiors.
Lit.: Emmons R. *The Life and Opinions
of Walter Richard Sickert* 1941. *P.C.Q.*
X, pp. 31-60. Sickert W. R. *A Free
House: or the Artist as Craftsman*
1947. *Studio* XCVII, p. 337. Troyen,
Aimée *Walter Sickert as Printmaker*
1979.

SIEBE and BURNETT fl. London
(12 Frith Street) mid 19th c.
Print (litho).
Music.

SIEVIER, Robert William 1794
(London) — 1865 (London).
Mezzo., stip.
Gen. / myth. / port.
Awarded a silver medal in 1812 by
the Society of Arts, Sievier became a
pupil of John Young and Edward
Scrivener, and in 1818 became a
pupil at the R.A. Schools. He studied
anatomy under Mr Brookes, and took
to sculpture in 1824, after which he
abandoned engraving. Later, being
interested in science, he took to the
manufacture of elastic fabrics and
indiarubber, and contributed to the
development of the electric telegraph
and of carpet manufacture.
Aft.: Beechey, W. Etty, M. Haughton,
Holbein, Jackson, Sir T. Lawrence,
G.S. Newton.

SILVESTER — fl. probably in the
Channel Islands, early 19th c.
Line.
Ex libris.

SIMMONS William Henry 1811
(London) — 1882 (London).
Line., litho. (chromolitho.), mezzo.,
mixed, steel., stip.
*An. / all. / gen. / hist. / lit. / port. /
relig. / sport. / topog.*
Simmons was apprenticed to
W. Finden (q.v.). At first he
concentrated on line engraving, but
later abandoned it almost completely
for mezzotint. A Mrs W.H. Simmons,
presumably his wife, engraved a plate
after a work by R. Farrier.
Aft.: R. Ansdell, Sophie Anderson,
T.J. Barber, Barraud, C. Baxter, J.H.
Beard, E. Béranger, Rosa Bonheur,
J.L. Brodie, T. Brooks, G.H.
Broughton, P.H. Calderon, C. Calix,
H. Calvert, S.J. Carter, J.A. Casey,
J. Collinson, D. Cooper, E. Crowe,
W.C.T. Dobson, G. Doré, L. Dubufe,
G. Duval, J. Dyckmans, T. Dyckmans,
Sir C.L. Eastlake, Edmondstone,
Mary E. Edwards (Mrs Staples), T. Faed,
Fisk, E. Frère, W.P. Frith, Sir F. Grant,
M.F. Halliday, J. Hallyar, H. Hardy,
G. Harvey, W.M. Hay, J.F. Herring
Sr., Heyes, W. Holyoak, J.C. Hook,
W.H. Hunt, G.G. Kilburne,
P. Labouchère, Sir E. Landseer, H. Le
Jeune, E.G. Lewis, J.D. Luard,

C. Lucy, A.A. Martin, Mrs Alexander
Melville, H. Merle, Sir J.E. Millais,
P.R. Morris, F. Newenham, C.W.
Nicholls, E. Nicol, H. O'Neill, J. (?)
Palmer, Sir J.N. Paton, A. Rankley,
A. Salomon, J. Sant, S. Sidley, G. Steel,
Steuben, F. Stone, J. Tissot, J. Van
Lerius, J.W. Walton, Mrs E.M. Ward,
F. Winterhalter, J. Wood.
Shared: S. Bellin, J.B. Pratt (qq.v.).
Simmons' plate of "The Lion at
Home" after Rosa Bonheur was
incomplete on his death and was
finished by T.L. Atkinson (q.v.).
Pub.: A. Ackermann; T. Agnew with
H. Blair Ansdell; Art Union of
Glasgow; Owen Bailey; H. Barraud;
Beeforth and Fairless; Thomas Boys;
Louis Brall; Joshua Brooke; J.
Dickinson; J.P. Fairless; Fores;
Gambart and Co.; H. Graves; A. Hill;
M. Knoedler; L.H. Lefèvre; Lloyd
Bros; London Fine Art Association;
H. Meeson; Moore, McQueen and Co.;
Pilgeram and Lefèvre; W. Schaus;
Shaw and Sons; A. Tooth; Robert
Turner; R. Turner for F. Barraud.
Lit.: *Art Journal* 1882, p. 224.
Engen R.K. *Victorian Engravings*
1975 *P.C.Q.* XII, p. 181; XXII, p. 138.

SIMMS P. fl. St Neots, Hunts. mid
19th c.
Line.
Ex libris.

SIMMS P. fl. St Neots, Hunts. mid
younger 1750 (London) — 1810.
Line., stip.
*All. / gen. / hist. / illus. / lit. / myth. /
port. / relig. / theat.*
Aft.: J. Downman, Fuseli,
Gainsborough, W. Hamilton, Kirk, J.
Northcote, J. Opie, W. Peters, Reynolds,
J.R. Smith, T. Stothard, F. Wheatley.

SIMPSON — fl. London (St Paul's
Churchyard) late 18th — early 19th c.
Pub.

SIMPSON Charles fl. early 19th c.
Colourist.
Gen. / illus. / relig. / sport.
The nature of Simpson's work as a
colourist is briefly indicated in the
book *The Sacred Annual* 4th ed.
London 1834; this contained twelve

327

illustrations "Coloured under the direction of Charles Simpson". An advertisement at the end of the book states that these illustrations "Elegantly mounted on Royal 4to tinted Drawing Boards, or Paper, surrounded by gold linen, with appropriate Extracts from the Work, and enveloped in AN ELEGANT AND UNIQUE PORTFOLIO, the exterior of which is embellished with an ILLUMINATED MISSAL BORDER, MAY BE HAD SEPARATELY FROM THE WORK, Price 25s." Proof impressions, price £2.10s are also mentioned.
Aft.: A.B. Clayton, D. Costello, J. Cruise, W. Etty, J. Franklin, B.R. Haydon, D. Maclise, J. Martin, T. von Holst.
Pub.: John Turrill.

SIMPSON Joseph 1879 (Carlisle) — 1939.
Et.
Caric. / port. / sport.
Also a painter and illustrator.
Lit.: *P.C.Q.* XIX, pp. 212-33.

SIMPSON T fl. London 1790—1815.
Line.
Port. / sport.

SIMPSON William 1823 (Glasgow) — 1899 (Willesden).
Line., litho.
Arch. / hist. / illus. / mil. / ship.
Simpson, who served an apprenticeship as a lithographer, came to London in 1851, and worked for Day and Son (q.v.). He worked in the Crimea and is said to have been the first war artist working in battle conditions. In 1859 he visited India.
Shared: T. Picken (litho. of Duke of Wellington's funeral).
Pub.: Day and Son.
Lit.: *Art Journal* 1866, p. 258.

SIMS Charles R.A. 1873 (Islington) — 1928 (Roxburgh).
Aq., et.
Fig. / gen. / myth.
Lit.: *P.C.Q.* XVIII, p. 375.

SINCLAIR John b. 1845.
Mezzo.
Port.
Aft.; W. Crabb, J.W. Gordon.
Pub.: H. Graves; Hill, Edinburgh.

SINGLETON Henry 1766 (London) — 1839 (London).
Litho.
Gen. / lit.
Best known as a painter and illustrator, Singleton was a pupil of his uncle Joseph Singleton the miniaturist. His own works were extensively engraved.

SINTZENICH Heinrich 1752 (Mannheim) — 1812 (Munich).
Stip.
All. / hist. / lit. / port.
German engraver, a pupil of F. Bartolozzi (q.v.), who worked in London for some years.
Aft.: Bach, Angelica Kauffmann, Rembrandt, Rosalba.

SKELT fl. London (Swan Street, Minories) 1835—72.
Pub.
Juv. dram. / tinsel.
This family firm was founded by Martin Skelt, a shoemaker, in 1835, trading as M. Skelt; his brother Matthew joined him *c.* 1837 as partner, when the name was changed to M. and M. Skelt. When Martin died in 1840 Matthew was joined by Ben Skelt, his uncle, and they traded as M. and B. Skelt. Matthew died in 1850, and Ben carried on alone as B. Skelt; he died in Stepney workhouse in 1862. For the next ten years Ben's son Ebenezer ran the business; he died in 1913.
 Some of Skelt's plays were taken from Robert Lloyd (q.v.); they also acquired, probably through Lloyd, some of the plates of D. Straker (q.v.).
 Mrs M. Hebberd and Myers and Co. (qq.v.) were agents for Skelt.
 Skelt's acquired most or all of the stock of G. Slee (q.v.) after 1935. The name G. Skelt was adopted by George Conetta, or George Wood (1881—1956) who issued plays by various publishers from 24 Clairview Street, Saint Helier, Jersey. His stock was acquired after his death by Benjamin Pollock Ltd. (q.v.).

Some of Skelt's plates were reproduced and sold by Andrews and Co. (q.v.).

SKELTON Joseph 1781 or 1782—1850.
Et., line., mixed.
Antiq. / illus. / port. / topog.
The younger brother of W. Skelton (q.v.), Joseph worked in Oxford until 1819, and later in Paris.
Aft.: W. Bradley, F. Mackenzie, H. O'Neil, C. Wild.

SKELTON William 1763 (London) — 1848 (Pimlico).
Line., litho., mezzo., mixed., steel., stip.
Antiq. / gen. / illus. / lit. / port. / relig. / theat.
Skelton, who was descended from an old Cumberland family, was a pupil of James Basire I (1730—1802) and W. Sharp (q.v.). He also studied in the R.A. Schools. He was the brother of J. Skelton (q.v.).
Aft.: W. Beechey, Briggs, Danloux, P. Fischer, W. Hobday, G.H. Joseph, W.E. Kilburn, J.H. Mole, Northcote, Pine, T. Stothard.
Pub.: Bowyer; Macklin.
Lit.: *Art Journal* 1849, p. 20.

SKILLIN Samuel 1819 (Cork) — 1847 (Cork).
Et.
Fig. / port.
Also a painter, Skillin was a pupil at the Dublin Academy.

SKIPP or SKIPPE John or J.B. or Jean 1741 (Ledbury) — 1811 (Overbury).
Et., line., wood (amateur).
All. / gen. / relig.
Skipp, who came from a rich family, was also a painter. He studied landscape under Joseph Vernet and engraving under J.B. Jackson (1701—80). He published between 1770 and 1812 a number of chiaroscuro wood-engravings after old masters, inspired by those of Ugo da Carpi.
Aft.: Correggio, Parmigiano, Raphael.

SKIRVING Archibald 1749 (Haddington) — 1819 (Inveresk).
Et.
Port.
Noted chiefly as a miniaturist and crayon draughtsman.

SKRIMSHIRE Alfred J. fl. Balham 1890s.
Line., mezzo.
Gen. / land.
Aft.: Boucher, Franz Hals, Sir T. Lawrence, J. MacWhirter, A. Parsons, Raeburn, J. Russell, A. Stark.
Pub.: Harry C. Dickins; Dowdeswell and Dowdeswells; Stephen T. Gooden; H. Graves; C. Klackner; A. Lucas.

SLADER Samuel M. d. after 1861.
Wood.
Illus.
Worked in London.

SLANN Robert fl. London 1820.
Line.
Hist. / illus. / port. / relig.
Worked as an assistant of T. Holloway (q.v.).

SLATER John F. 1857—1937.
Et.

SLEE G. fl. London (5 Artillery Lane, Bishopsgate) 1814 — after 1835.
Pub.
Juv. dram.
No toy-theatre sheets bearing Slee's name appear to have survived. He was probably in partnership with J.K. Green and G. Anderson (qq.v.) at various times, but after 1835 operated alone. Later some or all of his stock was acquired by Skelt (q.v.).

SLEIGH Bernard b. Birmingham 1872.
Wood.
Illus.

SLEIGH John fl. Hampstead mid 19th c.
Et.
Illus. / lit.
Also a painter.

SLOANE Mary Annie fl. 1889—1902.
Et.
Illus.
Born in Leicester; also a painter.

SLOCOMBE Alfred fl. London
1850—1900.
Et., wood.
Flor. / land. / topog.
Slocombe worked also in Holland and
Switzerland. He was the brother of
C.P., F.A. and E. Slocombe (qq.v.).

SLOCOMBE Charles Philip 1832—95.
Dry., et.
Flor. / gen. / illus. / land. / port. / topog.
A brother of A., E. and F.A. Slocombe,
Charles also practised watercolour
painting. He worked in London and
was an instructor in the Art Schools at
Somerset House (later at South
Kensington).
Aft.: G. Boughton, F. Holl, A. Moore,
J. Pettie, Rembrandt, J.F. Robertson.
Pub.: Fine Art Society; M. Knoedler.
Lit.: *Art Journal* 1879, p. 78.
Portfolio 1881, p. 169.

SLOCOMBE Edward 1850
(London) — 1915 or after.
Et., mezzo.
*All. / arch. / gen. / land. / lit. / port. /
topog.*
A brother of F.A., C.P. and A.
Slocombe (qq.v.), Edward was also a
painter. He lived in Watford.
Aft.: J. Fulleylove, Maude Goodman,
Florence Graham, C.N. Hemy,
G. Leslie, C. Perugini, W.C. Wyllie.
Pub.: Buck and Reid; Fine Art Society.
Lit.: *Art Journal* 1887, pp. 61, 257.
Portfolio 1889, p. 161.

SLOCOMBE Frederick Albert 1847
(London) — 1920 or after.
Et.
Land. / topog.
A brother of E., A. and C.P. Slocombe,
Frederick was also a painter of genre
and landscape. He lived in London.
Aft.: J. Farquharson, J. MacWhirter,
A. Parsons, S. Waller.
Pub.: Boussod, Valadon and Co.; Fine
Art Society; Arthur W. Foster;
M. Knoedler; B. Leader; C. Whymper;
H. Zuber.
Lit.: *Art Journal* 1879, p. 78; 1882,
p. 204; 1883, p. 204; 1884, p. 144;
1885, p. 65; 1886, p. 64; 1888, p. 192;
1889, p. 64; 1895, p. 284. *Portfolio*
1885, p. 166; 1889, p. 200; 1891,
p. 248.

SLOUS or SELOUS Henry Courtney
1811—90.
Litho.
Illus.
Also a painter.

SLY S. fl. 1833—42.
Wood.
Illus.
At one time an assistant of
J. Jackson (q.v.), Sly worked, among
others, for such periodicals as *The
Penny Magazine* and *Illustrated
London News*; he engraved the
title-block for the latter, the lettering
being by Vizetelly (q.v.).
Pup.: F.W. Fairholt (q.v.).

SMALL F. fl. 1870s.
Wood.
Illus.

SMALLFIELD Frederick 1829
(Homerton) — 1915 (London).
Et.
Lit. / port.
Smallfield was a pupil at the R.A.
Schools. He worked in London and
was known chiefly as a watercolourist.

SMART Douglas Ion 1879—1970.
Et.
Ship. / topog.
Smart, who studied under Sir F.
Short (q.v.), worked in London and
was also a watercolourist.
Lit.: *Apollo* V, pp. 174f.
Studio Special No. 1920, p. 110.

SMART John 1838 (Leith) — 1899
(Leith).
Et.
Land.
Smart was the son of a lithographer
and became a pupil of M. McCullogh
(q.v.). He worked mainly in Edinburgh,
and was also a noted painter of
Highland scenery.

SMART J. fl. London (35 Rathbone
Place, Oxford Circus) 1821.
Pub.
Juv. dram. / tinsel.

SMART R.W. fl. early 19th c.
Et., line.
Mil. / port. / railways / sport. / topog.

Aft.: S. Bourne, Herring, Sir J.T. Lee, Capt. H. Mitchell, J. Pollard, Spode. Shared: C. Hunt, H. Pyall, R.G. Reeve, T. Sutherland (qq.v.).
Lit.: Wilder F.L. *English Sporting Prints* 1974.

SMEETON Burn fl. Paris 1840—60.
Wood.
Illus.

SMETHAM James 1821—89.
Et.
Gen.
Also a painter and writer.
Lit.: Malins E. *James Smetham and Francis Danby* 1974. Smetham Sarah and W. Davies (eds.) *Letters of James Smetham* 1891.

SMILLIE James 1807 (Edinburgh) — 1885 (Poughkeepsie).
Line., steel.
Sport.
Smillie was placed at the age of twelve with an engraver of plate. He then worked for a time with E. Mitchell (q.v.) and at the age of fourteen went to America. Among his activities in the U.S.A. was banknote engraving. He was the brother of W.C. Smillie (q.v.) and father of the American etcher and painter James David Smillie.

SMILLIE William Cumming
b. Edinburgh 1813.
Line.
Banknotes.
The brother of J. Smillie (q.v.), this engraver was employed on security engraving by the Canadian government.

SMIT Joseph fl. 1870s—90s.
Litho.
An. / illus.
Probably a German national working in London.
Shared: J. Wolf (q.v.).

SMITH — fl. 1830—50.
Steel.
Illus. / land.
Aft.: Leach, S. Prout, J.M.W. Turner.

SMITH Alfred 1810— after 1870.
Line., mezzo.
Gen. / land.
Aft.: J. Israels, R. Tucker.
Pub.: H. Graves.

SMITH Anker A.R.A. 1759 (London) — 1819 (London).
Line., stip.
All. / arch. / hist. / illus. / myth. / port. / relig. / theat.
Smith was the son of a silk merchant of Cheapside. It is claimed that he was called Anker because he was the "anchor" of his parents' hopes. After being educated at Merchant Taylors' School, he was apprenticed to his uncle, a solicitor, but showed such aptitude in art, his indentures were cancelled and he was placed with James Taylor (q.v.); he also was a pupil of F. Bartolozzi (q.v.). He became an assistant to James Heath (q.v.) and later worked for John Bell the publisher. Frederick William Smith the sculptor was his son.
Aft.: Da Vinci, Metz, Northcote, Rubens, R. Smirke, Titian, H. Woodford.
Pup.: W. Humphrys (q.v.).

SMITH Benjamin 1775 (London) — 1833 (London).
Stip.
All. / arch. / gen. / hist. / lit. / port. / relig.
Pupil of F. Bartolozzi.
Aft.: Appiani, E.T. Banks, Sir W. Beechey, M. Browne, J.S. Copley, Guercino, Hardy, Hogarth, H. Hone, W. Miller, Peters, J.F. Rigaud, S. Romney, B. West.
Assist.: W. Evans (q.v.).
Pup.: A.R. Burt, H.B. Hall, W. Holl the elder, H. Meyer, T. Uwins (qq.v.).

SMITH Charles 1749 (Orkneys) — 1824 (Leith).
Et.
Port.
Trained in London. Visited India. Also a painter.

SMITH Charles John 1803 (Chelsea) — 1838 (London).
Line., steel.
Antiq. / illus. / topog.

The son of a surgeon, Smith was at the age of sixteen apprenticed to C. Pye (q.v.).
Aft.: C. Stothard.

SMITH C.N. fl. mid 19th c.
Aq., line.
Sport.
Aft.: S. Alken, A. de Prades, H. Hall.
Lit.: Wilder F.L. *English Sporting Prints* 1974.

SMITH D. fl. 1830.
Line., steel.
Illus.
Assistant to C. Heath (q.v.).

SMITH Edward fl. London 1823—51.
Line., steel.
Gen. / hist. / lit. / port.
Aft.: G. Clint, Sir C. Eastlake, Reynolds, Sir D. Wilkie.
Pub.: Gambart, H. Graves.

SMITH Emma fl. London early 19th c.
Line.
Gen. / port.
Also a watercolourist and miniaturist, Emma was the sister of J. Rubens Smith and daughter of J. Raphael Smith (q.v.).
Aft.: Maria Cosway, De Wilde, Walter.

SMITH Frederick fl. 1830s—60s.
Steel.
Arch. / illus.
Aft.: T.H. Gromek, W.L. Leitch, G.B. Moore, D. Roberts, J.O. Westwood.

SMITH G.B. fl. 1842—81.
Steel.
Arch. / illus.
Aft.: R.W. Billings.

SMITH George Barnett 1841 (Ovenden) — 1909 (Bournemouth).
Et.
Port. / topog.
Smith, who worked mainly as a writer, studied in Halifax and later moved to London, where he worked as a journalist.

SMITH H. fl. 1829.
Steel.
Arch. / illus.
Aft.: G. Shepherd.

SMITH J. fl. 1872.
Steel.
Port.
Aft.: R. Walker.

SMITH J.C. fl. 1843.
Steel.
Illus. / heraldry.

SMITH J. Caswell fl. 1900.
Photo-eng., pub.
Gen.
Aft.: C.N. Hemy.

SMITH J. John b. London *c.* 1775.
Et.
Gen.

SMITH James fl. Brighton (2 King's Road), ?1840s.
Steel.
Topog.

SMITH John b. *c.* 1798.
Line., steel.
Land. / topog.
Pupil at the R.A. Schools. Worked in London.
Aft.: W.H. Bartlett, J.C. Brown, W. Brown, A. Donaldson, J.D. Harding, D.M. Mackenzie, C. Stanfield, W. Tombleson, J.M.W. Turner, Sir D. Wilkie.

SMITH John fl. Edinburgh 1800—30.
Line.
Port.
Aft.: Reynolds.

SMITH, John Clarendon 1778 (London) — 1810.
Line.
Topog.
Also a painter.

SMITH John Orrin 1799 (Colchester) — 1848.
Wood.
Illus. / lit. / port. / relig.
J.O. Smith came to London in 1818 where for a time he trained as an architect, but he came into money

which he lost by bad investment. He then tried wood-engraving and became a pupil of W. Harvey (q.v.). His wood-engraving became very refined but lacked virility. He took W.J. Linton (q.v.) into partnership in 1842, trading as Smith and Linton, working among other customers, for the *Illustrated London News*. His son, who took the name of Harvey Edward Orrinsmith, was a wood-engraver for a time, but later became a director of a bookbinding firm.
Aft.: J. Leech, J.K. Meadows.
Pup.: H. Harral (q.v.).

SMITH John Raphael 1752 (Derby) — 1812 (Doncaster).
Mezzo., stip.
All. / an. / gen. / hist. / lit. / myth. / port. / relig. / theat. / topog.
One of the greatest mezzotint engravers, J.R. Smith scraped a total of nearly 400 plates. He began life as an apprentice to a linen draper in Derby, then came to London, and opened a successful drapery shop in the Strand, which earned him the nickname "Old Drapery Face" from G. Morland. Angelica Kauffmann was one of his customers. He devoted his spare time to miniature painting and before long successfully took up engraving. He was appointed engraver to the Prince of Wales and became a print publisher and dealer while still continuing to engrave. He also painted portraits.
Aft.: L.F. Abbott, A. Appiani, J. Barry, Sir W. Beechey, W.R. Bigg, M. Brown, H. Bunbury, R. Cosway, Danloux, A.W. Devis, De Wilde, J. Downman, Engleheart, H. Fuseli, Gainsborough, N. Hone, R. Hone, Hoppner, Sir T. Lawrence, W. Lawranson, G. Morland, J.H. Mortimer, Northcote, J. Opie, Parkinson, Rev. M.W. Peters, W. Pether, Reynolds, Rigaud, G. Romney, S. Shelley, J.M.W. Turner, Vandergucht, Van Dyck, J. Walton, W. Ward, Westall, S. Woodford, J. Wright of Derby, J. Zoffany.
Des. eng.: W. Ward.
Pup.: W. Hilton, C. Josi, S.W. Reynolds, J.M.W. Turner, J. Ward, W. Ward, J. Young.
Pub.: C. Bowles (probably);

W. Humphrey.
Lit.: Frankau Julia *John Raphael Smith: His Life and Work* 1902. *P.C.Q.* IX, pp. 315-20. Smith J.C. *British Mezzotint Portraits* 1883.

SMITH John R. fl. London 1890s.
Line.
Gen. / hist. / land.
Aft.: J.W. Curtis, J. Pettie.

SMITH John Rubens 1775 (London) — 1849 (New York).
Aq., mezzo., stip.
Gen. / port. / topog.
The son of J. Raphael Smith and brother of Emma Smith (qq.v.), John Rubens Smith learned his technique from his father and studied at the R.A. Schools where his teachers included Fuseli (q.v.), Barry and Opie. He went to live in Boston, Mass., in 1806 and remained in America for the rest of his life. His son, John Rowson Smith was an American landscape painter.
Aft.: G. Morland, H. Sargent, J. Ward.

SMITH John Thomas 1766 (London) — 1833 (London).
Aq., et., litho.
Antiq. / fig. / illus. / land. / topog.
A son of the sculptor Nathaniel Smith, J.T. Smith studied successively under Nollekens, at the R.A. Schools and under the engraver J.K. Sherwin (1751—90). He was also a painter and a writer on art.
Aft.: W.D. Fellowes.

SMITH M. fl. 1898—1915.
Litho.
Flor. / illus.

SMITH O. fl. 1846.
Steel.
Illus. / land.
Aft.: W. Tombleson.

SMITH Samuel 1745 (London) — early 19th c.
Et., line.
Gen. / hist. / land. / myth.
Married the daughter of P.W. Tomkins (q.v.).
Aft.: De Loutherbourg, Ruysdael, Wilson, Zuccarelli.

Shared: J. Caldwell, T. Cook, W. Sharp (qq.v.), J. Thornthwaite (fl. 1770s).

SMITH Samuel S. 1810—79 (London).
Line., steel.
Hist. / port.
Worked in London.
Aft.: Domenechino, Dürer, Sir C. Eastlake, A. Elmore, Sir T. Lawrence.
Pub.: Gambart; Hering and Remington.
Lit.: *Art Journal* 1879, p. 109.

SMITH T. fl. 1831.
Steel.
Fig.
Aft.: Hogarth.

SMITH W. fl. London (20 Paul Street, Finsbury), *c.* 1835.
Pub.
Tinsel.

SMITH W.B. fl. 1818—35.
Steel.
Illus. / land.
Aft.: C. Stanfield.

SMITH William 1808 (London) — 1876 (London).
Printseller.
William Smith's father, also a printseller, died while his son was up at Cambridge and he terminated his university career in order to take over the business. He managed the Art Union of London and was responsible for the sale of several large and famous collections.

SMITH William James fl. London 1825.
Et.
Aft.: Rembrandt.

SMITH William Raymond fl. London 1830s — early 1850s.
Line., steel.
Illus. / land. / myth.
Aft.: S. Prout, W.C. Stanfield, J.M.W. Turner.
Pup.: J. Godden (q.v.).
Pub.: T. Agnew.
Lit.: Hayden A. *Chats on Old Prints* 1906.

SMITH and LINTON — see Smith, John Orrin.

SMYTH F.G. fl. mid 19th c.
Wood.
Illus.
Engraved much figure work for *Illustrated London News.*

SMYTH John Talfourd 1819 (Edinburgh) — 1851 (Edinburgh).
Line., steel.
Gen. / hist. / port.
After studying at the Trustees Academy, Edinburgh, J.T. Smyth became a pupil of an engraver, but his master died after a year, and he was thereafter self-taught. He moved to Glasgow in 1838.
Aft.: Sir W. Allan, Faed, W.P. Frith, Sir J.W. Gordon, W. Mulready. A. Scheffer, Sir D. Wilkie.

SMYTHE Lionel Percy 1839 (London) — 1918.
Et., mezzo.
Gen.
Also a painter.

SMYTHE Richard 1863 (Cromford) — after 1902.
Et., mezzo.
Fig. / gen. / port.
After being apprenticed to an engineer, Smythe studied painting at Manchester School of Art. He lived and worked in Hampstead and Hampton Hill. Also a portrait painter.
Aft.: W. Etty, Gainsborough, Greuze, Hoppner, Sir T. Lawrence, Reynolds, G. Romney, Saintpierre, C. Wilkins.
Pub.: T. Agnew; Cadbury and Jones; J. Connell; T. McLean.

SNAPE Martin fl. Gosport 1870s—1901.
Et.
Land.
Snape also worked as a genre painter. He lived with another painter-etcher, William H. Snape, probably a relative.

SOILLEUX A.F. fl. mid 1870s — mid 1880s.
Line., mixed.
An. / sport.
Aft.: Sir E. Landseer, G.W. Quatremaine.
Pub.: H. Graves.

SOIRON François 1755 (Geneva) — 1813 (Paris).
Stip.
All. / gen. / mil. / sport. / topog.
Soiron, a French national, worked in London for a period. His son, Philippe David (1783 — after 1857) was an enamel and porcelain painter.
Aft.: H. Bunbury, E. Dayes, Grignon, G. Morland, Singleton.
Shared: T. Gaugain (q.v.).

SOLOMON Simeon 1840 (London) — 1905.
Et.
Gen. / illus.
Better known as a painter and draughtsman, Solomon studied under his brother Abraham Solomon.
Lit.: Ford J.E. *Simeon Solomon, an Appreciation*, 1908.

SOMERVILLE Andrew 1808 (Edinburgh) — 1834 (Edinburgh).
Et.
Gen.
Also a painter, Somerville studied at the Trustees Academy, Edinburgh. He achieved rapid success and was elected an associate member of the Royal Scottish Academy in 1831, and academician in 1832.

SOMERVILLE David fl. Edinburgh 1798—1825.
Line., litho.
Gen.
Aft.: A. Ramsay, W. Weir.

SOMERVILLE Howard 1873—1952.
Et.
Gen. / port.
Best known as a painter.

SOPER George Thomas 1870 (London) — 1942.
Dry., et., wood.
Genre.
Pupil of Sir F. Short (q.v.).
Lit.: *Studio* LXXX.

SORRIEU F. fl. mid 19th c.
Litho.
Music. / theat. (ballet).

SOTHERS R. Dodd fl. early 19th c.
Aq.
Sport.
Aft.: J. Ibbetson.

SOULANGE-TESSIER Louis Emmanuel 1814 (Amiens) — 1898.
Litho.
An. / gen.
French national who made a number of prints after works by British artists, which were published in England.
Aft.: T. Earl.
Pub.: Gambart.

SOUTHCOTT William Frederiks b. Middlesex 1874.
Litho.
Illus.

SOWERBY George Brettingham Sr. 1788 (Lambeth) — 1854.
Litho.
An. / illus. / nat.
Noted chiefly as a painter and conchologist.

SOYER Mrs — See Jones, Emma.

SPARK W.J. and A. fl. London (215 Globe Road, Mile End) c. 1880.
Pub.
Juv. dram.

SPARKS Nathaniel 1880 (Bristol) — 1957.
Et.
Land. / topog.
Sparks, who worked in London, studied at Bristol School of Art and the Royal College of Art, London, under Sir F. Short (q.v.). He was also a watercolourist.
Pub.: E. Parsons.
Lit.: *Art Journal* 1908, p. 328; 1909, p. 160. *P.C.Q.* XI, p. 372. *Studio* Winter number 1915-16, pp. 94, 100, 177, 189.

SPARROW Henry 1831—1916.
Et.

SPEAR — fl. c. 1900.
Pub.
Juv. dram.
Published the toy-theatre sheets known as "The Spear Series".

SPENCE Charles James 1848—1905.
Et.
Also a watercolourist. Father of
R. Spence (q.v.).

SPENCE Robert 1871 (Tynemouth)
— 1964.
Et.
Hist. / theat.
Worked in London. Also a painter.
Noted for his etchings of scenes from
the operas of Wagner. Son of C.J.
Spence (q.v.).
Lit.: *Studio* LXIX, p. 29.

SPENCELAYH Charles 1865 —
c. 1950.
Et.
Gen.
Best known as a painter of genre and
as a miniaturist.

SPENCER — fl. 1832.
Steel.
Illus. / land.

SPENCER J. fl. London (65 East
Street, Manchester Square) 1818.
Pub.
Juv. dram. / tinsel.

SPENCER Lavinia Countess
1762—1831.
Et. (amateur).
Port.
Also a designer.
Aft.: M. Bovi, R. Cosway, Reynolds.

SPENCER Thomas fl. Liverpool
1838.
A picture-frame maker who invented
electrotyping.

SPILSBURY Jonathan fl. 1766—1823.
Mezzo., stip.
All. / gen. / hist. / land. / port. / relig.
There has been some confusion between
the brothers John (c. 1730—c. 1795)
and Jonathan Spilsbury, but it is
claimed that John did not engrave
portraits, but only maps, plans,
ornaments and handwriting.
Jonathan is sometimes called "Inigo"
to distinguish him from his brother.
Perhaps the name was first given him
because of his mezzotint portrait of
Inigo Jones.

Aft.: Chamberlin, Gainsborough,
Heemskerk, Angelica Kauffmann,
Murillo, Rembrandt, Reynolds, Sadler,
Maria Spilsbury.
Pub.: Orme.

SPINELLI Raffaele fl. mid 1880s—
1900.
Et.
Gen.
Italian national who made a number
of plates after works by British artists,
which were published in England.
Aft.: J.C. Hook.
Pub.: H. Graves, M. Knoedler,
E.E. Leggatt.

SPOONER William fl. c. 1844.
Pub.
Litho.
Theat. (ballet).

SPREAD William d. 1909.
Et.
Arch.
Also a painter.

STACPOOLE Frederick A.R.A.
1813—1907 (London).
Line., mezzo., mixed., stip.
*All. / gen. / hist. / mil. / myth. / port. /
relig. / ship. / sport. / topog.*
Stacpoole was the son of a naval
officer. Educated in Ghent, he
became a student at the R.A. Schools,
where he was awarded two silver
medals. He worked in Hammersmith.
His engravings are exclusively
reproductive.
Aft.: R. Ansdell, C.B. Barber,
J. Barrett, A. Bouvier, T. Brooks,
R. Collinson, T. Faed, F. Goodall,
J.W. Gordon, Sir F. Grant, Alice
Havers, W. Holman Hunt, Sir E.
Landseer, G.D. Leslie, Meissonier,
P.R. Morris, Reynolds, B. Rivière,
J. Sant, F. Tayler, Elizabeth
Thompson (Lady Butler).
Shared: T.L. Atkinson, T. Landseer,
A. Scott.
Pub.: T. Agnew; B. Brooks; R. Brooks
and Sons; C.E. Clifford; Colnaghi;
J. Dickinson; Dixon and Ross; Fine
Art Society; Fores; H. Graves and
Co.; Lefèvre; Lloyd Bros.; W. Lucas;
T. McLean; E.S. Palmer; Pilgeram
and A. Lucas.

Lit.: Engen R.K. *Victorian Engravings* 1975.

STADLER Joseph Constantine
fl. London 1780—1812.
Aq., et., mezzo.
Arch. / cost. / gen. / illus. / land. / mil. / port. / ship. / topog.
Stadler was either a German or of German descent. He used a special method of building up his aquatint prints, using three or four different plates, one for each tint and one for the outline of the design, this one being printed in brown and applied last. This replaced the method in which the aquatint was printed in two colours ready for the colourist.
Aft.: Atthalin, Billington, A. Buck, F.G. Byron, De Loutherbourg, Ekstein, J. Farington, R. Freebairn, T. Girtin, Glendall, Heriot, Horne, Lt. Col. Irving, Laing, Livesay, Pocock, R.K. Porter, Prout, A. Pugin, T.H. Shepherd, Vernet, E. Walsh, R. Westall.
Pup.: F.C. Lewis (q.v.).
Shared: S. Freeman, D. Havell, F.C. Lewis, J. Mitan, P. Roberts.
Pub.: Ackermann; Boydell; W. Byrne.

STAINES Robert 1805 (London) — 1849 (London).
Line., steel.
Illus.
A pupil of J.C. Edwards, Staines later transferred to W. Finden (qq.v.), and afterwards continued to work for the firm.
Aft.: C.R. Leslie, F.P. Stephanoff, J.W. Wright.

STAINFORTH Martin F. fl. Highgate 1890s.
Line.
Fig. / gen. / relig.
Also a sporting painter.
Aft.: Borgogne, G.H. Boughton, A. del Sarto, K. Halswelle, A. Legros, Mantegna, W. Owen, Raphael.

STALKER Ebenezer fl. 1805—33.
Line., steel.
Port. / vignettes.
Worked in Philadelphia *c.* 1815, at other times in London.
Aft.: Hogarth.

STAMP Ernest 1869 (Sowerby — 1942.
Et., mezzo., mixed.
Gen. / land. / port. / topog.
A pupil of Sir H. Herkomer (q.v.), Stamp worked in Northampton from 1894. He also practised as a portrait painter.
Aft.: F. Barraud, F. Boucher, Constable, C. Duran, Gainsborough, Lely, S. Lucas, Meissonier, Sir W.Q. Orchardson, Raeburn, Reynolds, G. Romney, F. Walker, W.F. Yeames.
Pub.: C.E. Clifford; Dickinson and Foster; H. Graves; Leggatt Bros.; T. McLean.
Lit.: *Portfolio* 1892, p. 219.

STAMPA George L. 1875 (Constantinople) — 1951.
Et.
Illus.

STANCLIFFE J. 1860s.
Line., steel.
Gen.
Aft.: A. Elmore, C. Landseer, H. Lejeune.

STANDIDGE AND CO. fl. 1840s.
Print. (litho).

STANIFORTH Joseph Morewood 1863 (Cardiff) — 1921 (Lynton).
Litho.
Illus.
Also a mural painter.

STANILAND Charles Joseph 1838 (Kingston-on-Hull) — 1916.
Et.
Gen. / hist.
Staniland studied at Birmingham School of Art. He also practised as an illustrator and painter in oils and watercolour.
Pub.: A. Ackermann; Fine Art Society.
Lit.: *Art Journal* 1884.

STANLEY Lady Dorothy — See TENNANT Dorothy.

STANNARD Alfred 1806 (Norwich)
— 1889 (Norwich).
Et.
Land. / topog.
Also a marine and landscape painter.
Brother of J. Stannard (q.v.) with
whom he shared a studio until 1843.

STANNARD Joseph 1797 (Norwich)
— 1830 (Norwich).
Et.
Gen. / land. / ship. / topog.
Also a painter, Stannard was a pupil
of R. Ladbrooke (q.v.). He was the
brother of A. Stannard (q.v.) with
whom he shared a studio until 1843;
he also shared a studio with E.T.
Daniell (q.v.).
Pup.: Rev. E.T. Daniell, J. Middleton
(qq.v.).

STANNARD and SONS fl. London
(7 Poland Street) mid 19th c.
STANNARD and CO.
STANNARD and DIXON
Litho., print.
Music.
Lit.: Spellman D. and S. *Victorian
Music Covers* 1969.

STAR — fl. London (Gunthorpe
Square) *c.* 1880.
Pub.
Tinsel.

STARK James 1794 (Norwich) —
1859 (London).
Et.
Land.
Stark was a pupil of John Crome
(q.v.) and was also a painter; only
six etchings by him are known.
Pup.: S.D. Colkett (q.v.).

STARLING J. fl. 1830s.
Steel.
Illus. / land.
Aft.: T. Allom, W.H. Bartlett,
W. Tombleson.

STARLING M.J. fl. first half of
19th c.
Steel.
Illus.
Aft.: T. Allom, W.H. Bartlett, C.
Bentley, H. Gastineau, W. Leitch,
T.P. Neale, G. Pickering, T.H. Shepherd.

STARLING Thomas fl. London
1820—40.
Line., steel.
Ex libris / maps.

STARLING William Francis
fl. London 1830s—1880s.
Line, mezzo., mixed, steel., stip.
Gen. / hist. / illus. / port.
Aft.: T. Brooks, J.W. Childe,
E.K. Johnson, A. Johnstone, G.
Smith.
Pub.: Owen Bailey; B. Brooks.

STEED J. fl. 1832.
Steel.
Land.
Noted especially for views of the
Rhine.
Aft.: W. Tombleson.

STEELE Louis John fl. London
1870s—1880s.
Et., line.
Gen. / hist.
Aft.: Helen Allingham, A.C. Gow,
Sir W.Q. Orchardson, B. Riviere,
M. Stone, S.E. Waller.
Pub.: T. Agnew; A. Tooth.
Lit.: *Portfolio* 1881, p. 73; 1882,
pp. 76, 105.

STEPHENS R. fl. Worcestershire
1815.
Et.
Topog.
Aft.: G. Grainger, a local artist.

STEPHENSON James 1828
(Manchester) — 1886 (London).
Et., line., litho., mezzo., steel.
*An. / gen. / hist. / illus. / land. /
lit. / port. / relig. / topog.*
The son of a shoemaker, Stephenson,
after attending school, was apprenticed
to a Manchester engraver, John
Fothergill. Afterwards he went to
London and worked in the studio of
W. Finden (q.v.). He was awarded a
silver medal by the Society of Arts.
He returned to Manchester *c.* 1838,
but went back to London *c.* 1847
and settled there.
Aft.: J. Boston, R. Dowling, T. Faed,
Gainsborough, Sir J.W. Gordon,
T. Graham, Sir F. Grant, Sir E.
Landseer, D. Maclise, T.H. Maguire,

J. Martin, Sir J.E. Millais, G.S. Newton, G. Steell, W.M. Tweedie, G.F. Watts.
Shared: Stephenson completed a plate begun by R. Graves (q.v.), a portrait after Gainsborough, left uncompleted on Graves's death.
Pub.: Colnaghi, H. Graves.
Lit.: *Art Journal* 1855, p. 110; 1874, p. 27. *Connoisseur* XCVII, p. 257.

STEPNEY G. and S. fl. 1840.
Stip.
Port.

STERNBERG or STERNBURGH Frank 1858–1924.
Mezzo.
Gen. / myth. / port.
A pupil of Sir H. Herkomer (q.v.) at his art school in Bushey, Herts.
Sternberg later worked in Leeds.
Aft.: Greuze, E. Hallé, Sir H. Herkomer, Meisonnier, Reynolds, H. Schmalz, S. Shelley, H.J. Thaddeus, G.F. Watts.
Pub.: H. Graves; M. Knoedler; Arthur Lucas.
Lit.: *Art Journal* 1896, p. 318.

STEVENS Alfred 1823 (Brussels) – 1906 (Paris).
Litho.
Arch.
Best known as a portrait painter.

STEVENS Charles fl. mid 1860s.
Pub.
First publisher of "The Boys of England"; see Edwin J. Brett.

STEVENS Francis 1781–1822 or 1823 (Exeter).
Et.
Arch. / land.
Also a watercolourist.

STEVENSON F.G. fl. 1890–1910.
Et., mixed.
Arch. / gen. / port. / sport. / topog.
Probably identical with the etcher George Stevenson, who made landscape etchings, and who encouraged Sir D.Y. Cameron (q.v.) to adopt etching.
Aft.: F. Barraud, W. Beechey, Botticelli, H.J. Brooks, da Vinci, S.T. Denning, Ghirlandaio, T.H. Hemy, G.A. Holmes, Sir E. Landseer, G. Morland,

J. Northcote, T. Phillips, Raphael, Rembrandt, Reynolds, Romney, Van Dyck, A.H. Wardlow, F. Winterhalter.
Pub.: C.E. Clifford; Harry C. Dickins; Dickinson and Foster; H. Graves; T. McLean; Archibald Ramsden.

STEVENSON George – See Stevenson F.G.

STEVENSON Robert Louis 1850 (Edinburgh) – 1894 (Samoa).
Wood.
All. / illus.
The famous writer and author of *Kidnapped, Treasure Island* and other books.

STEVENSON T. fl. 1854.
Steel.
Fig. / illus.
Aft.: T. Phillips.

STEWART Graham b. 1786 (Dublin).
Wood.
Illus.

STEWART James 1791 (Edinburgh) – 1863 (South Africa).
Aq., line., steel.
An. / gen. / hist. / illus. / sport.
After being apprenticed in Edinburgh to R. Scott (q.v.) Stewart became a student at the Trustees Academy. He was an original member of the Royal Scottish Academy at its foundation in 1826. In 1833 he emigrated to Algoa Bay where he bought a farm which was destroyed next year in the Caffre insurrection. He was forced to flee and found refuge at Somerset, in the colony, where he recouped by practising and teaching his art. Afterwards he bought another property and became a magistrate.
Aft.: Sir W. Allan, W. Kidd, Pollard, Sir D. Wilkie.
Pub.: H. Graves.
Lit.: *Art Journal* 1863, p. 165. *P.C.Q.* XVI, p. 273.

STOCK C.R. fl. late 19th c.
d. 1902 or after.
Aq., mezzo., mixed.
Sport.

Aft.: H. Alken, H. Bird, E.A.S.
Douglas, W.C. Lee, Sayer, W. Shayer,
G. Veal.
Pub.: A. Ackermann, W.C. Lee,
F.C. McQueen.

STOCKDALE Frederick Wilton
Litchfield d. after 1848.
Et.
Land.
Also a painter and writer.

STOCKS Bernard O. fl. London
1880s.
Mezzo.
Gen.
Also a painter. Son of L. Stocks (q.v.).
Aft.: A. Stocks.
Pub.: Leggatt.

STOCKS John fl. mid (?) 19th c.
Line., steel.
Illus.

STOCKS Lumb R.A. 1812
(Lightcliffe, Halifax) — 1892 (London).
Line., steel.
*Fig. / gen. / hist. / illus. / lit. / myth. /
port. / relig.*
Educated at Horton, near Bradford,
Stocks also received lessons in drawing
from Charles Cope, father of C.W.
Cope R.A. He came to London at the
age of fifteen and was articled to
Charles Rolls (q.v.) and thereafter set
up on his own account. At times he
worked as assistant to the Finden
brothers (qq.v.). He was the father of
B.O. Stocks (q.v.); two other sons,
Arthur and Walter Fryer were also artists.
Aft.: J.B. Burgess, A. Burt, Sir A.W.
Callcott, G. Cattermole, T. Faed,
W.P. Frith, J.C. Horsley, J. Inskipp,
C. Landseer, J.E. Lauder, R.S. Lauder,
Lord Leighton, C.R. Leslie, D. Maclise,
Sir J. Millais, W. Mulready, Murillo,
Sir J.N. Paton, Steinla, T.P. Stephanoff,
T. Stothard, T. Uwins, E.M. Ward,
T. Webster, Sir D. Wilkie, P. Williams.
Shared: J. Cousen, C.H. Jeens,
J. Outram (qq.v.).
Pub.: Art Union of Glasgow; Art Union
of London; Association for the
Promotion of Fine Arts in Scotland;
Fine Art Society; T. McLean.
Lit.: Engen R.K. *Victorian
Engravings* 1975. *Portfolio* 1883, p. 1.

STODART Edward Jackson 1879
(Barnsbury) — after 1928.
Mezzo., stip.
Gen. / port.
The son of E.W. Stodart (q.v.), E.J.
Stodart lived and worked in West
Hanningfield, Essex. He signed his
work "E. Stodart", later "Jackson
Stodart", and then "E. Jackson
Stodart".
Aft.: Jennie Brownscombe, R. Cosway,
Hoppner, Sir T. Lawrence, G. Morland,
J.M. Nattier, W. Ward, F. Wheatley.
Pub.: Alfred Bell; Dowdeswell and
Dowdeswells; H. Graves; C. Klackner;
Museum Galleries.
Lit.: *Connoisseur* LXII, p. 50.

STODART Edward William
1841—1914.
Steel., stip.
Illus. / port.
Father of E.J. Stodart (q.v.). Plates
signed "H. Stodart" are thought
to be his.
Aft.: R. Cosway, Fragonard,
A. Plimer, W. Ward.
Pub.: F.B. Daniels; H. Graves.
Lit.: *Art Journal* 1864, pp. 150, 375.

STODARD George J. fl. mid 1880s —
early 1890s.
Mixed., steel.
Gen. / illus. / port.
The son of an engraver, George Stodard
(d. 1889), G.J. Stodard lived and
worked in Godstone, Surrey, and Great
Yarmouth.
Aft.: Helen Allingham, Kate
Greenaway, W.E. Miller, G.B. O'Neill,
F. Sandys, H.T. Wells.
Pub.: Fine Art Society; George Rees;
A. Tooth.

STOKER W. fl. 1813—15.
Aq.
Illus.

STOKES George Vernon 1873—1954.
Dry., et.
An. / sport.
Also a painter.

STOKES J. fl. 1832.
Line., steel.
Illus. / land.
Aft.: W. Tombleson.

STOKES Sarah c. 1790—1844.
Pub.
Juv. dram.
Stokes was housekeeper to W. West
(q.v.) and published some of his
plays when illness prevented him from
doing so. Her address was 57 Wych
Street, London.

STONE Frank A.R.A. 1800
(Manchester) — 1859.
Et.
Gen. / lit.
Father of the painter Marcus Stone,
Frank moved to London in 1831 and
worked for C. Heath (q.v.) for whom
he made pencil drawings. He is best
known as a painter of genre and of
portraits.
Des. eng.: J.H. Robinson, W.H.
Simmons, C.E. Wagstaff (qq.v.).

STONE J. fl. 1832.
Steel.
Illus. / land.
Aft.: W. Tombleson.

STONEHOUSE Charles fl. 1833—65.
Et.
Lit.
Also a painter.

STOPFORD Robert Lowe 1813
(Dublin) — 1898 (Cork).
Litho.
Land.
Also a painter.

STORER Henry Sargant 1795
(? Cambridge) — 1857 (London).
Line.
Arch. / topog.
Storer lived in Cambridge for many
years. He was also a draughtsman.
Shared: J.S. Storer (his father, q.v.).
Aft.: H. Gastineau.

STORER James Sargant 1781
(Cambridge) — 1853 (London).
Line.
Antiq. / arch. / illus. / lit. / topog.
Storer lived most of his life in
Cambridge. He was the father of
H.S. Storer (q.v.) with whom he
shared work on some plates. He
was associated with J. Greig

(q.v.) on a series of antiquarian and
topographical plates.

STORM G.F. or G.P. fl. 1834—50.
Steel.
Illus. / land. / port.
Worked for a time in U.S.A.
Aft.: W.H. Bartlett, H. Bone,
T. Phillips.

STOTHARD Charles Alfred
1786—1821.
Aq.
Illus.
Second son of the painter and
illustrator, Thomas Stothard (q.v.).

STOTHARD F.R.J. fl. c. 1840.
Litho.
Theat. (ballet).
Aft.: R.T. Stothard.

STOTHARD Thomas R.A. 1755
(London) — 1834 (London).
Et., litho.
Gen.
Stothard is best known as a painter
and illustrator; his work was
reproduced by numerous engravers,
although he made a handful of
original prints. He was the father of
C.A. Stothard (q.v.).
Lit.: Bray Anna Eliza *Life of Thomas
Stothard R.A.* 1851.

STOW James c. 1770 (Nr Maidstone)
— 1820.
Line.
Gen. / illus. / lit. / port. / relig. / topog.
The son of a Kentish labourer, Stow
was apprenticed to the engraver
William Woollett (1735—85), the
premium being raised by public
subscription. He transferred to
W. Sharpe (q.v.) when Woollett died.
Aft.: Edridge, Gainsborough, Murillo,
B. West.

STOWE J. fl. 1829.
Steel.
Arch. / illus.
Aft.: N. Whittock.

STRAKER D. fl. London
(21 Aldersgate Street) 1825—30. .
Pub.

341

Juv. dram.
Straker ceased activities about 1830 when it is thought he had a fire. His plates became the property of Dyer and Lloyd and later of Park and Skelt (qq.v.).

STRAND PHOTOGRAVURE COMPANY
STRAND ENGRAVING COMPANY fl. early 20th c.
Pub.
Photo-eng.

STRANG William R.A. 1859 (Dumbarton) — 1921 (Bournemouth). Aq., dry., et., line., litho., mezzo., wood.
All. / arch. / ex libris / fig. / gen. / illus. / lit. / port. / relig. / topog.
Strang, after being educated at Dumbarton Academy, studied at the Slade School under A. Legros and Sir E. Poynter (qq.v.). He made some 747 etchings. He was also a noted portrait painter and illustrator.
Aft.: Correggio, C.W. Furse, Rembrandt, Velasquez.
Pup.: Sir C. J. Holmes (q.v.).
Pub.: C.E. Clifford, E. Parsons.
Lit.: *Art Journal* 1910, pp. 47f. Dodgson C. *The Etchings of William Strang and Sir Charles Holroyd . . .* 1933. *Magazine of Art* 1902—3, pp. 177, 235. *P.C.Q.* VIII, pp. 349—76; XXIV, pp. 394—409; XXIX, pp. 42—56.

STREET F. fl. Edinburgh 1810.
Line.
Ex libris.

STRUDWICK William fl. London 1860s—80s.
Et.
Land.
Also a painter.

STRUTT Alfred William 1856 (Taranaki, N.Z.) — 1924.
Et.
Gen.
The son and pupil of the painter William Strutt. After spending the early part of his life in Australia he came to England, attended the South Kensington School of Art and worked thereafter mainly in London. He was also a painter.
Aft.: W. Strutt.
Pub.: A. Lucas; I.P. Mendoza.

STRUTT Arthur John 1819 (Chelmsford) — 1888 (Rome).
Et.
Gen.
A pupil of Jacob George, Strutt was also a landscape painter.

STRUTT Jacob George fl. 1820— 1850.
Et.
Topog. / trees.
Lived in Lausanne and Rome from *c.* 1831 to 1851.
Also a painter of landscape and portraits.

STUART J. fl. Chester 1780—1810.
Line.
Ex libris.

STUART Sir John James 1799—1849.
Et.
Lit.
Pub.: Colnaghi.

STUART Sir James 1779 (Rome) — 1849 (Edinburgh).
Line (amateur).
Mil.
Lit.: *P.C.Q.* XXIX, pp. 236—49.

STUBBS George Townley 1756 (London) — 1815.
Et., line., mezzo., stip.
An. / gen. / port. / sport. / topog.
Son and pupil of the great painter and engraver George Stubbs (1724—1806).
Aft.: Ansell, J. Barenger, Burke, Grignon, Singleton, G. Stubbs, J. Wickstead.
Pub.: Orme; Stubbs; Turf Gallery, Conduit Street, London.

STUBBS James fl. 1830s.
Steel.
An. / illus. / sport.
Pupil of E. and W. Finden (qq.v.).
Aft.: R.W. Buss, Spalding.
Pub.: H. Graves.

STUBBS James Henry Phillipson
1810 (Marylebone) — 1864 (London).
Steel.
Illus.

STUMP Samuel John or John Samuel
d. 1863.
Line., stip.
Port. / theat.
Stump, who worked in London, was
also a miniaturist and a portrait painter.

SUFFIELD J. fl. Evesham 1800—40.
Line.
Ex libris / port.
Also a medallist.

SULLIVAN Edmund Joseph 1869
(London) — 1933 (London).
Et., litho.
Fig. / illus. / lit. / port.
Also a painter and art critic.

SULPIS Emile Jean 1856 (Paris) —
after 1900.
Et.
Myth.
French national who made at least
one plate after a work by an English
artist, which was published in
England.
Aft.: Sir E. Burne-Jones.
Pub.: A. Tooth.

SUMMERFIELD John c. 1785—1817
(Buckinghamshire).
Line., stip.
Gen. / port.
A pupil of F. Bartolozzi (q.v.),
Summerfield was awarded a gold medal
by the Society of Arts.
Aft.: Reynolds, Rubens.

SUMMERS W. fl. London, second
half of 19th c.
Aq., litho.
Mil. / ship. / sport. / topog.
Aft.: H. Alken, B. Bradley, H. Hall,
W. Heath, B. Herring, Norie and
Durton, J. Sturgess.
Shared: J. Harris (q.v.).
Pub.: L. Brall and Sons; F. Herbault;
McQueen.
Lit.: Wilder F.L. *English Sporting
Prints* 1974.

SUMMER George Heywood Maunoir
1853—1940.
Et., wood.
Land. / topog.
Worked in South Kensington.

SUTHERLAND Elisabeth, Duchess of
1765—1839.
Et., (amateur).
Land. / port.
Also a painter.
Lit.: *P.C.Q.* XVIII, p. 296.

SUTHERLAND Thomas b. c. 1785.
Aq., mezzo., mixed.
*An. / gen. / hist. / illus. / mil. / marine. /
ship. / sport. / topog.*
Worked in London about 1810—40.
Aft.: H. Alken, S. Alken, J. Barenger,
R.B. Davis, Dolby, J. Glendall, C.
Henderson, J.F. Herring, W.J. Huggins,
J. Pollard, Stephanoff, T. Whitcombe,
C. Wild, D. Wolstenholme.
Shared: H. Alken, W.T. Fry, J. Harris,
H. Merke (qq.v.). Also with an
engraver named Cooper, but it is at
present impossible to say which one.
Pub.: R. Ackermann; Fuller; Heath;
Thomas Kelly; T. McLean; Sheardown
and Son.
Lit.: Wilder F.L. *English Sporting
Prints* 1974.

SUZMAN — fl. London 1830.
Pub.
Juv. dram.
A partner of J. Bailey (q.v.).

SWAIN Charles 1801 (Manchester) —
1874.
Et., litho. (amateur).
Port.
Best known as a poet and composer
of music.

SWAIN Edward — See SWAIN Ned.

SWAIN John fl. mid 19th c.
Wood.
Illus.
Possibly identical with John Swaine
(q.v.).
Aft.: R. Doyle, J. Leech.

SWAIN Joseph 1820 (Oxford) —
1909 (Ealing).
Wood.
Illus.
Educated at private schools in Oxford
and London, Swain was in 1834
apprenticed to the engraver Nathaniel
Whittock, transferring in 1837 to
Thomas Williams (qq.v.). He became
manager of the engraving department
of *Punch* in 1843, and set up on his
own account in 1844, though remaining
responsible for all the engraving for
Punch until 1900. He worked also for
the *Cornhill Magazine,* most of the
engravings for which he made. His work
was signed "Swain sc." but this
signature was also used by his
numerous assistants. His manager was
W.H. Hooper (q.v.). He later took
over the photo-engraving firm of J.
Leitch and Co.
Aft.: R. Ansdell, F. Barnard, C.
Bennett, R. Doyle, H. Holiday,
C. Keene, Lord Leighton, W. Linton,
Sir J.E. Millais, W.H. Rogers, F. Sandys,
J. Tenniel, F. Walker and very many
more.
Pub.: James Nisbet and Co.
Lit.: de Maré, E. *The Victorian
Woodblock Illustrators* 1980.

SWAIN Ned (Edward) 1847 —
c. 1902.
Et.
Arch. / ex libris / topog.
Also a painter. Worked in S. Africa
in 1880.

SWAINE John 1775 (Stanwell,
Middx.) — 1860 (Soho, London).
Line.
*Antiq. / facsimiles of old prints /
illus. / port. / scien. /*
Also a draughtsman, John Swaine was
a pupil of Jacob Schnebbelie (1760—92)
on whose death he was transferred to
Barak Longmate (d. 1793), whose
daughter he married. J.B. Swaine (q.v.)
was his son. Possibly identical with
John Swain (q.v.).
Pup.: J. Fahey (his nephew, q.v.).

SWAINE John Barak ?1815—38.
Et., mezzo., wood.
Illus.
Son of John Swaine (q.v.).

SWAINSON William fl. 1830s.
Litho.
An. / illus.

SWAN Joseph d. 1872.
Aq., line., steel.
Ex libris / flor. / illus. / maps.
Worked in Glasgow.
Aft.: W. Brown, A. Donaldson,
D. Mackenzie, T. Stewart.

SWAN Sir Joseph Wilson 1828—1914.
Photo-eng.
Inventor of a number of photo-
engraving processes.

SWAN ELECTRIC ENGRAVING
COMPANY fl 1890s — early 20th c.
Photo-eng.
Pub.: Dott, Aitken and Son; G.F.
Jefferys and Co.; Lawrence and
Butler; McQueen Bros.; Morgan and
Swan; J. Reville and Co.

SWARBRECH Samuel Dunkenfield
fl. Scotland 1839.
Litho.
Arch. / land. / topog.

SWIFT W. fl. 1816—20.
Wood. (including coloured).
Flor. / illus.

SWINSTEAD George Hillyard
1860—1926 (London).
Et.
Gen. / land.
Swinstead attended the R.A. Schools
from 1881. He was also a painter of
genre and landscapes, and lived and
worked in London.
Pub.: I.P. Mendoza.

SYER John, the Younger 1815
(Atherstone) — 1885 (Exeter).
Litho.
Ship.
Best known as a watercolourist and
landscape painter.

SYMS or SYMNS W. fl. 1829—31.
Steel.
Arch. / illus.
Aft.: T.H. Shepherd.

SYNGE Edward Millington 1860
(Gt. Malvern) — 1913 (London).
Et., mezzo.

Illus. / land. / topog.
A pupil of Sir F. Short and Sir F.
Seymour Haden (qq.v.), Synge
worked in London and abroad.
Lit.: *Art Journal* 1908, pp. 289,
302. *Graphic* II, p. 8. *Studio* 1908,
p. 218; 1913, p. 8; 1914, pp. 98f;
1916, pp. 195f.

TABLEY John Fleming Leicester, Baron de — See DE TABLEY John Fleming Leicester, Baron.

TAGG Thomas b. Kennington 1809.
Et., line.
Port.

TALLBERG Axell 1860 (Gefle, Sweden) — 1928.
Aq., et., mezzo.
Gen. / land. / port. / topog.
Swedish national who made a number of prints after works by British artists which were published in England. He lived near Windsor 1886—95. The following works on etching were written by him: *About Etching and Engraving* (1911); *Etching and Engravings, a Handbook for Private Collectors* (1917); *The Etcher, his Ways and Means* (1917); *The Etcher, a Practical Handbook for the Art Student* (1924).
Aft.: F. Barraud, J. Dixon, S. Fox, A.H. Wardlow.
Pub.: Dickinson and Foster.

"TALLY-HO Ben" — Pseudonym of H.T. Alken (q.v.).

TALMAGE Algernon Mayow R.A. 1871—1939.
Et.
An. / gen. / land.
A pupil of Sir H. Herkomer (q.v.), Talmage was an official war artist for the Canadian Government in 1918. He ran an art school in St Ives, Cornwall.

TASSAERT L. fl. probably early — mid 19th c.
Mezzo.
Port.
Little is known of this engraver.
Aft.: T. King.

TATHAM Charles Heathcote 1772 (Westminster) — 1842 (Greenwich).
Et.
Antiq. / arch.
Tatham's etchings represent only a minor part of his work, most of which was devoted to architecture. He was the father-in-law of G. Richmond (q.v.).

TAUBMANN Frank Mowbray b. London 1868.
Et. (?)
Land.
Also a sculptor, painter and draughtsman.

TAYLER John Frederick 1802 (Boreham Wood) — 1889 (Hampstead).
Et., litho.
Gen. / illus. / lit. / sport.
Tayler was the son of a gentleman who was ruined by his agent while the boy was still at school; however, due to the efforts of influential relatives, he was educated at Eton and Harrow. He was destined for the church but soon decided to devote himself to art which he studied successively at Sass's School, the R.A. Schools and under Horace Vernet in Paris. He became president of the "Old Water-Colour" Society,

346

being also a landscape painter in that medium.
Pub.: T. McLean.

TAYLOR B. fl. 1812.
Line.
Port.
Also a draughtsman.

TAYLOR C.S. fl. 1823—27.
Line.
Port.
Also a draughtsman.

TAYLOR Charles 1756 (Shenfield) — 1823 (London).
Line., litho.
Gen. / myth.
Pupil of F. Bartolozzi (q.v.).
Aft.: Angelica Kauffmann.

TAYLOR Charles William 1878 (Wolverhampton) — 1960.
Line.
Gen. / land.
Taylor, who received his training at the Royal College of Art, London, lived and worked at Southend-on-Sea.
Lit.: *P.C.Q.* XXIII, pp. 125-43.

TAYLOR Edward Clough 1786 (Kirkham Abbey) — 1851.
Et. (amateur).

TALOR Isaac II 1750 (London) — 1829 (Ongar).
Line., stip.
All. / arch. / hist. / illus. / land. / port. / relig. / topog.
The son of Isaac Taylor I (1730—1807), Isaac II was educated at Brentford Grammar School. He studied engraving with his father. Retiring to Lavenham in 1786 he became a Noncomformist minister. In 1791 he was awarded a gold palette and 25 guineas by the Society of Arts. In 1796 he took up a post as a Nonconformist pastor at Colchester, but continued to engrave. In 1810 he took on yet another Nonconformist ministry at Ongar, and lived there for the rest of his life. His children included Isaac Taylor III (1787—1865) line engraver, author, inventor and artist; and Ann (1782—1866) and Jane (1783—1824), writers for the young. Jane was the author of the nursery poem "Twinkle, twinkle, Little Star."
Aft.: Opie, Smirke, T. Stothard.

TAYLOR John, called "Old Taylor" 1739 (London) — 1838 (London).
Mezzo.
Gen. / port.
Also a painter, Taylor was a pupil of F. Hayman.

TAYLOR Josiah (Joshua) fl. about 1860—70.
Litho.
Marine.
Also painted genre, portraits and marine subjects.

TAYLOR Luke 1876—1915.
Aq., et.
Fig. / gen. / illus. / land. / relig. / topog.
Attended Royal College of Art. Lived and worked in Deptford.
Aft.: F. Madox Brown, J. Constable, G.J. Finwell, Meisonnier, A. Moore, D. Roberts, Van Dyck.
Pup.: Lt. Col. Collison-Morley (q.v.).
Pub.: Fine Art Society.
Lit.: *Art Journal* 1903, p. 274; 1905, p. 332; 1908, p. 230; 1909, pp. 128f, 134f. *Connoisseur* XLVII, p. 228. Singer H.W. *Modern Graphic* 1914. *Studio* 198, pp. 213, 218; Special number 1916, pp. 10, 97.

TAYLOR R. fl. 1870—1900.
Wood.
Illus.

TAYLOR Thomas fl. London 1780—1810.
Line.
Lit. / myth.
Aft.: Opie, S. Rosa.

TAYLOR W. James fl. 1830s—40s.
Line., steel.
Topog.
Aft.: C. Deane.
Pub.: H. Graves.

TAYLOR W. John fl. London 1790—1810.
Line.
Gen. / land.
Aft.: A. Both, A. Cuyp, P. Potter, W. Sharp, J. Ward.

347

TAYLOR Weld fl. 1838.
Litho.
Theat. (ballet).
Pub.: T. McLean.

TAYLOR William Benjamin Sarsfield
1781 (Dublin) — 1850 (London).
Aq.
Land. / mil. / topog.
Taylor attended Dublin Academy
1800—4 and later taught there. He
came to London in 1829 and became
curator of St Martin's Lane Academy.
He wrote several books on art
including *The Origin, Progress and
Present Condition of the Fine Arts in
Gt. Britain and Ireland* (1841).
Lit.: *Art Journal* 1851, p. 44.

TAYLOR William Deane 1794—1857.
Line., steel.
Gen. / illus. / land. / myth. / port.
Lived and worked in London.
Aft.: W. Collins, R. Cook, D. Cox,
H. Howard, Sir T. Lawrence,
T. Webster.
Pub.: Art Union of London; Colnaghi;
J. Hogarth.

TEMPLE W.W. fl. early 19th c.
Wood.
Illus.
A pupil of T. Bewick (q.v.), Temple
engraved some blocks for *British Birds:*
rough-legged falcon, pigmy sandpiper,
red sandpiper and eared grebe. He
abandoned his art after completing
his apprenticeship and became a
draper and silk mercer.

TEMPLE PUBLISHING CO. fl. 1865.
Pub.
Juv. dram.
Also published boys' stories.

TEMPLETON J. fl. 1842.
Steel.
Illus. / land.
Aft.: W.L. Leitch.

TEMPLETON John Samuelson
fl. London 1820—57.
Litho.
Gen. / port. / ship. / theat. (ballet).
A pupil at the Dublin Society's
drawing school, Templeton also
painted landscapes and portraits.

Aft.: A.E. Chalon, A. de Valentini,
E.U. Eddis, J. Hayter, Sir W.C. Ross.
Pub.: H. Graves, T. McLean, T.
Mitchell.
Lit.: *P.C.Q.* XVIII, p. 237.

TENNANT Dorothy 1855—1926.
Et.
Gen.
Also a painter, Miss Tennant became
the wife of the African traveller Sir
H.M. Stanley and edited his auto-
biography posthumously. She later
married Henry Curtis, the noted
bacteriologist and surgeon.

TENNICK W.G. b. Darlington 1856.
Line. (?)
Gen. / hist. / land. / topog.

TENNIEL Sir John 1820 (London) —
1914 (London).
Et.
Lit.
Tenniel was one of the greatest
political cartoonists of his times. It is
said that for *Punch* he made more than
2500 designs. His most famous works
outside the political area are his
illustrations for Lewis Carroll's *Alice's
Adventures in Wonderland* and *Through
the Looking Glass.*
Des. eng.: Dalziel (q.v.).

TERRY Garnet fl. London
(Paternoster Row) 1795—1810.
Line., print.
Bank.
Security engraver who became an
official engraver and printer to the
Bank of England 1795—1809.

TERRY Henry John 1818 (Gt.
Marlow) — 1880 (Lausanne).
Litho.
Arch. / land. / topog.
A pupil of A. Calame at Geneva, Terry
was also a painter.
Aft.: A. Calame.

TESTOLINI Gaetano fl. London and
Paris 1760—1811.
Aq., line.
Illus. / port.

THELOT E. late 18th — early 19th c.
Line.
Gen.
Pupil of V. Green (q.v.).
Aft.: D. Teniers.

THIBAULT C.E. fl. 1878—84.
Steel.
Fig.
Aft.: J.E. Aubert.

THIELCKE H. fl. 1805—16.
Stip.
Gen. / port.
Also a painter.
Aft.: Princess Elizabeth.

THIRTLE John 1777 (Norwich) —
1839 (Norwich).
Et.
Land.
Also a miniaturist and watercolourist,
Thirtle married a sister of J.S. Cotman
(q.v.).

THOM Andrew fl. ?Edinburgh, 1845.
Steel.
Illus. / land.
Aft.: J. Fleming.

THOMAS Francis Inigo fl. 1893—1902.
Et.
Land.
Also a painter and horticulturist.

THOMAS George Houseman 1824
—68.
Wood.
Illus.
Brother of W.L. Thomas (q.v.) who
was also his pupil. Also a painter.

THOMAS J.S. fl. London (2 York
Street, Covent Garden) 1826.
Pub.
Tinsel.

THOMAS John fl. 1832—35.
Steel.
Arch. / illus. / land.
Aft.: T. Allom, T. Boys, H. Gastineau,
J. Harwood.

THOMAS Percy 1846 or 1847
(London) — 1922 (Hove).
Dry., et.
Arch. / gen. / illus. / land. / port. / sport.

Thomas studied at the R.A. Schools
and was also a pupil of J. McN. Whistler
(q.v.). He studied printing under
Auguste Delâtre, the French printer of
Whistler's etchings, who had come to
London.
Aft.: J. Crome, J. Goode, Sir T.
Lawrence, B. Rivière, J. McN. Whistler.
Pub.: Art Union; Boys; Graves;
J. O'Malley and Son; William Reeves;
Worsley.
Lit.: *Connoisseur* LXXVII, p. 125.
Portfolio 1876, p. 156. Wedmore F.
Etching in England 1895.

THOMAS Phillip fl. mid 19th c.
Mezzo.
Gen.
Aft.: W. and H. Barraud.
Pub.: Ackermann and Co.

THOMAS Robert Kent 1816
(London) — 1884.
Et., litho.
Arch. / illus. / sport.
Also a painter, Thomas began life as a
lithographer, but dropped it for etching.
Lit.: *P.C.Q.* XX, pp. 69, 73. *Portfolio*
1876, p. 188; 1879, pp. 96, 132; 1881,
p. 105; 1884, pp. 125-128; 1887, p. 69.

THOMAS William Luson 1830—1900.
Line., mezzo., stip., wood.
Gen. / hist. / illus. / mil. / port.
Thomas was also a well-known illustrator
and watercolourist. He was a brother and
pupil of G.H. Thomas (q.v.). He worked
in London, New York, Paris and Rome,
and was founder of *The Graphic* and of
The Daily Graphic.
Aft.: J. Dower, J. Linnell, D. Maclise,
G. Mareau, G.H. Thomas.
Lit.: Jackson J. and W.A. Chatto,
A Treatise on Wood Engraving Second
ed. 1861.

THOMPSON Charles fl. London, early
19th c.
Line.
Almanacs / illus.

THOMPSON Charles 1791 (London)
— 1843 (Bourg-la-Reine, Paris).
Wood.
Illus.
C. Thompson, who was a pupil of
Thomas Bewick and Allen Robert

Branston, was a brother of John Thompson and father of C.T. Thompson (qq.v.). In response to demands for wood-engravings by British artists, he visited Paris in 1816, where his success was so great that he settled there. In fact, he introduced wood-engraving to the Continent where it was previously unknown (as distinct from woodcutting).

THOMPSON Charles Thurston 1816 (Peckham) — 1868 (Kensal Green).
Wood.
Illus.
The son of C. Thompson (q.v.), Charles Thurston helped to arrange the 1851 Exhibition, after which his interest in photography being aroused, he became wholly occupied by that.
Aft.: R. Doyle, Sir J.E. Millais, Thurston.

THOMPSON D. fl. 1830s.
Steel.
Illus. / land.
Aft.: W.H. Bartlett, J. Salmon, W. Tombleson.

THOMPSON Eliza fl. mid 19th c.
Wood.
Illus.
Daughter of John Thompson (q.v.).

THOMPSON Henry T. 1820 (Framlingham) — 1904 (London).
Et. (amateur).
All. / illus.
By profession a surgeon, Thompson was also a painter and was a pupil of Sir L. Alma-Tadema (q.v.) and of A. Elmore. He was also an author.

THOMPSON J. fl. 1811.
Et.
Arch.
Aft.: Prout.

THOMPSON or THOMSON James
1788 (Mitford) — 1850 (London).
Line., mezzo., mixed., steel., stip.
Antiq. / gen. / illus. / myth. / port. / relig. / sculp. / sport.
The son of a clergyman, Thompson served an apprenticeship with a London engraver; he came down to London by sea from Shields, a voyage which took nine weeks and for a time he was presumed lost. He left his master and set up on his own on completion of his apprenticeship, having in the interval worked for two years for H. Cardon (q.v.). He was also a pupil of T. Holloway (q.v.).
Aft.: E.H. Baily, H. Corbould, J. Hayter, J. Jackson, J. Jenkins, D. Maclise, Rembrandt, R.W. Satchwell, T. Uwins, Sir D. Wilkie.

THOMPSON John 1785 (Manchester) — 1866 (Kensington).
Line., mezzo., mixed., stip., wood.
Bank. / ephem. / gen. / illus. / lit. / port. / sculp. / theat.
The son of a London merchant, Thompson became a pupil of A.R. Branston (q.v.). His work represents the closest approach possible to line-engraving in wood-engraving. He was one of the leading wood-engravers of the 19th century. From 1852 to 1859 he was director of the Female School of Engraving at South Kensington. He was employed, with Professor Cooper of King's College and Mr Applegart, by the Bank of England to produce a banknote which could not be forged. This had been brought about by the frequent appearance of forged £1 notes. He was employed thus 1819—21, but the policy changed and his notes were not issued. Nevertheless the figure of Britannia he engraved was used on banknotes for many years. He made the brass plates used for printing the design of W. Mulready for covers and envelopes issued in May 1840 at the same time as the first postage stamps. He worked for a time with W.J. Linton (q.v.), and was a brother of Charles Thompson (q.v.).
Aft.: Sir A. W. Callcott, C.W. Cope, Corbould, G. Cruikshank, P. Delaroche, W. Dyce, A. Fussell, Grandville, G.H. Harlow, W. Harvey, Hogarth, J.C. Horsley, W.H. Hunt, T. Johannot, Sir E. Landseer, D. Maclise, Sir J.E. Millais, W. Mulready, Sir J.N. Paton, H.K. Powers, S. Prout, G. Richmond, A. Scheffer, W.A. Sextie, T. Stothard, F. Tayler, J. Thurston, H. Vernet, B. West.
Pup.: Andrew (q.v.).

Shared: T. Thompson (q.v.).
Pub.: T. Agnew; H. Graves; J. Hogarth.
Lit.: *Art Journal* 1866. Jackson J. and
W.A. Chatto *A Treatise on Wood
Engraving* Second edition 1861. *P.C.Q.*
XXXIII, pp. 175-6. *Portfolio* 1891, p.83.

THOMPSON T. fl. 1860.
Steel.
Illus.
Probably a relation of John Thompson
(q.v.) with whom he shared work on
some plates.
Aft.: C.W. Cope, J.C. Horsley.

THOMSON C. fl. Edinburgh 1800—30.
Line.
Port.

THOMSON George fl. late 19th c.
Litho.

THOMSON H. fl. London 1818.
Line.
Port.
Also a miniaturist.

THOMSON James — See
THOMPSON James.

THOMSON Paton *c.* 1750—*c.* 1822.
Line., stip.
Port. / theat.
Aft.: D. Allan, Anne Mee, Nasmyth.

THORBURN Archibald fl. 1870s—
90s.
Litho.
An. / illus.

THORNTON J. fl. London (4 New
Turnstile, Holborn) 1824.
Pub.
Juv. dram. / tinsel.

THORP William Henry b. Leeds 1852.
Et.
Arch. / land.
Also a watercolourist and writer on art.

THORPE James b. London 1876.
Wood.
Illus.
Thorpe worked in Buckfastleigh and
executed many commissions for *Punch.*

THORPE John Hall b. Victoria,
Australia 1874.
Wood.
Flor.
Also a painter of flowers and landscape,
Thorpe worked in London.

THURGAR W. fl. 1854.
Steel.
Arch. / illus.
Aft.: G. Thompson.

THURSTON John 1774
(Scarborough) — 1822 (Holloway).
Line., wood.
All. / illus. / lit. / marine / sport.
A pupil of J. Heath (q.v.), Thurston
originally worked on copper, later took
to wood for which he both designed
and engraved, but later devoted himself
entirely to designing. For a time he
was the principal artist on wood in
London. He was also a watercolourist.
Des. eng.: A.R. Branston, L. Clennell,
C. Nesbit, C.T. Thompson (qq.v.).
Shared: J. Heath (q.v.).
Pub.: R. Ackermann, Chiswick Press.

TILLOCH Alexander fl. London
(Carey Street) early 19th c.
Line.
Bank.

TILY Eugene James b. Walker, Hull
1870.
Aq., et., mezzo., stip.
Gen. / port.
Tily, who studied at Bedford Park
School of Art, lived and worked in
Sutton, Surrey. He also painted in oil
and watercolour.
Aft.: H. Bone, G.B. Cipriani, R.
Cosway, Downman, Gainsborough,
Hoppner, Sir T. Lawrence, Meissonier,
G. Morland, Raeburn, Reynolds,
F.S. Sindici, J.R. Smith, F. Wheatley,
R.C. Woodville.
Pub.: H. Graves; F.C. McQueen.
Lit.: *Connoisseur* LVIII, p. 122.

TIMMS — fl. 1823.
Aq.
Illus.

TINGLE James fl. 1824—60.
Aq., mezzo., steel.
Arch. / illus. / land.
Aft.: T. Allom, W.H. Bartlett,
Calvert, Harwood, F. Herve, W.L.
Leitch, H. Melville, G. Pickering,
T.H. Shepherd.

TINGLE Robert fl. 1828.
Steel.
Arch. / illus.
Probably a brother of J. Tingle.
Aft.: T.H. Shepherd.

TISSOT James Jacques Joseph 1836
(Nantes) — 1902 (Buillon, Doubs).
Dry., et., mezzo.
Fig. / gen. / illus.
French national who came to England
during the Paris Commune of 1870—71
and settled here. He studied under Sir
F. Seymour Haden. Best known for his
genre paintings, Tissot abandoned
engraving to illustrate a *Life of Christ*
during his remaining ten years. For this
he made 350 watercolours in
Palestine. It was published as *The Bible
of James Tissot.*
Lit.: Abdy Jane *J.J. Tissot — Etchings,
Drypoints and Mezzotints* 1978. Tissot
J.J. *Eaux-fortes, Manière Noire, Pointes
Sèches* 1886. Tunick D. *Twenty-one
Prints by Tissot* 1972. Wentworth
M.J. *James Tissot: Catalogue Raisonné
of his Prints* 1978.

TODHUNTER T.E. fl. London 1860.
Trading name of the security printers
Dando, Todhunter and Smith.
Stamps.

TOLLEY J. fl. 1790—1810.
Line.
Ex libris.

TOMBLESON William b. *c.* 1795.
Line., steel.
Illus. / land. / topog.
Also a draughtsman and publisher.
Aft.: T. Allom, W.H.Bartlett, S.
Prout, T.H. Shepherd.

TOMKINS Charles 1750 (London) —
c. 1810.
Mezzo.
Land. / topog.
Also a landscape painter.

TOMKINS Charles Algernon A.R.A.
1812 (London) — *c.* 1903.
Et., mezzo.
*An. / fig. / gen. / hist. / myth. / port. /
relig. / sport.*
Lived and worked in London.
Aft.: A. Anker, R. Ansdell, Armfield,
E.C. Barnes, J. Barrett, C. Baxter,
H.J. Brooks, T. Brooks, S. Carter,
J. Collier, R. Collinson, C.W. Cope,
W.C.J. Dobson, A. Dodd, G. Earl,
E.U. Eddis, T. Faed, F. Feller,
E.A. Fellows, W.P. Frith, S.B. Godbold,
F. Goodall, H. Graves, J. Hallyar,
J.F. Herring Jr., G.E. Hicks, A.
Hopkins, C. Johnson, G.G. Kilburne,
Sir E. Landseer, Lord Leighton,
H. Le Jeune, J. Lucas, C. Lucy,
G. Morland, W.W. Ouless, L. Perrault,
H. Philips, H.W. Pickersgill, G. Pope,
Prynne, Reynolds, G. Romney,
J. Sant, H. Schmeichen, G. Smith,
T. Uwins, H. Weekes.
Pub.: B. Brooks; Dickinson and Co.;
J. Dickinson; Dowdeswell and
Dowdeswells; H. Graves; E.E.
Leggatt; Lloyd Bros.; T. McLean;
G.P. McQueen; J. McQueen; Moore,
McQueen and Co.; Pilgeram and
Lefèvre.
Lit.: Engen R.K. *Victorian
Engravings* 1975.

TOMKINS Charles John b. 1847.
Mezzo.
An. / gen. / hist. / port. / relig.
C.J. Tomkins who was the son of the
engraver and painter C.A. Tomkins
(*c.* 1750—*c.* 1805), lived and worked
in London.
Aft.: G. Boughton, E. Douglas,
J.M. Hamilton, F. Holl, Sir E.
Landseer, G. Morland, H.T. Munns,
G. Richmond, J. Sant, H. Schmalz,
Ida Verner, H. von Angeli; and after
photos.
Pub.: Eyre and Spottiswode; H. Graves;
M. Knoedler; H. Littaur; T. McLean;
C.A. Millard.

TOMKINS Peltro William 1759
(London) — 1840 (London).
Et., mixed., printseller, pub., stip.
*All. / gen. / hist. / illus. / lit. / mil. /
myth. / port. / relig.*
The son of W. Tomkins the landscape
painter, and brother of the aquatinter

and draughtsman, C. Tomkins (fl. 1779), Peltro William was a pupil of F. Bartolozzi (q.v.). He had a shop in Bond Street, London, and was appointed engraver to Queen Charlotte in 1793, and drawing master to the Princesses. His daughter married Samuel Smith (q.v.).
Aft.: L. Ansell, Artaud, Bartolozzi, W.R. Bigg, M. Brown, G. Bugiardini, H. Bunbury, Miss A. Combe, Julia Conyers, P. Cortona, M. Cosway, L. da Heere, Delâtre, A.W. Devis, J. Downman, Princess Elizabeth, H. Fuseli, Gainsborough, D. Gardner, W. Hamilton, Hoppner, A. Kauffmann, Kendall, T. Lawranson, S. Medley, Morland, J. Nixon, Palmer, Ramberg, Raphael, Reynolds, J. Russell, J.T. Serres, T. Stothard, Lady Templeton, Walton, F. Wheatley, Zoffany.
Des. eng.: J.M. Delâtre (q.v.).
Pup.: probably W.S. Leney (q.v.).
Shared: F. Eginton, A. Pastorini (qq.v.), E. Jel.
Pub.: J.P. Levilly.

TOMLINSON John fl. London 1805 d. Paris 1824.
Line.
Land. / topog.
After studying his art in London, Tomlinson went to Paris. He became a drunkard and took his life by throwing himself into the Seine.

TOOKEY James fl. early 19th c.
Line.
Illus.
Aft.: Ibbetson.
Pub.: Bell.

TOOTH Arthur and Sons fl. London (5-6 Haymarket) and New York from early 19th c.
Publishers, printsellers and art dealers.

TOOVEY Richard Gibbs Henry 1861—1927.
Dry., et.
Fig. / gen. / land. / port. / topog.
Worked in Chelsea and Leamington.

TOPHAM Francis William 1808 (Leeds) — 1877 (Cordova, Spain).
Line., steel.
Gen. / illus.

Topham, who was also a painter, served an apprenticeship with a calligraphic engraver in Leeds and worked as an heraldic engraver in London c. 1830. He travelled a great deal in Spain, and then in Ireland in the company of his son F.W.W. Topham the painter.
Aft.: T. Allom, W.H. Bartlett, Miss Byrne, Sir A.W. Callcott, G. Cattermole, J. Gilbert, H. Melville, W. Muller, E.T. Parris, S. Prout, J.M. Wright.

TOPHAM Samuel fl. Halifax and Leeds 1800—40.
Line.
Ex libris.

TOPHAM W.F. fl. mid 19th c.
Line., steel.
Illus.
Aft.: W.H. Bartlett.

TOROND H. fl. London (4 West Street, Soho; 49 Gun Street, Bishopsgate) c. 1820.
Pub.
Tinsel.

TOUSSAINT Charles Henri 1849 (Paris) — 1911.
Et.
Land.
French national who made at least one plate after a work by a British artist which was published in England.
Aft.: J.M.W. Turner.
Pub.: Colnaghi.

TOUSSANT M. fl. 1880s.
Et.
Land.
Aft.: J. Constable.
Pub.: Colnaghi.

TOWNSEND Frederick Henry 1868—1920.
Et.
Gen. / hum.
Also an illustrator, Townsend was art editor of *Punch* from 1905. He studied at Lambeth School of Art.

TOWNSEND Henry James 1810
(Taunton) — after 1866.
Et., line.
Fig. / gen. / illus. / land. / lit.
Townsend began life as a surgeon, but
abandoned this profession for art.
He became director of the Government
School of Design.
Pub.: Art Union.
Lit.: *Art Journal* 1855, p. 188.

TOWNSEND T.S. fl. *c.* 1880.
Et.
Land.
Possibly identical with Thomas S.
Townsend, the sculptor.
Aft.: R.P. Bonington.

TRAIN E. fl. 1828.
Line.
Port.

TRAYNOR Anthony Henry
d. Dublin (?) 1848.
Line.
Port.
Also a painter.

TREACHER E.G. fl. 1830s.
Steel.
Arch. / illus.
Aft.: W.H. Bartlett.

TREGEAR G.S. fl. late 18th —
early 19th c.
Pub.
Sport.

TRESHAM Henry R.A. 1751
(Dublin) — 1814 (London).
Mezzo.
Illus. / lit. / port. / relig.
Also a painter, poet and picture dealer,
Tresham came to London in 1775
after studying in Dublin. He spent
fourteen years in Italy, studying
from the antique and from the old
masters. He became professor of
painting at the R.A. in 1807 but
bad health forced him to resign two
years later.
Aft.: G. Chinnery, G. Dance, J. Opie.
Des. eng.: F. Bartolozzi, J. Fittler,
L. and N. Schiavonetti (qq.v.).

TREVELYAN Lady Paulina (née
Jermyn) d. 1866.
Et. (amateur).
Illus.

TREVISANY Frank b. 1840.
Litho.
Music.
Came to England from Bavaria in
1860.
Lit.: Spellman D. and S. *Victorian
Music Covers* 1969.

TRUSCOTT AND SONS
fl. London (Suffolk Lane) 1860s.
Litho., security printer.
Telegraph stamps.
Lit.: Lister, R., *Private Telegraph
Companies of Gt. Britain and their
Stamps* 1961.

TUCK J. fl. 1819—22.
Line. (?).
Port.

TURNBULL J. fl. 1850.
Steel.
Arch. / illus.
Aft.: C. Marshall.

TURNBULL Thomas fl. 1830s—40s.
Steel.
Arch. / illus. / land.
Aft.: T. Allom, W.H. Bartlett,
R. Garland, W.L. Leitch, H. Winkles.

TURNER Charles A.R.A. 1773
(Woodstock) — 1857 (London).
Aq., et., mezzo., mixed., steel., stip.
*All. / an. / gen. / hist. / marine. / mil. /
port. / ship. / sport. / topog.*
The son of a collector of excise who
got himself into financial difficulties,
Charles Turner obtained through the
influence of his mother, who had been
a maid to the Duchess of Marlborough,
the post of custodian of the china at
Blenheim. He made a drawing of an
oriental plate which caught the
attention of the Duke, as a result of
which Charles was sent to London to
attend the R.A. Schools. He made
little progress as a painter but was at
once successful in engraving, in which
he was at first much influenced by
Bartolozzi. At the R.A. Schools he
was a fellow pupil of J.M.W. Turner,

but was not related to him. Later he engraved many of the plates for Turner's *Liber Studiorum* and was a trustee of Turner's will. He was appointed engraver to the King in 1812. Altogether he executed over 900 plates, two-thirds of them being portraits.
Aft.: J.L. Agasse, C. Back, Beechey, T. Bennet, C. Blake, T. Blake, H.P. Briggs, J. Bristow, Sir A.W. Callcott, H.B. Chalon, J.J. Chalon, T. Clarke, Collins, A. Cooper, J.S. Cooper, J.S. Copley, R. Cosway, F. Countz, W. Cumming, Decaisne, T.R. Davis, W.A. Davis, A.W. Devis, Sir C. Eastlake, A. Elmore, R. Fagan, Fairthorne, E. Fisher, H. Fradelle, Gainsborough, A. Geddes, W. Giller, Greuze, D. Guest, J.J. Halls, Sir G. Hayter, T. Heaphy, J.F. Herring Sr., Hogarth, Hoppner, G. Horner, J. Howe, J. Jackson, James, Capt. Jones, G. Jones, R. Jones, Jordaens, Joseph, Kennett, S. Lane, Sir T. Lawrence, C. Le Brun, W.H. Lizars, Lonsdale, Maily, B. Marshall, Masquerier, Metz, F. Nash, W. Northcote, D. Orme, W. Owen, J. Parry, C.W. Pegler, T. Phillips, Pocock, Raeburn, J. Ramsay, Reinagle, Reynolds, H. Richter, S. Rosa, Russell, M.A. Shee, Singleton, T. Smith, Maria Spilsbury, T. Stothard, Stuart, G. Stubbs, W. Tegg, F.C. Turner, J.M.W. Turner, H. Villiers, J. Ward, T. Watson, T. Weaver, R. Westall, F. Wheatley, Willemin, H. Williams.
Shared: W. Barnard, C. Hunt, J. Mitan, W. Walker, J. Ward (q.v.).
Pup.: D. Wilson (q.v.).
Pub.: T. Belcher; Boydell; McQueen; W. Tegg.
Lit.: *Apollo* IX, pp. 17f. *Connoisseur* XLV, p. 197; XLVIII, p. 2; LI, pp. 88, 92; LX, pp. 213f; LXXVII, p. 10; LXXXIV, pp. 159, 194, 227, 261. Davenport C. *Mezzotints* 1904. Gage, J. (ed.) *Collected Correspondence of J.M.W. Turner* 1980. *P.C.Q.* XII, pp. 72, 81f, 135f, 151; XIV, pp. 27, 29; XVI, pp. 120, 123, 128; XVII, pp. 258, 331; XVIII, pp. 360f. Prideaux S. *Aquatint Engraving* 1909. Whitman A. *Charles Turner* 1907. Wilder F.L. *English Sporting Prints* 1974.

TURNER Mrs Dawson fl. 1830s.
Et., steel.
Port. / relig.
The wife of Dawson Turner, patron of Cotman.
Aft.: H. Corbould, Guido, Raphael.

TURNER G.A. fl. early to mid 19th c.
Litho.
Sport. / theat. (ballet).
Aft.: F.C. Turner.
Pub.: T. McLean.

TURNER H.N. Jr. fl. 1840s.
Litho.
An. / illus.

TURNER H.S. fl. early 19th c.
Litho.
Port.

TURNER James Mallord William R.A. 1775 (London) — 1851 (Chelsea).
Aq., et., mezzo.
Land. / myth. / port.
The great painter, Turner studied engraving under J.R. Smith (q.v.). From 1807—19 he made drawings from painted landscapes he had made earlier, for his *Liber Studiorum*. This was to consist of 100 plates after these drawings, seventy-one being actually made. He etched a few outlines himself and mezzotinted eleven of the plates, the remainder being made by various artists including C. Turner, F.C. Lewis and W. Say (qq.v.); they were published in fourteen parts from 1807—19. Autotypes were made and published in 1864 and in 1882—84, and facsimile etchings in 1878, while facsimile etched and mezzotinted plates were made by Sir F. Short (q.v.).
Another series of plates of Turner's landscapes, known as "The Turner Gallery", was published in 1859 in *The Art Journal* from line engravings by J.T. Wilmore, R. Brandard and E. Goodall (qq.v.). Other paintings by Turner were reproduced by many engravers.
Pub.: B. Brooks; H. Graves; J.A. Virtue and Co.
Lit.: Finberg A.J. *The History of Turner's Liber Studiorum* (with a new catalogue raisonné) 1924. Finley G.

*Landscapes of Memory Turner as
Illustrator of Scott* 1980. Hermann L.
*Turner: Paintings, Watercolours, Prints
and Drawings* 1976. *P.C.Q.* III,
pp. 394-414; IV, pp. 303-24; V,
pp. 363-65; XVI, pp. 165-81.
Rawlinson W.G. *Turner's Liber
Studiorum, a Description and
Catalogue* 1878, 1906.
Rawlinson W.G. *Engraved Work of
J.M.W. Turner* 2 vols. 1908-13.
Studio LXXXIV, p. 201.

TURNER Robert fl. 1850s—70.
Pub.

TURNER of Oxford William 1789
(Oxford) — 1862 (Woodstock).
Et.
Land. / topog.
Known primarily as a watercolourist,
Turner was a pupil of John Varley
(1778—1842) in London, but returned
to Oxford in 1833. He travelled
widely in England, Wales and Scotland.
Lit.: *P.C.Q.* XXI, pp. 340, 345.
Walker's Quarterly IX, 1923.

TURNERELLI Edward Tracy 1813—
96 (London).
Et. (?)
Land.
Lived for a period at Kazan.

TURREL Edmond fl. London 1821.
Line. (?)
Arch.

TURRELL Arthur fl. London
1870s—90s.
Et., mezzo., mixed.
Gen. / hist. / mil. / port.
Father of A.J. Turrell (q.v.).
Aft.: C.B. Barber, A.F. Bellows,
G.H. Boughton, E.F. Brewtnall, W.S.
Coleman, F. Dadd, T.F. Dicksee,
E. Douglas, Mary Ellen Edwards
(Mrs Staples), J.W. Godward, F.P.
Graves, W.W. Grossmith, R. Hannah,
Sir H. Herkomer, E.K. Johnson,
G.D. Leslie, Sir J.E. Millais,
F. Morgan, G.B. O'Neill, R. Peacock,
J. Pettie, J.R. Reid, D. Sadler,

F. Sargent, J.M. Strudwick, O. Weber,
W.B. Wollen.
Shared: F. Sargent (q.v.) with whom he
worked on a mixed-method plate,
"Drawing Room at Buckingham
Palace".
Pub.: B. Brooks; Fishel, Adler and
Schwartz; Goupil and Co.; H. Graves;
S. Hildesheimer and Co.; M. Knoedler;
L.H. Lefèvre; A. Lucas; T. McLean;
F.C. McQueen; Pilgeram and Lefèvre;
A. Tooth; Raphael Tuck and Son.

TURRELL Arthur James 1871
(London) — after 1910.
Et.
Arch. / gen. / port. / topog.
The son of A. Turrell (q.v.), A.J.
Turrell studied at South Kensington
School of Art and in Paris. He worked
in London, Germany and Italy.
Aft.: F. Bramley, G. Douw, A.J.
Foster, Hals, Lippi, S. Lucas, Sir J.E.
Millais, P. Moreelse, Rembrandt,
W.D. Sadler.
Pub.: H. Graves; L.H. Lefèvre; T.
McLean; I.P. Mendoza.
Lit.: *Art Journal* 1897, p. 4.
Connoisseur L., p. 237. Holme, C.
Modern Etchings 1913. *Studio* 1916,
p. 132.

TURRILL John fl. London
(250 Regent Street) early 19th c.
Pub.
Relig. / wood.

TWINING Elizabeth 1805—89.
Litho.
Flor. / illus.
A member of the well-known family
of tea importers. Another member
of that family, Louisa Twining, was
an artist and took lessons from Samuel
Palmer (q.v.).
 In addition to her botanical work
Elizabeth took a leading part in many
philanthropic and educational schemes.

TYLER — fl. *c.* 1810.
Line.
Ex libris.

TYMMS W.R. fl. 1863.
TYMMS and AUDSLEY
Chromolitho.
All. / illus.
Pub.: Day and Son.

TYTLER George 1797—1859
(London).
Litho.

Land. / topog.
Tytler, who was also a draughtsman,
travelled in Italy *c.* 1820. He was
appointed draughtsman to the Duke of
Gloucester. He is said to have assembled
from his studies a pictorial "alphabet";
this was produced lithographically,
and then engraved on copper.

UHLRICH Heinrich Sigismund
b. Oschatz 1846.
Wood.
Illus.
Worked in Kent.

UNDERWOOD Thomas 1809—82
(London).
Line.
Arch. / illus.
Also a writer, his most notable work
being *The buildings of Birmingham,
past and present*.

UNKELS — fl. Cork, 1835—39.
Litho.

UPHAM John William ?1773
(Offwell) — 1828 (Weymouth).
Et. (?)
Land.
Also a painter.

URWICK William H. d. 1915.
Et.
Land. / relig. / topog.
Worked in London.

VAILLANT V.J. fl. *c.* 1874.
Et., (amateur).
Land.
Also a painter, Vaillant worked in
France, England and Wales.

VALMON Léonie fl. 1880s—1900.
Et.
Land. / topog.
French national who made a number of
plates after works by British artists,
which were published in England.
Aft.: V. Cole, K. Halswelle, J.
MacWhirter, E. Parton, J. Webb.
Pub.: A. Tooth.

VANASSEN Benedictus Antonio
d. *c.* 1817 (London).
Et., stip.
All. / illus. / myth. / port.
Also a designer.

VAN BAERLE BROTHERS
fl. 1890s.
Pub.

VANDERLYN Nathan 1872—1946.
Et.

VARDY John b. London 1765.
Line.
Arch.
Also an architect, Vardy was a pupil
of W. Kent.

VARIN Pierre Amédée 1818
(Châtons-sur-Marne) — 1883 (Crouttes,
Aisne).

Line., mixed., stip.
Gen.
French national who made at least one
plate after a work by a British artist
which was published in England.
Aft.: P. Morris.
Pub.: Boussod, Valadon and Co.

VARLEY Cornelius 1781 (Hackney)
— 1873 (Stoke Newington).
Et., litho.
Land. / ship.
The brother of John Varley (q.v.),
Cornelius was himself a painter. He
was also an inventor and improved a
number of scientific instruments
including the camera obscura, the
camera lucida and the microscope.

VARLEY John 1778—1842.
Litho.
Land.
Best known as a watercolourist,
astrologer and teacher. Brother of
Cornelius Varley (q.v.).
Des. eng.: J. Linnell (q.v.) and others.
Lit.: Bury A. *John Varley of the "Old
Society"* 1946. Story A.T. *James
Holmes and John Varley* 1894.

VARRALL John Charles fl. 1818—
48.
Steel.
Arch. / illus. / land.
Aft.: W.H. Bartlett, W. Brockedon,
G. Cattermole, H. Gastineau, J.D.
Harding, C. Marshall, J.P. Neale,
G. Pickering, D. Roberts, W. Tombleson.

VASEY George fl. early-mid 19th c.
Wood.
Illus.

VENDRAMINI Francesco fl. 1820.
Line., stip.
Relig.
Probably a brother of G. Vendramini
(q.v.) whom he followed to Russia,
settling there. He became a member of
the Academy of Fine Arts, St Petersburg.
Aft.: Titian.

VENDRAMINI Giovanni 1769
(Roneade, Bassano) — 1839 (London).
Stip.
All. / gen. / illus. / mil. / myth. / port. /
relig.
Vendramini studied art until he was
nineteen, when he came to London
where he settled and studied under
F. Bartolozzi (q.v.). His work became
very popular and when Bartolozzi
retired in 1802, he took over his
premises, pupils and practice. He went
to Russia and was employed by the
Tsar, who thought so highly of his
work that he was refused permission to
leave the country, and he had to escape
in disguise. In 1802 he married an
Englishwoman of Portuguese descent.
He was probably a brother of
F. Vendramini (q.v.).
Aft.: F. Bartolozzi, Cipriani, Da Vinci,
S. del Piombo, H. Eldridge, P. Jean
Pellegrini, Sir R.K. Porter, Raphael,
Spagnoletto, Stella, Veronese,
F. Wheatley.
Pub.: Colnaghi.

VERNON The Rev. Henry John
fl. 1840s.
Litho.
Ship.
Lit.: Chatterton, E.K. *Old Ship Prints*
1927.

VERNON Thomas 1825
(Staffordshire) — 1872 (London).
Line., steel.
Bank. / fig. / gen. / illus. / lit. / port. /
relig.
Vernon, who studied in Paris and later
in London, was a pupil of P. Lightfoot
(q.v.). He lived and worked in London,
but from 1853—56 he worked in New
York as a banknote engraver.

Aft.: C.W. Cope, W. Dyce, E.D. Leahy,
C.R. Leslie, Murillo, Raphael, Rubens,
Van Dyck, F. Winterhalter.
Pub.: H. Graves.

VIBERT John Pope 1790—1865.
Line.
Ex libris.
Lived and worked in Penzance.

VICTORIA Queen 1819
(Kensington) — 1901 (Osborne).
Et.
An. / fig. / port.
The Queen was a pupil of Sir Edwin
Landseer and Sir George Hayter (qq.v.).
Both Prince Albert (q.v.) and the Queen
took up etching in 1840 and shared
work on some plates. A copperplate
printing press was installed in
Buckingham Palace by the printers
R. Holdgate and H. Graves (qq.v.).
Her etchings are signed *VR del. et*
scult., *Albert del VR sclt.*, or
VR delet A.sct.
Aft.: Stefano della Bella.
Pub.: William Strange, who published
impressions surreptitiously made
without the Queen's permission. They
were the subject of a court case and
the injunction was upheld.
Lit.: Warner Marina *Queen Victoria's*
Sketchbook 1979.

VINALL Joseph William Topham
1873—1953.
Et.
Illus.

VINCENT F. fl. early 19th c. (?)
Stip.
Topog.
Aft.: J. Cristall.

VINCENT George 1796 — c. 1831
(Norwich).
Et., mezzo.
Land. / topog.
Best known as a watercolour painter.

VINING J. fl. London 1800—20.
Line.
Ex libris.

VINTER John Alfred 1828—1905.
Litho.
Gen. / port.

Also a painter, Vincent lived and worked in Holborn.
Aft.: J.W. Gordon, Sir F. Grant, W. Gush, W. Hunt, Sir E. Landseer, Lauchert, K. Macleay, E. Nicol, S. Pearce, F.R. Say, R. Tait.
Pub.: Gambart; H. Graves.

VIRTUE and CO. fl. from 1850s.
VIRTUE J.A.
VIRTUE J.A. and COMPANY LTD.
Pub.
At various times the partners included J.A. Virtue, George Henry Virtue, William A. Virtue and James Sprent Virtue. Among their publications were *The Art Union, The Art Journal* and various collections of engravings. The firm collaborated on some publications with Goupil and Co. and Boussod, Valadon and Co. (qq.v. under Goupil).

VIVARES Thomas 1735– c. 1810.
Aq.
Illus. / sport.

VIVIAN W. fl. London 1810–15.
Litho.
Land.
Pub.: Ackermann.

VIZELLY
VITZETELLY Henry (1820–95).
VIZITELLY BROTHERS and CO.
fl. mid 19th c.
Print., wood.
Illus.

Pioneers in the illustration of periodicals.
Collaborators included J.O. Smith, J.W. Whymper, S. Williams, W. Wright (qq.v.).
Lit.: Jackson J. and W.A. Chatto *A Treatise on Wood Engraving* Second edition 1861. Vitzetelly H. *Glances back through Seventy Years* 1893.

VOLLWEILER G.J. fl. late 18th – early 19th c.
Pub.
Litho.
German national who worked for a time in England.
Assist.: D.J. Redman (q.v.).
Reissued, with additions, in 1806 Philip André's (q.v.) *Specimens of Polyautography.*

VON HENTSCHEL Carl fl. 1860.
Print., pub.
A pioneer in the technique of transferring a drawing to a wood block by photography.

VON HERKOMER Sir Hubert – See HERKOMER Sir Hubert von.

VOSPER C. Curnow b. Plymouth 1866.
Et.
Also a watercolourist, Vosper was a pupil of the Académie Colarossi in Paris.

WADDINGTON J.J. LTD. fl. early
20th c.
Photo-eng., print.
Some of their photo-engravings were
published by Lawrence and Bullen.

WAGEMAN Thomas Charles 1787—
1863.
Aq., et.
Illus. / port.
Also a painter.

WAGNER F.R. fl. 1851.
Steel.
Fig.
Aft.: H. Howard.

WAGSTAFF Charles Eden 1808
(London) — 1850 (London).
Line., mezzo., mixed., steel.
Gen. / hist. / lit. / mil. / port. / sport.
Wagstaff lived and worked in London,
but from 1840—45 was in Boston,
Mass., U.S.A.
Aft.: A.F. Biard, R. Buckner, A.
Chalon, W. Collins, E.H. Corbould,
R. Davis, Count D'Orsay, L.A. Du Val,
B.R. Faulkner, W. Fisk, W.P. Frith,
G. Harvey, Sir G. Hayter, Sir E.
Landseer, C. Lees, J. Lucas, D. Maclise,
E.T. Parris, G. Patten, H. Pickersgill,
F. Stone, J.W. Walton.
Pub.: A. Ackermann; T. Agnew;
Gambart; H. Graves; Alexander Hill;
Hodgson and Graves; F.G. Moon.

WAGSTAFF J.E. b. 1805.
Steel.
Fig. / illus. / port.
Aft.: H.W. Pickersgill.

WAGSTAFF W. fl. 1830s.
Steel.
Port.
Aft.: A. Wivell.

WALCOT William 1874 (Odessa) —
1943.
Et., mixed.
Arch. / hist. / land. / myth. / topog.
Walcot, who was also a draughtsman
and water-colourist, was the son of an
English father and of a Russian mother
whose father was a rich landowner. He
travelled widely in his youth in Europe
and South America, but received his
education mainly in France. He
returned to Russia when he was
seventeen and studied architecture at
St. Petersburg, but soon went back
to Paris where he studied the subject
at the École des Beaux Arts and the
Atelier Redon. He started a practice
in Moscow but not long afterwards
came to London and it was there that
he took up etching.
Pub.: H.C. Dickins.
Lit.: *Apollo* I, pp. 221f. Blomfield R.
*William Walcot, Watercolours and
Etchings* 1920. *Connoisseur* XLII,
p. 60; LVI, pp. 64, 186; LXII, p. 53;
LXXV, pp. 57, 62. Salaman M.C.
William Walcot Modern Masters of
Etching No. 16, 1927. Studio 1907,
pp. 308f; 1908, pp. 142f; 1922, pp.
88f; 1923, pp. 311f; 1925, p. 166.

WALERY AND CO fl. 1890s.
Photo-eng., pub.

WALKER Charles fl. 1826.
Et.
Reproductions of rare prints and old
masters.

WALKER E. mid 19th c.
Litho.
Illus. / mil. / port. / topog.
Possibly identical with a lithographer
named Edmund Walker, who was an
assistant at Day and Haghe (q.v. under
Day and Son). Some lithographs were
published under the imprint of the
printers, Walker and Norrie
Aft.: S. Alken, Downman,
G. Sebright, Thomas.
Lit.: Twyman M. *Lithography*
1800—1850 1970.

WALKER F.F. b. 1805.
Line., steel.
Illus.
Aft.: T. Allom, Hogarth, N. Poussin,
F.P. Stephanoff.

WALKER Francis Sylvester 1845
(Co. Meath, Ireland) — 1916 (London).
Et., mezzo.
Arch. / gen. / illus. / land. / port. /
relig. / topog.
Walker, who was also a landscape
and genre painter, studied at the Royal
Dublin Society and the Royal
Hibernian Academy. He came to
London in 1868. He also worked
as an illustrator for the Dalziels (q.v.)
and was much influenced in his
etching by R.W. Macbeth (q.v.).
Aft.: Gainsborough, Greuze, T.
MacWhirter, Raphael, Reynolds, G.
Romney, Rubens, J. Stark.
Pub.: T. Agnew; Cassell and Co.;
Colnaghi; Stephen T. Gooden;
C. Klackner; L.H. Lefèvre; A. Lucas;
T. McLean; A. Tooth.

WALKER Frederick A.R.A. 1840
(Marylebone) — 1875 (St. Fillans,
Perthshire).
Et., litho.
Gen. / port. / posters.
Best known as a painter, Walker was
a pupil at the R.A. Schools.

WALKER H. fl. mid 19th c.
Litho.
Sport.
Aft.: P.J. Ouless.

WALKER H.F. fl. first half of 19th c.
Line.
Gen.
Aft.: Sir E. Landseer.
Shared work on at least one plate with
J. Burnet (q.v.).

WALKER H.P. fl. second half of
19th c.
Line.
Ex libris.

WALKER J. and C. fl. 1830s.
Steel.
Maps.

WALKER Marcella M. fl. Highgate
1870s—1901.
Mezzo.
Gen.
Was also a painter.
Pub.: C. Klackner.

WALKER Robert McAllister
b. Fleetwood 1875.
Et.
Also a painter, Walker worked in
Bothwell.

WALKER William 1791 (Markton,
nr. Edinburgh) — 1867 (London).
Mezzo., mixed., stip.
Gen. / hist. / port.
The son of an unsuccessful salt
manufacturer, Walker studied his art
at Edinburgh under E. Mitchell (q.v.).
He came to London in 1815 and
worked for James Stewart, learning
stipple from T. Woolnoth and subse-
quently taking lessons in mezzotint
from T. Lupton (qq.v.). He returned
to Scotland in 1819 but settled in
London from 1832.
It has been said that Walker's
engraving of Raeburn's self-portrait is
the finest example of stipple engraving
ever made.
Walker's wife Elizabeth was a
miniature painter. A daughter of S.W.
Reynolds (q.v.) she also engraved
portraits in mezzotint and assisted her
husband on some of his plates.

363

Aft.: H.P. Bone, W. Bradley, G. Cattermole, J. Doyle, E. U. Eddis, J. Gilbert, Sir T. Lawrence, D. Maclise, A. Nasmyth, H.W. Phillips, H.W. Pickersgill, Raeburn, S.W. Reynolds, F. Say, J.L. Skill, Sir D. Wilkie, T. Woolnoth.
Shared: S. Cousins, S.W. Reynolds Jr., D.G. Thompson, C. Turner, G. Zobel.
Pub.: Owen Bailey; H. Graves; E. Parsons; W. Walker; Walker also published his own work.
Lit.: *P.C.Q.* XIX, pp. 321f.

WALKER William 1878—1961.
Et.
Arch. / topog.
Also a painter.
Lit.: *Studio* LIX, p. 271.

WALKINSHAW A. fl. 1796—1810.
Line.
Ex libris / port.

WALLACE John d. 1903.
Litho.
Port.
Also a painter, Wallace studied at the Royal Scottish Academy Edinburgh. He adopted the pseudonym "George Pipeshanks".

WALLIS C. fl. 1830s.
Steel.
Illus. / land.
Possibly identical with Charles Wallis (q.v.).
Aft.: E. Pritchett, W. Purser.

WALLIS Charles fl. London 1823.
Line.
Illus. / land.
Possibly identical with C. Wallis (q.v.).

WALLIS George 1811 (Wolverhampton) — 1891 (Wimbledon).
Et.
Gen.
Better known as a painter, Wallis also wrote and lectured on art. He became director of the schools of arts at Manchester and Birmingham (1852—57).

WALLIS Henry ?1805—1890.
Line., steel.
Illus.
Brother of R. and W. Wallis (qq.v.), Henry Wallis abandoned engraving through illness and became a picture dealer.
Aft.: T. Allom, W.H. Bartlett, J.M. Baynes, C. Bentley, W. Chambers, T. Creswick, J.P. Neale, T. Phillips, E. Pritchett, W. Purser, J.B. Pyne, J. Salmon, G. Sharpe, T.H. Shepherd, W. Tombleson, A. Vickers, P. Williams, A.W. Wray.

WALLIS Robert 1794 (London) — 1878 (London).
Line., steel.
Gen. / illus. / land. / ship.
The son and pupil of Thomas Wallis (q.v.) from whom he learned the craft of engraving, and brother of H. and W. Wallis (qq.v.). He worked in Tottenham, London.
Aft.: T.J. Barker, W.H. Bartlett, A. Callcott, Cockburn, D. Cox, T. Creswick, De Wint, Fripp, E. Gambart, J.D. Harding, J. Hardy, S. Owen, S. Prout, D. Roberts, C. Stanfield, J.M.W. Turner.
Assist.: J.B. Allen (q.v.).
Shared: W. Greatbach (q.v.).
Pub.: Ackermann; T. Agnew; Gambart; H. Graves; R. Turner.
Lit.: Gage, J. (ed.) *Collected Correspondence of J.M.W. Turner* 1980.

WALLIS Miss Rosa b. Stretton 1857.
Et.
Flor.
Also a painter, Rosa Wallis was a pupil in the Manchester Academy.

WALLIS Thomas fl. early 19th c.
Steel.
Fig.
Assistant to Charles Heath and father of Robert Wallis (qq.v.).

WALLIS William b. 1796.
Line., steel.
Arch. / illus. / land.
Brother of Henry and Robert Wallis (qq.v.).
Aft.: T. Allom, J.C. Armytage, T. Barber, W.H. Bartlett, W. Brockedon, G. Cattermole, H. Gastineau, J.P. Neale, S. Prout, T.H. Shepherd.

WALN M. fl. 1820s.
Litho.
Flor. / illus.

WALTER H. fl. early-mid 19th c.
Litho.
Sport.

WALTER AND COHN fl. 1840s—80s.
Print. (litho.).

WALTNER Charles Albert 1846
(Paris) — 1925 (Paris).
Et., line.
Gen. / myth. / port.
French national who engraved many
plates after works by British artists
which were published in England.
Aft.: Sir E. Burne-Jones, F. Dicksee,
W. Firle, Gainsborough, F. Goodall,
J.J. Henner, F. Holl, Hoppner,
W. Hunt, G. Mason, Sir J.E. Millais,
J. Pettie, Reynolds, G. Romney,
M. Stone, F. Walker.
Pub.: T. Agnew; Boussod, Valadon
and Co.; British and Foreign Artists'
Association; Colnaghi; Fine Art
Society; Goupil, E.E. Leggatt;
William Schaus; A. Tooth.
Lit.: *Portfolio* 1874, pp. 33, 129;
1886, p. 105.

WALTON C.W. fl. London *c.* 1850.
Litho.
Port.
Also a draughtsman. Possibly a
partner of C.J. Hullmandel (q.v.).

WALTON W.L. fl. 1860s.
Litho.
An. / illus. / sport.
Also a painter. Possibly a partner of
C.J. Hullmandel (q.v.).
Lit.: Wilder F.L. *English Sportin*
Prints 1974.

WANDS Charles fl. 1800—44.
Steel.
Fig. / illus.
Aft.: J. Martin.

WARD — fl. 1832.
Steel.
Illus. / land.
Aft.: W. Tombleson.

WARD George Raphael 1798
(London) — 1879 (London).
Line., mezzo.
Gen. / hist. / port.
The son and pupil of James Ward
(q.v.), G.R. Ward studied in the R.A.
Schools. He was also a miniaturist.
Aft.: A. Chalon, Sir F. Grant, J.R.
Herbert, A. Johnstone, J.P. Knight,
Sir T. Lawrence, T. Phillips, H.W.
Pickersgill, J. Sant, J.R. Swinton,
E.H. Wehnert.
Shared: H. Davis (q.v.).
Pub.: Art Union of London; T. Boys;
Colnaghi; T.W. Green; Hering and
Remington.
Lit.: *Art Journal* 1880, p. 84.
Connoisseur LXX, p. 57.

WARD James R.A. 1769 (London)
— 1859 (Cheshunt).
Litho., mezzo., stip.
An. / all. / gen. / hist. / lit. / mil. /
myth. / port. / sport. / theat.
Ward was a pupil of J.R. Smith and
an apprentice of his brother, W. Ward
(qq.v.). Also a painter, he was
appointed painter and mezzotint
engraver to the Prince of Wales in
1794. He engraved 55 plates, but
abandoned mezzotint in 1817 to
concentrate on animal painting.
Much of his own work was
reproduced by other engravers.
 Some of William Ward's plates
after works by G. Morland were
probably engraved by James during
his apprenticeship. Good impressions
of these plates are of great rarity. They
have often been reproduced.
Aft.: Beechey, W.R. Bigg, Copley,
R.B. Davis, T. Green, Hoppner, Sir
T. Lawrence, Q. Matsys, G. Morland,
Northcote, W. Owen, Raeburn,
Rembrandt, Reynolds, Rubens,
Wright of Derby.
Pup.: W. Say (q.v.).
Lit.: *Apollo* VIII, p. 64; IX, pp. 22f;
XXI, pp. 39f; XXIII, p. 150. *Art*
Journal 1849, pp. 179f; 1860, p. 9;
1862, pp. 169f; 1897, pp. 185f.
Connoisseur XI, pp. 69f; XXIV, pp.
177f; XXXV, pp. 136f; XXXVII,
p. 73. Davenport C. *Mezzotints*
1904. Frankau Julia *William Ward*
and James Ward: their Lives and
Works 1890. Grundy C.R. *James*

Ward R.A. 1909. Man Felix H.
Homage to Senefelder 1971. *P.C.Q.*
XII, pp. 91, 148, 153; XVII, p. 268.

WARD Leslie Moffat 1888
(Worcester) — 1922.
Et., litho.
Arch. / land. / topog.
Was a teacher at Bournemouth
School of Art.
Lit.: Studio LXXXIX, p. 203.

WARD William A.R.A. 1766
(London) — 1826 (London).
Mezzo., stip.
*An. / all. / gen. / hist. / illus. / land. /
lit. / port. / relig. / sport.*
William Ward was the brother and
teacher of James Ward (q.v.); he
married a sister of G. Morland (q.v.).
W.J. Ward (q.v.) and the painter
Martin Theodore Ward (?1799—1874)
were his sons. He learned the
technique of engraving from V. Green
and J.R. Smith (qq.v.). His home
and studio were at No. 50 Warren
Street, Soho, London. He was
mezzotint engraver to the Prince
Regent and the Duke of York.
 Some of his plates after works by
G. Morland were probably engraved
by his brother James during his
apprenticeship. Good impressions of
these plates are of great rarity. They
have been reproduced. Some plates,
too, were re-engraved and signed
"Bartolotti".
Aft.: L.F. Abbott, Allen, Beechey,
W.R. Bigg, Bol, Braddyll, H.B. Chalon,
J.W. Chandler, A. Cooper, J.S. Copley,
R. Courbould, N. Dance, W. Etty,
Frankland, Fuseli, Gainsborough,
G. Garrard, Honthorst, Hoppner,
Ibbetson, Jackson, Sir E. Landseer,
B. Marshall, G. Morland, R. Müller,
Opie, W. Owen, R.M. Paye, H. Pelham,
Peters, Phillips, Pickersgill, Raeburn,
J.H. Ramberg, Reynolds, S.W.
Reynolds, S. Ricci, G. Romney,
Rubens, H.C. Selous, Shee, J.R. Smith,
T. Stewartson, Stuart, J. Ward, T.
Weaver, R. Westall, F. Wheatley.
Pub.: Collins and Morgan; W.
Dickinson.
Lit.: Frankau Julia *William and
James Ward: their Lives and Works*
1890. Wilder F.L. *English Sporting
Prints* 1974.

WARD William James A.R.A. ?1800
(London) — 1840 (London).
Mezzo.
Gen. / myth. / port. / relig.
W.J. Ward was the son and pupil of
W. Ward and a nephew of J. Ward
(qq.v.). Also a pupil of Landseer, he
was awarded a medal at the age of
twelve by the Society of Arts for a
drawing after Raphael, and later gained
two further medals. He was in 1803
appointed mezzotint engraver to the
Duke of York, and engraver to the
Prince Regent in 1809. He was also
engraver to the Duke of Clarence,
later King William IV. He died insane.
Aft.: T. Carrick, R. Farrier, W.
Fowler, A. Geddes, Sir F. Grant,
Hogarth, J. Jackson, Sir T. Lawrence,
J. Lucas, J. Opie, W. Owen, H.W.
Pickersgill, Reynolds, H. Thompson,
Van Dyck.
Pub.: J. Fowler; H. Graves; Hodgson
and Graves.
Lit.: *Art Union* 1840, p. 39.

WARREN Alfred William fl. 1830s—
60s.
Chromolitho., et., line., mezzo., steel.
All. / gen. / illus. / port.
Brother of C.T. Warren (q.v.). *The
Dictionary of National Biography*
lists an Ambrose William Warren
(?1781—1856), but it is possible that
this is really Alfred William.
Aft.: W. Allan, G. Cattermole, A.
Cooper, R. Farrier, J. Gilbert, Smirke,
Sir D. Wilkie, Witherington.
Pub.: Day and Son.

WARREN Charles Turner 1762
(London) — 1823 (Wandsworth).
Line., steel.
Illus.
C.T. Warren was the father-in-law of
Luke Clennell and H.C. Shenton and
brother of A.W. Warren (qq.v.). In his
youth he worked as an engraver on
metal for calico printing. From 1802
he was engaged mainly on book
illustration. He received a gold medal
from the Society of Arts for effecting
Raimbach's (q.v.) process of engraving
on steel plates.
Aft.: E. Bird, R. Smirke, T. Uwins,
Sir D. Wilkie.
Pup.: S. Davenport, T. Fairland, H.C.
Shenton (qq.v.).

WARWICK Henry Richard Greville,
Earl of 1779—1816.
Litho.
Pub.: Philip André.

WARWICK B. fl. London 1810—50.
WARWICK J.
Line.
Ex libris.
Possibly brothers.

WARWICK R. fl. 1849.
Steel.
Illus. / land.
Aft.: J. Russell.

WASHINGTON KELL AND CO
fl. 1890s.
Pub.
Possibly connected with Kell
Bros. (q.v.).

WASS Charles Wentworth c. 1817—
1905.
Line., mezzo., steel., stip.
*An. / ex libris / fig. / gen. / hist. /
illus. / relig. / sport.*
Worked in London.
Aft.: R. Ansdell, J. Bateman, W.
Etty, J.F. Herring Sr., Sir E.
Landseer, P.F. Poole, H. Selous.
Pub.: T. Agnew with H. Graves;
Art Union; O. Bailey; G. Brooker;
Fores; Gambart; J. Gilbert.
Lit.: *Art Union* 1848, pp. 116,
227.

WATERLOW and SONS fl. London
from 1860s.
WATERLOW BROS and LAYTON
LTD.
Security printers.
Stamps.
Lit.: Gibbons Stanley Ltd. Various
stamp catalogues. Lister R. *Private
Telegraph Companies of Gt. Britain
and their Stamps* 1961.

WATERS J. fl. 1832.
Steel.
Illus. / land.
Aft.: W. Tombleson.

WATERSON David 1870
(Brechin) — 1954.
Et., mezzo.
Ex libris / gen. / land.

WATKINS H.G. fl. London
1830s—40s.
Mezzo., steel.
Illus. / land. / sport.
Aft.: H. Gastineau, J.F. Herring Sr.,
A.C. Pugin.
Pub.: H. Graves; Lloyd Bros.

WATKINS John fl. London
1870s—1908.
Et.
Arch. / illus. / topog.
Also a painter, Watkins studied at the
National Art Training School, South
Kensington. He illustrated handbooks
for the Victoria and Albert Museum.

WATKINS W.G. fl. London 1823—48.
Line., steel.
Illus. / land. / port.
Aft.: T. Allom, T.B. Baynes, W. Callow,
J.D. Harding, J.P. Neale, G. Pickering,
T.H. Shepherd.

WATSON Caroline 1758 (London) —
1814 (Pimlico).
Mezzo., stip.
*All. / gen. / lit. / myth. / port. / relig. /
theat.*
The daughter of James Watson
mezzotint engraver (1740—90),
Caroline Watson was appointed
engraver to Queen Charlotte in 1785,
not to Queen Caroline as stated in
some reference works.
Aft.: Sir W. Beechey, Correggio,
Maria Cosway, R. Cosway, Downman,
C.M. Fanshawe, Hoppner, R.E. Pine,
Raphael, Reynolds, G. Romney,
Russell, S. Shelley, Sheriff.

WATSON Charles John 1846
(Norwich) — 1927.
Dry., et., litho.
Arch. / gen. / land. / topog.
Also a painter.
Aft.: J.S. Cotman.
Lit.: *Apollo* VII, p. 293.
Art Journal 1907, pp. 134f. *Studio*
1896, p. 3; 1897, pp. 3f; 1908, p. 322;
1914, p. 217; 1915, p. 140; 1916,
pp. 115, 118. Special numbers 1900,
1913, 1915-16, 1917. Wedmore F.
Etchings in England 1895.

WATSON J. fl. 1840s—50s.
Pub.

367

WATSON John Dawson 1832
(Sedbergh) — 1892 (Conway).
Et.
Gen.
Best known as a painter and illustrator.
Lit.: *Art Journal* 1861, p. 46.
Portfolio 1873, pp. 92f; 1892, p.vi.

WATT Fides b. Aberdeen 1873.
Mezzo.
Port.
Also a painter.

WATT James Henry 1799 (London)
— 1867 (London).
Et., line., mixed., steel.
An. / gen. / illus. / lit. / port. / relig. / sculp.
Watt became a pupil of C. Heath (q.v.)
when he was eighteen, and continued
thereafter to work for him.
Aft.: Carracci, Sir C. Eastlake,
W. Hilton, Sir T. Lawrence, Sir E.
Landseer, C. Leslie, R. Smirke, T.
Stothard, R. Westall.
Pub.: T. Boys; Day and Sons; H.
Graves.
Lit.: *Art Journal* 1867, pp. 171f.
Engen Rodney K. *Victorian
Engravings* London 1975.

WATT Thomas fl. 1840s.
Steel.
Illus. / land.
Aft.: J.C. Brown, D. McKenzie.

WATT William Henry 1804—45.
Line., steel.
Fig. / illus. / lit. / port.
Aft.: R.P. Bonington, W. Hilton,
T.G. Hurlstone, Sir E. Landseer,
C.R. Leslie, J.H. Mortimer,
T. Stothard.
Pub.: Art Union of London.
Lit.: Engen Rodney K. *Victorian
Engravings* London 1975.

WATTS George fl. first half of
19th c.
Wood.
Illus.
Settled in Germany in 1820.

WATTS George Frederick R.A. O.M.
1817 (London) — 1904.
Et.
Port. / sport.

This great Victorian sculptor and
painter served an apprenticeship
under the sculptor William Behnes
from 1827 and studied at the R.A.
Schools from 1835.
Aft.: N. Wanostrocht.
Des. eng.: L. Flameng, D. Lucas,
P. Rajon, J. Stephenson (qq.v.) and
others.
Pub.: Knight.
Lit.: Blunt W. *England's Michelangelo*
1975.

WATTS J. fl. 1821.
Aq. (?), steel.
Flor. / illus. / land.
Aft.: W. Tombleson.

WATTS S. fl. 1820—40s.
Litho.
Flor. / illus.

WATTS W. fl. 1846.
Steel.
Illus. / land.
Aft.: W. Tombleson.

WATTS William 1752
(Moorfields, London) — 1851
(Cobham).
Aq., line.
Illus. / land. / lit. / topog.
The son of a master silk-weaver, Watts
received his art education from the
watercolourist Paul Sandby and the
engraver and draughtsman Edward
Rooker (1712—74). On Rooker's
death he continued the *Copper-plate
Magazine* which Rooker had
founded. He travelled to Italy in 1786,
going as far as Naples. After a year he
returned to England and lived for a
time at Sunbury. After this he went in
1789 to Carmarthen, to Hot-Wells,
Bristol in 1790 and to Bath in 1791,
staying there for two years. Later he
lived for a time at Mill Hill, Hendon
and in 1814 finally settled at Chobham,
Surrey. He supported the French
Revolution and invested his savings
in French funds which were confiscated.
He was also a painter and illustrator.
Aft.: Bunbury, J. Constable, L. Mayer,
P. Sandby.
Des. eng.: Laurent Guyot (French).
Lit.: *Art Journal* 1852, p. 76.

WAY Thomas Robert 1851—1913
(London).
Litho., print.
Port. / sport. / topog.
Way is noted as the printer of the
plates of J. McN. Whistler (q.v.). He
introduced Whistler to lithography.
Also a writer, he was the author of
Mr Whistler's Lithographs (1905) and
The Art of J.A.M. Whistler (1905).
Aft.: F. Barraud, W. Strang, F.
Wheatley, J. McN. Whistler.
Lit.: *Art Journal* 1896, pp. 13f.
William Weston Gallery, London
*Victorian London . . . Lithographs
by Thomas Way 1851—1913* 1978.

WEATHERHEAD J. fl. 1869.
Steel.
Fig.

WEAVER Walter fl. 1890s.
Pub.

WEBB Duncan d. 1832.
Line.
An.
Aft.: Ferneley, A. Ramsay.

WEBB Edward *c*. 1805—64.
Line.
Gen. / hist.
Also a painter.
Aft.: E.H. Corbould.

WEBB H.J. 1852—1933.
Pub.
Juv. dram.
Son of W. Webb (q.v.), whose
sheets he republished. His address
was 124-146 Old Street, St Luke's,
London.

WEBB J. fl. London (75 Brick Lane,
St Luke's; Central Street, St Luke's)
c. 1830.
Manufacturer of tinsel embellishments
for theatrical portraits, and retail
agent. He was the uncle of W. Webb
(q.v.).

WEBB John fl. London 1790—1835.
Line.
An. / port.
Aft.: Hoppner, Reinagle, Reynolds.
Shared: J. Scott (q.v.).

WEBB John Cother 1855 (Torquay)
— 1927 (London).
Mezzo. (incl. steel).
*An. / all. / fig. / gen. / hist. / land. /
lit. / myth. / port. / ship. / sport. /
topog.*
Pupil of T. and Sir E. Landseer.
Aft.: R. Ansdell, J.B. Burgess, S.J.
Carter, J. Charlton, J. Collier,
A. Cooper, P. Cuno, W.P. Davies,
E. Douglas, H.J. Draper, S.M. Fisher,
Gainsborough, H. Garland, Hoppner,
Blanche Jenkins, E. Lambert,
Sir E. Landseer, Sir T. Lawrence,
Lord Leighton, E. Long, C. Lorrain,
W.H. Margetson, Sir J. Millais, P.R.
Morris, W.W. Ouless, Raeburn,
Reynolds, J. Ritchie, A.C. Sealy,
J.J. Shannon, Elizabeth Thompson
(Lady Butler), J.M.W. Turner, Van
Dyck, Mary L. Waller, A. Ward, A.H.
Wardlow, J.H. Williams, W. Wonter.
Shared: E. Duncan, B.P. Gibbon.
Pub.: T. Agnew; H. Blair Ansdell;
Alfred Bell; Harry C. Dickins;
Dowdeswell and Dowdeswells;
Fine Art Society; Fishel, Adler and
Schwartz; Frost and Reed; Gooden
and Fox; Goupil; H. Graves; L.H.
Lefèvre; T. McLean; I.P. Mendoza;
W. Shaus; A. Tooth; Washington,
Kell and Co.; J. Williams.
Lit.: *Connoisseur* LXII, p. 49;
LXVII, p. 176.

WEBB W. 1820—90.
Pub.
Juv. dram.
Webb served an apprenticeship with
A. Park (q.v.) and was a traveller in
theatrical portraits until he set up
in business for himself. He worked
at various addresses: Ripley, Surrey;
Cloth Fair, London; Bermondsey
Street, London; 49-104-124-146
Old Street, St. Luke's, London.
 His sheets are variously inscribed:
W. Webb, W.C. Webb, W.G. Webb.
Speaight (*Toy Theatre* p. 196)
mentions that an earlier authority
(A. How Matthews) considered these
initials indicated two separate
artists, but Speaight considers this
unlikely, as the family say that Webb's
own initials were W.G. and it is
therefore possible that the C in the
W.C. initials is a G with the bar missing.

W. Webb was succeeded by his son H.J. Webb (q.v.). His agents included H.G. Clarke and J.T. Wood (qq.v.).

WEBSTER Thomas R.A. 1800 (London) — 1886 (Cranbrook).
Et.
Gen. / lit.
Best known as a genre and history painter, Webster was intended for a musical career but in 1820 he decided to be a painter and became a pupil at the R.A. Schools.

WEDDELL E.S. fl. 1830s—50s.
Aq., line.
Flor. / illus.
Aft.: M. Hart.
Shared: F.C. Lewis (q.v.).

WEDGWOOD John Taylor 1783 (London) — 1856 (Clapham, London).
Line., steel.
Antiq. / fig. / gen. / hist. / port. / relig.
Aft.: Correggio, Gainsborough, S. Rosa, W.E. West.
Lit.: *Connoisseur* LXVIII, p. 76.

WEEKES Frederick fl. London 1850s—90s.
Et.
Mil.
Best known as a painter of genre and military subjects.

WEEKS H. and J. fl. 1832.
Steel.
Illus. / land.
Probably brothers. Plates are signed by either.

WEHRSCHMIDT Daniel Albert 1861 (Cleveland, Ohio) — 1932.
Litho., mezzo.
Gen. / port.
Also a painter, Wehrschmidt, who was of German descent, was a pupil of Sir H. Herkomer (q.v.) at Bushey 1883—84, and taught there 1884—96. He settled in Doneraile in Ireland.
Aft.: P.H. Calderon, J.D. Engleheart, L. Fildes, Sir H. Herkomer, F. Holl, Sir T. Lawrence, Sir J. Millais, Sir W.Q. Orchardson, Reynolds, G. Romney, H. Schmalz, J. Wilson.
Pub.: C.E. Clifford; Colnaghi; Fine Art Society; Goupil; C. Klackner; L.H. Lefèvre; F.C. McQueen; Mawson, Swan and Morgan; A. Tooth.
Lit.: *Connoisseur* XXVIII, p. 131. *P.C.Q.* XIX, p. 187. *Studio* 1915, p. 113; Special number, 1919.

WEIGALL Charles Henry fl. 1860s.
Line.
Gen. / hist.
Also a painter.
Pub.: Ackermann.

WEIR Harrison fl. mid 19th c.
Wood.
An. / illus. / land.

WEIRTER or WHIRTER Louis 1873 (Edinburgh) — 1932 (London).
Et.
Mil.
Also a painter and inventor.

WELCH J.S. fl. *c*. 1846.
Litho., pub.
Theat. (ballet).
Perhaps identical with the Welch in the firm Welch and Gwynne (q.v.).

WELCH T. fl. London 1794—1820.
Line.
Ex libris.

WELCH AND GWYNNE fl. London *c*. 1840.
Litho., pub.
Theat. (ballet).
Possibly the Welch in the firm was J.S. Welch (q.v.).

WELLES E.F. fl. Mid 1820s — mid 1850s.
Et.
An. / land.
Welles worked in Earl's Croom (Worcestershire), London, Cheltenham and Herefordshire. He is known chiefly as a painter of animals and landscape.

WELLESLEY Rev. H. fl. 1850s.
Et. (amateur).
Port.

WELLON W. fl. 1850.
Litho.
Arch.
Aft.: J.J. Dodd.

WELLS J.G. fl. London 1785—1809.
Aq.
Arch. / land. / mil. / ship. / sport. / topog.
Wells lived in Norway after 1809.
Aft.: Capt. Allen, Freebairn, Guest, R. Livesay, W. Mason, Peachey, N. Pocock, Powell, Lieut. Ramage, Whitcombe.
Shared: F. Chesham, R. Pollard (qq.v.).
Pub.: B.B. Evans.

WELLS William 1842—80.
Wood.
Illus.

WELLS William Frederick 1762 (London) — 1836 (Mitcham).
Et. (soft-ground).
Land.
A pupil of J.J. Barralet, Wells was also a painter in oil, pastel and watercolour, and was one of the founders of the "Old Water-Colour" Society. He travelled abroad, especially in Scandinavia.
Aft.: Gainsborough.

WESLEY J. fl. 1828—31.
Steel.
Arch. / illus.

WEST — fl. Bath 1813—15.
Litho.
Probably amateur.

WEST — fl. 1877.
Steel.
Fig. / illus.
Aft.: Overbeck.
Pub.: Virtue and Co.

WEST Benjamin P.R.A. 1738 (Springfield, U.S.A.) — 1820 (London).
Litho., mezzo.
Relig.
West, who is best known as a painter, came to Europe in 1760 and visited several Italian cities. In 1763 he visited London, where he was so well received that he settled there. He became President of the R.A. on the death of Sir Joshua Reynolds in 1792. Father of Raphael Lamar West (q.v.).
Pub.: Philip André.

WEST Joseph Walter 1860 (Hull) — 1933 (Northwood).
Et., litho., mezzo., stip.
Ex libris / gen. / illus.
West studied under A.A. Calderon at the St John's Wood School of Art and under Edwin Moore and in Paris. He was also a painter. He lived and worked in Northwood, Middlesex.
Aft.: F. Walker.
Lit.: *Magazine of Art* 1902, pp. 433f. *P.C.Q.* XIX, p. 252. *Studio* 1896, pp. 138ff.

WEST Raphael Lamar 1769 (London) — 1850 (Bushey Heath).
Et.
Gen. / myth.
Son of Benjamin West (q.v.).
Pub.: Thompson.

WEST William 1783—1854.
Pub.
Juv. dram.
West worked in London at 13 Exeter Street, Strand and 57 Wych Street, Strand. He probably acquired some of the plays of Mrs M. Hebberd (q.v.).
His plays were re-published by W. Love (q.v.). When he became too ill to attend to publication, they were published by his housekeeper. Sarah Stokes (q.v.).

WEST William fl. London 1830—40.
Line.
Ex libris.

WEST AND CO. fl. 1858.
Litho.
Illus.
Pub.: Willis and Sotheran.

WEST, NEWMAN AND CO.
fl. 1880s.
Litho.
Flor.

WESTALL Richard 1765 (Hertford) — 1836 (London).
Aq., et., litho., mezzo.
Illus. / myth.
Also a painter, Richard was the elder brother and teacher of W. Westall (q.v.). He was apprenticed to an heraldic engraver on plate and became a student at the R.A. in 1785.

He is best remembered as an illustrator and his own designs were reproduced by many engravers.

WESTALL William 1781 (Hertford) — 1850 (London).
Aq., et., line., litho.
Illus. / land. / topog.
The younger brother and pupil of R. Westall (q.v.), William also attended the schools of the R.A. In 1801 he went as landscape draughts-man on a cruise to Australia under the command of Matthew Flinders. After many adventures he went to China and India, returning to England in 1805. Soon afterwards he went away again, this time to Madeira and thence to Jamaica. On his return he settled in England and devoted himself to the production of works of art from materials gathered on his travels. Many of his designs were reproduced by other engravers.

WESTWOOD Charles d. 1855.
Line., steel.,
Illus. / land.
Possibly a brother of W. Westwood (q.v.). Worked in Birmingham. Emigrated to U.S.A. in 1851 and committed suicide in 1855.
Aft.: W. Brockedon, Sir E. Landseer, S. Prout, T.H. Shepherd, W. Tombleson.

WESTWOOD W. fl. 1835.
Steel.
Illus. / land.
Possibly a brother of C. Westwood (q.v.).
Aft.: W.H. Bartlett.

WETHERHEAD W. fl. 1843.
Steel.
Fig. / land.
Aft.: T. Allom.

WESTLAKE Alice 1840—1923.
Et.
Land.
Also a watercolourist, Alice Westlake was a daughter of Thomas Hare, the political reformer. She worked in London.

WEYDE Henry Van Der fl. London 1875—80.
Photo-eng.
Port.
Worked in London and Paris. Also a miniaturist.
Pub.: T. McLean.

WHAITE H. fl. Manchester (4 Bridge Street) 1835.
Pub.
Tinsel.

WHAITE Henry Clarence 1828 (Manchester) — 1912 (Conway).
Et.
Gen. / land. / lit.
Also a painter, Whaite studied art at Manchester School of Design, at the art school at Somerset House and at the Schools of the R.A. He was much influenced by John Ruskin and J.M.W. Turner. He travelled in Italy and Switzerland.

WHESSELL John fl. London 1792—1825.
Line., steel.
An. / flor. / gen. / mil. / sport.
Aft.: Agasse, J. Barney, J. Boultbee, Bourgeois, Gainsborough, B. Gale, T. Hilton, Lewis, B. Marshall, G. Morland, Sartorius, Singleton, T. Stothard, F. Wheatley, J. Whessell.

WHIMPER Josiah Wood — See WHYMPER Josiah Wood.

WHIRTER Louis — See WEIRTER Louis.

WHISTLER James Abbott McNeill 1834 (Lowell, Massachusetts) — 1903 (Paris).
Dry., et., litho., wood.
An. / arch. / fig. / gen. / land. / port. / topog.
A prominent American painter and engraver who settled in Chelsea in 1859, and worked largely in England and Russia. He learned the technique of etching while working as a navy cartographer. He studied in Paris from 1856. T. Way (q.v.) introduced him to lithography. Much of his work was printed by F. Goulding, but Whistler considered that only the

etcher could print his own plates well.
He formed with A. Legros (q.v.) and
the French artist Fantin-Latour, a
"Society of Three".
Pup.: H. and W. Greaves, M.L. Menpes,
T. Roussel, W.R. Sickert, P. Thomas.
Pub.: Dowdeswell and Dowdeswells;
Ellis and Green; Fine Art Society.
Lit.: Arts Council *James McNeill
Whistler* 1960. Dodgson C. *The
Etchings of James McNeill Whistler*
1922. Kennedy E.G. *The Etched
Work of Whistler . . .* 6 vols., 1910.
Levy M. *Whistler Lithographs: A
Catalogue Raisonné* 1975. MacDonald,
Margaret and others *Whistler — The
Graphic Work: Amsterdam, Liverpool,
London, Venice* 1976. Naylor Maria
*Selected Etchings of James A. McNeill
Whistler* 1975. *P.C.Q.* I, p. 32-61; III,
pp. 277-309, 366-93; V, pp. 256,
433-43; VI, pp. 374-95; VII, pp.
217-20; XXIV, pp. 305-7; XXVIII,
pp. 274-91. *Prints* I, pp. 1-10.
Salaman M.C. *James McNeill Whistler*
Modern Masters of Etching Series No.
13 (2 vols., 1927) and No. 32 (1932).
Spencer R., and others *James McNeill
Whistler (1824—1903)* 1969. Way T.R.
The Art of J.A.M. Whistler 1905.
*Mr Whistler's Lithographs: The
Catalogue* 1905.

WHITCOMBE Henry b. Birmingham
1878.
Et. (?)
Also a painter, Whitcomb worked in
Bournemouth.

WHITE David Thomas fl. London
(7 Maddox Street) 1850s.
Pub.

WHITE Edward Fox fl. 1880s.
Pub.

WHITE Henry d. after 1861.
Wood.
Illus.
At first apprenticed in London to the
wood-engraver James Lee (d. 1804),
White, on Lee's death, put himself
under T. Bewick (q.v.) at Newcastle-
on-Tyne. On completion of his time
he returned to London where he built
up a first-rate reputation.
 There was also a Henry White Jr.,

presumably a son, who was also a
wood-engraver.

WHITE John T. fl. 1890s.
Pub.

WHITE William Johnstone fl. late
18th — early 19th c.
Aq., Line.
Ship.
Aft.: W. Anderson.
Shared: J. Jeakes (q.v.).

WHITECHURCH Robert 1814
(London) — after 1883 (Washington).
Line., mezzo., stip.
Port.
Worked in Philadelphia and Washington.

WHITEHEAD Frederick
fl. Leamington 1870.
Et.
Land.
Also a painter.

WHITFIELD Edward Richard
b. London 1817.
Line., steel.
Gen. / myth. / port.
A pupil of A. Fox (q.v.), Whitfield
settled in Dresden in 1859.
Aft.: H. Briggs, Domenechino,
W. Hilton, H.W. Pickersgill, T. Stothard.
Pub.: Colnaghi, R. Roe.
Lit.: *Art Journal* 1852, p. 304; 1854,
p. 364.

WHITHAM Mrs S.F. b. 1878.
Et.

WHITING Charles fl. London
(Beaufort House, Strand) 1820s—60s.
Security printer.
Ephem. / stamps.
Whiting used the method of Sir W.
Congreve (q.v.). He made many designs
for postage stamps.
Lit.: Lister R. *Private Telegraph
Companies of Gt. Britain and their
Stamps* 1961.

WHITING Frederic 1874 (London) —
1962.
Dry., et.
An. / gen. / illus. / land. / sport.
Also a painter and journalist, Whiting
was a pupil at the Royal Academy.

WHITTLE AND LAURIE or LAURIE AND WHITTLE fl. late 18th — early 19th c.
Pub.
Maps / mil. / ship. / sport. / topog.

WHITTOCK Nathaniel fl. Oxford and London early 19th c.
Litho., steel., wood.
Illus.
Aft.: W.A. Delamotte.
Pup.: Joseph Swain (q.v.).

WHYMPER Charles b. London 1853.
Wood.
An. / illus.
Also a painter, Charles was a son of J.W. Whymper and a brother of E. Whymper (qq.v.).

WHYMPER Edward 1840 (London) — 1911 (Chamonix).
Wood.
Illus.
Edward Whymper, who was privately educated, was the second son of J.W. Whymper and a brother of C. Whymper (qq.v.). He entered his father's wood-engraving business, to which in time he succeeded, maintaining its high reputation until the technique was overtaken by photographic reproduction. Whymper was a well-known mountain climber and was the first man to climb the Matterhorn as related in his book, *Scrambles amongst the Alps* (1871). He illustrated many works for the Christian Knowledge Society. Also a watercolourist.
Aft.: P. Skelton.

WHYMPER Josiah Wood 1813 (Ipswich) — 1903 (Haslemere).
Et., wood.
Illus. / topog.
J.W. Whymper, who was the son of a brewer, was educated at private schools and then apprenticed to a stonemason. His apprenticeship was ended by an accident and in 1829 he went to London where he took up wood-engraving, in which he was self taught, founding a successful and noted firm. Several of his engravings are signed WHIMPER. He was also a watercolourist, and was the father of E. Whymper (q.v.).

Aft.: Sir J. Gilbert.
Pup.: C.V. Brownlow, J.D. Cooper, C. Keene, (qq.v.) and the painter Fred Walker.

WICKENDEN Robert b. Rochester 1861.
Litho.
Gen. / land. / port.
Also a painter and writer on art, Wickenden visited New York in his youth and then became a pupil in Paris at the École des Beaux-Arts and in the studios of Ernest Hebert and Luc Olivier Merson. He used the lithograph with great understanding and imagination.

WIGSTEAD Henry b. London 1793.
Et.
Caric. / gen.
Also a painter.
Shared: T. Rowlandson (q.v.).

WILD Charles 1781 (London) — 1835 (London).
Aq., et., mixed.
Arch.
Also a designer and painter.

WILDBLOOD A.W. fl. 1847.
Steel.
Fig. / illus.
Aft.: L. Pollack.

WILKIE Sir David R.A. 1785 (Cults, Fifeshire) — 1841 (at sea, Mediterranean).
Dry., et.
Fig. / gen. / port.
This great Scottish painter, who received his art training at the Trustees Academy, Edinburgh, and at the Schools of the R.A., made thirteen plates, some in etching, some in drypoint. He was painter in ordinary to George IV, and travelled widely.
Des. eng.: A. Reimbach, J.H. Robinson, E. Smith (qq.v.), and by many others.
Pub.: E. Parsons.
Lit.: *Art Union Journal* II, p. 10. Dodgson C. *The Etchings of Sir David Wilkie* 1923 (Vol. XI, Walpole Society). Dodgson C. *The Etchings of Sir David Wilkie and Andrew Geddes — A Catalogue* 1936. Laing D. *Etchings by Sir David Wilkie and Andrew Geddes* 1875. *Portfolio* 1887, pp. 90-7.

WILKIN Charles 1750 (London) —
1814 (London).
Mixed., stip.
Gen. / port.
In 1771 Wilkin was awarded a
premium by the Society of Arts. He
worked and published at the following
London addresses: 19 Eaton Street,
Pimlico; 83 Queen Anne Street East.
He was probably also a miniaturist. His
son was F.W. Wilkin (q.v.).
Aft.: Beechey, Hoppner, Reybolds,
H. West.

WILKIN Franck W. *c.* 1800—42
(London).
Line.
Port.
The son of C. Wilkin (q.v.). Also a
miniaturist.

WILKINSON H. fl. 1840s—50s.
Printer of copper and steel plates.

WILKINSON Joseph fl. 1810.
Et. (amateur).
Land.
Pub.: Ackermann.

WILKINSON Norman C.B.E.
1878—1971.
Dry., et.
Fig. / land. / marine / ship. / sport.
Also a painter.

WILKINSON Sir N.R. 1869—1940.
Et. (amateur).
Land. (?)

WILKINSON W.S. fl. 1836.
Steel.
Arch. / topog.
Aft.: T. Allom, E. Blore, J.C.
Buckler, Sir F. Chantrey, C. Fielding,
T.H. Shepherd.

WILLEMENT Thomas 1786 (London)
— 1871 (Faversham).
Line.
Ex libris.
Also an heraldic and glass painter,
Willement was heraldic painter to
George IV and Queen Victoria.

WILLIAMS Alfred Mayhew 1826—93.
Et.
An. / topog.

WILLIAMS C. fl. 1815.
Aq., mezzo.
Illus. / land.

WILLIAMS Edward fl. late 18th
and early 19th c.
Et., line., stip.
Gen. / port.
Aft.: T. Rowlandson, W. Ward, H.
Wigstead.

WILLIAMS Edward Charles 1815 —
after 1880.
Et., mezzo.
Gen.
Son of the landscape painter, Edward
Williams (1782—1855), E.C. Williams
himself practised landscape painting.
Aft.: W. Oliver, O. Rhys.

WILLIAMS Hugh William ("Grecian
Williams") 1773 (at sea) — 1829
(Edinburgh).
Et.
Land.

WILLIAMS J. fl. from 1850s.
WILLIAMS, STEVENS, WILLIAMS
and CO.
Pub.

WILLIAMS J.T. fl. London 1831—35.
Line.
Ex libris.
Also a carver of cameos.

WILLIAMS John (known as "Anthony
Pasquia") 1761 (London) — 1818
(Brooklyn, U.S.A.).
Line.
Williams studied at the R.A. Schools,
and was apprenticed to the engraver
and caricaturist, Matthew Darly
(fl. late 18th c.). He later emigrated to
the U.S.A. Also an art critic, little is
known of his engraved work.

WILLIAMS Joseph Lionel
d. London 1877.
Wood.
Illus.
Also a painter.

WILLIAMS Mary Anne fl. 1858—
1908.
Et., wood.
Illus.
Sister of S. and T. Williams (qq.v.).

WILLIAMS Morris Meredith
fl. Edinburgh late 19th — early 20th c.
Et. (?)
Illus.
Also a painter and glass painter,
Williams was a pupil at the Slade
School.

WILLIAMS Penry 1798 (Merthyr
Tydfil) — 1885 (Rome).
Et.
Fig. / gen.
After studying at the R.A. Schools,
Williams settled in Rome, where he
met many visiting artists, including
S. Palmer and G. Richmond (qq.v.).
Best known as a genre and landscape
painter.
Des. eng.: D. Lucas, C. Rolls, L.
Stocks (qq.v.).
Lit.: *Art Journal* 1864, pp. 101f.
Connoisseur LVI, p. 126; LXXVII,
p. 59.

WILLIAMS Samuel 1788
(Colchester) — 1853 (London).
Wood.
Illus. / land. / nat.
The son of poor but respectable
parents, Williams was apprenticed to a
Colchester printer named Marsden.
He taught himself etching, then wood-
engraving, which he adopted as a
profession after completing his time
under Marsden. After practising for
some time in Colchester, he settled in
London in 1819. His brother and pupil
Thomas and his sister Mary Anne
(qq.v.) were also wood-engravers, as
were Samuel's four sons and his
daughter, Miss E. Williams.
Aft.: J. Constable, W. Harvey, W.
Hilton, Sir E. Landseer, C.R. Leslie,
J. Martin.
Pub.: Crosby.
Lit.: *Art Journal* 1853, p. 311. *Art
Work* VII, pp. 112-15. *Connoisseur*
L, p. 228. *Essex Review* XXVI, pp.
165-73. Jackson J. and W.A. Chatto
A Treatise on Wood Engraving Second
edition 1861. Linton W.J. *The
Masters of Wood Engraving* 1889.

WILLIAMS Thomas *c.*1800–*c.*1840.
Wood.
Illus.
Brother and pupil of S. Williams and

brother of Mary Ann Williams (qq.v.).
Aft.: T. Creswick, W.H. Hunt, J.
Martin, Sir J.E. Millais, R. Westall.
Pup.: Joseph Swain (q.v.).

WILLIAMS W. fl. 1760–1815.
Line.
Ex libris / port.

WILLIAMS-LYOUNS Herbert Francis
b. Plymouth 1863.
Wood.
Illus. / relig.
Also a painter.

WILLIAMSON Thomas fl. London
c. 1800–32.
Et. (soft-ground), line., stip.
All. / gen. / land. / port.
Aft.: Absolon, J. Barrow, J. Boyne,
Buck, Drummond, G. Morland.

WILLIE W.L. fl. 1889–1900.
Et. (?)

WILLIS Edward fl. early 19th c.
Wood.
Illus.
Pupil of T. Bewick (q.v.).

WILLIS Ethel Mary b. London
1874.
Et.
Port. (?)
Also a painter, Ethel Willis was a pupil
at the Slade School.

WILLIS Frank 1865 (Windsor) —
1932 (Windsor).
Et.

WILLIS Henry Brittain 1810 (Bristol)
— 1884 (Kensington).
Litho.
Port.
Willis was also a painter of animals
and landscape. He visited America in
1842 and on his return settled in
London.
Aft.: J. Palmer, J. Watkins.
Pub.: Lloyd Bros.

WILLIS J. fl. 1846.
Steel.
Illus. / line.
Aft.: W. Tombleson.

WILLIS W. fl. 1830s—40s.
Steel.
Arch. / flor. / illus.
Aft.: T. Barber.

WILLMORE Arthur 1814
(Birmingham) — 1888 (London).
Line., steel.
*Fig. / gen. / hist. / land. / marine /
myth. / relig. / ship.*
The brother of J.T. Willmore (q.v.),
Arthur worked in London.
Aft.: S. Bough, O.W. Brierly, W.
Collins, E.W. Cooke, T. Cooke, D.
Cox, T. Creswick, F. Danby, H.
Dawson, Jr., E. Duncan, J.C. Hook,
J. MacWhirter, S. Prout, L. Roberts,
Rubens, C. Stanfield, Van Dyck.
Shared: E.P. Brandard (q.v.). Arthur
finished work left uncompleted by
his brother J.T. Willmore (q.v.) at the
onset of his last illness.
Pub.: Art Union of London; Lloyd
Bros.

WILLMORE James Tibbitts A.R.A.
1800 (Handsworth, Birmingham) —
1863 (London).
Line., steel.
*Gen. / hist. / illus. / land. / lit. / mil. /
myth. / port. / sport. / topog.*
The son of a silver manufacturer,
Willmore was apprenticed for seven
years to W. Radclyffe (q.v.) at
Birmingham. At the end of his time, in
1823, he came to London and worked
for three years for C. Heath (q.v.) after
which he worked on his own account.
He was the brother of A. Willmore
(q.v.).
Aft.: Allom, R. Ansdell, W.H. Bartlett,
S. Bough, W. Brockedon, A. Callcott,
G.B. Campion, J.J. Chalon, A. Cooper,
T. Creswick, C. Eastlake, Birket
Foster, J.D. Harding, E. Jones, Sir E.
Landseer, B.W. Leader, W.L. Leitch,
H. Le Keux, W. Linton, R. Nasmyth,
S. Prout, W.C. Stanfield, J. Thompson,
J.M.W. Turner.
Shared: J. Saddler (q.v.). Some of his
plates left incomplete at the onset of
his last illness were finished by his
brother A. Willmore (q.v.).
Pub.: T. Agnew; Art Union of
London; Dixon and Ross; J.L.
Fairless; E. Gambart and Co.; H.
Graves; Leggatt, Laywood, Leggatt;

Lloyd Bros.; London Printing and
Publishing Co.; F.G. Moon; Jacob
Thompson.
Lit.: *Art Journal* 1863, pp. 87f.

WILLSON Harry fl. London 1813—52.
Litho.
Land.
Also a painter.

WILMSHURST J. fl. 1830s—40s.
Steel.
Arch. / illus.
Aft.: R. Garland.

WILSON — fl. 1833.
Wood.
Illus.
An assistant of J. Jackson (q.v.).

WILSON A. fl. 1840.
Steel.
Gen. / illus.
Aft.: Descaine.

WILSON Andrew 1780 (Edinburgh) —
1848 (Edinburgh).
Line.
Land. / topog.
A pupil of Alexander Nasmyth and
at the schools of the R.A., Wilson
was also a painter. He rounded off his
education by a visit to Italy. His work
was much admired by Napoleon I, who,
on being told the artist was English,
declared: "Le talent n'a pas de pays".
He was the father and teacher of
C.H. Wilson (q.v.).

WILSON Charles Heath 1840
(Edinburgh) — 1882 (Florence).
Line.
Land.
The son and pupil of A. Wilson
(q.v.), Charles Heath was also a painter.
He became director of the Edinburgh
School of Art in 1843 and of the
Glasgow School of Design in 1848,
but resigned in 1869 so that he could
join his family in Italy.

WILSON Daniel fl. 1835—40.
Line., steel.
Land. / myth.
Pupil of C. Turner (q.v.).
Aft.: D.O. Hill, C. Stanfield, T.
Stothard.

WILSON Edgar 1861—1918.
Et.
Land. / ship.
Wilson's work shows the probable
influence of J. McN. Whistler (q.v.).

WILSON Eli Marsden b. Ossett 1877.
Et., mezzo.
Land. / topog.
Wilson, who studied at Wakefield
School of Art and the Royal College
of Art, London, lived and worked in
London.
Lit.: *Art Journal* 1909, pp. 257f.

WILSON J. fl. 1840.
Steel.
Arch. / illus.
Aft.: W. Tombleson.

WILSON R. fl. 1832.
Steel.
Arch. / illus.
Aft.: W. Tombleson.

WILSON Sydney Ernest b. Isleworth
1869.
Mezzo.
Gen. / lit. / port. / sport.
Pupil of J.B. Pratt (q.v.).
Aft.: W.R. Bigg, Gainsborough,
Greuze, Hoppner, Sir T. Lawrence,
Le Brun, G. Morland, Nattier, Rev.
W. Peters, Raeburn, Reynolds, Romney,
J. Russell, H. Walton.
Pub.: Vicars Bros.

WILSON Thomas Harrington
fl. London 1842—86.
Line.
Gen. / port.
Also a painter.

WIMPERIS Edmund Monson 1835
(Chester) — 1900 (London).
Wood.
Illus.
Also a landscape painter, Wimperis
began life in a bank, but at the age
of sixteen was placed with the
engraver Mason-Jackson with whom
he spent seven years. He designed
illustrations as well as engraving them.

WINBY Frederick Charles b. Newport
1875.
Et.
Also a painter. Worked in London.

WING C.W. fl. 1826.
Litho.
Topog.

WINKLES or WINKELES Benjamin
fl. 1829—42.
Steel.
Arch. / illus.
Brother of H. Winkles and probably
of R. Winkles.
Aft.: J. Archer, W.H. Bartlett,
B. Baud, H. Browne, W.G. Colman,
R. Garland, S.A. Hart, G. Petrie,
J. Salmon, G. Shepherd, T.H.
Shepherd, C. Warren, W. Warren,
H. Winkles.

WINKLES Henry fl. 1818—42.
Aq., steel.
Arch. / illus. / land.
Brother of B. Winkles and probably
of R. Winkles.
Aft.: W.H. Bartlett, Browne,
R. Garland, Pugin, W. Tombleson.

WINKLES J.R. fl. 1829—31.
Steel.
Arch. / illus.
Possibly identical with R. Winkles
(q.v.).
Aft.: N. Fletcher.

WINKLES Richard fl. 1829—36.
Steel.
Arch. / illus.
Probably a brother of B. and H.
Winkles. (qq.v.).
Aft.: T. Allom, Harwood, G.T.
Philips, G.S. Philips, G. Shepherd,
T.H. Shepherd.

WINTER George fl. 1842—52.
Steel.
Arch. / illus.
Possibly a German.

WIRGMAN or WIRMAN Theodore
Blake 1848 (Louvain) — 1925
(London).
Et.
Illus.
Of Swedish origin, Wirgman attended

the schools of the R.A. where he obtained a silver medal for a study from the antique.

WISE William fl. London and Oxford 1823—76.
Line. (?)
Gen. / land. / port. / relig.
Aft.: F.W. Burton, W. Etty, Sir E. Landseer, Lord Leighton, Mantegna, W.B. Richmond, J. Ward.

WITHERS Alfred 1856 (London) — 1932 (London).
Et.
Land. / topog.
Best known for his paintings of architecture and landscape, Withers worked in London, Kent and Surrey.
Lit.: *Art Journal* 1903, pp. 184, 186; 1904, pp. 47-48; 1909, p. 171.
Studio 1906, p. 112; 1907, pp. 58-9, 153f.; 1908, p. 135; 1910, p. 27.

WIX J. fl. 1840s.
Steel.
Arch. / illus.
Aft.: W. Tombleson.

WIZANI J.F. 1770 (Dresden) — 1835.
Et.
Topog.
German national who engraved at least one plate after a work by a British artist.
Aft.: G. Harley.

WOLF Joseph 1820 (Mörz, Prussia) — 1899 (London).
Litho. (inc. chromolitho.)
An. / illus.
Shared: J. Smit (q.v.).
Lit.: Palmer, A.H. *The Life of Joseph Wolf, Animal Painter* 1895.

WOLSTENHOLME Dean, the elder 1757 (Yorkshire) — 1837 (London).
WOLSTENHOLME Dean, the younger 1798 (Waltham Abbey) — 1883 (Highgate).
Aq., line., mezzo., mixed., pub.
Gen. / land. / nat. / sport.
Father and son, these engravers were descended from Sir John Wolstenholme of Stanmore, Middlesex. They were also painters of animals and sporting scenes.

Some of their plates were later acquired by R. Ackermann who reissued them with his own address. Dean junior used a special mixed method of aquatint and etched lines to interpret his father's style.
Aft.: A. Chalon, Dearman.
Des. eng.: J. Dean (q.v.).
Lit.: Wilder F.L. *English Sporting Prints* 1974.

WOOD Francis Derwent 1871 (Keswick) — 1926 (London).
Wood.
Relig.
Also a sculptor and painter.
Lit.: *P.C.Q.* XVI, p. 103.

WOOD H.N. fl. mid 19th c.
Wood.
Decorative borders, illus.

WOOD J.T. fl. London (33-41 Holywell Street, Strand; 287 Strand; 17 Addle Street, Aldermansbury Street) c. 1845.
Pub., retailer.
Juv. dram.
Agent for J.K. Green and W. Webb (qq.v.).

WOOD John George d. 1838.
Et.
Illus. / land.
Also a painter.

WOOD Lewis John 1813 (London) — 1901.
Litho.
Land.
Also a painter.

WOOD Thomas Peploe 1817—45.
Et.
Arch. / land.

WOOD Ursula b. 1868.
Litho., wood.
Land. / topog.
Pupil at the R.A.

WOOD William Thomas 1877—1958.
Et.
Gen. / land.
Also a painter.

379

WOODBURY Walter Bentley 1834
(Manchester) — 1885 (Margate).
Inventor of the photo-engraving
process called Woodburytyping.

WOODCOCK T.S. fl. 1830—40s.
Line.
Port. (?)
Born in Manchester, Woodcock settled
in New York in 1830 but returned to
England after 1840.

WOODMAN John fl. first half of
19th c.
Line.
Arch. / land.

WOODMAN Richard 1784 (London)
— 1859 (London).
Aq., line., mixed., steel., stip.
Gen. / illus. / myth. / port. / sport.
The son of Richard Woodman
(fl. late 18th c.) a little-known
engraver, from whom he received
some instruction, the younger Richard
became a pupil of R.M. Meadows
(q.v.). After leaving Meadows he
earned his living colouring imitations
of works of William Westall (q.v.). In
1808 he became for a short time
superintendent of engraving at
Wedgwood's pottery works. Thereafter
he returned to London where he
worked as an independent engraver.
Woodman seldom engraved later in
life, and earned a living painting
watercolours and miniatures. His
sons Charles H. Woodman and
Richard H. Woodman were landscape
painters.
Aft.: H. Barraud, W. Barraud, J.
Bérenger, R.B. Davis, De Wilde, G.E.
Herring, J. Jackson, B. Marshall,
Poussin, Rubens, T. Weaver.
Pub.: W.D. Jones (Cambridge).
Lit.: *Art Journal* 1860, p. 47.
Connoisseur LXXII, p. 178;
LXXXXIV, p. 194. Prideaux S.
Aquatint Engraving 1909. Wilder
F.L. *English Sporting Prints* 1974.

WOODMAN Thomas fl. London
first half of 19th c.
Chromolitho., line.
Inventor of a chromolithographic
process.

WOODS John fl. 1830s—40s.
Line., steel.
Arch. / illus.
Aft.: R.W. Billings, H.K. Browne,
W. Capon, R. Garland, W. Purser,
J. Salmon, G.F. Sargent, J.H.
Shepherd, J.R. Thompson,
W. Tombleson.

WOODTHORPE V. fl. London first
half of 19th c.
Line.
Ex libris.

WOODWARD George M. 1760
(Derbyshire) — 1809 (London).
Et.
Gen. / hum. / sport.
Also a designer, caricaturist and writer.
Des. eng.: I. Cruikshank, T.
Rowlandson.
Pub.: Fores.

WOOLLARD Dorothy E.G. fl. end
of 19th c.
Aq., et., mezzo., stip.
Arch. / land. / port. / topog.
Pupil of R.E.J. Bush and Sir F. Short
(qq.v.).
Lit.: *Studio* LXI, p. 123.

WOOLNOTH Thomas A. 1785—
c. 1839.
Aq., line., steel., stip.
All. / flor. / gen. / illus. / port. / relig. /
sport. / theat. / topog.
Also a painter. Brother of William
Woolnoth (q.v.).
Aft.: Correggio, Finnie, Sir T.
Lawrence, Lee, Murillo, E.T. Parris,
C.F. Taylor, Van Dyck, Wageman,
Wivell.
Pup.: W. Walker (q.v.).

WOOLNOTH William b. c.1770.
Steel.
Arch. / illus. / land.
Brother of Thomas Woolnoth
(q.v.).
Aft.: W.H. Bartlett, R.W. Billings,
H.K. Browne, G. Cattermole,
R. Garland, H. Gastineau, J. Hastings,
J. Murphy, J.P. Neale, S. Prout, T.H.
Shepherd.

WOOLWARD Elizabeth fl. 1890s.
Litho.
Flor. / illus.

WOONE Godfrey fl. 1837.
Inventor of the process known as
gypsography (see Chapter VIII).

WORTHINGTON William Henry
c. 1790 — after 1845 (London).
Line., steel.
*All. / antiq. / gen. / hist. / illus. /
lit. / physiognomy / port.*
Also painted portraits and literary
subjects.
Aft.: J. Allen, C. Andras, T. Bewick,
R. Bowyer, De Loutherbourg, W.
Dobson, H. Eldridge, F.X. Fabre,
J. Greenhill, G.H. Harlow, Angelica
Kauffmann, H.L. Keens, H.
Pickersgill, Reynolds, Romney,
W.C. Ross, S.J. Stamp, T. Stothard,
J. Thurston, Sir W. Wilkie, Zoffany.
Pub.: H. Graves; Pickering.

WORTLEY Caroline Elizabeth Mary
Stuart (née Creighton) 1778—1856
(London).
Et. (amateur).
Theat.

WRANKMORE W.C. fl. 1844.
Steel.
Gen.
Aft.: C. Wrankmore.

WRIGHT A. fl. 1820s—30s.
Steel.
Gen.
Aft.: Hogarth, W.H. Worthington.

WRIGHT H. Boardman 1880—1917.
Et.

WRIGHT J.A. fl. 1847—84.
Steel.
Gen. / illus.
Aft.: H. Thompson, J.D. Watson,
Sir D. Wilkie.

WRIGHT J.H. fl. early 19th c.
Aq., mezzo.
Antiq. / illus. / land.

WRIGHT John or Inigo *c*. 1745
(London) — 1820 (London).
Line.
Port.
Aft.: Hoppner, W. Owen.

WRIGHT John 1857 (Harrogate)
— 1933 (Brasted).
Et., wood.
Illus.
Husband of the American painter and
engraver Louise Wright.
Lit.: *Studio* XXXIX, p. 69.

WRIGHT Richard Lewis fl. 1829—40.
Steel.
Arch. / ex libris / illus.
Aft.: O. Jewitt.

WRIGHT Thomas 1792 (Birmingham)
— 1849 (London).
Line., steel., stip.
Illus. / myth. / port.
Thomas Wright came to London with
his parents and at the age of fourteen
was apprenticed to Henry Meyer
(q.v.). After completing his time he
assisted his fellow pupil W.T. Fry
(q.v.) to complete some engravings. He
spent four years with Fry, and then
set up independently. He went to
St. Petersburg in 1822 to engrave
works after George Dawe, his
brother-in-law, returning to England
in 1826. In 1830 he went back to
St. Petersburg to arrange the affairs of
Dawe, who had returned from Russia
to England and died in that year; he
remained there fifteen years. Altogether
Wright made some 300 plates. He
was also a portrait painter and
miniaturist.
Aft.: G. Clint, G. Dawe, W. Drummond,
Reynolds, S.C. Smith.
Pub.: Colnaghi; Gambart.
Lit.: *Art Journal* 1849, p. 206.

WRIGHT W. fl. mid 19th c.
Wood.
Illus.
Worked for a period for Vizitelly
(q.v.).
Aft.: H. Weir.

WRIGHTSON John d. 1865.
Line., steel.
Illus. / land.
Worked in Birmingham, and from 1854
to 1860 in New York.

WRIOTHESLEY Mrs — See E.L.H.
Russell.

WYLD James 1812—87.
Steel.
Maps.

WYLD William 1806 (London) —
1889 (Paris).
Litho.
Illus. / topog.
Wyld abandoned a post as secretary
to the British Consul at Calais to
become an artist. Also a painter.

WYLLIE Harold b. London 1880.
Et.
Maine.
Also a painter, Harold was the son of
W.L. Wyllie (q.v.).

WYLLIE William Lionel R.A. 1851
(London) — 1931 (London).
Aq., dry., et.
Gen. / marine. / mil. / ship. / topog.
Noted as a painter of marine and
coastal scenery, Wyllie was the son of
the genre painter William Morison
Wyllie, brother of the landscape painter,
Charles William Wyllie and father of
H. Wyllie (q.v.). He studied at
Heatherley's and the R.A. Schools,
winning the Turner gold medal at the
latter. His own paintings were much
engraved, some in photogravure.
Pub.: Fine Art Society; L.H. Lefèvre.
Lit.: *Art Journal* 1889, pp. 221-26;
Christmas number 1907, p. 1.
Connoisseur LXXXVII, pp. 335, 340.
Dolman F. *William Lionel Wyllie
and his Work* 1898. Wedmore F.
Etching in England 1895.

WYMAN R. fl. late 19th — early
20th c.
Pub.

WYON Allan 1843—1907
(Hampstead).
Line.
Ex libris / stamps.
Allan Wyon was the son of
Benjamin Wyon, chief engraver of the
royal seals and a member of the
famous family of medallists. He was
himself a medallist and seal engraver,
and carried on the business founded
by his grandfather Thomas Wyon. He
engraved the private messenger stamps
of Lincoln College, Oxford.
Lit.: Lister R. *College Stamps of
Oxford and Cambridge* 1966, repr.
1974.

WYON Leonard C. 1826—91.
Line.
The son and pupil of William Wyon
and his assistant and successor at
the Royal Mint. Also a die sinker he
made the working dies for the G.P.O.
embossed stamped envelopes
c. 1851—2.

WYON William 1795 (Birmingham) —
1851 (Brighton).
Line.
Of German extraction, William Wyon
was apprenticed to his father, Thomas,
in 1809, in Birmingham, and to a
cousin, another Thomas, in London.
Also a die sinker, he was in 1816
appointed second engraver at the
Royal Mint and in 1824, chief
engraver.
 The head on his medal commemorat-
ing the first visit of Queen Victoria to
the City of London was used for the
Queen's portrait on the 1840 one
penny black postage stamps, engraved
by F. Heath (q.v.) from a watercolour
copy by Henry Corbould.

YATES E. fl. 1820s.
Litho.
Flor. / illus.

YATES James fl. 1840s.
Printer of engraved plates.

YATES Samuel fl. Liverpool
1790—1810.
Line.
Ex libris.

YATES and CO. fl. Nottingham
(Old Radford Works) *c.* 1890.
Print., pub.
Juv. dram.
Their sheets were issued as "The
Penny Theatre Royal".

YORK William Chapman fl. 1850s.
Line.
Topog.
Lit.: Engen Rodney K. *Victorian
Engravings* 1975.

YOUNG — fl. London (Union
Street, Clarendon Square) *c.* 1870.
Painter of clouded backgrounds to
tinsel portraits.

YOUNG — fl. 1840.
Steel.
Arch. / illus.
Aft.: W. Tombleson.

YOUNG E. fl. 1832.
Steel.
Arch. / illus.
Aft.: T. Allom.

YOUNG John 1755—1825
(London).
Et., mezzo.
*All. / gen. / illus. / myth. / port. /
relig. / sport.*
A pupil of V. Green and J.R. Smith
(qq.v.), Young was appointed
mezzotint engraver to the Prince of
Wales in 1789. He was honorary
secretary of the Artists' Benevolent
Fund 1810—13, and keeper of the
British Institution.
Aft.: Sir W. Beechey, Bestland,
Brand, A. Buck, Downman, G.
Garrard, D. Guest, Hoare, Hopkins,
Hoppner, Huck, Sir T. Lawrence,
Monnier, G. Morland, Mortimer,
R.M. Paye, E. Penny, Peters, H.
Richter, J. Rising, G. Romney,
T. Stothard, J. Ward, B. West, Whitby,
Zoffany.
Pub.: R.W. Sievier (q.v.).
Lit.: Chaloner-Smith J. *British
Mezzotint Portraits* 1926.

YOUNG R. fl. 1830s.
Steel.
Illus. / land.
Aft.: W.H. Bartlett.

YOUNG Robert fl. early — mid
19th c.
Et., steel., stip.
Illus. / port.
Principal assistant of Hablot K.
Browne (q.v.).
Aft.: J. Hayter.
Lit.: Steig Michael *Dickens and Phiz*
1978.

383

Young

YOUNG William Weston fl. late 18th
— early 19th c.
Et.
Illus. / land.
Also a painter on porcelain.

YOUNGMAN John Mallows 1817–99.
Et.
Land.
Pupil of Henry Sass. Worked in
London and Saffron Walden. Also a
landscape painter.
Lit.: *Art Journal* 1899, p. 94.

ZEITTER John Christian
d. London 1862.
Et., line., mezzo.
An. / gen. / lit. / port. / sport.
Born in Germany, Zeitter became the
son-in-law of H.T. Alken (q.v.). He
also painted landscape, flowers and
genre.
Aft.: H.T. Alken, W. Kidd, A. Nasmyth,
Wouverman.
Lit.: *Art Journal* 1859, p. 143; 1862,
p. 163. *Connoisseur* LXXXVII, pp. 224,
229.

ZIEGLER Conrad *c.* 1770 (Zurich) —
c. 1810.
Aq.
Illus. / mil.
Swiss national, a pupil of Conrad
Gessner, who worked for a time in
England.

ZINCKE W.T. fl. mid (?) 19th c.
Et.
Land.

ZOBEL George J. 1812—81 (Brixton).
Et., line., mezzo., mixed.
An. / gen. / hist. / nat. / port. / sport.

Aft.: G. Armfield, J. Bateman, A.J.
Battan, Rosa Bonheur, T. Brooks,
R. Buckner, S.J. Carter, L. Chialvia,
W.D. Clater, H.W.B. Davis, Comte de
Montpezat, A. de Salome, T.F.
Dicksee, E.U. Eddis, M.E. Edwards
(Mrs Staples), T. Gerdin, J.W. Gordon,
Sir F. Grant, H. Hardy, G.A. Holmes,
T.H. Illidge, T.M. Joy, E.S. Kennedy,
Sir E. Landseer, Lauchert, Lord
Leighton, J. Lucas, W. Maddox, A.
Melville, H. Merle, Sir J. Millais,
G. Morland, F. Newenham, J.S.
Noble, H.W. Phillips, H.W. Pickersgill,
A. Piot, Reynolds, Rippingill,
Rochard, Romney, C. Smith, W.
Simpson, G.A. Storey, J.R. Swinton,
W.F. Tiffin, H. Von Angeli, H.
Weigall, A. Williamson, F. Winterhalter,
C.H. Wright.
Shared.: F. Holl, W. Walker (qq.v.).
Pub.: Ackermann and Co,; T. Agnew;
Louis Brall; Brooker and Son;
B. Brooks; Colnaghi; Gambart;
Goupil; H. Graves; Leggatt, Hayward
and Leggatt; T. McLean; A. Tooth.
Lit.: *P.C.Q.* XVIII, p. 239.

385